G000066659

STEVE CARVER

WESTERN PORTRAITS
OF GREAT CHARACTER ACTORS

THE UNSUNG HEROES & VILLAINS
OF THE SILVER SCREEN

STEVE CARVER (Photographer & Author)

Brooklyn native Steve Carver studied photography at the University of Buffalo and Washington University in St. Louis. He pursued a formal education in filmmaking at the American Film Institute's Center for Advanced Film Studies, also participating in the Directors Guild of America's apprenticeship program. Prolific motion picture producer Roger Corman hired Carver to direct four movies, including *Big Bad Mama*. Carver also directed American action star Chuck Norris in *An Eye for an Eye* and *Lone Wolf McQuade*.

C. COURTNEY JOYNER (Co-author)

USC alum C. Courtney Joyner is an award-winning novelist, film journalist and screenwriter with more than twenty-five produced films to his credit, including *The Offspring*, starring Vincent Price, and *Prison*, starring Viggo Mortensen. His novels include the adventure *Nemo Rising* and the Western series *Shotgun*. A noted film historian, he has appeared in more than eighty documentaries on cinema, and his books on film include *The Westerners, The Book of Lists: Horror* and *Perspectives on Stephen King*.

STEPHEN B. ARMSTRONG (Editor)

Stephen B. Armstrong, Ph.D., is a professor of English at Dixie State University in St. George, Utah. His writing has appeared in numerous publications, including *Film Quarterly, Film Score Monthly, Filmfax* and *Quarterly Review of Film and Video*. His books include *Pictures about Extremes: The Films of John Frankenheimer, Paul Bartel: The Life and Films* and *Andrew V. McLaglen: The Life and Hollywood Career*. He also directed *Return to Little Hollywood*, an award-winning documentary about the history of motion picture production in southern Utah.

ROGER CORMAN (Foreword)

One of the most prolific and influential figures in the history of movies, Roger Corman sponsored several directors during the early parts of their careers, including Francis Ford Coppola, Peter Bogdanovich, Penelope Spheeris and Steve Carver. Corman has served as producer on hundreds of motion pictures. He has directed dozens of films himself, including the Westerns *Five Guns West* and *Gunslinger*. In 2009, he received an Honorary Award from the Academy of Motion Picture Arts and Sciences for "his unparalleled ability to nurture aspiring filmmakers."

WESTERN PORTRAITS

OF GREAT CHARACTER ACTORS

The Unsung Heroes & Villains
of the Silver Screen

PHOTOGRAPHER & AUTHOR: STEVE CARVER
CO-AUTHOR: C. COURTNEY JOYNER
EDITOR: STEPHEN B. ARMSTRONG
FOREWORD: ROGER CORMAN

Ⓔ EDITION OLMS

First published in Switzerland by
© 2019 Edition Olms AG, Zürich

EDITION OLMS AG
Willikonerstr. 10
CH-8618 Oetwil am See/Zürich
Switzerland

Mail: info@edition-olms.com
Web: www.edition-olms.com

A catalogue record for this book is available from the Deutsche Bibliothek
More detailed information under
http://dnb.ddb.de

ISBN 978-3-283-01290-8

Typesetting & Design: Weiß-Freiburg GmbH – Grafik und Buchgestaltung
Photography: Steve Carver
Cover Image: David Carradine
Illustrations: stock.adobe.com

Printed in Germany

TABLE OF CONTENTS

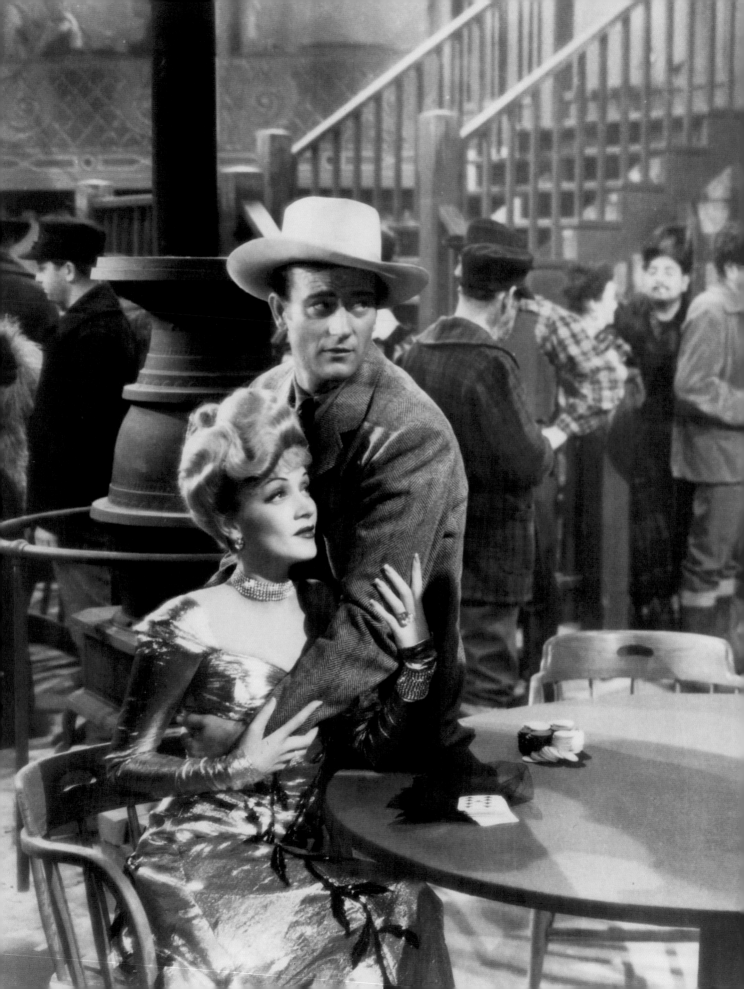

FOREWORD
Why Westerns Matter

BY ROGER CORMAN

WHEN I WAS fourteen, my father retired from his job as a civil engineer in Detroit and moved his family out west—to Beverly Hills. And as a teenager living near Hollywood, I became quite interested in movies. The ones I liked best often were Westerns, and to this day, I count John Ford's *My Darling Clementine* and George Stevens's *Shane* among the pictures I admire most.

One of my earliest professional experiences in motion picture production involved a Western. In 1948, I was twenty-two. I'd just completed an engineering degree at Stanford, but I knew I wanted to work in pictures. So I went back to Los Angeles and got a job at Twentieth Century Fox as a story analyst. A friend at the studio asked me to look over a script about a gunman who no longer wants to kill people. Gregory Peck was interested in the picture, but there were problems with continuity in the story, and the treatment of the hero's conflicted personality was not compelling. So I analyzed the script, and in the report I prepared for the studio executive assigned to the production I argued that more attention should be given to the main character's psychological disposition, especially his distaste for violence. My suggestions were adopted, and Gregory Peck agreed to star in the picture with Henry King directing. The resulting film, released as *The Gunfighter* in 1950, performed quite well at the box office. Critics liked it, too. The *New York Times* called the picture "one of the tautest and most stimulating Westerns of the year." And the screenplay received an Academy Award nomination.

I received little more than a thank you, however, for my contributions, and I eventually quit that job as a story analyst. The experience nevertheless was immensely important for me later when I began to make pictures myself as a director and producer. A good Western, I had learned, should tell a simple story that targets viewers' emotions and their convictions: their beliefs in right and wrong. George Stevens, Howard Hawks, John Ford, Budd Boetticher, Sam Peckinpah, Anthony Mann, Sergio Leone, Sam Fuller, Nicholas Ray, William A. Wellman, Fritz Lang, Delmer Daves—all masters of the movie Western—consistently took this approach, never overlooking the most

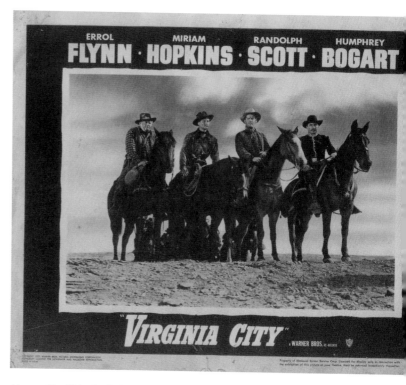

Above: Alan Hale, Errol Flynn, Guinn "Big Boy" Williams and Douglas Dumbrille ready for action in the 1940 Civil War epic *Virginia City*, directed by Michael Curtiz.

important function of a commercial film, which is to entertain. Their strongest pictures—Hawks's *Red River* comes to mind—also deliver depictions of how this country came to be—how settlers, lawmen, soldiers and even criminals brought order to the West. These directors were mythmakers, in short, who used scenes of action, comedy and sometimes even sex to help audiences understand this country's origins, and to better understand, arguably, what it means to be American.

The Westerns that still speak to me frequently feature characters drawn from the margins of society—drifters, convicts, prostitutes, bandits, renegades and the like. The central character in *Shane* is a gunman, for example, who protects a family of homesteaders from a vicious cattle driver. Through gunplay and bloodletting, Shane saves his friends, but in doing so he recognizes what he is—a killer—and the new

Left: Saloon owner Marlene Dietrich holds onto gold prospector John Wayne in the 1942 Universal production of *The Spoilers*, co-starring Randolph Scott.

American West, represented by the law-abiding homesteaders he's aided, really has no place for him. Shane is what Hemingway called "a man alone," and in helping to build this country, he loses his place in it.

In the mid-1950s, when cowboy pictures were at the height of their popularity, with dozens if not hundreds of features and TV shows in production in and around Los Angeles, I directed four low-budget pictures set in the Old West: *Five Guns West*, *Apache Woman*, *The Oklahoma Woman* and *Gunslinger*. *Five Guns West* was not just the first Western I directed, but the very first movie on which I was credited as director. In it, five soldiers, all convicted of violent crimes, are freed by their jailers to search for lost Confederate gold. We shot the film over nine days with a budget of sixty-thousand dollars, working out at the Iverson Movie Ranch, where John Ford had filmed parts of *Stagecoach*. On the first day of shooting, I remember, a rainstorm came in as I headed to the set in my car, and I pulled over and threw up!

The Westerns I directed were each conceived to exploit the public's appetite for action and entertainment, and all of them generated profits. But much as John Ford and Howard Hawks introduced social commentary into their depictions of the West, I did, too. *Apache Woman*, for instance, considers the conflicts that arose between Native Americans and white settlers in the nineteenth century and features a strong female protagonist. All four of my Westerns, by the way, give women prominent roles. I did this because women exemplify an "underdog" position that appeals to me as a filmmaker, and their contributions to American culture and history have been too often overlooked. The presence of attractive actors like Dorothy Malone and Beverly Lund in these pictures was something we could promote to ticket buyers, too.

Although *Gunslinger* was the last Western I directed, my affection for the genre never diminished. I had hoped to do a picture about Robert E. Lee at one point in the mid-1960s as Lee had served as an officer in the Mexican-American war decades before the Civil War. A film like this would have considered the manner yet again in which an outsider figure influenced the trajectory of history, but the picture was never made, which is a shame. During this same period, however, I did finance a pair of Westerns for a talented director named Monte Hellman, *Ride in the Whirlwind* and *The Shooting*. These films were shot in the southern Utah desert with Jack Nicholson playing leading roles in both.

Jack had appeared earlier in some of my own pictures, including *The Little Shop of Horrors* and *The Terror*, and he was at a stage in his career when he was deciding between becoming a screenwriter and an actor. It was his script upon which *Ride in the Whirlwind* was based, actually.

Jack was just one of several actors I worked with who wanted to write pictures but became well-known for acting in them instead. Another was Dick Miller. Dick had come to Hollywood from New York City in the mid-1950s. I had an office back then above the Cock'n Bull restaurant on Sunset Boulevard. A mutual friend, Jonathan Haze, introduced us, and during our first conversation Dick mentioned his interest in writing movies. I said, "I don't need a writer, I need actors." So I cast him in *Apache Woman* as a Native American character named Tall Tree. He played a cowboy in that picture, as well. Dick and I went on to make another fifty or so pictures together. He is one of those actors who never limited himself to a particular type of screen role, which can happen for traditional leading men. On occasion, Dick did play the lead in films, among them two pictures I directed, *War of the Satellites* and *A Bucket of Blood*. More often, though, he took on smaller supporting roles, playing cops, reporters, gangsters and so forth. A good character actor like Dick, and Dick is probably the best character actor I've worked with, complements the principals rather than competing with and trying to dominate them.

Toward the end of the 1960s, I was attached briefly to a Western that I was to direct for Columbia titled *The Long Ride Home*. This isn't the place to explain why things didn't work out, but the experience contributed to my decision to create my own production-distribution company, New World Pictures, in 1970. While we didn't make Westerns at New World—the public's appetite for these films I felt had started to lapse—I would argue that many of our releases owed a great deal in terms of theme and visual style to the genre. Pictures such as *Angels Hard as they Come* and *Bury Me an Angel*, for instance, tell stories about outlaw bikers who ride their motorcycles like horses through the same southern California locations used in many cowboy pictures. *Angels Hard as they Come* was in fact shot at the Paramount Movie Ranch, where John Sturges's *Gunfight at the O.K. Corral* had been filmed. And one of our later pictures, *Battle Beyond the Stars*, focuses on a band of mercenaries who protect a group of imperiled farmers—an homage, if you will, to Sturges's *The Magnificent Seven*. We even cast one of the original stars

from *The Magnificent Seven*, Robert Vaughn. Our picture was set in outer space, however, to capitalize on the popularity of *Star Wars*.

When I started New World, I wanted to take a break from directing and work primarily as a producer. Though I developed the bulk of the ideas for our movies, I gave young filmmakers the opportunity to direct them. Jonathan Demme got his start as a commercial motion picture director at New World. So did Joe Dante, Allan Arkush, Ron Howard, Penelope Spheeris and Steve Carver.

Steve came to work at New World around 1971 or 1972 as I recall. He'd been studying film production technique at the American Film Institute, where he'd had the opportunity to work with and learn from the likes of George Seaton, Dalton Trumbo and Alfred Hitchcock. For his student project, he had shot an adaptation of Edgar Allan Poe's "The Tell-Tale Heart." As someone who knew Poe's work well, I was impressed by Steve's handling of the material, and I offered him a job at New World.

At first, Steve cut trailers and features for us. He was conscientious and fast and willing to work long hours. I recognized in his editing work the same outstanding storytelling sense that I'd detected in his Poe film, so I gave him his own feature to direct, *The Arena*, a female gladiator film, which was shot in Rome. Later, after Steve returned to Los Angeles, I asked him to direct a second feature for us about a mother and her teen daughters who rob banks, which we titled *Big Bad Mama*. Angie Dickinson agreed to play the lead in this picture along with Bill Shatner and Tom Skerritt as her love interests. Although *Big Bad Mama* is set during the Depression—not unlike Arthur Penn's *Bonnie and Clyde* and my own *Bloody Mama*—the influence of the Western on this picture is pronounced. Angie, during the first decade of her career, had appeared in numerous TV Westerns and two memorable Western features—Sam Fuller's *Run of the Arrow* and Howard Hawks's *Rio Bravo*. In our picture, she presented herself credibly as a social outsider at odds with the same unpleasant figures of authority that the gunfighter hero faces in *Shane*. *Big Bad Mama* looks like a Western, too, as Steve and the director of photography, Bruce Logan, made extensive use of the ranchland and sandy desert hills that surround Temecula, California, where much of the picture was shot. Another feature Steve directed for me, *Fast Charlie... The Moonbeam Rider*, a motorcycle picture starring David Carradine, looks like a Western, too, with sections in it that were shot on location in Oklahoma as well as the desert landscape in southern California that stretches east of the San Bernardino mountains over to Victorville.

Altogether, Steve directed four pictures for me, those I've cited and a feature about Al Capone with Ben Gazzara as the lead. These movies all earned profits, and I would have liked to work with Steve further, but he went on to make films with budgets that ran higher than ours, among them a big hit, *Lone Wolf McQuade*, with Chuck Norris and David Carradine. Seeing David's photographic portrait in Steve's book, I should note, brings back numerous memories. David starred in several New World productions, most famously, perhaps, *Death Race 2000*. But as he grew older, as so often happens, he evolved into a compelling supporting actor, just the sort Steve and writer C. Courtney Joyner honor so successfully. Dick Miller shows up in these pages, as well, as do a number of others who worked on my pictures, among them R. G. Armstrong, Robert Carradine, Johnny Crawford, Henry Silva, Robert Forster, Rick Dano and Jesse Vint. I'm happy to see that Karl Malden had himself photographed by Steve, as well, for this project. Karl played a bartender in *The Gunfighter*—the Western that more or less started my career in movies.

Do Westerns still matter? Decades have passed since the genre's heyday, and neither the big studios nor the independents turn out Western-themed features and TV programs with anything like the frequency that characterized Hollywood sixty or seventy years ago. Yet the genre, I believe, remains vital—culturally, if not commercially. Consider a picture like Ford's *The Searchers*, which depicts the problem of racism, a problem that has afflicted this country for centuries. *The Searchers* fulfills its obligation to entertain the audience with scenes of action, comedy, even some sex. And yet it doesn't forgo the ethical convictions that drove Ford as he made the picture. The case can be made, I would argue, that the best Westerns are always the ones that dramatize the conflicts that arise from opposing moral perceptions. This happens in *Shane*. *The Man Who Shot Liberty Valance*, too. And *The Ox-Bow Incident* and *My Darling Clementine*. This tendency has persisted up to the present, materializing in such excellent productions as the Coens' *True Grit* and Quentin Tarantino's *Django Unchained*. If a Hollywood genre has been able to show American society how it sees itself through its crises and its aspirations, it's the Western. As long as this country exists, I suspect, these films will matter.

PREFACE
Thoughts on the Photography of Steve Carver

BY KIM WESTON

PHOTOGRAPHY IS A very technical discipline. You're using a camera and all the chemistry of the darkroom, that wizardry, all combine because that's the process. Most photographers go out and look for things to capture, and at least in my work I wanted everything in that photograph to be something that I decided.

That kind of creation is very exciting to me. Now I don't know if that means I'm a control freak, but it meant more to me to build those sets, find the props and put in the lighting and control it, and not allowing these things to chance. When I photograph a model, that's an interaction between two people and another part of the process that I particularly enjoy. I'm not just recording her, we're working together as artists, on the set, in that lighting. It's a team effort to create a work of art.

I think Steve Carver is doing the same thing.

By recreating a period, time and place with these actors who made so many Westerns, Steve isn't just doing a tribute to the movies, but to these performers, and their lives, and their work.

Every detail in these photographs is a re-enactment, but this is a recreation in the best sense. The actors are walking onto a set, and they are immediately comfortable because they've spent so much of their time and careers in places exactly like Steve has recreated, and it relaxes them to be in that kind of environment, so their personalities shine through, and you get these amazing expressions on their faces, which Steve has captured brilliantly.

These images were directed like they were directed in a scene for a film, and that's what's so unique about Steve's work, because he's capturing a moment in time, something that no longer exists, and done it splendidly, and all of it on sets that he built. There's so much of the landscape stuff, outdoors with the trees, that really doesn't interest me as a photographer, so the idea that Steve can work on his process like this, in a created world, over a long period of time, to capture exactly what he wants to honor is wonderful.

When I build my sets, I don't just haphazardly go at it. It's got to be planned: sitting down, drawing the sets out, where the people are going to be: And I think Steve has done exactly the same thing. It's very movie-like, as it should be, and the finished product is a record of that process.

Frankly, I was blown away to see, and recognize, all of these faces from Western movies and TV presented in this way: to bring back all of these memories of who they were and still are.

To me, portrait work is some of the hardest to do. With my grandfather's work, I always loved his portraits. Even though they're not his most famous images, he was an incredible portrait photographer. Over the fireplace in my living room, there's a portrait of Tina Modotti that he did in Mexico, and she's actually reciting poetry while he photographed her, and you get this incredible sense of motion from that photograph, and I think Steve has captured that same feeling with the portraits of these actors.

Some of the character actors, whose names I didn't know or couldn't remember, I instantly recognized in the photographs because they carried their history with them. You see that portrait, and you flash back to the movie. I was thinking, "Now what Western was he in?" Because they'd made this incredible impression when I saw the film all this time ago.

There's an emotional aura about them that really makes you understand that they're really iconic people, because their connection to Western movies is so complete. And the personalities of each, who was funny or an outlaw, is right there in Steve's photographs. Everything is constructed to bring out the essence of these actors, which I think he really did.

But also, each image is brilliantly different. They are unique, the images, just as the character actors are as individuals. Even the ones who weren't the stars, without them playing their roles, the whole movie would fall apart.

Photography is not like painting, where all you have is paint and a canvas. The materials that Steve used, and the research to find them; to replicate a sort of older genre type of photograph from the 1800s; to get the right film and controlled lighting and props

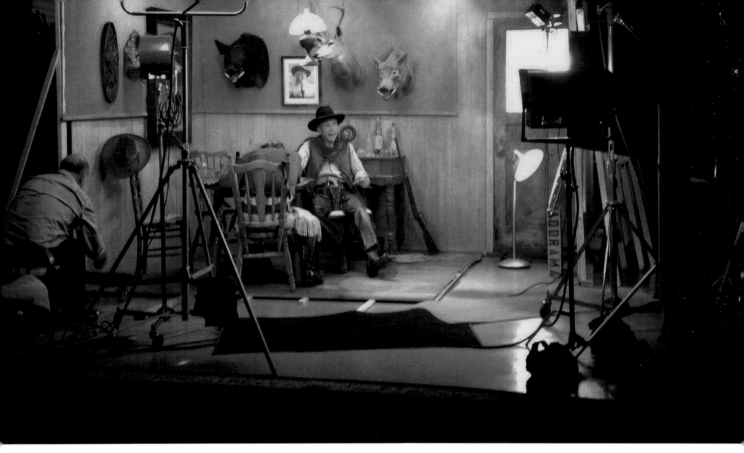

Above: Johnny Crawford posing for his photograph at IMAGE Studios.

all play a part, and very few other art processes have that sort of craft built into them.

Photography is that way when you're working with your models or actors. Here, we see the actors in their famous costumes, or the way we think of them onscreen. But Steve was putting them into the 1800s through his process also. They had to hold a pose, as they did in the 1800s. You had to stand still for the exposure, and Steve recreated that also, adding something authentic from the period, and that's another piece of the puzzle.

It's also Steve's printing and his attention to detail in the darkroom that makes these photographs so unique and brings out so much in each image. That's his craft. From the moment he placed his actors on the set and took the photographs, using smoke as atmosphere, he was building a piece of artwork. Every single step is a choice, another decision. Photography lends itself to having all these steps, these gadgets, to make the final process happen.

There are many, many different creative choices Steve has in taking these images, and then printing them, for the final product. He really nailed it when he put all of his technical skills together to come up with the finished product that he has.

These portraits are a labor of love and dedication to craft to make it all work. I think they are legendary, about a legendary subject, and will live forever.

11

BY STEVE CARVER

In early 1993 I was in Russia directing *The Wolves*, a feature film for a German production company. A vagrant in Red Square approached me about buying a used Nikon FE 35mm camera. "Probably stolen," I thought, "but what the heck. Somebody else will buy it, no doubt, and it's only a few rubles."

I hadn't touched a single lens reflex camera for over twenty years, but once I started using the Nikon, it spoke to my memory. On weekends off, I took expeditions throughout the countryside, shooting black-and-white photographs, capturing penetrating portraits of Russian farmers, peasants and gypsies. As my collection of negatives and images grew, it became apparent that photography was something that I needed to pursue again.

After returning to Los Angeles, I decided to take a break from directing and turned my attention to a different kind of creative enterprise, establishing a photography lab in Venice Beach, which I called The Darkroom. For five years, I held the distinction of being the sole owner, operator, technician, educator and photographer, laboring to support the facility. I should mention that I lived on the premises, as well.

With brisk business and the meticulously-designed mechanics and plumbing of the lab and darkroom working smoothly, in my free time I began researching portrait photographers from the late-nineteenth and early-twentieth centuries: Edward Sheriff Curtis, Alfred Stieglitz, Edward Weston, Alfred Steichen, Henri Cartier-Bresson and others. In turn, I focused my efforts on using applications of early chemical processes, liberally incorporating old and new technologies into my photography as a means of expression.

After months of testing, I favored a Kodak panchromatic film with a slow speed, high resolution, extended tonal range and archival capabilities initially developed by NASA. In the field of artistic photography, black and white photography is most complex. There is discovery of a whole new character in a familiar subject—a way of letting the viewer really experience the image, from the composition to textures and tonal qualities, as color is absent. Because of the dynamic effects of light and shadows, the image has a completely different impact from the color portrait. Using long exposure photography and then "pulling" the negative several stops during processing, I captured numerous subtleties, producing images with enhanced tonal characteristics on fiber based photographic paper. Applying gold, sepia and selenium image permanence treatments that incorporated the complexion of stylized portraiture enabled me to render rare evocative tones and complex patinas reminiscent of historical photographs.

The Darkroom gained popularity and attracted a core group of accomplished photographers, conservators, private collectors, archivists and museum curators. Although at the outset the business was a work quest, my experimentation on the side generated a personal collection, a series of formal portraits, tests, playful exercises and serious works of art. I constructed small set pieces in the lab and asked friends to come over and sit for portraits. Often late at night I would stand in front of The Darkroom and persuade an occasional passerby or homeless person to come in and let me photograph him or her. When that became tedious, Sundays turned into party nights with food and drink—and a set.

As a portraitist, I began creating sensuous, even moody, studies that I regarded at the time as being among my highest artistic achievements. My portraiture served as an expressive and diverse cultural document, chronicling life and history while conveying the emotional, psychological and spiritual dimensions of the subjects. In short, I was rendering something more than likenesses as I worked.

My interest was further directed toward archival collections of prints and negatives used by researchers and scholars to ensure the preservation of cultural heritages. By borrowing historical negatives from private collectors and printing the images on vintage paper purchased from local photographers, I created "replicas," using advanced printing techniques that re-established the finer details and aspects of the original photographs. The end results were images processed using the highest-quality chemistry and

toned to insure archival permanence, strengthening values to withstand the wear and tear of urban pollution, weather and a host of other causes of deterioration, at the same time ensuring the safe preservation of the originals.

I had begun collecting a number of historical replica prints, as well, and sought assignments from museums, offering my services to supplement their holdings. It was my understanding then that many great museums acquire replicas for their permanent collections due to deterioration of original prints—and I foresaw a potential opportunity at the J. Paul Getty Conservatory Institute. In my haste of preparing prints, and failing to mention that these were replicas, I submitted four archival photographs to the Institute's photography curator. While three of the prints were recognizable as the work of Weston, Stieglitz and Cartier-Bresson, the fourth was a "new" portrait of a Native American woman that I had created, which was remarkably similar to an Edward Sheriff Curtis image, whose work I greatly admired. After several weeks, to my surprise, the response from the museum was less than favorable. While the replica prints, first mistaken as originals, seemed engaging enough to warrant a polite response, my image of the Native American woman drew outright disdain. In a subsequent conversation with a Getty insider, I was told that the curator believed when he first saw my photograph that he had discovered an unknown Curtis print and that it was a huge embarrassment for him later when he learned about its actual origin. Further attempts to contact the curator were unsuccessful, and any hope of obtaining an assignment from the Getty faded.

Below: Bo Hopkins posing for his photograph at IMAGE Studios.

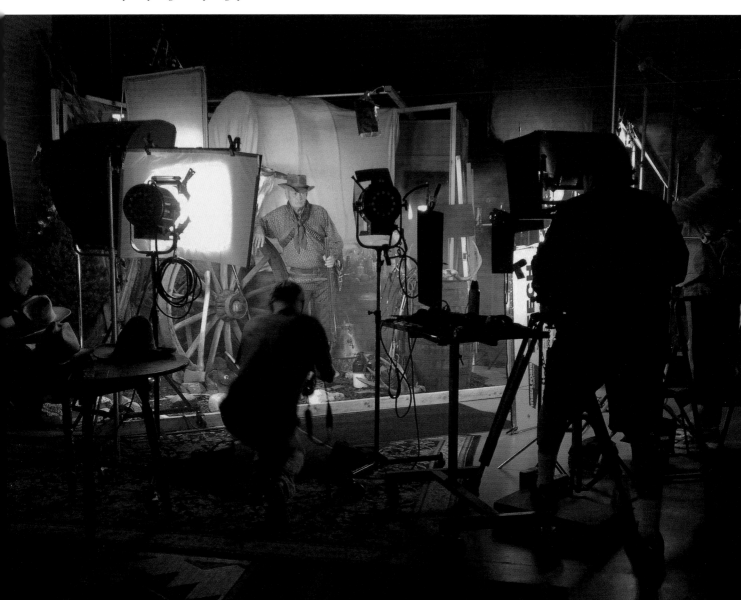

Nevertheless, several smaller museums and galleries that required preserving their original photographs purchased my replica prints. I recognized, as well, that a market for vintage portraiture existed, and to enhance sales to private collectors, I started to search for experienced sitters. "What better sitter than an actor?" I thought, and I turned to my friend R. G. Armstrong, who had appeared in several feature films I directed.

For years R. G. and I played pool. It was over a game, in fact, that we first discussed the idea of a photography book. I asked him point blank which character he'd want to portray. Without hesitation, he declared in his gruff Alabamian drawl that the characters who mattered most to him were the ones he played in movies he made with Sam Peckinpah, pictures like *Ride the High Country*, *The Ballad of Cable Hogue* and *Pat Garrett and Billy the Kid*. He typically found himself cast in these movies as lawmen, clergymen, drunks or sharecroppers, most all of them extremely angry, and a good fistful crazy to boot. As he was such a charming, cordial and funny guy in person, I was struck by Peckinpah's remark that R. G. played "righteous villainy" better than anybody he had ever seen. When I asked R. G. why he was so good in these roles, he explained that growing up with a belligerent father, and not wanting to be a violent man himself, he learned to repress enormous anger; but when he played these villain roles, drawing on that anger enabled him to descend into an instant rage. It was not acting, it was real.

Our discussion that night left an immediate, and emotional, impression. I wondered if his portrait would testify to his psyche—perhaps capture his inner workings. As an actor with so many facets, it was exciting to have the opportunity to photograph R. G.'s persona. And from this came the idea for this book, a photographic collection of America's most respected Western character actors.

In March of 1996 formal preparation for the book began. Putting together a reliable crew and gathering the set dressings and props involved an enormous amount of work and some luck. I had met Robert Zinner, a fine arts collector and an Old West historian, a few months earlier when he was visiting Bob Burkinshaw, an antiques dealer who lived next door to The Darkroom. Burkinshaw had all the furnishings that I would need to dress the sets. To my surprise, not only had I reproduced several Curtis images for private collectors that Zinner himself owned, but Zinner was also an avid collector of Western costumes, artifacts and firearms. He would

work closely and passionately with me for the entire project. Rounding out the small, efficient crew were Carol Hills, a close friend who was handy with tools and assisted with the set building, Randy Lalaian, who helped me with the lighting and special effects, and Linda Sixfeathers, a wonderfully proficient hair-and-makeup artist.

During the days that followed my conversation with R. G., The Darkroom bustled with photographers processing their film and prints. The lab was well-kept and orderly as a photography facility should be. But on Sunday morning, after closing down and covering the sensitive equipment with plastic sheeting, the place was reduced to an eerie setting. Assembling the Western set for R. G. consisted of nailing plank walls together, laying down a wooden floor, bringing in set pieces, lights and camera. The once immaculate lab was now a cluttered stable, complete with straw strewn about. To illuminate this small set standing in front of the enlarger booths and sinks, I used incandescent halogen fixtures affixed with scrims and dimmers, which bounced light off mirrors and shiny boards to reflect back into the space, producing warm, soft lighting. My Nikon 35mm camera was positioned as far back from the set as possible and stabilized with a custom-designed, heavy table-top tripod head firmly braced to absorb vibrations during time exposures.

With prep complete just minutes before R. G. walked in, the first portrait session for the book commenced. Seated in a wooden chair, wearing a buffalo skin coat, an 1873 Winchester carbine slung over his shoulder, his wild eyes staring at the camera, R. G. resembled a curious cross between Buffalo Bill and Grizzly Adams. Each of the thirty-six shots taken on 35mm film that day required him to remain very still and take shallow breaths as I counted off the seconds. Using long exposures like those taken during the late-nineteenth century due to slow film emulsions, I could mimic the old process with low, complex lighting, permitting the negative to record outstanding tonal qualities and details. Theatrical smoke in the rear of the set made the photograph appear similar to a vintage rendering.

Striving to capture a familiar image of R. G. from some vaguely remembered Western was too intriguing to resist, and the shoot went on for hours until we finally wrapped out well after midnight. After disassembling the set and restoring the lab back to its former spotless condition, I was left with a few hours of sleep before I had to open the door for business on Monday morning. As soon as I had an opportunity,

I went into the darkroom and prepared the negatives for processing in the lab. The rich, detailed results revealed that I was on the right path.

R. G.'s shoot helped to define my creative strategy. Rather than a sentimental representation or glorification of the Old West, I would pursue a straightforward depiction of reality and design sets that would complement the actor's "character." Dressing the set with artifacts from the era and creating a "role" for each actor to engage in would stimulate viewers' imagination and, coupled with their knowledge of the subject matter, would allow them to piece together the "story" being told.

Recruitment for the collection prompted me to research other Western character actors.

L. Q. Jones immediately came to mind. In classic Westerns such as *Ride the High Country, Hang 'Em High, The Wild Bunch, The Ballad of Cable Hogue* and *Pat Garrett and Billy the Kid,* L. Q. frequently portrayed sly, villainous characters. I had directed him, as well, in several movies with R. G., including *Lone Wolf McQuade,* in which he played a Texas Ranger. When L. Q. learned that R. G. had posed for the book, he was determined to participate, too; to play a role before the camera, albeit it a still camera, impassioned L. Q. just as it had his old friend. In keeping with the image of a late-nineteenth-century lawman, sitting in a richly decorated Victorian parlor, L. Q. wore a black leather vest, bib shirt, matching pants and ribbon tie. Without much prodding or direction from me, his craggy, gaunt looks and naturalistic manner, highlighted by his shockingly white hair, were uniquely captured.

David Carradine, one of the leads in *Lone Wolf McQuade,* was next to pose. He had appeared in several Westerns, too: *Mr. Horn, High Noon II: The Return of Will Kane, The Long Riders, Miracle of Sage Creek* and *All Hell Broke Loose.* Having worked with David on several films, we were good friends and our relationship created private moments during the shoot when sometimes our imagination and the photographic image aligned perfectly. Many of his portraits achieved an honest and convincing representation of the passions of his soul.

Several adjustments early on shaped the course of the work. The plan was at first to photograph character actors who helped define the gritty, harsh and mysterious personae that dominated the Western genre—and, fundamentally, to choose recognizable actors valued equally for their Western films and fame. Each photograph would match in style and technique with other images in the collection. Set design and construction during the project's earliest stages were to be based on vintage Western photographs. But the actors themselves often offered suggestions for the inclusion and placement of props in the shots, prompting us to improvise as we collaborated, resulting in sets that were better suited for them. Another change concerned the book's working title, *The Dying Breed.* Some actors at first declined to sit for the camera because they did not like the connotation of the word "dying"—so I changed the title to *Western Portraits of Great Character Actors: The Unsung Heroes & Villains of the Silver Screen.* Although this helped win over some of the actors, several were still reluctant to pose. These few held the notion of some dramatic code—that taking their portrait was a serious matter, part of a "visual legacy," something so personal that it created an impasse, ending any further discussion. At times I felt like a salesman getting a door slammed in my face!

Word of mouth around Hollywood nevertheless brought the project to the attention of all sorts of actors who eventually came to The Darkroom to get their portraits taken. And the fact that several comedians and movie producers associated with Westerns dropped in by chance and circumstance allowed me to expand the scope of the collection. Many of the subjects, confined within small sets, projected an intriguing sense of isolation visually, which is most evident, I think, in the portraits of John Beck, Robert Carradine, Billy Green Bush, John Dennis Johnston, Harris Yulin and Horst Buchholz. Engaging narratives could be decoded from their faces and gestures. For example, the expression of former studio chief and one-time actor Robert Evans—eyes staring intently, his pose dramatically lighted, a Winchester rifle at ready—is haunting.

Buddy Hackett's deportment as a brooding and melancholic ranch hand seated alone in a bunkhouse lends humor to his portrait. As a sort of confession to his inner state, he set the stage for Jan-Michael Vincent, Hunter von Leer, Max Gail, Gregory Harrison and a handful of other actors in unconventional depictions. Favoring the complex patinas of vintage photographs, I began assembling a collection in which each image provided a visual moment for the actor to perform as if he were in a movie scene. The photograph of Denver Pyle, who was stricken at the time with ultimately fatal cancer, delivers a penetrating rendering of a proud lawman, a momentary, selected facet of a strong persona. A similar psychological presence characterizes my portraits of Karl Malden, Morgan Woodward, Henry Silva, William Smith and Hugh O'Brian somewhere in the spaces

15

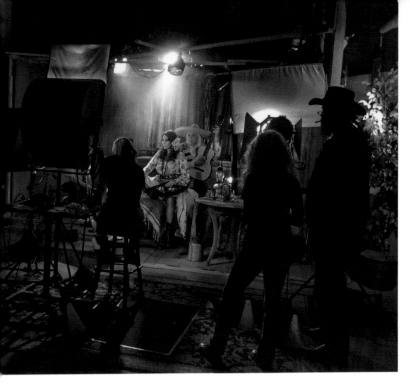

Above: BarBara Luna posing for her photograph at IMAGE Studios.

between the warm, silvery tones of the images—the feeling of tough men recreating their place in the Old West.

The project gained momentum, and the collection increased in size, but then new owners took over the building, the lease for my space was terminated, and, after five years, The Darkroom closed. Putting the book on hold, I began to accept film and writing assignments again. Years flew by. During that time, however, I drew up floor plans for a custom lab and darkroom and occasionally searched for another location, but nothing seemed quite right. Getting back into the photography proved difficult, too, as cost became a factor—photographic equipment and supplies had considerably gone up. In the spring of 2014, I was determined finally to drop everything I was then doing. My promise to R. G. Armstrong to complete the book project before he died precluded any reasonable judgment concerning the cost that it would take. I managed to secure some additional funding and committed myself full-time to completely restoring a building that was once part of the Hostess Cakes Bakery in mid-city Los Angeles. There I set up IMAGE, a photography studio, lab and darkroom, a unique environment for creativity, experimentation and artistic exchange.

IMAGE features an expansive photography studio with rollup doors and high ceilings, a second floor progressive chemical laboratory and darkroom, work rooms for post-photography, wardrobe and makeup, a workshop, plenty of storage space and a comfortable private residence—just about everything I needed to complete the book project.

Asking C. Courtney Joyner to compose the text specifically for this book was a no-brainer since I had collaborated with him on several film projects over the years. An award-winning writer, Courtney provided anecdotal essays from the personal vantage points of the actors, which now appear on the pages opposite their photographs. These essays pay tribute to the actors' contributions to Westerns, and film history in general, as so many of them worked alongside Hollywood greats like John Wayne, John Ford, Howard Hawks, Sam Peckinpah and my mentor Roger Corman.

My highly capable and eager friend Bobby Zinner contributed to stocking the studio with an abundance of Western wardrobe, weapons and artifacts, which Al Frisch, one of the best authorities on Hollywood movie costumes and guns, later supplemented. Complementing the crew was stylist Tami Orloff, several hair and makeup artists, studio interns, who helped with set construction and lighting, and Danny Chuchian, an all-around assistant and special effects man—his use of theatrical smoke would greatly add to the visual effect of the images.

Unlike the simply designed portraiture created at The Darkroom, I realized that the photography at IMAGE would require different, larger sets that would have to be constructed with greater authentic detail, complete with a movable stage and interchangeable walls that could accommodate a variety of classic Old West themes. Many of the pictorial devices employed previously required improvement—the new sets dressed with elaborate and authentic artifacts and their versatility allowed endless interior and exterior scenes to tell unique visual stories.

I also upgraded to a Hasselblad Flexbody View Camera with an 80mm Zeiss/Hasselblad lens. Appreciated for its remarkable precision, as a medium-format camera that produces a larger negative, it was the essential tool for the resurrected project. To create warm, silvery-toned images, a specific strategy for lighting using only incandescent elements and specifically designed diffusion was employed—also mirrored board surfaces that refracted light, thereby enhancing the sets' shadowed areas.

I now sought out the most immediately recognizable character actors to photograph. Drawing upon nearly five decades of great character actors who had been in Westerns became a considerable task, par-

ticularly when so many were in their later years and living in distant locations. I received a number of suggestions after spreading the word about the book project within the Hollywood film community to enhance the collection with actresses who had important roles in Westerns, most notably Ruta Lee.

The time came to resume photography. During the first shoot with Bo Svenson, the staging, though acutely defined, set a "dramatic" course for the photography that would follow. Bo portrayed a character strictly for nostalgic reasons, selecting a scenario based on an imaginary love interest, which brings to mind a quote by photographer Richard Avedon who maintained that "when the actor portrayed is playing a role, in disguise, or otherwise fictionalized, an alter ego is encountered." Bo's face, you will find, is etched with emotion, and his body language reveals the story that he wished to tell.

Staging and posing actors with a given perspective, scenarios as "performance," could yield clear and convincing stories. Two weeks later, posing in a simulated brothel with an attractive "soiled dove" by his side, Bruce Glover acted out a scene that could be in a Fellini movie, his face reflecting pride and passion. Portraits that followed provided similar clues for a deductive narration—stories being told not only from the expressions on the faces of the actors, but also from artifacts and dressings on the set. Clu Gulager is barely recognizable as an Indian trader in a cluttered teepee. So, too, Ruta Lee conflates her personality with the idealized beauty of Annie Oakley. And there is George Hamilton assuming the classical pose of a nineteenth-century gambler with two beautiful, adoring women. In a Civil War setting, Union officer Bruce Davison poses with his rifle beneath a tent next to a field cannon, and Tim Thomerson standing in a blacksmith's shed quietly leans on a post and stares at the camera—the image a subtle homage to the Western hero.

As fictional narrative conveyed through performance Jeff Kober poses amid several ladies in a rich boudoir setting. Robert Forster's deportment is that of a proud cattleman as he sits with a rifle against his leg, Native American finery embellishing his ranch house. Bruce Boxleitner, Paul Koslo, Marty Kove, Lana Wood and Bo Hopkins are represented as colorful personalities of the Wild West, too. All exhibit a profound involvement with their surroundings. In her portrait Stefanie Powers stands in a stable as a rugged gun-toting woman. In a Mexican cantina, BarBara Luna enacts a dramatic moment as she's serenaded. In another role, Peter Mark Richman

portrays a cardsharp, revealing a winning hand to us. Johnny Crawford, the kid in *The Rifleman* TV series, sits at a poker table as a character quite unlike himself, smug and victorious. In keeping with the romantic West, John Schneider assumes the classic stance of a handsome cowboy at a wagon campfire set.

One overriding characteristic of the pictorial illusion created through extended time exposure, creative lighting and smoke effects was the occasional unforeseen "anomaly" appearing on the film. Although some of these irregularities can be interpreted as a trick of light or imaginary distortion, in the portrait of Buddy Hackett, for instance, an historic Winchester rifle appears on the left of the image as a latent "ghost"—the same rifle positioned in the exact space a week earlier on a set with L. Q. Jones. This was not a double exposure but an unexplained visual incongruity associated with the photographic process, surfacing in numerous images throughout pictorial history under the guise of "paranormal phenomenon."

The most disquieting anomaly arose during the photography session with Denver Pyle. At the time, he was ill and weakened from cancer treatments. In the processed images, his facial features were so distorted that he appeared spectral. Believing that the show must go on, Denver agreed to return a week later. With his energy vastly improved, dressed as a frontier lawman, he appeared normal, his true self emanating in heroic form.

During June 2017, a few crew members and I posed for the book, and after twenty-two years and three months, the collection for the book was complete. The time had come to close down the Western sets and put aside the camera. Having such a coherent group of images devoted to a single theme was indeed remarkable. In a way, the portraits enhanced an already deep appreciation I had had for the actors and actresses striving to underscore their roles within the Western genre.

As a unique photographic collection of America's most respected and remembered supporting players, the purpose of this collection is twofold—to celebrate some of the great character actors who have strong, distinctive personalities; and to serve as an important resource, featuring as it does Hollywood's best-loved players and their history. It will awaken memories and introduce the actors to those who do not have the benefit of knowing these wonderful heroes and villains of the cinema.

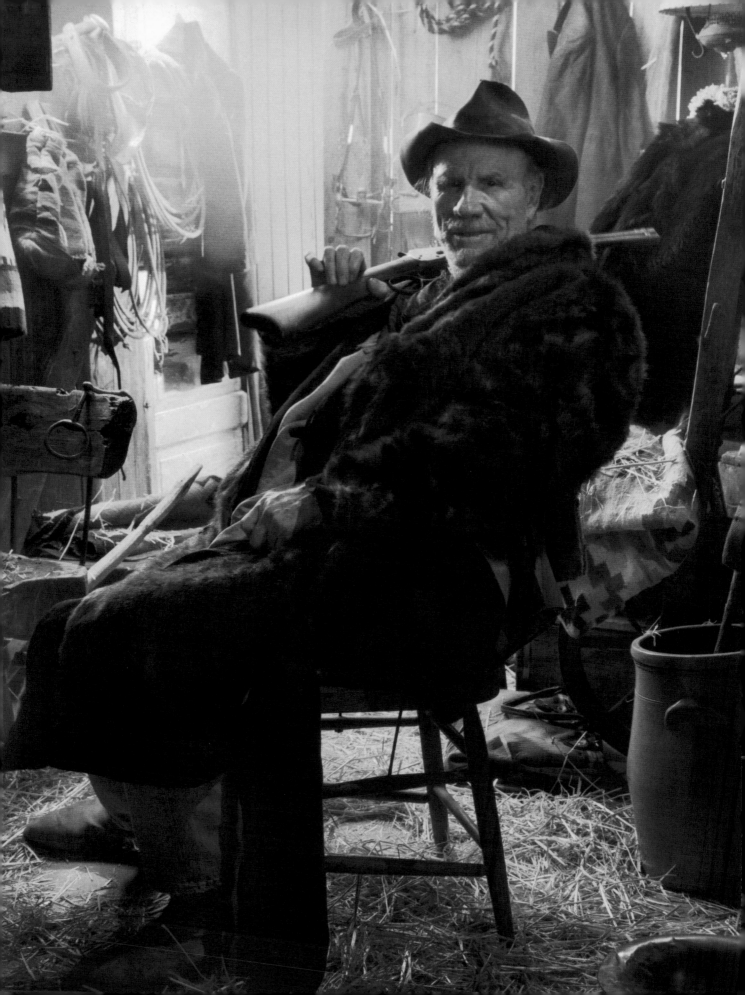

R. G. ARMSTRONG
THE WRATH OF GOD

"I got my shotgun filled with sixteen thin dimes, enough to spread you out like a crazy woman's quilt. Why don't you sing the song of Jesus while there's still a way?… Repent you son-of-a-bitch! I'll take you on a walk across hell on a spider's web!"

THESE LINES OF dialog all come from Sam Peckinpah's memorial-to-legend *Pat Garrett and Billy the Kid*, and they are spoken by R. G. Armstrong as zealot Deputy Bob Ollinger, who rages against a defiant and blasphemous Billy (played by outlaw country music singer Kris Kristofferson). This is the famous, historical moment when Billy escapes from Pat Garrett's jail and murders Ollinger with his own shotgun. Before the blast, R. G. looks up at Billy, knowing he's going to meet his maker, and his final line is a simple but authoritative "He's killed me, too."

Prior to this scene, Peckinpah places R. G. Armstrong in the room's corner on a hard-backed chair, shotgun resting across his knees. Cinematographer John Coquillan paints it all with the light-brown shadows and burnt yellow of the afternoon sun, capturing a pose and image truly from another time, one that R. G. completely embodies with stillness before his self-righteous rage explodes.

Robert Golden Armstrong could dominate a scene simply by being in it, and when he spoke, the echoes of his Alabama accent still intact, there was no doubt that this was a character, a man, to be reckoned with. Raised in a fundamentalist Christian family and expected to pursue the ministry, Armstrong broke with tradition to follow a calling to New York, where, with good friend Andy Griffith, he found Broadway success as an actor while also making an off-Broadway name for himself as a playwright. Early television kept him fed, but it was his performance as Helen Keller's stoic father in *The Miracle Worker* that contributed to his casting in "The Turkey Shoot," the half-hour pilot for *The Rifleman*, written and directed by Sam Peckinpah.

Working in television in the late 1950s and early '60s meant that he appeared regularly on Westerns. He'd ride a horse into Dodge City or across the Cimarron Strip like every other character actor in town, moving from one episodic program about the Old West to another, racking up more than sixty appearances. But Armstrong wasn't a journeyman interchangeable with anyone else. His size and voice made him unique, and when he confronted a hero, whether it was James Arness or Clint Walker, he met them with his own force of personality; he was the rock against which all men crashed, until the final shoot-out, and, even then, R. G. Armstrong might survive.

Brought up in a strict, religious home himself, Sam Peckinpah bonded with Armstrong, and the two formed a friendship and alliance that saw the actor cast the southerner in *Ride the High Country*, *Major Dundee*, *The Balled of Cable Hogue* and *Pat Garrett*. Peckinpah found in Armstrong the unwavering iron will of a man of the Bible, and it was no accident that the actor was often armed with a copy of the Old Testament along with a Colt .45 or a double-barreled shotgun while delivering sermon-like dialog. R. G. laughed at the typecasting: "That's just how Sam always saw me."

In Howard Hawks's *El Dorado*, he again plays a father who stands up for his children, as he did in *Ride the High Country*, but here he tries to right the wrongful death of his son (Johnny Crawford). The problem is, it is John Wayne who shot the boy, and Armstrong must come to terms with Wayne's guilt, summoning empathy instead of calling the Duke out for a showdown. We'll never know who'd win in a shootout between these two giants, but can be sure it'd be a hell of a thing to see.

During *The Great Northfield Minnesota Raid*, a solid re-telling of the Jesse James saga, director Philip Kaufman has his director of photography, Bruce Surtees, linger on R. G., allowing him to be the symbol of the film's historical era, the outlaw years of the 1880s, with his locked jaw and steady eyes showing pain, strength and history. To look into the face of Armstrong is to look into the past, not only of Hollywood but also of a time when men and women were made of something tougher because they had to be, taking their lessons from the Good Book or the barrel of a gun, with no apologies needed. The resounding lesson that R. G. Armstrong ultimately delivered from his actor's pulpit is that good work guarantees life after death. It is on film, and it is forever—just as *he* is. No actor ever delivered that message, that piece of history, better or with more sincerity and truth.

JOHN BECK
MODERN COWBOY

JOHN BECK IS the cowboy of contrasts. With strapping fit-to-his-jeans and almost-model good looks, he could be menacing as hell, and yet he also had eyes that wrinkled together in moments of amusing puzzlement, proving his comedic skills. Growing up in Chicago, Beck found acting early in high school as therapy for a nearly crippling case of shyness. It worked. He could go on stage in small plays, and he could throw a solid punch as his status as an amateur boxer surged. He moved to L.A. when he was nineteen, and his looks got him jobs in commercials and even a line or two on *I Dream of Jeanie*.

After churning through the 1960s in episodic cowboy shows like *Lancer* and *Death Valley Days,* Beck got his first Western feature role in Michael Winner's bloody *Lawman,* starring Burt Lancaster and Robert Ryan. Like Bo Hopkins, Beck was the youngster on the block, playing opposite the legends and learning their best camera habits. He could throw out an arrogant line like a punch; he could be the hot-tempered kid who ended up on the wrong end of the gun. But there was also something more. When Beck donned a sweat-stained shirt, hat and six-gun, they suited him. Not just his frame, but his attitude; the actor was every strapping farm boy who left home for adventures West.

And then *Nichols* happened.

Created by Frank Pierson, who would win an Academy Award for writing *Dog Day Afternoon,* this eccentric Western set just before World War I was one of James Garner's personal career favorites and one of his rare failures on television. The world of *Nichols* wasn't Dodge City or the Ponderosa but, rather, a laid-back, humorous version of the West set in Nichols, Arizona, where odd folks would do odd things, soothing their resentments more often than not with kind words and gestures of friendship, for instance, instead of blowing each other away whenever disputes boiled up. Garner's character, also named Nichols, was a born-again pacifist who leaves the Army after years as an officer in charge of weapons training. When the mobile Gatling gun comes along, Garner abandons wholesale killing and wanders home, hoping for a quieter life. The program's offbeat tone didn't sit well with Warner Brothers or the sponsors, however, and fans who longed for the roguish poker player Brett Maverick were thrown off by the almost anti-Western feel of the show, except whenever John Beck started a brawl.

Beck's Ketcham, the short-fused town lout, served as a perfect foil for Garner, and their confrontations were the highlights of the show. Always stirring Garner into a fight, Beck played Ketcham with a sly bent of bullheadedness and rascally likability. It's a wonderful turn for the actor, who comes across as oddly amiable and even sympathetic as his constant frustration boils over in not being able to get the upper hand against Garner.

The Ketcham character gradually slipped into the show's background. The actor wasn't written out of the show, though, playing instead another role as a townie named Orv who always gets Nichols into trouble. Margot Kidder as Ruth was the girl who won everyone's heart, and Stuart Margolin as the town's deputy sheriff added another odd ingredient into the mix, which was the root of the problem for the show, as Garner later admitted. Garner, that is, had previously played slick off-center characters in conflict with the normal world, and here the pattern, now reversed, made him the straight man, and it ultimately didn't work.

Nichols ended after one season, but John Beck's performance showed he was capable of something well beyond gunplay and fistfights: great comic timing. Woody Allen noticed and cast him in *Sleeper,* while Sam Peckinpah wanted the menacing side of Beck's talents when he had him ride alongside James Coburn's surly lawman Pat Garrett in *Pat Garrett and Billy the Kid.* At the end of this film, an older Beck gets the final laugh as he arranges for Garrett's assassination. You can hear Beck's contemptuous laugh as the Lincoln County sheriff falls to the ground in Peckinpah's bullet-riddled slow motion, the symbol of a time gone by. In many ways, this film, Peckinpah's last period Western, was a genre swan song for its amazing cast, too.

As the classic Western began to fade further away, Beck found himself in demand as an action star (*Rollerball*) and as a modern-day cowboy, riding down fortunes instead of outlaws on two hit TV series: *Flamingo Road* and *Dallas.* The shy actor from Chicago had gone from bit player in TV Westerns to leading man, exchanging a horse for a Maserati, never losing a step and never losing his Western image.

20

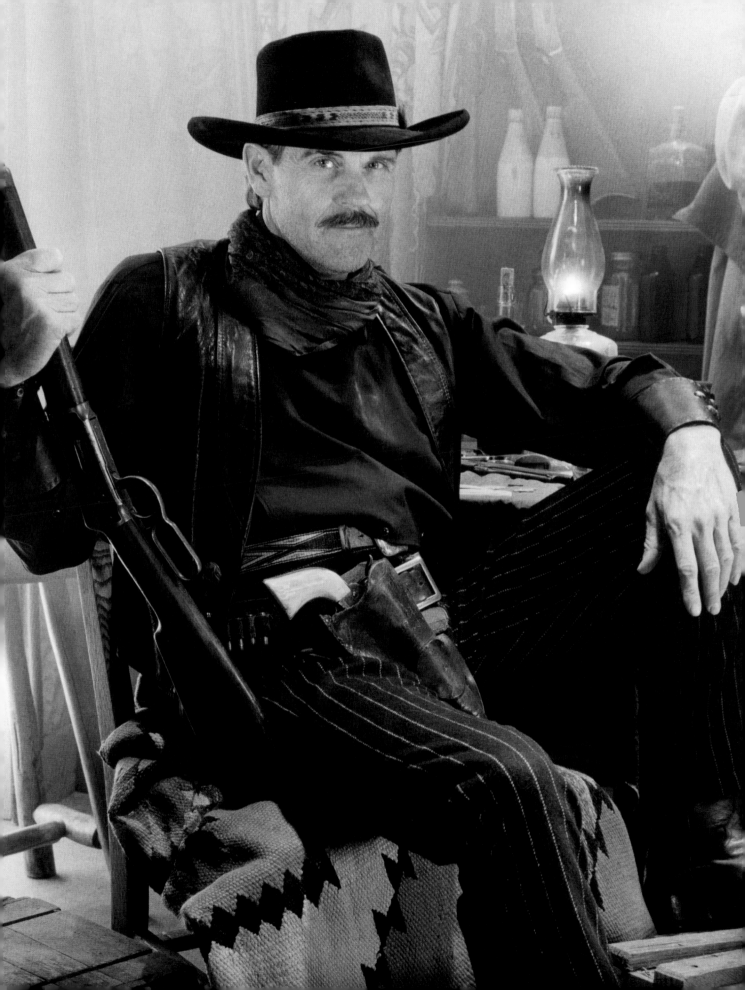

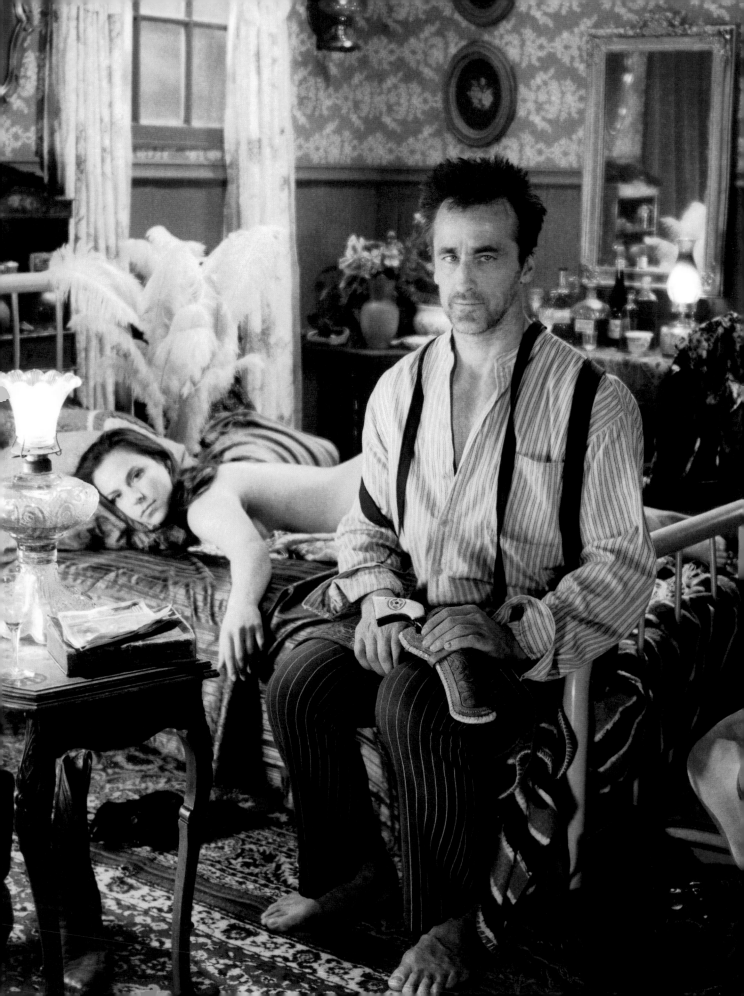

CRISPIAN BELFRAGE
THE EUROPEAN TRADITION

THE WORLD OF the Euro-Western, that barren landscape filled with gloriously exaggerated characters, came into being for most moviegoers with Sergio Leone's *Dollars* trilogy in the 1960s, which then bore hundreds of Westerns over the next fifteen years or so. The miles of film exposed in Rome and Spain completely transformed the genre from the classic tropes typified by Ford, Wayne and Hawks into something stylized, where the hero was a fast gun who would litter the ground with bodies without remorse.

Yet as quickly as the Euro-Western took over movie screens around the world, it faded. Eastwood and Bronson moved on to mainstream stardom, while Franco Nero, Henry Silva and Lee Van Cleef found steady work starring in Italian *policias*, chasing Mafioso hitmen through Rome alleyways instead of tracking outlaws into the mountain and canyons of Almeria. Yet the intense interest in the genre its fans have displayed has never subsided, and as the older films are given rebirth through Blu-ray, new movies are being made in that tradition, making use of locations made famous when Franco still ruled Spain. The Euro-Western is having a new lease on life, that is, with actor Crispian Belfrage emerging from the blood-soaked dust as one of the genre's newest faces.

The British actor stepped into the world of the Euro-Western with a role in the Italian television film *Doc West*, starring Terence Hill. "I had a very small part, playing a Pony Express rider. They were actually teenagers, the real riders, and were risking their lives, but the Express only ran for a short time. We shot in Santa Fe, and I had a scene where I delivered a message to Paul Sorvino's character but unfortunately didn't have a scene with Terence Hill." Although the actor would return to the Euro-Western genre, playing in films with a distinctive European attitude and feel, his next project was grounded in one of the most horrific incidents in the history of the American frontier. "I did a film with Crispin Glover called *The Donner Party* that was set during that period and told the story of when everyone was eating each other to survive the blizzard. Terrence Martin wrote and directed, and it was a great experience. Really fine actors. I thought Mark Boone, Jr., from *Sons of Anarchy* was just amazing."

Filmmaker Danny Garcia saw a photograph of Belfrage as Dolan in *The Donner Party* and decided he wanted the actor for his next Western. "We shot a trailer for *The Bounty Killer* to raise money on that. Danny was running a film festival in Almeria and was showing a film from a director named Tanner Beard, *The Legend of Hell's Gate*. Tanner got talking to Danny, who'd written a screenplay called *Six Bullets to Hell*, and Tanner and Ken Luckey and that bunch said: 'Why don't we all be in it, and you can use our costumes and things from *Hell's Gate*.' So they came down, and that's how we got it made. Like a lot of independent films—piece by piece. And Tanner ended up directing it."

The classic revenge structure of *Six Bullets to Hell* allowed Tanner Beard to indulge in a Euro-Western-influenced shooting style that heightened the no-frills storyline. And despite its low budget, the film is sleek and evocative, evoking the ratty grandeur of Leone and Corbucci, while Belfrage's sincere performance as a rancher seeking his family's killers summons the best work of Glenn Ford rather than delivering an imitative homage to either Eastwood or Nero, making the film better for it.

Belfrage understands well the financial realities of independent filmmaking, especially when tackling a Western. "Pulling the money together is always the trick, isn't it? The budget on *Six Bullets* was higher than others, but that's the journey of getting those Westerns done. To be in Almeria, on the exact same sets that Sergio Leone used, that's the wonder of it."

For Crispian Belfrage, the star of this new crop of independent Euro-Westerns, no matter the budget, having the films find their audience is the satisfaction. "At the end of the day, we're making a little bit of noise, but everybody right now seems so consumed with Marvel superhero movies and all that kind of stuff, so to know that these smaller movies are finding an audience, I'll take that. I've been doing these kinds of films for a while, and it's been a great experience. When I was a boy, I had a poster of *The Outlaw Josey Wales* on my wall, so this is something I've always dreamed of. And even though I haven't done it the way that Clint Eastwood did with Leone, it's been great to do these films. It is great to be a part of a Western."

Left: Crispian Belfrage posing with Ali Mueller at IMAGE Studios.

TOM BOWER
FILMMAKING JOURNEY

THE FINEST ACTORS can walk into a scene in any genre and find their organic place. Jack Palance, for instance, was a star we accepted in the halls of a medieval castle, a dusty cattle trail, the back alleys of New York City. Actor Tom Bower carries on in this grand tradition, his presence always working within the time and place of his films.

The theater veteran, who studied with John Cassavetes at The American Academy of Dramatic Arts, had his first television roles set against the squealing tires and gunfire of *Get Christie Love!* and *The Rockford Files*. Eventually he settled for a stay on Walton's Mountain: "*The Waltons* was a wonderful time," he says, "not only because the show's creator, Earl Hamner, Jr., was around a lot, but I had the great privilege of working with Will Geer, Richard Thomas, Ellen Corby and my good friend Ralph Waite. Plus all the kids. Earl's scripts were wonderful. That show was the real deal."

Bower has been in demand ever since, in roles ranging from a scruffy country type in *The Hills Have Eyes* to Frank Nixon, the stern father of a president, in Oliver Stone's *Nixon*. He's also played his share of lawmen—small-towners who can't understand the happenings around them, in the ghost story *Lady in White*, for example, and the 2010 adaptation of Jim Thompson's *The Killer Inside Me*.

Bower has made his mark in fine, traditional Westerns, too, such as *Riders of the Purple Sage*, which Charles Haid directed. "Charlie was a friend from *Hill Street Blues*, where I did two episodes, and he wanted me in *Riders*. My grandfather used to tell me Zane Grey stories all the time, so I wanted to do this. Ed Harris and Amy Madigan were producing *Riders*, and we'd founded a theater company together. I was also in *Appaloosa* with Ed directing, and he did a great job." Bower appeared in Haid's next Western, too, the powerful TV film *Buffalo Soldiers*, starring Danny Glover. "It's about the way it was in America right after the Civil War. The Army didn't know what to do with Black soldiers and sent them out to kill Indians. That was their mission; it was straightforward, with no mousing around about it."

For all of the film, television and stage productions that Tom Bower has devoted his talent to, nothing has given him more satisfaction than *The Ballad of Gregorio Cortez*, director Robert M. Young's depic-

tion of the hunt for and subsequent conviction of a fugitive who killed a sheriff he believed wanted him dead. This well-regarded project came together through friendship and professional dedication, beginning at the Sundance Institute. "Eddie Olmos, Bob Young and I were at the first day of the Sundance Institute's Filmmakers Lab in June 1981. There were about twenty-five actors participating, all working on each other's projects, and Eddie, Bob and I got to know one another. The producer Moctesuma Esparza owned the *Cortez* book and had money from the National Endowment for the Arts and the National Endowment for the Humanities, but he didn't know what to do with it. He didn't give us the money: he gave us the run of the picture. So Eddie and I cast the movie among our friends. The only guy we didn't know was Bruce McGill, who came from a casting director, and was fantastic. Then we got Bob Young involved as a director.

"We started shooting in New Mexico, working with ranchers because we needed horses. We brought them on the movie. There are a number of characters in the film who're locals who really helped us. We went to Gonzalez, Texas, to the actual jail where Cortez, who was played by Eddie Olmos, was a prisoner, and then we used the courtroom where all the proceedings happened. We were writing the script as we went along; Bob had about forty pages of the script written, and the rest we wrote the night before. We gathered up the actual courtroom transcripts, newspaper accounts, testimony of the families involved and incorporated all of this into the stuff we'd shoot the next day. I'd never had an experience like that in making a movie."

The film debuted on PBS's *American Playhouse*, but Bower and his fellow filmmakers wanted *Cortez* to make its way to theaters. "Eddie and I carried that movie around the world for two-and-a-half years before it was discovered by Norman Lear at Embassy Pictures. We opened it in San Francisco, then took it around the country." When Embassy folded, *Cortez* was unavailable for home distribution for decades. But a restored version now exists, and for Tom Bower it's the end of a moviemaking journey. "*The Ballad of Gregorio Cortez* is the primary thing I've done in my professional life that I am most proud of, because of how we made it, what is was about and who we made it with."

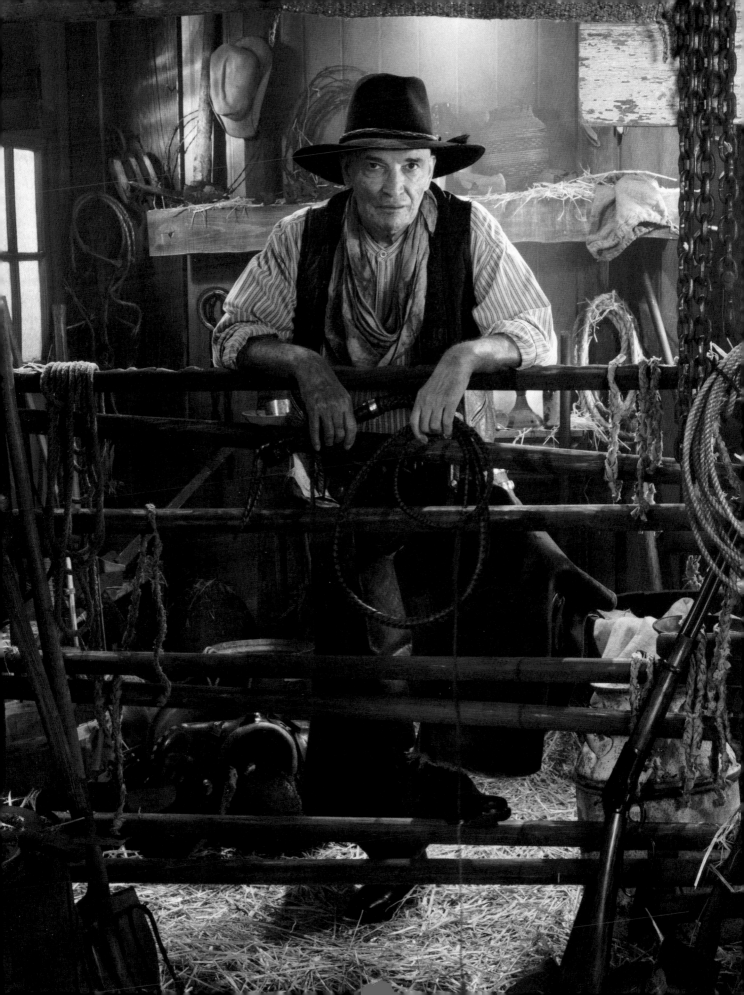

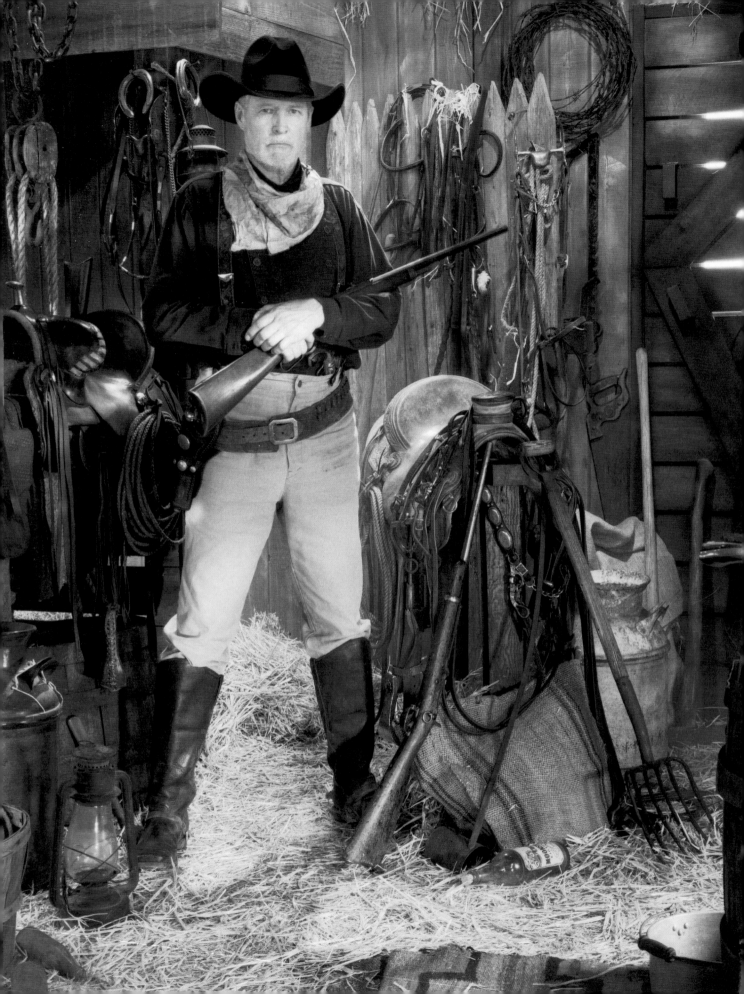

BRUCE BOXLEITNER
THE SADDLE AND THE STARS

BRUCE BOXLEITNER'S FILMIC journey, which has taken him from the wide open spaces of the American West to the farthest reaches of the galaxy, actually began in a now-iconic Minneapolis TV newsroom. "After I came to California, *The Mary Tyler Moore Show* was the first thing I ever did. That's how I got my SAG card, and the fees were my entire paycheck. It was a small part, but Mary was very gracious, and Ted Knight killed me he was so funny."

Playing the station's mailroom boy, who catches the attention of Gavin MacLeod's teenage daughter, Boxleitner projected a good guy charm that the camera and the TV audience picked up. The Illinois native, who'd worked on his parents' farm and then trained at the School of Drama at the Art Institute of Chicago, proceeded to get roles in two superior television movies before appearing in the "Sharecroppers" episode of *Gunsmoke*, bringing him and James Arness together for the first time. Shot for *Gunsmoke*'s final season in 1975, this guest-starring role would be the first step in what would become an important relationship for the young actor, both professionally and personally. Boxleitner remembers when he got the show, his first Western. "I didn't get to know Jim right away, but *Gunsmoke* was a big deal for me. I was making appearances on shows that my parents watched, that I grew up with. The episode was for the last season, so I was lucky to have gotten on the show at all."

Luck had little to do with the actor's rise as he continued to impress producers and audiences with his combination of looks, talent, a quick grin and an easy manner that could turn deadly in a shootout. The scruffy low-budget flick *Six Pack Annie* took Boxleitner to the big screens of drive-ins, while supporting parts on shows like *Hawaii Five-O* and *Police Woman* kept him busy on the living room TV. In 1976, he was cast to play Seth in the pilot for *The Macahans*, which would become the series *How the West Was Won*, returning Boxleitner to his favorite genre. "Jim Arness actually chose me to play his son, which I didn't know for years afterwards. But this was like a dream for me. To be on these incredible locations, on a horse when I finally learned how to ride well, and to be with Jim, Eva Marie Saint or Lloyd Bridges doing scenes. It was a school for me because I got to know Jim Arness the man. He was my men-

tor, and I saw how he treated people on the set, how gracious he was and good-natured. He taught me what it meant to be the lead in a series and how you conduct yourself."

How the West Was Won, a ratings powerhouse for ABC, was guided by *Gunsmoke* veterans Jim Byrnes, Calvin Clements and producer Albert S. Ruddy. And *Gunsmoke* directors Bernard and Vincent McEveety helmed most of the two-hour episodes, so Boxleitner knew he was in good and learned hands for the program's realistic tone. The show's success brought him the lead in the mini-series *The Last Convertible* before he rolled into two more Westerns, *Wild Times*, co-starring Sam Elliott and Ben Johnson, and *Kenny Rogers as The Gambler*, with Clu Gulager. Boxleitner eased into the part of Rogers's partner, Billy Montana, by drawing on another gambling film he'd recently completed: "I'd just done *Baltimore Bullet* with Jim Coburn as an ace gambler, where I'd been his protégé, and Billy Montana in *The Gambler* was Kenny's protégé. Billy Montana, though, was the fast draw. He was slick and could shoot. I was the one who would clear the room of the riffraff so Kenny could get down and play."

Boxleitner would return to the role of Billy Montana four more times, standing beside Kenny Rogers with a grin and gun ready, even after he'd starred as Frank Buck in the adventure series *Bring 'Em Back Alive* and delivered a fine and historically authentic performance as Wyatt Earp in *I Married Wyatt Earp*, with Marie Osmond as Josephine Earp. Also during this period, another genre pulled Boxleitner in when he starred with Jeff Bridges in Disney's science fiction epic *TRON*. The voyage inside the microchip "mind" of a computer earned excellent reviews for its amazing visuals and decent box office around the world, but it didn't become the new *Star Wars* as the company had hoped.

From *TRON*, Boxleitner starred in another TV series, the hit *Scarecrow and Mrs. King*, playing a spy with Kate Jackson as a housewife caught up in his espionage. The actor was now a true television star, but his status never overwhelmed his personal passion for Westerns. And in 1984, as *Scarecrow and Mrs. King* was ending, he returned as Billy Montana in *The Gambler Part III: The Legend Continues*.

For the TV remake of *Red River*, Boxleitner found himself billed above his mentor and friend, James

*"I'd rather be
doing Westerns.
More than anything else
I've ever done,
that's what
I love best.
That's who I am."*

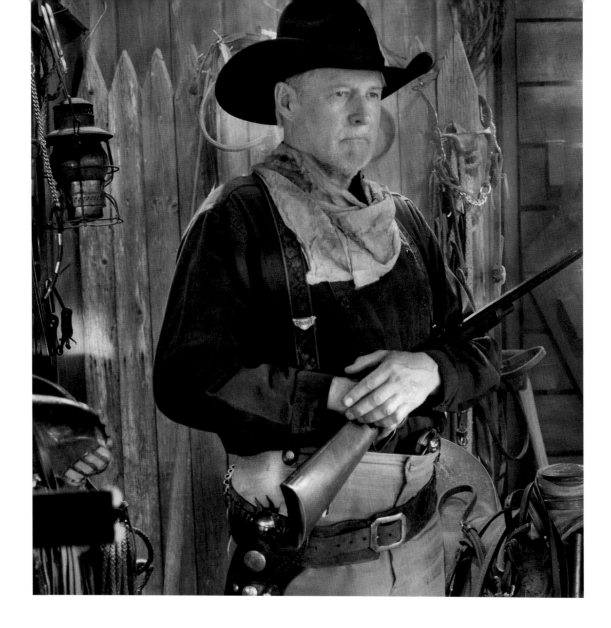

Arness, who took the shift in stride. The reaction to producer Gregory Harrison's announcement that he would be tackling the Howard Hawks classic drew a collective moan from Western fans, but those fears were wiped out by the film itself, beautifully photographed as it was while showing different sides of both Arness and Boxleitner. Western veterans L. Q. Jones, Ty Hardin and a crusty Ray Walston filled out the cast, and Arness is particularly impressive in his portrayal of a man blind to his own cruelties.

After appearances on several high-profile mini-series and TV movies, Bruce ventured West again in 1994 for Rob Word's production of *Wyatt Earp: Return to Tombstone*, starring Martin Kove, Bo Hopkins and Hugh O'Brian himself. Then it was his

last venture with Arness, the TV movie *Gunsmoke: One Man's Justice*. It's evident throughout, especially in the close-up shots of Arness's leathery face, the senior actor's great paternal pride over Boxleitner's accomplishments and talent.

Being identified with both Westerns and science fiction, an amazed Boxleitner savors the devotion of the fans who've embraced him: "The science fiction fans are so hardcore, and they follow everything. It's incredible because they're so knowledgeable about the shows and the characters. But even now, even with my identification with the science fiction, I'd rather be doing Westerns. More than anything else I've ever done, that's what I love best. That's who I am."

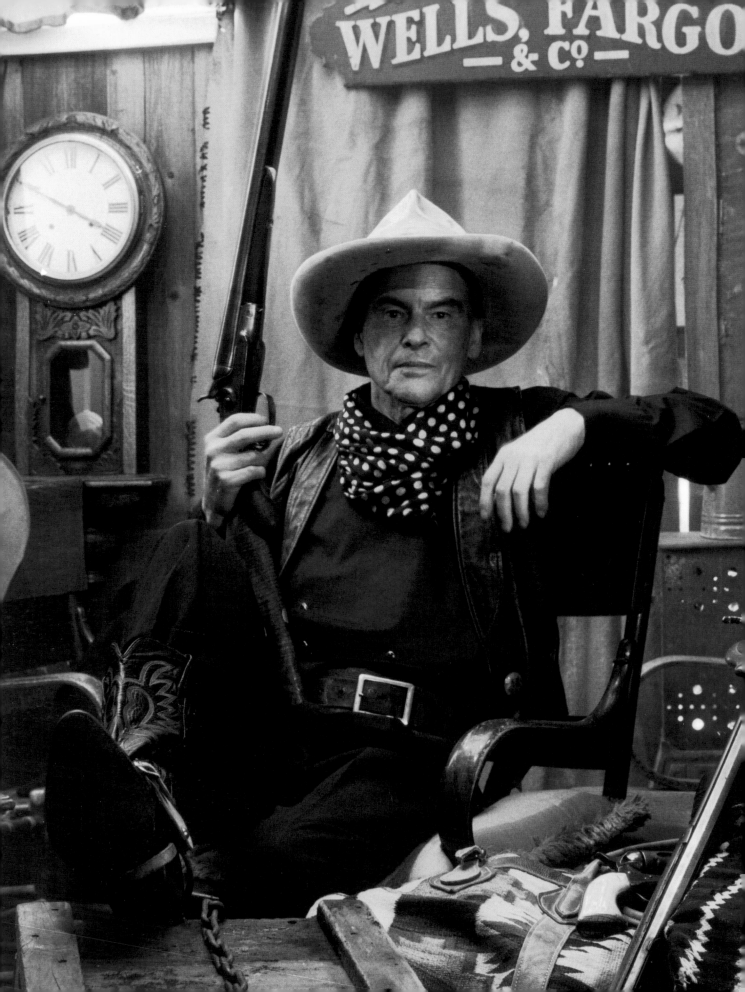

HORST BUCHHOLZ
BREAKING FROM THE *WOLFPACK* TO THE *SEVEN*

WHEN HORST BUCHHOLZ made his first films in Germany in the early 1950s, rebels like Marlon Brando and James Dean were scorching screens around the world. Older stars who'd been part of the movies since the 1930s like James Cagney, with whom Buchholz would co-star in Billy Wilder's 1961 Cold War satire, *One, Two, Three*, were being replaced by the likes of Burt Lancaster and Robert Mitchum. Teens screamed for their own identity in a world that was undergoing tremendous change. Button downs were tossed for t-shirts and leather jackets and switchblades. Songs that had once swept sweetly out of radios like "How Much Is That Doggie in the Window" were obliterated as Chuck Berry's guitar riffs. Jerry Lee Lewis's hellish defiance at the piano and Elvis Presley's swinging hips upended the universe.

In 1956, Horst Buchholz was Europe's sexy rebellious teenager. When he starred in *Die Halbstarken*, released in the U.S. as *Teenage Wolfpack* for double-features and drive-ins, distributors anglicized Buchholz's name, changing it to "Henry Bookholt." The posters compared "Henry" directly to James Dean, and his dark good looks and brooding manner, which could explode instantly, was capturing young girls who wanted to know more. The teenager character had found its way into Hollywood in every incarnation—from snot-nosed punks to "gee whiz" class presidents.

Teens were often portrayed as troubled thugs, action heroes and the leads in rock-and-roll musicals, defying parents and teachers to arrange a dance with their favorite stars. Horst Buchholz surely fit into the formula, but on a higher tier; he was destined for international stardom and wasn't just playing the lead in B movies, proving himself grounded in adult dramas about young people, too. In *Tiger Bay*, for instance, he and Hayley Mills are young lovers on the run after Buchholz kills a woman, with Mills as the witness. It's a thriller, to be sure, but what Buchholz brings to his performance, the sense of doom and sympathy, made him the perfect choice for Chico in producer Walter Mirisch and director John Sturges's *The Magnificent Seven*.

As the cocky, fiery Chico, Buchholz is the wild card of the Seven—the young hothead, who's as un-

predictable as a bucking bronc, yet gives the group that one extra gun they desperately need to win against Eli Wallach and his bandits. Compared with the steady steel-eyed gunmen personified by Brynner, McQueen and Bronson, Buchholz was the juvenile delinquent, wanting to be taken seriously and demanding respect before he'd earned it. Firebrand youths had always been a part of Westerns. But the misunderstood angry young man fighting his own internal battles really entered Westerns with *Red River*'s mutinous, tormented Montgomery Clift. Even though the character needs to prove himself, to come into his own on the cattle drive, he won't bend to the demands of John Wayne.

By the 1950s, young stars John Cassavetes, John Drew Barrymore and Russ Tamblyn all hit the trail, often set on undermining the law. Westerns were morality tales, after all, and the young folks were typically in the wrong, and either learned their lessons and stood with Robert Taylor or Henry Fonda in the final shootout or else caught a bullet for being punks on horseback.

Not so with Horst Buchholz. That wasn't his character or his persona. The wild eyes projected heart and soul. He was a young man who was thinking beyond himself, even when making terrible mistakes, but always learning from them, and pulling himself together to do the right thing. It would take some doing, but Buchholz would be the only one of the sympathetic heroes in *Seven* who would find his way, spiritually, home. He stays in the village with his girl to start a new life. These are the very things that the gunfighters for hire will never have, and as they pass the rude graves of the ones who do not survive, the men damn well know that the wild-eyed youth Horst Buchholz is the one who has chosen the best path for his remaining years.

This moment is the real message of *The Magnificent Seven*. Earlier in the film, Charles Bronson chides the village children for not seeing their fathers as heroes because they're not fighting the bandits. Bronson tells the kids that they're wrong because he knows what's waiting for him, which is death. With all the heroic gunplay and action to sweep us away, the film ends on a melancholy note, and Horst Buchholz, by simply remaining alive, is the messenger reminding us that

"The actor often joked that he was the one from 'The Magnificent Seven' that everyone forgot because they couldn't pronounce his name."

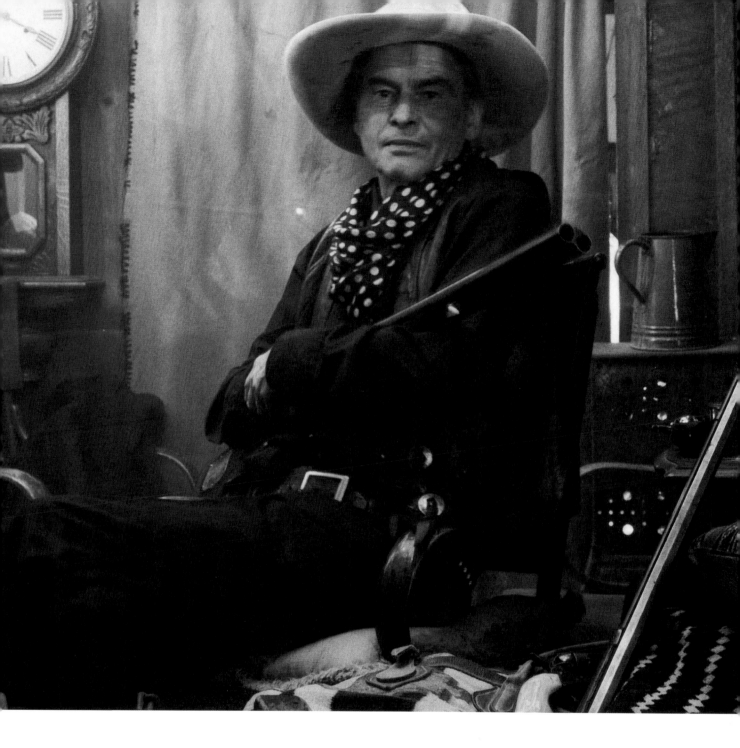

to keep going, to keep living, is the proof of manhood, not just how good you are with a gun.

The actor often joked that he was the one from *The Magnificent Seven* that everyone forgot because they couldn't pronounce his name.

Not so.

Horst Buchholz *is* remembered: because in a film that wasn't just an enormous success, but that has be-come a part of cinema history, the young actor from Germany held his own against some of the movies' most legendary stars and, on film, outlived them. Few actors can make that claim, and in the wake of this early cinematic success, of course, he continued working in films and TV for decades. As in life, ca-reer and the *Seven*, he survived.

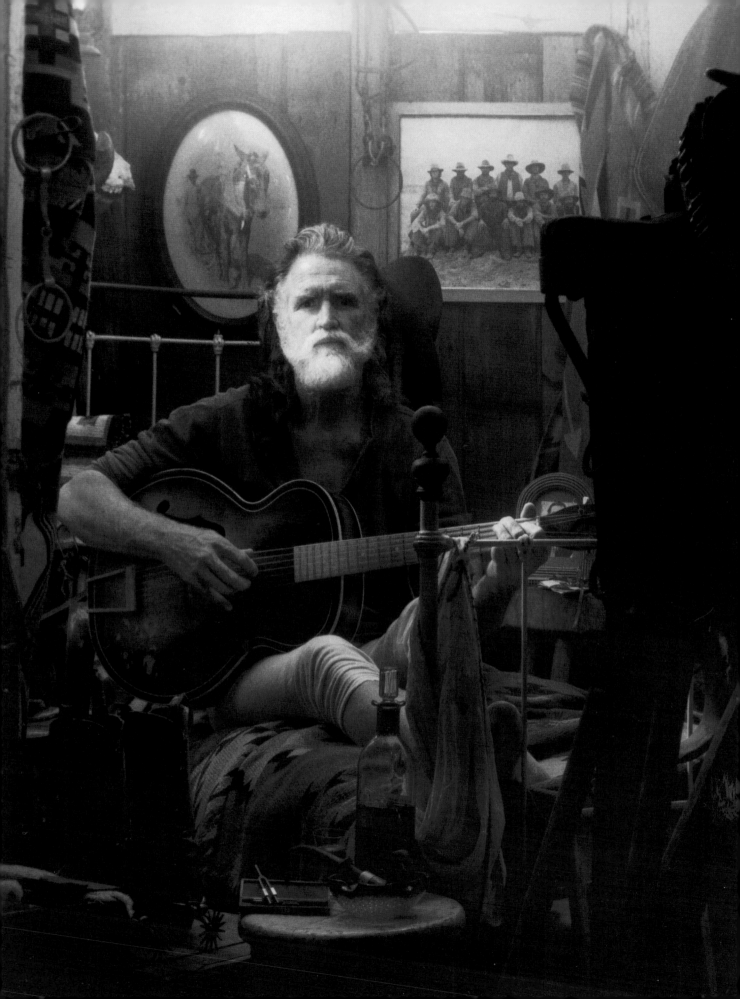

BILLY GREEN BUSH
A MATTER OF FAITH

THE ROLE WAS planned for Gregory Peck. But when Billy Green Bush as Mr. Culpepper looks down from his horse to eye an eager Gary Grimes, who chirps that he "wants to become a cowboy," and responds with a flat, sardonic "That's a hell of an ambition," there could be no other actor better suited for the part. At that moment, it's as if Bush were an actual trail boss who'd stepped out of another time to appear in director Dick Richards's *The Culpepper Cattle Co.* Co-starring Bo Hopkins and Geoffrey Lewis, *Culpepper* is one of the most realistic depictions of life on a cattle drive attempted up to that point in time. It's also a coming-of-age story, but one without an iconic movie star at its dramatic center, and so has a feeling of being the West as it truly was.

The film owes some of its visual flourishes to Hawks's *Red River*, but *Culpepper* isn't seen through a romantic gaze; it's not a film about the in-born camaraderie of cowboys on the trail. *Culpepper*, rather, is about working men who handle livestock, how they stretch every bit of themselves riding, roping and herding to earn their day's pay and be done with it. A cattle drive isn't an adventure, it's work. And that's the attitude, the made-of-the-earth realism, that Billy Green Bush brings to his performance.

Getting to Mr. Culpepper was a long trek for the actor, starting in the 1960s with an audition for legendary teacher Lee Strasberg. Bush's first small-screen roles were bit parts in episodes of *The Outer Limits* and *Stoney Burke*, both created by writer-director Leslie Stevens. "Those were good starts. I tried to work wherever I could and whenever I could, to learn the functions of a set and how it worked. I learned how to do things for the camera, how to move properly for a certain lens, all those things you have to know. As much technical information as I could for acting, that is, and it was always a learning experience."

On a *Bonanza* episode, "Long Way to Ogden," Bush found himself at odds with veteran director Lewis Allen. "He didn't understand me as an actor being creative. I was playing a bad guy. We're going to rob a bank, and we're sneaking around to check it out. I have spurs on, and you can hear yourself walk, and we're trying not to attract any attention. I tried to enter the scene on my toes so you wouldn't hear my footsteps, and Lewis Allen embarrassed me in front of the whole company, saying I was a ballerina because I was walking on my toes."

Two major films followed, *Five Easy Pieces* and *Monte Walsh*. Bush's portrayal of Elton, Jack Nicholson's loyal friend in *Pieces*, still resonates. He captures the realities of a kind of life in Texas with little to look forward to and lots to regret, which pushes Nicholson to return to family and music, while good ol' boy Elton goes to jail for robbing a gas station. The now-classic *Monte Walsh* fit Bush like a wrangler's glove as he had become more adept at interpreting characters in period settings. *Monte Walsh* was also the first of his collaborations with actor Mitchell Ryan, who would be on hand for the troubled production *Electra Glide in Blue*, which also gave Bush one of his finest roles. Director Rupert Hitzig had cast Bush in the role of Zipper, Robert Blake's racist motorcycle cop partner, who sees being a peace officer as a chance to hassle hippies and anyone whose skin he doesn't like. In one of the film's many plot turns, Zipper's suspicions about a "longhair smartass" suspect actually turn out to be true, and the suspect kills Blake with a shotgun.

Blake's character in the film is a good-natured patrolman trying to work his way up to detective rank. But on set, he was anything but personable as he set out to undermine Hitzig constantly. "Blake didn't want me to play the part and had a friend in mind, but it was too late because Hitzig cast me. One day, Robert Blake got so ugly and foul with Hitzig, and it offended Rupert so much he had no alternative but to invite Blake outside to kick his ass. Now I'm watching this, and producer James Guercio, who always wanted to be the director, steps forward to break them up. I was offended because it was all a setup to fire Rupert."

After more than sixty roles, Bush retired. He'd proven himself over and over as an actor blessed with range and empathy, but what he read in scripts often disturbed him. He looked inward and decided on a different path: to devote his life to God. It's a choice he doesn't regret, and he reflects on his career with not only fondness but also objectivity as to what he wanted to achieve and when he was successful and when he fell short. But no matter what character he was given, whether riding a stallion or a motorcycle, Billy Green Bush brought them to creative life.

R. D. CALL
LOVER OF WESTERNS

"MY GREATEST REGRET is that I was never associated with a really great Western, and that was my dream. Westerns are my favorite films, my favorite genre: even a bad Western I'll watch." R. D. Call is as firm in his "Western regret" as he is unassuming about his accomplishments: several excellent performances in major film, television and theatrical productions over a span of more than thirty-five years, among them Walter Hill's *48 Hrs.*, Dennis Hopper's *Colors* and Kevin Reynold's *Waterworld*.

From the start, this Utah native's talent was obvious. Actor-director-producer Michael Landon took note and gave Call one of his early roles. "*Little House on the Prairie* was my second job. Michael Landon directed the two episodes I did. I had a great time on that, and Michael was a great guy."

Call went from *Little House* directly to *48 Hrs.*, his first of three films for Walter Hill. "That film became a kind of an action movie icon of that era. I loved being a part of it, and I loved working with Walter. I particularly liked doing *Last Man Standing*, which was the second version of the film *Yojimbo*, the first being *A Fistful of Dollars*. Walter wanted to go back to Dashiell Hammett's story *Red Harvest*, which was the basis for all the versions. I told him when we wrapped that 'Making this film is probably the closest I will ever come to working with a guy like John Ford.' I think he was a little embarrassed, but I meant it. I came along a little late in the day to work with those directors like Ford, but Walter, I think, is very close to their quality."

Call adores Ford. "The cavalry trilogy—*Fort Apache, Rio Grande* and *She Wore a Yellow Ribbon*— is so tremendous. But the non-Western films are also magnificent: *The Quiet Man* and *How Green Was My Valley*. Filmmaking just doesn't get better. As successful and great as Ford was, he's underrated by a lot of people who haven't seen much of his work. I'm always reminded of that quote from Orson Welles: when someone asked him who the greatest directors were, he said, 'John Ford, John Ford and John Ford.'"

Call recalls with fondness his role as a posse member in Frank Roddam's *War Party*, a thriller about the re-enactment of a battle between Blackfeet warriors and U.S. soldiers. The present and the past collide as the modern characters find themselves in the wilderness reduced to fighting and surviving as their ancestors did. Call notes that "*War Party* had an interesting message, but when you're in the middle of it, you don't think about the greater context of the film. I just think about doing the very best job I can with the script and give the director what he needs. If the story's based on anything real, you have to do your homework. That's the way I approached all my work: I suited up and did the best I could."

The chance to appear in a period Western, *Young Guns II*, presented itself to Call in 1990. Emilio Estevez starred as Billy the Kid. Call played cattleman D. A. Rynerson. He says that he would have loved to have had more roles of this sort, but "Westerns were far and few between at that time, and so I didn't get much opportunity to do others." Call adds: "The gold standard for Westerns is *Shane*. Everybody wanted another *Shane* to come along, and it never happened. *Red River* is one of my favorite films, except for the last four minutes. I have to turn away. I can't watch those last minutes where everyone's happy and gleeful. It's like Howard Hawks sold out the end of the film. That's my own personal opinion. I'll watch it any time it comes on, except for those last four minutes. There are two Robert Mitchum Westerns that I think are up there with *Red River*. One is *Blood on the Moon*, and the other is *The Wonderful Country*, where he's brilliant. The rodeo film *The Lusty Men* is a little gem, and it's not shown a lot. I'll always watch anything with Arthur Hunnicutt. I love his work in *Lusty Men* and also *The Big Sky*. I knew there was going to be something worthwhile watching if he was in the film."

Altogether Call made three pictures with Dennis Hopper. This meant long talks about Westerns, John Wayne and Henry Hathaway. "Dennis was great, and he'd tell us stories about making *True Grit* with Hathaway that had us on the floor." Call reflects further, explaining, "In order to be a great director or actor or artist, and I don't want to sound too highfalutin about this, but you have to have a certain sensitivity, and that sensitivity with some of those guys like Ford or Hawks or Hathaway was always on the hot button. It didn't take much to set them off. It's kind of like inviting the devil into your house if he promises to make you great. Well, as an actor back then, you'd have to deal with that because those guys had that ability to make those incredible Westerns."

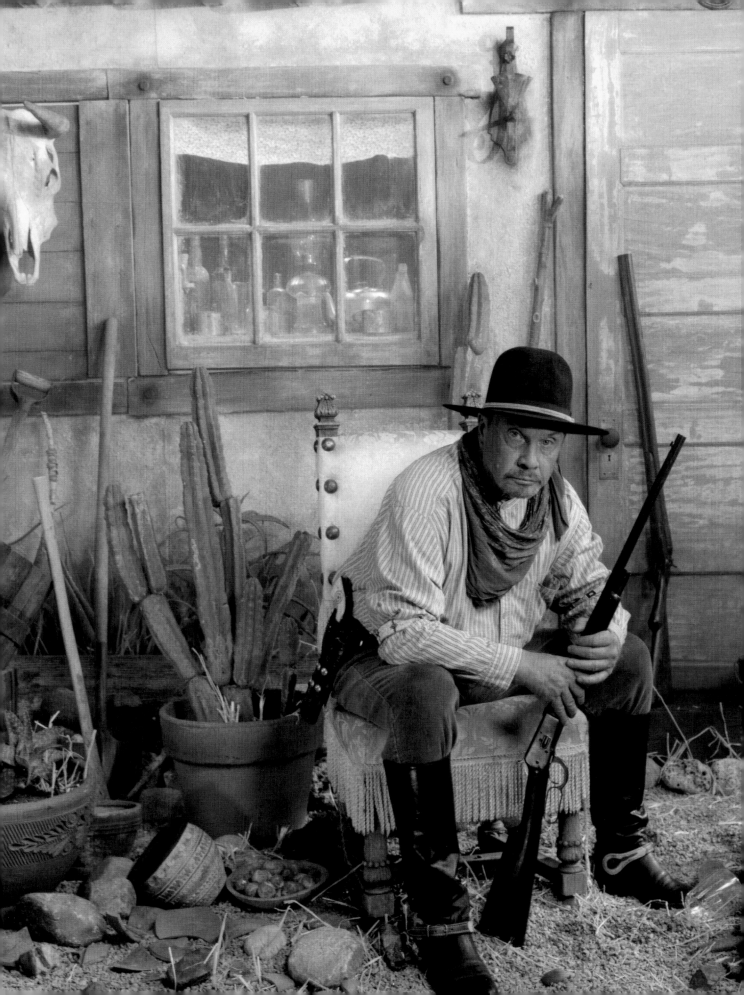

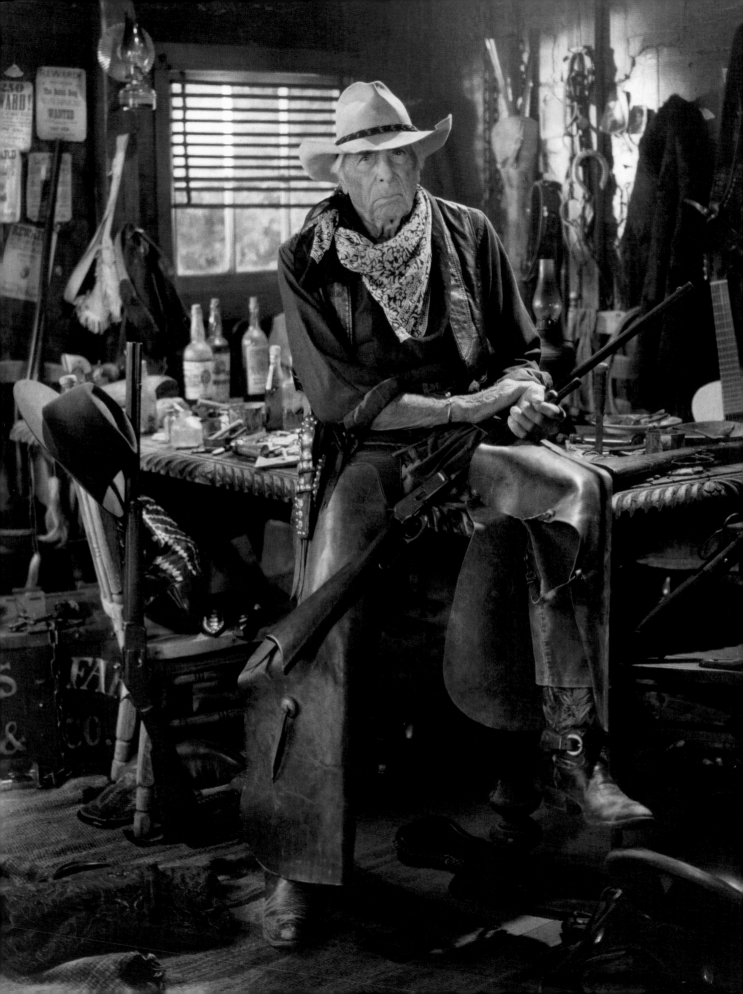

JOHN "BUD" CARDOS
INDEPENDENT WESTERNER

In the poster for the Western-horror flick *Kingdom of the Spiders*, directed by John "Bud" Cardos, a giant tarantula looms over a town as a hero and heroine flee from its dripping mandibles. Above the monstrous arachnid's legs appears the movie's tagline: "A living, crawling, Hell on Earth!"

One of those great B films that tore down the box office walls to become a hit that's honored and popular thirty years after its release, *Kingdom of the Spiders* arose from all Bud had learned working with everyone from Roy Rogers to Alfred Hitchcock, with stop-offs for Sam Peckinpah, Dick Clark and the ultimate low-budget king, Al Adamson. He did stunts, wrangled horses, flew airplanes, made budgets and spouted lines in dozens of movies before directing William Shatner and a town full of tarantulas.

A drive-in idol, Bud Cardos came up through the movies the hard way, taking every opportunity, every chance, and along the way creating his own legacy as a genre filmmaker. In the 1940s, when Bud stood in the forecourt of the legendary Chinese Theatre, where his uncle was manager, watching stars step from limousines, he had no idea what was lying ahead for his own movie-life. His father managed the Egyptian Theatre down the block on Hollywood Boulevard, but for Cardos, there was no great attachment to these movie palaces other than as the way people in his family made a living. Later, his father would open one of California's most famous eateries, Cardos Club Café, and when Bud got his release from the military, he worked there serving prime rib that had customers standing in line for hours.

At the restaurant, the movies seemed far away, but not the life of a rancher. An avid horseman, Bud left the Cardos Club Café behind and worked as a rodeo clown, ranch hand, then as an animal wrangler for a TV series, which led to doing horse stunts for Roy Rogers, which meant a good paycheck. "I could ride pretty much anything with hair on it. I remember I was herding horses with rodeo champion Casey Tibbs, working on *Born to Buck*, and we herded three-hundred head. They got stuck up in a valley, so I got in my airplane and flew down near the herd and got them moving out of there down to the flats, and they were able to round them up. Monty Montana said, 'I ain't never seen a cowboy herding horses with an airplane before!'"

Asked by a TV series boss if he knew how to catch crows, ravens and sparrows, Bud agreed to herd birds for Alfred Hitchcock's *The Birds*, and Bud knew where to look. "They'd build nests in street signs, in that space between the front and the back. So I'd go out at night and use a stick to reach up into the sign and give them a poke and, when they flew out, catch them in a sack. We had to have ton of sparrows for the scene where they attack from the fireplace, where they fill the room. I stood up there with that bag full of birds and just emptied it down the chimney, and they flew out like a hurricane." The Master of Suspense struck Bud as a director who observed from a distance. "Hitchcock would set up the shots, but it was like the second assistant would shoot it. He had it all planned in his head, and if those instructions were followed, he'd step away."

The Birds became a classic, but at the time, it was just another gig, and Bud resumed the hunt for work. "There was a construction boom in the valley, and I had a small company, and we were framing houses, putting in the woodwork. I would work all morning, get off at 3:00, and be in Hollywood, beating on doors, and then back to the construction site to finish up. And I did it every day."

The doors Bud was beating on included those of legendary low-budget director Al Adamson, who was about to prepare his biker flick *Satan's Sadists*, and Bud was the kind of master of all trades perfect for Adamson's rough-and-tumble productions. "Al never told us anything about his budgets, and I worked as his unit manager, and he wouldn't tell me! He'd get fifteen-thousand or something, and he'd start a picture, and his producer would dig up another ten so we'd keep going, be almost broke, and then some more cash would appear."

Adamson, whose father Victor made Westerns in the early sound days under the name Art Mix, approached his biker movies like Westerns, the choppers filling in for horses with rival gangs attacking as outlaws or savage hordes. All this fit Bud to a T as he continued doing stunt work, small roles and directing action scenes. Adamson populated his exploitation casts with older stars like Scott Brady, Kent Taylor and, on *The Female Bunch*, Lon Chaney, Jr., with whom Bud struck an immediate kinship. "Ever since I was a little kid, I tried to put make-up on to be the Wolfman. So when I worked with Lon

"Hitchcock would set up the shots, but it was like the second assistant would shoot it. He had it all planned in his head, and if those instructions were followed, he'd step away."

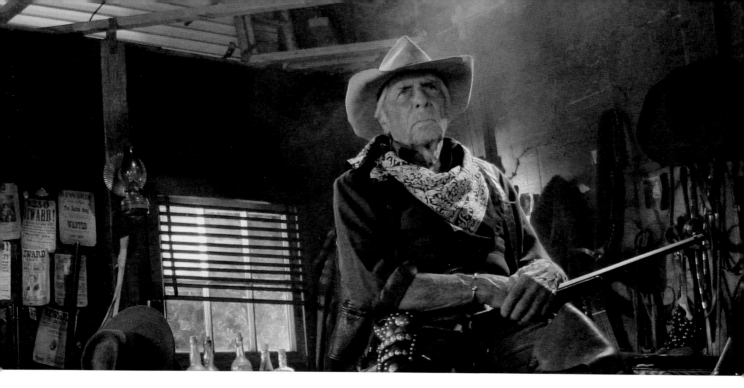

Chaney it was really a pleasure. And the make-up for the Wolfman really hurt him years ago, putting it on and taking it off for the camera. We became good buddies, except I never drank as much as he did."

Bud had more onscreen time as a wild villain and Adamson a bit more cash for the supernatural Western *Five Bloody Graves*. "John Carradine, Paula Raymond, Scott Brady. We had a good cast for that little picture." The Adamson movies were booked constantly into drive-ins, often with altered titles so unsuspecting moviegoers wouldn't know they were seeing the same mini-epic they'd paid for six months before. The work for Bud was constant, going from film to film, and it was while doing his duty on stunts and special effects that he struck up a friendship with Stefanie Powers, which led to his working on one of the most important Westerns of all time.

"Stefanie Powers and I went out for lunches, and she was a dynamite lady, and that's how I met Bill Holden. He was on set to see her, and she introduced us. From that little meeting, I got close to Bill, and he invited me onto *The Wild Bunch*. Some stunts and some second-unit shooting. Just a little bit of stuff, from the title sequence. And Bo Hopkins marching around the bank in the opening. I shot some of that stuff. And Bo later starred in one of my movies."

Bud finally found himself in the director's chair in 1977 for *Kingdom of the Spiders*, co-starring William Shatner and Woody Strode, and co-written by Western author Stephen Lodge. An effective B horror feature about a town under siege by millions of tarantulas, the ex-animal wrangler went for the real thing, "Today, it would be all done with CGI effects. But we did not have that. They were all real spiders."

This film, like Bud's *Mutant* and *The Dark*, is regarded these days as a true cult classic, a perfect example of well-made, economical genre filmmaking once common in Hollywood but now all too rare. Even though many of Bud's films as director were either horror or science fiction, the feel of the Western is never far away. *Kingdom* features great horse action with rancher Shatner galloping like hell across a wide landscape with the camera keeping pace while *Mutant* is filled with standoff scenes against toxic creatures that are staged with Howard Hawks-like bravado, reminding us of the siege of the jailhouse in *El Dorado*.

No matter what the project, those echoes of the West, Bud's true enthusiasms, always found their way into his work, and he was excited by a chance to direct a true period Western. Sadly, *Legends of the West*, an underfinanced TV series, only had one season, but it allowed Bud a chance to make historical Westerns by directing episodes about Custer and Billy the Kid. It was a testament to him that his work was honored by his peers, even as the series vanished. "I got the award from the Cowboy Hall of Fame for that, and I never got anything like that when I was rodeoing!"

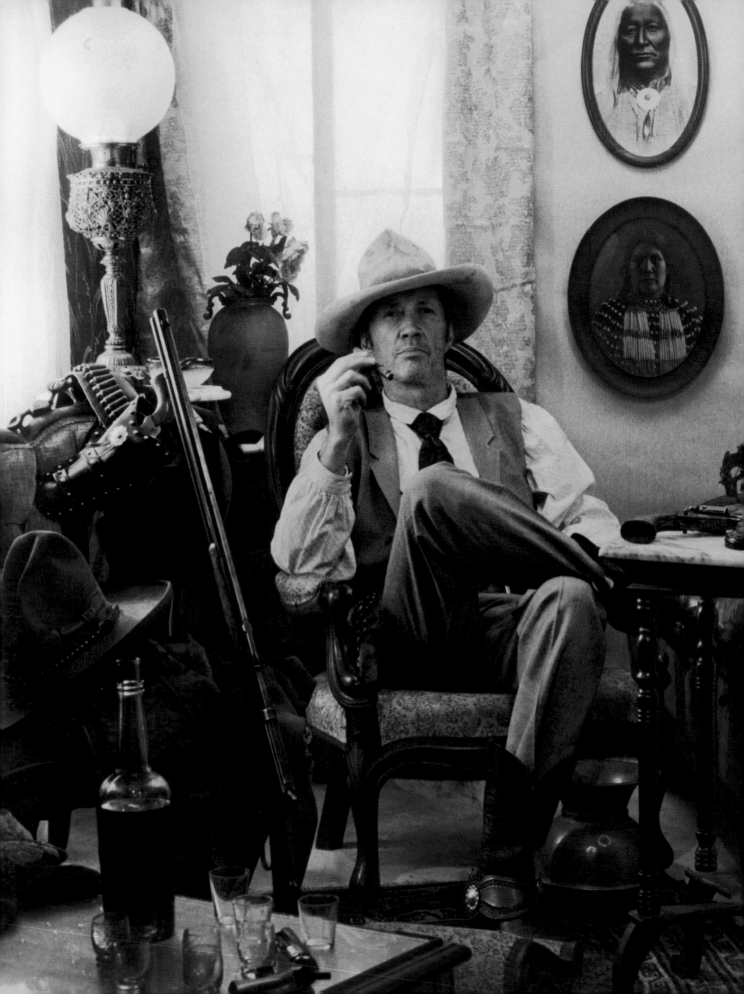

DAVID CARRADINE
A FAMILY LEGACY AND MORE

THERE'S A MOMENT, just mere seconds, in the 1969 Western *Heaven with a Gun*, which has Glenn Ford and David Carradine face off before a brawl. The characters are Western archetypes: a preacher with a gun (Ford) takes his stand against an outlaw (Carradine), who's as bad as one could find. But there's more going on here; Ford was nearing the twilight phase of his movie career while Carradine, lean, with a lopsided, defiant grin, was at the start of his. As the heavy, Carradine pays for his sins, but he is the one you remember, not the older star. Carradine's presence alone challenges Ford's, drawing the eye no matter his action.

The concentrated energy that ran through Carradine helped him secure the lead in one of the most successful Western TV series of the 1970s. Although he'd been consistently cast in cowboy movies—including *Macho Callahan* and Burt Kennedy's *The Good Guys and the Bad Guys* opposite his father, John Carradine—the world of Eastern thought had long fascinated him, and it was remarkable good fortune when elements taken from Westerns and Shaolin religion came together in ABC's *Kung Fu*. In this show, Carradine played a character named Kwai Chang Caine, a monk who drifts across America righting wrongs.

Legend has it the concept for the series came from Bruce Lee (*The Green Hornet*, *Enter the Dragon*). Carradine was not originally considered for *Kung Fu*, having starred in the ill-fated *Shane* TV series in 1966. But when he read for the Caine part, he had six additional years of experience behind him. He transformed himself utterly into the contemplative, always–moving Caine, whose contained dynamism could explode when pushed. Interestingly, the pacifist nature of *Kung Fu*, its thematic trademark, stemmed from ABC's concern over excessive violence, despite the show being a Western. Carradine sided with the brass, sensing that the effort to limit his character provided an opportunity to tell action stories in a different way, to direct viewer's attention not only to the physical encounters that mark Caine's life but also the interior conflicts he experiences as he embraces a philosophical code that permits him to fight but not kill.

Kung Fu's success was near-atomic, becoming an instant part of the culture and popularizing martial arts for millions. Carradine stayed with the show for four seasons, finally ending it himself so he could move on to other challenges. Even with wild fluctuations in his career and personal life, the actor never stopped his training in the martial arts or turned his back on Eastern philosophies.

Carradine would later say, "I tried some studio stuff after the show," starring in films like Hal Ashby's biography of Woody Guthrie, *Bound for Glory*. He also returned to television in a role inherited from Steve McQueen, *Mr. Horn*, the infamous range detective who was hanged for murder. *Mr. Horn* acted as a preamble for Carradine's finest Western, Walter Hill's *The Long Riders*, which had him play Cole Younger alongside his brothers, Keith and Robert, as the other Youngers. Written and produced by James Keach and his brother, Stacy, who cast themselves as Jesse and Frank James, and brothers Dennis and Randy Quaid as the Millers, the story of the Northfield Minnesota Raid is part fiction and part pastoral legend—a tone poem spattered with the blood of a thousand gunshots.

Neither overly romantic nor introspective, Carradine's Cole Younger is simply who he is: the tough farm boy who picked up a gun and chose the criminal path. It's a note-perfect performance, and both Keith and Robert respond with their own salutes to the criminal life. As a modern take on the infamous James Gang, *The Long Riders* also has an emotional reach into movie history, shouldered by the Carradines, with their father's own performance as Bob Ford in the 1939 *Jesse James* and its 1940 sequel, *The Return of Frank James*

The Long Riders faded into memory as David Carradine plowed on into an astonishing number of projects that ran the gamut from TV shows (*Matlock*), TV movies (*Last Stand at Saber River*) and mini-series (*North and South*) to solid action films (*Lone Wolf McQuade*, *Bird on a Wire*) to an assortment of ultra-low budget films that had him fighting everything from androids and vampires to zombies and psychotic cartoons.

There were few regrets, though, as David never stayed away from either the big or small screen too long. Life settled down in his later years. He married for the fourth time and welcomed grandchildren.

Quentin Tarantino cast Carradine toward the end of his life as the eponymous antagonist in *Kill Bill, Vol. 1* and *Vol. 2*. Bill was the ultimate role for the actor, all of his most villainous parts fitted together,

43

*Carradine's
Cole Younger is simply
who he is:
the tough farm boy
who picked up a gun
and chose
the outlaw life.*

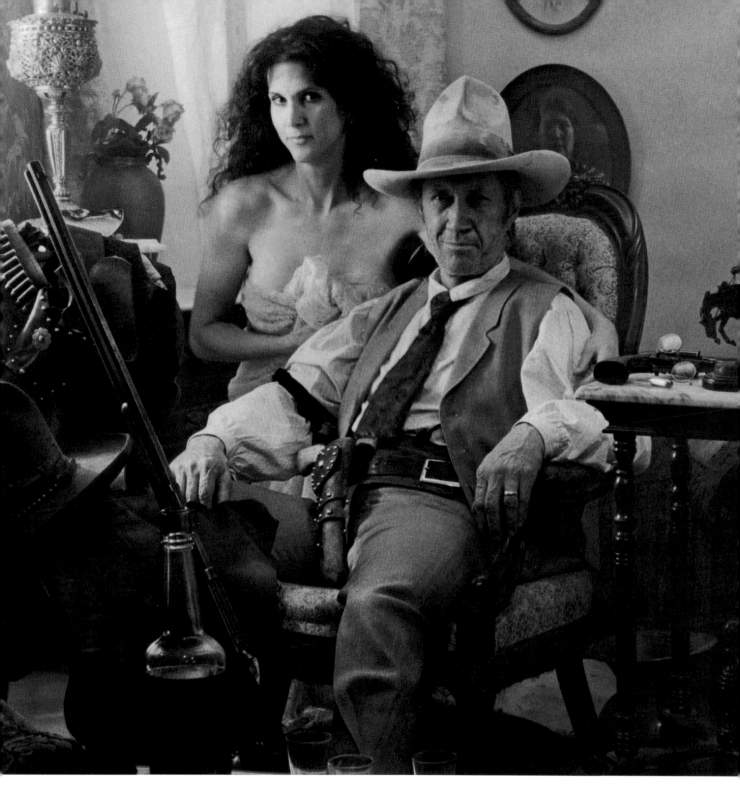

Above: David Carradine and Marina Anderson posing at The Darkroom.

with a martial arts expertise that brought us back to Caine, just as Tarantino planned it. The blow that kills Bill almost seems to have in it all that cobra-like energy that David Carradine himself invested in his characters over more than forty years. It's a glorious movie death, one the actor talked about with pride, even as he moved—he was always moving—on to other roles.

ROBERT CARRADINE
COWBOYS MEMORIES

EIGHT YEARS BEFORE portraying the Younger Brothers in Walter Hill's *The Long Riders* with his own brothers, David and Keith, Robert Carradine stepped into Western cinematic lore portraying Slim Hunnicut, the young cowboy who takes over a cattle drive after a psychotic outlaw (Bruce Dern) murders his boss (John Wayne). Directed by Mark Rydell, *The Cowboys* was a Western of serious intent and purpose, a major project for Warner Brothers.

The film's creators initially hoped to have David Carradine join the cast. "Rydell wanted David to play the part of Long Hair, the Bruce Dern character, and David didn't want to be the guy that killed John Wayne. David asked if I wanted to get on the movie as one of the boys, and I said, 'No, not really.' David said, 'Listen, brother, you've got everything to gain and nothing to lose.' I did an audition, and it was a scene where John Wayne and Slim Pickens go to the schoolhouse. Well, I had to read in front of the class a poem. One of the boys lets his frog loose, and all the girls freak out. My character was really nervous, trying his damnedest to get this poem right, and I was not doing a whole lot of acting because I was nervous reading a scene in front of Mark Rydell."

After casting him, Rydell had Robert learn the skills that go with being a true cowboy. "I'd been on a horse once, and Mark put us on horseback with a riding instructor for two-and-a-half months. Our instructor, Red Burns, taught us how to throw a rope. By the time we got to location, we were pretty tuned up. It was another two-and-a-half months filming, so by the end we were all very, very handy." Riding well and getting handy with a rope were the first challenges; the next was working opposite a legend: "John Wayne was gentle with us, but I had kind of an infamous start with him. There's a scene where the cowboys were supposed to ride this bucking horse named Crazy Alice as a test. A Martinez, who played Cimarron in the picture, jumps on the horse, breaks her, then goes over to the next kid and throws the reins at him. I jump off the fence and get into a fight with A Martinez. Duke breaks us up, tells me to get back on the fence where I belong. I actually had the audacity to tell him that I didn't think he should tell me to get back 'where I belong' because I'm the head kid. 'Maybe just tell me to get back on the fence, and that's it.' You could hear a pin drop in the middle of the Santa Fe desert after I said that. Nothing moved

for several seconds, then he really lit into me. So that was my first significant head butting with John Wayne."

The young actor more than proved his mettle as a cowboy later, quickly winning Duke's respect. "One of the mandates on the show was that when we weren't actually in school, we were supposed to be practicing the roping. I had more time off than the rest of the kids because I was older, and I had a smaller class load, and on this particular day the whole crew were out shooting camera car shots with the Duke. He's supposed to be galloping alongside the camera car with the herd in the background. I'm practicing my roping, and I hear this galloping that sounds like a horse running flat out as hard as it can. I turned around, and it's the Duke, and he's not stopping. He's heading for this carport area, sitting on a horse that's seventeen-hands high. It's going to take Duke off mid-chest if he runs through there. I just did what I saw the wranglers do, waved my arms and whistled. The horse slowed up, and the wranglers caught up to Duke and helped him off. They hustled him back to his Winnebago, and I went back practicing my roping. About an hour later, I had a sense that somebody was sneaking up on me, and it was the Duke. He said, 'The roping looks good.' I said, 'Thank you, Mr. Wayne.' He said, 'Yeah, nice day we're having. Well, carry on.' I said, 'Yes, sir, Mr. Wayne.' And after that, it was smooth sailing."

John Carradine, Robert's father, had a rich movie history with Wayne that reached back to Ford's *Stagecoach* in 1939. "Oh, he was pleased when I was cast. He came by the set. I have photographs in my archives of the Duke and my dad and me standing outside of the stage door. In a way I felt like maybe a de facto member of the Ford stock company because I'm a Carradine, and I'm working with John Wayne."

Despite its excellence, *The Cowboys* didn't open well, which surprised the filmmakers, who knew they had been part of something special. "The timing wasn't that great when it came out. You know, it was the end of the wild '60s. Something as straight and narrow as the story of *The Cowboys* just didn't really find an audience. But that said, it's still a really fine motion picture. I feel I'm blessed to be included in *The Cowboys*. That film was a real gift and an incredible way to start my career."

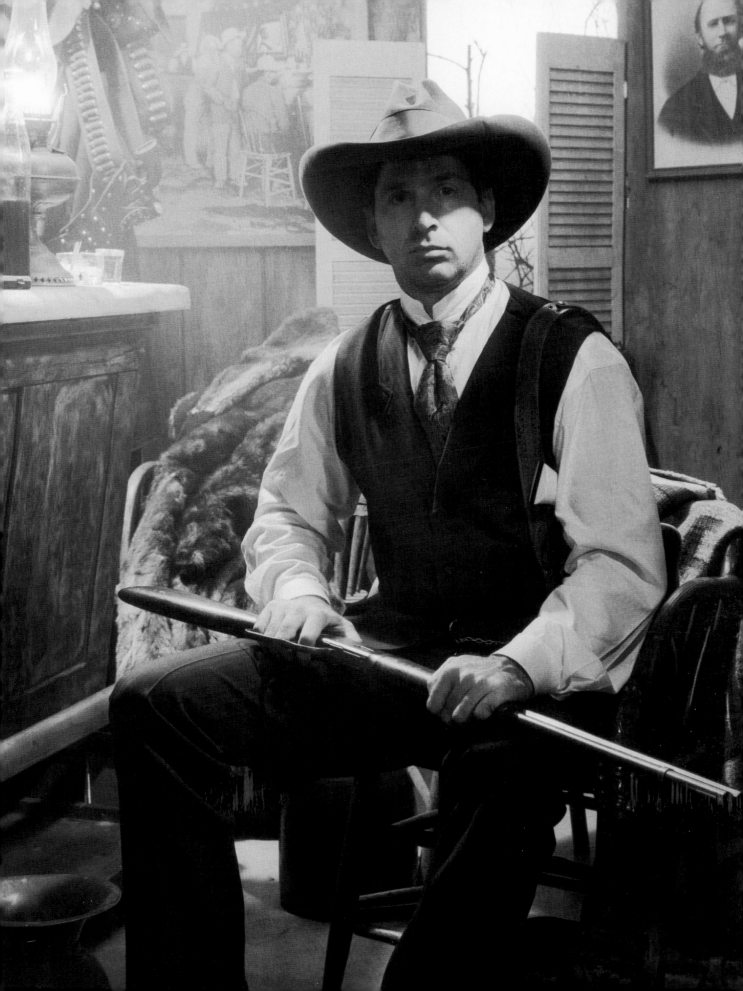

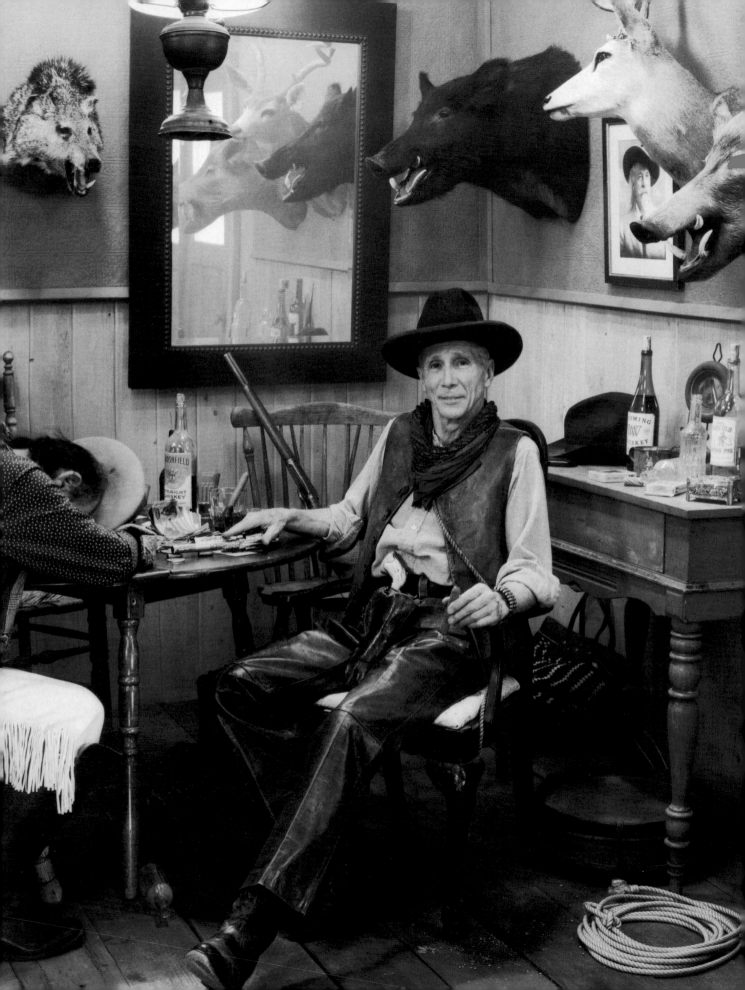

JOHNNY CRAWFORD
BEYOND MARK MCCAIN

ON MARCH 7, 1958, *Dick Powell's Zane Grey Theatre* presented an episode titled "The Sharpshooter," an intimate story of a widowed rancher and his son getting involved in a shooting contest against a reluctant, but pistol-sure, young man forced to compete by his greedy uncle. It was a drama of contrasts between two separate families: a father who cares for his son, trying to build a new life for them by winning the prize money as down payment on a ranch versus an uncle who uses his skilled nephew as a cash register.

Scripted by Sam Peckinpah, the episode earned praise for its writing and the measured, steady performances of Chuck Connors as widower Lucas McCain and guest star Dennis Hopper as the young man he must outshoot. At the center of the drama was young Johnny Crawford as Mark McCain, the motivation behind all of his father's actions. In a nice twist, Crawford bonds with Hopper's character, and they compare upbringings, with Hopper admitting that the boy has a better life than he does.

After its *Zane Grey* premiere, *The Rifleman* began in its own time slot, running for five years and never straying far from its focus on family. Whether protecting Mark or teaching him a lesson, when Lucas put his rifle into action it was for a just reason, with roots in his commitment to his son. From the start, Crawford was a natural in front of the camera, never cloying or cute. Legend has it that when he arrived for *The Rifleman* audition, all Chuck Connors did was take one look at the young actor with sympathetic eyes and said, "That's him. That's my son."

The choice was enormously successful, but Johnny Crawford already had years of experience behind him and knew his acting business. He'd been chosen as one of the original Mouseketeers for *The Mickey Mouse Club*—but was cut from the show its second season, which left Crawford, he claims with a smile, "Washed up at age nine. But I had a great agent who believed in me and kept me working."

His first work in a Western was a 1956 episode of *The Lone Ranger*, followed by stints on *Tales of Wells Fargo*, *The Adventures of Wild Bill Hickok*, *Wagon Train*, *Trackdown* and *Have Gun – Will Travel*. With all this activity, which also included situation comedies and dramas, Crawford was cast by director Jack Arnold in his science fiction film *The Space Children*.

The story of an alien presence taking over the kid's minds at a military installation plays as a near-sequel to Arnold's classic *It Came from Outer Space*.

Crawford's relaxed, realistic acting style was one of the reasons that Chuck Connors immediately responded to him. His performance as Mark embodied the wide-eyed dreams of boyhood and also the disappointments when those expectations don't come true. If Lucas was the man with the gun who had to dole out justice and fairness, then Mark was the lad who sometimes didn't understand that the real West and its outlaws weren't like what he'd read in the penny dreadfuls. Crawford recalls, "The idea of a widower with a young son was new. On TV, we usually always saw a complete family, with both parents. It really was unusual. I remember my mother read the first batch of scripts, and she had tears in her eyes because she thought the writing was so good."

Between shots Crawford brushed up on his riding and roping skills with the show's wranglers. "I loved hanging around with the wranglers. I could ride, but they really taught me how to handle a horse. Rodeo champion Monte Montana was on the crew, and he showed me how to handle a rope." Crawford also focused on music and took roles on *The Big Valley* and other shows before saddling up again in 1967 for director Howard Hawks's *El Dorado*. "I thought I'd be given a scene to read, but Howard Hawks just talked to me, then said he'd 'find something for me to do' in the film. It was a small scene, but important to the story, when John Wayne kills me. Chuck was very lighthearted between scenes, but I didn't find that with Wayne. I respected him very much, and still do, but with me he was all business."

Crawford starred in the USC student film *The Resurrection of Bronco Billy*, co-written by John Carpenter and Nick Castle. He played a store clerk who dreams of the bygone glories of the movie cowboy. In a nod to *The Rifleman*, Crawford also appeared as Mark McCain alongside Chuck Connors in *The Gambler: The Luck of the Draw*. By this time, he'd established himself on the stage performing in musicals. He became a prominent band leader, specializing in the dance music of the 1930s and '40s, another passion and another dream fulfilled: "Music's been great for me, as have Westerns. I'm very lucky."

RICK DANO
CARRYING ON THE TRADITION

RICK DANO HAS always heard the call of the ocean. The passionate surfer who grabbed a board when he was edging into his teens remembers his father, the legendary character actor Royal Dano, coming home with a special surprise. "I was about twelve, and I remember my dad was doing a *Gunsmoke*, and he'd gotten an autographed picture for me from Big Jim Arness, and it said, 'Rick, so glad to know you're part of the greatest sport in the world. Keep surfing! Your friend, Matt.' Jim was a great guy, a real surf rat, going back to the forties, when you had hundred-pound redwood surf boards. That's what he loved to do."

Rick Dano had a reunion with Arness decades later when he was cast in *Gunsmoke: The Long Ride*. "I brought that picture with me to show him and said, 'You wrote this to me thirty-five years ago!' He got a kick out of that. I only did the one *Gunsmoke* movie, but Royal did thirty-five of the shows or something. Jerry Jameson directed the movie, and he was great, very funny. The only thing was, by that time when you did your close-ups in Matt Dillon scenes, you did them with Ben Bates, Arness's stand-in, who was also a big, giant guy. We were doing a scene in this tiny cabin, and I was supposed to get shot while I'm in bed with this hooker, and the crew is outside the room. We do a rehearsal, and I hear Jerry yelling from outside, 'Hey, Richard, you're not going to do it that way, are you?' No direction, just asking that question! So, I had to yell back, 'No, Jerry, don't worry, I won't!'"

From 1950 onward, Royal Dano was in demand for film and then television, working with Alfred Hitchcock (*The Trouble with Harry*), Don Siegel (*Hound-Dog Man*) and several times with Anthony Mann, including one of Mann's darkest works, *Man of the West*. Another signature performance from Royal was as the Tattered Man in John Huston's adaptation of Stephen Crane's *The Red Badge of Courage*, starring Audie Murphy. Dano, his uniform shredded into rags, is the image of the ravages of war, and his voice signals its uselessness. The actor echoed that role in the opening scenes of Andrew V. McLaglen's *The Undefeated*, where he plays a one-armed Confederate soldier.

The McLaglen film brings back a specific memory for Rick. "He's just in that one scene, but my dad was so effective he only needed thirty seconds and could steal an entire film. John Wayne used to call him 'Kid,' because he was a week older than Royal. He worked a lot with Andy McLaglen. Every time you watched a good *Gunsmoke* or a *Have Gun - Will Travel*, ninety-five percent of the time they were directed by Andy. I did a *Criminal Minds*, and the director was a woman name Gwyneth Horder-Payton, who said, 'Your dad worked a lot with my uncle, Andy McLaglen.' So we had that connection! She was a very nice lady and a very good director."

Rick's own acting was spurred on by working on Steve Carver's action-crime comedy *Big Bad Mama*, which Roger Corman produced and in which Angie Dickinson and William Shatner starred. "I played a bellboy, but I was on the crew. Steve also had me in *Capone*."

Surfing friend John Milius cast Rick in his ultimate ode to their favorite sport, *Big Wednesday*, co-starring Jan-Michael Vincent and Gary Busey. "I love John. He's a good guy, and I've known him a long time. He'd had his huge success with *Apocalypse, Now* and *Jeremiah Johnson*. On *Big Wednesday*, he decided to take his shot and make a real movie about surfers. He told me, 'I'm gonna go for it.' And that's what he did. We got slaughtered when it first came out by most of the critics. A few really liked it, but then it made its money back in Japan alone. And now it's a cult classic, and people have *Big Wednesday* parties!" Milius made a special effort to cast Rick in *Rough Riders*, co-starring Tom Berenger and Sam Elliott. "John had tried getting me into several projects, but it never worked out with the casting people or whoever. One day I got a call from Milius's assistant, and he said, 'Hey, Dano, let me tell what John just did. He took seven guys who had one line and made it into one guy, and that's you. So get on a plane.' That's how *Rough Riders* happened—as a favor to me."

The Dano family's special history with Walt Disney goes back decades to Royal's being the model for, arguably, the most famous American President in one of the park's most famous attractions. "At Disneyland, 'Great Moments with Mr. Lincoln' was the first animatronic robot, and all the voice sessions with Royal were directed by Walt Disney. I was a little kid when it opened, but it's fascinating to see it now, because it's my dad. It talks like him, it walks like him. I took my daughter to see it, because she was born after Royal died, and I said, 'Look, here's your grandpa.'"

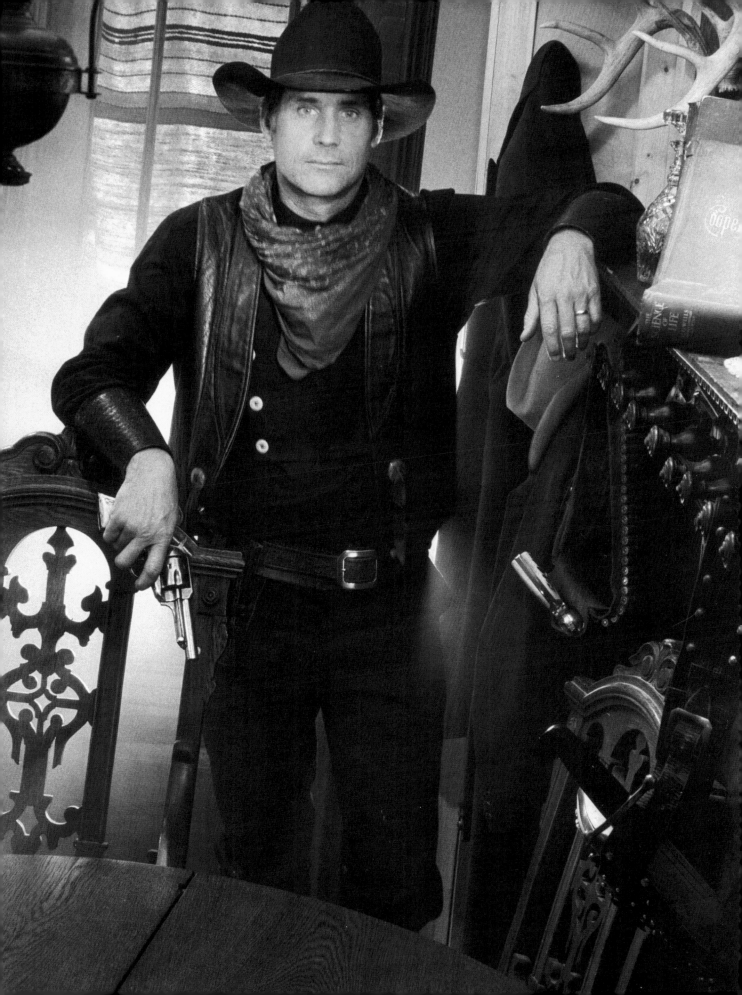

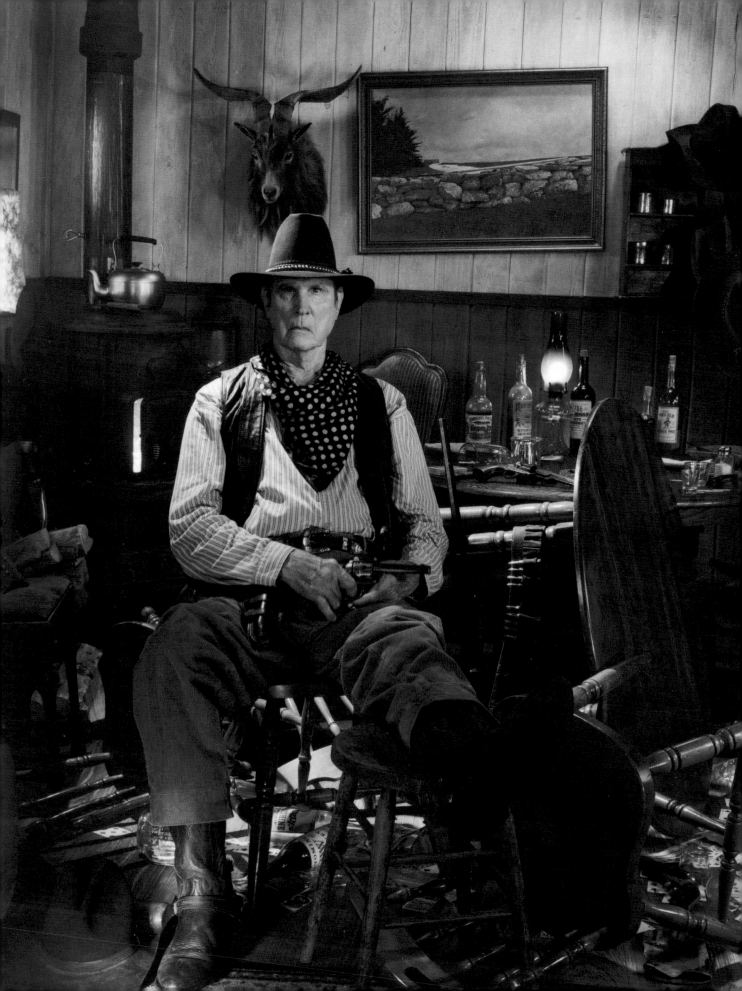

MICHAEL DANTE
HONORING THE WARRIOR

WINTERHAWK BEGINS WITH a heartfelt dedication to the American Indian followed by the voice of Dawn Wells as beautiful images of the land of the Blackfoot Nation wash across the screen. We revel in the photography, but the strength of the Blackfoot isn't captured until the first close-up of a stoic Michael Dante in the title role, pain behind his eyes, as Leif Ericson pronounces his young son dead from smallpox. Roger Ebert praised this independent film for its narrative clarity and Dante's performance, noting it as one of the few times that a Native American character spoke only his own language on-screen.

Filmmaker Charles B. Pierce in *Winterhawk* surrounded Dante with a grand assortment of great Western faces, including L. Q. Jones, Woody Strode and Denver Pyle. Pierce reveled in the contrast between their wild and wooly personas and the steady, quiet dignity of Dante's performance. The actor regards *Winterhawk* as a high-point in his career and a piece of a child-hood dream come true. "I was always at the movies, always sneaking in with my friends, especially to see Westerns. My dream growing up was to someday ride alongside the Lone Ranger as a new Tonto."

A natural athlete, the Connecticut-born Ralph Vitti excelled on the baseball field, and after high school was drafted by the Boston Braves, using his salary bonus to buy his parents a new car before moving on to the Senators in Washington, D.C. His time in the Nation's Capital marked a turning point as Vitti's other passion, acting, took hold, particularly when he attended drama classes near the team's Florida training camp. It was bandleader Tommy Dorsey who extended his hand to Vitti, bringing him to the attention of Warner Brothers, where his name was changed to Michael Dante. And after unbilled roles in *Somebody Up There Likes Me*, *Jeanne Eagels* and *Raintree County*, he was cast in the TV Westerns *Colt .45* and *Sugarfoot*.

Dante's guest-starring roles were in three of the best *Sugarfoot*s, particularly his turn in "The Dead Hills," where central character Tom "Sugarfoot" Brewster (Will Hutchins) tries in vain to save a ranch owned by Ruta Lee. After three episodes of *Cheyenne*, Dante secured a role in the feature *Fort Dobbs*. Written by Burt Kennedy and directed by Gordon Douglas, this bleak Western is the finest of the ve-hicles the studio fashioned to launch Clint Walker's movie career. It's a tough film with solid dramatic work from Walker, Virginia Mayo and Dante.

In 1959, Dante played opposite Randolph Scott in *Westbound*, the last of Scott's collaborations with director Budd Boetticher. The star lived up to Dante's expectations. "An absolute total gentleman. I was newly married, and Randolph Scott sat me down and talked to me about making some investments for the future, saying he'd lend me five-thousand dollars to buy a stock he was recommending. I told him there was no way I could accept that sort of loan, as I'd never be able to repay it. He said, 'Oh, yes, you will.' I thanked him but refused, and the stock was for a new company called IBM, and Randolph Scott made himself another fortune. I don't regret missing out on getting the money, and I so cherish the memory that he made that generous offer."

One of the actor's favorites films came next, Henry Hathaway's *Seven Thieves*, co-starring Edward G. Robinson, Joan Collins and Rod Steiger, an expertly crafted and acted caper film the success of the original *Ocean's 11* released around the same time unfortunately overshadowed. Dante returned to the saddle for *Apache Rifles*, the first of his films with director William Witney and star Audie Murphy. "Audie and I trusted each other as actors very quickly. There were no troublesome temperaments or anything like that. I found him very easy to work with." Dante took on the role of Red Hawk, the warrior son of the great Apache Chief Victorio, who clashes with "Indian killer" Murphy, a notorious cavalry officer whose attitudes about the Apache change as he falls in love with a half-Indian teacher portrayed by Linda Lawson. When Murphy tries to negotiate a peace treaty, it's broken by rebel miners led by L. Q. Jones, who want all the Apache dead and buried.

The film carries a heavy message about the treatment of the tribes at the hands of the military, a position that Dante embodied in his role. "Red Hawk was the one who would be the leader of his nation, and I wanted to maintain that dignity he possessed. His people had been victimized too many times, and he wasn't going to bend. That's the character, and that's what I played. Of course, he must compromise to save his people." Dante found an instant rapport with his co-star. "Audie had great finesse with weap-

"I was always
at the movies, always
sneaking in with
my friends,
especially to see Westerns.
My dream growing up
was to someday
ride alongside
the Lone Ranger
as a new Tonto."

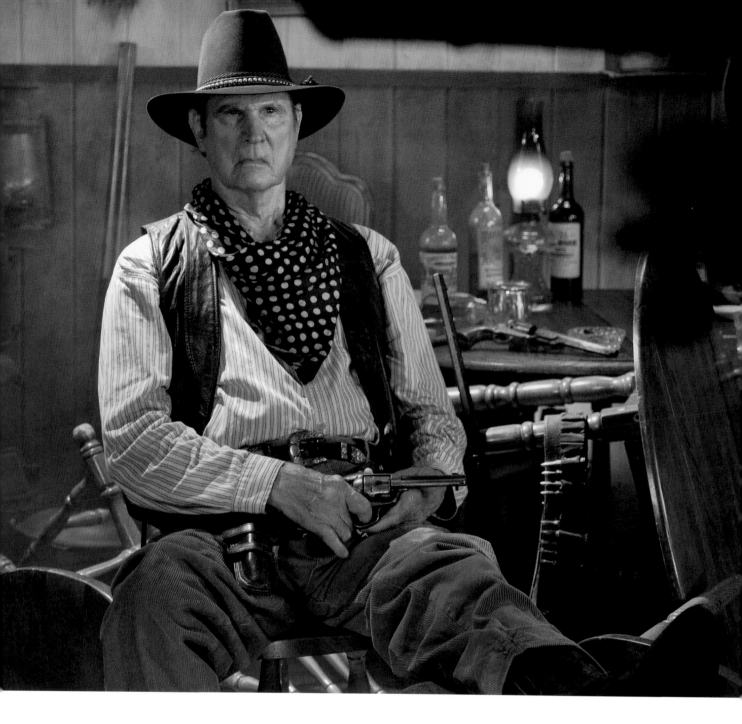

ons. When he held a pistol it was like an extension of his hand. He wasn't a highly trained actor at all, but he was very honest in his playing. He was a much better actor than they gave him credit for."

Michael Dante's ability to imbue his interpretations of Native American characters with authenticity was the reason behind Charles B. Pierce hiring him for *Winterhawk*. Released the same year as *Breakheart Pass, Bite the Bullet* and *Rooster Cogburn*, this independent film generated a decent box office return. Its star feels that the approach used by writer-

director-producer Pierce exemplified the perseverance shown by the hearty folk who lived in the West prior to the advent of industrialism as he put the film together through his own determination, battling the Hollywood elements to craft something honest and simple. "It was as if we made the movie the way the Indians lived; we used everything we had, all of our resources to make the film. Everything we took from the land and all that surrounded us. And that helped capture the spirit of the story, the spirit of those brave Native Americans."

ROBERT DAVI
CHARACTER STAR

When guerilla leader William Quantrill, a Confederate sympathizer, died from wounds sustained in his final skirmish with Union troops, he was twenty-seven years old. With his gangly frame and foppish moustache, he may not have looked like a murderer, but this former school teacher from Ohio had commanded one of the most vicious bands of renegades during the Civil War, and the blood of hundreds smeared his hands.

Robert Davi portrayed Quantrill in the 1979 made-for-television Western *The Legend of the Golden Gun*, when he himself was twenty-eight. The film, which co-stars Hal Holbrook and R. G. Armstrong, follows the efforts of John Golden (Jeff Osterhage) as he seeks revenge against Quantrill after being left for dead during one of the killer's terrible raids. Golden, the source of the movie's title, carries a special revolver with a seventh chamber to hold a bullet to be "used against evil." *The Legend of the Golden Gun* precipitated debate among Civil War buffs over the manner in which it challenged assumptions about American history and its icons, questioning the glory and romance attributed to an earlier, turbulent era. As Quantrill, Davi achieved a satanic dimension, dominating this dreamlike Western by revealing how the rage in the man's personality could overtake his meeker tendencies.

Born in Astoria, New York, and classically trained as a singer, Robert Davi had the great luck to make his debut TV appearance in a feature about the mob and the police in New York City, *Contract on Cherry Street*; his idol, Frank Sinatra, both produced and starred in the film. Davi gave his small role as Mickey Sinardos some bite, impressing the legendary star. The younger man's imposing height and handsome, scarred face practically ensured he would regularly secure parts as contract killers and mob bosses.

Davi established an imposing presence on TV screens as Vito Genovese in *The Gangster Chronicles*, an original miniseries produced for Universal Television that followed the rise of the Mafia in the United States under the leadership of Lucky Luciano and Bugsy Siegel. Good ratings and critical favor helped the actor secure subsequent roles in the box-office blockbusters *Die Hard* and *The Goonies*. He also scored as the smooth international drug lord in *License to Kill*, the second and most serious James Bond film starring Timothy Dalton.

Somehow amidst all this work, Davi managed to make another Western. This time he joined Fred Dryer as a bad guy in the pilot for Stephen J. Cannell's *The Rousters*, the prolific producer's modern-day look at the bounty hunter descendants of Wyatt Earp. The show lived for only half a season but managed to provide work for many engaging actors, including Hoyt Axton and Chad Everett. Intriguing in an *A-Team* sort of way, the pilot had Davi and Dryer causing mayhem as brothers.

Smokewood, Nevada was a comic pilot made for cable TV that presented viewers with a unique take on the Western. Although its characters live in the 1890s, the program borrows concepts and conventions from contemporary reality shows as it tracks the inept footsteps of a tenderfoot mayor, Dale Baxter (Mark Odlum), in the town of Smokewood, where a war rages between cattleman Bruce Boxleitner, outlaw Martin Kove and black-clad bad man Davi. Phil Spangenberger, writing in *True West* magazine, praised the program for delivering "plenty of good old Western action and catchy dialogue, along with a flavorful look at the real West, as well as the reel West." Sadly, the pilot didn't sell.

Davi rolled through dozens of roles in cable and direct-to-video action and horror films, securing major parts in big studio productions like *Cops and Robbersons* and the infamous dud *Showgirls*. Despite all the time in front of the camera, however, there was something missing. As the actor said, "I was working, but not fulfilling my creative objectives." What wasn't being fulfilled was his music, and he set about to build a concert tour based on his incredible interpretations of songs recorded previously by Frank Sinatra. The concerts and CDs from these performances have given new life to the performer, who now travels around the world with a microphone in his hand rather than a .45.

He's still an in-demand tough guy, though. Just as his hero, Ol' Blue Eyes, stepped into Westerns like *Johnny Concho*, *Dirty Dingus Magee* and the Rat Pack adventures *Sergeants 3* and *4 for Texas*, Robert Davi has found himself in Westerns every once in a great while. And it's a form that he loves, as proven years ago when he brought one of history's true monsters, William Quantrill, terrifyingly to life.

Right: Robert Davi posing with Z at IMAGE Studios.

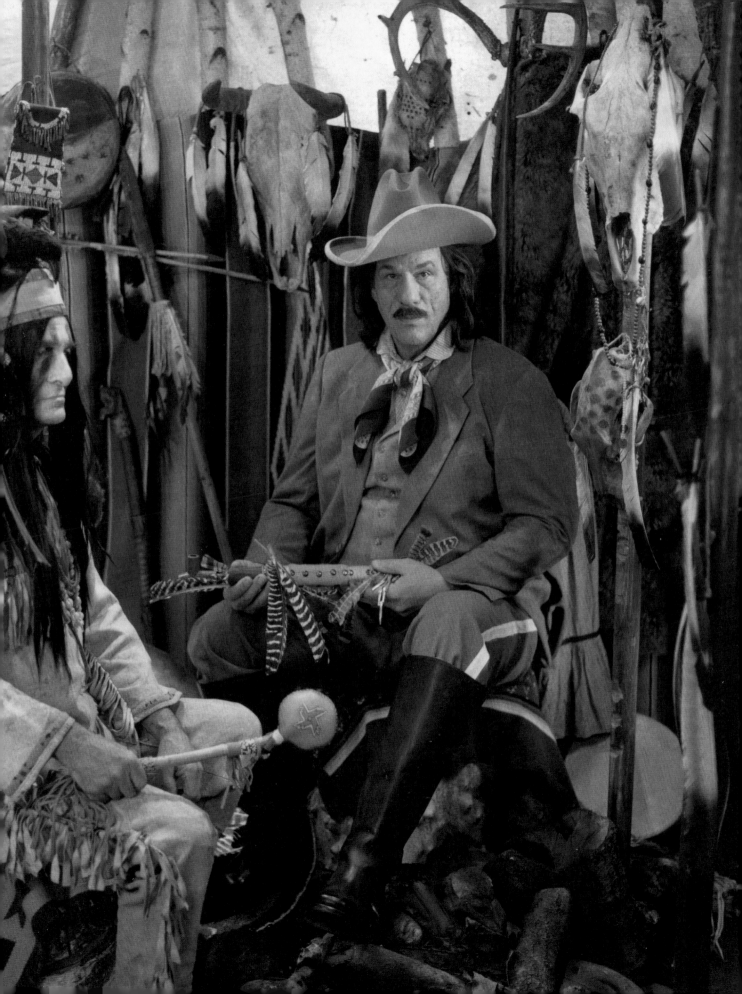

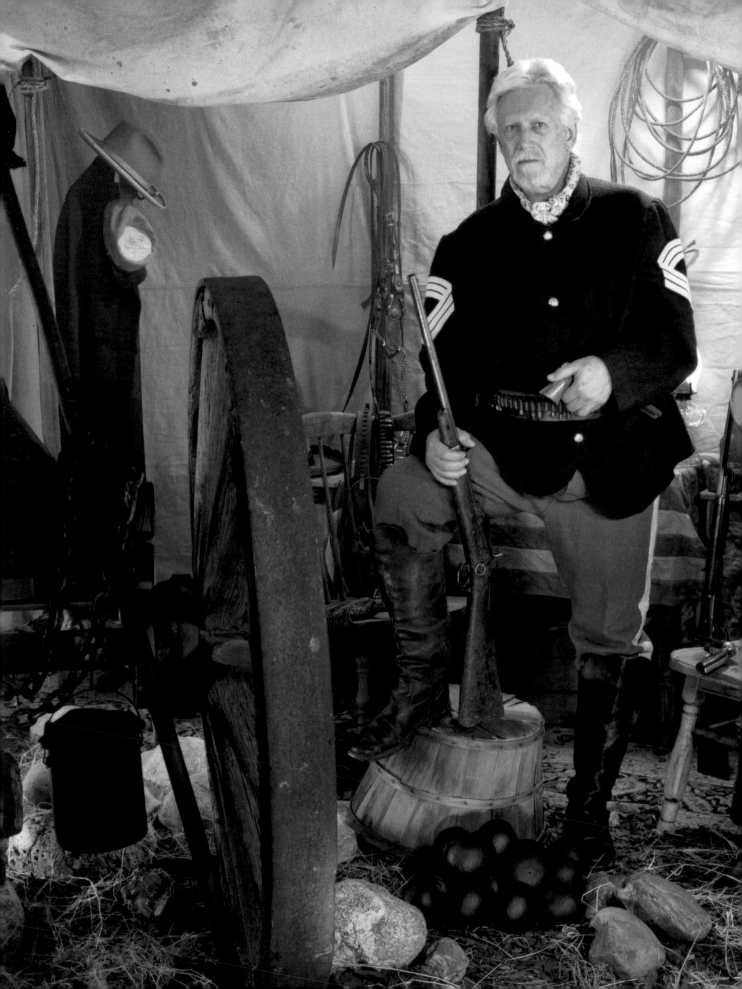

BRUCE DAVISON
LT. DEBUIN TAKES COMMAND

When Bruce Davison walked into Robert Aldrich's office to discuss his playing Lt. Debuin in *Ulzana's Raid*, he'd already made an impact in his debut as one of the young stars of Frank Perry's *Last Summer* and in John Flynn's underrated espionage thriller *The Jerusalem File*. Still this experience didn't stop him from making a rookie mistake when talking to the director of *Vera Cruz*, *Kiss Me Deadly* and *The Dirty Dozen*: "When I met Robert Aldrich, I told him that *The Sand Pebbles* was one of the greatest films I'd seen, and he said, 'Thank you very much, but that was my friend Robert Wise.' Well, I nearly threw up in my mouth and needed to leave. He told me later, 'That's when you got the part, kid. I needed someone with your naiveté.'"

Written by Alan Sharp (*Night Moves*), the intense story of the chase of a renegade Apache who jumps the reservation to go on a personal raid against settlers served as both a metaphor for the Vietnam conflict and an unusual coming-of-age story. Davison plays Lt. DeBuin as a young, inexperienced officer of earnest convictions and black-and-white morality that rarely have a place in war, a hard truth taught him by his half-Indian scout, MacIntosh, brilliantly embodied by Burt Lancaster. The film was Davison's first Western, and he was excited to be in such great company, making a movie in a genre that he loved. "Being a young kid coming in, I was sort of a comma in the long history of Westerns. The Westerns I remember growing up were the black-and-white ones, and then *The Searchers* had a profound impact on me. Later, getting to know Natalie Wood afterwards and hearing her take on the film was just wonderful."

With the focus of the story on the change in Davison's character as he learns the realities of his mission, the director offered some advice on the realities of show business. "The best advice I ever got was from Robert Aldrich. He said, 'Kid, you don't want to be a leading man; you'll be washed up at thirty. Be a character actor, do the supporting roles. Be the villain and the victims. Play the doctors and lawyers and Indian chiefs and you can raise a family in this town.'" Lancaster had a different perspective. "Burt's advice was to save it for the close-ups. 'Don't shoot your wad. Don't be acting for the cameraman and the lighting men and the guy laying the marks, because you'll use it all up in the wide shot, and you'll be exhausted for your close-up. Work with the baby blues and the pearly whites, that's what I do. You have that marvelous head of hair, work with that.'"

Davison's personal interest wasn't in just the American history being portrayed but also the history of all the filmmakers he was working with. "Cameraman Joe Biroc was great and always wore a scarf. He was quick but got amazing results. He and Aldrich had done a lot of films together. He was legendary. All the stuntmen that worked on that film were the horsemen that came from John Ford days. I love Westerns, I always have. They're the most fun. And I love talking to people about their experiences. I loved talking to Burt about *Vera Cruz* and *Apache*. I loved talking to Henry Fonda about Sergio Leone. Any time I can get hold of a great character actor or a stuntman, I love hearing the history, especially the elder stunt families, like Yakima and Joe Cannut and their history with John Wayne going back to the '30s."

When *Ulzana's Raid* was released by Universal in 1972, the Western was undergoing a transformation, with one foot in a new sense of historic realism and movie violence and the other in the traditional tropes of the genre going back fifty years. Says Davison, "The point was that the violence was in your face. It was a metaphor for Vietnam, and Burt and Bob and Alan Sharp and I talked about that. A lot of people didn't see it, but *Ulzana's Raid* was about the military getting in over their heads, fighting an enemy they didn't know how to fight. My favorite scene is when I'm given the assignment, and I'm with the colonel of the fort, and I say, 'My father believes in the Christian charity, and there's a better way to treat the Apache.' And the colonel says, 'From a pulpit in Philadelphia that's an easy mistake to make.'

"It wasn't stylized like *The Wild Bunch*. It's almost like a documentary. We were watching this shit from the news every day about Vietnam, and so that was the approach. There were a few who picked it as one of the top films of the year, but Universal didn't give it a lot of support." All the same, Davison relishes the experience he had making *Ulzana's Raid*. "Those telephoto lens shots, when we were lost in Nogales! I'd turn around and see Richard Jaeckel bouncing in his saddle, just thrilled to be out there to play cowboys and Indians. But I was just enamored with all of these actors, stuntmen, Burt and Robert Aldrich. These men, they'd ridden the trail before."

LEE DE BROUX
BRINGING HIS BEST

"He's come to work."

WHEN ACTOR MICHAEL BRANDON made this statement, it was during a script reading for a television production of *The Red Badge of Courage*, and the person he was referring to wasn't the director but fellow actor Lee de Broux, whose preparation for his part and research into Stephen Crane's iconic novel was so complete that Brandon had to express his admiration.

A 1967 Western featuring one of MGM's most famous leading men got Lee de Broux his SAG card: "That was *The Return of the Gunfighter* with Robert Taylor. I had started on the TV Westerns. I remember *The Guns of Will Sonnet* with Walter Brennan quite well. He was an old man and still very game. He was suffering from emphysema, so it was hard for him to walk very far. We shot up at the Bronson Caves, and that location wasn't easy for him. But it was TV work, and the important thing was to get on with it, which he did."

Every actor who broke in doing Westerns in the 1960s faced the same challenges: handling a horse, handling a fight and handling a gun, whether you were skilled or not. De Broux perfected those skills, which he saw as simply part of an actor's toolkit. De Broux's discipline paid off early when he became one of those character actors who were part of the *Gunsmoke* family, appearing in a half-dozen episodes. "The director Robert Totten and Victor French had gone to Valley College, and when I was there, I was in a festival of one-act plays. My acting partner and I had put together this elaborate fight scene, and the head of department actually held the curtain because he knew Totten was coming to the festival and didn't want him to miss our scene. Totten saw it, and cast me in my first *Gunsmoke* with Morgan Woodward and Chill Wills. At that time, TV directors could hire who they wanted, so Totten would bring me in for his shows as he would Mills Watson and Victor French. It was a little repertory company, not unlike John Ford's. But you had to be handy, and fortunately I was one of those guys who could fight and fall and ride a horse and make sure nobody got wrecked."

De Broux's last *Gunsmoke* in 1974 was directed by Victor French, who believed in returning to theater between TV and film work. "I studied with him for years. Victor would come to the college to teach a class and established the Company of Angels, of which I was a part, and we'd do several plays a year. And that's how we learned to grow, through theater, and we'd bring that experience into our film work."

The contemporary Western *Tell them Willie Boy is Here*, co-starring Robert Redford and Robert Blake, remains a vivid experience for de Broux because of the filmmaker behind it. "Abraham Polonsky wrote and directed, and it was the first time he'd used his real name since being put on the Hollywood blacklist. We did it in 1968, and I'd only been acting for four years, and it was very exciting because I was a fan of Polonsky's work. Robert Redford and I had a great fight scene that we did ourselves."

De Broux also appeared in three episodes of *Bonanza*, including "Forever," a deeply felt episode of emotional loss that paid tribute to recently departed star Dan Blocker, which was also one of the first shows directed by Michael Landon. De Broux describes this period as "perking up," going from motorcycle flicks to prestige television to roles in major films like Blake Edwards humor-laced *The Wild Rovers* and *Sometimes a Great Notion* directed by Paul Newman before returning to television for more episodes, approaching each role with care and dedication.

"For all those Westerns, you had to be handy with horses and the rest and be able to bring those characters to life off the page, finding traits in the character to make it work. But when you get great material, then you rise to the necessity to the character and the scene. I love to work, and it's always a good time when you're working with cowboy hat and boots on."

It was while in an LAPD uniform that de Broux brought a special touch to the classic *Chinatown*. "To be in film at that time was very exciting. We were filming in San Pedro, and we were all standing around the dripping pipe where the illegal water was coming from, and Jack's humiliated and I laughed at him. I touched the side of my nose as I walked by, which meant 'Keep your nose out of other people's business.' But he'd already had his nose slit, so I'm making fun of that, and Jack's reaction was great."

De Broux's association with Walter Hill began with *Geronimo* and continued with *Wild Bill*. "Geron-

Right: Lee de Broux posing with Denise Ocampo at IMAGE Studios.

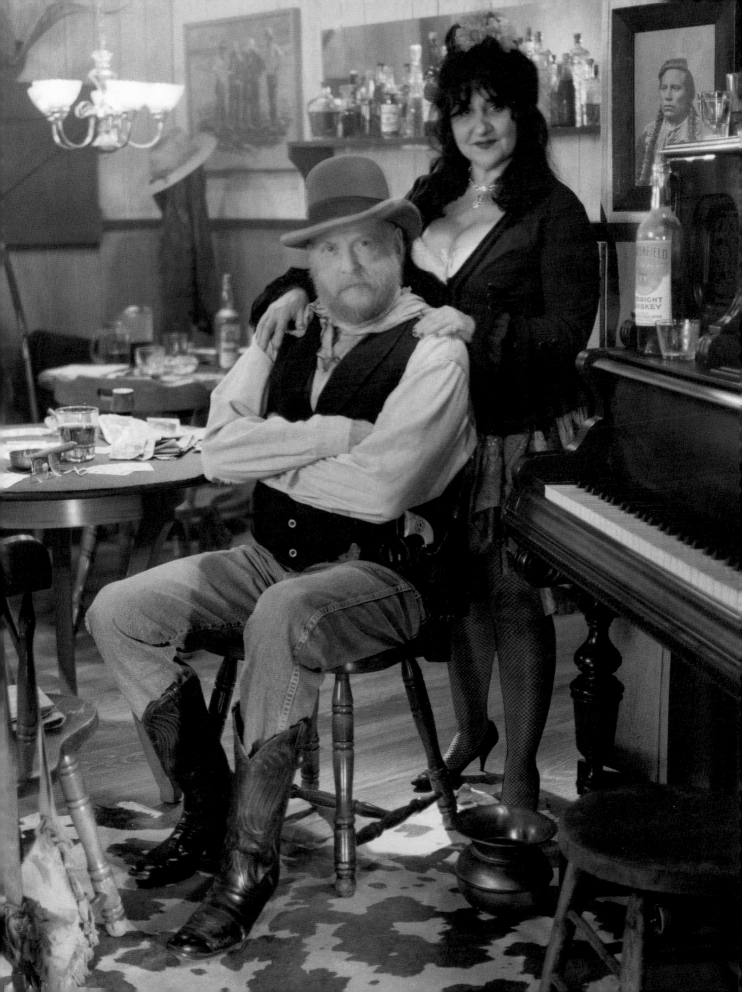

"I love to work,
and it's always
a good time
when you're working
with a cowboy
hat and boots on."

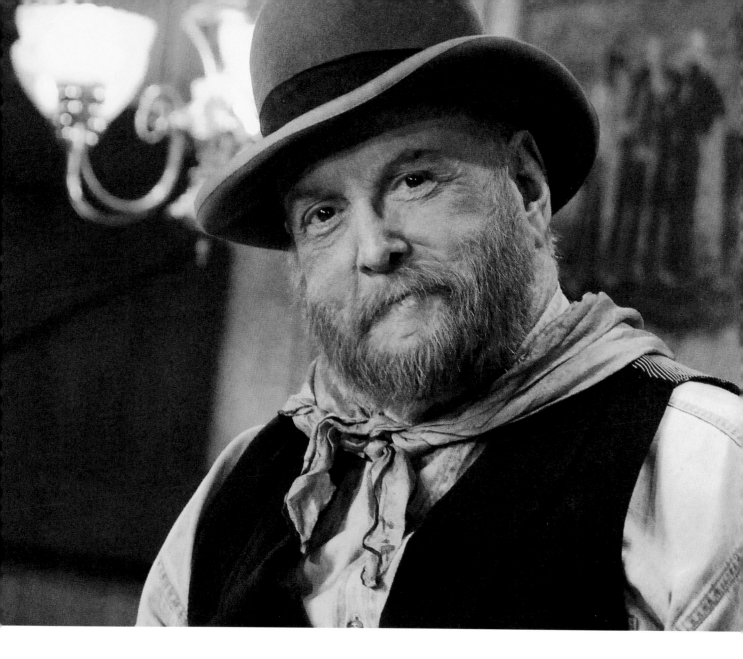

imo was another situation where I had to be handy. Alan Graf, the second-unit director and stunt co-ordinator, asked if I could ride, and I assured him I could. I went to Utah for the filming on my birthday, which was a wonderful gift. I did all my riding shots, and then came the scene where Geronimo is aiming at my head, but he hits the jug of whiskey in my hand. Walter asked me if I'd do the scene, and I said I would if the effects coordinator would do it first. He did, and it was safe. So we're filming, and the squibs go off, blowing up the bottle, but I'm on my horse. We were both startled, and I had to control the animal! We were shooting with three cameras, and

Walter said, 'That'll jangle a man's nerves.' When I was wrapped, Walter told me to steal the big white hat I was wearing. I still have that hat, which is terrific. Walter then cast me as the bartender in *Wild Bill*. He was gracious enough to see that I was in the film, and I was treated very nicely."

Lee de Broux's career so far has seen him in more than a hundred-and-forty roles that stretch from TV situation comedies, mini-series and cop shows to classics like *Chinatown*, *Norma Rae* and *RoboCop*. "I always say I'm like a plumber: this is the work that I do, and this is the training that I've had, and I try to bring my best to whatever I do."

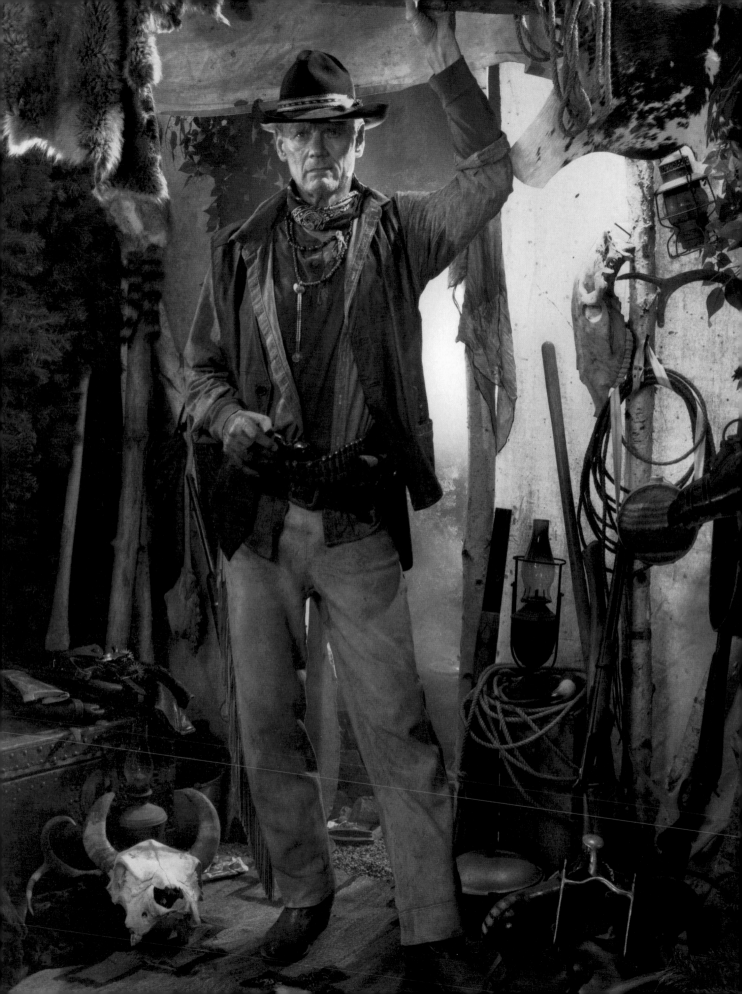

FRED DRYER
THE COWBOY WAY

*"I'm a horizontal person,
and New York is all vertical."*

THESE WORDS ARE Fred Dryer's, and they come from a 1973 television special as he left the East Coast, following record-setting seasons with the New York Giants and the New England Patriots. This son of Hawthorne, California, was returning to the Golden State to take his place with the L.A. Rams. Behind the wheel of his van, captured in 16mm as he crossed the desert, Dryer revealed the sentiments of the true Westerner, a man who can't stand the confinement of a city any longer and yearns for wide open spaces and his own piece of land.

Los Angeles lies on the edge of those spaces, and Dryer's piece to call his own was the yards between opposing goal posts. He would set still-standing records with the Rams, play in two Pro Bowls, the Super Bowl, too, and emerged as a true football legend when players hit the field hurt and salaries were a fraction of what they are today. He accomplished all this while showing off a personality that was as large as his frame, delighting fans with his off-the-wall wit that disguised brutal honesty, poking fun at everything from pretentious sports journalists to the sense of privilege he saw around the game.

After thirteen seasons in the NFL, Fred Dryer followed his other passion: appearing before the camera. He was a natural fit for an episode of *Lou Grant* about a paralyzed football player, where he guest-starred with Fred Williamson. Stephen J. Cannell's TV movie *The Rousters* followed, a comic tale about the eccentric, modern descendants of Wyatt Earp, who're all carnival folk. Starring Jim Varney and Mimi Rogers, the backdoor pilot became a short-lived series with Dryer as tough guy Will Clayton. The role of Sam Malone on *Cheers* was almost his, but when it went to Ted Danson, the producers had another idea for Dryer and created the role of egotistical sports announcer Dave Richards for the beloved situation comedy.

Introduce all Dryer's exciting traits and add some Old West values to an L.A. detective and you get *Hunter*. "As a kid," he recalls, "you had the fantasy that was Westerns and horses and all that stuff, but as we grew up other things came in. It wasn't that the Western was gone: it had been modified by modern urban existence. So you started seeing the interpretations on TV of the Western brought to policiers. It was still good versus evil, just not on horseback. And for an audience, it didn't matter about politics or religious differences, or any differences, you still responded to that dynamic. In the Western it was the good guy versus the bad guy, whether it was a stranger coming along to help defend a family like in *Shane*, or a showdown with a gang. Those simple Western stories can transfer over to something modern day with the police."

Dryer played Rick Hunter as a man of few words. "I always thought there was too much exposition, too many scenes in the captain's office telling me what to do. You didn't need all that kind of dialogue; you just needed the characters in action. That carries the story. When I became a producer of the show for the last two years, I told the writers to think of it as a Western and to come up with scenes without all that exposition. Have dialogue, but as a Western would. Make it spare, terse, and think of the storytelling visually. That's the challenge."

Following Dryer's lead of showing and not saying, the show was turned into more of an urban Western than it had been before. "I talked to producers Roy Huggins and Steve Cannell about this, and once everyone understood what I was talking about, it worked beautifully. My co-star Stepfanie Kramer was great with dialog. She'd get the lines, and then we'd be out the door. The show's got faster and more exciting. I remember a scene with Hunter looking for a suspect, tracking the guy to his apartment. I knock on the door, and he goes out the window. There was going to be this chase all around the neighborhood, through yards, under clotheslines, and the guy gets across a roof, lands on a carport, and I stop him at his car. I told them there was a better way to do it. So the guy jumps out the window, gets to the carport, and I'm waiting for him, with my gun in my lap. Laconic, with a little humor, because I'd nailed him. There was some resistance to cutting all that other stuff. But when Roy Huggins saw the scene, he told me it was just right—right for the character, which is what I was after. This is a TV series, so I have to establish a behavior that's consistent. Making Hunter a Western character, but on the streets of L.A., was a great way to do it."

"What it comes down to for me is the purity of the Western form, the true history and the stories, the character of the land testing the character of the man."

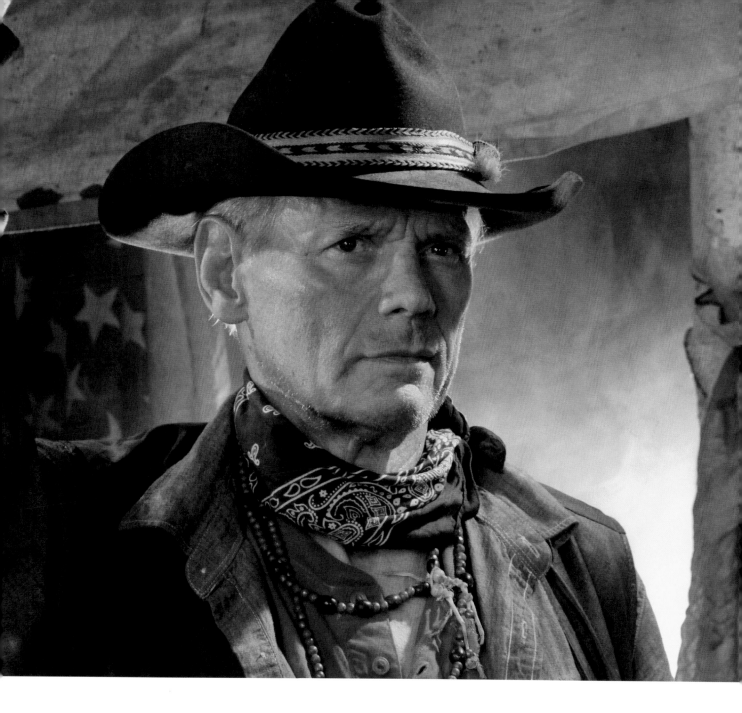

At the height of the show's popularity, Dryer starred in the hit film *Death Before Dishonor* with Brian Keith and then returned to his series. After *Hunter*, he continued on television and in films in a variety of parts, including a new adventure series, *Land's End*, co-starring Tim Thomerson. Comic book fans cheered as Dryer acted in DC and Marvel productions, playing Sgt. Rock in *Justice League* and Nick Fury's nemesis, Octavian Bloom, on *Agents of S.H.I.E.L.D.*

In 2003, Fred received the NFL Alumni Career Achievement Award and continues as both a sports radio host and color commentator. But the West and the Western retain a special place for the NFL legend: "What it comes down to for me is the purity of the Western form, the true history and the stories, the character of the land testing the character of the man. Growing up watching those stories and admiring those people, that's what's stayed with me."

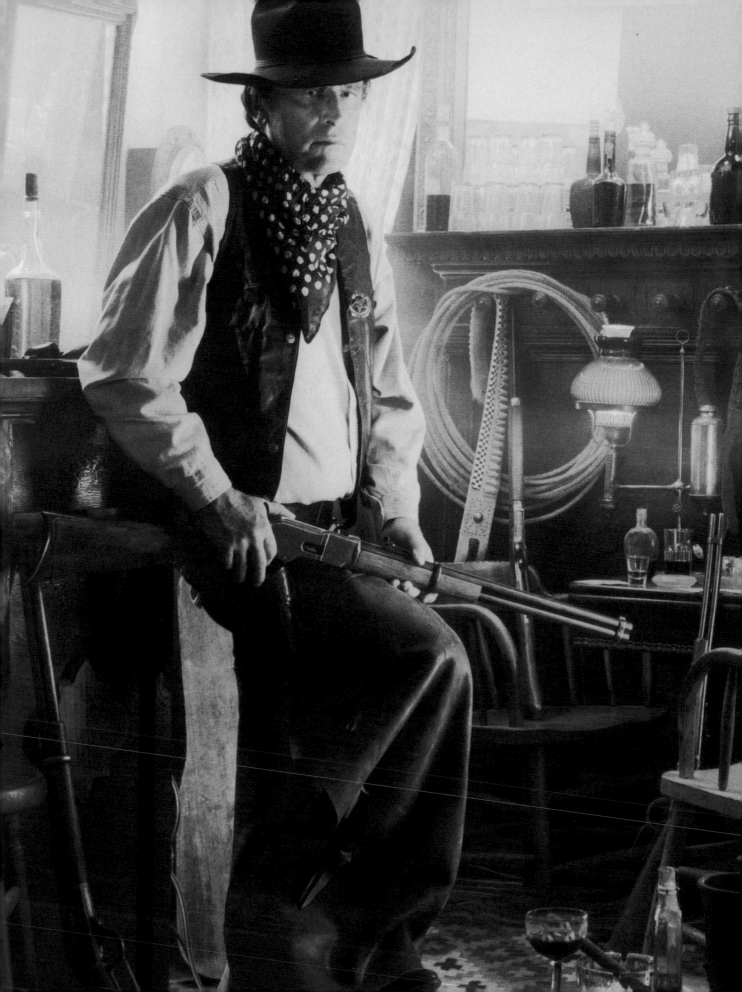

ROBERT EVANS
IN FRONT OF THE CAMERA, BEHIND THE DESK

IN HIS AUTOBIOGRAPHY *The Kid Stays in the Picture*, Robert Evans notes that actress Norma Shearer personally approved his portrayal of her deceased husband, MGM chief Irving Thalberg, in the 1957 Universal film *Man of a Thousand Faces*, the story of silent-screen legend Lon Chaney (James Cagney). The movie was dismissed by the Chaney family for smoothing over some rough facts about the actor's private life, but they felt it accurate in its presentation of Chaney's friendship with and respect for Thalberg. The handsome prince of the Evans-Picone fashion dynasty, Evans was actually under contract to 20th Century-Fox at the time and had only appeared in bit parts in two films before being chosen as the one actor who not only looked like a young studio head but projected the necessary cool authority of the best movie executives. After *Man of a Thousand Faces*, Evans returned to Fox for his impressive turn as a young matador in *The Sun Also Rises*, co-starring Errol Flynn and Tyrone Power.

In 1958 he made his only Western, the infamous *The Fiend Who Walked the West*. "Don't turn your back on this beast with a baby face! He's a kooky killer! The most diabolical horror that ever roamed the earth!" So cries a panicked voice describing Evans's character in the movie's trailer. Instead of promoting the film as a simple Western, Fox touted *Fiend* as full-out horror, with Evans pre-dating Anthony Perkins as the screen's most attractive psychopath. During the 1950s, 20th Century-Fox boss, Darryl Zanuck, invested huge money in Cinemascope epics like *The Robe* and *Land of the Pharaohs*, some of which scored big at the box office and others that did not. A program of quickly shot black-and-white features like *Fiend* was started to cushion the cost of the bigger films by turning fast profits, keeping new Fox product on movie screens between gigantic releases.

The Fiend Who Walked the West began simply as a contracted remake of Fox's earlier classic *Kiss of Death*, the crime film that made Richard Widmark famous as the giggling killer Tommy Udo. Working from Ben Hecht's classic 1947 script, old hand Philip Yordan cleverly changed the rain-dark streets into dusty trails and rewrote city hoodlums into scruffy outlaws. Director Gordon Douglas pushed the melodrama as high as he could, making *Fiend* an outlandish example of the noir Western. In the original, Widmark famously pushes an old lady in a wheelchair down stairs; in *Fiend*, Evans shoots an old woman with a bow and arrow, impaling her against her wheelchair. Evans refuses to recreate Widmark's Tommy Udo character; rather, he tries to escape it, being more dangerous, more explosive, than the original—his "baby face" obscuring his sadism.

Unfortunately, the strategy for besting *Kiss of Death* did not work. When *Fiend* opened, the combination of Western, film noir and over-the-top horror failed critically and commercially. By then, though, Evans had a starring part in Fox's soap opera *The Best of Everything* with Joan Crawford. He had a new sense of where he was going in the business, too. Instead of haunting Hollywood nightspots, he hung around in studio editing rooms, gleaning all he could from the veteran film cutters who spent their lives bent over reels of film shaping and re-shaping scenes. He was fascinated by the process and what it could mean to a finished movie. Evans also recognized that his urge to be a filmmaker was now stronger than his desire to be a movie star, which was a good thing. As he later said, "God, I was a lousy actor."

The "kooky killer" turned himself into a producer by optioning Roderick Thorpe's novel *The Detective* and setting it up as a movie starring Frank Sinatra, which *Fiend's* Gordon Douglas directed. Evans became the youngest head of production at Paramount ever, bringing the ailing studio out of the doldrums with a slate of successful movies that included *True Grit* and *Rosemary's Baby*.

Robert Evans only appeared in one Western, but that film's failure inspired different ambitions for the actor, resulting in several movie masterpieces. If *The Fiend Who Walked the West* had succeeded, perhaps we might never have had *Love Story* or *The Godfather* and certainly not Evans's personal production of *Chinatown*. Evans might have simply continued on as a young contract star, always hoping the next movie would take him to the top of the industry mountain. He got there, but on different terms. His terms. No stranger on horseback could do it better.

EDWARD FAULKNER
STANDING WITH THE LEGENDS

"Are you any relation to Bill Faulkner?"

THE QUESTION WAS asked in slow and deliberate style by director Howard Hawks, addressing actor Edward Faulkner on the set of *Rio Lobo*. Made in 1970, the film was Hawks's last as a director and his fifth with John Wayne. For Faulkner it was his first and only time with Hawks but his sixth outing with the Duke.

Born in Lexington, Kentucky, Faulkner recalls, "I told him that William Faulkner was a distant relative of mine, and my mother and father had been in his home in Oxford, Mississippi. I never met Mr. Faulkner, but Hawks was very fond of him, worked with him quite a bit, and I think he liked that we were related. I'll never forget the first scene I had with Duke on the picture. We're at a station waiting for this train loaded with the gold. We shot it a couple of times, and Mr. Hawks said, 'All right for you, Duke?' Then Hawks motions me over. I thought, 'Oh, gosh, I've done something wrong.' Hawks puts his arm around me and said, 'Ed, did I ever tell you about the time Bill Faulkner, Clark Gable and I were playing golf?' And he proceeds to tell me this wonderful story. They're on a golf course, and Hawks says, 'I asked Bill Faulkner who do you consider the four finest living American authors?' Well, he mentioned Hemmingway, Orwell, Steinbeck, and he included himself. At that point, Clark Gable said, 'You're an author, Mr. Faulkner?' and Faulkner turned to Gable and said, 'What do you do, Mr. Gable?

This wasn't just small talk between takes, this was one of Hawks's favorite tales, and it has become part of Hollywood history. That the legendary and known-to-be-aloof director chose to share it with Faulkner is proof positive of his regard for the actor. Faulkner, the gentle giant, shakes his head, "Well, Mr. Hawks was being nice." "Being nice" hardly covers the reason that in a fifty-year career Edward Faulkner earned the respect and affection of Hawks, John Wayne, Jack Webb, Richard Boone and James Stewart and became a fixture in a long string of films and television programs directed by Andrew V. McLaglen. Faulkner wasn't just a reliable character actor, he was a presence who held his own opposite legends.

Ed Faulkner's interest in acting was encouraged by none other than Vincent Price, whom he met while the star was performing in *The Van Gogh Let-* *ters* at the University of Kentucky. Price fanned a fire for Faulkner to come to Hollywood, but his arrival was delayed by an enlistment in the Air Force as a fighter pilot. When he and his bride, Barbara, arrived in Los Angeles in 1958, a letter of introduction from a family friend led him to director Andrew V. McLaglen. "Andy was a staff director at CBS doing *Have Gun - Will Travel*. I was to meet Andy while they were filming at Western Studios. It was my first time on a sound stage. I was also introduced to Dick Boone, who became my mentor." Faulkner regards his friendship with McLaglen as "the longest, and most important of my life."

After the first Western, Faulkner appeared in scores of shows, from *Lassie* to *Wagon Train*, *Laramie*, *Destry* and a multi-episode role on *The Fugitive*. On *Rawhide* he made his mark in seven different episodes. Besides TV, Faulkner continued to be in high demand in features, in everything from the Elvis musical *Tickle Me* to the outrageous cult horror of *The Navy vs. The Night Monsters*, but it would be McLaglen's casting Faulkner in *McLintock!* that provided the introduction to John Wayne. "I went over to Batjac, and when I was ushered into the office, Duke came over and said, 'I'm John Wayne, I've heard a lot about you. I want you to meet your pappy.' That was Bruce Cabot, and off we went to make *McLintock!*" Appearing with Maureen O'Hara, Stefanie Powers and Chill Wills, Faulkner is a hot-headed youth, whose romantic dalliance gets the film's famous mud-pit fight underway. "I've never been involved with the atmosphere, the ambience, in the kind of films that Wayne did. It was like a family and was just marvelous."

The father of three continued working with McLaglen, who cast him in *Shenandoah* opposite James Stewart. More work with Wayne followed, including Hawks's *Rio Lobo*, *The Hellfighters* and *Chisum* for McLaglen and the controversial but incredibly successful *The Green Berets*, which the Duke directed himself. "I did three back to back with Duke. He just kind of took me under his wing. We played a lot of chess together. He never got mad at me. Duke had a temper. If anybody wasn't towing their weight, he could lower the boom. I can't remember Duke with a script in his hand. He'd be the first man on the set and knew what he wanted. But he was jovial, and he had his hands full on *Green Berets*.

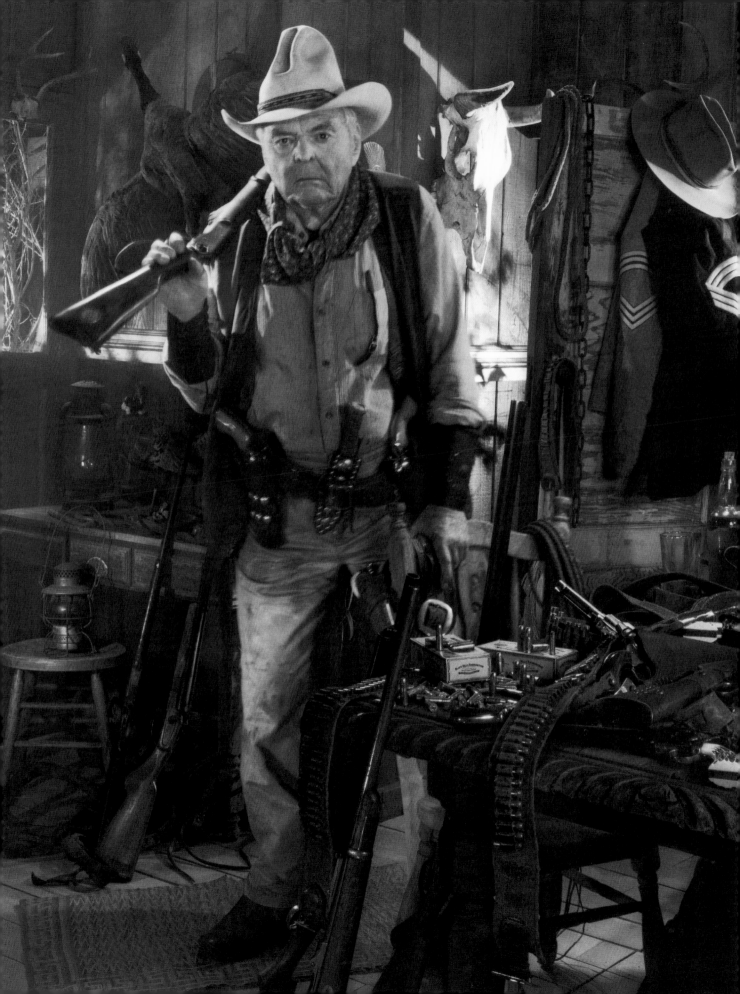

"I've never been involved with the atmosphere, the ambience, in the kind of films that Wayne did. It was like a family and was just marvelous."

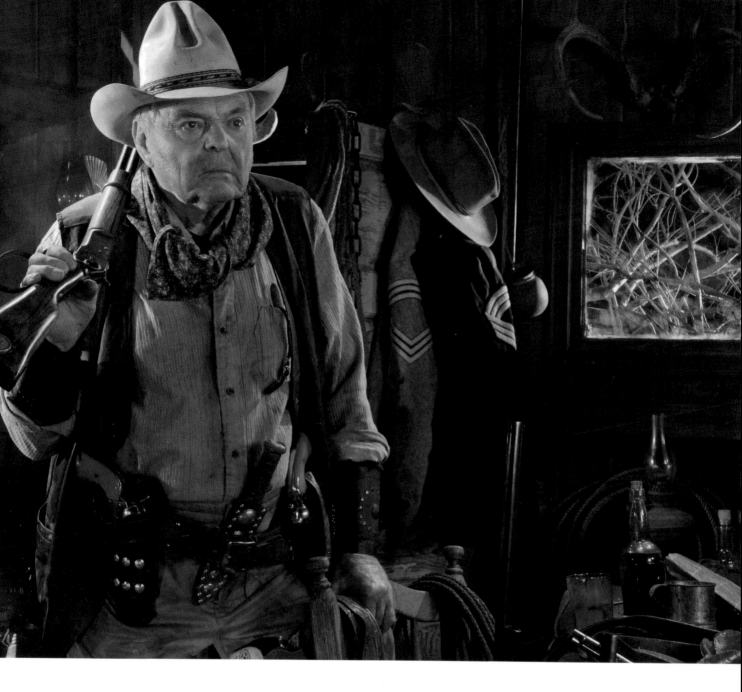

"When I left for the Georgia location, Barbara was pregnant with our fourth child. We already had a girl's name picked out, and she was going to be delivered by cesarean section. It turned out it was a boy. I was to call her when she was in recovery. I told my co-star Jimmy Hutton about the arrangements, but I didn't tell Duke. We arrived at the location and were about an hour away from a phone, and I was disappointed I couldn't make the call. Remember, this is long before cellphones! All of a sudden, there's an arm around my shoulder. And it's Wayne, and he said, 'Well, you're supposed to be making a phone call.' Here comes Duke's driver and he said, 'George will get you to a phone,' and I was able to call Barbara."

Faulkner smiles, adding, "I've been extremely fortunate working with the number of directors who would continue to use me. By the same token, you've got to bring something to the table. If you can't live up to their expectations, then they're not going to continue hiring you. But, for whatever it was, they continued to do so, and I really feel blessed."

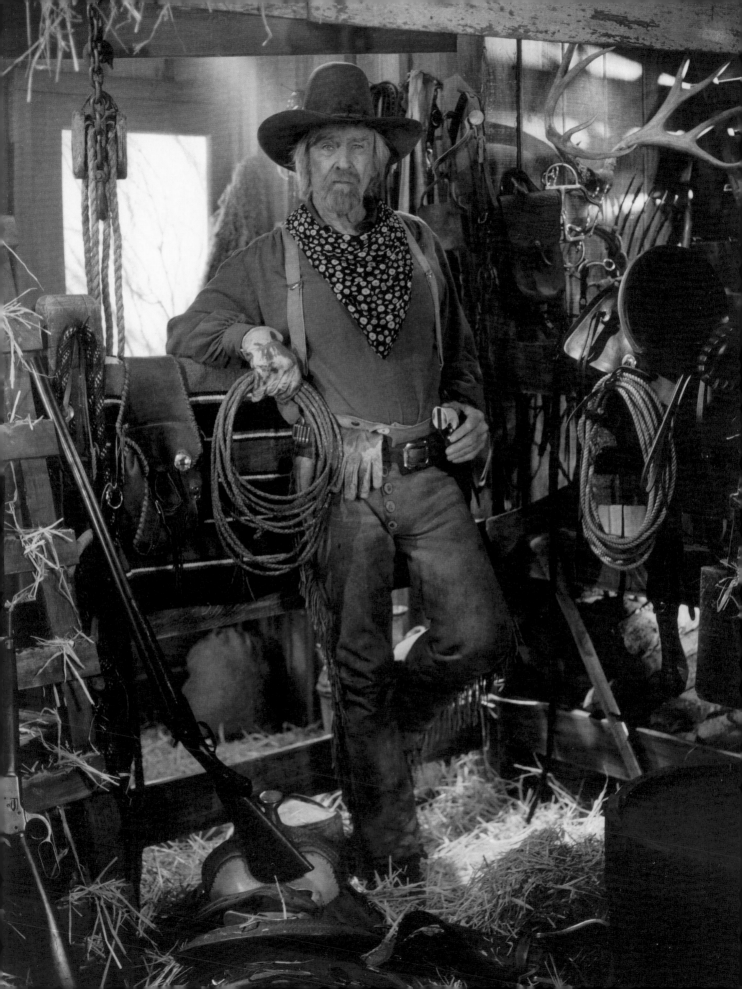

AL FLEMING
GIANT BEHIND THE SCENES

FLEMING SPOTTED HIS own name on the screen as the final credits for Walter Hill's *Wild Bill* rolled. He'd contributed mightily to the movie's look and wardrobe, but he never expected an acknowledgement.

"Danny Moore was Walter Hill's costumer for most of his pictures and asked about my knowledge of the West; he was getting ready to do a film called *Wild Bill* about Hickok," Fleming says. "I'd just finished reading every book I could find on Hickok, so I answered some questions, then asked who was actually going to make the costumes. He said, 'Western Costume.' I said, 'Oh, shit.' I had to tell him they're going to make a costume that will look like it just came out of Nudie's of Hollywood. I knew all of Hickok's costumes he wore in his shows, when he'd been a buffalo hunter, so I did a mock-up of one. I had about four days to put it together and brought it to a production meeting. They thought it was old. I told them I'd just made it but aged it down for the right look. They hired me on the spot. Walter would talk to me all the time, ask about the history behind the costumes and why I made the choices I'd made."

Fleming earned his stripes in the movie business as a trick shooter who had his own Montana ranch. He'd ridden and raised hell with the best when Western shows saturated TV programming. "I got into fast draw and gunspinning back in the '50s and came to Hollywood in the early '60s to work with Arvo Ojala, who invented the fast-draw holster." Fleming later joined legendary leather artisan Alfonso Pineda at his handcrafted gunleather store in Hollywood and shot competitively. "I won a few championships, and actors used to come into the shop, so I taught them how to spin guns and use a single-action pistol. The first TV show I worked on was pretty bad: *Frontier Circus* with John Derek and Chill Wills. That was around 1961, for Revue Studio, which was the television division of Universal-International. I worked on *Wagon Train*, *Laramie*, *Laredo* and spent a lot of time on *The Virginian* with Clu Gulager. I trained Sammy Davis how to spin guns and fast draw before he did *Ocean's 11*. He was a good learner and became very proficient.

"I was on staff at MGM for about fifteen years. We did *Hang 'Em High* over there and then did the series *The Rounders* with Pat Wayne and Chill Wills.

That was Burt Kennedy, who was one of my favorite directors. He was such a gentleman, and so much fun to work with. We were great pals." When Kennedy tackled the TV pilot for *How the West Was Won*, he reached out to Fleming. "Burt wanted me to research all the Indian tribes that were going to be in the series and had me do sketches and watercolors of their war paint and costumes."

Fleming's closeness to Kennedy lasted until the writer-director's death, as would his kinship with another rebellious Western icon. "Most of my movie work was with Sam Peckinpah. I did *The Ballad of Cable Hogue*, *The Wild Bunch*, *The Getaway* and *Cross of Iron*. Sam just took a liking to me, and everybody else hated him." Meeting Peckinpah for the first time was intense. "I got called into Warner Brothers and was told to go to 'Bungalow 12' and see Sam Peckinpah. I didn't know who he was. I went down to the little trailer he had as his office, and as I walked in I could hear him cussing somebody out in the other room. Just raising hell. The door burst open, and this guy came out saying, 'Fuck you, you son of a bitch!' And Sam was right behind him yelling. The guy leaves, and Sam looks at me and says, 'Who are you?' I didn't know what was going to happen. I told him I did special effects make-up. He said, 'I will make a deal with you—if I ask you to do something, and you tell me you can do it and screw up, you're on the bus back to Hollywood. But if you tell me you're going to try and do it, and you screw up, then you're home safe.' I never had a problem with Sam at all, and I learned more from that man than anyone else in the business."

Fleming also won an Emmy for his work on *The Magnificent Seven* TV series. "Danny Moore asked me to design the costumes for the principals, and they told me about this character called the Buffalo Man, who does a cameo in every other show. It was fun to come up with: a scraggly old beat-up buffalo hunter. Then Danny told me we were nominated for an Emmy! They had a dinner, and I didn't want to go since we both knew we weren't going to win anything anyway. The next morning I go to work, and there's a box waiting for me. It was the Emmy with a certificate from the Academy of Television Arts & Sciences! And Danny said, 'Of all the things we've done, we win it for that show!'"

ROBERT FORSTER
STALKING THE MOON

THERE'S A MOMENT in Robert Mulligan's *The Stalking Moon* during which trail scout Robert Forster tells old friend Gregory Peck that he will be brutally murdered by the mysterious Apache known as "Salvaje" or "The Ghost," and there'll be no escape. When Forster's character, who is an Indian, delivers this death sentence, it's with a grin because he knows there's no outrunning the serial killer who's already slaughtered dozens.

Mulligan's 1968 combination of horror and Western broke many rules, and this scene is one of them. It isn't photographed in menacing shadow with the characters balanced on the edge of an emotional razor. Rather, Mulligan and cinematographer Charles Lang (*The Magnificent Seven*) chose a bright day to shoot, the scene dappled in sunlight, with Forster's matter-of-fact approach generating anxiety for us. He accepts the bloody death to come, even if Peck refuses to.

It was an inspired directing choice, and Forster, in only his second movie, was the perfect actor to carry it off. Of his first, *Reflections in a Golden Eye*, Forster recalled, "John Huston gave me a Zen piece of advice for acting. He gave me the responsibility and the permission to deliver what was inside the frame, what the audience would see. I thought that was my job and my duty, so I was always thinking, 'What must I put inside that frame?' And what I could bring to the moment, regardless of what way the executives thought it should be."

Forster, Oscar-nominated decades later for *Jackie Brown*, can look back at more than one-hundred-and-fifty roles. On working with Hollywood directorial giants like Huston and Mulligan, he says, "They were authors of their stuff. They didn't need to go to anyone else to get permission for what they wanted. When I went to television, everybody, all the way up to the execs at the top of the studio, had something to say about what the show would be like. But these guys were their own bosses and didn't have to ask anyone for anything."

When the young actor was cast by Huston in *Reflections in a Golden Eye*, he found himself making his screen debut opposite Marlon Brando, Elizabeth Taylor and Brian Keith in a steamy, intense drama set on a military base, with Forster the object of Brando's and Taylor's personal obsessions. "I was totally ignorant of the business when I started, and totally ignorant of what was at stake as far as the cost of the film, and so I was just a guy who asked what needed to be there for the camera, and that's what I did. One of the things I learned about acting right at the beginning was that all material is different. Never the same thing twice. Every time I got a shot at a picture, I realized it was nothing like what I had just been in. The thing that holds everything together is that when you're shooting a movie all day all you're doing is a few shots. They're individual moments. It's like a magic trick; you don't think about the whole movie, only what you're doing at the moment. And you're trying to do that moment perfectly to make it a jewel with your lines and movements. Then you're on to the next."

The Stalking Moon marked the first reunion of Peck and director Mulligan since their collaboration on the classic *To Kill a Mockingbird*. Forster remembers, "Gregory Peck was a real gent, in the truest sense. Mulligan took the Western genre and combined it with a horror movie that had the threat of the unseen." Salvaje is a feared and silent killer of both Indians and whites, who takes life without pause or thought, making him a great warrior in times of conflict but a murderer when there is peace.

Forster feels the film's realism is what makes it work. "There can be all kinds of situations where you're reacting to something that is not real, and you have to believe in the material and bring it to life, using yourself. The actor has to understand what the material requires from him: the ability of the actor to bring it to life using himself and the ability to make it exciting for an audience to watch. Something you can watch with belief—that's what holds. Documentary could always hold me, so I always tried to make my work believable, no matter what was around me. And this was a great movie to work on, because I love Westerns. I grew up on Audie Murphy."

The work itself, despite changes in technology, has not changed substantively for Forster. "They can shoot all day long now with digital. In the old days, it was lights and sound and a huge crew, and if something got messed up, you had to start over. I liked that pace, and when you did coverage in a scene, it gave you a chance to really work with the other actors. Now it's done at a faster pace, but you still have to shoot scenes in pieces. You still have to capture those perfect moments when everything comes together in order to make the drama work."

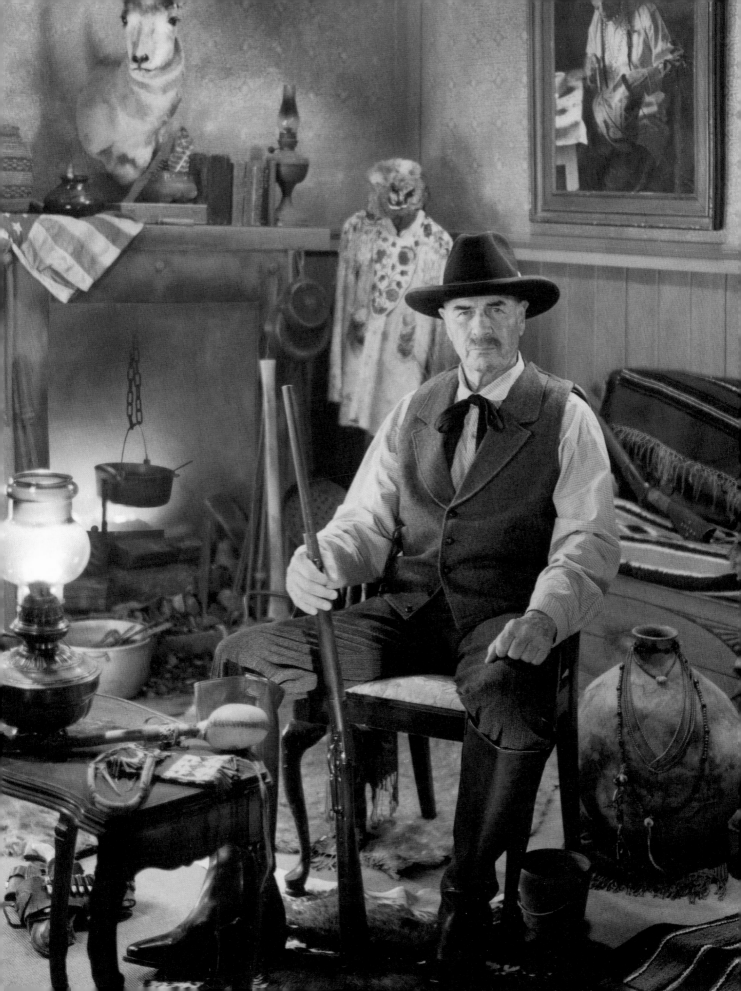

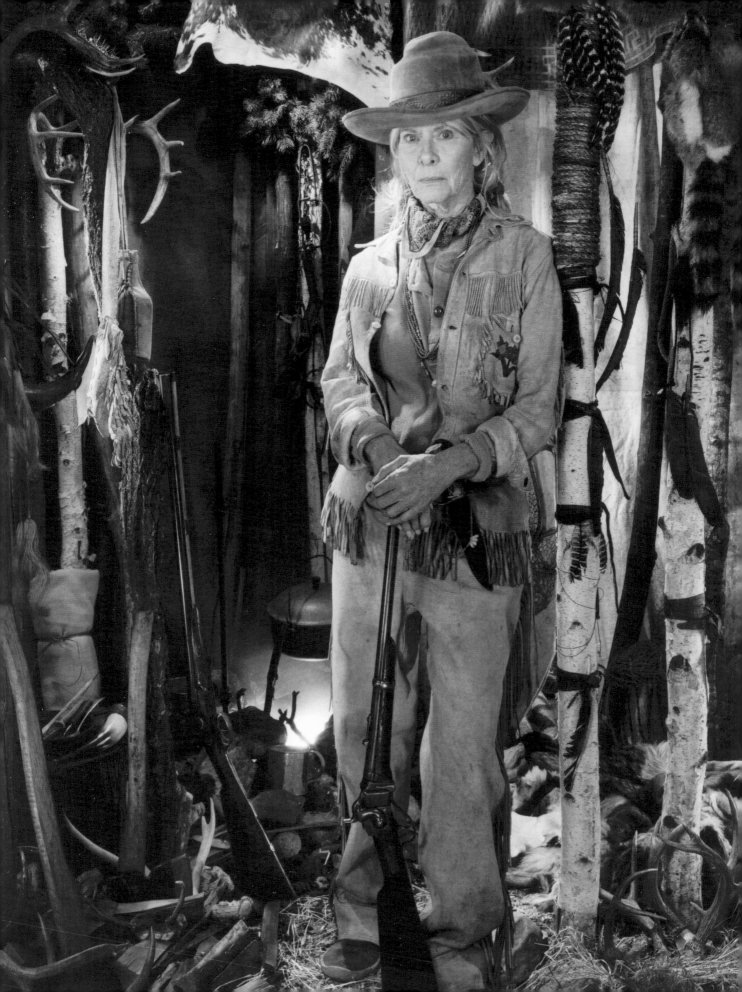

ROSEMARY FORSYTH
THE HEART OF *SHENANDOAH*

THE SCENE IN Andrew V. McLaglen's *Shenandoah* is quiet, stirring, memorable: James Stewart as farmer Charlie Anderson rolls a cigar while he counsels his prospective son-in-law, Doug McClure, about marriage, insisting that a man must not only "love" the woman he marries but "like" her, too. McClure loves and likes Stewart's daughter, Jennie, a role that Rosemary Forsyth played with such strength and empathy she received a Golden Globe nomination.

Shenandoah tells the story of a defiant Virginian who refuses to involve himself or his family in the Civil War and fights on all fronts to keep his children from marching off to battle. The war shatters Anderson's dreams as his children take sides in the conflict, and he sets out on a mission to find his youngest son, a prisoner of war, and bring him home. The journey is long and heartbreaking for the father as he battles on for what's left of his family, ultimately reuniting them for the wedding that isn't just about his daughter but also symbolizes new hope for the Shenandoah Valley.

"I was put under contract to Universal," the actress recalls, "and was told I was going to be in *Shenandoah*. What a wonderful first film, and I was scared to death to meet Jimmy Stewart. He was this huge star, who couldn't have been nicer or more patient with all of us 'youngsters.' Of course, I was surrounded by all these beautiful young men, and I got to marry Doug McClure. Andy McLaglen was just wonderful—and how he staged it. That moment in the wedding, when the young boy enters the church at the end, that's what everyone remembers."

McLaglen filled *Shenandoah* with great character performers he'd worked with and known most of his life. Denver Pyle, James Best, Strother Martin and George Kennedy all played substantive parts, which delighted Forsyth. "George was great, and all of these wonderful actors that were in the film, with hundreds of movies behind them. Of course, casting that way came from Andy's coming up with John Ford and John Wayne. We shot for several weeks in Oregon and then the Universal backlot."

Shenandoah was a hit, and Universal's faith in its new star was solidified by her performance as Bronwyn in Franklin J. Shaffner's *The War Lord*, co-starring Charlton Heston and Richard Boone. "It seemed like we shot on that film forever, and later I did another film with Chuck Heston, *Grey Lady Down*. I also played tennis on his court! But I was so lucky in the way Universal was handling me then as I could do a movie a year around the television programs they were making, like *The Name of the Game* and the other shows I was in. This really was the last of the studio system, when they were building talent, and it so happened they cast me in three very good films in a row."

The third film for the young Canadian-born actress was the comic Western *Texas Across the River*, which saw her again starring opposite screen giants, in this case Dean Martin and Alain Delon. "Dean Martin was great, so professional and always prepared. I really liked the director, Michael Gordon, who had done the hit films with Doris Day." Gordon had directed *Pillow Talk*, and in *Texas Across the River*, he gave Forsyth one of her rare chances to play comedy as she was almost always cast in dramas, particularly on television. Gordon also directed Forsyth in *How Do I Love Thee?* which featured another Western legend, Maureen O'Hara.

Universal's wünderkind, Steven Spielberg, directed Forsyth in an episode of *Columbo* titled "Murder by the Book." "That was Steven's first or second job, and I was amazed! I was maybe two years older; I was usually cast older because I was tall and was playing Martin Milner's wife. But Steven, who looked like a kid, did a fantastic job on the show! He just did everything really well, and it started him off."

After her Universal contract ended, the actress continued with an amazingly diverse variety of roles, taking on everything from *Kung Fu* and *Mannix* to *WKRP in Cincinnati* and the gritty Fred Williamson vehicle *Black Eye*, directed by Jack Arnold, to a touchingly authentic turn as the grieving mother-in-law of Tony Shalhoob's obsessive detective on *Monk*.

Looking back at her film debut, Rosemary Forsyth is modest about her role as Jennie Anderson, in which she displayed innocence, strength and young wisdom all in a single performance. "People would come up and say that *Shenandoah* was a classic, and I'd get a little upset, because 'classics' were black-and-white movies I grew up with, watching people like Jimmy Stewart. I surely wasn't old enough to have been in a classic! But a classic isn't just a film that belongs to a particular era: a classic is a great movie. And I'm proud to have been in *Shenandoah*. Because it's a great movie."

GRAY FREDERICKSON
TURNING FILM INTO ART

THE CREATION OF a film that defines artistic quality for generations is rare. Gray Frederickson has been instrumental in three.

As associate producer for *The Godfather*, working with Al Ruddy and Robert Evans, Frederickson stood by a young Francis Ford Coppola. A critical and commercial triumph, the film ensured the director's status as a cinematic innovator with talent to burn. But this accomplishment wasn't enough for Coppola and Frederickson, who pooled their talents again to create the greatest sequel of all time, *The Godfather Part II*, which yielded enormous box office returns and multiple Oscars. The pair then moved on to the bloody tableau of Vietnam for *Apocalypse Now*.

All three films now appear on the American Film Institute's list of the 100 Greatest American Movies. Mention any of this to Frederickson and his response is a modest "Oh, thank you," followed by a quiet laugh.

Before collaborating with Coppola, Frederickson worked as a go-to producer for Italian film companies. "American movies were outperforming Italian-made films at their own box office. You'd see a theater playing an American film, and there'd be a line around the corner, and nobody was lined up for the Italian films playing next door. So they started to 'Americanize' names of Italian actors, like Terence Hill and Bud Spencer, who were both Italian, and they did the same for directors. I became the specialist for Italian productions to shoot in New York or the Grand Canyon for a week or two before finishing up the movie in Italy. We'd have an American name in there, and they'd put them out that way."

Frederickson's reputation as an "American specialist" reached producer Alberto Grimaldi, who asked him to work on what became a classic Western. "Grimaldi was producing *The Good, The Bad and the Ugly*, and he wanted to shoot in Monument Valley. They hired me to bring them over to Spain, so I went to Almeria first and then to Covarrubias, and we had the famous scene with the bridge that didn't blow up." One of the picture's leads, Eli Wallach, often shared his memory of standing on a hill, watching the enormous bridge between the two Civil War forces being wired with explosives as Clint Eastwood calmly swung a golf club behind him. Wallach thought they should be in their positions for the camera, and Eastwood said, mid-swing, "They'll blow it up by accident. You'll see."

Frederickson found himself in the middle of the chaos. "The bridge was the last thing we were supposed to shoot before we were to go to America. A Spanish crew had rigged it. The first time we shot it only the railing fell off from the blast. The next time, it just shook. So they brought in an Italian special effects team who wired it and gave the privilege of blowing the bridge to a Spanish general, who had already failed twice with his demolition team. We had a tied-off Arriflex under the bridge, and they told the cameraman to run down and start the camera going for the shot. The general hears this order, thinks it's his cue and blew up the bridge without a single camera rolling! A two-by-four went sailing by our heads, and Lee Van Cleef had just had a brand new Mercedes delivered to the set, and the two-by-four went right through its door like someone had thrown a javelin! We were stunned. There was nothing left of the bridge at all. This meant we had to stay in Spain and rebuild the bridge. The cost of the bridge was fifty-thousand dollars, so rebuilding it meant we had to cancel the shoot in America, and Sergio didn't get to shoot in Monument Valley until *Once Upon a Time in the West*."

It was Frederickson's acquaintance with Clint Eastwood that led him to Hollywood. "Clint went back, and I followed him, and he introduced me to Al Ruddy, and that was my break into the American film industry." Eastwood arrived on the day Frederickson was moving into his new home and proposed that Frederickson produce for his newly formed company, Malpaso. "I'd just gotten with Al Ruddy, and Paramount was going to pay me a thousand a week to co-produce *Little Fauss and Big Halsey*. I said, 'Clint, I have this other gig. Can you pay me since I'd rather be with you?' He said, 'I can't pay you now, but I'm going to get money, and you'll do all my movies, and you'll get paid a lot.' I told him I had to take the money, and he told me, 'Fine,' and to do what I had to do.

"Much later, Francis and I were doing *Unforgiven*. At the time it was called *Whore's Gold*. We were set up at MGM. Robert Duvall was cast. And they pulled the plug. I called Clint and told him we'd been cancelled, and I wanted him to have the script. 'Clint, it's the best script I've ever read, and this is a gift I want to give you.' He asked me to produce, but I was committed to another film, so that was the second time I didn't get to work with Clint!"

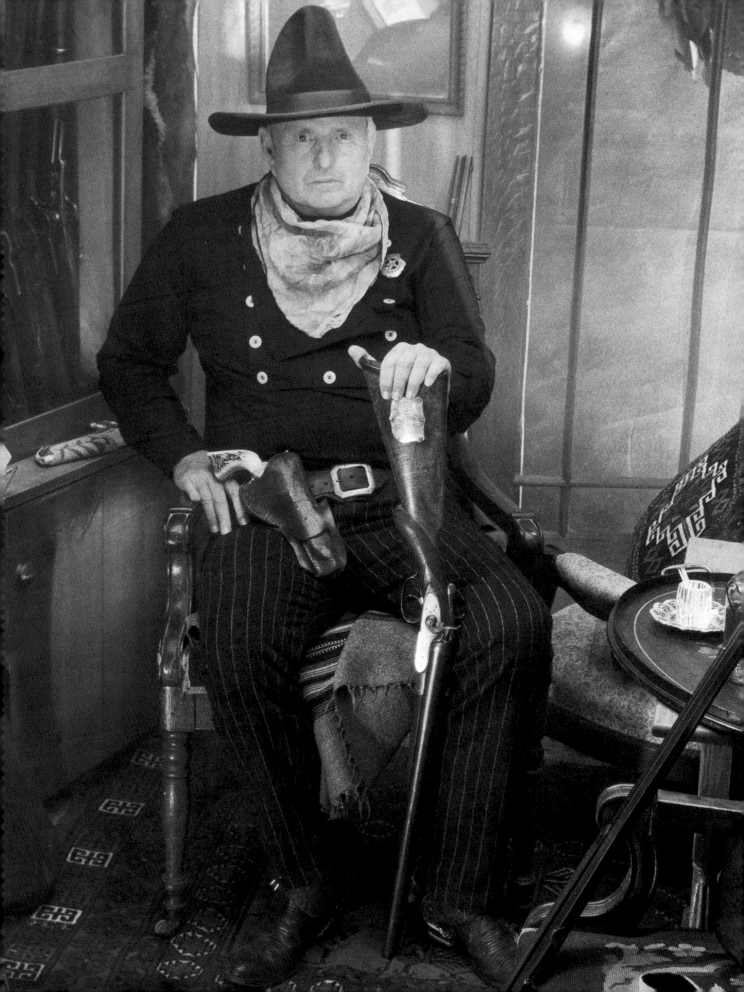

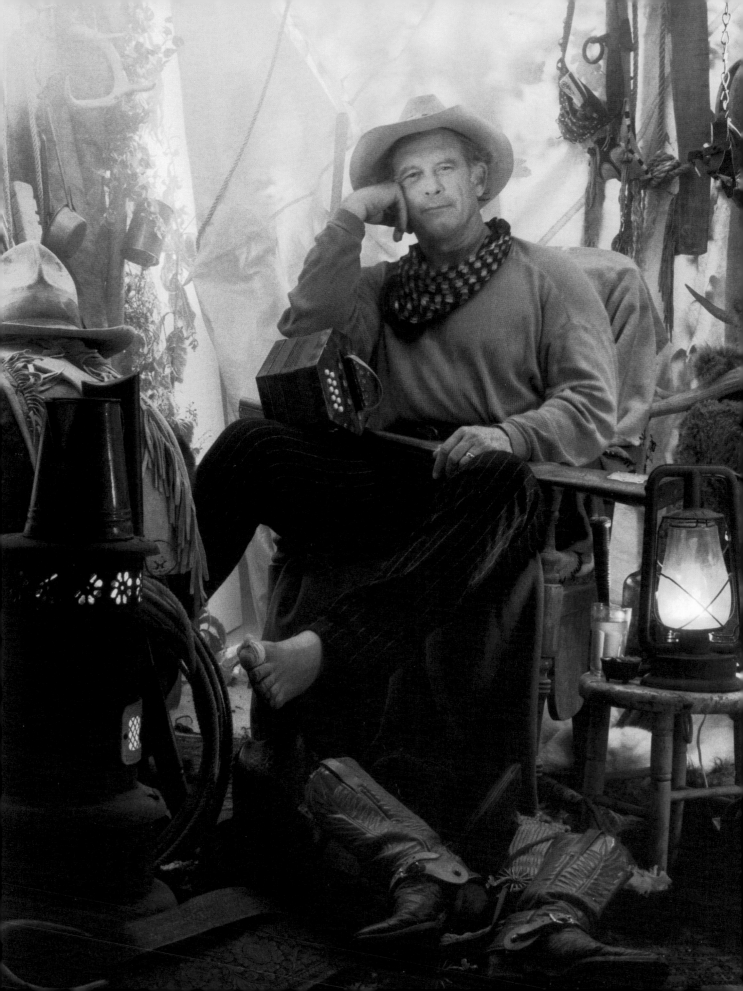

MAX GAIL
SODBUSTING

IN 1971, MAX GAIL watched Clint Eastwood confer with Don Siegel. This was during the one night of work Gail did on *Dirty Harry* playing a mugger who tries to rob Harry and fails spectacularly. The moment between the movie star and the director has stayed with Gail. "They were easy with each other, very cool in their communication. The filming went off like clockwork."

Gail's journey from unbilled walk-on in an iconic action movie of the 1970s to *Barney Miller*, which featured one of the most admired ensemble casts on television, might at first seem meteoric. Shortly after graduating from Williams College, Gail, a Detroit native, had taken a teaching position at the prestigious University Liggett School in Grosse Point Woods, Michigan. He taught at the private school, which counts Julie Harris and Gilda Radner among its theatrical alumnae, for several years. But he never abandoned his own acting, eventually landing the part of the brooding, silent Chief character in the first theatrical production of Ken Kesey's *One Flew Over the Cuckoo's* Nest, which premiered in San Francisco in 1970. Gail stayed with the production when it moved to Broadway before racking up scores of episodic television and movie credits, including the earlier mentioned *Dirty Harry*.

The first half of the 1970s was a time when dramatic cop shows dominated the networks, and Gail labored his way through the episodic jungles, appearing on *Cannon*, *Get Christy Love!* and Arthur Penn's superb neo-noir, *Night Moves*, starring Gene Hackman. In television, he excelled with each guest-star part, particularly on *The Streets of San Francisco* and in the mini-series *Pearl*. But what Max Gail didn't have on his resume was a Western. "I missed out on *Gunsmoke*, and all of those other TV programs set in the Old West, and then *Barney Miller*, a comic cop show, started." The Danny Arnold-created series about New York City police detectives ran for seven years, with Gail shining as the good-natured, but sometimes puzzled, Det. Thaddeus Wojciehowicz. For his work as "Wojo," Gail was nominated for two prime-time Emmy Awards. The interplay between Hal Linden's police captain and his squad not only drew laughter, it also touched occasionally on deeper social issues. "It was the 1970s, and there was a lot going on socially, and we didn't turn our backs on that. I think network comedies lost that over the years."

After *Barney Miller* ended in 1982, Gail went back to movies (*D.C. Cab*) and Broadway (*The Babe*) and took roles in two more series, *Whiz Kids* and *Normal Life*, before finding his way out West for Eugene Levy's comedy *Sodbusters* in 1994. Written by *Second City Television* alumnus John Hemphill, along with Levy, and starring Kris Kristofferson, John Vernon, Fred Willard and Gail, it's the Second City take on *Shane*, with a lone stranger riding into town to save its folks from an evil cattle baron.

The plot acts as the framework on which to hang the jokes and gags, which Kristofferson makes funnier by playing his ex-gunfighter character, Destiny, as the story's straight man. Gail as a gay rancher named Tom Partridge understood the tone immediately and remembered one of the first rules for making people laugh: "You don't play funny. That's the mistake. We had all of these characters, and this great cast, but you have to react as if everything is normal. Don't exaggerate. Play it straight, instead. Because that's when it's funny. Eugene Levy was a good director for this, and it was shot beautifully."

Although in on the joke, Kristofferson approached his role as the reformed gunslinger with the same sincerity he brought to *Pat Garrett and Billy the Kid* and *Heaven's Gate*. Gail agrees: "I thought Kris did a great job because he'd been in so many Westerns, but he got the humor and played his part straight down the line, which made all of our stuff funnier. I think the highlight for me was when Jim Pickens and I reveal our relationship." Made for Showtime, *Sodbusters* impressed critics and eventually developed a cult following. Gail would later guest-star on the Western-themed TV program *Dr. Quinn, Medicine Woman*, before securing several supporting roles on other series and finding a home on the American soap opera *General Hospital*, for which he won an Emmy.

Continued success in front of the camera has also pushed forward Max Gail's work as a producer of fine documentaries that address topical issues, including the challenges posed by nuclear energy. While Gail may be a socially conscious filmmaker, he still has that too rare gift for making us feel good by making us laugh. He did this as Wojo on Barney Miller. And he did this as Tom Partridge on one of his few journeys out West in Eugene Levy's little comic gem.

BRUCE GLOVER
CHARACTERS WITH HEART

WALKING TALL, CHINATOWN and *Diamonds Are Forever*. These three films, each with their own tone and focus, share a common thread: the presence of Bruce Glover. Whether it's Buford Pusser's deputy, an operative for private detective J. J. Gittes or a quirky hit man targeting James Bond, Glover gives these characters a sense of life that exists beyond the frame. A son of Chicago, Glover thought that football, which he played religiously and well, would be his way out of the inner city, but he had two other passions: art and acting. These interests collided in an art class when a nude model asked the football player if he'd like to be "a gorilla." Glover donned a gorilla suit and the bizarre circumstances fueled his impulse to perform.

Following a stint in Korea, from which he came home with malaria, Glover focused on acting, landing in a stock company that became a drama boot camp as he had to perform in a new play every week for a full year. The actor says "it was the best training" as he learned his craft and earned reviews. After more than a decade in the theater, including Broadway, Glover came to Los Angeles with his wife and newborn son, Crispin, to find his way into movies and television.

Among his first assignments in Hollywood were the bizarre cult classic *Frankenstein Meets the Space Monster*, episodes of *Perry Mason* and *The Rat Patrol* and his first TV Westerns: *Dundee and the Culhane*, *The Big Valley* and *The Guns of Will Sonnett*, starring Walter Brennan. "I did two *Will Sonnett*s. Brennan was sweet to me. He'd say, 'You can come to my ranch anytime!'" Glover perfected a smiling con-man persona for the "What are Pardners For?" episode of *Bonanza*, which was followed by a drought of work. "It was around Christmas, and I had a wife and son but wasn't getting anything. I told my agent to just send me out. I went in for a *Mission: Impossible*, a really small part. I told the director, 'Look, you don't know my work, you shouldn't waste me on something like this, but I'd love to do a guest shot.' And the director told me he'd seen me in a play at the Mark Taper Forum, and said I was right. So I walked out feeling good, but without a job. I looked into selling vacuum cleaners. I knew that I could fool people into signing up for this vacuum cleaner, where they think they're getting a free test model but actually have to pay for it every month. I couldn't do

it, morally. I called Yellow Cab about driving. Then my agent told me that 'You got a *Mission Impossible*!' It was a guest-star, right before Christmas, and just saved my ass."

After appearing in *Bless the Beasts and Children* for Stanley Kramer, Glover transformed into the scorpion-wielding Mr. Wint in *Diamonds Are Forever* and continued on television with *Gunsmoke* and *Police Story*, also making a huge impact in *Walking Tall*. "Phil Karlson was a really good director," he says, "and he'd done those great black-and-white crime films like *The Phenix City Story*. But it was the relationship between me and the actors Felton Perry and Joe Don that made it all work. You got the feeling of what it's like for a small-town sheriff."

Glover also made the comic Western *One Little Indian* for Disney, the story of a Union soldier (James Garner) on the run from the U.S. Cavalry's Camel Corps, who finds himself the surrogate father to an orphaned boy. Glover, Morgan Woodward and Ken Swofford played the soldiers who pursue Garner. "Eighteen weeks on *One Little Indian*, riding and riding, all over Utah, chasing Jimmy Garner and the little Indian boy. I'd had an automobile accident. I could ride, but it was hard, and Ken Swofford couldn't ride at all. Ken had a great quality, but he wasn't an athlete. We're riding together, and he went right into a tree, and the branches came sweeping back and hit me. So they didn't have us on horseback after that, until we got back to Disney. They were doing close-ups of us. The horses we rode in Utah on were Roley Poley thoroughbreds, so they could walk in place. They shot me and Morgan Woodward, then Swofford. He's on his horse, and it's getting excited—it wants to mate! Poor Swofford, he's at Disney of all places, on this excited horse, so they had to bring in another horse to get the shot. God, that was funny."

For Bruce Glover, Westerns were another creative triumph in a long line of film and television roles that he's brought to life by making unusual choices. For this actor, deriving satisfaction from the process, no matter the project, is the thing. "It's amazing when you think about how lucky we are to find something that we love and make a living at it."

Right: Bruce Glover posing with Indigo at IMAGE Studios.

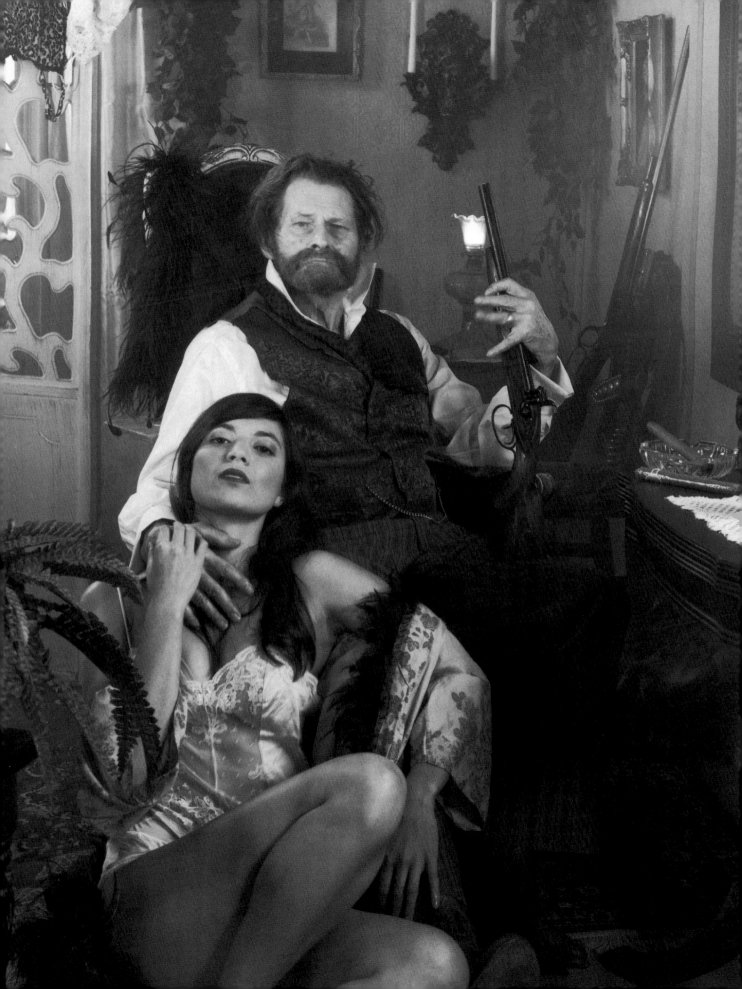

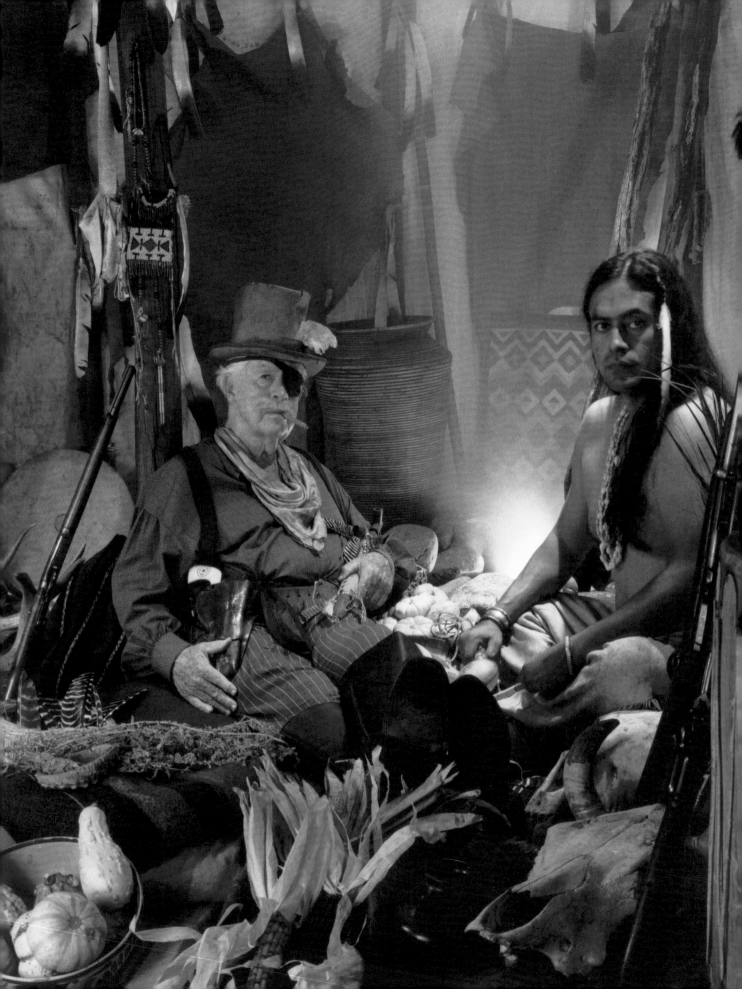

CLU GULAGER
THE STRENGTH OF THE CHARACTER

THE PHOTOGRAPH OF Clu Gulager sets the imagination spinning. It's the perfect image of a buffalo hunter, a ragtag who's spent most of his life hunting on the trail. Home could be a teepee with his Cherokee wife, a bedroll under a curving tree or a flop in the corner of a saloon. The process of taking this photograph was not meant to be simple. Steve Carver's objective in this book is to vividly evoke an era, as if the subjects were snatched out of the 1800s, while also honoring each performer's history in Western films and TV. Clu Gulager took this notion to heart.

Born in Holdenville, Oklahoma—his Cherokee mother gave him the name "Clu," which means "red bird"—Gulager spent his youth tending the family ranch. He recalled, "There could be three feet of snow on the ground, and I'd be checking the herds. If I saw a hole in the fence, I'd patch it, and I can say with pride we never lost one white-face calf." Gulager's first cousin was Will Rogers, but it was the presence of another Oklahoman, Gene Autry, who inspired him to perform. "I remember seeing Autry and Smiley Burnette, and they did their show, and Gene sang. They were these famous musical artists from Hollywood, and that really made an impression. My father had been on stage with George M. Cohan, so there was all this background to my wanting to be in the theatrical world, but I was living the life of a cowboy."

After a stint in the Marines, Gulager enrolled at Baylor University, where he met his future wife, Miriam, and got a surprise look at the realities of a working actor's life. "Bruce Bennett came and talked to us, about Hollywood careers and their ups and downs. He had a cigarette holder and looked like some old, washed-up movie star to us. Of course, absolutely everything he said about Hollywood was true, unfortunately."

New York came next, both the stage and live television offering Gulager a perfect forum to display his talents. The actor was in high demand, along with his acting buddies Steve McQueen, Warren Oates and George Peppard. "George was the first of our group to hit it big, and we all knew he would. He was wonderful on Broadway and then off to the movies." Gulager soon departed for L.A., too, finding work in TV Westerns. "The first thing I did was an episode of *Have Gun - Will Travel*. I'd already worked with Dick Boone. Andy McLaglen was the director. Andy was

a big man, and if he didn't like what you were doing, he stood on your feet. And yes, he stood on my feet."

After guest-starring on the Western *Riverboat*, and other shows, he played Billy the Kid opposite Barry Sullivan's Pat Garrett in *The Tall Man* for NBC. Audiences and critics immediately picked up on Gulager's matinee looks, his sauntering walk and his cockeyed smile that sometimes followed a devilish laugh. There was something unpredictable and dangerous about Gulager's persona that made him popular with viewers but wasn't enough to stop *The Tall Man* from being cancelled when a congressional panel determined the show was harming American youth as its lead character was an outlaw.

Gulager continued to land one-off parts in TV episodes until his old friend Frank Price, an executive at Universal, brought him in as Sheriff Emmett Ryker on *The Virginian*, where he stayed for more than one-hundred episodes. Starring James Drury and a host of iconic actors, among them Doug McClure and Lee J. Cobb, the show is now considered a TV classic. Between appearances on *The Virginian*, Clu pursued other projects, among them roles on *Wagon Train, Dr. Kildare* and *The Alfred Hitchcock Hour*. In 1964, director Don Siegel thought Gulager would be the perfect, offbeat partner to Lee Marvin's hitman in his remake of *The Killers*, which featured Angie Dickinson and, in one of his final parts, Ronald Reagan.

A talented director himself, Gulager made the short "A Day with the Boys," which Universal distributed. In front of and behind the camera, Gulager never stopped working. In theaters, he famously seduced Cybil Shepherd in *The Last Picture Show*, double-crossed John Wayne in *McQ* and fought zombies in Dan O'Bannon's cult masterwork, *Return of the Living Dead*.

At age ninety-two, and after more than two-hundred-and-fifty movies and TV episodes, he was cast in Quentin Tarantino's *Once Upon a Time in... Hollywood* and is now planning a series of films for himself and his son John, who directed his dad in the high-octane horror film *Feast*.

The day of the session at Steve Carver's studio, John Gulager applied the buffalo hunter makeup to his father, enhancing the character's realism. "After all," Clu Gulager recollected, "what is an actor if he isn't someone who has the ability to make you believe?"

Left: Clu Gulager posing with Daniel Galindo at IMAGE Studios.

BUDDY HACKETT
A DARKER SIDE

HIS FACE SEEMED to be a bowl of mush, eyes dropped into the middle with a life all their own, rolling in separate directions, before meeting in the middle and crossing. The voice was a nasal croak, which could hit a high-pitched note when excited or fall back into a pitiful sob.

Buddy Hackett always called himself "a saloon comedian," coming up the hard way in grungy clubs and strip joints before breaking through to New York's poshest spots. But the World War II veteran and Las Vegas headliner, who could be filthy-blue and innocent at the same time, also knew the batwings of a Western saloon, finding his place in several dramatic turns on TV Westerns. By the mid-1950s, Hackett had managed to climb up from to seedy night spots to talk shows to supporting roles in features, including the mediocre *Fireman, Save My Child,* where Hackett and Universal contractee Hugh O'Brian were hired to finish up an awful Abbott and Costello film, when the older comedians were both ailing.

The movie almost buried Hackett's Hollywood career before it had a chance to start. It was still "scratch and draw blood" for the saloon comedian. More guest shots and standup work followed, and then director Anthony Mann recognized the tearful clown in Hackett's persona and put him in 1958's *God's Little Acre* with Robert Ryan and an always-glistening Tina Louise. There was a bit of Chaplin's Little Tramp about Hackett as he seemed out of his depth surrounded by acting heavyweights, yet he could still steal scenes from them as Pluto Swint, a hapless candidate for local sheriff. Hackett himself would be named an Honorary Sheriff of Ventura County and carried the badge with him most of his life.

Hackett subsequently wandered into the Western town of North Fork for his first *Rifleman* episode on 1959. In "Bloodlines," Hackett played the seemingly easygoing father of some wild sons, Warren Oates among them. The character played by Oates sought blood-revenge against Chuck Connors's Lucas McCain for a killing McCain didn't commit. It's a straight, solid role for the comedian, showing a darker streak once he turns into the avenging father.

When Hackett returned to *The Rifleman* again in 1961, the enormous recognition *The Music Man* would bring him was still a year or so away. His unique movie and TV presence as a comedian remained his own. Those rolling eyes and the tongue that got in its own way were becoming trademarks, yet he traded them for a mop and pail in a heartbreaking turn as Clarence Bibs in the appropriately titled "Clarence Bibs Story." The actor embodied Bibs, a janitor who accidentally kills a notorious gunfighter and enjoys an afternoon of glory until the reality of having to defend his reputation rains down, especially when Lee Van Cleef challenges him. What Hackett captures rides directly into the Western myth of the stoic loner with the gun—he's a man-child lost in a world that too often requires a true and thorough understanding of the gun. He's the man who never wins, even when playing solitaire. It's a well-turned, thought-out performance from the comedian, especially in his clumsy handling of a pistol, as Hackett was a well-known antique firearms expert, having amassing a very valuable collection with a focus on weapons from 1911, and he could shoot with skill and accuracy.

Hackett would appear on *The Rifleman* yet again, this time as one of a trio of brothers that include Warren Oates, who cause trouble for Lucas McCain. Buddy's just as troublesome playing an Irish con man claiming to be Heath Barkley's long-lost father on *The Big Valley,* with Bruce Dern backing him up with a gun. It would be Hackett's last role of any substance in a formal Western, and he shines. Although there would be a small turn for his old friend Burt Kennedy in *The Good Guys and The Bad Guys,* with Robert Mitchum in the lead, Hackett would turn his attention elsewhere, away from the West, and back to more television hours than anyone could count and headlining runs in Vegas showroom on the Strip.

But the human essence of the dreamer, the janitor who always wanted to be the fast-draw hero, even for a day, or the con man always trying for the next score, allowed Buddy Hackett to reveal another side of his talent. And with these performances, the saloon comic who became the nightclub and talk-show superstar got to step away from the microphone and, for a brief time, live in the West.

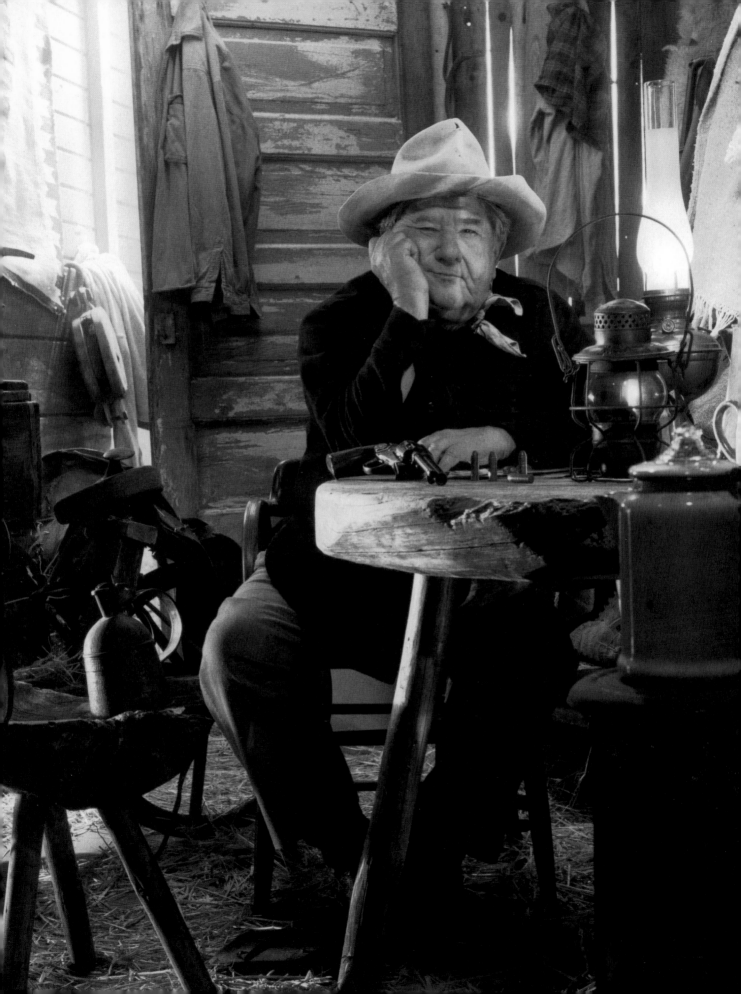

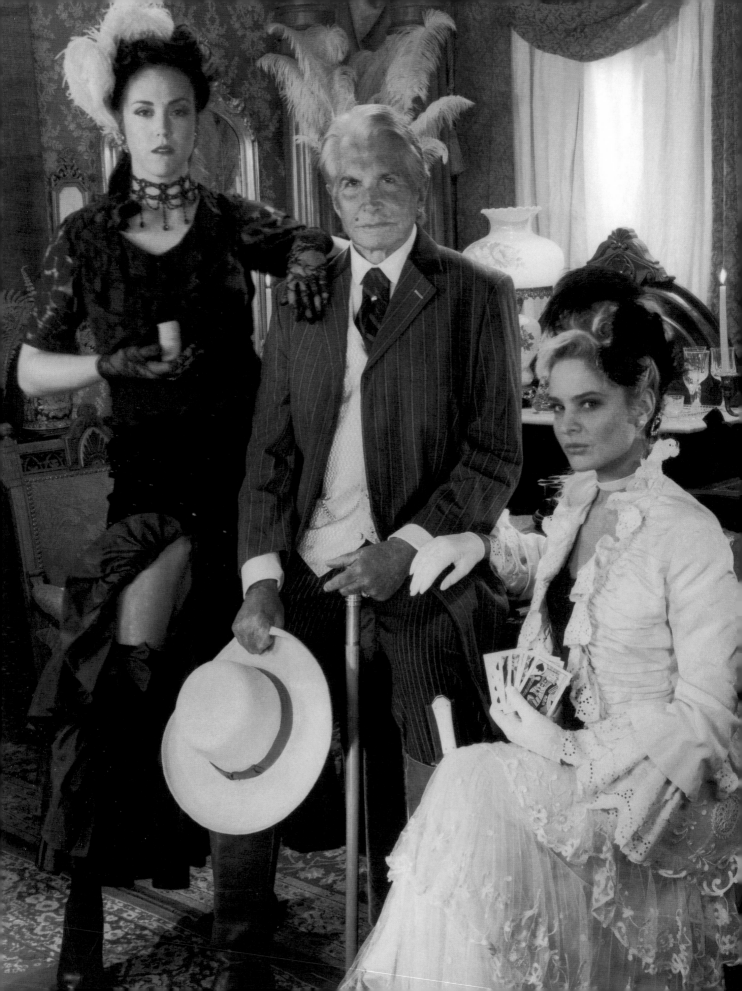

GEORGE HAMILTON
THE ACTOR AS MOVIE STAR

"WHEN I WENT under contract to Metro, the first thing they made me do was ride a horse because they wanted to put me in a Western. They had a school then to teach you how to ride bareback, with an English saddle, every way you could. I love riding. I was in military school, in the cavalry, so it came naturally to me."

Vincente Minelli, one of MGM's premier directors, in 1959 spotted George Hamilton in the melodrama *Crime and Punishment U.S.A.* and cast him in *Home from the Hill* opposite Robert Mitchum and George Peppard. *Home from the Hill* wasn't a Western, but this melodrama set in the Deep South was the young actor's training ground for all the films to follow. "Minnelli was quite specific about what he wanted. He made a film like he was painting a painting, and the acting was just a component of it. He wanted to have it visually perfect; they could have two hundred extras, and he'd see a lady in the wrong color hat, and that would throw him off. We had a scene with a lot of cowboys. Denver Pyle and Dub Taylor and ol' Slim Pickens. And they're all talking about my character. These fellas had worked with John Wayne and John Ford, and they didn't understand Minnelli at all. And he directed the lines like it was a symphony or a ballet, and it was so perfectly timed, and they could never get it exactly right because it wasn't the way they were used to working."

For newcomer Hamilton, Minnelli's technique suited him well. "I didn't know anything about acting, but I liked the way Minnelli wanted to do it, just following his direction. I wanted the director to tell me what to do, and Minnelli was willing to tell me." Co-star George Peppard was not so accommodating. "George Peppard was a very good actor, but he was an internal actor, who was using the Method. And he 'lived' in his character. He had an ID bracelet made with his character's name that he always wore, and he was adding things like that. And Minnelli said, 'George, I know you're a brooding volcano about to erupt, but there's nothing happening on your face.' And he kind of got George crazy. I was always working on making George crazy because he took it so seriously, and I was more loose. I wanted to be flexible, to listen to the director and Mitchum. But George wasn't that way. It was like he was in the film by himself. There was a little boy who came on set and asked George, 'Are you a movie star?' And he said, 'No, I'm an actor.' And the kid turned to me and said, 'Are you an actor?' And I said, 'No, I'm a movie star!'"

Hamilton's seemingly casual attitude contradicts his dedication to craft, which resulted in a fine performance in *Home from the Hill*. After the film, he went back to training on horseback despite the studio still not casting him in a Western. "I worked on training every day because it was the Western lifestyle. They'd get you up, and you'd go out to the campfire at 5:30 or 6:00 in the morning, and the wranglers would give you instructions about 'mosey on down here' or 'there,' and then you'd get on a horse and ride. I loved it. I thought it was paradise to work this way."

Before the actor could ride out to the Old West, he found himself in Florida playing the lead in a smash hit for the studio, *Where the Boys Are*, which would establish his tanned, smiling persona for decades. The film gave Hamilton enormous popularity with a young audience, especially the girls, and he was an instant favorite of movie fan magazines that featured him on hundreds of covers. The actor found himself working with some old stars: "MGM was a training ground for the very best. But after *Home from the Hill*, I didn't have any faith in my own instincts. I'd been schooled in how Minnelli wanted it, and it was a time of the Method, and people going deeper into their own process without the director. I found myself working with old-school movie stars one day, who were kind of rigid, and Method actors the next, so I had to develop my own technique."

Hamilton's singular, suave style worked, and he was cast in a tough Western, *Thunder of Drums*, opposite Richard Boone, Charles Bronson and newcomer Richard Chamberlain. The film was one of the studio's lower-budgeted projects to test Hamilton's new image with him having to prove himself to one of his co-stars: "Boone didn't like me. He showed no kindness toward me at all. We'd do a scene, and he'd be dismissive. Richard Chamberlain was young and just learning, and he was about to do *Dr. Kildare*; he was being groomed for that. Bronson was moody and difficult to deal with. I was to have a fight scene with him, and it's an ambitious scene, and Bronson's someone who's physically fit. Not a gym guy who's developed a six pack: he's muscle through and through. And he doesn't have all the humor in the world, and

91

"I had to learn trick riding and trick shooting and how to mount horses over the saddle for the fast mount. And I loved it and got good at it, and I was also good with guns."

he didn't particularly like me. Bronson would find a way to stand near me, to try and intimidate without saying anything, but when we got down to that fight, he knew what he was doing."

If all the studio promotion was annoying to some of Hamilton's co-stars, his popularity pushed him into the studio's sprawling *How the West Was Won*, which was the actor's dream. Hamilton doubled down on his preparation for the film, only to have the opportunity yanked away by one of his co-stars: "They wanted me to do another Western, so they started to prepare me to work with John Ford for this segment, where I was going to play the Sundance Kid. There were several directors on *How the West Was Won*: John Ford, Henry Hathaway and George Marshall. I had to learn trick riding and trick shooting and how to mount horses over the saddle for the fast mount. And I loved it and got good at it, and I was also good with guns. So the first day I was brought out for John Ford, and I went out on the backlot, which was huge, and they said we're going to do your first scene with Glenn Ford. I got on my horse and off my horse and had a scene with Glenn and they all huddled together afterwards. And the assistant director told me I wasn't going to work for the rest of the week, and I didn't. And then the studio called to say, 'Unfortunately you're not going to be working in this movie.' I asked, "Why" And they told me that 'Glenn Ford had a problem with your height.' So they let me go."

Hamilton continued to enormous success on the big and small screens, and although he kept up his riding and shooting skills, he wouldn't make another Western for six years when he was cast in the lead of *The Long Ride Home* written by Robert Towne (*Chinatown*) and co-starring Glenn Ford and Inger Stevens. Hamilton remembers his return to the genre he loved: "We shot in Kanab, Utah, and Zion National Park. I was playing a Confederate soldier in a stockade, and there was Glenn again, only this time he was the second lead, and I was the first. I came out on the set, and Glenn had a great horse, and he'd work that horse up before every shot, really getting ready. He really knew how to ride, and he was a good actor, but he'd forgotten *How the West Was Won*. Timothy Carey was in the cast, and he was a real character who could hog the camera just doing crazy things.

I made the director put him behind Glenn Ford to steal the scene a bit, which he did. And Glenn kept moving on my lines, which pissed me off.

"And I said, 'This guy had me fired off a movie, and I'd put a lot of work into it.' Tim Carey was stealing the scene from both of us with all he was doing with his horse, and Glenn's moving around, thinking the camera would go to him—but it all went to Tim Carey! And I looked at him and said, 'Do you remember me on *How the West Was Won*? And you had me fired because I was too tall?' He denied everything, and I said, 'Unfortunately, you're too short for me on this movie!' Well, he got mad and called his agent about quitting. So I went to his dressing room, and he said he had nothing to say to me. I told him, 'Yes, you do. I owed you one, and I just paid it back. You can walk away, like I had to, and be unhappy, or we can start fresh.' And Glenn offered me a drink. He went to the water fountain that he had filled with vodka! I thought I was getting a drink of water, so we drank vodka, and from that moment on we were the best of friends."

Hamilton is good in this desolate but surprisingly bloody Western; no longer an eager youth, he projects a violent side that surprised some critics who didn't expect the winning actor to tap into a darkness that was becoming more and more a part of the Western as the 1960s were coming to a close, when Leone and Peckinpah arose as major influences. Says Hamilton, "That was when Westerns were starting to go away; the majors were looking at other things. It was a rough little picture. I had this rubber knife, and I stabbed an Indian, and he screamed, because the knife had a metal rod inside the rubber blade that was about three inches long. That thing pierced the poor Indian. God, I felt awful. But that was all part of it, making Westerns. I got hurt sometimes. How could you avoid it? You move into a motel in Arizona, and you just do it. You're making a Western, living that life. When guys were away on location—well, actors by nature tend not to include each other. I wouldn't do that. I would have a poker game or a barbecue so everyone could be together. Harry Dean Stanton was in the film, and he always had his guitar. We'd sit around the campfire. The food was great, and we all had good times. That whole era is gone."

GREGORY HARRISON
RED RIVER CROSSING

FOR GREGORY HARRISON, a lifelong surfer, the long journey to producing and co-starring in the television adaptation of *Red River* began in another genre. He'd been, by his own admission, a "scuttling actor" when producer Dan Curtis cast him in *Trilogy of Terror*, a made-for-TV horror-themed anthology movie starring Karen Black. All three segments in the feature were adaptations of Richard Matheson stories, the most famous ("Prey") being about a Zuni doll that terrorizes Black. In "Julie," Black plays an alluring psychopath who stalks Harrison.

The 1970s were very good to Harrison. He appeared in episodes of *M*A*S*H* and *Barnaby Jones* and the award-winning Christmas drama *The Gathering*, which had him portray a troubled son living under a flawed father's expectations. He got the lead part in the *Logan's Run* television series, too, which exposed Harrison to old-school filmmaking techniques. "Our director of photography on *Logan's* was Irving Lippman. He'd been a still photographer on *Gone with the Wind*. We were shooting in the high desert, and he'd never bring the light down on the actors: he'd just match this intense sunlight and shine it on us. I went to a doctor because I was having eye issues, and he asked me if I was staring directly into the sun! 'No, I'm shooting with Irving Lippman,' I'd say, 'who believes in having six suns all around you!' That was his training from the '30s and '40s, just bright light hitting everything. That's also how it was on *Centennial* with Duke Callahan shooting with reflectors and these huge arc lights."

In the *Centennial* television mini-series, Harrison portrayed Levi Zendt, an ostracized Mennonite who settles in the Colorado frontier. The saga took six months to shoot. Jesse Vint and Harrison appeared in many of the same installments, primarily directed by longtime TV Western director Virgil Vogel. "Virgil was funny. Ornery. And a great director. It was a massive production, and he was one of the old school guys who knew how to keep the shooting on track. Virgil wanted to shoot a scene with the mountains in the background and me in the foreground, sleeping by a campfire with my head on a saddle. He kept trying to frame the shot, couldn't get what he wanted. He finally had it the way he liked, and my feet were in the fire! 'Come on, just keep your feet there! Don't move!' And I told him my feet were burning up, and he'd say, 'It looks great! We can see the mountains in the background.' So I stayed put, and he got his shot."

The actor had always wanted to produce, and *Trapper John, M.D.* provided him the chance. A mega-hit for CBS, the series gave Harrison the freedom to initiate his own projects, including *For Ladies Only*, an entertaining look at the world of male strippers. The TV movie racked up decent ratings, enabling Harrison's company to expand and produce more than twenty features for the small screen, most notably a new take on a Western classic.

Harrison remembers: "*Red River* had always been one of my favorites, and my producing partner, Matthew Rushton, loved that movie, as well. He had a script written, and we took it to CBS, and they loved it, giving us a conditional green light depending on cast. Well, the John Wayne role was going to be the toughest, but when we got Jim Arness, it was a true green light from then on. Everybody in the original was great. But when you do a remake, you're always worried about living up to those standards. It'd been forty years since the Hawks film, so there were two generations who probably hadn't seen the original. I thought there was enough distance that a new version would find an audience."

Harrison initially planned to take on the Matthew Garth character, who defies his father figure, Thomas Dunson (Arness). "We'd developed it with the idea of me playing the old Monty Clift role, but we decided to cast Bruce Boxleitner, who was great, and then we needed a Cherry Valance. We couldn't find anyone who suited us, so I threw myself into that role at the last minute and played the gunslinger. And I'm glad I did, because I had a great time doing it."

For *Red River*, Harrison wanted as many great faces in his cast as possible—those actors we recognize as a part of the landscape of Western films and television. Cowboy heroes Ty Hardin and Guy Madison signed onto this cattle drive epic, along with L. Q. Jones. "L. Q., what an icon he is! Just great," Harrison says. "Ray Walston took on the Walter Brennan part. He was such a character, wore sunglasses day and night and always grumpy, but in a lovable way. I just love people who've been in the business a long time, the stories they tell. Jim Arness told us that he'd been surfing in Hawaii since 1939. When there was a good swell running, *Gunsmoke* had to shut down because he wouldn't come to work. Sitting in the desert in Tucson, where we filmed, talking all night about surfing, that was amazing."

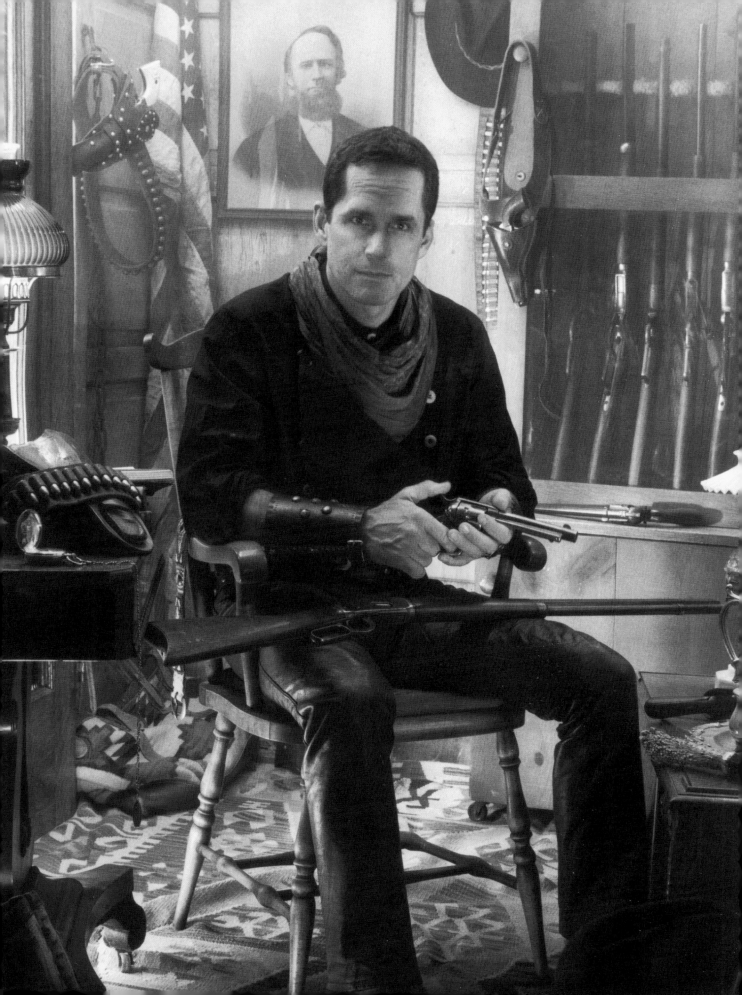

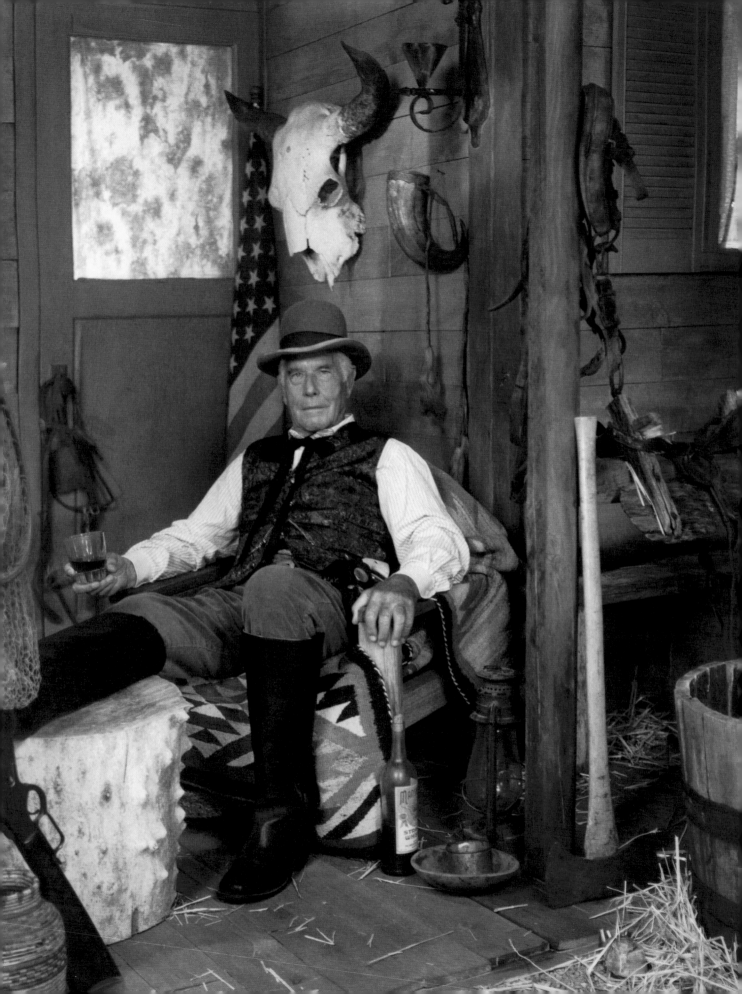

RICHARD HARRISON
A EUROPEAN LEGACY

WHEN ACTOR RICHARD Harrison managed Vic Tanny's gym in Santa Monica, the movie business was changing. By the late 1950s, the major studios were doing more with television, but around the world, motion picture production soared, and American companies were turning their films into international affairs by shooting overseas, taking European partners from Italy, France and Germany. Though Harrison's own bodybuilding routine at the gym had been devised as therapy for a leg injury, the sculpted appearance that resulted from his workouts, along with his charismatic personality, attracted the attention of producers. "I was lucky enough to go under contract to 20th Century-Fox, where I studied acting with Sandy Meisner. Then I was under contract to American International Pictures, which was run by my ex-father-in-law, James Nicholson, who was a very, very fine man. He and Roger Corman had a long history together."

Harrison had already appeared in *Jeanne Eagles* with Kim Novak and the great Rodgers and Hammerstein musical *South Pacific* when he was cast in American International's *Master of the World*, which also featured Vincent Price and Charles Bronson. "I was supposed to play the fiancé of the girl, but as it happens in cinema, Vincent Price wanted to put a different young man in that role. Jim Nicholson told me, and I was fine. They put me in a small role. My agent eventually got me a very good contract in Rome. I wanted to go because I love the art and the culture, so I went to Italy and started working in Europe."

Harrison's first film in Italy was *Invincible Gladiator*, which had him lead a revolt against a tyrant. "Whatever is working at the moment, that's what everyone makes. *Invincible Gladiator* had a fine producer who knew the business. You had the gladiator adventures, the war films and then the Westerns. There were a few good ones and a lot of bad ones."

1963's *Gunfight at the Red Sands*, directed by Richard Blasco, was a solid revenge story with Harrison playing against the villainous Aldo Sambrell. "We made that in Spain. I thought *Gunfight* was a pretty good movie, and it was Ennio Morricone's first Western score. The executive producer, Georgio Papi, offered me another film, and I wasn't too interested. You grow up in America watching the Westerns made by the great directors, but Blasco wasn't one of those filmmakers. I'd been offered *Giants of Rome*, and I asked people about the director, Antonio Margheriti. I asked Papi, too, about Sergio Leone, who was directing his first Western, *A Fistful of Dollars*. Leone had only made one other movie, *The Colossus of Rhodes*, and it was a bomb.

"The thing about the Leone Western that intrigued me most was that Gian Maria Volonté was playing the bad man, and I would have liked to work with him. They offered, but I didn't do it. They asked me about different actors: one was Eastwood, one was James Brolin. I mentioned Clint because he'd been on *Rawhide*. I never met him until he came to Rome. I took him around to a couple of parties because he didn't know anyone. Later when I asked Clint how the film was going, he said it was terrible. He'd seen the rushes and didn't like them at all. The film came out in Naples in really bad cinemas. The first few days, there were only a few people; then it grew, and by the end of the week, the theaters were filled. The rest is history."

Harrison made his greatest Western, *Vengeance*, with director Antonio Margheriti, who had fashioned the superbly visual *Horror Castle* starring Christopher Lee and later guided Fred Williamson in *Take a Hard Ride*. Margheriti worked in all genres, but with *Vengeance* he found the perfect alchemy—blending gothic horror with the violent intensity of the Euro-Western—as Harrison, a wronged gunfighter, spills blood to atone for everyone's sins. The regard in which *Vengeance* is held genuinely surprises Harrison. "I didn't know about its status. Antonio was very much into special effects, and I liked him as a person, but I didn't think that much about the film. He was a good man and a competent director."

In the humorous Euro-Western *Two Brothers in Trinity*, on which he served as a producer, Harrison was able to exert a high degree of creative control. "I enjoyed doing that one because I wrote it, and it was comical, my way of being comical. I produced and directed, and when we opened, it got good reviews. But it didn't do as well as it needed to. The Western was the thing that was happening at the time, and so that's what we did. It was a moment that was special; I was treated very well and got to travel and was very fortunate to have that opportunity."

RICHARD HERD
EVOKING THE PAST

It is memory that draws Richard Herd to the Western: the strong ties that came with growing up tending horses. "I lived for a while with my grandma and grandpa in Brighton, Massachusetts, which was where all the railyards came in, and that was the time when they were shipping all the cattle and horses by rail. I used to go down there, and if any of the calves got away from the pens, my cousin and I would chase them. For every one we caught we got a quarter. My grandfather worked at a place training police horses, so he put me up on a horse at an early age. I always had that in my background."

The actor who has become so identified with playing white-collar types in everything from *The China Syndrome* to the *Seinfeld* TV show and Jordan's Peele's enormously popular thriller, *Get Out*, has his emotional roots sunk down deep into another genre and dramatic tradition. "I always loved Westerns, but I was working in the theater so much that I promised myself that I had to get out to California, and it broke my heart. By the time I got out to Hollywood, most of the Westerns had been put away, and everyone was doing detective things. But I went out and did some riding at the stables, to get myself back up on a horse, so I was pretty good. I met a lot of the Western guys at the time, like Bob Fuller, who had done *Lancer*. Guys like him were very helpful to me."

After appearing in revered films like Alan Pakula's *All the President's Men* and Anthony Page's *I Never Promised You a Rose Garden* and landing guest parts on detective and police dramas like *Kojak*, *The Rockford Files* and *The Streets of San Francisco*, Herd had the chance to work with iconic Western writer-director Burt Kennedy (*Support Your Local Sheriff*, *The War Wagon*). "Burt wrote all those great Randolph Scott pictures like *The Tall T* and *Ride Lonesome*, and he worked for John Wayne. I did a rough-and-tumble movie with him down in Mexico, kind of a modern Western called *Wolf Lake*, with Rod Steiger. It was very rough country. On my days off, another actor, Jerry Hardin, and I would go riding down through Creel, which was very lonely and desolate. Their horses weren't as tall as our horses, a little scrubby, but tough, and we'd go riding and had a hell of a good time.

"After *Wolf Lake*, Burt called me and said, 'I'm doing a Western called *Kate Bliss and the Ticker Tape Kid*.' And it had a hell of a cast, with Suzanne Pleshette and Tony Randall, because this was a comedy, and Burt wrote Western comedies. Now all my scenes were on a train, so I would go out and ride a little, then come back and sit in the train car with Harry Morgan, who was a great guy and had done so many Westerns. We had Buck Taylor and Dobe Carey and Gene Evans, who was a wonderful Western star. On this movie, I had the perfect opportunity to work with the last of some of the great Western stars. Burt would call me about other things, but I was always on other projects, unfortunately, but he was one of the nicest guys I ever met."

The in-demand Herd worked constantly, taking on major roles in smash comedies like *Private Benjamin* and *Planes, Train and Automobiles* and appearing on several series, playing William Shatner's chief, for instance, on *T. J. Hooker* and George Costanza's magnificently oblivious boss on *Seinfeld*, before tackling another traditional Western, a two-part episode of *Dr. Quinn, Medicine Woman*. "I did a little bit of riding in that, but not a lot, and I played a very un-nice guy. I was an old-time doctor who was a pain in the butt. Eddie Albert's son was in it, and he was a great guy, and he was a really fine rider, and he spoke fluent Spanish. From that, I went directly into *The Adventures of Brisco County, Jr.* I played President Grover Cleveland in two episodes, and I was so surprised that they didn't pick that show up."

There were no more traditional Westerns lined up for Richard Herd, but two more decades of constantly fine work followed with roles upon roles in hit television series like the revived *Hawaii Five-O* and *Star Trek: Renegades*. He shows no sign of slowing down. "I'm eighty-six, and there's been this kind of reincarnation going on with me. I got a really good part in *Get Out*. Then from out of nowhere I did *The Mule* and had a wonderful time with Clint Eastwood, so I'm still out there. Morgan Woodward and I were great friends, and I used to tell him how I needed to do a real gosh-darn Western, even now. I worked on a dairy farm when I was a kid, and to be around the horses and the cattle on a movie or at a stable, well, that just takes me back to my memories of my grandpa and all the people I knew and loved. The Westerns are all a part of that."

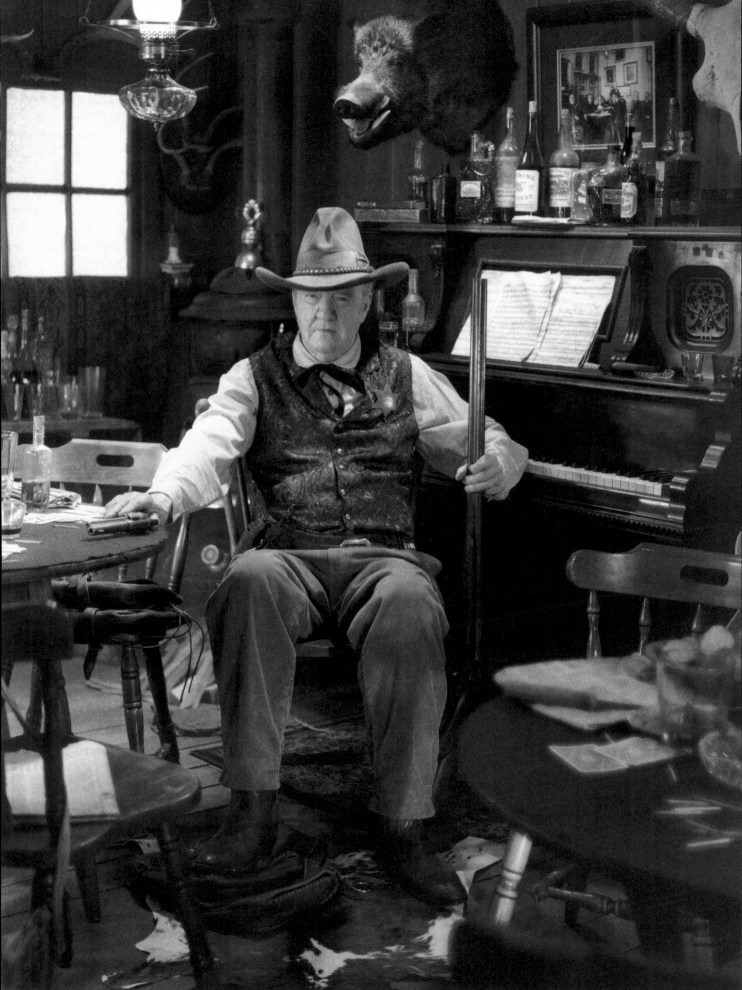

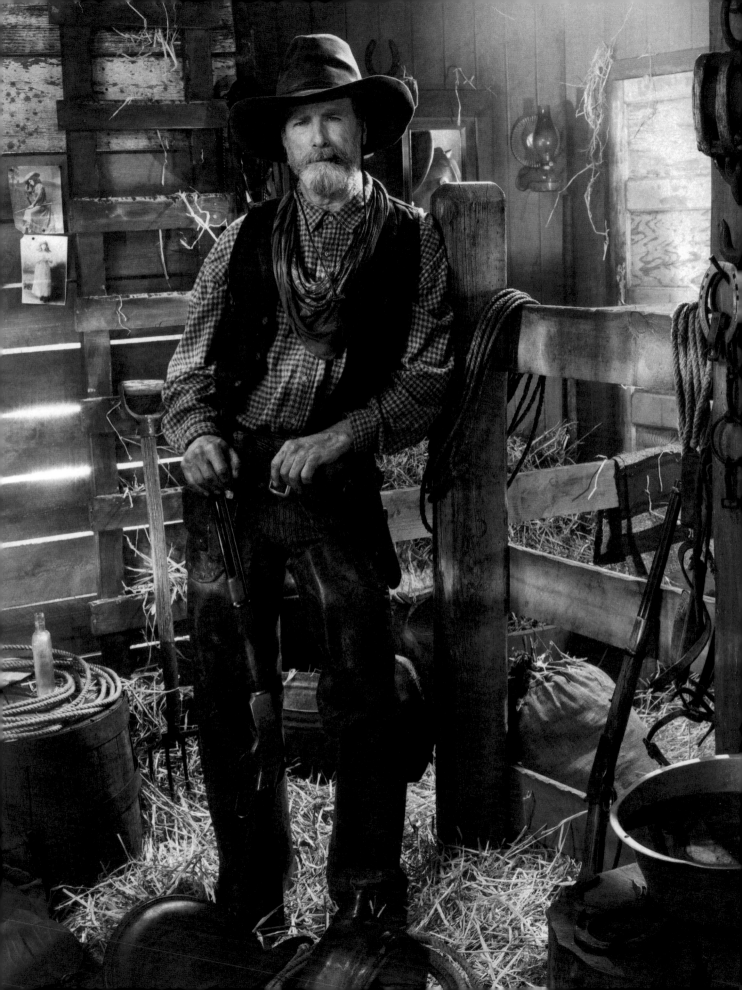

LOUIS HERTHUM
FROM LOUISIANA TO THE BACK LOT

IT WASN'T STEVE MCQUEEN on horseback from *The Magnificent Seven* that drew Louis Herthum to a life in front of the camera: it was McQueen in a green '68 Mustang GT. "I've been wanting to be a stuntman since I was twelve. When I first saw Mc-Queen in *Bullitt*, I told my dad, 'That's what I want to do when I grow up.' And he said, 'You want to be in movies?' I said, 'I want to drive cars like *that* in movies.'"

Though the future regular on the Western television programs *Longmire* and *Westworld* initially yearned for the rough-and-tumble side of movies and TV and wanted to roll fast cars and take a punch, a family outing to a Hollywood movie studio prompted a shift for his professional ambitions. "In 1978, I took a cross-country trip with my mother and sister from Louisiana, and we went on the Universal tour. It was overwhelming. During the tour I said, 'I'm going to work here one day.' A good ten years later, I was gainfully employed on the Universal lot. I did my first *Murder, She Wrote* there in 1989, and two years later I started playing Deputy Andy for the show's last five seasons. It was just incredible getting to work with all these people that I admired. I got to work with Robert Vaughn, who co-starred in *Bullitt*, and like an idiot, I was too shy to talk to him about it!"

This unabashed movie buff, who'd been working his way up to his recurring role on the TV whodunit *Murder, She Wrote* through dozens of plays and television commercials, is still excited by the guest-stars the show featured. "It was amazing. My favorite was Chad Everett—such a great guy with such great stories. Did you know that he did the voice of John Wayne for the animatronic figure out at Disneyland? People can mimic the way Wayne talked, but there are nuances in the gargle in his voice—that pause—that Chad got."

After *Murder, She Wrote* ended its run in 1996, Herthum charged into one role after the other on programs like *JAG* and *Vengeance Unlimited*, often playing the law and sometimes the lawbreakers, always bringing an element of himself to the parts. Several of these movies and television shows were shot in the Big Easy itself, New Orleans, Louisiana, which delighted this native son of Baton Rouge. In fact, working with director Steven Esteb, Herthum played the lead in a feature titled *Fortunate Son*, which was filmed in and around his hometown.

There was one role, as a modern Westerner in Wyoming, he seemed born to play. "My dad was a gunsmith, so I was shooting guns before I was in school. When I got the audition for the *Longmire* pilot, the character I was to play, Omar, knew guns and weapons. It felt tailor-made, but the producers didn't know who I was, and they had so many choices. My manager bugged them until they saw me. Then executive producer said, 'Louis, you're the very first Omar we read, and we could never see anyone else in that role.'"

Longmire ran for six seasons on A&E, with Herthum making eight appearances as an abrasive, but skilled, hunter, who's always ready to take down a wild animal or help a buddy. Adapted from Craig Johnson's novels, the hit Western series was noted for its strong performances, writing and depictions of Cheyenne life on the reservation—in the TV show, Lou Diamond Phillips, himself Cherokee, plays central character Henry Standing Bear. "The producers got a lot of praise from the Native American community; they really did respect the culture and the people, so that's a great thing to be a part of, and I'm proud of that."

Moving from one innovative Western to another, Herthum was thrilled to play the vengeful robotic lawman Peter Abernathy on HBO's *Westworld*: "I could've recited dialog from the original movie or told you what was going to happen when the film's leading man Yul Brynner turned his head. I was a junior in high school when it came out, and it's one of those movies that really stuck with me. So when I got a call for *Westworld*, I said, 'The movie?' And they told me it was a series based on the old film. And they wanted me to audition for one of the robots. I was genuinely excited, and the way they approached the concept was amazing. I think the show is a masterpiece."

Now a producer himself, Herthum still loves the Western. "The first movie I ever cried over was *Shenandoah*. That final scene when the kid comes into the church—that was just so moving. But my favorite Western of all time is *Once Upon a Time in the West*, especially when Henry Fonda shoots the guy off the train, and he's got the belt and suspenders, and Fonda says, 'How can you trust a man who doesn't even trust his own pants?' That's great."

DARBY HINTON
THROUGH YOUNG EYES

WHEN *Daniel Boone* premiered on NBC on September 24, 1964, star and producer Fess Parker was prepared for a decent airing, having garnered enormous acclaim as another monumental figure of American folk history, Davy Crockett, two years earlier. He was confident about the pilot and the first season's episodes but could not anticipate the popularity that would carry the series through the next seven years.

Boone's relationship with his son Israel served as one of the elements of the show that critics and audiences responded to most enthusiastically. Yet the young actor who played Israel for the entire run of the series, Darby Hinton, didn't even know he was trying out for the part when the show's creators selected him. Hinton, who had already appeared in George Pal's *The Wonderful World of the Brothers Grimm* at the ripe old age of four, laughs at the memory of this 'non-audition' audition: "I thought I was going to 20th for *The Sound of Music* to interview for the youngest von Trapp. My mom was running late, and she dropped me off to go park the car. I saw a line of kids, and I ran up to them in my stockings and edleweiss. The secretary looked at me in this getup and took me into this room before all these other kids as a joke, I thought, because of how I looked. There were all these big guys sitting around a table, and I kidded around with them, having a good time. I came out of it, and I saw my mom, who was running up and down the halls saying 'Where have you been? They've been looking all over for you! They're waiting for you upstairs!' I said, 'I don't know, but whatever's in that room, I just got it.' And that was *Daniel Boone*."

Hinton won the role of Boone's son, but the question of *which* son remained; the historical Boone had six boys. The producers "actually didn't have a part for me. They were casting Israel Boone, and they gave that to another kid. Then they wrote in Nathan Boone, a younger brother, for me. But during the pilot, the director, George Marshall liked me and wrote a scene where I pulled a flaming arrow out of a powder keg, and when they saw that in the dailies, the producers decided they didn't need an older brother. So that's how I became Israel Boone, and it would be me and Veronica Cartwright as the Boone children." Episodes were shot quickly, with interiors filmed at Fox's small lot on Sunset Boulevard and Western Avenue. "That was an old silent film studio, with four big soundstages, where all our interiors were shot and the exteriors were at the Fox Ranch. They were shot in five days. When I wasn't shooting the show, I was off making personal appearances. It was constant, but a lot of fun."

Daniel Boone's popularity grew, and several movie veterans and future stars appeared in episodes. "It was a hit show and a big deal for anyone to come in and do it: Ida Lupino, as a director; actors Cesar Romero, Slim Pickens, Rafer Johnson, Rosie Grier, Ronny Howard, Kurt Russell. Every week they brought in great people. Rosie Grier was one of the first actors of color to be a regular on a show like this. Woody Strode, too. We used a lot of wonderful actors and athletes of color, so we got to talk about slavery and injustice without hitting anyone over the head, without preaching, but through story and, hopefully, good acting."

Daniel Boone ran until 1970. Even as police and variety shows replaced Westerns on the networks, high ratings for *Boone* continued. But 20th Century-Fox, cash poor due to budget overruns from features like the musicals *Star!* and *Hello, Dolly!*, sought to minimize costs by shutting down productions, even popular TV programs. Parker was certain that the studio cancelled *Daniel Boone* in part because the series could be sold into syndication to yield a quick financial return.

While the cast and crew of *Daniel Boone* moved on to other projects, Hinton continued his education, travelling around the world as he completed college, then returning to acting, appearing in dozens of film and landing several television roles. "I was lucky. I stayed in it. I finished up my high school in Switzerland, and I did my college aboard a ship, circling the globe. And when I started acting again, I picked projects that let me travel around the world."

Hinton now has a major role in a new Western, *Bill Tillman and the Outlaws*. "I play Cole Younger, and Bobby Carradine is Frank James. Lana Wood's in it, too, and we're making an old homage to the classic-style Westerns. In those films, there was a hero, a white hat and a black hat. Now everyone has a major flaw. But it's nice to have heroes, people to look up to, and that's why I think *Daniel Boone* has endured. I love acting. I'm not one of those child actors who say, 'Oh, my God, work stole my childhood.' Having a part on that show really made it a wondrous childhood."

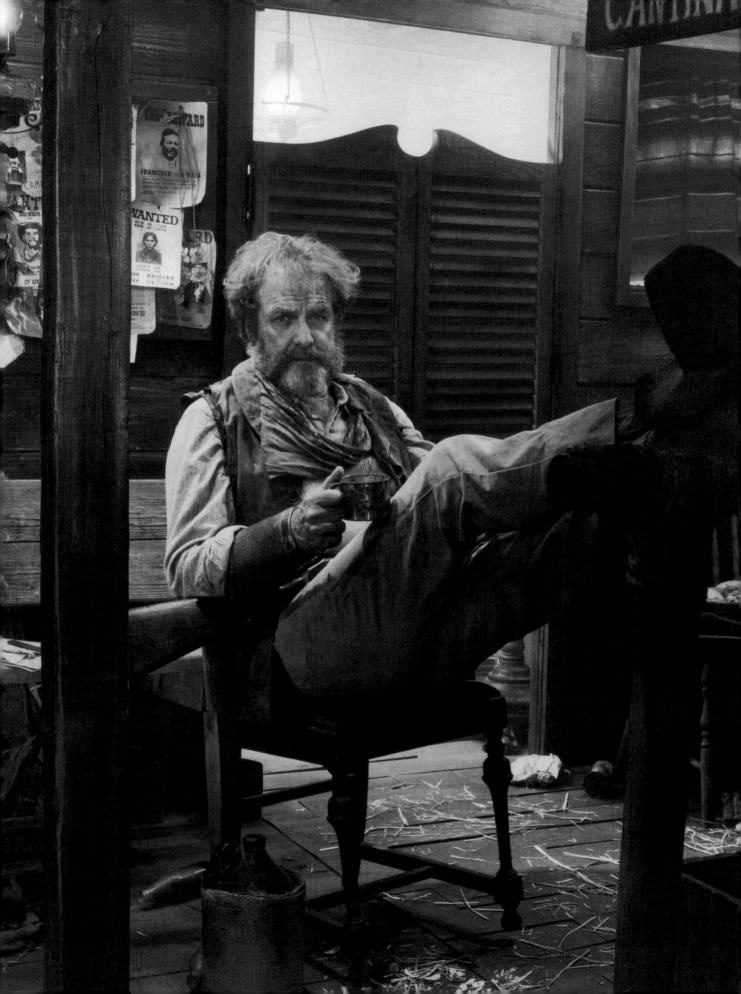

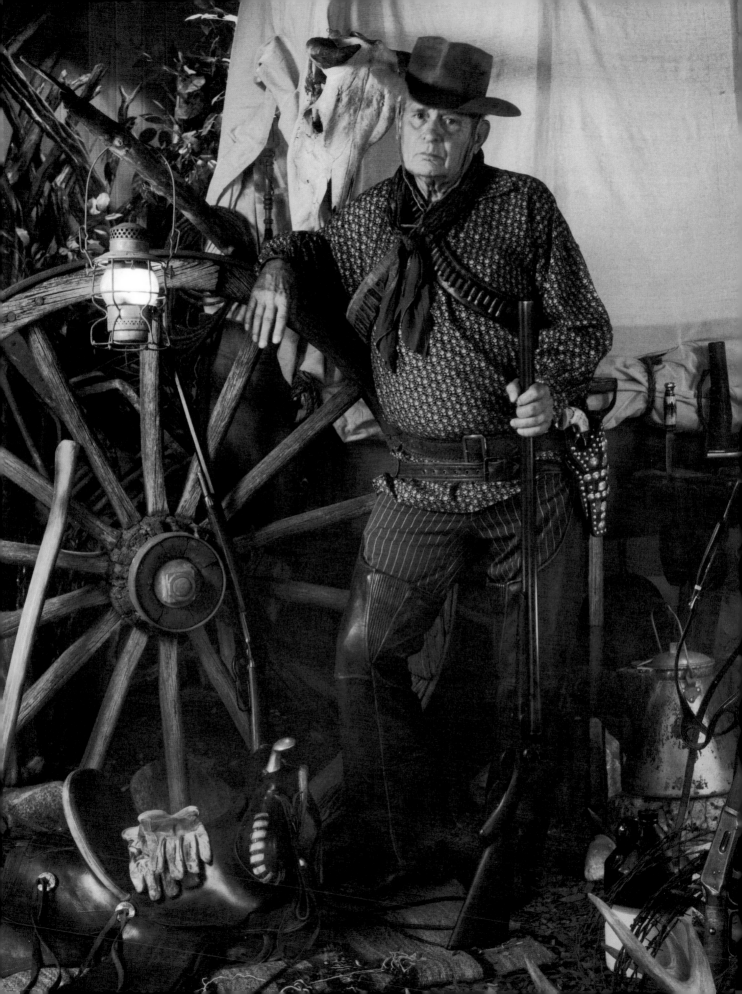

BO HOPKINS
LEARNING FROM THE GIANTS

AFTER MAKING HIS noteworthy request in Sam Peckinpah's *The Wild Bunch* to "kiss my sister's black cat's ass," Bo Hopkins, the wild boy from Greenwood, South Carolina, hot-rodded through *American Graffiti*, helped Jim Rockford get out of jail, drove cattle for Mr. Culpepper, robbed a Texas bank in *The Getaway* and became a power player on *Dynasty*. He's an actor who can seemingly fit in anywhere: a wide-eyed Southerner with a hound dog on the front seat of his truck, a menacing redneck, a business tycoon, a crooked detective, a cowboy with his thumb hooked in his belt loop ready to draw a sidearm.

His enormous talent, he candidly claims, has benefitted from lessons passed on to him by great movie stars with whom he shared the screen from the very start. Looking back on these conversations about craft he had with the likes of James Garner and Kirk Douglas, Hopkins asks, "Has anyone ever had a better acting school?"

As a teen, he had gotten into some trouble and landed in reform school before joining the Army and serving in Korea. Shortly after his return to the States, he started to appear in plays in New York, where he also studied dance and oratory, before migrating to Hollywood and becoming one of Lee Strasberg's pupils.

When he was summoned to join *The Wild Bunch*—he had some television work under his belt—*The Rat Patrol*, *The Mod Squad* and *Gunsmoke*, for instance—but no features. "I'd never heard of a squib before when they wired me up for my death scene. I've told this story many times, but it's a great memory, because when those squibs were going off. And that piece flew into my eye and cut me, Sam was right there to help. He wanted to wrap, and I wanted to go on, and we did. Everybody was there to help me. Ben Johnson and I became great friends. Bill Holden helped me get my next movie, *The Bridge at Remagen*, and Ernie Borgnine was like a father. They all gave me advice. How lucky I was to be working with my heroes! Sam was tough on the crew but nice to the actors, as long as you were prepared and knew your business." Hopkins would also appear in two more Peckinpah pictures, *The Getaway* and *The Killer Elite*, and several notable Westerns, among them Rob Wood's production of *Wyatt Earp: Return to Tombstone* and Dwight Yoakam's *South of Heaven, West of Hell*.

William A. Fraker's end-of-the-West saga *Monte Walsh* saw Hopkins with Lee Marvin, Jeanne Moreau and Jack Palance. "Those are movie icons, and they were great to me, also all the wonderful stuntmen and the wranglers. As you go along, you hope you'll be working with your friends again and doing Westerns, which happened pretty often with the stuntmen, which for me meant working with Hal Needham and Walter Barnes and Jerry Gatlin. We'd sit around after a long day, have a couple of beers and see who could tell the biggest lie. When I did *Posse* with Kirk Douglas, Burt Lancaster was making a movie nearby, and they invited me to dinner. Some of the stunt guys were at another table laughing at me because I was just entranced by the actors' stories."

Bo went right from the ranch in *Monte Walsh* to a cattle trail when he signed on as one of the cowboys for *The Culpepper Cattle Co.* "Gregory Peck was the original choice for Mr. Culpepper, but something came up, and he couldn't do it. So we got Billy Green Bush, and he was fantastic. This was a realistic story from beginning to end, and he fit it perfectly. Plus, we were herding cattle and riding. Director Dick Richards had the whole film in his head and knew exactly what he wanted, but when you're on a horse, it's the boss—I don't care how much you've ridden. Working the animals, things didn't always go as planned, just like a real cattle drive. The West really wasn't that romantic a place to be—that all came from the movies—but we love it.

"What a cast *Culpepper* had! Gary Grimes was a very nice kid, I enjoyed him, and, of course, Charlie Martin Smith had been Terry the Toad in *American Graffiti*. Geoff Lewis and Matt Clark and Luke Askew were all in there. They were great friends and great actors who could play those characters. I wish they had a hall of fame for character actors because they made the movies what they were. I don't care if the star was Bogart or Spencer Tracy, they had these character actors around them. Walter Brennan had all the tricks in the world to steal a scene, because that was the character. John Wayne would surround himself with these great actors. I love actors, I love the business and the great people I've worked with."

JOHN DENNIS JOHNSTON
STEADY CHARACTER

WHETHER A BUMBLING crook foiled by the fictional Jim Rockford or a dependable onscreen heavy favored by action-movie director Walter Hill, John Dennis Johnston carries on the character-acting tradition with aplomb. The Nebraska native and avid cycler with honest eyes and a hangdog demeanor came to notice in fine seriocomic roles on television (*Police Woman, Baretta*), as well as the motorcycle cop who arrests a flustered Woody Allen in *Annie Hall* and wonderfully as a misguided member of a paramilitary group run by an old lady in the "The Battle of Canoga Park" episode of *The Rockford Files*.

No matter what you were watching, you could expect to see his face somewhere—in everything from *Close Encounters of the Third Kind* to the TV rock-and-roll kitsch classic *Kiss Meets the Phantom of the Park*. Johnston wasn't cast in a period Western for years after he'd established himself in the industry, though. TV Westerns had been fading for quite a bit, with variety shows and police dramas replacing them during prime time, and the studios hadn't yet put Johnston on a horse or given him a six-shooter. An episode of the short-lived comedy *Best of the West*, which followed in the tradition of zany Westerns set by *Destry Rides Again* and *Blazin' Saddles*, gave him his first trip to the dusty 1800s. Among his castmates were the esteemed character actors Tom Ewell and Tracey Walter.

Then, fortunately, John Dennis Johnston co-starred with a troupe of the best character stars who'd ever acted in the Westerns of Peckinpah and Hawks in *The Beast Within*, a down-south horror tale about a teenager transforming into a giant insect that included in its cast L. Q. Jones, R. G. Armstrong, Luke Askew, Don Gordon and Ronny Cox. Produced by Harvey Bernhard (*The Omen*), this bizarre film, which some claim is an allegory for puberty, delivers surprising delights thanks to its veteran cast members who face the monster with straight faces and dedicated performances. Johnston has a great onscreen death: a good guy scared out of his mind, he blasts the transforming boy-insect with a shotgun, does a bit of damage, but then gets his head twisted apart by the beast.

Eastwood brought Johnston into his fold with the role of a death-dealing deputy named Tucker who works for Marshal Stockburn (John Russell) in *Pale Rider*, the actor-director's beautifully shot take on *Shane*. Johnston assumes the deadly persona of an assassin, betraying his vow to serve and protect his fellows. The fatal mistake he makes is in confronting Eastwood's Preacher character, who leaves him bleeding in the snow. Walter Hill had already cast Johnston as a redneck who's shaken down by Eddie Murphy in one of the most memorable scenes in *48 Hrs*. Hill called on the actor again to play a gun dealer in his neo-noir Western-inflected *Streets of Fire*. This "rock-and roll fable" unspools like a John Wayne feature from the 1950s but with Hill's neon-violence-and-music twist.

Longarm was an ill-fated attempt to translate Tabor Evens's adult-oriented Western novels into a TV series, failing both at being sexy enough for general audiences and tough enough for hardcore Western enthusiasts. Johnston co-starred in this undertaking with Lee de Broux and René Auberjenois. Much more successful—as it played to the actor's strengths—was his recreation of real-life outlaw Frank Stillwell for Lawrence Kasdan's *Wyatt Earp*. Stillwell was the prime suspect in the murder of Morgan Earp, and that killing in part triggered the famed O.K. Corral gunfight. Wyatt avenged his brother's death, famously shooting Stillwell in a trainyard with a shotgun. An arrest warrant was sworn out for Earp, who escaped capture, and was technically wanted for the murder the rest of his life. Johnston evokes Stillwell perfectly. The actor had come to specialize in characters who looked over their shoulders before making wrongheaded decisions, men who'd spent their lives feeling shortchanged only to get themselves killed trying to prove their worth. To achieve this much complexity in a portrait of such an unsavory figure reveals again Johnston's tremendous range as an actor.

Always popular with casting directors, he landed a continuing role on the hit hospital series *St. Elsewhere*, too, taking on other parts when his schedule permitted. *Wild Bill* gave him another opportunity to work for Walter Hill. Taken from Thomas Babe's play *Fathers and Sons*, this underappreciated Western masterpiece chronicles the story of Wild Bill Hickok's last night in Deadwood before he was gunned down. Johnston took on the role of Ed Plummer, bringing his own sense of truth to the part, just as he always has. This actor's best instrument is his finding the humanity in a role so that it's relatable, bringing it to us with open hands and heart.

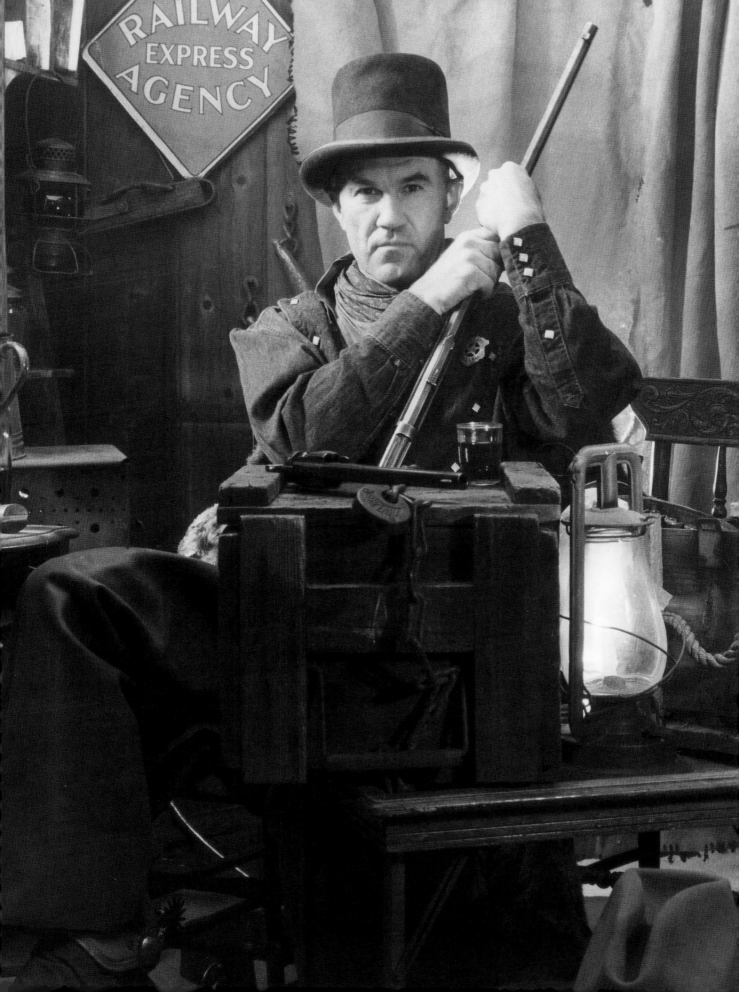

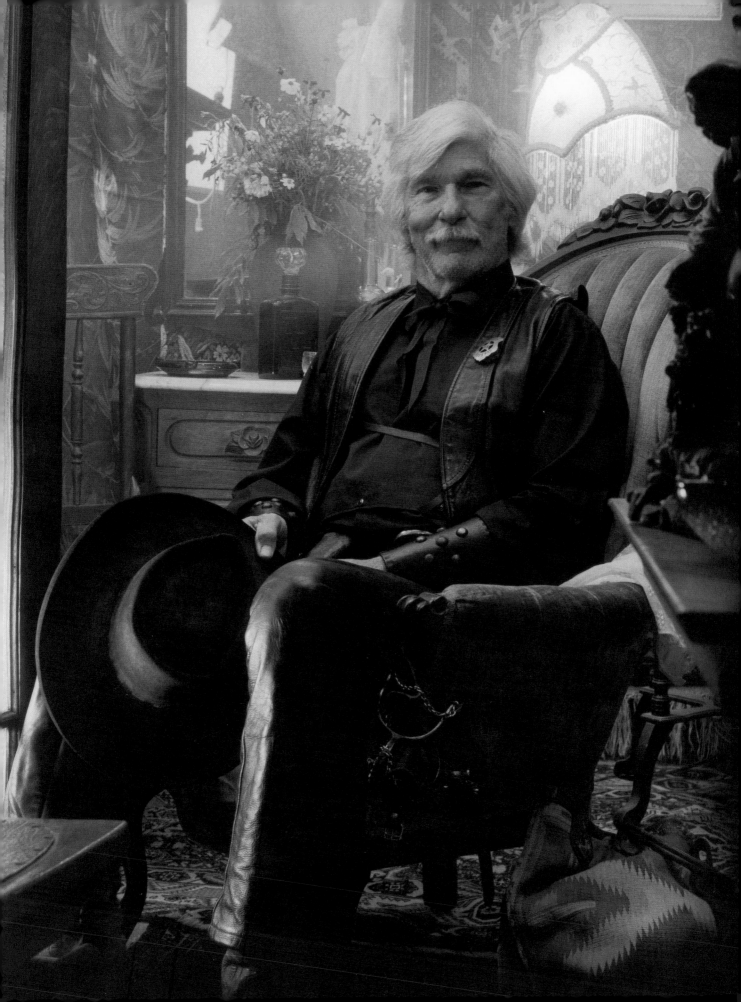

L. Q. JONES
THE GOLD STANDARD

DIRECTOR RAOUL WALSH surely noticed the smile tugging around the corners of Justice McQueen's mouth as he worked through his test scene, secretly rewritten by Burt Kennedy, for *Battle Cry*. The reed-thin McQueen allowed a touch of the devil, dry humor and a note of empathy to color his line reading, delighting Walsh, who cast him in the picture as Pvt. L. Q. Jones.

The character name stuck for Justice, as did the notion that he wrote his test scene. "Fess Parker took me to Burt, who rewrote it under the proviso that we never tell anyone because he'd get in trouble with the union. Sure enough, Raoul loved the changes and thought I'd done them. The first day I worked, it was the scene with the landing craft. We had Aldo Ray, Van Heflin, maybe three Oscar winners in that group. Raoul tells me the actors don't like the script and asks me to rewrite based on the test scene, which I didn't write but couldn't tell anyone! So I worked on the scene, and that's what's in the picture. I wrote another six or ten percent of the show but couldn't tell Raoul I didn't know what the hell I was doing since he was shooting my rewrites! Raoul rolled his own cigarettes, and when you did a take, he'd walk away to roll one. What he was doing was listening, to hear if it sounded natural. That was the most important thing. We also did *The Naked and the Dead* together."

Jones was under contract at Warner Brothers when the studio launched *Cheyenne* in 1955, the first hour-long Western on television. Clint Walker starred, with Jones as his sidekick, Smitty. "Clint didn't need me trailing along, so I bowed out. But this was the luck of the draw in this business because TV was coming on so heavy, and I was right there. It was very good to me, and the work was constant. I know I've made more than a hundred-and-fifteen movies and something like three-or-four-hundred television episodes."

When L. Q. Jones, his identification with the Western so absolute, walks into a scene, audiences know exactly who he is. Martin Scorsese cast him as Sheriff Pat Webb in *Casino* because he wanted a Westerner to challenge Robert De Niro. The scene with Jones's tremendous "you're just our guests" speech isn't simply a screen conflict between two characters, it's a war of filmographies, *Goodfellas* versus *The Wild Bunch*, with each actor carrying his own enormous cinematic history.

Reflecting on decades of remarkable work with iconic filmmakers, Jones laughs that Don Siegel was "so easy with what he did. I was taught to play ping pong by a guy who was champion in three states, so Don challenged me to a game. I took all the bets I could, and the son of a bitch beat the hell out of me! That was on *Annapolis Story*, and we did five pictures together after that, including *Flaming Star*, which was the best work Elvis ever did."

On *An Annapolis Story*, Jones met Siegel's dialog director, Sam Peckinpah, with whom he collaborated on television and seven movies. "Sam was a genius because it takes a genius to make a great picture and destroy his own life like Sam could. He made fourteen pictures, and three or four are classics. Who else has that record? But self-destructive? Like nobody's business." *The Wild Bunch* rightly ranks as a masterpiece, with Jones and Strother Martin as two of the worst examples of humanity put on film. These are glorious performances, but a quiet moment in the Peckinpah classic *Ride the High Country* resonates permanently with the actor: as one of the gutter-trash Hammond Brothers, L. Q. has been shot by cowboy Ronald Starr. He can't believe it. Death's been delivered, and the look in Jones's eyes is the final gaze of every movie outlaw who met the same fate.

"Budd Boetticher was the best man I ever worked for that paid no money but made good pictures," adds Jones. "I was in *Buchannan Rides Alone* with Randy Scott, written by Burt Kennedy, who was responsible for me doing it. There was literally no money at all, but that's the way Budd liked it. Because if it was a tight budget, you had to be ready to go with no arguments. Henry Hathaway had a terrible reputation as a tyrant, but was marvelous to me on *Nevada Smith*, although he ate poor Strother Martin alive. Tony Mann couldn't say two words without one of them being a curse word but was a fine director. On *Men in War*, we shot the whole thing in order; I've never done that before or since. Bob Ryan was great, and we had no idea it would be as good as it is. When we did *Cimarron*, how we didn't kill four or five people in that land rush I don't know. People were run over by horses and wagons. There were wrecks. At the end of the race, everybody applauded because we were still alive, with Tony probably applauding louder than anyone. It's a miracle every time a picture gets made."

LEON ISAAC KENNEDY
RAPPELLING WITH THE LONE WOLF

LEON ISAAC KENNEDY had already played Martel "Too Sweet" Gordone, the imprisoned boxer in Jamaa Fanaka's hit *Penitentiary* trilogy. Lean and muscled, Kennedy solidified his image as a man of action with his own remake of *Body and Soul*, a look at the corruption that can come with fame. Kennedy was all rage with two iron fists and the perfect choice as a no-nonsense FBI agent in Steve Carver's modern-day Western *Lone Wolf McQuade*, too. Kennedy laughs over the irony of the casting: "I was on the right side of the law on that one! I went from being behind prison bars to being one of the authorities. Now that was a switch!"

Lone Wolf McQuade was a major step in a career that included acting, writing and directing, and Kennedy embraced the chance to work with top-flight action stars and an experienced director. "I was really looking forward to this film, which was a major crossover for me. I was in a film that I didn't have to carry the whole thing, with big stars like Chuck Norris, David Carradine and the lovely Barbara Carrera, who'd made such an impact as a Bond girl, and all the others: Robert Beltran, L. Q. Jones and R. G. Armstrong. Just excellent. Classic choices. Steve Carver was one of the best directors I've ever worked with. He was totally on top of everything. The production ran so smoothly: no stress, no turmoil, just harmony."

The harmony included a bonding with Norris over shared heroes. "First, he's a spiritual man, and that affects how someone goes about their daily lives. Chuck and I would work out together in the mornings. I was great friends with Muhammad Ali, and he was one of Chuck's heroes. One of my heroes was Bruce Lee, and Chuck obviously knew Bruce quite well [as his co-star in *Way of the Dragon*]. So after working out in the morning, I would tell Chuck Muhammad Ali stories, and he would share with me Bruce Lee tidbits. It was a wonderful exchange."

Lone Wolf McQuade tells the story of a Texas Ranger (Norris) tracking down a gun runner (Carradine) to exact revenge. The movie has always been noted for its visual and musical nods to Sergio Leone, but there is also the echo of James Stewart's obsessed journey in Anthony Mann's *Winchester '73* that draws the film closer to a classic Western structure. One of those moments was the scaling of a mountain as the lawmen close in on their prey, and the sequence has stayed with Kennedy since he filmed it.

"There was a scene where we were supposed to rappel down the mountain. None of us had rappelled before, Chuck, Robert and me. They were going to teach us the proper use of the ropes, and all the techniques. So they took us to the equivalent of a forty-story building as the stand-in for the mountain. You get way, way up there, and you look way, way down, and it can be a jarring moment. The day for the actual scene comes. We're taken up on the mountain. And before we even get up there, Chuck's wife said, 'You know, Chuck, you don't have to do this. This is dangerous. Have a double to shoot from the distance.' And I'm thinking that this is great, because if he doesn't do it, then I don't have to do it.

"So we're on the top, and Robert looked down and said, 'Screw it, I can't do this.' The director, Steve, says, 'We'll do it with the two of you.' And Chuck and I are looking over this sheer edge. That he-man thing kicks in, and Chuck says, 'Well, if it's just the two of us, I'll do it. C'mon, Leon let's do it!' And I'm thinking 'Dammit! Now I have to!' They had a double go down for Robert, then Chuck goes, and then it was my turn. And you can go down slow or fast, and I just felt like 'screw it,' and I took big bounds—boom, boom—to get to the ground and get it over with. It was done, and I was happy about it, but it haunted my psyche for the rest of the day. It was the most dangerous stunt of the whole film.

"To me, that sequence symbolizes the classic Western because of the bonding that's taking place with these characters. It's the great 'We don't know what's going to happen tomorrow, we may be dead, but this is what we have to do.' It's the moment of us going on with our destiny. [For the same reason] *Tombstone* is one of my favorite newer Westerns because it had such great bonding with those characters."

Unsurprisingly, *McQuade* still holds a special place for Leon Isaac Kennedy. "Some people think you can only create in a chaotic environment, or you need to raise your voice and holler in order to be heard, and there was none of that. A very harmonic experience: that's the biggest impression I carried with me after making that movie."

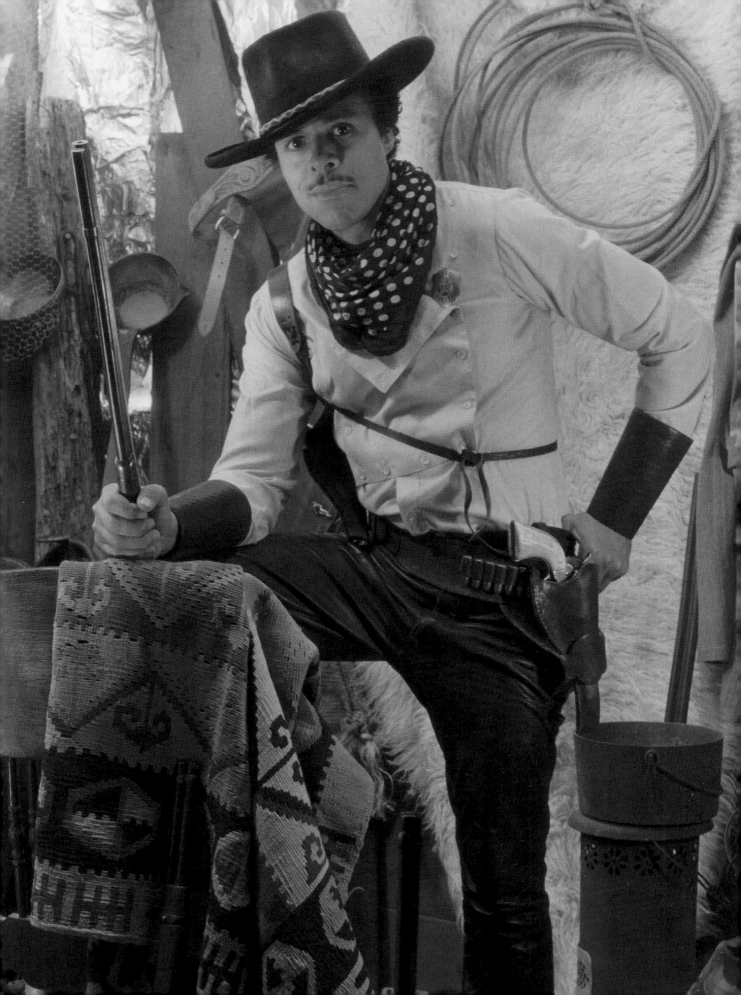

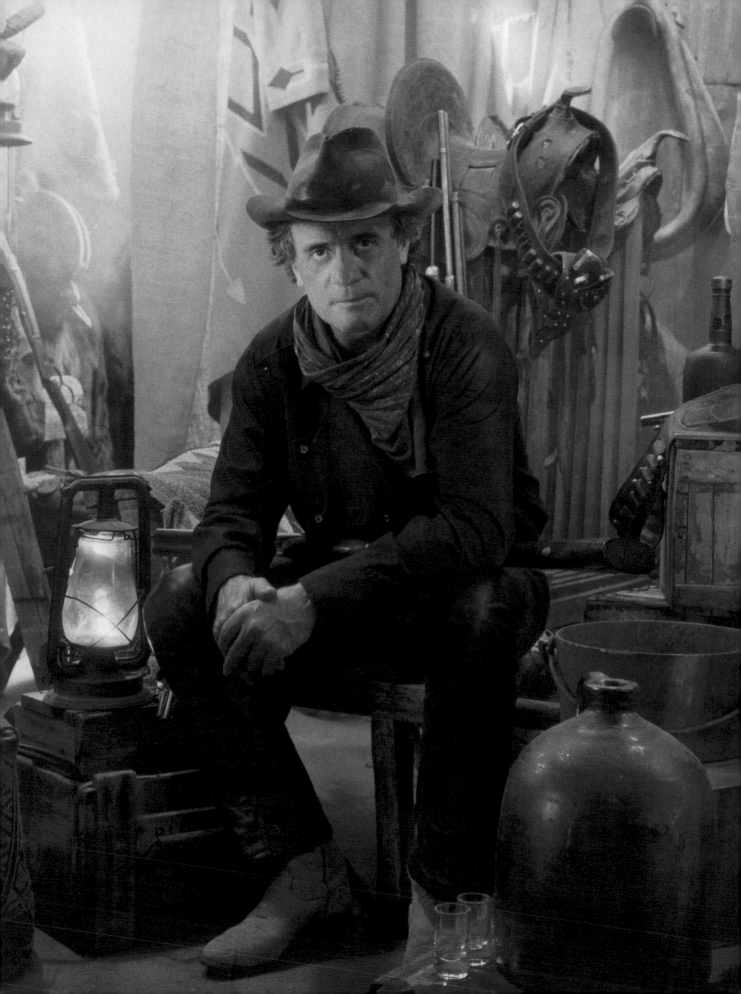

TERRY KISER
THE MAN WHO IMORTALIZED THE DALTONS

TERRY KISER IS a tightrope walker. From his first film, Paul Newman's *Rachel, Rachel*, where he became a flamboyant revivalist preacher, to his gloriously goofy interpretation of the deceased Bernie character in the *Weekend at Bernie's* romps, Kiser has always kept one foot in drama and the other in comedy. At his most slapstick extreme, he's shown an amazing physicality that honors the great silent comedian Buster Keaton. He's also flourished in roles as unscrupulous types on shows like *Hill Street Blues* while always walking the character actor's walk, arousing laughter, gasps and tears. Steve Carver recognized Kiser's dexterity as a player and cast him in pictures like *Fast Charlie…The Moonbeam Rider*, *Steel* and *An Eye for an Eye*.

In *Benny and Barney: Las Vegas Undercover*, which was scripted by Glen A. Larson right before he scored big with the *Battlestar Galactica* TV show, Kiser and co-star Tim Thomerson played a pair of Vegas comedians who hire themselves out as private detectives between club gigs. The pilot was shown as a TV movie without follow-up episodes ordered but served as a showcase for both performers, allowing them time with the mic for stand-up, and then some action and shootouts. Kiser remembers, "God, that was fun working with Tim. Great memories. That was the kind of show they wanted me for at the time. I still hadn't done a Western, and until *Dalton Gang* I wasn't seen as a 'period' type."

Written by *Gunsmoke* alum Earl W. Wallace, the three-hour *The Last Ride of the Dalton Gang* took a humorous tone, à la *Butch Cassidy and the Sundance Kid*, as it recounted the history of the famous outlaws and their bloody demise at Coffeyville, Kansas. Kiser, a native of Nebraska, had in fact graduated from the University of Kansas. The production marked a departure for producer-director Dan Curtis who, after *Dark Shadows*, was known as a master of television horror. When Curtis moved into the world of TV movies, he scored history-making ratings by producing *The Night Stalker*, which led to him directing Jack Palance as the eponymous lead in *Dracula*. He also helmed *Trilogy of Terror*, a well-received portmanteau TV feature starring Karen Black. Though Curtis thrived at making these garish grindhouse-influenced stories of gothic unease, he'd always wanted to mount a Western, and *Dalton Gang* gave him his chance.

Starring Cliff Potts, Randy Quaid and Larry Wilcox as the infamous brothers, it was the cast of amazing character actors that gave the film its color and spirit: R. G. Armstrong, Bo Hopkins, Sharon Farrell and Kiser, who played a Ned Buntline-inspired journalist determined to turn the Daltons into legends, deserved or otherwise. Stepping away from a contemporary setting and immersing himself in a different style of character proved liberating for Kiser, whose memories of the production rank among his best experiences.

"Dan Curtis relayed a very open and creative feeling to the actors, and a lot of times you don't get that. Sometimes the directors don't even speak to you, and you just do your lines and leave. But on *Daltons*, it was a very free exchange with the director. For me that was an eye-opener. He didn't want us to just say the lines, he wanted to hear the ideas, wanted to know what we were comfortable with. I remember that very vividly because it was so different than what I was used to, particularly on television. Curtis was a lovely man." Kiser used Ned Buntline, the dime novelist who'd written sensationalistic stories inspired by William "Buffalo Bill" Cody, as his model for the character of Naifus, the reporter. "The show wasn't specific naming Buntline. And by not naming him, it let me do some creating and some research to find that character on my own."

Kiser moved on to more than a one-hundred-and-fifty other roles, but this single performance in a television film leaves a distinct mark. A model of restrained mood, Kiser's character rings authentic as though we're watching a bit of flesh-and-blood history in a film that bends the truth about the outlaw Dalton brothers a dozen different ways. His performance is anchored in historic realism. "It's just the only Western I did. I never got those period pieces, and I always wanted to do one. I loved it because it's a throwback; you get to be on horseback, playing these unusual characters, who're part of our history. It's all about the legend, isn't it? That's part of doing a Western."

JEFF KOBER
BORN WESTERNER

DESPITE HAILING FROM just outside Livingston, Montana, and knowing his way around horses and cowboys, actor Jeff Kober had his first major career breakthrough when he landed a role on the modern, immensely successful nighttime soap *Falcon Crest*, an irony that isn't lost on an actor who'd rather be on the back of a horse than anything. "I've had a very blessed career. Anyone who can make a living doing what they love to do is blessed. And later, to finally do Westerns, was just wonderful. I was born in the '50s and raised on a farm. Westerns were the thing at the time; it was how you learned to be a man by watching Westerns. The fact that those things together—being raised around horses, cowboys and nature, and watching so many Westerns—well, it just lives in you if you've grown up that way."

Reflecting on the cowboy movies that matter the most to him, Kober says, "My favorite Westerns are *Red River*, just an amazing movie, and all the stories behind it with Joanne Dru and John Ireland, and that fantastic Howard Hawks relationship between Wayne and Clift. And *Once Upon a Time in the West*, with so many iconic moments with Henry Fonda, who is as bad as bad gets."

Kober's performance as Sgt. Evan "Dodger" Winslow brought him acclaim as one of the stars of the Vietnam television drama *China Beach*. Shortly after the series ended, Kober played outlaw Tors Buckner in *Ned Blessing: The True Story of My Life*, sharing screen time with Daniel Baldwin and Chris Cooper. "When you have a complex character like the one I played in *Ned Blessing* then you're golden; you just go for it. I've done quite a bit of research, reading letters and diaries. Out West, you had to know who your friends were, and your enemies. And you had to stand up against the elements. It took a lot of effort to stay alive in those days."

For an episode of *The Magnificent Seven* TV series, Kober strapped on his bad man's gun. "I got to be a bad ass and ride a horse, but I broke my finger on it. I got it tangled in the reins when I had to do a quick jump on the horse. It was on that show that I started working with wranglers in a different way. Instead of pretending like I knew what I was doing, I started asking how to do things I didn't know how to do."

Kober worked with *Shane* bad man Jack Palance on *Keep the Change*, written by Thomas McGuane (*The Missouri Breaks*). And on *Aces and Eights*, he co-starred with one of his movie favorites. "Ernest Borgnine was ninety-one when we did that. Talk about a legend. Everyone was committed to doing it as real as possible, and director Craig Baxley was just a joy to work with. Just so much fun." Baxley, a stuntman himself, had grown up on movie sets under the guidance of his father, stunt coordinator Paul R. Baxley (*Dukes of Hazzard, Mr. Majestyk*), a lineage Kober respects. "There are just some people who have everything about the film industry living in them, and that was Craig. He really took care of you as an actor."

The Baxleys had a history with Don Siegel and Clint Eastwood, too, collaborating on *Coogan's Bluff* and *Dirty Harry* long before Eastwood directed Kober in *Sully*. "Clint's iconic. I was working with this kid who'd never done a movie before. And we're doing a Steadicam shot, and he kept blocking me, by accident, as we were moving in the shot. So Clint took me by the elbow to place me exactly so I wouldn't be blocked, saying, 'What I'm doing to you is one of the reasons I became a director.' I didn't mind, but it was very nice that he said it. He's a great filmmaker, and his crew is one-hundred-and-twenty people who would take a bullet for him."

More recent television series, such as *Sons of Anarchy* and *The Walking Dead*, have brought Jeff Kober to the attention of a new generation. Playing Davy Crockett on the sci-fi time-travel show *Timeless* broadened his fan base, too. "Crockett was a gift. The language and the sentiments of the scripts were so beautiful. The scene where I admit I didn't kill a bear with my bare hands, and they ask me why I let that story go on, and I say, 'Sometimes folks need a hero': I loved that I got to say those words because they're true. There has to be someone out front to volunteer to be willing to take the heat. Not necessarily being better than anyone else, but someone's got to do it, and that's who Davy Crockett was. I did research, and he was a regular human being, who gambled away his money and went to Texas to make money for his family. Crockett ended up where he ended up but made the best of it because that's what a man does. That's a hero."

Right: Jeff Kober posing with Heather Johnson, Marta Alberti and Melinda Alberti at IMAGE Studios.

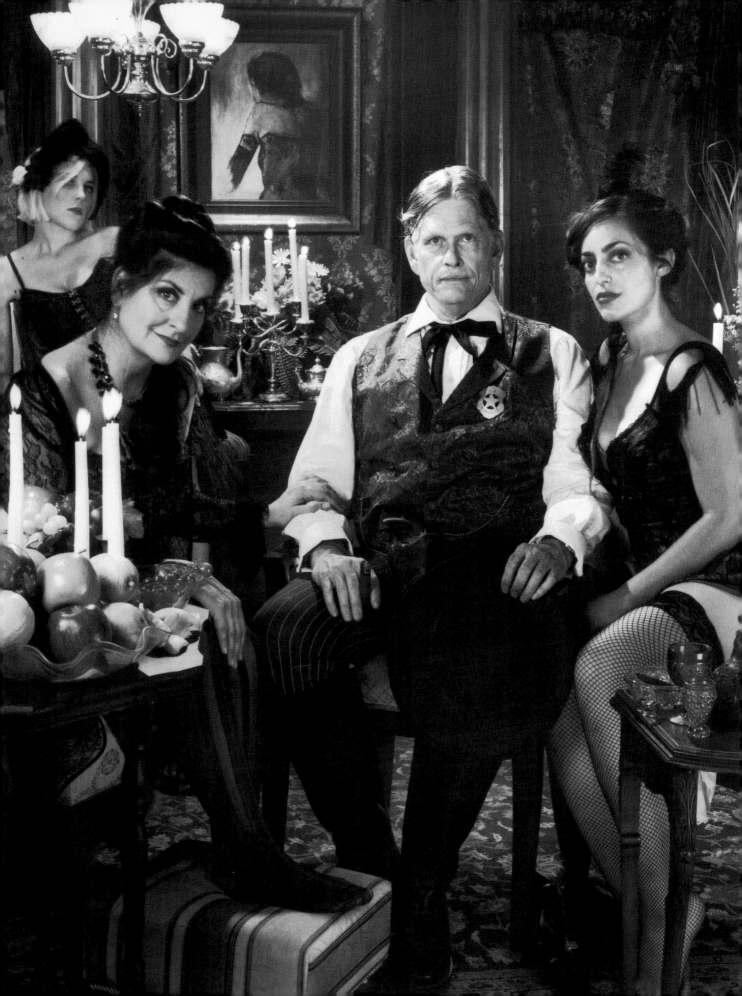

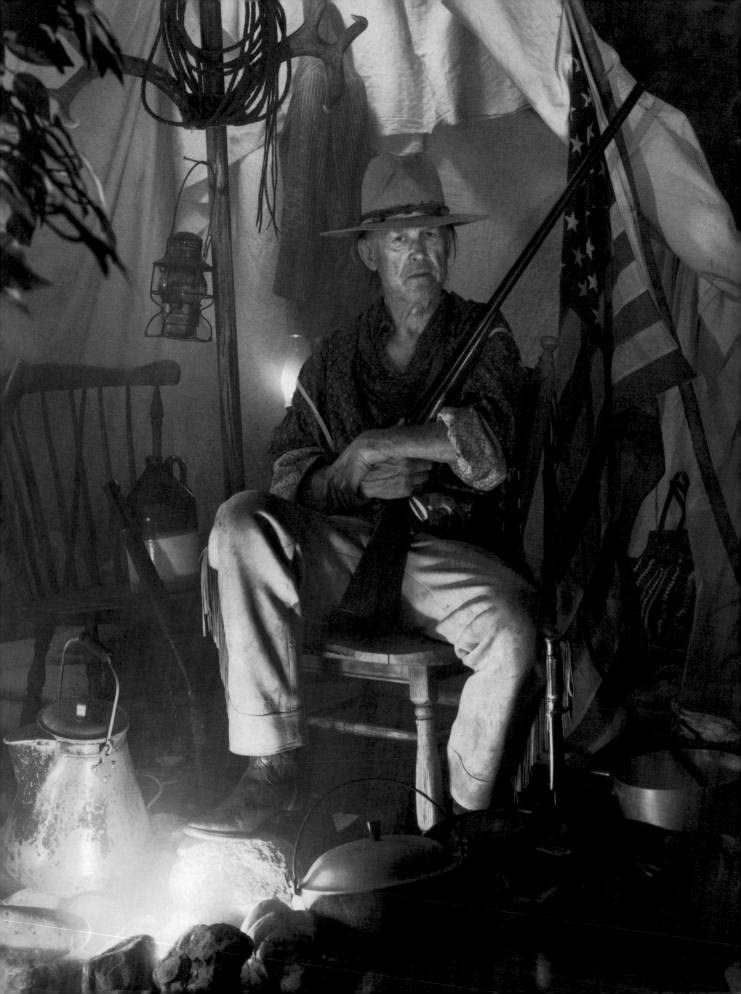

PAUL KOSLO
STREAK OF LIGHTNING

"He had the biggest hands I'd ever seen!" laughs Paul Koslo, recalling an encounter with John Wayne during the production of *Rooster Cogburn*, the sequel to *True Grit*. "I play the guitar, and sometimes I bring it to set, and one time I did, Duke's grandkids were there with their guitars, and we played together. That night he slapped me on the back, saying, 'My grandkids say you're all right.' He was being nice, but he nearly knocked me out of my chair. It was like being slapped by a grizzly bear!"

In *Rooster Cogburn*, Koslo, along with Anthony Zerbe and Richard Jordan, is tasked with giving the Duke and co-star Katherine Hepburn a rough time over a shipment of nitroglycerin and, like many of the characters Koslo played, gets shot for his trouble. "Acting with John Wayne, you're acting with living history. You're seeing all these performances going back fifty years, but there he was, and he was better than I thought he'd be as an actor. Really natural in front of the camera, very loose, very funny. The thing with the Duke, you had to know your business and be ready to go when he was. He was a pro from the old school and expected the same from everybody."

Born in Germany to Polish parents, Paul Koslo grew up in Canada, where he worked fighting forest fires before pursuing acting. Just out of his teens, he spent a year with the National Theatre School before landing roles on Canadian television in the late 1960s. Director Jack Starrett cast Koslo in the low-budget *House of Zodiac* before unleashing him to drive-ins in the 1970 biker hit *The Losers*, and Koslo quickly followed with the modern comedy Western *Scandalous John* for Disney, with Brian Keith as a ragged old cowboy who wants to live, and die, on his own terms.

Koslo was a streak of lightning across the screen; he'd walk into a scene with a grin, a smart-ass line and a presence that contrasted the acting styles of stars Charlton Heston, Clint Eastwood, Charles Bronson and Wayne. Koslo was their perfect foil, who sometimes lived, but more often died, after walking away with every scene in which he appeared. The role of Dutch, the post-apocalypse biker boy in *The Omega Man* opposite leading man Heston, led to roles for Koslo on TV in shows like *Ironside* and *Mission: Impossible* before he found himself appearing with Clint Eastwood and Robert Duvall in *Joe Kidd*

with a script by Elmore Leonard. Koslo recalls Duvall's ribald humor: "Bobby's a serious cut-up, and he blew a record-breaking fart in the middle of a desert windstorm that nearly killed all of us! Clint was great. A class act, and when he got in his horse, he just rode beautifully. That's what you think of, that image. I liked the director, too, John Sturges, who made some really classic Westerns."

The TV movie *The Daughters of Joshua Cabe* came next, and its rascally tale of cowboy Buddy Ebsen hiring three girls from the local bordello to pose as his daughters to fool a land company made it a ratings hit. For Koslo, this meant striking a lighter tone, which he does with skill, and with admiration. "Buddy Ebsen, what a fine man. I've worked with a few actors I didn't care for, Charlie Bronson's on that list, but Buddy Ebsen was just a class human being." Although none of the three films with Bronson were Westerns, *Mr. Majestyk*, also featuring an Elmore Leonard script, surely played like one with Koslo as a smirking gunslinger trying to muscle a local melon farmer, leading to a showdown.

Director Michael Cimino wasn't surly, but he puzzled Koslo, and most of the cast and crew during the shooting of his epic, *Heaven's Gate*. "It wasn't a large role, the Mayor, and the location was gorgeous, but we'd wait for days, then weeks, to shoot the smallest scene. He had everyone, all the extras, in full wardrobe waiting around to be used, and he'd never put them in a scene. The money spent was amazing, but the movie's now part of film history, isn't it?"

A founder of the MET Theatre in Hollywood, Koslo has never deserted his love for the stage, which he shares with his wife, Allaire Paterson-Koslo. He continued as an in-demand villain in more than a hundred films and television shows, ranging from an award-worthy turn in *Roots: The Next Generation* to *Louis L'Armour's Conagher* to the cult science-fiction film *RobotJox*.

Big role or small, Paul Koslo always leaps off the screen, bringing energy and fire to everything he does, impressing those who work with him. "When we finished *Rooster Cogburn*, the Duke gave me a coffee mug that said 'To Paul from John Wayne.' Pretty great gesture, and it's those little things that take the pain out of the ups and downs, that make the journey rewarding."

MARTIN KOVE
SOUL OF THE WEST

THE SCENE IN *The Karate Kid* has become a part of 1980s movie history: Pat Morita as Mr. Myagi enters the dojo of Martin Kove's Coach Kreese to get Kreese's students to leave his pupil, Daniel (Ralph Macchio), alone. It does no good. Daniel has stood up to Kreese's star students, and now the coach and his protégés want revenge. A deal is struck: the youngsters elect to meet in a tournament to determine not only the best new karate champion but also the best martial arts teacher.

Kove had moved to Los Angeles in 1975 and got himself cast in Steve Carver's *Capone* as well as Paul Bartel's *Death Race 2000*. Yet this cinephile and expert horseman didn't find any opportunities to make the kind of movie he loved best, the Western. Then came Dino De Laurentiis's *The White Buffalo*, with Charles Bronson and Kim Novak. De Laurentiis loved the idea of doing "Moby Dick out West" with Bronson as Wild Bill Hickok obsessively tracking a legendary buffalo that's been stampeding through his nightmares.

Kove played outlaw and assassin Jack McCall. "I had a great scene, where Jack McCall meets Wild Bill Hickok years before he kills him, and it was cut. It was really a shame because it was the big scene I had with Bronson. I was always a Charlie Bronson fan, but I knew from my friend Paul Koslo, may he rest in peace, who'd worked with Bronson, that Charlie was a loner. I brought in some stills, one from *When Hell Broke Loose* and another from *The Magnificent Seven*. I didn't ask for an autograph, but I showed him the pictures, and he said, 'I'm a real ugly guy,' and I said, 'No, you're not.'"

Roles on well-regarded television series like *Cagney & Lacey*, a pair of *Karate Kid* sequels and *Rambo II* were all behind Kove when he addressed historical figures again in 1994, playing Ed Ross in Lawrence Kasdan's epic *Wyatt Earp*, with Kevin Costner as lead. Produced around the same time as *Tombstone*, the film's tone was more somber than the Kurt Russell-Val Kilmer vehicle but also more expansive in its telling of the Earp saga. Roger Ebert felt the Kasdan movie "doesn't want to be just one more retelling of the gunfight at the O.K. Corral. The subject is the whole life span of Wyatt Earp."

Kove agrees that the Costner film offered viewers a largely authentic rendering of history. "I've sat in Tombstone, Arizona, at the auditorium there, with historians who saw both films. The bottom line was that *Wyatt Earp* with Kevin was much more factual. It was darker, but it was true. I remember being with Kevin a year or so before the movie started shooting, and he wanted to do it as a trilogy, like *The Godfather*, but about the Earp family. It would be entertaining but more real than the red-sash cowboys of *Tombstone*. *Wyatt Earp* was the first time that audiences really saw Kevin playing anything that intense, and he was terrific. But people didn't go."

Kove's next project related directly to Wyatt Earp, too, and also the classic TV show the Earp legend spawned in the 1950s. Produced and written by Rob Word, *Wyatt Earp: Return to Tombstone* was a nostalgic ride into television's Western past. "Hugh O'Brian was really fun. Of course, he tried to upstage everyone! And Bo Hopkins and I had a scene that was great to do."

With more than two hundred roles to his credit, including appearances with David Carradine on *Kung Fu: The Legend Continues*, Martin Kove has no intention of turning his back on the genre he loves, even appearing in independent Westerns with budgets stretched to the breaking point. Recent outings for him include *Six Gun Savior* and *Wild Bill Hickok: Swift Justice*. Big budget or small, he always makes a production more compelling by contributing his understanding of the history of the West and Western movies.

This specialized knowledge also reveals itself in Quentin Tarantino's depiction of the Manson murders, *Once Upon a Time in … Hollywood*. Kove's character is "this marshal on a fictional Western TV show from the 1960s. So the scene is Leo DiCaprio, who's supposed to be the show's star, bringing in four dead men, and I'm waiting for him in front of my office. I've got my feet up, crisscrossed on a post, leaning back in a chair like Henry Fonda did. And Quentin says, 'So you know the language of John Ford.' And I said, 'Do you think you're the only guy who knows *My Darling Clementine*?' If you get the flavor of John Ford in there, you're getting the flavor of the Western. The American heritage of cinema started with the Western in 1906, and it's carried on from there, from those silent films to today. `I was born the day the Alamo fell, and I've always felt, metaphysically, that I was there. I feel as if I was in Texas a hundred-and-fifty years ago. That connection to history is very real for me. That's why I love the genre so much."

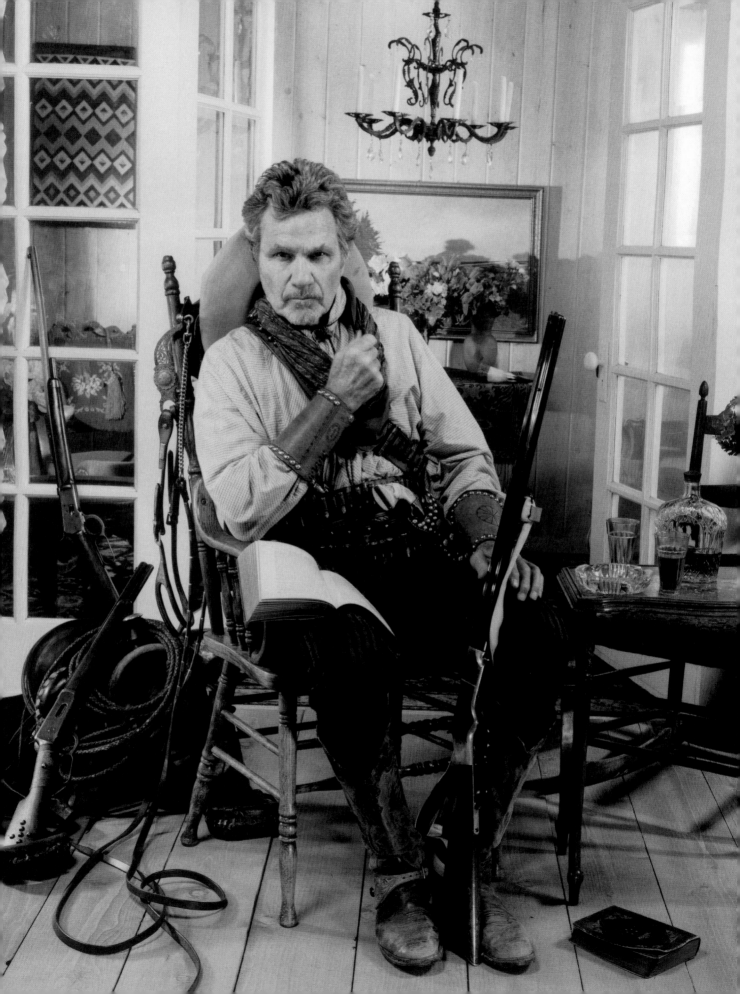

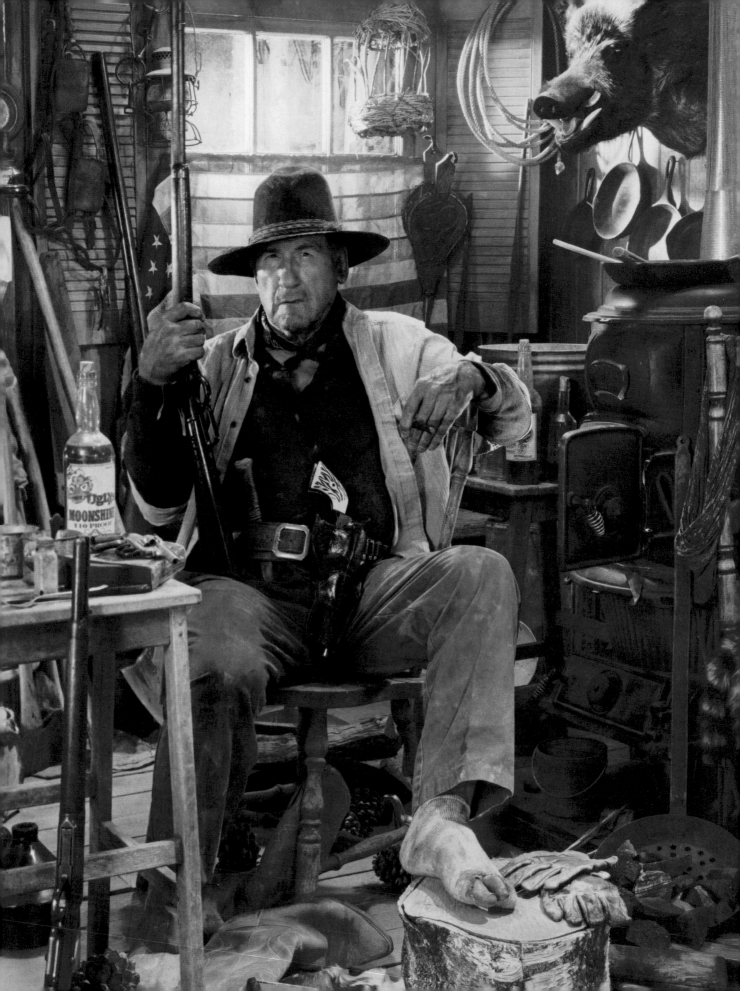

ART LAFLEUR
FINDING THE COMEDY

He seemed to have been carved from granite, massive shoulders bent forward, his expression a permanent scowl with narrow eyes signaling either intense frustration or about-to-explode anger. The frustration is there, but the explosion is usually held off as Art LaFleur has mastered the "slow burn" better than any character actor since the great days of screwball comedy.

To find a performer with the same skills, it would take rolling back to the 1940s to the comic timing of William Demarest *(Ride on Vaquero)* or William Frawley *(The Virginian),* and LaFleur belongs to that grand tradition. But the co-star of *Field of Dreams* brings something else to the table, as well, when he confronts a serious role head-on, frequently surprising audiences that expect something comic but get a dramatic moment instead.

The native of Gary, Indiana, arrived in Hollywood in the 1970s with scripts under his arm, ready to pound on producer's doors to get them read. But a friend's advice led him instead to a series of auditions, and LaFleur soon had his first role as a goofy Russian agent named Ivan in the made-for-television feature *Rescue from Gilligan's Island.* The over-the-top clowning he dispensed got him started on a steady stream of TV guest shots that exploited his great range as a performer. From the straight-faced delivery of a joke on *M*A*S*H* or *Soap,* for instance, to clenched-fist menace on *Charlie's Angels,* LaFleur managed to play either way with deceptive ease.

His first Western, a guest-starring role on the short-lived ABC series *Best of the West,* gave him the chance to develop his craft and his comic delivery with leads Joel Higgins and Tom Ewell. In an episode titled "Mail Order Bride," Ewell's character plans to marry a one-time prostitute played by the always funny Betty White. LaFleur walked away with his scenes, evoking sympathy, frustration and laughs at the same time, the real comedic hat trick, showing that his instincts were already honed. "I'll always lean more toward comedy, to find that humor in a role. That's certainly true in all the Westerns I ever did."

An episode on the *Maverick* revival TV series for NBC, *Brett Maverick,* came next. "I liked doing that show very much. On set, there was a chair, and I thought I'd take a seat, and someone told me that it was 'Maverick's chair.' So I got out of it right away!

But Jim Garner was great, and that was really a fun show to do because it had that sense of humor about it."

The actor steadily leaned toward comedy in his motion picture work, too, finding just the right balance with Clint Eastwood in *Any Which Way You Can,* the knockabout sequel to *Every Which Way but Loose,* and the gangster satire *City Heat,* featuring Eastwood, Burt Reynolds and Richard Roundtree. Eventually, LaFleur eased into parts as military officers, often career men with sardonic wit and toughness to spare. Roger Spottiswood's *Air America* would fit that casting bill in its story of pilots who flew secret CIA missions into Vietnam, with LaFleur and his frequent co-star Tim Thomerson among Mel Gibson's gang of flyers. *Air America* would be LaFleur's first with Gibson but certainly not his last when, years and dozens of roles later, he was cast as a slickster cardsharp in the large-scale feature version of *Maverick* with Gibson, Jodie Foster, James Garner and an array iconic Western supporting players, such as Geoffrey Lewis, Paul L. Smith and Denver Pyle. "I auditioned for that role of the poker player, and I got the part, I think, because of the way I shuffled the cards."

Once again attached to a *Maverick* spinoff property, LaFleur was called upon to strike the difficult balance between comedy and threat. Figuring out how to interpret characters wasn't the only concern facing him, though, each time he took on a Western part. "The thing about getting on a horse was that I always asked for a gentle horse, one I could handle. I wasn't afraid to ride a horse, but I asked for a gentle one that would stand there while I was doing dialog. That's always been a big thing with me, making sure that the horse is handled properly."

Whether delivering an ultimatum from the back of a horse or dealing a crooked hand of poker, Art LaFleur looks back to Westerns with a sense of personal appreciation, enjoying the opportunity to watch the actors that inspired him. "Of course, Eastwood was great, but going back, so was Hopalong Cassidy when I was growing up. I liked the actors that handled Westerns well, like Ernest Borgnine and William Holden, actors who did Western movies, not just the cowboy stars. Jimmy Stewart, for instance, and those films of his from the 1950s. That's what had an impact on me."

RUTA LEE
GORGEOUS LAUGHTER

"Solitary." Ruta Lee lets the word hang in the air for a heartbeat as she describes Audie Murphy, her co-star in *Bullet for a Badman*. "We would have fun on those Westerns, laughing all the time, because it was a great way to work, to be relaxed. We were in Utah, and you get to know each other when you're on location, and you get close to people. George Tobias and Alan Hale were just wonderful, but Audie was by himself, even when he was with us. He didn't want to join in. He was never rude, just alone. When I would talk to him when no one else was around, he was shy, very nice and very polite. Sweet. But even then, by himself."

Following her initial success in the cinematic version of the hit musical *Seven Brides for Seven Brothers*, Ruta Lee had parts in ten feature films and more than fifty television roles. Says the Montreal-born entertainer and philanthropist, "It seems I did every Western there was. When a casting director at the studios liked what you did, it was a conveyor belt—you went from show to show. They liked me at Warner Brothers, so I was on shows like *Cheyenne*, *Sugarfoot*, *Maverick*. Jimmy Garner on *Maverick* had so much charm and charisma, my God, and so funny. Always with that twinkle in the eye, that bit of mischief that he plays so well. Jack Kelly projected something different, a more quiet charm. He's wonderful. Because they came off differently, you could believe them as brothers."

Ruta had dreamed of performing professionally her entire life. Her parents saw that their eight-year-old daughter received dancing and singing lessons, which came to use later when Ruta appeared on *The Roy Rogers Show* and *Adventures of Superman*. After a fiery audition at MGM, she became one of the betrothed heroines in *Seven Brides for Seven Brothers*, dancing and singing through this Western-themed musical starring Howard Keel and Jane Powell, which Stanley Donen, who'd just made *Singin' in the Rain*, directed. Choreographer Michael Kidd put the cast through murderous rehearsals to perfect the movie's muscular folk dances. She's billed on this picture as Ruta Kilmonis, which she eventually changed to Ruta Lee.

She revealed her dramatic chops in Billy Wilder's *Witness for the Prosecution* as Tyrone Power's secret lover. "Wilder was a genius and so funny, but when Marlene Dietrich saw my blonde hair in the test, she said, '*Nein!*' They made me a brunette, and here I was working with Tyrone Power and Charles Laughton, these legends, and I was terrified, especially about Charles Laughton, because I'd been told he was mean and very difficult. Well, my first day he swats my backside and says, 'That's the nicest ass I've seen in ages!' Of course from then on we were great friends!"

Work came in an avalanche, with roles on *M Squad*, *The Lineup,*, *77 Sunset Strip* and the TV Westerns *Shotgun Slade*, *Wagon Train* and *Rawhide*. "The wranglers and stuntmen on those shows were marvelous. They taught me the proper way to ride and how to handle a gun. Just everything I needed—and always so funny and gracious! I could toss out a dirty joke with the best of them, so they saw me as a kid sister." She also starred in a *Gunsmoke* episode titled "Jennie" that Andrew V. McLaglen directed. "I was the girlfriend of a bank robber and decided to go after Marshal Dillon. I'm upstairs at Kitty's, on a little bed, with a curtain blocking off my tiny space. Dillon comes in and won't be seduced! He throws a quilt over my head and tosses me over his shoulder, stands up, and as he threw aside the curtain, turned and slammed my head into the door frame. I was knocked out. I woke up with Jim Arness leaning over me, tears down his face, saying, 'Thank God I didn't kill you!' It was very sweet."

It was Billy Wilder's courtroom drama rather than Westerns that helped her land a part in *Sergeants 3*. "Frank Sinatra screened *Witness for the Prosecution* at his house and said to producer Howard Koch that he wanted me for their new Western. I'd worked for Howard many times, so he said, 'Great!'" John Sturges directed this sendup of *Gunga Din*, a Rat Pack extravaganza with Sinatra, Dean Martin and Sammy Davis, Jr., as well as Henry Silva. The production's remote location in Utah didn't stop Sinatra and his buddies from playing hotels in Las Vegas during shooting or taking off in private airplanes for business and pleasure.

Says Lee, "Frank was very sweet to me. They all were. I was one of the 'boys,' or at least I wasn't in line to be a conquest, but I don't know why! Frank always saw me as just a good friend, a buddy, and that lasted until the day he died."

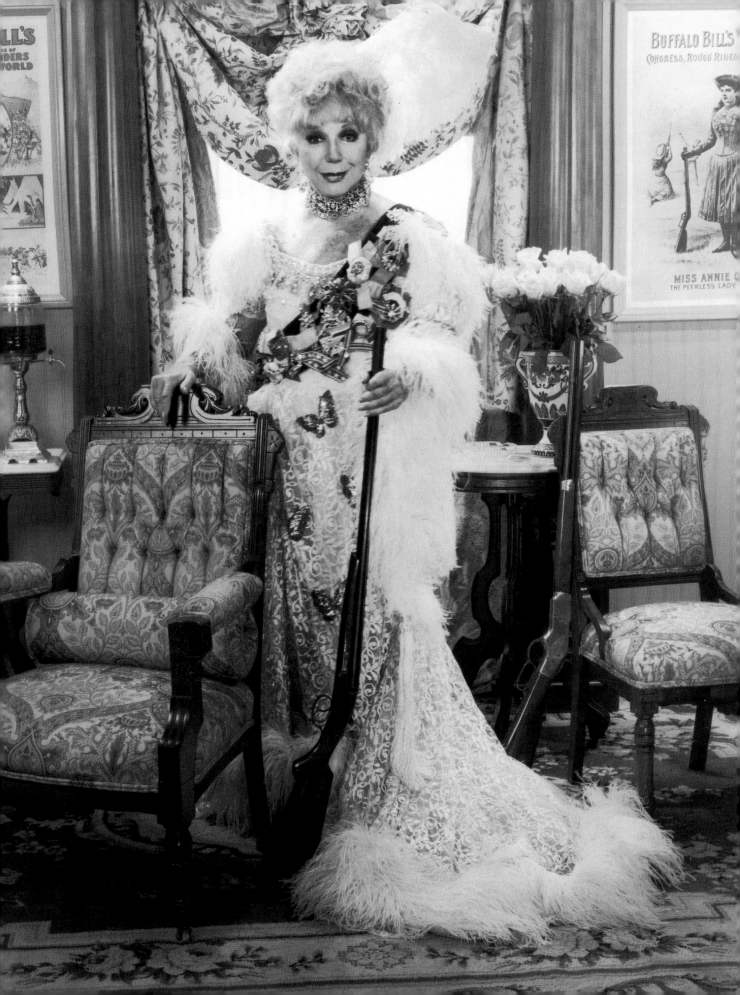

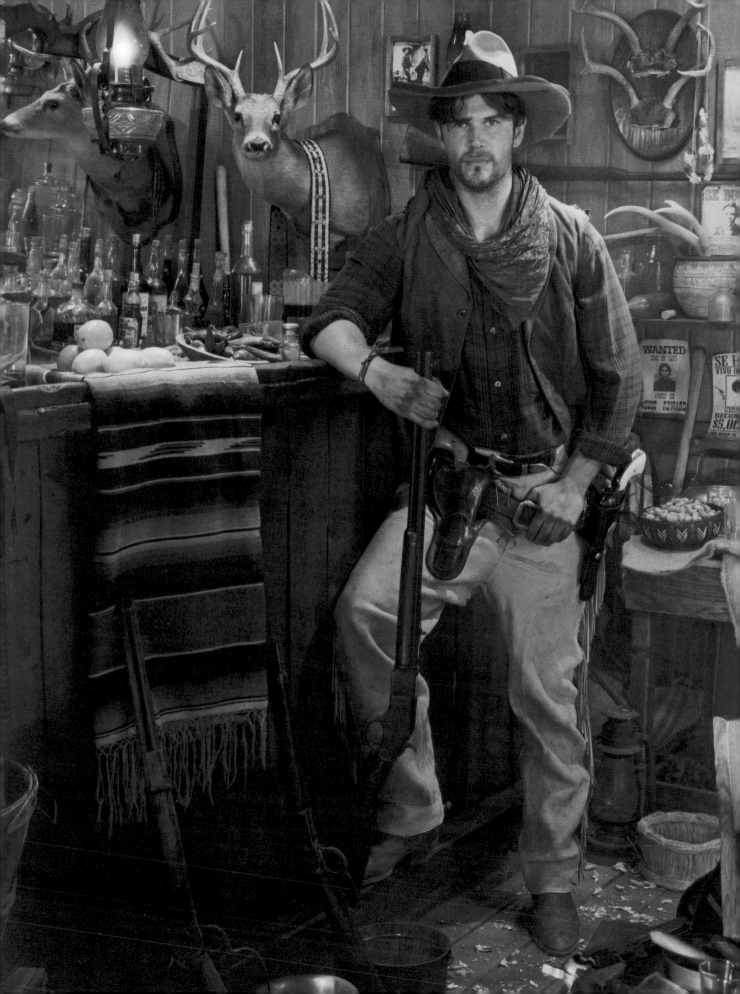

KEN LUCKEY
ACTING WHERE THE LEGENDS WERE BORN

For Ken Luckey, making his first Western was a dream come true. The actor and lifelong Western fan from Texas was well aware of the stars who rode across the screen before him.

After director Tanner Beard cast him in *The Legend of Hell's Gate: An American Conspiracy*, Luckey could claim his own place as a movie Westerner. "Tanner and I met in an acting class. It's funny how Texans gravitate toward each other in L.A. We connected in that class because he was from west Texas, and I was from Dallas. Tanner had made a short called *Mouth of Caddo*, which was based on the stories that surround Hell's Gate, which is in Texas. He expanded that into a feature and said, 'Hey, Luckey, you want a part in this Western I'm making?' Of course! It was shooting in Texas, so I signed up immediately. I went down there, and Tanner was shooting himself a Western. It was great."

Hell's Gate uses the bloody history of this wooded corner of the Lonestar State, where the souls of executed Union spies are said to be trapped, as a jumping off point for a violent tale of outlaws starring Eric Balfour and Buck Taylor. "I played a shopkeeper. The role was to inject a bit of humor into the heavy drama, and I had a little scene with the lead actress of the movie. This was my first taste of what it was like to be a part of this grand town scene, with this huge crane shot to show what the West looked like. I felt like I was on the set of *Deadwood*. Plus we had a lot of actors from *Deadwood*, so it was pretty amazing because this wasn't a big budget production. I think actors are interested in Westerns whether they're made for a big studio or not. It's the genre we all grew up with."

Hell's Gate took first place at a Western festival in Almeria, Spain, where Luckey and Beard met filmmaker Danny Garcia, initiating a creative collaboration titled *Six Bullets to Hell* that would also include Crispian Belfrage. "Danny told us they only had a little bit of money but had access to the sets from *The Good, the Bad and The Ugly*. You have three Texans with a chance to make a Western on the same sets that Clint Eastwood used, of course we're going to do it."

Luckey adds, "When we landed in Spain, we get out to this town, and it's desolate. We met Danny and the crew, and it's only a few people, so we're looking at each other, thinking it's pretty barebones, but then they take us to the set, and we're in the Yellow Rose saloon from *The Good, The Bad and The Ugly*. The inspiration of being on these sets was incredible. We sort of took over this place, and there were a lot of locals who wanted to get involved. We realized quickly that we had something really special going on."

Despite the desolation, the sets attract tourists from around the world, so *Six Bullets to Hell* was shot before an audience. "There was tourism happening while we were shooting, and the parents were telling their kids about the history of the set, getting excited that this is where Eastwood was or Lee Van Cleef. The kids were probably bored out of their minds, but the parents loved it, and that was fun to see."

The rigors of low-budget filmmaking in this pocket of Spain remain to this day. "When we realized we weren't going to have a stunt crew and we're on horseback, surrounded by folks who don't speak our language, something horrible could have gone wrong. But we didn't care. It's the feeling that 'We're here, let's make a Western.' And everything worked out great. A lot was asked of this crew and the other actors, and they all pitched in. We naturally thought that the language barrier was going to be a problem, but we had a common thing: our passion about film."

A personal ambition for Luckey was to transform himself into a desert rat. "I always feel I'm a character actor in a leading man's body. I grew out my hair, grew a beard and referenced a bunch of old Westerns so I could be one of those grungy characters. I used some teeth dye—like nail polish, and it made my teeth really yellow."

Ken Luckey and Crispian Belfrage are becoming the acting mainstays in independent productions that honor the best of the Euro-Western tradition. "In the world of big budget action features, it's hard to get something going like this. Obviously audiences are going to go see the Marvel movies, but we have a place, too. There's something about Westerns that always strikes a chord. People return to them. Hollywood is all cycles, and we'll see a resurgence of Westerns. I think for us the best is yet to come."

BARBARA LUNA
RAVEN-HAIRED FLAME

IT'S THE STUFF of legend—little kids in pajamas gathered around a TV set, waiting for a bolt of lightning to split the rolling storm clouds, singing along with the chorus: "Out of the night, when the full moon is bright, comes a horseman known as Zorro!"

Zorro was *the* swashbuckling hero of television, dispatching outlaws and corrupt soldiers with a flash of a foil, slashing a "Z" across the belly of those who dared to challenge him. Every episode promised action, a clean comeuppance for the villains and a tweak of a joke, as we knew foppish Don Diego was really the masked man, and we shared his secret amusement at fooling everyone. But there was another reason to watch besides dueling exploits: the stunning Theresa Modesto, who sold food in an Old California plaza, stealing the hearts of villagers and noblemen alike, while the one she truly adored was Don Diego.

Before becoming Theresa, BarBara Luna was already a veteran of three iconic Broadway shows (*The King and I*, *South Pacific* and *Teahouse of the August Moon*) and had guest-starred on *Perry Mason*, *Mike Hammer* and *Have Gun - Will Travel*. On the set of *Have Gun*, a drunkenly amorous Richard Boone chased her about. "My memories don't have to do with the script, but the experience. We were in a barn, and Mr. Boone liked to drink a bit, and he kept trying to hug me, and I kept escaping him, leaping over the hay bales. We were laughing there for a long time, but he wouldn't calm down. Mr. Boone was hilarious, but he didn't catch me!"

After more guest-starring parts, the role of Theresa materialized. Yet despite being more than perfect for the job, which included singing and dancing, Luna had to prove herself to veteran director Charles Barton. "*Zorro* I just loved, but I had to audition because Theresa sang on the show. Coming from Broadway, this was very exciting for me. Charlie Barton came to a dance studio, and I sang and danced for him. I remember they asked me if I could ride since I was a city girl from New York. I told them I could ride because I'd ridden in Central Park since I was a little girl. *Zorro* was quite wonderful: to sing and dance, ride a horse, kiss a leading man, that was just a dream."

Luna's encounter with the "presence" of *Zorro* executive producer Walt Disney was no dream, however. "I asked one of the wranglers if I could ride at lunch,

and they said, 'Sure. We were on the backlot riding toward the commissary, and I was wearing shorts, and I heard this loud voice coming over a megaphone. 'Get off that horse. And put some clothes on! Mr. Disney wants you off that horse now!' I thought I was going to get fired! It was Disney studios, and I got down off the horse and never did meet Mr. Disney, whom I'd heard was nice, but I would have been terrified!" Years later, the popularity of the show and the way it was made as family entertainment hasn't dimmed. "I just loved doing *Zorro*. After it went off the air, they used to run the shows at night for years, even colorized episodes. I think to this day the *Zorro* fans are trying to get them to run them again."

Following her turn as Theresa, Luna was in demand for dozens of Westerns that needed beautiful, frequently Latina, women to either lure the star into a gunfight or die by the hands of the bad guy. As love interest or Western femme fatale, Barbara Luna often faced doom on *Bonanza*, *The Texan*, *Death Valley Days*, *Tales of Wells Fargo* and *Overland Trail*, where she met and married its star, Doug McClure. "I was the señorita of the month, or the year, for I was being cast in those roles to dance in the cantina or whatever. When I left New York and came to Los Angeles, everyone said I was going to be typed because I'd played ethnic roles on the stage. If that's being typed, then that's okay."

Ever practical, Luna saw the ethnic "typing" as an advantage in that producers and directors sought her out for parts where she could find a certain nuance and never allow herself to approach them in exactly the same way, even if, on reflection, the parts were "hard to distinguish" from each other. As she continued in other Westerns, as well as roles in the classic films *Elmer Gantry* and *Ship of Fools*, she was also establishing herself on the iconic science fiction shows *The Outer Limits* and *Star Trek*.

After the surprisingly dark and explosive *Firecreek* with James Stewart and Henry Fonda, Luna was cast as Soledad in Andrew J. Fenady's spooky TV Western feature *The Hanged Man*, with Steve Forrest and Will Geer. Forrest survives a hanging through a stroke of fate and becomes both a protector and a messenger of death as he takes on a greedy land baron. Luna remembers the unusual television film clearly. "For me, the experience over-powered what was in the script. We'd got done shooting, and

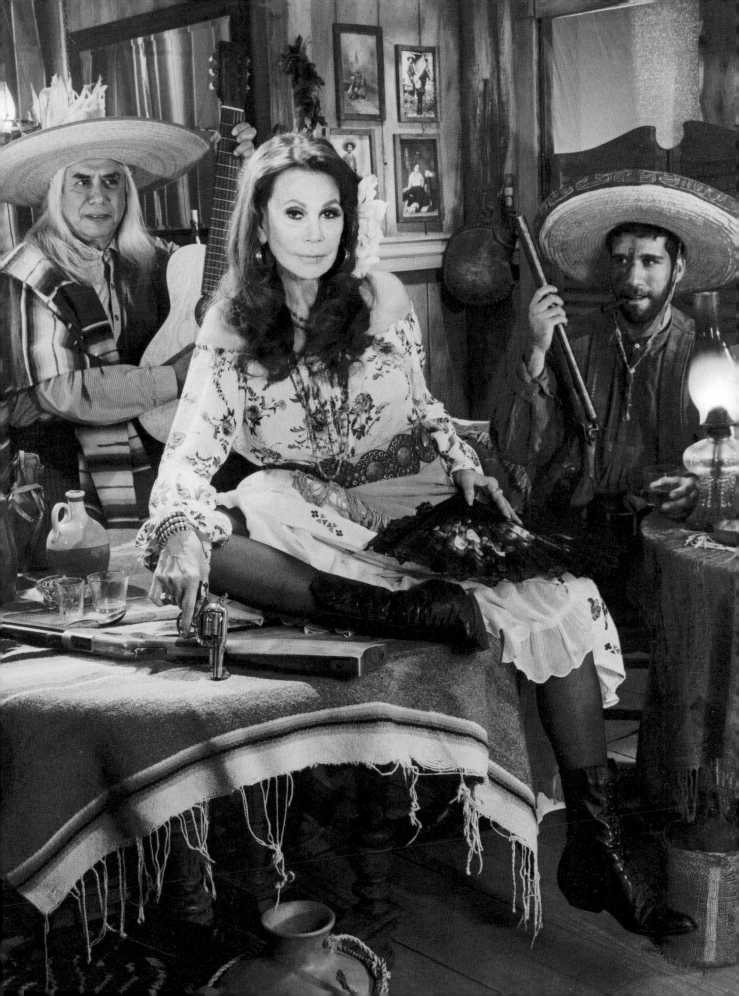

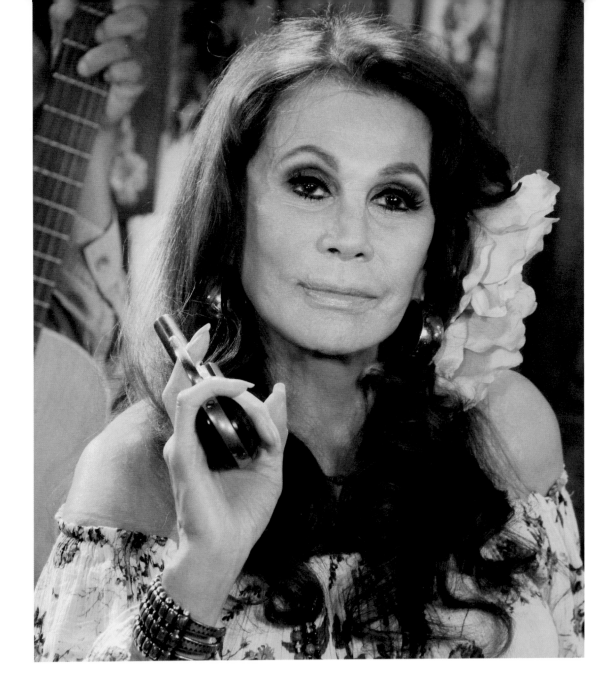

I'd come home. Literally as I walked into my apartment the phone was ringing. They told me I had to go back and reshoot because there was a huge scratch across the film. I didn't even unpack, I just turned around. Steve Forrest was a lovely man, and it's too bad it didn't go as a series. I think it was ahead of its time because of the mixture of horror and the Western."

For Luna it was one more role of over a hundred that she crafted in her own way before retiring from acting in 1988 to concentrate on producing. What strikes us about those years before the camera is the sheer volume of high-quality work from the actress, a credit to her taste and talent. "I think one of the reasons I worked as much as I did is I was always prepared. Directors just didn't have the time to give you your motivation, especially in television. I had a great drama teacher, and she taught us about hitting the camera marks and all those things, even before I'd done a movie. I thought if I was going to work with these people, I better know my p's and q's. I feel like I had to know what I was doing and do it well."

"'Zorro' was
quite wonderful:
to sing and dance, ride
a horse, kiss
a leading man,
that was just
a dream."

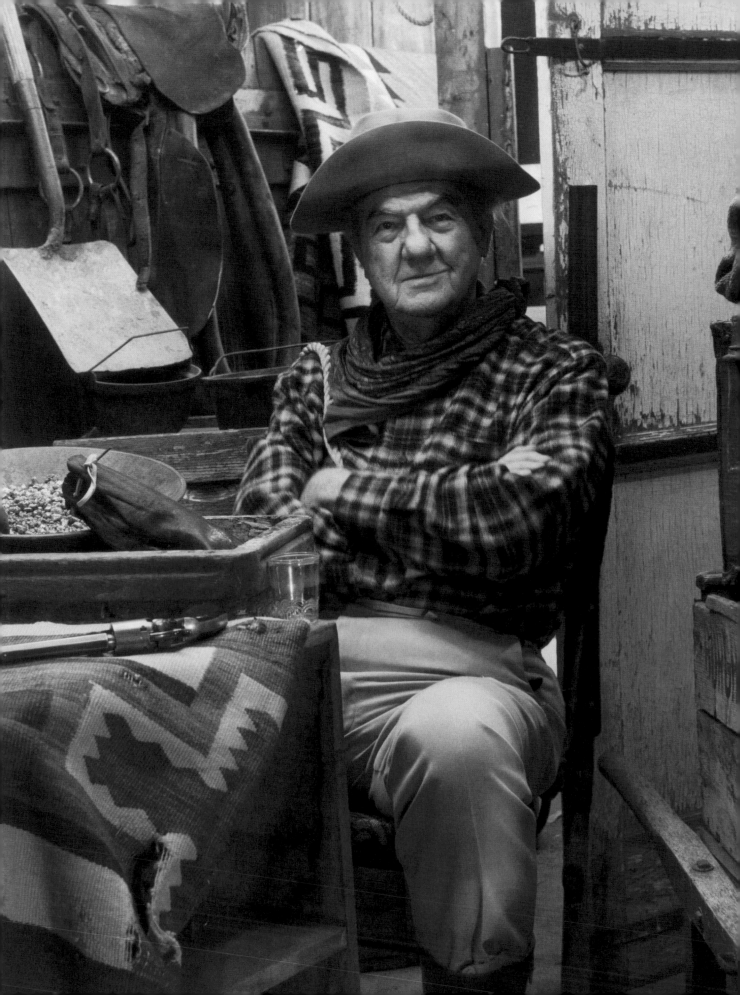

KARL MALDEN
RAGE WITH A GUN OR A BADGE

THE MOMENT IN American history depicted on the screen was the aftermath of the battle between Cheyenne men, women, children and the soldiers who were keeping them captive at Fort Robinson instead of allowing them to continue the trek from an Oklahoma reservation to their own land in Wyoming. In restaging the slaughter, John Ford wanted an actor who could portray the fort's short-tempered barking Prussian captain who condemns the Cheyenne to death with his thoughtlessness and who must bear witness to the carnage he's ordered and, ultimately, feel mortification for what he's done.

Ford chose Karl Malden for this single moment in *Cheyenne Autumn* that personifies the horrors the Cheyenne endured at the hands of unsympathetic military officials following brutal and inhumane orders. Malden's shell-shocked, speechless reaction to the death around him is all Ford needed, and his close-up delivers more impact than a thousand lines of dialog. Coming in the sunset of Ford's career, *Cheyenne Autumn* is flawed but has moments of human poetry that recall some of the director's finest achievements. The image of Malden wandering from the fort into the snow, his mind shattered, is one of those moments.

As he had for Hitchcock and Kazan, Malden was again working with a master filmmaker in the genre for which he was famous. It was Malden's only movie for Ford but not the only classic Western for the actor, who'd won an Oscar for *Streetcar Named Desire* and blistered the screen confronting Marlon Brando in *On the Waterfront*. The factory worker or the slum priest were the "Karl Malden parts" audiences expected, roles as far away from the American frontier of the 1800s as one could get. The first horses Mladen George Sekulovich probably ever saw were the nags that pulled the wagons his father would take on runs as a milkman in Gary, Indiana. The image of the cowboy was something you saw on the cover of magazines, and if you could afford it, the movies were for the weekend. Interested in acting, young Mladen, soon "Karl," never dared dream of riding across the screen in a classic Western.

His Serbian family had found a home in the Midwest, where Karl and his three brothers excelled at high school sports, especially basketball. It was on the courts that Karl had his nose broken three times, accidentally creating a facial trademark for the fu-

ture Oscar winner. His father, who also worked in the steel mills, directed local theater productions with his mother often acting in them, and Karl pursued roles in the productions, his dialog sometimes in Serbian. This was the hardscrabble life for the immigrant family that thrived on muscled work and discipline, two characteristics that carried over into Malden's professional acting career. The road for the young actor was filled with detours, including working in a steel mill himself and serving in the Army Air Corps during World War II. Malden had already moved to New York City, where he hit the boards alongside new friend Elia Kazan, when war broke out.

It was actually the Air Corps that brought Malden to the movies. He had appeared in a small role in *Winged Victory* in 1944, but it was the spy film *13 Rue Madeleine*, produced in 1946 with Malden as an Air Corps officer, that set him on the path to a long association with 20th Century-Fox and *Madeleine's* director Henry Hathaway, who would cast the actor five times.

Hathaway's temper was as well-known as his generosity and industry clout, and he saw in Malden an actor who could dredge honest feeling and anger from deep inside, then let it spill out across the screen. Hathaway pushed studio boss Darryl F. Zanuck to take notice of Malden, whom the director had used again in his iconic crime film *Kiss of Death*. Malden scored with his major supporting role as a district attorney and was subsequently cast in another top-shelf Fox project, *The Gunfighter*, co-starring Gregory Peck and directed by Henry King. As Mac the bartender, Malden personifies the idolatry of Peck's gunfighter, who would like nothing better than to escape his reputation and be left alone. But the enthusiastic Malden won't let that happen, and his stoking the fires of Peck's infamy gets the gunfighter killed. Malden plays the part of a man with "wrong-headed good intentions" perfectly, suffering twinges of guilt as Peck lies dying, the ultimate victim of barroom gossip.

In 1951, for his Oscar-winning performance in Kazan's *Streetcar Named Desire*, Malden recreated his stage role as the pathetic Mitch who can't hide his love for Blanche DuBois.

The Academy Award in the Best Supporting Actor category, which Malden didn't expect to win,

"Henry always liked me to let loose at some point, really come into the scene boiling."

thrust him into a wave of supporting parts in superb films, including *I Confess* directed by Alfred Hitchcock and *On the Waterfront,* again with Kazan, earning him another Oscar nomination. Malden also took the lead in the 3D horror *Phantom of the Rue Morgue,* playing a Vincent Price-like madman.

But he didn't go West again until taking on the part of the snarling Frenchie Plante in 1959's *The Hanging Tree.* One of Gary Cooper's last films, this dark Western was directed by Delmer Daves, who pitted Malden opposite Cooper, his explosive delivery smashing against Cooper's legendary solemnity. Malden's acting style had been perfected, with every question becoming an accusation and even the quietest lines seeming to have an exclamation point. During the shooting, Daves became ill, and Malden, who had already helmed *Time Limit,* directed the last weeks of shooting. Despite Daves's confidence in the actor-director, it wasn't until star Gary Cooper expressed his total faith that Malden felt comfortable in taking on the job, which he did admirably, and without credit. It was known around Hollywood that he had finished the film, so producers offered Malden other Westerns to direct, but he felt that big outdoor films were not his specialty. The genre demanded filmmakers with a true feeling of landscape, scope and grandeur, like Ford or Hathaway.

However, his next Western wasn't in the creative hands of a Western veteran, but another actor-director, Marlon Brando, who cast Malden as the sadistic sheriff in *One-Eyed Jacks.* This now-cult Western had gone through a tough development period, with filmmakers as diverse as Stanley Kubrick, Sam Peckinpah and Arthur Penn working on scripts. Shooting had already commenced when Brando decided to take the project over himself. Loosely based on the life of Billy the Kid, *One-Eyed Jacks* became a model of directorial excess during its shooting as Brando waited for "the perfect waves" for the seacoast sequences, sometimes reworking the script as the scenes were shot. It was a grueling process that resulted in a fascinating nightmare vision of the West, crisply photographed under a blazing sun. Throughout, Brando is the ultimate martyr and Malden his ultimate tormentor.

The scene of lawman Malden whipping Brando as he's tied to a hitching post remains a definitive Western moment, and its influence can be clearly detected in Clint Eastwood's *Unforgiven* with Gene Hackman's portrayal of the self-righteous, vicious Sheriff Little Bill, who whips Morgan Freeman to death. Malden's performance in *One-Eyed Jacks* has

become the template for any actor playing a lawman corrupted by personal indignation; he's shown us how easy, how understandable it is, for a man with a tin star to justify crossing the line.

Malden's rage transformed into a declaration of hope for Henry Hathaway's segment in *How the West Was Won*, the MGM Cinerama super-epic. "The Rivers" begins the saga in 1839, with Malden as the patriarch of the Prescott family, which includes wife, Agnes Moorehead, and two daughters, Debbie Reynolds and Carol Baker, as they move through the Eerie Canal, destined West to start a new life.

Malden's cheerful but brave father is a soulful and funny creation, spinning tall tales to mountain man James Stewart about his single daughters, unaware that Baker is already in love with him. After an attack by cutthroats led by Lee Van Cleef, the family is forced to shoot the river rapids to save themselves, but Malden and Moorehead drown, leaving the girls to fend for themselves. The lives of Baker and Reynolds supply the framework for the film's telling of the growth of the West over the next fifty years. Billed fifth among the massive cast, which included John Wayne, Richard Widmark and Gregory Peck, Malden is the personification of the optimistic settler: the man who knows the challenges ahead but takes them on with faith and muscle

Hathaway would direct most of the four-section epic, sharing the credit with George Marshall and John Ford, keeping his eye on the spectacle but never forgetting the humanity of each section. This time, Hathaway wouldn't ask Malden to find his darker side—that would wait until after Ford's *Cheyenne Autumn*, when the filmmaker cast Malden in *Nevada Smith*, taking on the worst villain of his career, who slaughters Steve McQueen's onscreen family. Malden would say, "Henry always liked me to let loose at some point, really come into the scene boiling." He would never make another Western. He didn't have to. He'd made his statement by playing every type of hero and villain, often to that Hathaway-boiling point and beyond. Malden's forceful staccato delivery was as powerful as a gun, and he used it sometimes with the same violence.

RAY MANCINI
COMING OUT OF THE CORNER

When Ray Mancini produced his own version of *Body and Soul*, he was treading into sacred waters. The original boxing classic starring Kirk Douglas had been re-made once, and its story of a fighter who loses his soul on the way to the top had been imitated ad nauseam, so Mancini was taking a chance, which was far from unusual as he had been doing that his entire life, pushing himself to become one of the greatest boxers in history.

What Ray Mancini truly did was to make a tale of caution about what can happen when a man forgets who he is. That's always been the basis of the story, but it's that note that rings loudest for the athlete, who had every opportunity in the world to forget his upbringing in Youngstown, Ohio, his family, his friends and his past, but refused to do so. To approach the classic wasn't a matter of arrogance but rather a matter of lessons learned and the chance to pass something on.

The athletic record of this prizefighter, who worked his way up from the local cards in northeast Ohio to become the World Boxing Association's lightweight world champion, has been written, recorded and documented hundreds of times. Mancini himself produced the documentary *The Good Son: The Life of Ray 'Boom Boom' Mancini*, which addresses the great success and subsequent descent of his career and spirit after Korean fighter Duk-koo Kim died following their championship bout in 1982. The excellent, heartfelt film shows where Mancini has been taking himself since his first acting role on the ill-fated comedy *Mutants in Paradise*.

Mancini in the first half of the 1980s had the eyes of the world on him, so appearing as a trainer in *Mutants* marked his effort to take on new professional challenges. He'd been in front of cameras frequently but never as an actor. Then in 1985, Sylvester Stallone, who'd looked to Mancini as a model for *Rocky*, produced a TV movie about the boxer's life, *Heart of a Champion*. Mancini stayed away from the camera this time, watching the filmmakers and the cast work, learning the craft. This was a chance few people get, to watch one's life rendered in a dramatic film, and he knew it. He also saw the movie as a chance to shine a favorable light on the mill town where he'd grown up.

With *Oceans of Fire*, directed by Steve Carver, and co-starring Gregory Harrison, David Carradine and R. G. Armstrong, Mancini played a diver on parole who risks his life to sink the world's deepest ocean well. Much like *The Dirty Dozen*, the film was filled with character actors (Tony Burton, Lee Ving) and stars (Billy Dee Williams) who're faced with an impossible mission, each with his own scenes and his own identity. And just like Charles Bronson in the earlier picture, Mancini fills the frame with humor, energy and toughness. All the heart he possessed in the ring he poured into his performance, and it showed. Mancini's screen presence also won him roles in director John Glen's *Aces: Iron Eagle III* and the offbeat *The Search for One-eye Jimmy*, which Sam Henry Kass directed. It was Kass who recognized that Ray Mancini was ready for an update of *Body and Soul*, and he was ready to direct it.

The world of professional sports has always been a superb launching pad for acting careers, from the earliest days of sound with Johnny Weissmuller to Dwayne Johnson. Writer-director David Mamet set out to make his own statement on competitive sports with his martial arts drama, *Redbelt*. Mamet wanted this film about Brazilian jiu jitsu to resemble the early films of Kurosawa. To do this, he had the film's central character, Chiwetel Ejiofor, live by what the *Los Angeles Times*'s Chris Lee calls "a strict samurai code of honor." Mamet made a point of filming his cast with professional athletes like Randy Couture and Dennis Keiffer, as well as such familiar stars as Joe Montegna, Tim Allen and Jennifer Grey. He got his friend Mancini to play a character named George in this rousing picture.

No matter where the champion boxer finds himself, he's never cut ties with Youngstown, a mill town that experienced a disastrous economic downturn from which it's still recovering. In 2010, he produced a documentary titled *Youngstown Resurrection*.

Of the sport that made him famous, he once said, "Nothing's more pure than a man facing another man in the ring. That's the moment of truth." The acting roles he takes on have all presented moments of truth, too, and Mancini meets them, just as he did in the ring, with dignity and grace.

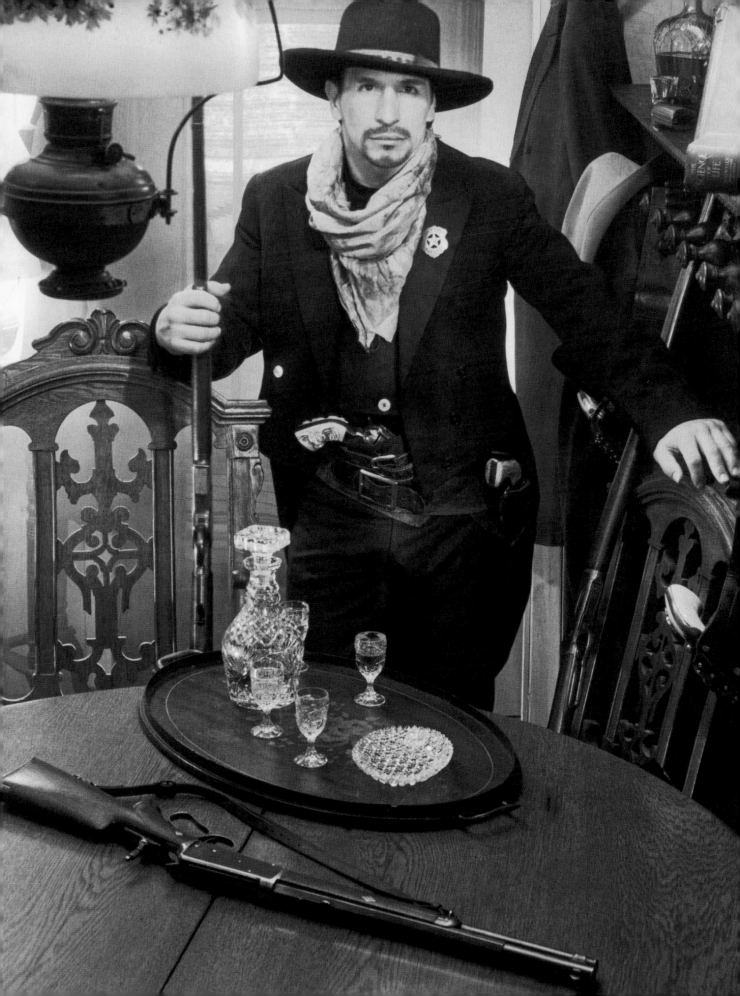

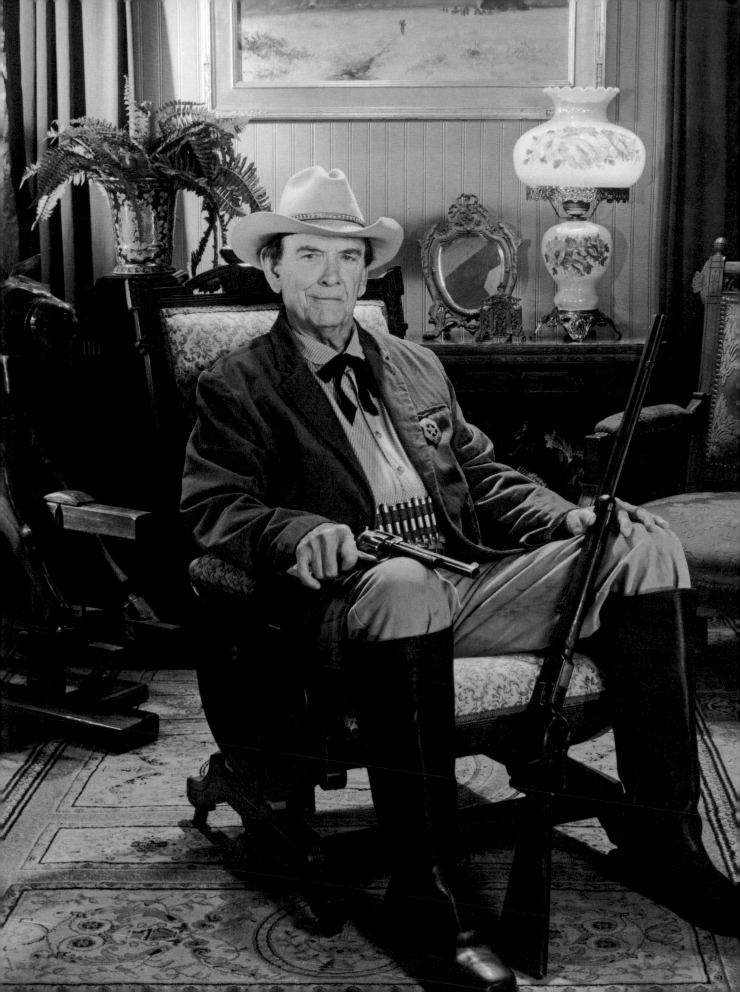

MONTE MARKHAM
CASUAL INTENSITY

THE EASE WITH which Monte Markham enters a scene can be deceiving. His trademark lopsided grin can convey a genuine hail-fellow welcome or mask the rage that precedes an explosive duel on a dusty Western street.

After years of impressive stage work and a two-part episode of TV's *Mission: Impossible*, Markham was called in for his first Western, John Sturges's *Hour of the Gun*, a continuation of *Gunfight at the O.K. Corral* that details the trial of the Earps after the famous shootout and Wyatt's subsequent effort to avenge his brother's death. Markham, who knew the film could be special, was offered a role on the spot. "The casting director, Lynn Stalmaster, said I'd be good for the part. Sturges said, 'I agree.' And that was it. Then in early December I flew to El Paso, and you had to take a taxi across the border into Mexico to grab another plane to Torreon, which was really in-country. They'd been making movies in Durango for years, but we were the first American company to film in Torreon."

Markham remembers Robards arriving at the airport in a style befitting Doc Holliday. "Jason and Bill Windom showed up in a '65 Mustang drunk as coots for the plane ride into Torreon. I got off the plane, and Sturges greeted me, then looked around me to see Jason coming down the steps still drunk, and his face just froze. But Jason was a pistol. Very friendly. He was going through a divorce and drinking a bit, but always ready. John Sturges was great. He was a big man and very impressive. I'll never forget the script reading, with Larry Gates, Sam Melville, Richard Bull—all these superb character actors—and Jim Garner and Jason, and Jon Voight, Lonny Chapman, all of us sitting in this big circle with Sturges."

Markham had been a great fan of Robert Ryan, who had just finished *The Dirty Dozen* before reporting for work as *Hour's* notorious Ike Clanton. "I knew all of his work. He told stories about everything, but he was an A-list actor who was never an A-list star. He always co-starred in the big movies while he starred in smaller films. He never got to the status of a Bogart, but was so excellent. He was just one of these guys who was an incredible actor, always strong and always good. And Jimmy Garner, he became a good friend from then on. The whole set was terrific. Lucien Ballard was our director of photography, so the local movie house ran *Ride the High Country* just for us."

Following *Hour of the Gun*, Markham guest-starred in an episode of *The Iron Horse* directed by Otto Lang, a prominent movie producer at 20th Century-Fox in the 1940s and '50s. "Otto had been a ski instructor up in Sun Valley. He was a champion and got to know Darryl Zanuck, who was an avid skier, and he made Otto a producer! That's how it was done in the old studio days."

Markham was subsequently cast in *Guns of the Magnificent Seven*, the 1969 sequel to the John Sturges-Yul Brynner classic. Burt Kennedy had fashioned a so-so follow-up to the original, *Return of the Magnificent Seven*, also with Brynner, but it lacked the feel of the original. Such was not the case with *Guns of the Magnificent Seven*, which Paul Wendkos directed. Joined on the screen by James Whitmore, Bernie Casey and Joe Don Baker, Markham delivers an extraordinarily athletic, likable performance, finding himself always in the center of the action as the seven heroes assault a prison to free political prisoners who're revolutionaries

"I came in at a time of transition; Old Hollywood and New Hollywood were co-existing on the studio lots as television really took over, and there were a lot of Westerns. When it came time to do our *Mag Seven*, Yul Brynner said, 'No way.' He'd done the second film, and it didn't work. George Kennedy had just won the Oscar for *Cool Hand Luke*, so he was hot, and played Chris, which had been Brynner's name, and I was in the second position. Paul Wendkos was a good director but was frustrated as hell because he'd come from prestige television in New York and wasn't getting the movies his fellow TV directors like John Frankenheimer were. But it was a great, great shoot, and he did a fine job. It was probably one of the happiest shoots I've ever had, with three months in Madrid."

Markham continues to act and looks back on his days in Westerns with fondness and true clarity. "As an actor you think of times and places. *Hour of the Gun* was just wonderful, great location and great people. Then *Magnificent Seven* was even more so. A hell of a role with great people, and good stuff to do in a good film. It was a great time because everyone was doing Westerns."

KEN MEDLOCK
TOMMY GUN FROM THE PITCHER'S MOUND

WHEN THE FILM adaptation of Michael Lewis's *Moneyball* premiered in 2011, critics and fans praised the realism of its portrayal of the hardscrabble world of baseball and how a system built on statistics rather than player potential can undervalue players and coaches. Ken Medlock's portrayal of Grady Fuson was singled out for laying bare the attitudes of major league coaches. For his performance, Medlock drew from his own life and experience as a pitcher, third baseman and coach, playing for the California Angels and the San Francisco Giants before he ever worked before the motion picture camera.

An injury and meager pay led him from the dugout to the soundstage in the 1970s: "My first casting was baseball-related. I was with the Angels, and I tore my Achilles tendon during spring training, and then we went on strike. At the time, the minimum yearly salary was seven-thousand-five-hundred dollars a year; it hadn't gone up since 1954. You look at the money now, and you think that can't be right, but it was. That was the minimum salary in the major leagues.

"The strike ended, and anyone they could deal with severely, they did. And I was in the category of someone who was injured, so they really came down hard on me. I was trying to get back to spring training, and I was in a park in Van Nuys throwing a ball against a fence. And these kids came over, saw my bag and said, 'Wow, you played for the Giants.' I told them about being in the major leagues, so they began showing up every day, and I started teaching them how to run and throw and hit. Their dad showed up one day and asked me what I was doing. 'I think I'm on the verge on being a washed-up baseball player.' He gave me a card, and I thought it said Universal Stereo, and he was selling stereo equipment. I got home and looked at it again, and it said Universal Studios, and he was the executive producer of *The Six Million Dollar Man*! Lee Majors was the new Superman; he was what George Reeves was to kids in the '50s. They hired me as a double for Lee because we were exactly the same size, same profile. It was kind of strange—but that's how I got in the business, and fifty-five movies later I'm still here."

Medlock's athleticism brought him to the attention of director Walter Hill, who was preparing *Brewster's Millions*, another baseball-themed film involving money for Medlock, with Richard Pryor and John Candy playing the leads. Even though it was a comedy, it began a relationship between Medlock and that great filmmaker that has lasted for decades. "On *Brewster's*, I told Walter that when I was playing in Mexico, some of the ballparks were so bad they would have to stop the game because the railroad tracks went through the outfield, and they had to open up the fence to let the train through! Walter thought that was funny, so he built the railroad track through the middle of the outfield for the movie."

On the opposite end of the genre spectrum, Hill's *Last Man Standing* was a hard-boiled homage to Dashiell Hammett's great novel *Red Harvest*, which had been the basis for both Kurosawa's *Yojimbo* and Leone's *A Fistful of Dollars*. Set in the twentieth century and choked with dust and bullets and blood, *Last Man Standing* treats the gang war that envelopes a small mountain town in a manner that betrays the influence of Fritz Lang's Western noirs, *The Return of Frank James* and *Rancho Notorious*, on Hill. Medlock savored the chance to play a thug. "I was with the Italian gang, and we're blowing the Irish gang to pieces with these machine guns. Back and forth. In the story, the godfather's son who was sent down there to learn the bootlegging business, he has all these guys, including me, around him to protect him."

There are no breaks in work planned for this actor-athlete, who declares Westerns his first love and the genre he most wants to appear in. "From the start, my heroes were cowboys. Even in church, the Sunday school teacher talked about the crucifixion, and I said, 'Those dirty sons of bitches wouldn't have gotten away with that if Roy Rogers had been around!' My first heroes were Hopalong Cassidy and Roy Rogers; my favorite movies were *The Searchers* and *The Magnificent Seven*. I got a fast draw going long before I could throw a baseball or was an athlete. I admired their behavior, their code, like the Lone Ranger, with Jay Silverheels, who was a great athlete from Canada. The Westerns were always one of those things I wished I could do because I always loved them."

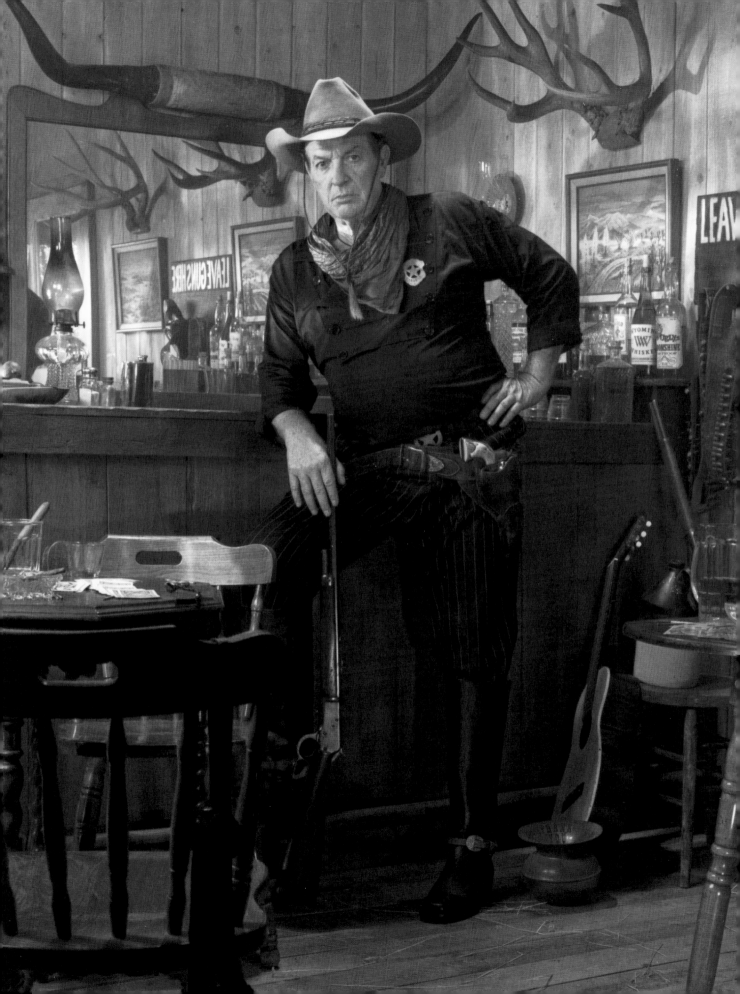

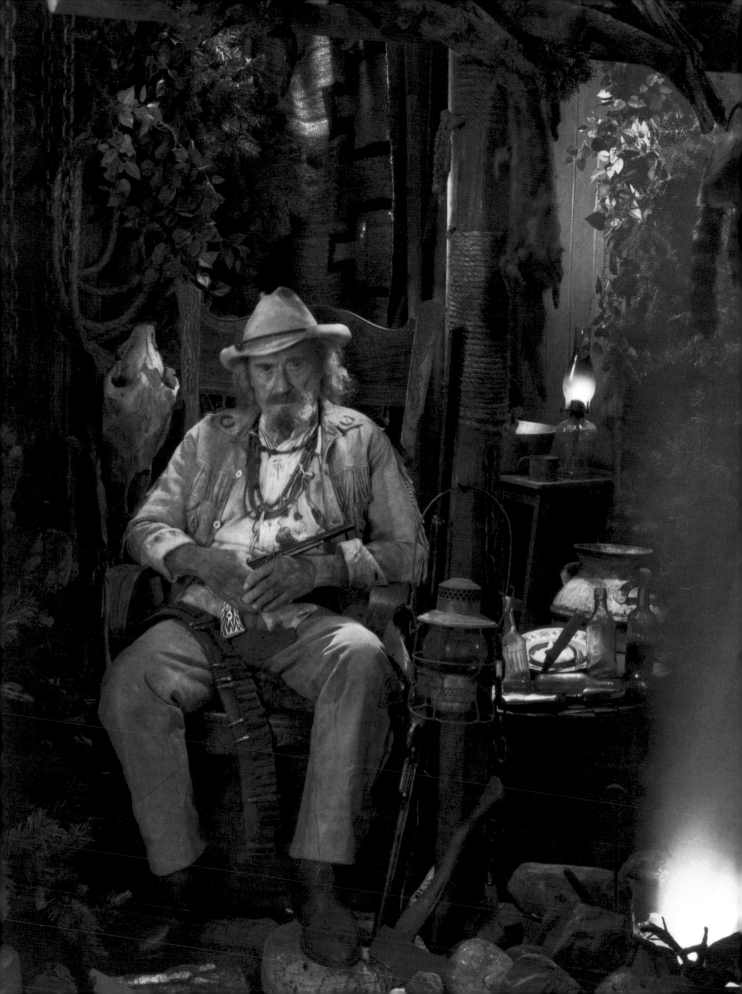

DICK MILLER
"I WAS BORN TO DO WESTERNS"

HEARING DICK MILLER declare "I was born for Westerns" might be as surprising as hearing Gene Autry say "I was born for urban crime dramas." Dick Miller is one of the legendary members of the Roger Corman's unofficial stock company who never compromised his delivery or his screen presence. He provided comic relief as a soldier fighting the "carrot from Venus" in *It Conquered the World*, scared us as a psycho punk in the amazing *Rock All Night* and secured his reputation as a B movie icon playing hapless sculptor Walter Paisley, who creates art from corpses in Corman's wonderfully insane satire of beatnik culture, *Bucket of Blood*.

Growing up in the Bronx, Miller reveled in the Technicolor Westerns he saw at the local movie palaces but never dreamed he'd be cast in one. After a stint in the Navy and college at Columbia University, Miller grew tired of knocking around New York for acting roles. He headed to Los Angeles not set on haunting casting offices but to begin a career as a writer. Old friend Jonathan Haze took Miller to meet Roger Corman, who was directing *Apache Woman* and needed actors.

It was 1955, and Dick Miller soon walked in front of the cameras for the very first time. The memory triggers a laugh: "Boy, that was a lucky break. I had worked for about three days as an Indian, and then Roger said, 'How'd you like play a cowboy?' I said, 'Sure, when is the next picture?' And he said, 'No, on this one!' I didn't think it could be done, and in the picture, it turns out I'm part of the posse that leaves the town to go out and kill me. So I got to try and kill myself!"

Miller's next two Westerns would be Roger Corman's female-driven *Gunslinger*, starring Beverly Garland and John Ireland, and *Oklahoma Woman*, which steered his career toward the TV stalwarts *Bonanza* and *Gunsmoke*. "Once I started to do the television shows, I thought I was going to be in Westerns for the rest of my life. But I moved into other types of pictures, gangsters and so forth, and that's where I stayed for a long time."

As Miller's star rose in the Corman universe, he worked on television shows at Paramount and Universal. His commitment to craft was always the same, no matter the budget. "There really wasn't a lot of difference because the early Westerns like *Gunsmoke* were half-hours and shot very fast, and Roger's pic-

tures were shot just as fast. We'd work a week and a half, and the picture was done."

As the late 1960s dawned, Dick Miller jumped between work for Corman and seemingly every other independent movie company operating in and around Hollywood. He found himself on horseback once again for the ultra-violent *A Time for Killing*, written by Corman protégé Robert Towne. Miller recalled: "That was a rough shoot. I was teamed with Kay Kuter, and we were supposed to be the comedy relief, so we worked in a lot of ad libs where we could. There was a scene where all the horses were breaking loose in a stampede, and I got caught in the middle. I grabbed one of the horses by the tail and just ran with him so I wouldn't get run over. Scared the daylights out of me!" For Miller, this last role in a Western was just one more part in more than one hundred and eighty movies and television shows. "Producers always took it for granted that you could ride a horse or use a gun. You were hired for a part, and you were expected to know all these things. I did some Westerns, so I learned how to ride while I did it."

In 1970, Dick Miller wrote the Euro-Western *Four Rode Out*, starring Parnell Roberts and Leslie Nielsen, bringing his writing ambitions back full circle. "They shot it in Spain, and it was quite acceptable and had a good international cast." The 1970s and '80s exploded for the iconic character actor as youngsters who'd seen him tussle with Boris Karloff or Peter Fonda on drive-in screens got the chances to direct their own films, many having made their debuts with Roger Corman before moving on to the biggest movies of the era. Miller found himself constantly in demand, for instance, by directors like Joe Dante, Jonathan Demme and James Cameron who wanted their favorite for *Gremlins*, *Swing Shift* and *The Terminator*. Dick Miller laughs in a familiar way at the suggestion he was a "good luck charm" for these directors who asked for him over and over. "They thought I was reliable, and most of the time, in the TV days, the director would come over and say, 'You're working again?' And we'd have a laugh and get on with it." Miller also appeared in two movies Steve Carver directed for Roger Corman: *Big Bad Mama* and *Capone*.

CHRIS MULKEY
ANYTHING BUT A TENDERFOOT

A WAGON ROLLS through the Missouri woods on a beautiful 1870s afternoon. Two of its passengers, a newly married couple, make small talk with a long-haired stranger and a grizzled Civil War vet on the merits of holy matrimony. In short order, the flirtatious stranger offends the tender-footed husband, who, before he can react, has a pistol leveled on him, and the stranger and his cohorts stage a highway robbery.

This moment, dappled in greens and yellows by cameraman Ric Waite, is from Walter Hill's saga of the James-Younger gang, *The Long Riders*, with the conversation taking place between Keith Carradine as Jim Younger, old vet Harry "Dobe" Carey, Jr., and hapless bridegroom Chris Mulkey. Violence becomes reality when the wagon turns a bend and the passengers are faced with James and Stacy Keach and Robert and David Carradine, the infamous James and Younger brothers.

The scene is all about laid-bare truth, and its center is the honest emotion we've now come to expect from Mulkey. His stammering husband character tries to do the right and brave thing but is outgunned and outmanned in front of his wife. Mulkey perfectly captures the feeling of anyone who's ever found themselves on the losing end of a fight, humiliation boiling into anger. The actor recalls that afternoon. "That was great. I knew Walter Hill from some other things I'd auditioned for, and they just called me up and asked me to do it. That was fun, but it doesn't help to be the chump. It's hard to play scenes like that: *Bet my bride'll regret it when she realizes that she left a good man behind for one who was going to get shot full of holes!*"

Harry Carey, Jr., in what was his one-hundred-and-thirtieth role, impressed Mulkey. "Dobe was great. We spent more than a few days together, and he made me realize how great it was to be part of the acting community in Hollywood. He was at it his whole life and was still excited to be making a movie. Now, many years later for me, I'm still at it. I remember what Dobe and I talked about—how you just keep going."

This son of the American Midwest had already made a decisive name for himself in Minneapolis theater productions and the independent film community by starring in the award-winning *Loose Ends* before coming to Los Angeles in 1975 and planting himself squarely in the world of drive-in madness working on a low-budget Western, *Ride the Rough Country*. The picture was the brainchild of character actor Gus Peters, who'd been working steadily in biker flicks and rough-edged horror movies. Peters put together partial financing to shoot some scenes with Aldo Ray and then Mulkey. "Gus was a friend, and he wanted to make movies. I rewrote it, and we shot in Bronson Canyon. I did a scene where I was a stable hand, and the bad guys beat me up. Then the hero arrives and chases them away." *Ride the Rough Country* was never finished, but the experience was the perfect introduction for Mulkey to the ups-and-downs of Hollywood dreams. He soon found his place as an actor with a reputation for bringing stock TV characters, and work came quickly, with Mulkey guest-starring on some top shows of the time, including *M*A*S*H*, *Charlie's Angels* and *The Waltons*.

In the time-travelling Western *Timerider: The Adventures of Lyle Swann*, Mulkey became a deputy marshal, taking orders from veteran lawman L. Q. Jones. Fred Ward played the eponymous lead. The story of a moto-cross racer who tumbles back in time to the Old West came from director Bill Dear, best known for *Harry and the Hendersons*, and ex-Monkee Michael Nesmith, who also produced. Mulkey and Jones were the men with badges chasing Swann as he tried to escape the 1800s and speed back to the present day. "It was so crazy, that film. Such a wild idea. L. Q. Jones and I were partners, and we had a ball together. We were on that about a month-and-a-half down in Santa Fe when Santa Fe was just a dusty spot on the side of the road, before it became this great place for artists. One thing I learned is, you don't play gin with L. Q. Jones, the man is a psychic with cards. Mike Nesmith was the producer and writer, and we had a hell of a cast. That was a cool movie."

Collaborating with his wife, Karen Landry, Mulkey wrote and starred in *Patti Rocks*, a film about sexual mores and moral choice, which works as a drama as well as a carefully observed human comedy and a classic of independent filmmaking. Since *Patti Rocks*, producers have constantly sought Mulkey for their projects, with the actor-musician amassing more than two-hundred credits in the last four decades, covering a wide range of characters, some

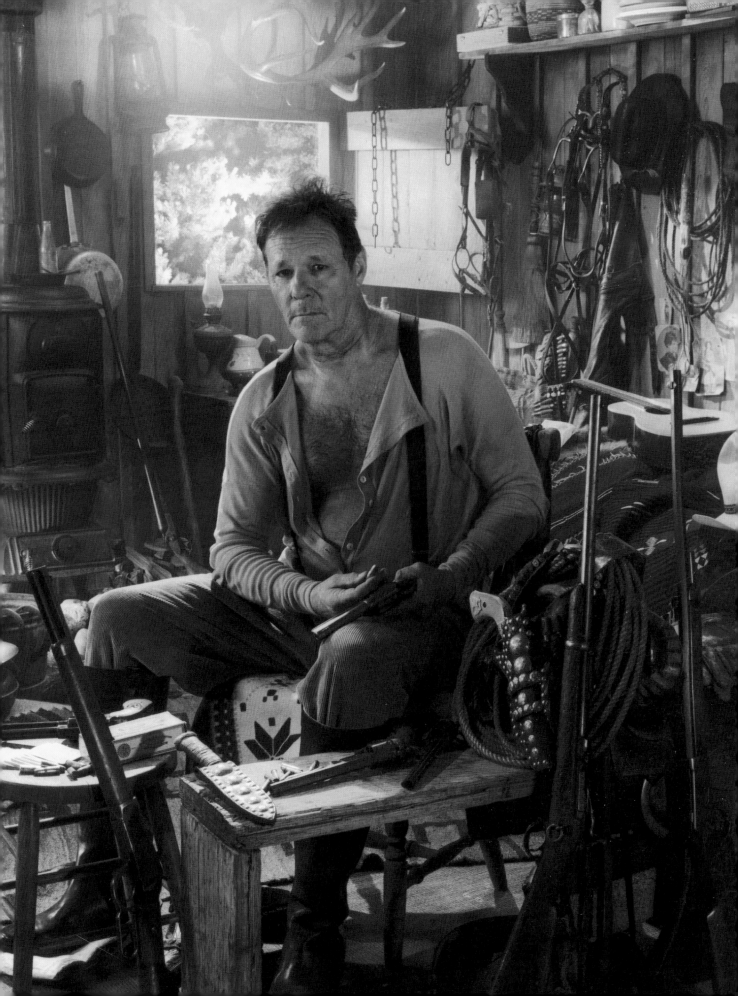

"When we
were going to do
the stagecoach
almost running me over,
I said,
'What if they do
run me over?'
And Walter said,
'Well, jump
out of the way
before they do that.'"

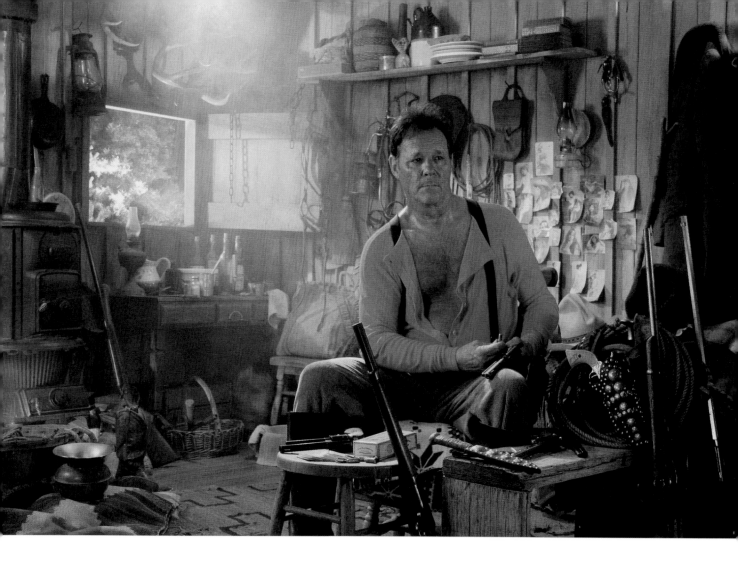

tortured and others innocent, but all with something else, something mysteriously dark behind the player's sad eyes.

That darkness served him well on television as Hank Jennings in the first *Twin Peaks* series and as the notoriously corrupt Mayor of Jersey City, Frank Hague, on *Boardwalk Empire*. Mulkey's tortured side also came through as desperate "reefer farmer" Walt Macready on *Justified,* a role that resonated with viewers. "People talk about that a lot. That was fun. I did the death rattle. Margo Martindale and her kids trapped me in a bear trap, then shot me, then poisoned me and then threw me away."

Mulkey and Walter Hill would reunite for another Western, and one of the actor's favorite roles, in *Broken Trail*. This saga of two cowboys (Robert Duvall and Thomas Hayden Church) who rescue a wagonload of young Chinese women bound to work in a brothel was an Emmy-winning hit with superb performances, delivering another, less familiar, aspect

of the classic Western narrative. Mulkey's memories of *Broken Trail* remain vivid. "Allan Geoffrion wrote it. He did a wonderful job and was around a lot. Robert Duvall is just a beast, he's so talented, just the greatest. Walter gave me one set of directions: 'Chris, low and slow.' He never said anything else about acting. One time he lowered his hand to his waist, like patting a dog that wasn't there, to tell me to slow it down. That was it. When we were going to do the stagecoach almost running me over, I said, 'What if they do run me over?' And Walter said, 'Well, jump out of the way before they do that.'

"So, the coach is coming down the hill, I'm in the road, and the horses are wiggling their heads back and forth, and they're telling me to get out of the way! And I wouldn't. I just stood there. If you've seen the shot, the horse's nose is literally four inches from mine. That's where they stopped. Looking back, I can see I was a crazy idiot—because I just stood there—but it was a great scene."

145

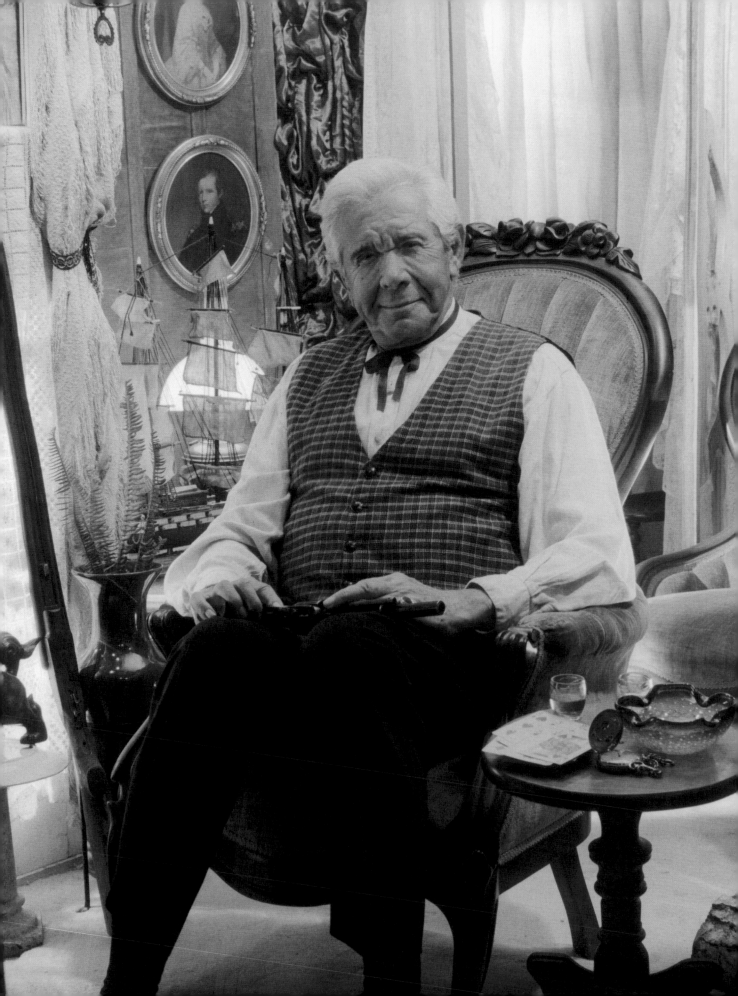

JAN MURRAY
AGAINST TYPE

HE WAS TALL, shoulders sometimes bent, with a sideways grin in a handsome face. Jan Murray didn't look like the borscht-belt veteran, stand-up comedian and gameshow host/creator that he was. In fact, he looked more like a smooth leading man than a comic and that led to the "serious" roles in fun exploitation movies such as the James Bond knockoff *A Man Called Dagger* and American-International's racing flick *Thunder Alley*, as well as episodes of *Dr. Kildare* and *Mannix*.

Jan Murray the comedian could play sinister villains but was at his dramatic best as a guy on the make, maybe a little desperate for that last big score. He could be a polished Mafia-type, but his comic timing always sent each performance in unexpected directions. In a throwaway like *Tarzan and the Great River*, Murray was a scruffy boat captain who had all the authority of a bar rag, yet he summons up his lost courage to help Tarzan in the end.

The Bronx-born entertainer trod the boards of New York vaudeville houses in the late 1930s, leading to a comedy career in the resort hotels in the Catskill Mountains. Murray was quick and didn't resort to the old routines of the baggy-pants school of comedy with its outrageous schtick. Orchestra leader Milton DeLugg said in an interview that Murray was "always looking to elevate what he was doing, always wanted to 'class it up.'"

Murray completely embraced television in the late 1940s as a host for game shows, many of which had been adapted from radio. He'd already hosted both *Blind Date* and *Dollar a Second* before creating *Treasure Hunt* in 1956, the show which had contestants answer questions for cash, and the winner was given the chance to trade it all for a pirate's treasure chest that might contain a fortune—and might not.

Originally broadcast five days a week in the afternoons, *Treasure Hunt* caught on so enormously that an evening edition was added, but all came crashing down when it was discovered that the performers who warmed up the guest audience before each show made deals on the side with some of the contestants in return for a share of prize money. And through no fault of his own, Jan Murray saw his creation get caught up in and cancelled over the infamous quiz-show scandals of the 1950s.

Although *Treasure Hunt* would be resurrected decades later, the show's termination prompted Murray to spend more and more time in front of dramatic cameras, including taking a role in an episode of one of the finest anthologies ever aired, *Dick Powell's Zane Grey Theatre*. Now best remembered for its career launch of Sam Peckinpah and his pilot for *The Rifleman*, *Zane Grey Theatre* specialized in human stories of the Old West, with a deep-rooted emphasis on character instead of trite gunfights and showdowns.

In 1961's "The Empty Shell," Murray took on the role of a weak man who knows himself and doubts he can change, wearing the part of Cletis Madden like a comfortable old suit. Murray epitomized the gambler who always looks for the forever-elusive winning hand as his wife begs for a "normal life" instead of one that's dependent on the next turn of a card. Jean Hagen is the gambler's long-suffering wife and, as she was in John Huston's *The Asphalt Jungle*, she's a character we sympathize with because she loves the wrong man. Director David Lowell Rich shrewdly surrounded Murray with old hands Denver Pyle and Dub Taylor, who see right through the gambler's slick veneer to the frightened loser inside. Written by Bruce Geller, who would collaborate with Sam Peckinpah on *The Westerner* and create *Mission: Impossible*, "The Empty Shell" is no morality play with a happy ending. It ends, not on a note of hope, but of realism, denying us the opportunity to learn what ultimately happens to Cletis.

Nightclubs, episodic television, stand-up gigs, movies and game-show hosting filled Jan Murray's schedule, and it would be fifteen years before he made another Western, *Banjo Hackett: Roamin' Free*, starring football great Don Meredith. For this sweet, episodic story about a horse trader, director Andrew McLaglen filled the cast with grand character actors: Chuck Connors, Slim Pickens, Jeff Corey, Dan O'Herlihy and L. Q. Jones. Murray is the scurrilous Jethro Swain who, along with bounty hunter Chuck Connors, brings a darker moment to the film's ballad-like tone. *Banjo Hackett* remains lighthearted in its telling, and its edges rounded off by the relaxed presence of Meredith, and with all the great characters who join in with gentle, home-spun humor. Unlike *Zane Grey Theatre*, *Banjo Hackett* professes no other ambitions than to tell a folk tale, but Jan Murray, the comedian who rode West twice, brings fine, versatile performances to both.

147

LOUIS NYE
THE MASK

Mounted above the smirk were the sad eyes like those in a classical actor's tragedy mask. Those eyes were Louis Nye's trademark, enabling him to draw on our sympathy as he made us laugh. He specialized in playing characters who put on airs that always seemed to come crashing down, much to his hilarious embarrassment. Nye was never a six-gun star or sidekick, yet he gave one of his funniest performances in a Western-influenced send-up of Texas oil men, *The Wheeler Dealers*.

Before the movies, Louis Nye specialized in characters whose snooty manner demanded deflation, often exploiting a wild accent that defied description when he was interviewed for the famous "Man on the Street" segments on *The Steve Allen Show*. His talent as a funnyman was huge, as was his popularity, but Nye didn't find an outlet for his dramatic skills on 1960s TV Westerns. He'd later make dramatic guest-star appearances on episodes of *Police Woman* and *Starsky and Hutch* in the 1970s, even when he was still largely perceived as a great comedian who could provoke a laugh by simply walking into a scene. But the fact was that Nye was too busy as a cut-up, working with the likes of Jack Benny and Danny Thomas and then as the star of his own situation comedy, *Needles and Pins*, to establish much of a competing identity as a dramatic actor, although drama is exactly where he started.

Before his service in the Army during World War II, which had him perform for his fellow soldiers, Nye worked in New York on radio shows, often as a utility actor, where he'd get himself cast as a young doctor one day on a soap opera and an aging grandfather the next. His vocal talents may have won him regular gigs, but Nye was not yet doing much in terms of comedy. These were his apprentice years. He later described this period as "amazing training. They would cast me in any type of role, and any age or nationality." When he moved on to television, he appeared on dramas like *Naked City* as well as variety programs like *The Dinah Shore Chevy Show*. Opportunities for movies came along, too.

One of Nye's first theatrical features, *The Last Time I Saw Archie*, had a deep connection to the Western. Written by William Bowers, the scenarist behind *The Gunfighter*, *The Last Time I Saw Archie* was a military comedy that chronicled Bowers's real-life friendship with Arch Hall, a scheming buddy always on the make, who became the infamous film producer of the Neanderthal horror flick *Eegah*, which starred Richard Kiel and Hall's son, Arch Hall, Jr. Jack Webb, who directed *The Last Time I Saw Archie*, played Bowers as a struggling screenwriter while Robert Mitchum playing Hall chewed the scenery. Nye was cast as Pvt. Sam Beacham, who bore more than a passing resemblance to Bowers's old writing partner, D. D. Beauchamp, with whom Bowers had written several Westerns, among them *River Lady* with Yvonne De Carlo, and the Abbot and Costello romp *Wistful Widow of Wagon Gap*. For Nye's very funny character, Bowers altered the name just a bit, but left his and Hall's alone, which resulted in a lawsuit from the picture's producer that was quickly settled with cash. Robert Mitchum always cited this film among his favorites, with Nye's performance being one of the reasons.

In 1963 came *The Wheeler Dealers*, a comedy about the sexist dynamics of Wall Street, with stockbroker Lee Remick and bogus Texas millionaire James Garner at its center. Directed by Arthur Hiller, *The Wheeler Dealers* satirizes corporate culture as Ivy League graduate Garner puts on a broad act as a rich, charming Texan to close shady business deals in "good ol' boy" fashion, while Lee Remick believes that all business should be honest and above board. Of course, Garner is exposed, and he and Remick fall in love, but the film has more comedic weight than that, thanks to the superb performances of Chill Wills and Louis Nye.

In *The Wheeler Dealers*, Nye plays an incredibly untalented painter that the slick Garner and his Texas cronies' mentor to prove the point that anything, including lousy art, can be sold if people are told it has value, despite their own eyes and opinions. Nye delivers a funny, eccentric, perfectly timed performance that stands out in wonderful contrast to Chill Wills's and Phil Harris's Texas bluster. Nye, in other words, could hold his comedic own alongside iconic Western personalities, leaving us to imagine what his work with directors like Andrew V. McLaglen and Burt Kennedy might have been like had he been given the chance to play the onscreen joker who could frustrate the likes of a John Wayne or Kirk Douglas.

All those possibilities read in the mask of Louis Nye, the great clown with the sad, twinkling eyes, who could have made the movie West even more fun.

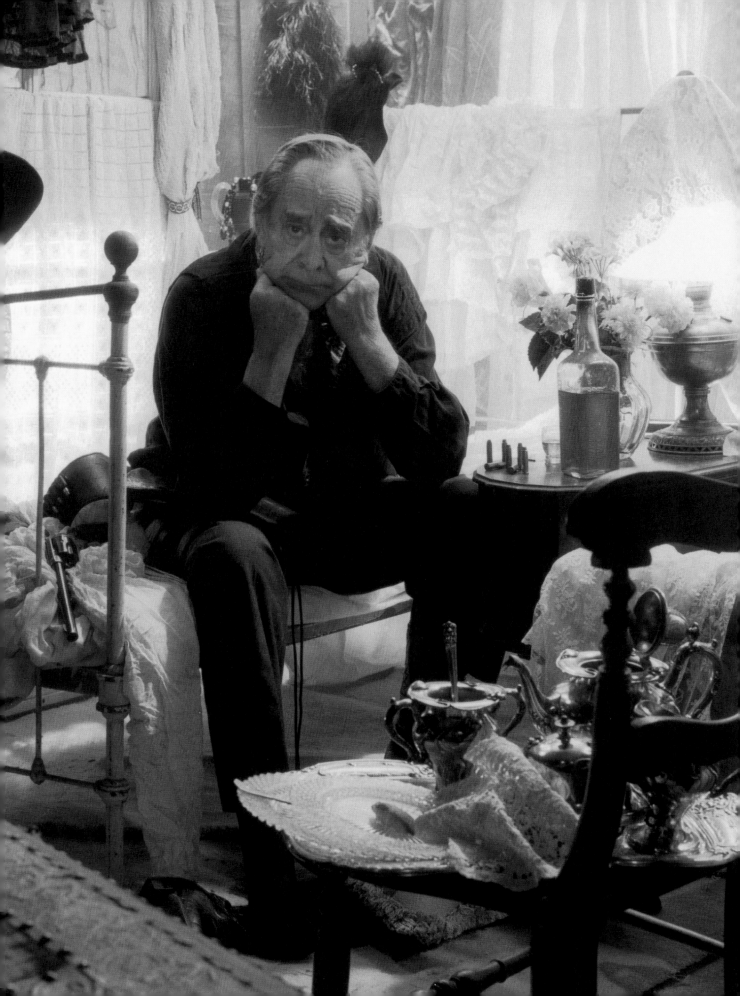

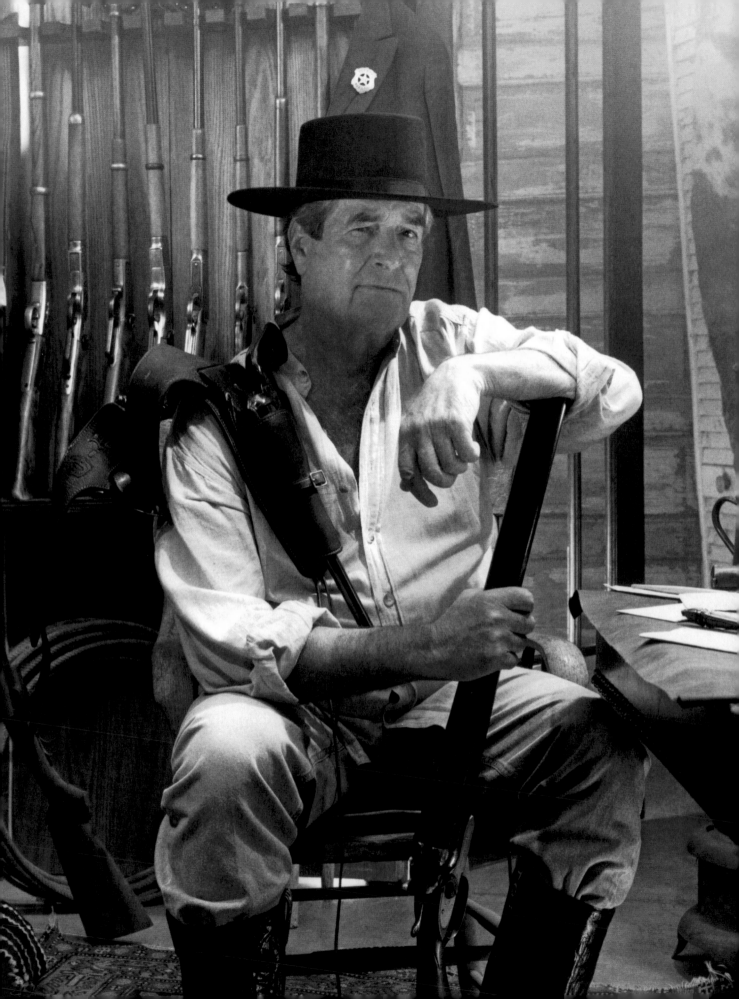

HUGH O'BRIAN
WYATT EARP WAS BORN FOR THE CAMERA

THERE WAS ALWAYS the hint of the swagger and a tug at the corner of Hugh O'Brian's mouth that turned his smile into an almost smirk of self-assuredness. The fact is, the camera loved O'Brian, and audience eyes went immediately to him as a walking bolt of energy moving across the screen, beginning with his first sizable part in 1950's *Rocketship XM*. This low-budget Robert Lippert production, made to compete with George Pal's science-fiction classic *Destination Moon* the same year, caused enough noise at the box office to alert talent scouts at Universal-International to put the young man with the swagger under contract and on a horse.

After receiving an honorable discharge from the Marine Corps, O'Brian scrabbled for parts like every other actor in Hollywood just starting out, but few had his physique or magnetic pull. He'd managed parts in Westerns at Republic and a turn in a stodgy Burt Lancaster vehicle at MGM, *Vengeance Valley*. But it was in 1951 at Universal-International where O'Brian was put through his paces, assigned to bit parts, working alongside newcomers like Sidney Poitier and Dennis Weaver in support of the studio's upcoming stars Audie Murphy, Rock Hudson and their new leading man, Jeff Chandler.

Casting of the contract players at Universal was done quickly, like someone ordering from an old-fashioned Chinese restaurant menu, with the producer picking an ingénue from column A, a supporting bad guy from column B, then, as dessert, looking at new talent to see who might connect with audiences or whose contract would be dropped after eight weeks. At the start, O'Brian was always stuck with the studio putting him in small Westerns like *Cave of Outlaws* before shuttling him over to tacky, but fun, Arabian Nights adventures like *Son of Ali Baba*.

The Cimarron Kid starring Audie Murphy was one of O'Brian's early films for Universal, the first of four films he would make with director Budd Boetticher, who recognized potential in O'Brian's ability to play characters from either side of the law with ease. He looked good on a horse and his boxing experience lent realism to his fight scenes, making him one of Boetticher's favorites contract players. O'Brian also worked for the legendary Raoul Walsh, who cast him in a featured role in *The Lawless Breed*. Not one of the one-eyed director's best, the film starred Rock Hudson as the infamous John Wesley Hardin with O'Brian good in support. But *The Lawless Breed* pointed up a problem that O'Brian and other actors were having with the studio: Hudson and Tony Curtis.

Hudson and Curtis had both been pulled from the supporting ranks and were being given massive buildups by the studio while others, future stars O'Brian, Marshall Thompson, David Jansen and bit-player Clint Eastwood among them, tended to be wrung through Universal's B units in nondescript parts denying them the chance at audience favor that would be theirs years later on television. O'Brian, who was getting better, if still supporting, roles went through the Universal period as he had boot camp, training for what was to come.

He won a Golden Globe in the Best Newcomer category for his work in Boetticher's beautifully shot *The Man from the Alamo*. The movie features Glenn Ford in the lead, and O'Brian received fourth billing. Later a good part in the Rock Hudson Western *Back to God's Country* came along. He wrapped up his time at Universal supporting Murphy again in the solid programmer *Drums Across the River*.

Hugh O'Brian left the studio in 1954, having appeared in eighteen movies in three years, ten of them Westerns. He'd made an impression in supporting roles and bit parts and was cast in 20th Century-Fox's Western remake of *House of Strangers*, re-titled *Broken Lance*, co-starring Spencer Tracy, Robert Wagner and Jean Peters, which Edward Dmytryk directed. Playing one of the Devereaux brothers, who must contend with their wild, youngest sibling (Wagner) as they divide their cattle empire according to father Tracy's wishes. O'Brian stakes his own dramatic claim in the motion picture, Fox's biggest Western of 1954, going nose to nose with Widmark, and building on his own screen presence, which was now being courted by television producers.

There were a number of big names in contention to play the lead in *The Life and Legend of Wyatt Earp* for Desilu Productions, but Earp biographer Stuart N. Lake took a liking to O'Brian, and the actor knew why: "He was a Marine, and I was a Marine.

"They let it be known that this was going to be the first adult Western TV show, which meant that the stories and the clothes and the rest would be as authentic as possible."

And there was something of the Marines in the way Wyatt handled things, getting a team together for a fight and working with others. They let it be known that this was going to be the first adult Western TV show, which meant that the stories and the clothes and the rest would be as authentic as possible. Lake knew Wyatt Earp from his time in Los Angeles, and he favored me because he thought I looked like him, a little gaunt, and I was chosen."

Premiering a week before *Gunsmoke*, when TV Westerns were still in *Annie Oakley* and *Hopalong Cassidy* country, *The Life and Legend of Wyatt Earp* was something markedly different. It wasn't just that it was "adult"—it was grounded in a stark but at times forgiving reality, where arguments didn't automatically end in gunfights or card games in brawls. This great show was about the West, made on the cheap, but with a point of view about the promise of building the country if law and order, maintained by men like Wyatt Earp, were maintained or, at least, the baddies corralled. Every half-hour segment carried a piece of this message, with O'Brian's Earp being more a voice of reason than one would expect, but with the fast-draw always at the ready. His performance in the series would earn him his only Emmy nomination.

Looking back, O'Brian felt that the show's realism "ebbed and flowed a bit. We always tried to start with history, with real people. Like Ned Buntline, for instance. He was a writer, and, of course, the pistols are named for him. He was a real character, who ran up against Earp. But we'd fictionalize his story a bit, to flesh it out, but tried not to go too far. I never wanted to go too far from the real events, if we could. Wyatt Earp had an amazing life, and there was a great story to tell about this man. But at first my agents didn't want me to do the series because I had some other offers for more money, and *Wyatt* wasn't going to be a big show. But I knew it would last. And it did, far longer than anything else I was offered, and it changed everything for me."

What the program changed was the actor's profile; the handsome swagger was now instantly recognizable as *The Life and Legend of Wyatt Earp* became a hit. The show set format templates for the half-hour Westerns that were to follow, including *Wanted: Dead or Alive, The Rifleman, Have Gun – Will Travel* and dozens of others, some becoming the show's direct competition, besting *Wyatt Earp* in ratings and quality, while others sank into oblivion as *Wyatt Earp* continued its long, successful run.

During this time, O'Brian was now recruited for movies, most notably the Wild West remake of *Kiss of Death, The Fiend Who Walked the West*, with O'Brian as the man tracking down psychopathic Robert Evans. Dismissed at the time of its release in 1956, the film's reputation has grown, thanks to the astounding career of Evans after he became the world-famous producer of *The Godfather* and *Chinatown*. The energetic direction of journeyman Gordon Douglas helped the film too, as well as the intense performance of O'Brian as the man who is driven to the brink in his hunt for the fiendish Evans.

In 1976, Hugh O'Brian would make a tremendous cameo appearance in a drama that's become a Western classic, *The Shootist*. In what is now noted as John Wayne's prophetic final film, O'Brian plays Pulford, a cocksure gambler who wants his chance to shoot it out with Wayne's legendary gunman who is dying of cancer. O'Brian gets his chance and is rewarded with a bullet in the head for his braggadocio. It is a scene of pure acting art because it could not be farther from the truth of the actor's true life, which was one of honor, discipline and selfless service.

MICHAEL PARÉ
TELLER OF TRUTHS

THE OPENING SHOT of Michael Paré in Walter Hill's *Streets of Fire* fixes on the actor's strapping back. Wearing a trench coat like a duster, awaiting an ambush, Paré takes a gunfighter's stance, deceptively casual, but ready to draw. This all takes place in Hill's neon-art-deco world, but it's the first of many images in the film that stir memories of classic Westerns with loner heroes.

Paré remembers the night this scene was filmed on the 'L,' Chicago's public transit system. Hill was adamant about restricting the presence of modern-day objects on the set and in the movie as a whole. Paré explains, "The whole company's on the 'L,' and the assistant director is walking through the train cars, saying, 'Let me remind everyone that we're treating this movie as if it were a Western, which means no Styrofoam cups, no filtered cigarettes, nothing.' And Walter was right there, nodding his head. 'That's exactly what I'm doing. I'm making a Western.'"

Hill has called his saga a "rock and roll fable," but as Paré's character, Cody, zooms into an urban badland that's been terrorized by outlaws on choppers to rescue a young kidnapped girl, the influence of Ford's *The Searchers* is evident. Paré could be riding a tall horse as easily as a stolen motorcycle. He carries a shotgun, too, not unlike the one Doc Holliday brought to Tombstone. Amy Madigan as a character named McCoy—an allusion, it seems, to Walter Brennan's TV Western *The Real McCoys*—rides along with Paré throughout the picture, providing cover for the hero as any good sidekick should. That Paré and villain Willem Dafoe pound each other with fists and sledgehammers in a scene inspired by John Wayne and Randolph Scott's brawl from *The Spoilers* is neither the last nor the most telling Western reference in *Streets of Fire*. There's a notable one in the ending, too, as Paré watches his love, Diane Lane, singing on stage. He's rescued her and brought her home, but knowing he has no place in her life, he walks on for her own good; just as John Wayne's Ethan Edwards walks away at the end of *The Searchers*, Cody will remain alone, too.

"There's something about Cody, that character that Walter created, that gets people excited. It's strange, because I'm from New York, and I played this Western loner. The Western is the iconic American genre. The gangster thing isn't American exclusively, but the Western is an American genre, it's our

mythology, our Shakespeare," Paré says. "The first movie ever made was a Western. A hundred years after the Civil War, we were walking on the moon. America became this incredible country, going from steam engines to walking on the moon in a hundred years, and the Western was part of that. The Western showed our story, the building of the country, to the world."

Paré regards the Western as a "leading man's genre," but his own work has had him work in every conceivable film category, typically in supporting roles, from John Carpenter's horror (*Village of the Damned*) to comedy with Sandra Bullock (*Hope Floats*) to mega-budget dramas like *The Lincoln Lawyer*. But he has never turned his back on independent film and notes with pride his success with the Western *Traded*. "We made *Traded* in sixteen days, and it did well, and we're working on a sequel. Hopefully, it will be a trilogy. I'm an actor, and an actor has to act. A piano player can sit at home and play music, a painter can go to his garret and paint, but an actor has to get on stage or on set, because if you don't you can get out of shape. I still go to the Actors Studio and work out, do the plays. I love it. You have to keep your body, mind and craft sharp.

"It's such a brutal business: you find out you didn't get a part because your social media profile isn't as good, isn't as high, as it should be, or the script says it's a forty-five-year-old veteran detective running a special unit, and the producers decide to hire a twenty-two-year-old girl. Every audition is like opening night, you put your heart out there, but it can all change in an instant. Boom, they love you, the play can run for two years. If they love you, you can get the big movie. And your life is different. Or it isn't. You have to have the skin of a rhino but the heart of a baby."

Paré, who's taken on more than a hundred-and-fifty roles and shows no sign of slowing, had a particularly fine turn in *Bone Tomahawk*, a brutal independent Western he appeared in with Patrick Wilson and Kurt Russell. "That movie did really well, and it's a Western. People still love the form. James Cagney said you have to hit your marks and tell the truth. That's why I'm working on Westerns—to tell the truth."

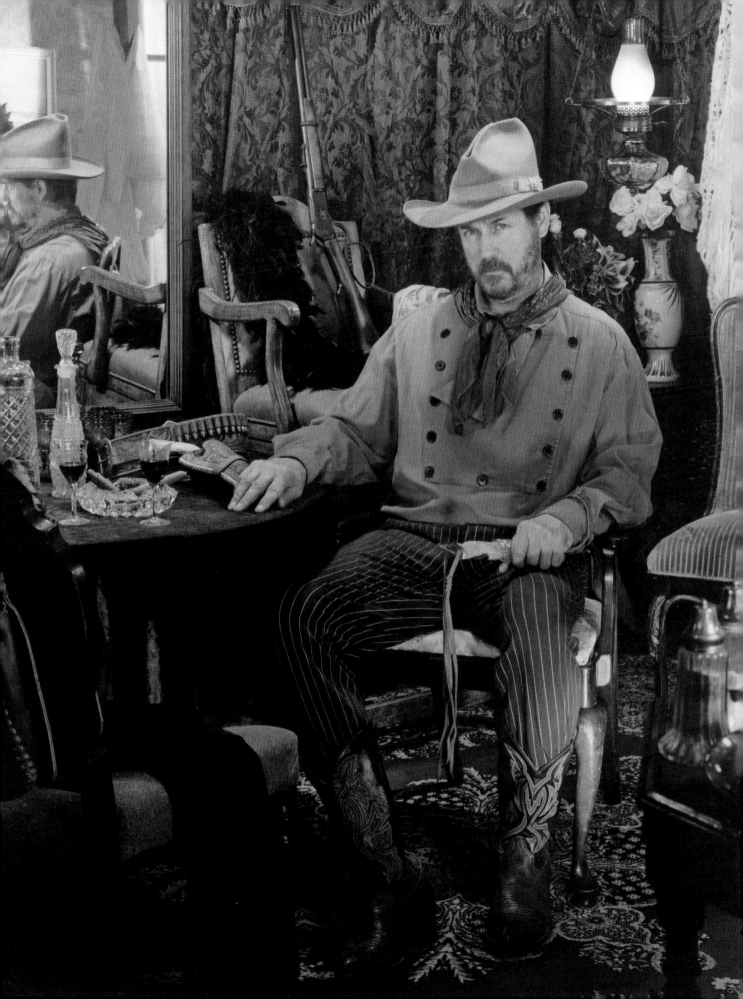

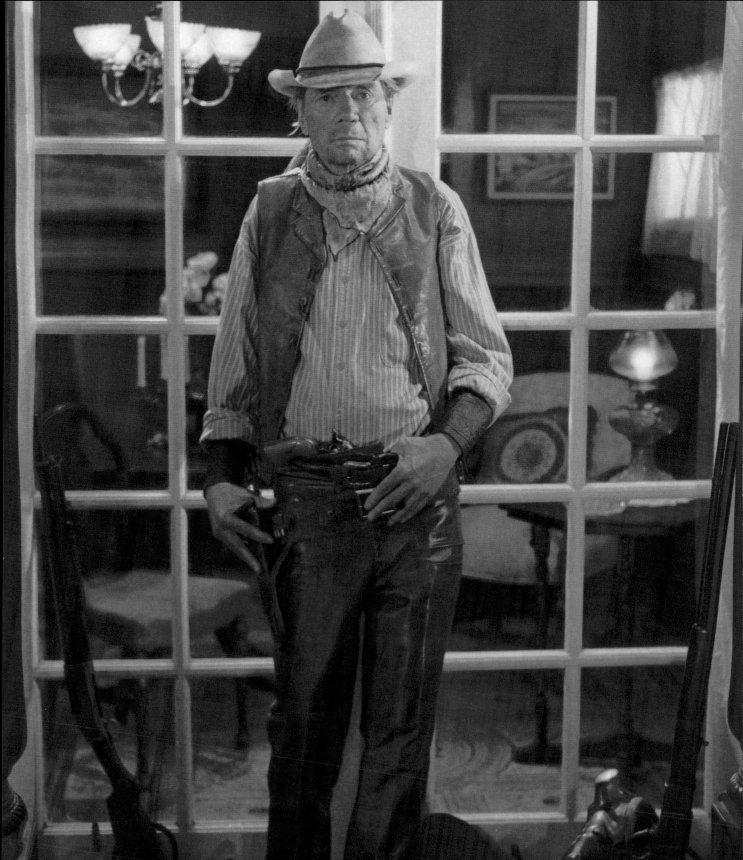

MICHAEL PARKS
HIGHWAY LEGEND

His first TV show was titled "Ransom," a crime-themed Western made for *Dick Powell's Zane Grey Theatre*. Budd Boetticher (*The Man from the Alamo*) directed a terse script from Harry Julian Fink (*Major Dundee*). His co-stars were hard-boiled Westerners, too: Claude Aiken had chewed the scenery in Hawks's *Rio Bravo*, and Lloyd Bridges in *High Noon* set his own safety ahead of fidelity to the badge. Mike Parks, as producers early on billed him, played a character named Juanito in this excellent program.

Parks had something special that needed to be in front of a camera, that could reach as many people as possible. The young actor could find the rough edge of truth in his roles, and his acting demanded attention, even if Parks did not. He just allowed himself *to be* his characters, finding a way to crawl into their skins, with all their flaws and merits. He soon found himself the star of *Then Came Bronson*, the saga of reporter Jim Bronson taking his motorcycle coast to coast in search of America and himself. Though he rode a Harley-Davidson rather than a stallion, Parks evoked the perfect Westerner in this short-lived series, rolling into towns to briefly become part of the lives of the people there, solving a problem, then riding on again. Preferring thought and heart over violence and mayhem, *Then Came Bronson* found its way to the ash heap of cancelled shows too soon. Perhaps if Parks had solved problems with a gun, the program would have stayed on air longer. But it died as its star wanted it to, without compromise.

Michael Parks continued on with an astonishing amount of work. One of John Wayne's favorite directors, Andrew V. McLaglen, would cast him in four movies altogether. Though Parks himself never worked with the Duke, he added a distinctly off-beat element to McLaglen's *The Last Hard Men*, which featured two other giants of the Western genre, James Coburn and Charlton Heston. Critics had faulted McLaglen for making slick, sanitized Westerns, often with a deep streak of comedy, and with this bloody film about a retired lawman facing old enemies the director abandoned the popular Wayne "family formula." When McLaglen moved again in unexpected creative directions, as he did with *Breakthrough* and *ffolkes*, two of his best films, he brought Parks with him.

Parks found himself starring in and directing *The Return of Josey Wales*, which gave audiences another chance to encounter the violent hero Clint Eastwood made famous with one of his finest films, *The Outlaw Josey Wales*. The original star had spurned the sequel, but the producers hoped they could still capitalize on the public's lingering admiration for the Josey character. Under-budgeted, the project was all uphill for Parks, who took on the titular role in an entirely different way than Eastwood had. Parks refrained from concealing Josey's psychological injuries, which war and the loss of family have caused, rather than passing them off stoically as mere battle stripes. Sadly, the script lacked the depth of Josey's first adventure and translated poorly onto the screen, undercutting Parks's own good work on the project.

If *The Return of Josey Wales* was destined for the VHS rack, Parks's next Western, *Gore Vidal's Billy the Kid*, was a true television event. This epic traces all aspects of the Kid's life—Val Kilmer played the lead—including his relationship with Pat Garrett, who killed him. Parks played a character named Rynerson, a lawyer who set out to prosecute the Kid. Although it was a standalone TV film, not a mini-series, *Billy the Kid* won praise for its historical accuracy. So did another biopic about another legendary Western heavy that came decades later, *The Assassination of Jesse James by the Coward Robert Ford*. Brad Pitt starred in this one, delivering a brave and image-shattering portrayal of the sociopathic outlaw, a role that we could have easily seen a youthful Michael Parks play. But now the once-young rebel, who'd ridden a motorcycle across our TV screens, was the face of scowling authority.

When Quentin Tarantino cast Parks as Texas Ranger Earl McGraw in the pseudo-Western vampire flick *From Dusk till Dawn*, it wasn't just a cinephilic filmmaker's effort to work with his movie-actor hero; it was a moment of recognition for all the truth-telling on display in the roles Parks had done before. *From Dusk till Dawn* came at an early point in Tarantino's career. The director was so delighted by Parks's take on Earl McGraw that the character re-surfaced years later in Tarantino's marvelous *Kill Bill* franchise and *Death Proof*.

Michael Parks didn't believe in bells or whistles in his acting. In great scripts and poor, driving a cop car, riding a Harley or horse, this acting legend found his own truth and shared it with us.

STEFANIE POWERS
BEAUTY ON HORSEBACK

STEFANIE POWERS WAS only eighteen years old when she was cast in her first Western, an episode of *Bat Masterson* titled "Dead Man's Claim." But the teenager felt right at home on horseback, riding among the old hands and wranglers: "I was a bit of tomboy. I loved riding horses and that collaboration between a horse and yourself when you put it to a test. I competed on horses and still do. It's very much ingrained in my life."

The young player with the deep-velvet voice and stunning eyes was a contract actress working for Columbia Pictures before she made a dramatic splash in the Blake Edwards thriller *Experiment in Terror*. Shortly after this triumph, she rolled onto the Ponderosa as Calamity Jane in a delightful episode of *Bonanza*, showing off her horsemanship and comedic skills, which prepared her perfectly for joining John Wayne and Maureen O'Hara in Andrew V. McLaglen's *McLintock!*

As Duke's stubborn but wide-eyed daughter, Becky, Powers combines bits of Wayne's temper with surprised innocence, creating a funny, irresistible character in the midst of all the rough-house comedy and slapstick delivered by Wayne and his old pals. Stepping into that corral of veterans was daunting. "They really embraced me. I was already in love with everything they represented because *The Searchers* was my favorite movie, and the idea of doing *McLintock!* with those people, and being so welcomed into that group, was wonderful because they had been working together for decades. They all had history together. It was like a private club, and they let me in."

Circumstances brought Stefanie Powers completely into the Ford camp when director McLaglen fell ill: "When Andy came down with something, John Ford took over for him. Ford was in retirement, and he wasn't making films, but all of his children that he felt he raised, including Duke, Mike Wayne, Andy and Maureen O'Hara, were making this movie and they hadn't consulted him. Everyone. The stuntmen, the crew and Bill Clothier, the cameraman. They were all part of John Ford's stock company, and then the moment came. It was clear that Andy was coming down with something, and one morning everyone was very nervous, speaking in hushed tones, and I was the junior member of the company. But we were all dressed and made-up and ready to go, but no

Andy. Now I didn't know what was going on because I certainly wasn't privy to the decisions of the higher-ups. We're waiting and waiting, and somebody said, 'I think he's arriving.' And I thought they meant Andy.

"We were working at the Green Ranch in Arizona, with a beautiful period house on a high plateau over a riverbed. It was just magnificent, the view, and you could see as far as tomorrow, and it was a very dramatic setting. We looked over in the distance and saw this rise of dust coming from the riverbed as this automobile was approaching, and you could hear everyone breathe it was so quiet, and this car pulls up. The dust clears, and the door opens, and one leg exits, followed by a dirty old jacket and a dirty old hat. And a man in sunglasses with an old bandana around his neck gets out. Duke went to him. This giant of a body gets out of the car, and he pushed Duke aside and walked over to Bill Clothier, leaned down and said, 'All right, Bill, let's go to work.' And that was how Mr. Ford made his entrance!"

John Wayne took to his on-screen daughter as soon as he saw how she handled a horse, as did the team of veteran stuntmen, especially Hal Needham. "On *McLintock!* Hal Needham and I did all kinds of work together. I did another Western with him, *Hardcase,* and we were shooting in Mexico, and there weren't enough stuntmen to play the Indians and bandits or double for the cast, so I did my own riding. Hal Needham stood up at a party and said, 'I want to raise a toast to the best rider in Hollywood!' I couldn't believe it. That's one of the greatest compliments I've ever had."

Although she has not headed West for the cameras in years, this horsewoman still loves the genre, which shaped her moral outlook profoundly along with giving her so much professional experience and some of her most treasured memories: "One of the abiding things about Western movies was that there were clear lines. The bad guys were going to be the bad guys, and the good guys were going to be the good guys. We know that the good guys were going to win and ride off into the sunset. It was a morality play. No matter what context or what drama happened within the telling of the story, there were these clear lines of behavior, of humanity, that everyone could identify with."

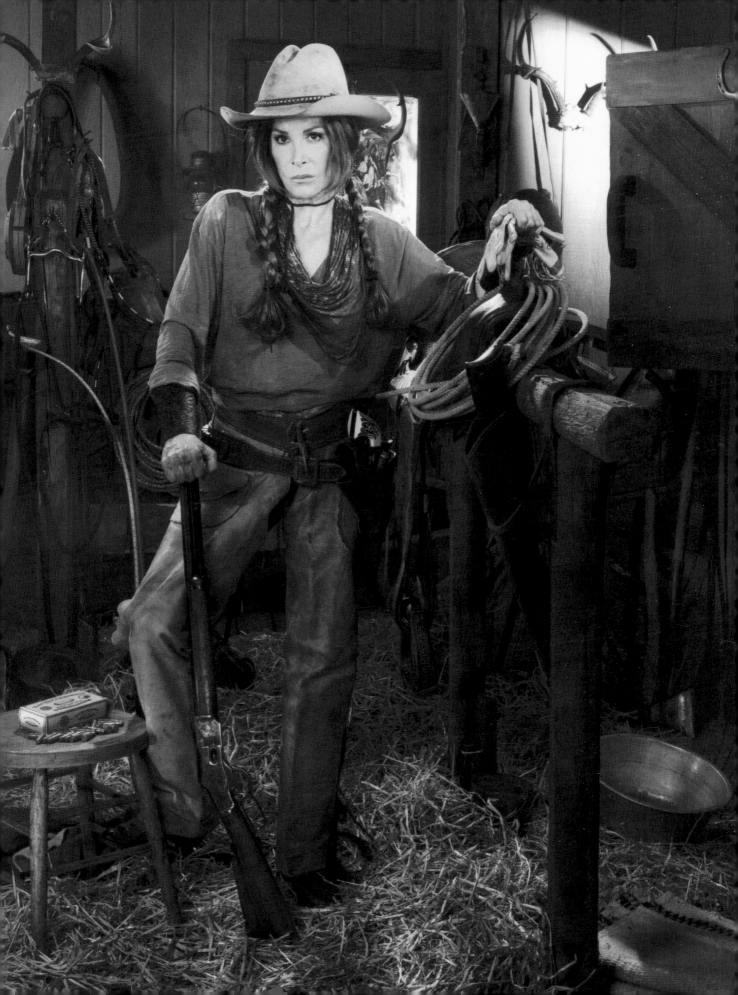

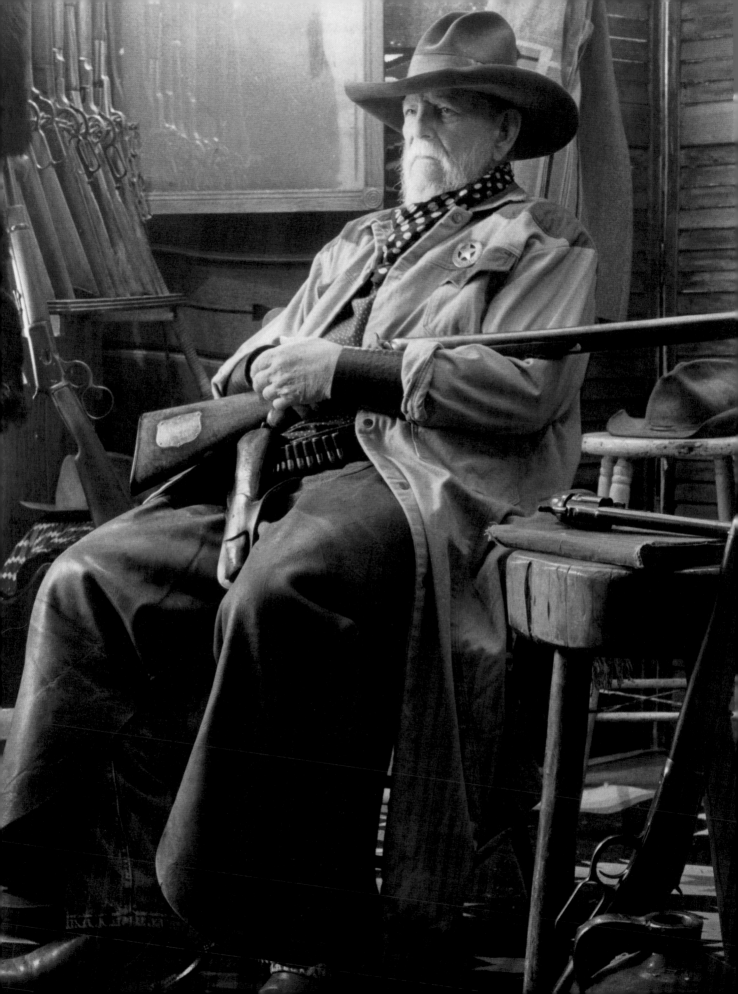

DENVER PYLE
THE HARD ROAD

DENVER PYLE NEVER gave up.

He was the man from Colorado who'd been outlaw and sheriff, stood with John Wayne in *The Alamo*, fought the Lone Ranger, tried to kill Superman and was one of the last of John Ford's stock company.

Tall, with anvil-like hands and long arms, it was Denver Pyle, his scowl menacing us from the corner of the movie or screen that immediately drew our attention. His dramatic power didn't just come from his imposing mien and stature. There was that voice, a sound that rumbled from the center of his massive chest, turning mundane dialog into a sonic boom, a voice that the groomed white moustache of his early years and the full beard he wore later could not impede.

Acting was the second choice for Denver Pyle, who turned to it when a career as a drummer didn't pan out. He put himself in front of the camera, hoping to create an impression that would lead to more work. Simple as that. And what happened was that he established an indelible image that would last more than five decades. The early parts that came were typical for a newcomer: unbilled bits in movies, with a little more camera time on television when the new medium was putting actors to work at a furious pace. If you missed Denver's Western turns for Nicholas Ray in *Johnny Guitar*, with Joan Crawford or *Run for Cover*, with James Cagney, you'd find him with more to do in multiple episodes of *The Gene Autry Show* and *The Adventures of Kit Carson*.

Made fast and cheap, syndicated TV programs in the 1950s became the testing ground for actors struggling to break through, which Denver Pyle did, throwing his lines like knives at one cowboy after another, at times allowing a comic quality to overtake his delivery, at other times a tragic one. He was often handed a script right before a scene was filmed, and with little or no rehearsal, he'd use only gut instinct to carry the role.

Denver Pyle had racked up more than one-hundred-and-fifty film and television appearances when John Wayne tagged him for *The Alamo* in 1960. Working with Wayne and John Ford allowed Pyle an insight into the two men's relationship when the veteran director appeared uninvited on *The Alamo* set and proceeded to undercut Wayne's authority as director and producer. The film had been Wayne's dream project for decades, and he was finally get-

ting it done his way, but the star had intense loyalty to his mentor and knew Ford had been feeling abandoned. Pyle remembered, "I think Ford was worried about Wayne getting it right, and Wayne didn't have the way with actors that Ford did. Still, it was Duke's show, but there was no way he was going to embarrass Ford by having him leave, so he gave him a crew and had him shoot scenes with the Tennesseans." The actor forged a bond with Ford on *The Alamo* that continued when the director cast him in his classic *The Man Who Shot Liberty Valance* as a townsman who knows the days of the Wild West are over.

Pyle continued to rack up credits, with the roles now being tailored for him, especially on *The Andy Griffith Show*, which allowed him to show off his musical bent. The days of simple, boisterous supporting roles standing beside stars culminated with a single, deeply felt dramatic turn as lawman Frank Hamer in Arthur Penn's 1967 milestone *Bonnie and Clyde*.

It is a performance drawn from the decades that had gone before, made of the flesh and blood of all of those characters he'd brought to life. *Bonnie and Clyde* was nominated for ten Academy Awards and won two, and Denver Pyle was one of the reasons. Can anyone imagine Estelle Parsons's brilliant portrayal of Blanche reaching its heights without Pyle's prodding her character to the edge?

It was a triumph, and the actor barely took a breath. He simply went back to work. More television, more movies, until finally settling in as the patriarch of the Duke clan in a corner of rural Georgia. *The Dukes of Hazzard* ran for one-hundred-and-forty-five episodes, with Pyle appearing in every one, becoming the show's most beloved character and enjoying a fan base of thousands that took to heart the homespun humor of the wise uncle character we all wish we had.

This was his grand performance, sewn together from the years he essayed lighter characters, never becoming a buffoon. Like the best work of compadres Jack Elam, Strother Martin or Hank Worden, what Denver Pyle created was the culmination of decades of dedicated work, of taking the smallest parts and doing wonders with them—pulling the best out of himself.

That's the road travelled by the best, and Denver Pyle travelled it long and well.

PETER MARK RICHMAN
FRIENDLY PERSUADER

MARK RICHMAN CREDITS his TV work on *Suspense* and *The Philco-Goodyear Playhouse* for getting cast in William Wyler's landmark Western, *Friendly Persuasion*. Richman was certainly tall and handsome, but there was an intensity behind his eyes that was capable of extending a warm hello or the deadliest of snarling threats.

The actor explains that "Wyler had seen me on television and thought I'd work as the young officer. I know there were other actors considered, but he liked me." The high-spirited movie director had a reputation for driving actors to the breaking point by asking for take after take of certain scenes until he was satisfied. All the same, this penchant for perfectionism yielded great movies like *The Letter*, *Mrs. Miniver*, *The Best Years of Our Lives*, *Ben-Hur* and *Funny Girl*. Wyler would be nominated for Oscars as Best Director twelve times, winning three, and his films still hold the distinction of being nominated for more Academy Awards than any other filmmaker's. Richman was aware of all of this intimidating history, but he and Wyler "met at his hotel, and we got along very well. He was a pussycat."

An adaptation of Jessamyn West's stories of a pacifist Quaker family caught up in the Civil War had initially belonged to Frank Capra, who'd brought on writer Michael Wilson to craft the script. Wyler loved the subject and took it on himself. Along with his friends Billy Wilder and John Huston, he had signed on to direct pictures for Allied Artists, which was B movie stalwart Monogram Pictures christened with a new name, and new management. *Friendly Persuasion* was one of the films that was to catapult Allied Artists into the spotlight, a fact that Wyler shouldered with grace as he put his cast through their paces in this gentle story with a hard moral lesson.

Gary Cooper portrayed Jess Birdwell, the father who has to stick to his pacifist beliefs in order to preserve his family's life and spirit. For Peter Mark Richman, working with the screen legend was a particular pleasure: "He was a true gentleman, in all ways." One of the new stars of the period, Anthony Perkins, took on the part of Cooper's son, who makes the agonizing decision to fight the Confederates. Part of the choice is spurred on by Richman as a young Union officer, who courts Perkins's sister. Richman's military figure is a mirror opposite of Perkins's in many ways;

they seem two pieces of a singular whole, from their appearances to their voices, just as Wyler envisioned them.

Wyler's first Western since *The Westerner* in 1940, also with Cooper, *Friendly Persuasion* was a hit for the director and star, securing another Oscar nomination for Wyler and garnering five additional nominations, including Best Picture and recognition for the Michael Wilson script, except the screenwriter couldn't be formally named by the Academy as he was then blacklisted and unable to receive credit for his work. Later, Wilson's name was restored to the credits.

For Peter Mark Richman, working with a great director and a legendary star was a glorious introduction to the movies, and the versatile actor immediately found himself in demand for roles on the big screen and small, so he relocated his family to Los Angeles from New York City and never stopped working over the next fifty years. During the 1950s and '60s, to work in television meant riding Westward as other young actors had before, and would again. Richman's journey was no different, except for the slick figure he cut; he was no barroom brawler or half-crazed desert rat. He held himself with distinction, with a Barrymore profile. Giving his dialog a clipped edge when needed got him several parts as villains, which was irksome at first. "I could play lots of roles, and certainly have onstage, but Hollywood does like to type you. And when I worked in Westerns, it was almost always as the heavy, which was fine, because you usually get the most interesting lines."

One of his first TV Westerns was the "Incident at Alabaster Plain" episode of *Rawhide*, where Richman first encountered Clint Eastwood. "You could tell from the start that Clint would become this huge star." Dramas, Westerns (*Hotel de Paree*, *Dick Powell's Zane Grey Theatre*) and multiple episodes of *Alfred Hitchcock Presents* kept Richman busy until he took the lead as the young lawyer ready for a courtroom fight against society's worst in *Cain's Hundred*, which ran from 1961 to 1962. *Caine's Hundred* showed Richman on the side of the angels for a change, and many of the typecasting bonds were broken. After the show's run, Richman's roles were as diverse as his talent, and he found himself in demand for genre shows like *The Fugitive* and also *The Twilight Zone*, in

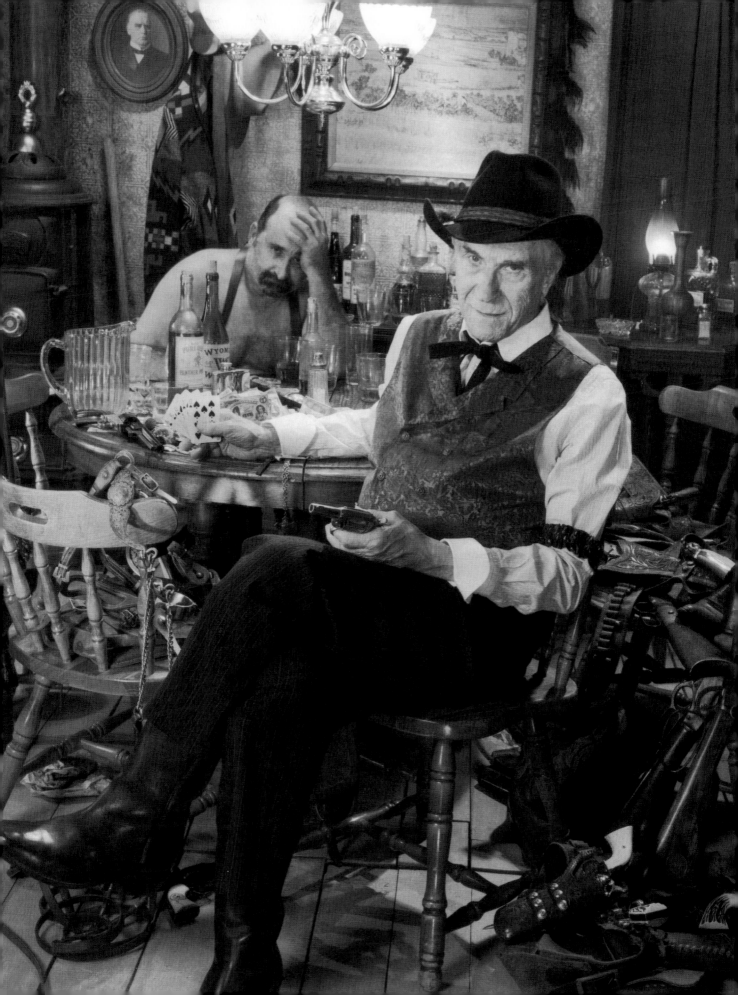

"And when I worked in Westerns, it was almost always as the heavy, which was fine, because you usually get the most interesting lines."

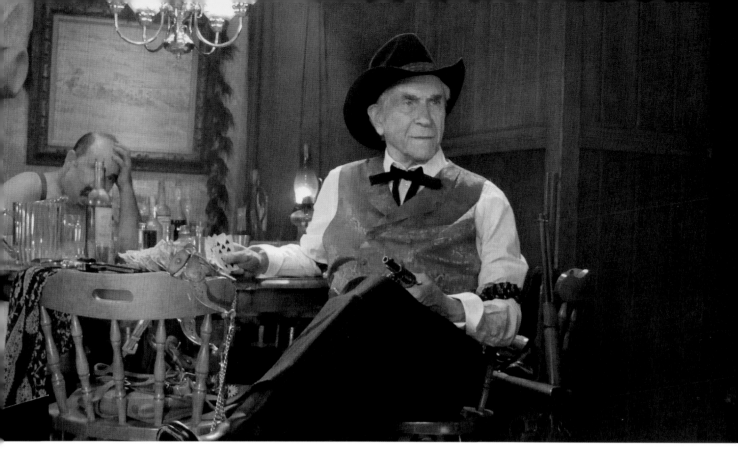

which he starred in the classic episode "The Fear" as a highway patrolman terrorized by a giant.

Richman found himself riding again for several guest-starring roles on *The Virginian*, *Wild Wild West* and *Lancer*. His appearance on *Bonanza* in "A World Full of Cannibals" was a triumph for him as he depicted an old lawman friend of Ben Cartwright's, who puts the entire family in harm's way when he leaves a prisoner in their charge. The episode was noted for its darkness and for the minimal presence of the folksy comedy so loved by audiences that sometimes played too large a role in this otherwise revered television saga.

The episode also established a relationship between Richman and *Bonanza* creator David Dortort that bore fruit twenty-five years later when he was cast in a new pilot, 1988's *Bonanza: The Next Generation*, co-starring Robert Fuller, John Ireland and John Amos. William F. Claxton, who was one of the original series' primary directors, guided this new tale of the sons of the original Cartwrights as they draft old family friends to help defend the Ponderosa. Money was spent, and the ratings were solid, but the show itself didn't take off. "I hadn't done a Western for some time when I was cast in the new

Bonanza, and it was all because of David Dortort. None of the original cast was there, and they'd hoped it would go to series, but it ended up as a TV movie. I would have liked to do the new series, but you move on to the next."

Following his early appearances on the original *Bonanza*, Richman's work included everything from co-starring with James Franciscus and Bruce Lee in Stirling Silliphant's well-regarded *Longstreet* about a blind detective, as well as recurring roles on *Dynasty*, *Santa Barbara* and even a quick turn in Paramount's *Friday the 13th Part VIII: Jason Takes Manhattan*.

This last horror credit solidified Richman's fan base with young people, who already loved him from classics like *The Outer Limits* and his voicework for both the *Superman: The Animated Series* and *Batman: The Animated Series*. Richman is pleased when he makes appearances at fan conventions that his work is reaching across the generations: "It's amazing that these young people know my work from *Batman*, from the horror films and *The Twilight Zone*. And Western fans know about those shows like *The Virginian*. It's very rewarding to see that the work has lasted."

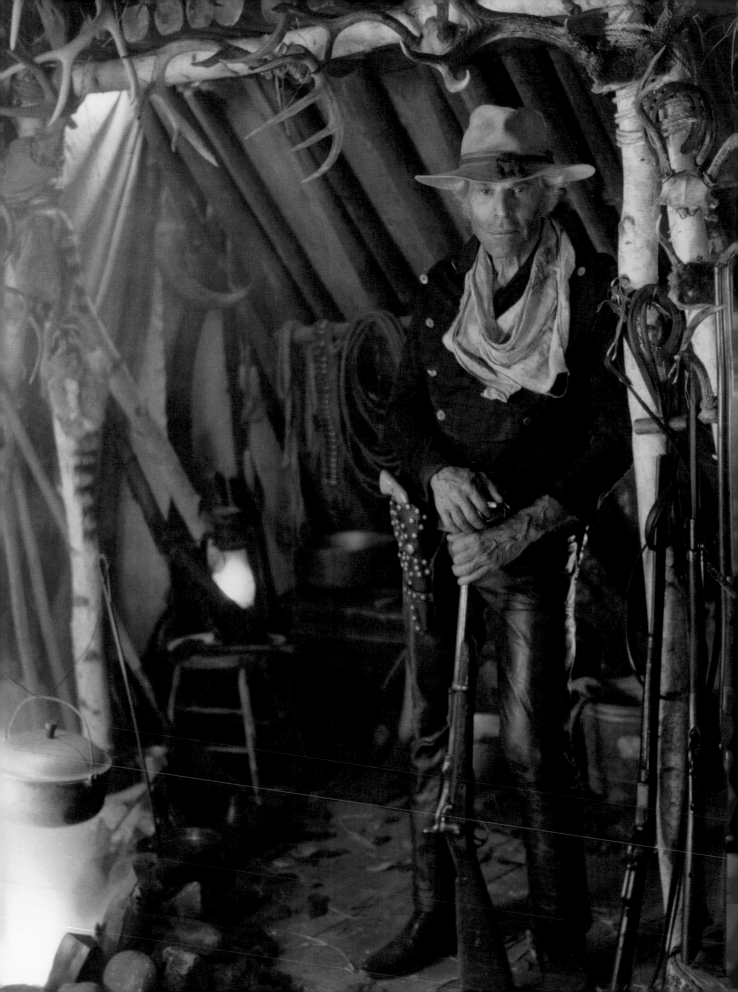

JORGE RIVERO
WORKING ALONGSIDE HAWKS, DUKE AND HESTON

DIRECTOR RENÉ CARDONA had made more than a hundred films in Mexico and was regarded as one of his country's most prolific and most original genre filmmakers. His movies that reached the United States dotted the late-night TV landscape, and a bona fide hit in the States didn't materialize until 1966 with *El Mexicano*, starring Jorge Rivero. Cardona and Rivero's collaboration yielded a series of successful Westerns and adventure films for both director and star, and soon offers came for Rivero to appear in Hollywood-financed films made in Mexico, notably director Ralph Nelson's violent saga of the infamous U.S. Army massacre of a Cheyenne village, *Soldier Blue*. Of this landmark film, Rivero recalls, "I was playing an Indian leader. Ralph Nelson was wonderful. I was very happy to play a part with this kind of dignity."

Rivero's presence, his popularity in Mexico and the figure he cut on horseback brought him into the sights of Howard Hawks, who was preparing what would be his final film, *Rio Lobo*. "When they hired me, I had to go to the American Embassy in Mexico to come over here and get permission to work, and I had to join the Screen Actors Guild. The government gave me six months to make the film. I hardly spoke English, and I was playing a Southerner, and John Wayne was playing a Yankee. What happened was that Wayne knew immediately about my problems with English, and he was very nice about it. When we had a scene together, he would call me. He didn't like to rehearse with anybody. But he'd go over the lines with me. 'Jorge, how're you going to say this?' I would try it, and he'd correct me or find a better way that was comfortable for me. He was the champion of the Westerns, so I'd follow his instructions." Hawks often sat with the cast each morning, going over the script and scribbling alternatives to the original dialog. Howard Hawks knew my English wasn't there but gave me a big hand in figuring out my lines, even if he changed them. If I said something wrong, Howard would cut and say, 'Let's do it again,' and then he'd advise me on how to say it."

Rio Lobo brought Rivero further international recognition and strengthened his stardom in Mexico. "When *Rio Lobo* was released, Wayne couldn't really travel because of his health, so I did the tour to promote the film. We went to London, and I was sitting with Howard Hawks. The Italians saw me, and they hired me. Spanish producers brought me onto films also. I got a lot of work because of the Wayne film. My first chance came along to produce a film. Once you've had some success, opportunities come your way. With *Indio*, I had the idea for a new Western, and—boom!—all of a sudden I had the money. We made the movie in Durango."

In *Indio*, Rivero plays an Apache warrior seeking revenge for the loss of tribal lands to a greedy land baron. Rivero recruited Mexico's best talent. "Emilio Fernandez was quite a tough guy and a very good director. At the time, I was young, and I was learning from everybody. Here I was, working with Emilio and also Pedro Armandarez, all of these great people who'd made so many fine films with John Ford and Sam Peckinpah. Really wonderful. Jorge Russek was another great inspiration when I made my first Mexican Western; he'd already made many American movies, like *The Wild Bunch*. In life you either have luck or you don't, and I was so fortunate to have all of these people around me."

Rivero's next American Western found him working with Charlton Heston and James Coburn in the bloody *The Last Hard Men*, directed by veteran Andrew V. McLaglen. "The people from that era of Hollywood, American and Mexican, were so nice. There were no computers, so everything was personal, wonderful and so different, as people actually spoke to one another."

The actor continues working, and his memories of John Wayne remain. "Once we finished *Rio Lobo*, Wayne invited me to Acapulco with him and his son and wife, Pilar. We went down on his yacht, the Wild Goose. We were in a restaurant, and Duke was by himself at the bar, and some American tourist said something to Wayne. He punched him so hard the guy crashed into our table just like in the movies! Duke got up and said, 'Take out that trash!' I still have no idea what the guy said, if it was an insult to his family or someone he worked with, but that was his reaction, his loyalty. All these people, they were wonderful. John Wayne and Howard Hawks opened up the industry for me.

RICHARD ROUNDTREE
DESTINED TO BE THE HERO

1973'S CHARLEY-ONE-EYE was a film made of ill-fitting European pieces. Talk show host David Frost produced it. Keith Leonard, a situation-comedy writer, carved out the screenplay. And director Don Chaffey, though he'd experienced great success in the world of fantasy with *Jason and the Argonauts*, had never made a Western before. Add to this the fact that star Richard Roundtree had never appeared in a period drama, much less a Western. When all these elements came together during filming in Spain, the last thing in the world anyone expected was that *Charley-One-Eye* would be featured in the Berlin Film Festival. But it was.

Honored in Europe yet received as just another Spaghetti Western upon its U.S. release, *Charley-One-Eye* has seen its reputation grow substantially over the years, drawing praise for its experimental aspects, its direction that pushed visual limits and its star who delivered a wild, raging performance at odds with the street-cool "bad mother" image he'd created in *Shaft* and its first sequel, *Shaft's Big Score!* Roundtree addressed his desire to thwart audiences' expectations in a 1975 interview he gave to Roger Ebert: "As much as possible, I'd like every role to be totally different from the one before. If you do the same thing too often, it gets to be the only thing you can do."

The actor shifted his image again with a sterling performance as Sam Bennett, the ambitious carriage driver in love with Kizzy (Leslie Uggams), one of the female protagonists in the groundbreaking mini-series *Roots*. An adaptation of Alex Haley's chronicle of his own family history—spanning the Atlantic slave trade, the Civil War and Reconstruction—the mini-series proved that controversial material could reach an enormous audience as popular entertainment, setting a record for viewership that holds to this day.

Appearing in Part VI of the series, which covers the first half of the eighteenth century, Roundtree stands out among a cast that also includes scene-chewing stars like Scatman Crothers, Ian McShane, Ben Vereen and George Hamilton, who plays a slick plantation owner. Roundtree bravely walks the razor's edge in his performance, showing charm, passion for Kizzy and determination. His lover's fondness sours, though, when she watches Sam denigrate himself in an effort to mollify his abusive owner. "Sam wasn't like us," Kizzy later laments. "Nobody ever told him where he come from. So he didn't have a dream about where he ought to be going."

Roundtree tackled a variety of parts in solid action films (Steve Carver's *An Eye for an Eye*, Richard Benjamin's *City Heat*) and television comedy (*The Love Boat*), but he would not find himself again on horseback, guns holstered, duster blowing back, until the science fiction Western series *Outlaws*. Created by Nicholas J. Corea, *Outlaws* was a time-travel adventure in which a sheriff (Rod Taylor) and five prisoners, Roundtree among them, are transported from the Old West to modern Los Angeles. The prisoners attempt to right the wrongs they discover in this "new world." The show's scripts always exhibited humor while celebrating the code of honor that existed between its displaced characters. Though the pilot was one of the highest-rated shows of 1986, subsequently the ratings slid, and *Outlaws* was cancelled after its first season.

Bad Jim was Roundtree's next Western, a fable about a man supernaturally visited by and persuaded to embrace crime by the spirit of Billy the Kid after he purchase's the outlaw's horse. Co-starring James Brolin, the fantasy aspects of the story nevertheless fall a bit flat, despite fine performances. Roundtree co-starred with Brolin again, along with Brolin's son Josh, for an excellent episode of *The Young Riders*, playing an ex-teacher captured by slavers. He took on the character of cowhand Jacob Briscoe in both *Bonanza: The Return* and *Bonanza: Under Attack*. These well-received television movies sought to introduce viewers to a new generation of Cartwrights, who would learn the lessons of running the Ponderosa from Ben Johnson, Jack Elam and Roundtree. Beautifully photographed, the programs evoke a sense of nostalgia, paying tribute to the original series, but the grand chemistry that existed between Johnson, Elam and Roundtree wasn't enough to ensure the classic TV series' revival.

After an incredible variety and number of roles, Roundtree has come full circle, playing the older, wiser uncle to his nephew, John Shaft (Samuel L. Jackson), in recent revivals of the *Shaft* movie series. Roundtree fashioned something iconic as the original films' tough-guy hero, pushing himself onward as an actor, driving himself to explore new dramatic territories. Fortunately, these territories included the Old West.

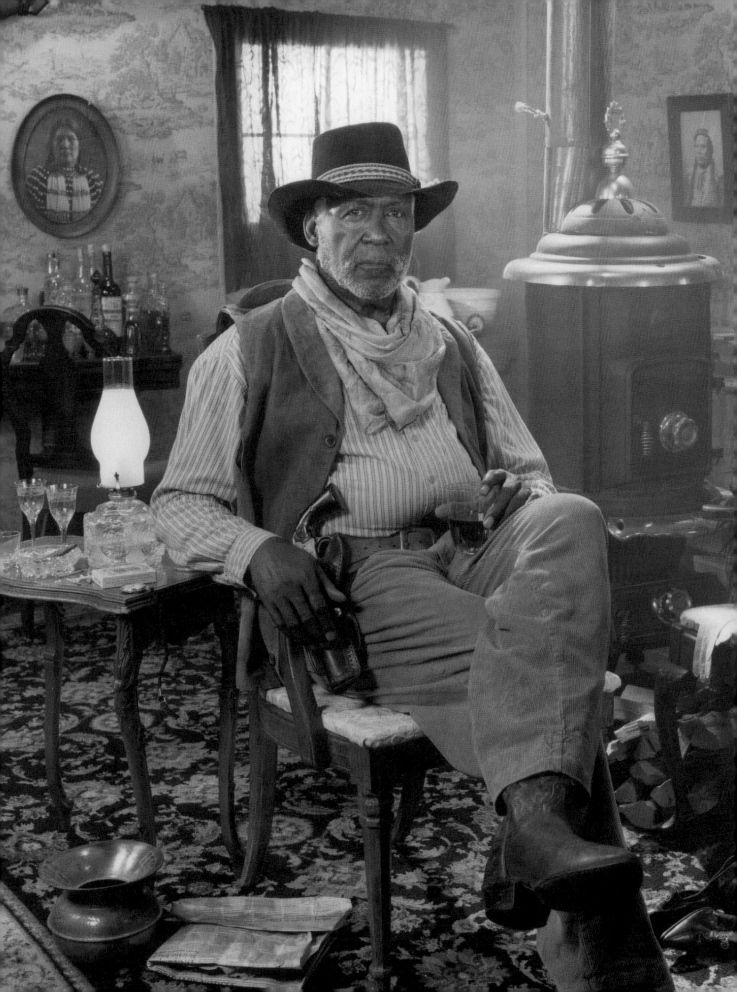

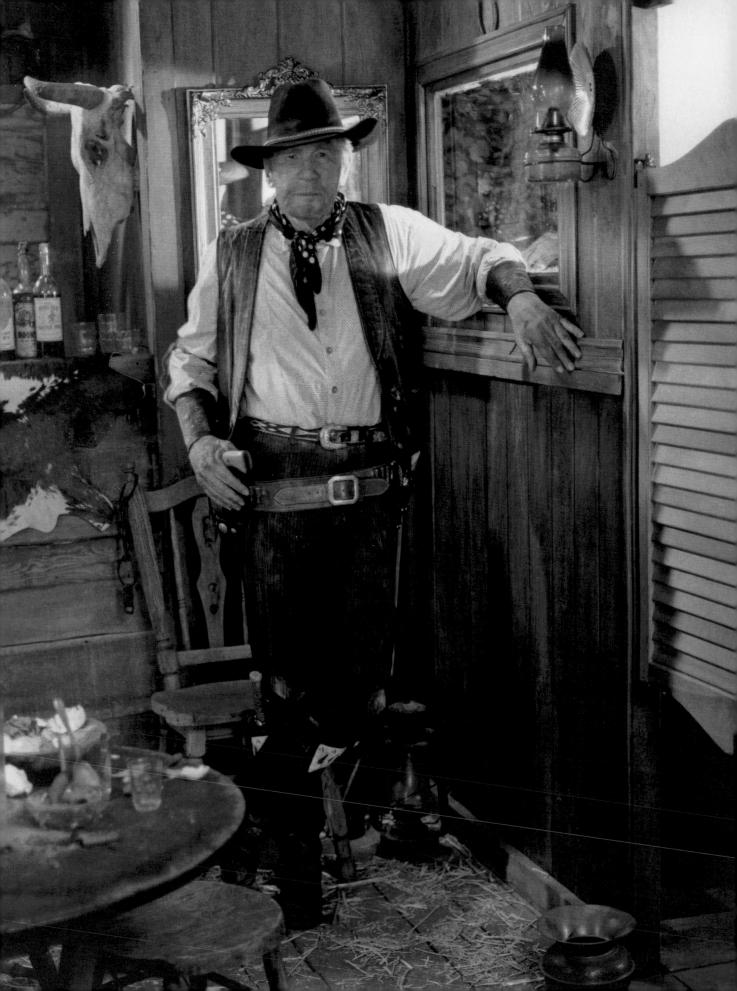

MITCHELL RYAN
CHARACTER IS TRUTH

TALL WITH CHISELED features, Mitchell Ryan has always had leading man's looks. And his voice commands authority or arouses sympathy as needed and, on occasion, both. He's been a monster-fighting hero on *Dark Shadows*, a cop gone rogue against "Dirty" Harry Callahan in *Magnum Force* and an ex-general running a drug empire in *Lethal Weapon*. Altogether, Ryan's half-a-century career has encompassed more than a hundred-and-twenty-five movies and television shows and countless stage performances.

His first movie came quickly following service in the Navy, 1958's *Thunder Road*, starring, produced and ghost-directed by Robert Mitchum, who gave the young actor "a grand time" in this now-classic road film about moonshiners. From *Thunder Road*, Ryan set out for New York and became a member of the famed Actors Studio, which led to several Broadway appearances, including the 1966 production of *Wait Until Dark*, in which he, along with Robert Duvall, terrorized blind Lee Remick.

New York City in the 1960s was still a creative hub for groundbreaking television dramas: "All the great shows were in New York in those days, before the big exodus to Hollywood. *The Defenders, Naked City* and *East Side/West Side* with George C. Scott were all New York-based. I was also doing a lot of theater, so this was a wonderful time. And we were working with great directors like Frank Shaffner, Sidney Lumet and Arthur Penn, who was also in the Actors Studio." Before heading west with his family, Ryan played the mysterious Burke Devlin on the gothic soap opera *Dark Shadows*, which introduced supernatural horror to daytime television.

In Los Angeles, Ryan got his first episodic Western, guest-starring on *The High Chaparral*, but it was a classic theatrical production that brought him to his role as Shorty Austin in *Monte Walsh*: "I was appearing in *Moon for the Misbegotten* at the Lindy Opera House on Wilshire Boulevard, the barn of all barns, and Bill Fraker and Lee Marvin came to see the show and cast me in *Monte Walsh*. I read the script, and I couldn't figure out how they saw me becoming a bronc buster. In the play I was as an Irish bum. That was really the first big movie. *Thunder Road* with Mitchum was so long before, and all the rest were TV shows." While Shorty Austin may look as if he was born on a horse, Ryan certainly wasn't. "Leroy Johnson would take me and Mickey Gilbert, who was my double, out riding every day. And they'd show me when I did something stupid, but they were pleased because I wasn't afraid, and that's a big part of it, just relaxing. They showed me how to ride, and I picked it up. I'm not a great rider or anything, but I did all right."

After his superb work in *Monte Walsh*, Ryan was cast opposite Clint Eastwood in *Magnum Force* as cop-on-the-edge Charlie McCoy before venturing to the fictional town of Lago in *High Plains Drifter*. "They were almost back to back, those films. It was great working with Clint, and he was starting to set up a repertory company of actors, kind of modelled after John Wayne and Ford." This story about a stranger riding into small town to exact revenge on a bunch of outlaws who'd whipped a marshal to death was Eastwood's follow-up as director to *Play Misty for Me* and represented a hike in budget and prestige as he returned to his signature genre and screen image. The question as to whether the film is merely a Western or a ghost story is something Eastwood slyly eluded for decades, but Ryan, as one of the town leaders, doesn't believe there's any otherworldly element: "I always thought it was the guy who came back, but that ending does make it 'up for grabs.' Lots of people see it as a ghost story because of that last shot of him seeming to vanish.

"That was a fun movie to make. It was the first time I'd been up in the High Sierra. We built that entire town, and painted it red, right on the edge of Mono Lake. And it's protected, like Fort Knox, by the Park Service. Very few films have been shot there—it's very hard to get permission. Later, I found out that when we finished, everything had to be taken down, and the area restored. Not a scrap of lumber or a nail could be left behind, and they did it."

For *The Gambler: The Adventure Continues*, Ryan appeared beside Kenny Rogers. Rogers had recorded a huge hit with his country-pop song "The Gambler" and played the lead in the series. Ryan recalled: "He was a very nice guy, but he'd write speeches for himself, explaining what we just did. So my co-star Cameron Mitchell did a great thing and asked if he'd ever seen *High Noon*, trying to get him to see the way Gary Cooper would do things—that less is more, that you don't have to over-explain. And it really helped."

JOHN SAVAGE
LIVING HISTORY

THERE HAS ALWAYS been a vulnerability to John Savage, a quality that brings a living, relatable aspect to the characters he's created, whether it's Steven in Michael Cimino's *The Deer Hunter*, the Army recruit who exchanges his uniform for love beads in *Hair*, the haunted detective of *The Onion Field* or even the scientist trying to defeat the beast in Roger Corman's *Carnosaur 2.*

No matter the project, the actor always stands tall.

Savage's career has stretched across every film genre and every budget, working with some of the most important filmmakers in the world, as well as those independent spirits who create with minimal money. After *The Deer Hunter*, Savage alternated between starring in prestigious film, television and stage productions and the projects of fledgling directors. He regards his roles in the smaller, unusual films as some of his most rewarding work.

Two of Savage's earliest movies were studio Westerns dealing with the trials of young people in harsh settings. A response to the Vietnam War, *Bad Company* focused on a group of boys who flee rather than get themselves drawn into the Civil War. Carried away by romantic notions of being outlaws, they soon face the realities of a bloody frontier. Written by *Bonnie and Clyde* scribes Robert Benton and David Newman, this revisionist Western was also Benton's first outing as director, and he cast it with amazing new talents like Jeff Bridges, Barry Brown and Savage, who played opposite such grizzled Westerners as Jim Davis and Ed Lauter. *Bad Company* was a novel war-themed Western, Savage says, because it "showed the other side of the coin, not the boys marching off with the drums playing. Making it, all I could think of were the images by Mathew Brady of the hundreds of thousands of people who were killed in the Civil War. When I was a kid growing up, looking at the books of those photographs, it really impacted me. I'd see these young faces of the soldiers and also cowboys. They were young people, just like today, caught in the middle of all this political and financial change and usually paying the price. At that time, if you were fourteen you were supposed to carry a gun and provide for the family. And if you crossed the wrong path, they'd string you up.

"There were a lot of great characters in that film, the actors who played the bad guys. Geoffrey Lewis was a real character star, and he was great. Ed Lauter—we stayed friends for years. When you're a young guy and you're facing Ed Lauter in a Western, you know you're in for trouble! He was beautiful, with a very dry sense of humor, a big-hearted man and very supportive of the young cast in the movie."

In *Cattle Annie and Little Britches,* two friends ride off in search of romantic adventure and penny-dreadful fame in 1880s Oklahoma. A valentine to the classic Western, the young leads, Diane Lane and Amanda Plummer, carry us along as they enlist the aid of Savage to teach them the ways of lawlessness in order to save their hero, Burt Lancaster, from being dogged by marshal Rod Steiger. Savage loved the film and filmmakers. "Lamont Johnson was a great director, and there were just great people involved with every part of the movie. The two young ladies in the film were just so professional and thoughtful. When you're working with people like that, they become your family. And Burt stood up for his gang; he had this energy that was very professional. He'd stand up, like a cowboy, and you'd hear his voice boom across the set. It brought everyone right back into line to go to work. When you have horses, they can get very easily distracted, and that can be a problem. But we had the best wranglers in the business, and they went way back with Burt. Those guys were just beautiful with the way they handled the animals and did their work."

For John Savage, each of his Westerns, including Bill Pullman's remake of *The Virginian* and *The Jack Bull* with John Cusack and L. Q. Jones, carry with them the historical past and the filmic history of the people making them. "With a Western, there are so many details, but you have these great experts with you when you make it. The chance to be in the skin of another human being is, for me, dependent on the time, locations, the story, the costuming and, with a Western, the history. All of that plays a role. Even images from your memory. Like in *Bad Company*, I was thinking about those photographs. I was always reading when I was young and always wanted more books. I saw all the old black-and-white movies and loved them. One of the first TV shows I did was *Cade's County* with Glenn Ford. He was a great man, and Cameron Mitchell was also in it. These are the actors that we grew up with, and that helped to build my interest in the part, my joy of it. I'm very lucky to be in this business."

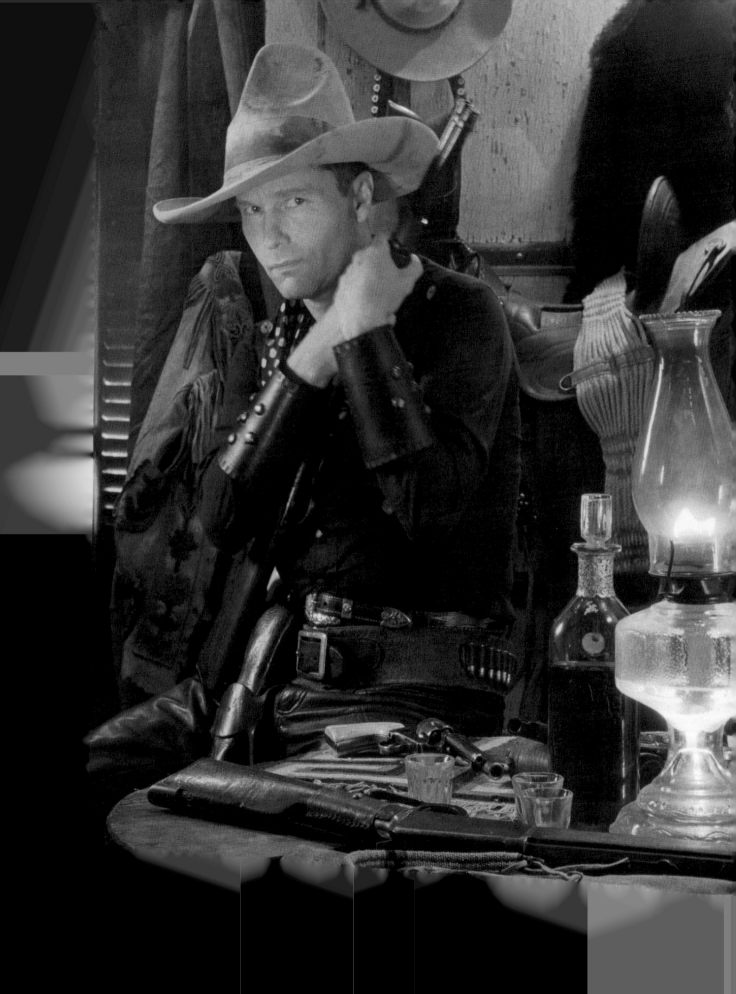

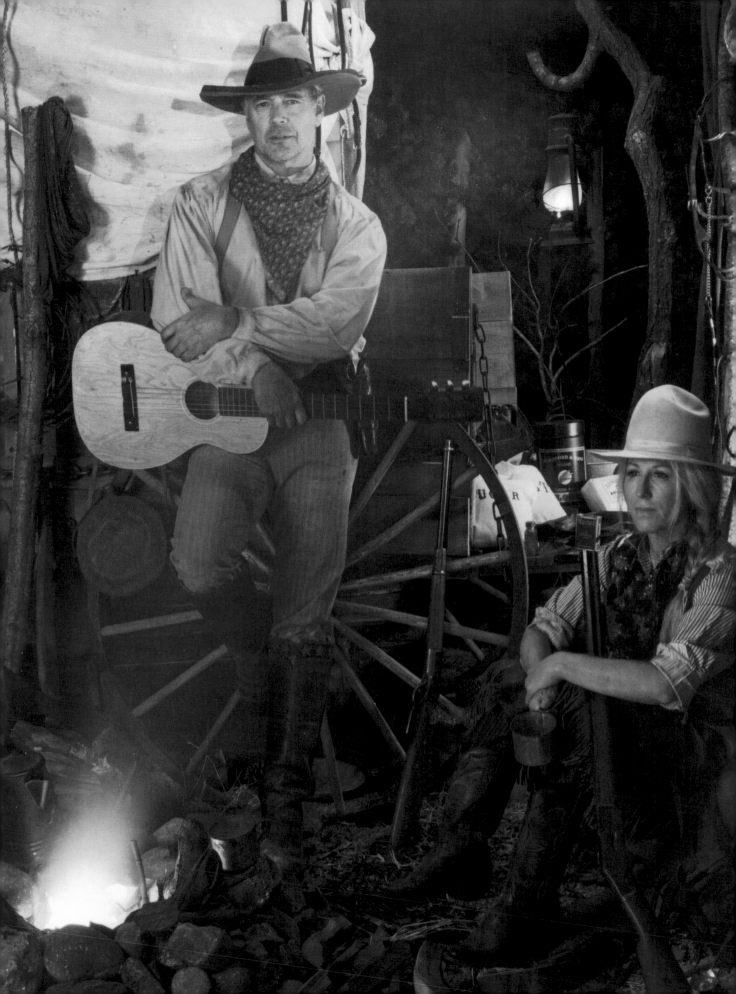

JOHN SCHNEIDER
JOURNEY FROM HAZZARD TO THE ALAMO

BEFORE TELEVISION STARDOM came to John Schneider at the age of eighteen, he'd done years of theater and gotten himself into the movies by jumping a fence to wrangling his way into crowd scenes of *Smokey and the Bandit*.

Schneider's family was living in Georgia when he got word that Burt Reynolds and Hal Needham were in town making the movie that would become a signature work. "I heard they were filming, skipped school, drove to where they were, climbed a fence at the location, found a guy with a headset and BS'd my way onto the set. It was my first time on camera, and I ended up spending the day with Jackie Gleason. I'm in a few crowd shots. Later, both Hal and Burt became really dear friends, and I told them what I'd done, and they admired my chutzpah. It's the kind of thing Hal would've done when he was starting, just walking onto a strange set and asking a wrangler, 'Where's my horse?'"

The teenage actor, blessed with country-boy good looks, had his professional life change forever in 1979 when he was cast as Bo Duke in *The Dukes of Hazzard*. The CBS show, derived from the drive-in hit *The Moonrunners*, became a ratings juggernaut, propelling Schneider and his younger co-stars Tom Wopat and Catherine Bach into TV stardom while introducing character greats Denver Pyle, James Best and Sorell Booke to a new generation of young fans, who loved the adventures of the Duke boys as they charged around Hazzard County in their souped-up Dodge Charger, the General Lee.

During a hiatus from *The Dukes*, Schneider made his way back to a movie set, but this time as the titular star of *Eddie Macon's Run*, where he worked alongside cinema legend Kirk Douglas. "Oh, my gosh, that was fantastic. You're making your first movie and co-starring with one of your heroes, who has done *The War Wagon* and so many great movies. That's amazing. Honestly, the overwhelming feeling I got was that I'm on a set with Kirk Douglas, and I'm really supposed to be here—my name's on the poster and on the call sheet, and I haven't climbed over the fence this time.

"Talk about tenacity, Kirk was in his sixties when we did *Eddie Macon's Run*, and there he was doing push-ups and pull-ups, all sorts of things, which re-

ally impressed me as a twenty-something. It was no wonder why this man was a movie star—because he took what he was doing seriously: the work, everything about it, and his physicality. He was very kind to my mother, and he told me he'd made a promise to himself that he would do push-ups or pull-ups, something physical, in every movie he did to show the audience that he was a guy who took care of his health. And obviously he does, because how many a hundred-and-two-year-olds do you know?"

When the series ended in 1985, John Schneider had stretched himself far beyond the good ol' boy comedy of *The Dukes* by pursuing his other dream of music and becoming a chart-topping country artist with a cover of Elvis's *It's Now or Never*. It was his work with music, his styling of lyrics and guitar, not simply his TV fame, that brought him into a remake of *Stagecoach* directed by Ted Post. With a cast of country-music superstars like Johnny Cash, Willie Nelson, Waylon Jennings and June Carter Cash, as well as Anthony Newley and Elizabeth Ashley, the project was designed not to tread on the sacred ground of the 1939 version but to approach the familiar story in an entirely different manner by including music for the characters written by the artists portraying them.

"There was going to be a lot of music in it, and each of us wrote a song, but we never recorded any of them because the project went a different way, and they decided to use all of Willie's music for the full movie. Kris wrote a song, Johnny wrote a song, but we never recorded what we'd written because there was no reason to. The Highwaymen's *Highwayman* was out, and I had a number one album, so for the five of us to record would have added easily another one-hundred-thousand dollars to the budget, so that was probably another factor."

The mini-series *Texas*, from James Michener's novel, gave Schneider an opportunity to portray a historical character, which he relished. "Unless you're making an entirely new, original Western, if you have the opportunity to do something historic, I think it's a good choice to go that way. Of course I'm a John Wayne nut, and to be able to play Davy Crockett at the Alamo Village, where Wayne made his *Alamo*, was a dream come true for me."

Left: John Schneider posing with Tami Orloff at IMAGE Studios.

*"I love that period
of our history,
that post-war period
in the 1870s,
when the West
really was wild."*

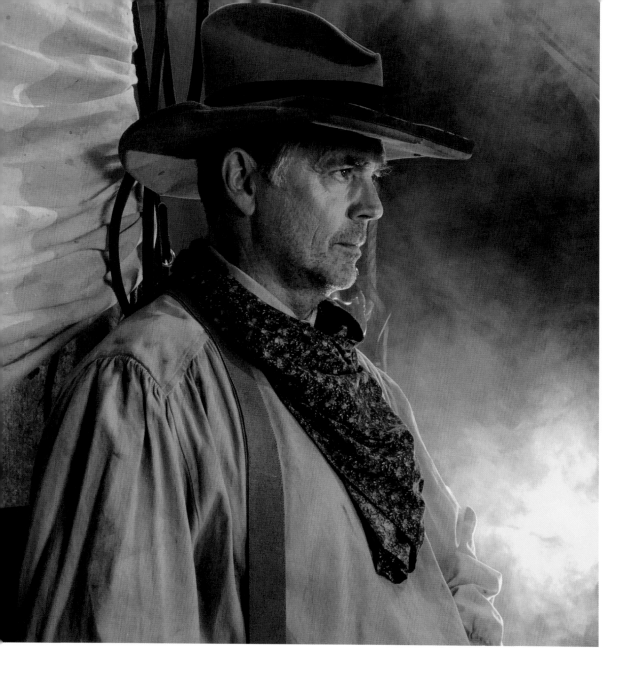

Later, in the telefilm *True Women*, co-starring Angelina Jolie, Schneider portrayed the man who didn't go to the Alamo. "I played Sam Houston, so I got to also be the guy who didn't show up at the Alamo to save Davy Crockett! We filmed that near historic ground just outside of Austin. We were within miles of where Sam Houston was with his troops when he decided not to go to the Alamo. Being there really gives you a feeling of the reality. It helps your process to become these people. Powers Boothe was in that, and what a great actor he was."

For an episode of *Guns of Paradise*, Schneider again played a historical figure, but one with a bloody history as a lawman, Pat Garrett. "This was all before the Internet. Now I'd just enter 'Pat Garrett' and see what came up. At the time, my research for a Western role was watching films, like *Little Big Man* and *Pat Garrett and Billy the Kid*. And reading. *The Assassination of Jesse James by the Coward Robert Ford* is a great book for that period. I love that period of our history, that post-war period in the 1870s, when the West really was wild."

JACQUELINE SCOTT
ALL-AMERICAN GIRL

In Don Siegel's thriller *Charley Varrick*, a young deputy has asked to see Jacqueline Scott's driver's license since she's illegally parked in front of a bank, having no idea that the woman is the getaway driver for a robbery. She digs into her purse for her wallet with a great smiling expression and then shoots him in the face. It is not the sudden, horrifying violence, it is Jacqueline Scott's perfectly natural presence that carries the sequence. Whether period or contemporary drama, she *belongs* in any scene in which she appears.

Mention this to the actress and the response is modest laughter that drifts into a Missouri hoot. "You always try to be real, but all those Westerns I did? I couldn't ride! Actors don't tell the truth and always claim to be able to ride, and they get out on location, and they can't. I told them that I couldn't ride and what they'd go through with me to get me to ride into a shot. I had uncles and cousins who were championship bronc riders, but I didn't get their genes. If the horse was standing still, then it was fine, but that was it."

A tap dancing little girl who loved the movies, Jacqueline Scott knew that acting was her destiny. After high school, impressive work with a theater company in St. Louis took her to New York and the legendary acting teacher Uta Hagen. Cast opposite Louis Calhern in a Broadway production of *The Wooden Dish* opened the eyes of producers to her talent, and Scott landed the ingénue role in *Inherit the Wind* with Paul Muni and Tony Randall. Her performance as the young girl in love with a teacher who's on trial for lecturing his students about evolution won her raves, and the dramatic smash, now Broadway history, brought her starring roles on live television as well as the horror film *Macabre*, directed by William Castle. No one collected on the thousand-dollar insurance policy against "death by fright" that the movie promised, but the gimmick drove *Macabre* to make more than five-million dollars, and Jacqueline Scott, who met her husband writer-photographer Gene Lesser on the film, had now starred in a hit movie. Roles in TV Westerns rolled in: "I did one *Have Gun – Will Travel* every year. The show ran for five years, and I did five. I think Andy McLaglen directed at least three of those, and he was also on *Perry Mason*. He was great." She was frequently asked back by producers and directors who loved working with her. "I did eight Gunsmokes. They were the most wonderful people to work with. And I was crazy about James Arness when he walked on the set. For me it was just Christmas. He held that show together in such an unobtrusive manner. He was the classic big, strong, quiet man who ran the world."

Gunsmoke director Vincent McEveety insisted on Scott for *Firecreek*, his dark Western with James Stewart, Henry Fonda, Barbara Luna and Morgan Woodward. "Fonda and Stewart, as enemies, that was something. It was so wonderful to work with Jimmy Stewart. I worked with Paul Muni on Broadway and Jimmy Stewart in the movies, so where do you go from there? You've hit the top in both venues, so you might as well retire and go to the beach!"

One of Scott's most dramatic turns was a guest-starring role on *The Virginian* in an episode titled "Throw a Long Rope," which delivered a brutal indictment of capital punishment, but co-star Jack Warden kept the shooting light. "One of the funniest men who ever lived, just witty and funny. Here comes the Virginian carrying my husband, who they'd tried to hang. And he comes crashing through the front door, with Jack in his arms, and Jack reached up and kissed him! Jim Drury nearly had a heart attack! Jack was such a fun person, a wonderful actor and a wonderful man."

The actress can't say the same about Richard Widmark, her co-star in *Death of a Gunfighter*. "I was cast by Robert Totten, but Widmark hated him. He was a wonderful director and wanted to do things in a realistic way. He had the man who was killed stretched out on a pool table in the bordello, and the hookers all around him in their dirty nightgowns like it really would have been in the Old West. But Widmark would not have it. Widmark was a nice man off the set, but working, he had to tell everyone what to do." Totten had been a protégé of Don Siegel's. When Widmark had him fired, Siegel took over the film, which resulted in a friendship between the director and Jacqueline Scott that would take both through five more movies. "I loved Don. He was so dear and funny. I was very fortunate. I loved what I did. I worked hard and had a good time. And luck. You have to have luck."

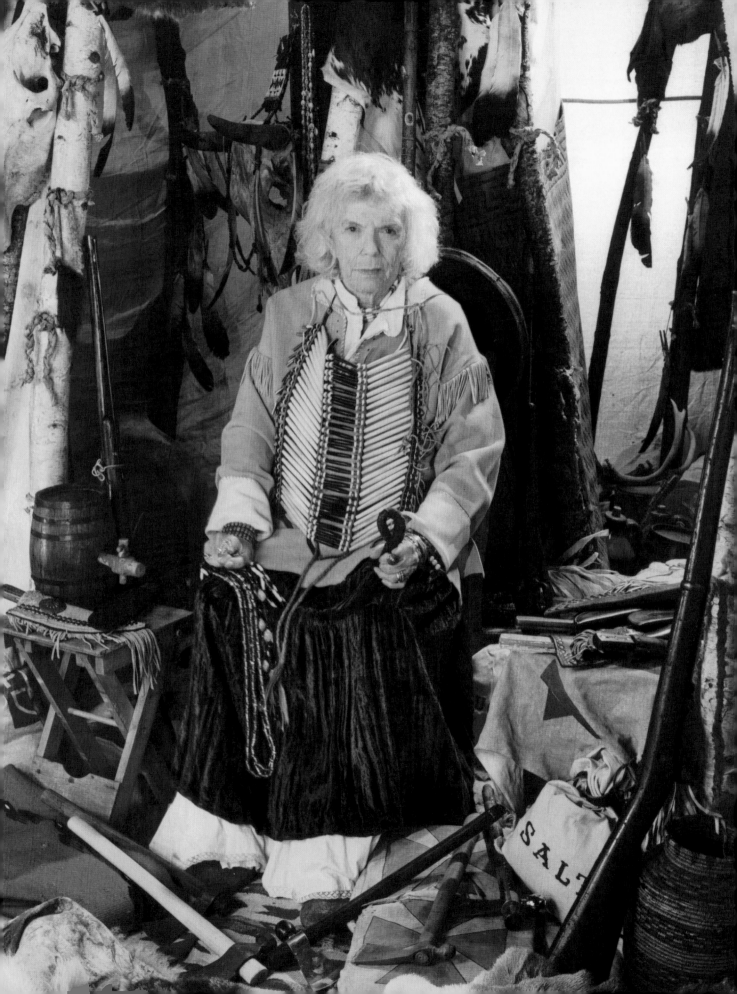

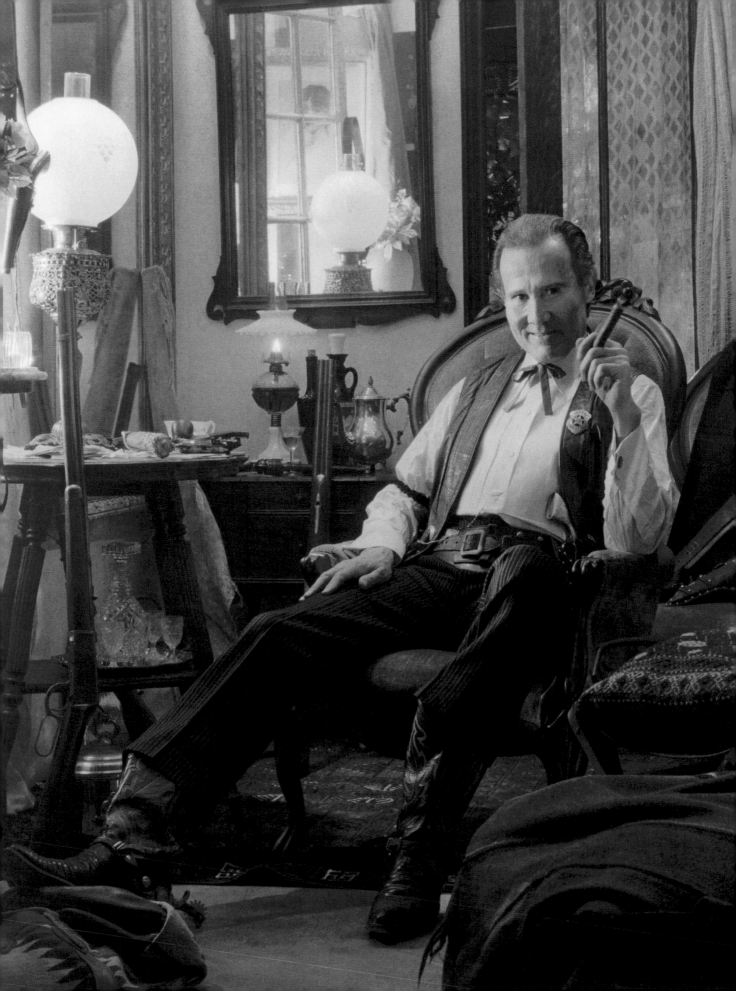

HENRY SILVA
BAD GUY HERO

"You didn't have to kill him." Chink shrugged.
"I would've, sooner or later." "Why?"
"That's the way it is."

WITH THIS PERFECTLY simple exchange of dialog, Elmore Leonard introduced one of his meanest villains in his 1955 novella, "The Captives." When director Budd Boetticher and screenwriter Burt Kennedy expanded the story for their star Randolph Scott the following year, they dubbed it *The Tall T*, which remains one of the classic Westerns of the 1950s, as Scott, kidnapped along with Maureen O'Sullivan, faces not just outlaw Richard Boone but also Henry Silva as the cold, psychotic Chink. Leonard later claimed that Boone and Silva were two actors who "understood the voice of the characters."

For the young actor, with just the little-seen *Crowded Paradise* and an unbilled part in *Viva Zapata!* as his only films, this was a mighty but not unexpected compliment. New York-born Henry Silva had been impressing audiences on the stage and in a handful of excellent television roles, including a classic episode of *Alfred Hitchcock Presents*, "A Better Bargain," which had him playa mob hitman for the first but not the last time. But *The Tall T* was the kind of movie that a younger Henry Silva had gone to see in his old neighborhood, and it gave him the chance to play opposite one of his heroes. "I grew up watching Randolph Scott. That's who we went to see, so this was a real honor. And what a gentleman he was. Of course, I was a bad guy, and he got me good, but that film set up a lot of other roles for me."

Recreating his stage role of Mother, a razor-edged drug dealer, in the movie version of Michael Gazzo's play *A Hatful of Rain* came next. Directed by Fred Zinnemann, this searing examination of a Korean War vet's morphine addiction was well-acted by Don Murray, Eva Marie Saint and Silva, who spreads narcotic misery among the cast with a snake's smile and a flicker in his eyes. That deadly smile was put to fine use in Silva's next Western, *The Bravados*, in which he played one of a band of killers tracked by Gregory Peck for destroying his family. What sounds like a standard Western tale is given an unusual twist by screenwriter Philip Yordan as Peck takes revenge for the death of his wife only to

discover that the men he's been hunting and killing were innocent. *The Bravados* makes the point that morality can be ambiguous, and the righteous don't always make the correct choices. At the film's end, Peck's conscience is almost washed clean by local townsfolk, who claim that outlaws like Henry Silva "are guilty of something" and deserved to die. The justification doesn't work, and Peck must live with the blood on his hands.

1963's *Johnny Cool* was the film expected to propel Henry Silva to leading man status. With Elizabeth Montgomery as leading lady and her husband, William Asher, directing, this tight, vicious gangster drama did well with critics and audiences, but its release as a second- rather than as a first-billed feature cost Henry exposure. If the film didn't transform him into the new Robert Mitchum, it did solidify his image in the minds of American audiences. They'd known for years that there was trouble ahead whenever Silva stepped into view, but *Johnny Cool* added another layer of character, a presence of danger that forever tied him to the crime genre while opening an entirely new career overseas, where Silva would be a major star.

In 1964, Leone's *A Fistful of* Dollars was a major hit in Italy, a full three years before it came to the United States. Clint Eastwood was back working on *Rawhide*, unaware that the Western he had shot in Spain was transforming the genre and that he was about to become an international superstar. Dino De Laurentiis was one of the first major producers to take notice of Leone's film before its U.S. release and put his Western *The Hills Run Red* into production in 1965 with Silva as its star villain. De Laurentiis slyly cast handsome but unexceptional Thomas Hunter as the protagonist, giving Silva the chance to dominate every scene by his mere presence. Taking a wild, near-operatic approach to his part as the bandito Mendez, Silva blows Hunter right off the screen.

Henry Silva would return to Europe several times in the wake of the Spaghetti Western boom, starring in features like *Assassination, Frame-up* and *The Manhunt*. Never a blond-haired, blue-eyed clone of Eastwood or McQueen, he specialized in playing Euro-cool cops, assassins and secret agents, fighting more often for the good than the bad. "It's funny," he recalls. "Over here in the States I'm a villain, but in Italy I was a hero."

TOM SIZEMORE
DANGEROUS CITY SLICKER

BAT MASTERSON ARRIVED in Tombstone in the Arizona Territory in February 1881, it was to help his old friend Wyatt Earp establish control over the wildness of the Tombstone gaming parlors. Thanks to the Battle of Adobe Walls in 1874, when he held off a war party of Comanche for four days, Masterson acquired a reputation as a man who could handle a gun. This is the Bat Masterson that Tom Sizemore epitomized in Lawrence Kasdan's 1994 epic, *Wyatt Earp*, which also featured Kevin Costner and Gene Hackman.

Masterson's later elegant style and trimmed mustache would become his signature, adding a sheen of sophistication to this lawman who kept Dodge City from blowing apart by using his reputation as a fast gun. In truth, he fatally shot just one man and wounded only three others over many years. The pile of outlaw corpses that Masterson reputedly left behind in Dodge City was a myth, in other words, and Bat embraced it, giving himself an edge at the gaming tables with ladies and the ornery cowboys he sometimes had to arrest.

The mythical Bat Masterson did not yet exist when he stepped in to help Wyatt and keep Doc Holliday, whom he disliked, either in line or just at bay. This bit of historic color is just one of the fine moments in *Wyatt Earp*, a film that opted for authenticity over Hollywood embellishment. From an original script by Dan Gordan, *Wyatt Earp* started production having to fight an uphill battle against Hollywood Pictures's *Tombstone*, which was being shot at the same time. A somber elegy to the West, *Wyatt Earp* lacked the pop-culture sizzle of *Tombstone* but made up for it with verisimilitude and a potent sense of its characters' mortality. For the famed gunfight at the O.K. Corral, *Tombstone's* Earp brothers, Sam Elliott, Bill Paxton and Kurt Russell, make great movie heroes, but the understated Costner as Earp in Kasdan's opus is made of bleeding flesh and bone, his ability to find a clean line between right and wrong at times limited by his own existential fatigue. The two motion pictures may cover similar themes and depict similar narrative scenarios, but their tones, in other words, couldn't be more different.

What this meant for Tom Sizemore was that he played Masterson as a man whose sense of self was his greatest weapon. Simultaneously, though, he prevented Bat from slipping into smirking arrogance.

The real Bat Masterson was a brave, complicated man of the West, and Sizemore captures all of this well.

Masterson had been brought to the screen already several times. Randolph Scott played him as a sophisticated cowpoke in *Trail Street*. George Montgomery made him into a stalwart town marshal for *Masterson of Kansas*, a Columbia B picture directed by horror maestro William Castle. And Joel McCrea invested his colored his treatment of Bat with sincere realism in *The Gunfight at Dodge City*. The historical character became the idol of kids everywhere thanks to the cane-wielding gambler Gene Barry created for the *Bat Masterson* TV series that ran from 1958 to 1961. The show's theme song summarized the character with lines its avid viewers would sing along to: "Back when the West was very young / There lived a man named Masterson / He wore a cane and derby hat / They called him Bat, Bat Masterson." Barry's dandyish take contrasted with the less effete Western heroes who galloped across TV screens at the time, and it stuck like a hot-iron brand to Masterson's history, which was at once far rougher and less bloody than Barry's interpretation.

For *Wyatt Earp*, Sizemore boils down the history and essence of the gunman and plays him as he would a heartland cop, a canny choice, as *Wyatt Earp* looks at the incident at the O.K. Corral as a dark and terrible act of violence, a crime. As good as it was, though, the film suffered when compared to *Tombstone*, both critically and commercially, and only now is it being re-examined. Tom Sizemore's performance as Bat Masterson is one of the reasons for its critical revival.

For Sizemore, the picture remains his only Western. His cinematic fame arises rather from his work in the hits *Saving Private Ryan* and *Black Hawk Down* and more than a hundred-and-fifty other roles. In fact, the actor has largely stayed away from period subjects, preferring the language of the streets to the prairie and the feel of an AK-47 to a six-shooter. But his single turn as lawman Bat Masterson in *Wyatt Earp* still resonates as one of the best portrayals of this icon of the American West.

Right: Tom Sizemore posing with Sierra Devia and Danielle Overbey at IMAGE Studios.

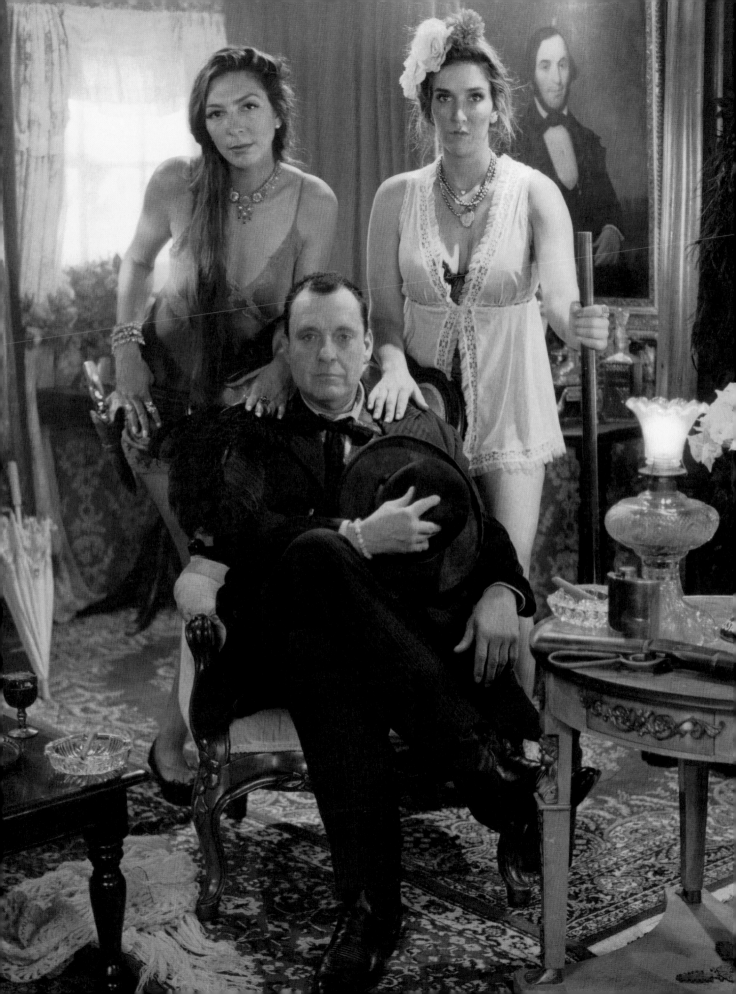

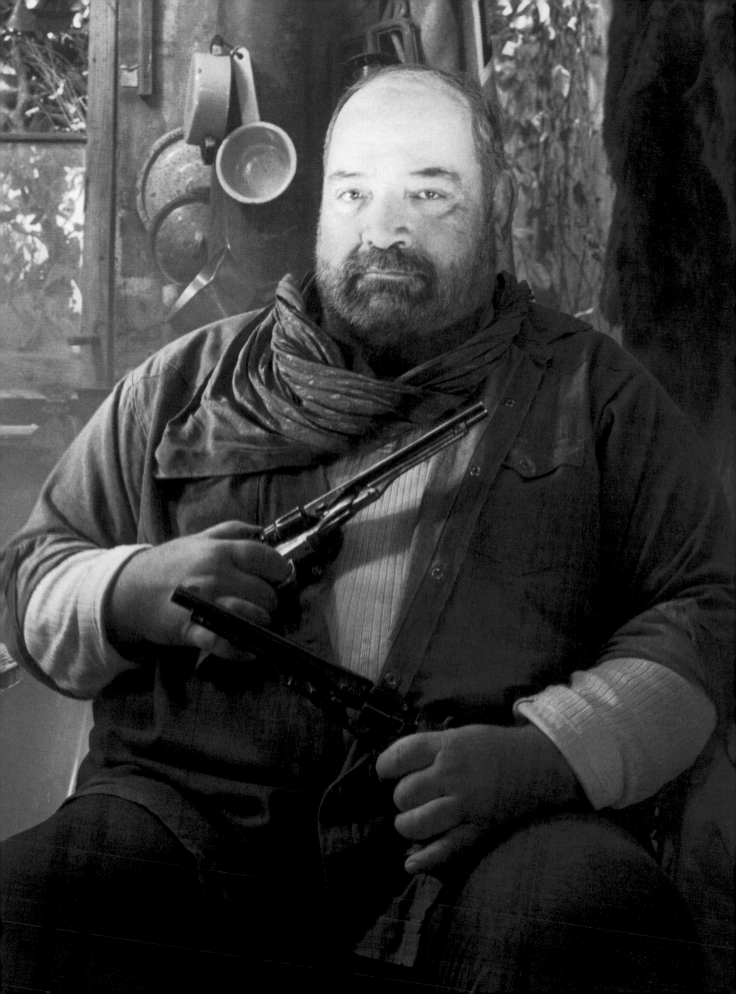

PAUL L. SMITH
TALENT OF THE BRUTE

HIS FACE SEEMED to be a muscled scowl that had his jaw permanently locked. His thick neck was one with his shoulders, which were one with his massive chest. That was Paul L. Smith as Bluto in *Popeye*, as Rabban in *Dune*, as the sadistic prison guard in *Midnight Express,* towering and terrifying. Until he broke into a grin, of course, and the monster became the good fellow sitting next to you at the diner or the guy who offers the helping hand when you have a flat tire.

Born in Massachusetts in 1923 and educated at Brandeis and Florida State, where he took a degree in philosophy and, like Burt Reynolds, played football, Smith dedicated himself to Judaism and to Israel, later moving there with his second wife. His film debut came in 1960's *Exodus,* the story of the creation of the Israeli state. He had a tiny role, but it started Smith on his professional path.

Smith made his movies in North America, Europe and the Middle East. A dead ringer for Euro-Western star Bud Spencer, he was cast opposite a Terence Hill-clone, Antonio Contafora, in a series of low-budget Italian action films with titles like *Convoy Buddies* and *Diamond Peddlers*, which threw as many jokes and gags as punches. Ever the dedicated craftsman, Smith got into a legal row with the American distributor of these pictures, who wanted to hide his name behind a pseudonym that would fool action audiences into thinking he *was* Bud Spencer.

This was all before *Midnight Express* and his astonishing performance as Hamidou, a guard who tortures Brad Davis's Billy Hayes, which gave audiences nightmares for a year. This unflinching depiction of life in a Turkish prison had Paul L. Smith take us into depths of suffering we'd rarely seen. The hugely successful film brought him more roles on prominent U.S. television programs, like *CHiPs* and *Barney Miller,* and larger films that included his first Western, *The Frisco Kid.* Directed by Robert Aldrich, it is one of the director's best later efforts, seamlessly combining comedy with action in its story of Gene Wilder's rabbi and his adventures with cowboy Harrison Ford. Smith played a ruffian who menaces Wilder.

The man-mountain continued on television, playing heavies on everything from *Wonder Woman* to *Hawaii Five-O,* always making a physical impression, dominating scenes with his size. Robert Alt-man perfectly cast Smith as Bluto in his big-budget version of *Popeye*, produced by Robert Evans and starring Robin Williams. The movie's recreation of the mud-covered seaside village of Sweethaven is a visual miracle that captures the feel and spirit of the original comic strip. Williams is wonderful as the famous one-eyed sailor, especially in capturing his famous animated-cartoon voice, but it's Smith as the volcanic Bluto, who hates Popeye as much as he loves Olive Oyl, who seems to have been torn directly from an old, yellowing copy of the funny papers.

Paul L. Smith continued in small and larger roles, but his attention and studies were turning more and more toward Israel as he returned there for a number of projects, such as *Masada* and also *Sadat*, in which he portrayed King Farouk. Yet he never ignored his action and exploitation roots, taking on menacing roles in the wonderfully schlocky *Jungle Warriors*, infamous as the film on which Dennis Hopper had a mental breakdown, and the bizarre over-the-top Italian gore-fest, *Pieces*, which had him slaughter a spate of victims with a chainsaw. *Dune* and the *Conan the Barbarian* sequel *Red Sonja* kept Smith busy with major American-financed studio projects, still scowling and flexing his muscles, too. But his inner calling was to Israel as he devoted more time to travelling there and studying sacred texts.

His final studio film was also his final Western, Richard Donner's grand-scale version of *Maverick*, with Mel Gibson, Jodie Foster, James Garner and an amazing array of Western guest stars. Everywhere one looked in the frame, there was a face from the movie or TV Western past, and Smith stood as tall and massive as the others in his role as the Archduke. He dominated his scenes, causing the eye always to stop on his remarkable, barrel-chested, hulking appearance. A major film on all counts, *Maverick* is a fitting farewell for the actor who took on roles in small-, medium- and large-budget projects.

Paul L. Smith cut his own place in movie history portraying the worst villains ever committed to celluloid. People remember him as the baddest of the bad, the villain who kept his quiet, intellectual and spiritual side away from the camera and saved it for himself and his family. The brutish bad man with a heart will be his enduring legacy.

WILLIAM SMITH
BEST OF THE BAD MEN

Cowboy you were America, you were the West
You were the legend, you were the best.

—from "Cowboy"

THE TWENTY LINES of William Smith's poem "Cowboy" relay the actor's love of the West with the rhythm of a blacksmith's hammer, each measured stanza making its point about the frontier and the men and women who settled there. The poetry is direct and honest, revealing the soul of the cowboy and a love of country from an actor who rode the range for decades but not always on the right side of the law.

Whether saving the heroine or facing a bloody end, William Smith always stood tall. No matter what, he owned the screen when he was on it. He began his career as a child actor, first appearing as one of a group of young village ruffians who are frightened by the monster in Universal's classic *The Ghost of Frankenstein*. Other parts followed in *A Tree Grows in Brooklyn* and the war allegory *The Boy with Green Hair*. Smith's expertise with multiple languages, including Russian, served him well during a stint in the Air Force, for which he flew missions over the Soviet Union.

During the early 1960s, he racked up an astonishing number of credits, taking on guest-starring parts on *Wagon Train* and *Bonanza* and Burt Kennedy comic oater *Mail Order Bride* opposite BarBara Luna. Winning the role of Texas Ranger Joe Riley in *Laredo* allowed Smith the chance to be a full-fledged Westerner. With a nod to *Maverick*, *Laredo* balanced comedy and drama, the bad guys dying at the feet of heroes, who always had a wisecrack or two. Smith's Riley character was definitely a wild card. If there was a scheme to be had or a beautiful lady bank robber on the prowl, you never knew which side of the law Smith was going to favor.

Laredo ended after two seasons, but Smith did not miss a step, moving on directly into guest-starring roles on *Custer* and returning several times to appear opposite James Drury in *The Virginian*. Beyond these trips West, Smith appeared in *I Dream of Jeanie*, *Batman* and *Felony Squad*, demonstrating beyond doubt to all watching his versatility. Like co-star Bruce Glover, Smith went for laughs as one of the baddies in *The Over-the-Hill Gang*, threatening Walter Brennan, with whom he'd worked on *The Guns of Will Sonnet*. Though Smith was making regular appearances

on *Daniel Boone* and *Death Valley Days*, he established another image for himself on the big screen, trading his horse for a Harley. Since Roger Corman's *The Wild Angels*, the biker flick had become a force at the drive-in box office, and Smith found movie stardom in *Angels Die Hard*, *Run, Angel, Run!* and *The Losers*, which co-starred Paul Koslo. Often working with hard-boiled director Jack Starrett, Smith, his massive arms exposed and mouth a curled gnashing snarl, was a true badass of the movies.

He eventually embraced darker roles on network television, too. He had appeared on *Gunsmoke* a number of times but never in a role like Jude Bonner in the landmark episode "Hostage." Smith here is an unleashed animal, terrorizing Miss Kitty, raping her and shooting her twice before facing Marshal Matt Dillon in a brutal showdown. During production, Amanda Blake, who played Miss Kitty, wanted to keep the mood on the set as light as possible, given the horrifying story they were filming. She joked with Smith: "You're playing Jude Bonner? Well, I haven't been had on this show yet, so do me up right!"

Blake was nominated for a Golden Globe for her incredibly strong performance, and Smith continued on, playing tough villains in films and television before being rewarded with the ultimate bad-guy role, the man with the eyepatch, Falconetti, on *Rich Man, Poor Man*. The mini-series broke viewership ratings, setting records with each episode, and Smith became one of the most recognizable heavies in the world. It was another accomplishment before moving on to other roles, including the *Rich Man, Poor Man* sequel, and two for John Milius, *Conan the Barbarian* and *Red Dawn*.

Smith returned to the Old West for Robert Aldrich's *The Frisco Kid* and the excellent series *Wildside*, among a stampede of other Western-themed projects. When those commitments ended, he forged ahead, amassing a credit list of more than two-hundred-and-fifty screen appearances, making his mark with each. But William Smith's heart has always beat with the spirit of the West and what it once meant to the country, which his poetry, especially "Cowboy," embodies:

The lines in your face marked the trails that you rode
The truth in your eyes mirrored that Cowboy's code
That code of the West that we lost so long ago
We love you, Cowboy. Where did you go?

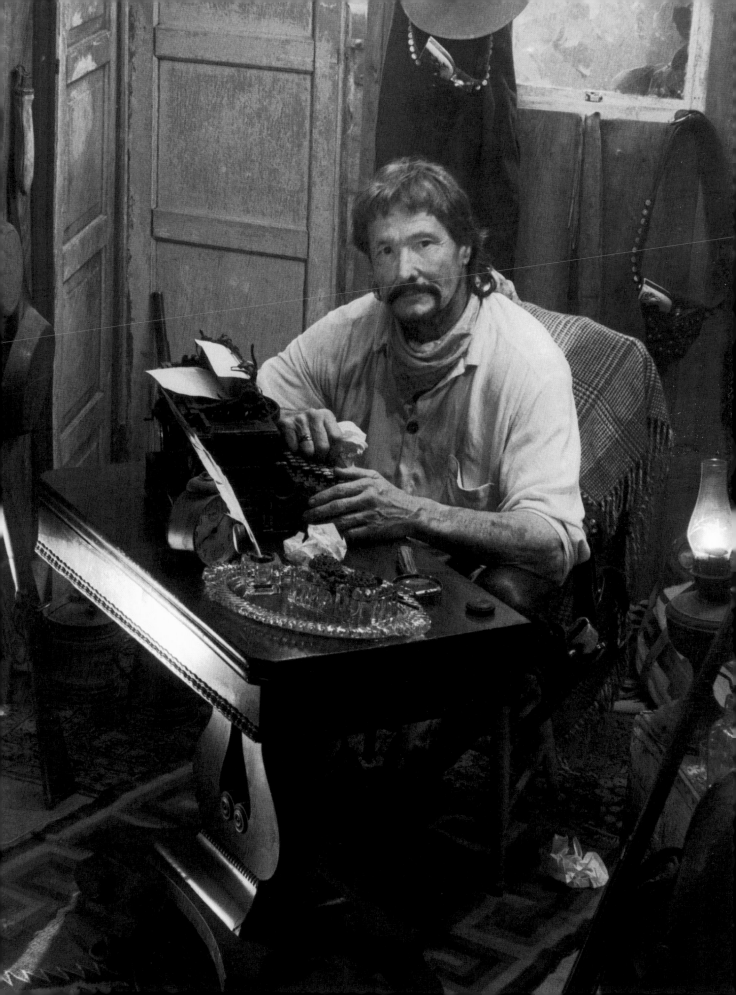

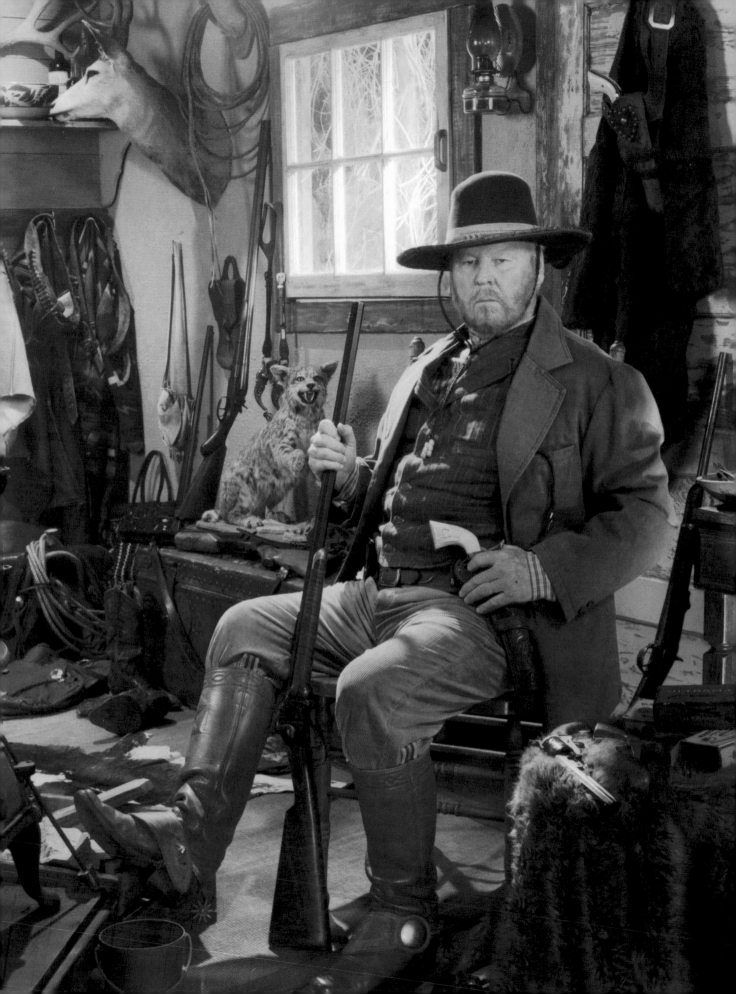

PHIL SPANGENBERGER
HISTORY'S HIRED GUN

THE WEAPONS THAT tamed the West are as much a part of our visual collective memory as any authentic tintype from the 1880s, any painting by Frederic Remington, any novel by Zane Grey or any dusty movie hero stepping through the batwings into a saloon. The winning of the West and the coming of law and order are forever tied to the guns used by pioneers, outlaws, lawmen, warriors and troopers.

Firearms editor for *True West* magazine, Golden Boot winner and *Guns and Ammo* contributor Phil Spangenberger has been the standard-bearing authority on the history of firearms produced over the last two centuries. But it is not enough that he is an expert collector, researcher and historian; Spangenberger also performs his own Wild West show, demonstrating his trick-shooting skills and recreating Buffalo Bill's famous routine of blowing away targets from the back of a running horse.

His unrivaled expertise brought him to the movies, where authenticity was sometimes sacrificed for dramatic license. Spangenberger refers to this tendency as "Firearms Fakery." He explains, "As an example, the studios used to use 1892 Winchester rifles and made them look like Henry rifles for all their Westerns because through the '40s, '50s and '60s, there were only a few Henrys in existence in Hollywood. You can see a real Henry rifle in Bill Holden's hands in the movie *Arizona,* which was 1940, but you never see him fire it because it couldn't take a .44 blank. Navy Arms made a reproduction of the Henry about thirty-five years ago, and now everybody uses them."

Alterations on weapons aren't uncommon. "John Wayne always used regular Peacemaker Colts. The only special work he had done on a weapon was the big loop lever on his Winchester, so he could twirl and fire it, like in *True Grit,* and he credited Yakima Canutt with that idea. The Rifleman character on the TV show had something similar, but the difference was Wayne had to actually pull the trigger, but for Chuck Connors, as soon as he cocked the rifle and pulled the lever back, it had a little screw on it that would pull the trigger so he could walk down the street and shoot—bang! bang! bang! bang!—real quick."

1980's *The Mountain Men,* starring Charlton Heston and Brian Keith, required special training for its stars to handle the muzzle-loading rifles the story required. "That film was a lot of fun, and Heston was very good. He told me, 'I've been a hunter all my life, but I've not handled guns like this.' He'd done a film about Andrew Jackson called *The President's Lady* and was riding on a horse with Susan Hayward. They got attacked, and he had to fire two flintlock pistols. So he's re-loading the pistols, talking to her, remembering his lines and controlling a jittery horse all at the same time! Heston said, 'It was really difficult, but thanks to guys like you, Phil, you make us look like we know what we're doing!'"

Never slowing on his work as journalist, collector, showman and historian, Spangenberger and his film duties have cut a wide trail. He's weapons-trained everyone from Milla Jovavich (*Resident Evil*) to the cast of *American Outlaws* to Will Smith in *Wild Wild West.* Every commitment produces new challenges, which Spangenberger fully embraces when the actors put forth genuine effort as well as an understanding of safe conduct. "I was showing some tricks with a pistol to an actor, a very good actor, and he wanted to do them right away. I told him, 'You have to walk before you can run.' He didn't want to learn the basics. The successful actors are like chameleons; they learn fast and they adapt. And I'm making them look like heroes, and if they're going to be the bad guys, then I make them look like somebody you don't want to fool with."

Mel Gibson's onscreen heroism was augmented considerably after Spangenberger went to work on *Maverick.* "I got a call from a prop man who was doing a gun-safety class after Brandon Lee had been killed by a blank on a movie set, when the bullet from a dummy cartridge had lodged in the gun barrel and no one knew it, and he was shot. I did my safety talk. Afterwards, they asked me to do a little bit from my show, so I twirled some guns and performed fancy tricks, and a fella came up to me and asked if I'd worked with big stars, and I told them about Heston. He was doing *Maverick* with Mel and wanted someone to work with him. Mel was so hot at the time. Of course I said, 'Yes.'"

"I wound up teaching Mel, and, unfortunately for me, he was too fast a learner! I would have liked to have spent a little more time with him. He was very good and fun to work with. Mel was used to semi-auto pistols but had no experience with a single-action revolver. The scene we really worked on

"Heston said, 'It was really difficult, but thanks to guys like you, Phil, you make us look like we know what we're doing!'"

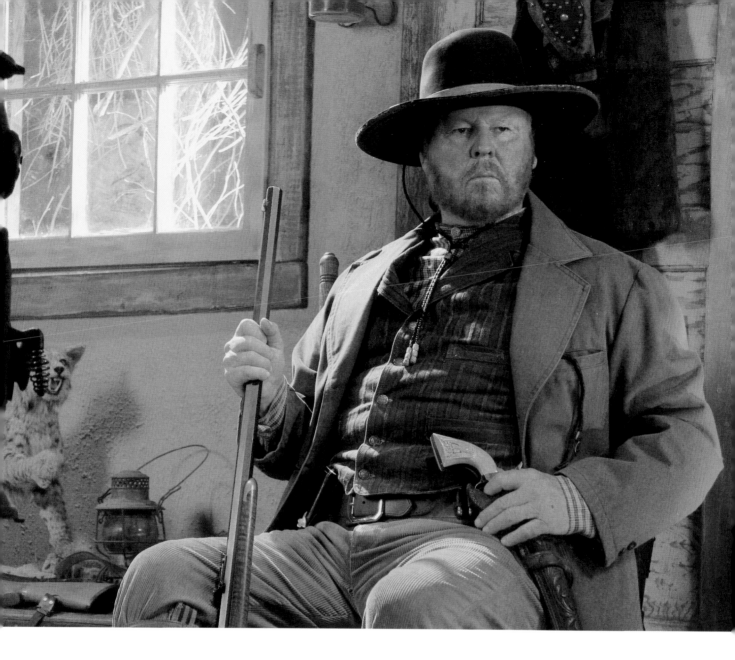

was the card game with John Wesley Hardin, and Mel pulls his gun. He wanted to do it lightning fast, and I said, 'That depends on you.' I noticed he was very tense when he drew his gun, so I told him he had to learn to relax. I twirled my guns and he had his hands on my arm so he could get the feel of the muscles, and he understood. In a fast draw one of the secrets is the element of surprise. So I'd draw my gun, and I had Mel clap his hands together to try to trap it when I brought it up to gauge his reaction time. Then he took the gun and tried it with me and said, 'Like this?' And I still had my hands out! I'd missed trapping him he was that fast. I knew that scene was going to make the final cut."

The scene is one of the signature moments from the blockbuster Western and the highlight of the preview trailer. Although he didn't receive a screen credit, Spangenberger does appear in "The Making of a Maverick," a featurette that brings attention to his gun-handling methods and their influence on the motion picture. "My credit fell through the cracks, but I ended up in a better situation because they did a documentary, and I'm in it for about three minutes showing some tricks, with Mel standing there looking astounded. They referred to me as 'The Best' when Mel did what I taught him. That's my signature calling card, even though it's an older film, because Mel did so well in it."

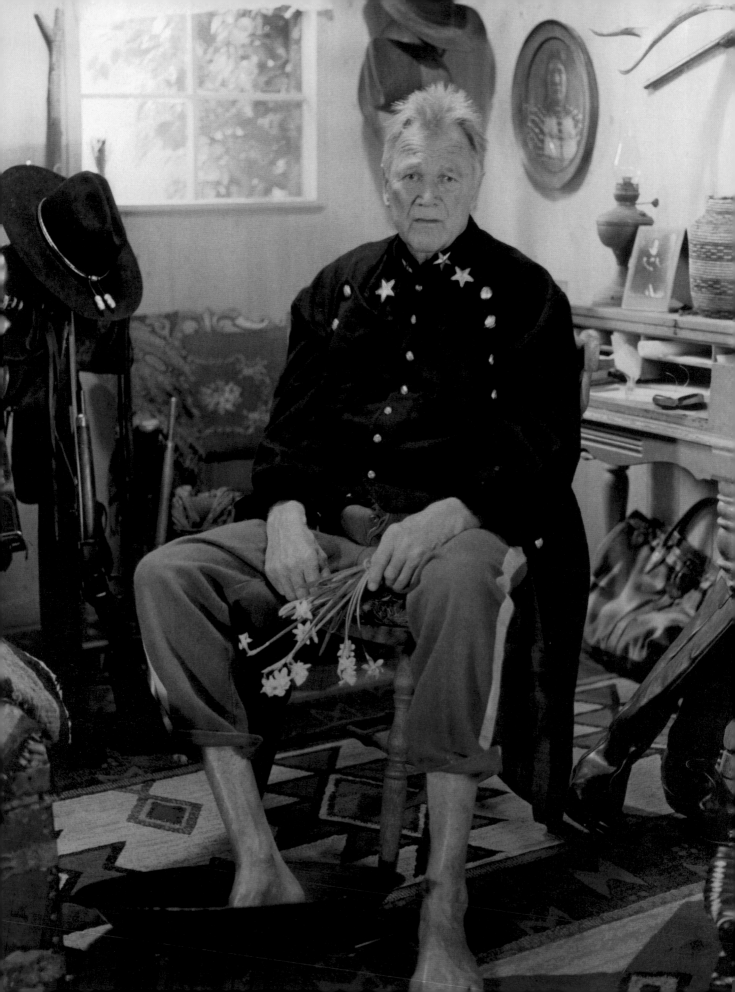

BO SVENSON
GENUINE ARTICLE

WHEN BO SVENSON was cast as Olaf in the Western series *Here Come the Brides*, it wasn't simply a matter of the right actor for the right role; he *was* the role. The Swedish-born martial arts champion, whose father had been one of the King of Sweden's bodyguards, had spent six years in the Marine Corps before deciding to pursue acting. He'd been a world traveler and competed in professional athletics, but the pull of acting, exploring that world, was something new and different.

A lead in New York's Circle in the Square Theatre production of *The Good Woman of Szechuan* opened doors for Svenson, assuring him his first small television roles, but it was Screen Gems Television that set his Hollywood acting career on its path. "I remember sitting outside Renée Valente's office, and there was Sam Elliott and Harrison Ford. They were both working as carpenters, but they were auditioning. I loved the fact that in those days casting directors would take the time to see actors who had value if not experience. They'd give them their first chances, and many went on to become something. On Friday afternoons, Screen Gems would have an open house for actors, and we'd come there for coffee and Renée would talk freely about this and that, and it made you feel welcome in the business."

After his work as Olaf in the lighthearted Emmy-nominated *Here Come the Brides*, the six-foot-six Svenson was in demand for more dramatic and realistic Westerns, including the unusual *The Outcasts*, starring Don Murray and Otis Young. The trials of a one-time Confederate officer travelling with a freed slave who fought for the Union, *The Outcasts* addressed difficult social issues head-on, remaining, at the same time, a tough-minded Western that gave equal space to character and violence. Svenson's experience on *The Outcasts* led to a friendship. "I liked Otis a lot, and we became good friends. Otis went back to New York—he had a master's degree and was teaching. E. W. Swackhamer directed one or two episodes, too. The show was another case of the Screen Gems scenario really being worthwhile."

Svenson would guest-star on multiple Westerns, among them *Lancer*, *The High Chaparral* and *The Virginian*, and developed an admiration for the TV directors he worked with. "Boris Sagal was a fine director, and I liked Herb Wallerstein who did *Snowbeast*. The TV directors back then had movie training and a sense of loyalty. They knew what they were doing and liked what they were doing. That made a difference."

It was while making the post-Civil War Western *The Bravos* with George Peppard, Parnell Roberts and L. Q. Jones that he received some unusual advice. "Ted Post was directing, and he would come to me, and say, 'Bo, I have in mind to do this and this, what do you think?' And I'd let him know what I thought, and he'd say, 'Oh, thank you.' Well, I talked to George Peppard about this, and George said, 'For God's sake, don't answer him! What you want to say is that you don't know or don't understand.' George thought if the director knows you have your own ideas, they'll never want to work with you again."

Fortunately for Svenson, who also became a fine director, Peppard's advice didn't apply. Svenson was chosen by Dan Curtis to play the Monster in a special three-hour presentation of *Frankenstein*, and his creative input and collaboration with the director brought him some of the best reviews of his career. "It was just amazing to do that show with Dan Curtis. I was getting my Ph.D. in metaphysics at UCLA, and I was paying for my schooling with these acting jobs."

After *Frankenstein*, Svenson rocketed through over two-hundred film and television roles, including *North Dallas Forty*, *The Great Waldo Pepper*, opposite Robert Redford and *Heartbreak Ridge*, with Clint Eastwood. He portrayed real-life lawman Bufford Pusser in two *Walking Tall* films and a successful television series, but when it ended the actor never paused in his career or looked backward. For decades, he continued acting in productions around the world, such as the original *Inglorious Bastards*, with Fred Williamson and later Quentin Tarantino's war film that borrowed from the earlier film's title. Working with Tarantino again, he had a role in *Kill Bill: Vol. 2*.

Svenson feels the actor must approach each role with a radical directness and simplicity, which requires enormous skill to bring off. "Art is the first part of artificial; but the greater the art, the less artificial it is. You have to find something within you that resonates with the character, and then you amplify that so that there's an organic truth on the screen. No one can effectively lie to that camera."

TIM THOMERSON
THE MANIC BENT

"OVER THE YEARS there have been a lot of great films, and one of my favorites has always been *Stagecoach*. And now I'd look to do for you *Stagecoach*, the entire film." After that deceptively simple introduction, Tim Thomerson worked the microphone at the Comedy Store on Sunset Boulevard, delighting the audience with his own version of running horses; then he dove into a near-psychedelic rendition of the classic that was wild, and wildly, funny. The comic, the movie lover and the actor all collided in that iconic 1976 performance on one of HBO's first efforts at series television, *On Location: Freddie Prinze and Friends*, which showcased Prinze's nightclub material while shining a new spotlight on young comedians like Thomerson, Elayne Boosler, Richard Belzer, Gary Mule Deer and a baby-faced Jay Leno.

Of those new comic talents, Thomerson was the loosest, the most fun, and the reference to a 1939 Western as a stand-up bit comes from an entirely different mindset than the others'. Nobody else was going to use John Ford to launch into a manic, one-man routine except Thomerson, whose own love of Westerns began when he'd see them on naval bases with his officer father. "My dad would take us to the show on the base, because he loved cowboy movies. I remember Lloyd Bridges and Lee J. Cobb in *The Tall Texan* and Cobb as a sea captain beating a guy with a snake. That was pretty wild, but most of what I saw was on TV. *Cisco Kid* I liked a lot. I wasn't that big on Roy and Gene, although I liked Gene better than Roy. There was a cool show called *Tate*, about a one-armed gunfighter. I loved the guy who played him, David McLean. He had a stone face but looked like a cowboy to me, and that stuck in my mind."

Raised in San Diego, Thomerson, along with high school classmate Fred Dryer, became a passionate lifelong surfer, honing his early skills in major competitions. In 1990 he told the *Los Angeles Times* that for him surfing is "like the bitchin'-est thing you can ever do. It's pretty close to sex." After a stint in the National Guard, he focused on acting, going to New York and becoming a student of Stella Adler's for four years while working as a waiter, set builder and anything else to keep the lights on. He also performed his first stand-up gigs. His leading man looks, paired with off-the-wall humor, struck a chord with audiences, and Thomerson found himself in de-mand at clubs across the States. A turn in *Car Wash* followed variety shows and episodic TV thanks to a recommendation from his friend Richard Pryor.

Leads in four TV series, *The Associates, Angie, The Two of Us* and the cult hit *Quark*, a sci-fi parody about the travels of an intergalactic garbage scow, further proved there was no genre in which Thomerson didn't excel. But he hadn't yet made a Western until *Gun Shy*, Disney's 1983 TV continuation of *The Apple Dumpling Gang* films. "That was fun, a real hoot, but I didn't ride that much. The only time I was ever on horseback, and I was riding pretty good, was on *The Cisco Kid, The Young Riders* and *The Magnificent Seven* for TV, and I only got to ride out of frame. Whenever I booked a Western, I'd take riding lessons to get tuned up so I'd look halfway decent."

The Osterman Weekend with Sam Peckinpah and the modern vampire-Western classic *Near Dark* came next, followed by *Cherry 2000*, a sci-fi tale about a female robot that co-starred Ben Johnson, Harry Carey, Jr., and Melanie Griffith. "I saw Ben Johnson was eating alone, and I asked if I could join him, and he welcomed me. That was really neat. I was in heaven, such nice guys. Later, working with Dick Farnsworth, that was the pinnacle for me."

Thomerson would take on the role of Lundquist in TNT's one-off feature, *The Cisco Kid*, with Jimmy Smits playing the titular lead, before appearing as the ultimate rogue Guy Royale on the 1990s television series *The Magnificent Seven*. Of this character he says, "He's the guy who'd take your house away. It was fun to play a villain like that. I had a belly gun to tuck in my waist band, and wardrobe didn't think that was accurate, wanted me to use a holster, but the prop guy was a real cowboy, and he backed me up. I was kind of a city slicker. I think I was channeling Ray Danton."

Tim Thomerson just missed the period for actors when Westerns dominated TV and movie screens. "I've only done a few, but I loved them. My love of Westerns came from reading Will James and seeing movies like *Buchanan Rides Alone* with Randolph Scott. And my dad was a Western guy. He'd always bring home cowboy boots for me that didn't fit, but I'd still wear them. It'd be great to do a new one, something like *Blood on the Moon* with Bob Mitchum. Now that's a great Western."

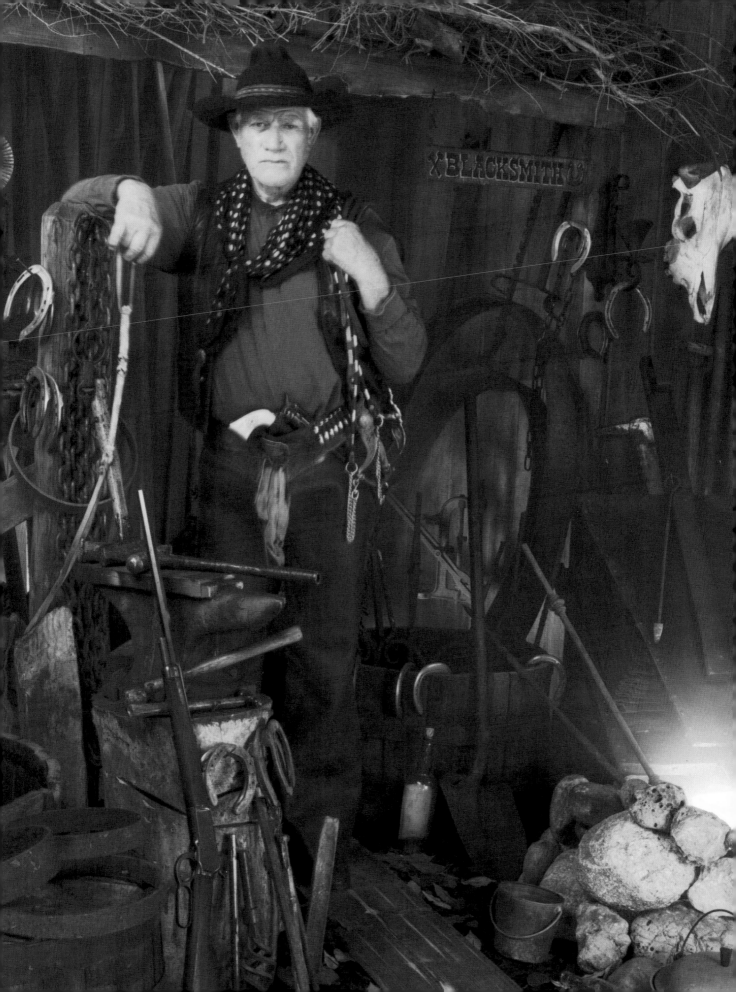

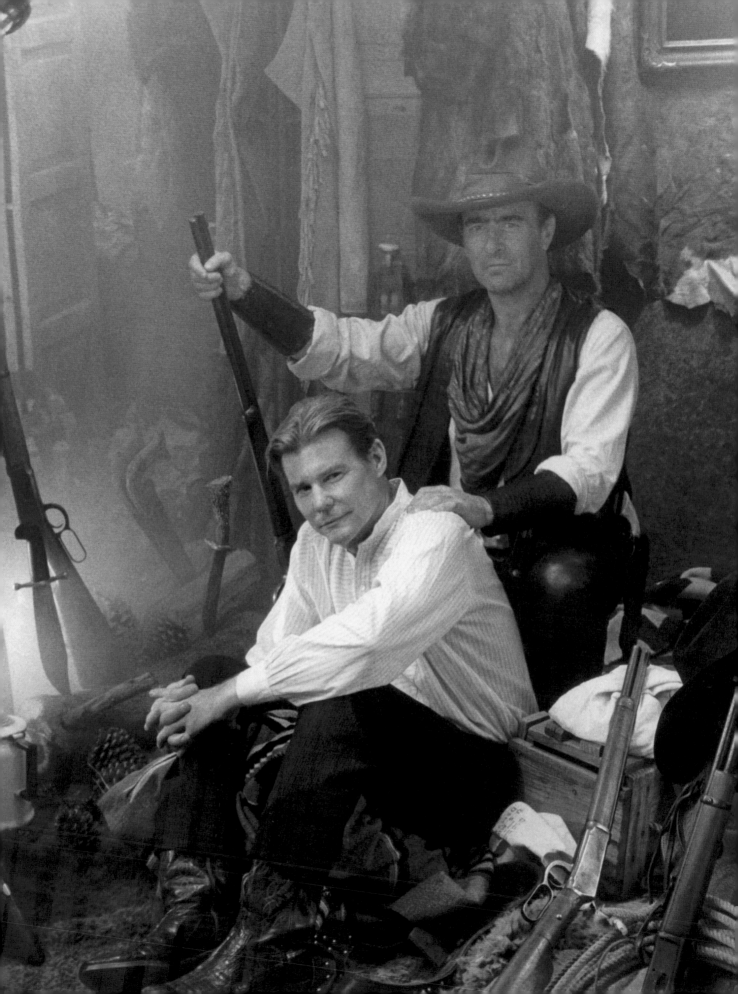

JAN-MICHAEL VINCENT
FALLEN ANGEL

Journey to Shiloh was a "testing ground" movie that studios once made to see which new contract stars clicked with audiences. This 1968 Universal Western starred James Caan, Michael Sarrazin, Harrison Ford and Jan-Michael Vincent, all of them fresh-faced. Set during the Civil War, the picture marked another step closer for each of them to bigger things. Caan was being groomed for stardom by Universal, as was Sarrazin. Ford would find his way to George Lucas. And muscular surfer Jan-Michael Vincent, in the smallish role of Little Bill Lucket, was about to ride into some guest spots on *Bonanza*. He'd already scored a small part as a defiant but tanned teenager dressed down by Sgt. Joe Friday on *Dragnet*.

In the first of his two *Bonanza* episodes, "The Arrival of Eddie," Vincent played a young man bent on avenging his father's death. His sympathetic take on the role led to his being cast with John Wayne and Rock Hudson in Andrew V. McLaglen's *The Undefeated*. As a young, idealistic Confederate, Vincent sports the grey even after surrender and joins Union cavalry officer Wayne to sell horses in Mexico. Vincent interprets the role solidly and with conviction, but his performance also feels perhaps too modern, not of the era depicted in the film. McLaglen wisely surrounded him with scores of veterans and Wayne regulars, like Edward Faulkner, Harry Carey, Jr., and Bruce Cabot.

Vincent continued racking up roles, and we witnessed his growth as an actor, finding the depth of his characters beyond his looks and charm. He held his own as an assassin in training against Charles Bronson in *The Mechanic* and scored with a fine performance in the TV movie *Tribes* as a young Marine locked in a battle of wills with his drill sergeant. Vincent was fast becoming Hollywood's golden boy and soon starred in action films designed for him, the best being *White Line Fever*, which had him play an independent trucker who defies a corrupt shipping business led by L. Q. Jones, Slim Pickens and R. G. Armstrong.

Structured like a Western, with tough actors riding in big rigs instead of on horses, *White Line Fever* presaged Vincent's role in one of the best Westerns of the 1970s, Richard Brooks's *Bite the Bullet*, a film that does the nearly impossible by combining comedy, violence and adventure as it recounts a 1906 cross-country horse race, with Vincent, the young buck, competing against Gene Hackman, Candice Bergen, James Coburn and a marvelously slick Ian Bannen. Brooks lets the rollicking attitude of the first acts transform into something darker as death assumes increasing importance in the story. As he had with *The Professionals*, Brooks in *Bite the Bullet* shows how people on a collective mission will change. Vincent, for instance, grows from a cocky rogue into a measured, mature youth.

Bite the Bullet would be his last Western as he took on roles in other thrilling pictures, including John Milius's ode to surfing, *Big Wednesday*, the action film *Defiance*, where he battled street gangs, and the mediocre *Damnation Alley*, in which he battled giant scorpions. There were more big films—some hits, some misses—and Vincent prospered as heartthrob and leading man. Cast in *The Winds of War*, a massive mini-series adapted from Herman Wouk's classic novel, he co-starred with Robert Mitchum and, as always, more than held his own.

The war epic led directly to his own series, *Airwolf*. Jan-Michael Vincent as Stringfellow Hawk, a soldier of fortune forever battling the bad guys, was tailor-made for the actor, his image and his abilities. Also featuring Ernest Borgnine as a faithful mechanic, the Universal series was high on juvenile action and thrills, nothing too deep, and it scored one of the most popular broadcasts premieres in the 1982 season. Audiences cheered every Friday night, but, sadly, success didn't last. Barely two years on, *Airwolf* was cancelled, with the actor's reputation in flaming tatters as he found himself picked up for drunk driving several times, charged with assault and sentenced to jail.

The tragic spiral continued, with more arrests and more problems with alcohol, which resulted in multiple car accidents that left Vincent's body shattered and his voice destroyed. He continued to work, making more than forty screen appearances before an infection in his right leg forced an amputation and retirement. Over the years, he fought to stay the sober course but ultimately veered off, leaving a sad, filmed record of his self-destruction, a harsh existence lived hard by an actor who could look back on it all like a Westerner would, as a man who's made his share of mistakes and more but feels, even at the end, that he has one last act to go.

Left: Jan-Michael Vincent posing with Robert Zinner at The Darkroom.

JESSE VINT
BORN TO THE WEST

"I'VE ALWAYS LOOKED like a cowboy," says Jesse Vint, whose lean and mean performances have graced more than one classic film. "I could put on a tuxedo, and they'd still say, 'You look like a cowboy,' but I never was one. I'm from Oklahoma, but I stayed away from horses."

A boyhood ride on a stallion that bolted and almost killed Jesse kept him off the saddle for years until he was cast as the young lieutenant in Arthur Penn's production of *Little Big Man*. The film remains one of the most successful and influential Westerns of the 1970s in its retelling of Custer's last stand through the eyes of survivor Jack Crabb, delivered by Dustin Hoffman in an amazing performance.

For Jesse it was a great opportunity, but he still had reservations about climbing back into a saddle. "I did not want to be on a horse. But that was the part. The stuntmen worked with me every day, and I got to the point where it looked like I knew what I was doing, even though I probably didn't. That's all that was necessary. Eventually I got pretty good on a horse because I did a lot of Westerns. But I have to say, I never really enjoyed riding because I knew the horses didn't enjoy it either! They didn't want me on their backs, and I didn't want to be there!"

Jesse worked on *Little Big Man* for six months, forming close ties with actors and crew, including stunt coordinator, and later director, Hal Needham. Those ties gave Jesse the opening line to meet his hero. "We were shooting *Swing Out, Sweet Land*, a TV special, and John Wayne was in it. I wanted to meet Wayne but didn't want to come up to him cold, as a stranger. Well, I was across the street from the studio at the Formosa Café, and I saw Hal, and I told him I was in this project with Wayne, and Hal was like a little kid, very excited by that, and wanted me to give Wayne his best wishes because he'd worked on some of his movies. So now I have a way to meet John Wayne without looking like a crazy fan and not break into a sweat. I walked up to him, and he is as big and as tall and as impressive as you'd think he was. He *was* John Wayne. I felt like I was shaking hands with the Grand Canyon. It wasn't a human being I was shaking hands with, it was an American Institution. When he passed away, I put "God Bless John Wayne" on the back of my pickup truck, and when anyone would see it, they'd honk their horns."

Jesse's naturalness won him the admiration of Bruce Dern, who recommended him for the science fiction milestone *Silent Running*. The ecology-minded space film, co-written by Michael Cimino, is now considered a major achievement as cinematic science fiction that took on major and sadly prophetic themes about the earth's destruction. *Silent Running* achieves genuine realism with its depiction of space travel and its effect on astronauts so long away from home, and Jesse's performance is a primary reason for its resonance and truth.

A chance meeting at a gas station led to Jesse's role in the largest Western epic ever attempted for television. "I was filling up my Dodge Charger on Ventura Boulevard. This guy pulls up in a Porsche and gets out, and I'd never seen him before, and he says, 'You're Jesse Vint. I'm John Wilder, and I produce *Streets of San Francisco*, and I'm doing *Centennial*, and there's a character in there I thought you'd be right for. Get the book and read it, and here's my phone number. You call me and tell me which character you think you'd be right for, and we'll see if it's not the same one.' So I read this huge book, and I come to Amos Calendar, and I knew that was me. I called John and said, 'Amos Calendar,' and he said, 'That's the guy.' I was pretty astonished I was right, because there were so many characters in that book, so I don't know if he was pulling my leg a little bit, but John hired me many times."

Based on James Michener's epic novel, the ambitious mini-series, featuring over one-hundred speaking roles, ran in twelve two-hour segments in 1977 with Jesse appearing in six. "*Centennial* had the largest longhorn steer herd that had ever been assembled in America, and director Virgil Vogel had a long shot of these cowboys driving this herd of longhorns, and it took forever to set this shot up. And a stuntman was wearing his sunglasses! Poor Virgil! They had to turn the whole herd around."

Being able to inhabit realistic characters meant television and movie roles came to Jesse at a furious pace. But he wanted more to create his own opportunities, especially after he and brother Alan had starred in the independent smash *Macon County Line*. "Actors will come to Hollywood, do three jobs back to back, and then not work for three months, and they don't know what the hell's going on. So I decided to be the master of my fate and start writing

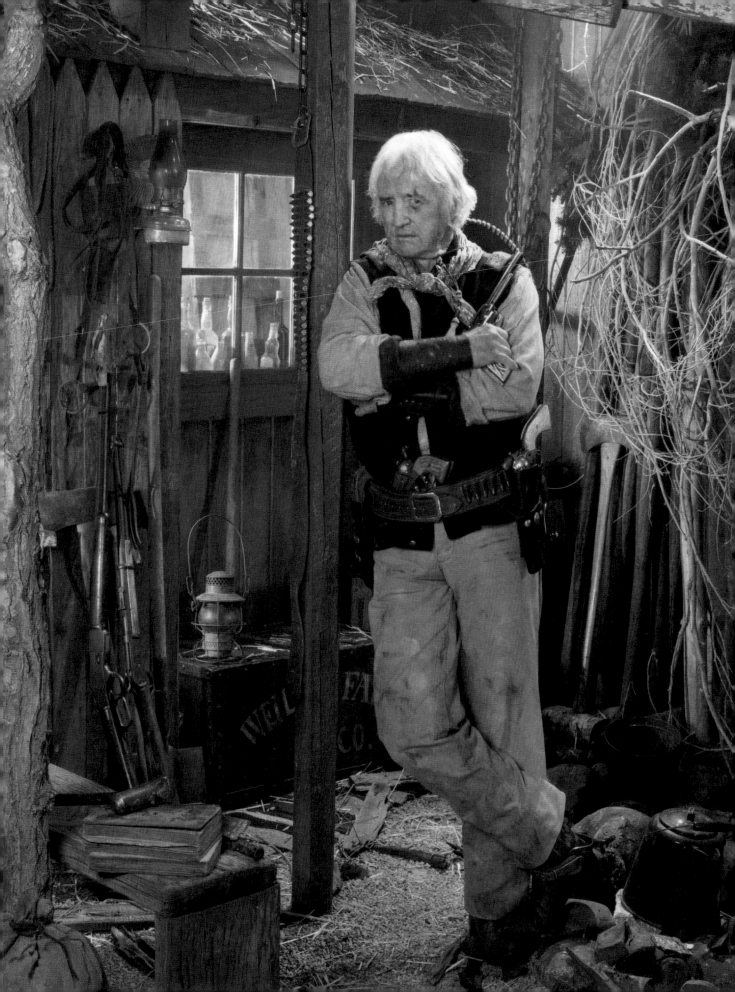

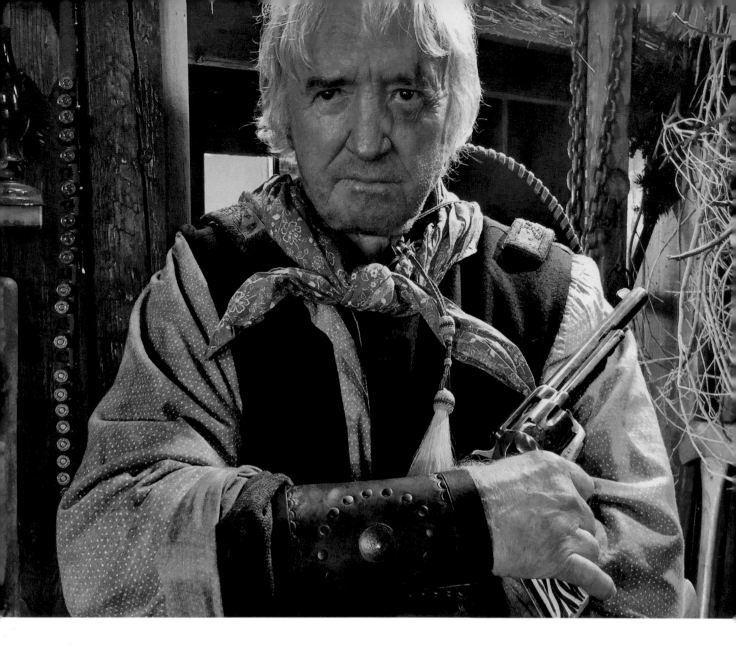

things and putting them together. I wasn't going to sit on my butt waiting for an audition, leaving it all to chance. I never took a writing class, but I wrote something that became *Black Oak Conspiracy*."

The story of a stuntman who returns to his small town to help his family only to uncover corruption actually plays as a modern-day Western; Jesse's character could have easily ridden into town on a tall horse before finding himself going up against the corrupt sheriff and his hired guns. That timeless theme ties *Black Oak Conspiracy* not only to the tenets of the Western but also to the rebellious independent movies that were raking in box office dollars, sometimes knocking out the major studio competition.

"It was like *Easy Rider*. You go out with a group of people you like and respect, and you don't know how you're going to shoot it, but you get the feeling from the people and from your location that you're not going to get from a set at 20th Century-Fox. There's a word in micro-brewing called open fermentation—that's what it is—from the air, and all the living organisms around you—that's where you get your inspiration—the people—it's all part of the picture organically. And you try to incorporate as much of that as you can into your film. And that's the kind of filmmaking we were doing. *Black Oak* had terrific reviews. The film is still playing, over forty years after its release, and that surprises me. But it's a nice thing."

"I've always looked
like a cowboy.
I could put on a tuxedo,
and they'd still say,
'You look like a cowboy,'
but I never
was one."

HUNTER VON LEER
MEMORIES OF THE GREATS

"To be in a triple-A movie with John Wayne, it doesn't get any better than that. The cool part was it also had Harry Carey, Jr., Walter Barnes, Jackie Coogan and Chuck Roberson, who was John Wayne's stuntman forever and who got me into the SAG. Andy McLaglen was the director. It was this group that Wayne always used, and we were staying at the Campo Mexico Courts in Durango, a little motel-hotel. We hung out in the restaurant, a tiny, family-run place, where you'd sit and talk to those guys for hours."

Speak to Hunter von Leer about making *Cahill U.S. Marshall* in 1972, and the actor's memories come tumbling out one after the other, the excitement in his voice contagious as he recalls the shooting: "John Wayne would come and have coffee with us in the morning. Even if I wasn't going to be working that day, I got up so we could all have breakfast with each other. And Wayne was a really class-act guy, the first one on the set, ready to go. Mike Wayne always produced for his dad, and we remained friends for years after that film."

For the athlete and movie lover from Indiana, *Cahill* wasn't just about working with Wayne but also sharing the screen with legendary character actors like Paul Fix and Hank Worden. Von Leer adds, "There never was a nicer man alive than Jackie Coogan. I worked with George Kennedy in four different movies, and Neville Brand was the second highest decorated soldier in World War II. The old pros, whether they were men or women, they were fantastic. They didn't become stars overnight. They had worked their way up, and they had that perspective. They were what made me glad I went into the business."

During *Cahill,* von Leer had the chance to audition for another Western shot in Durango, Mexico. "I was up for a part in *Pat Garrett and Billy the Kid.* I went over to Sam Peckinpah's house to audition, but they'd been partying pretty hard the night before, and so the audition never happened. But Jim Coburn was there, ready to read with me, and I thought that was very cool."

Von Leer, who has set several records for his extraordinary skills as a shark fisherman, was cast as everything from a good-natured lifeguard on *The Rockford Files* to a businessman determined to destroy J. R. Ewing on *Dallas.* He also got to join two Hollywood giants, Burt Lancaster and Robert Ryan, in *Executive Action,* a controversial feature about the Kennedy assassination that works up a paranoid stew of fiction and documentary realism. A forerunner to "Oliver Stone's later and more well-known *JFK,*" writes film historian Gordon B. Arnold, *Executive Action* "sets out to dramatize how a conspiracy could have been behind the murder of the president in 1964 [after] figures from within American business and government decide that Kennedy must be removed." Says von Leer, "When I did that film, I understood Robert Ryan was dying of cancer, but he wanted to do it because he thought it would be historic. But the politics plagued the film. It was written by Dalton Trumbo, all taken from the FBI files, and they wouldn't let them shoot in Dallas." Trumbo, notably had been blacklisted previously for his ties to the Communist Party, as well as one of *Executive Action*'s supporting actors, Will Geer.

Von Leer appeared with Bo Hopkins, Harris Yulin and Sally Kirkland in the ABC television movie *Kansas City Massacre,* as well, which similarly combined Hollywood storytelling and real American history. "When I did *Kansas City Massacre* for the director Dan Curtis, who was just a joy to be around, just so much fun, I'd talk to Dale Robertson, who was playing Melvin Purvis. He was unpretentious, a great guy who'd really hit it big in the oil business. But you'd never know it. And he still sounded just like he did narrating *Tales of Wells Fargo!*"

Von Leer showed up in Arthur Penn's powerful *The Missouri Breaks,* too, with leading men Marlon Brando and Jack Nicholson, about the killing of ranchers for their grazing land during a cattleman's war. "I didn't get an opportunity to work with Brando, but I was one of five outlaw gang members of Nicholson's, and the first one to be caught and hanged. Jack Nicholson was the sweetest guy. The first time I met him, everyone was having dinner, and he called out, 'This must be Sandy!' because that was my character's name. He made me feel very welcome. I worked with so many great actors. Sometimes I forget, and then I will see something on TV, and I'll say, 'Hey, I worked with that guy!'"

Now back in Indiana with his own cattle ranch, von Leer looks back gratefully on the films and television shows he made. "I was very lucky because I got to work with some heroes. Those Western actors were exactly who you wanted them to be."

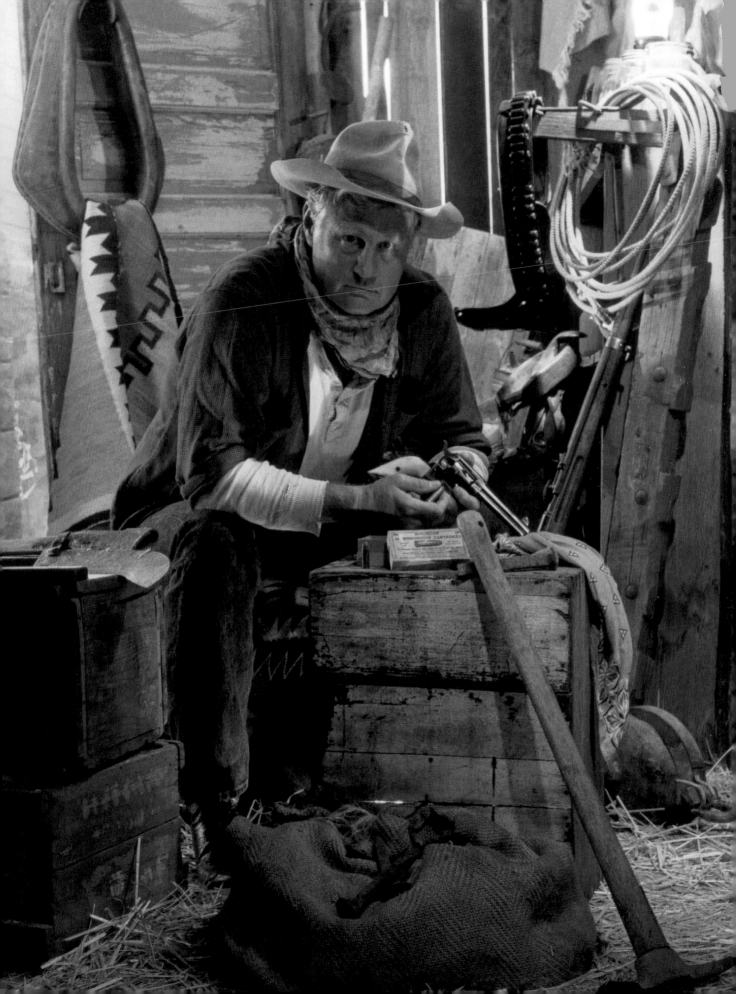

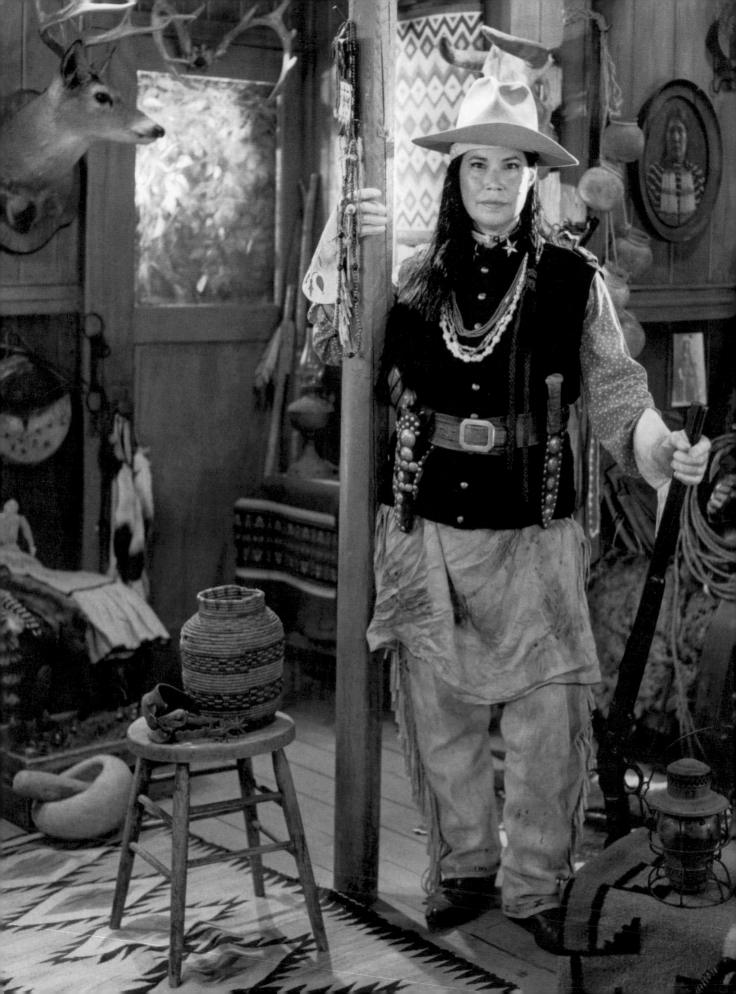

KATERI WALKER
HONORING THE PAST, BUILDING THE FUTURE

KATERI WALKER AND Charlie Hill's video, *The Longest Walk Through Hollywood*, is cheerful, sometimes funny and never preachy as the two Native American activists stroll the Hollywood Walk of Fame, detouring for studios and landmarks along the way. At one point, Walker and Hill hark back to the origins of Paramount's *The Squaw Man*, the first feature-length movie ever produced in the U.S., as a starting point for understanding the position and stereotyping that Native actors have faced in Hollywood since the first cameras cranked.

There's a wonderful moment when Walker stands in front of the Capitol Records Building to pay homage to singer Kay Starr of the Iroquois Nation, reminding us of the singer's historic breakthrough as the first Native American woman signed by a major record label. She experienced notable commercial success, as well, scoring a chart-topping hit with "Wheel of Fortune."

When Walker and Hill honor Jay Silverheels, a Canadian Mohawk, it isn't just for his recognition as a champion boxer and wrestler or for having established himself as one of the most recognizable performers on television, it's that he used his influence to speak up for Native American actors. As the actress Lois Red Elk noted after Silverheels's death in 1980, "He created the atmosphere for us to get into the industry. Before that, Indian people had to play props, extras, background."

Watching the video, we wish we were along for the walk ourselves, to stop for a drink and talk about these issues. *The Longest Walk* leaves some serious questions unanswered, which is exactly the point the filmmakers want to make; what they ask for simply is for people to pay attention and then follow their hearts.

Kateri Walker, a member of Chippewa of the Thames First Nation (Canada), and the Saginaw Chippewa Indian Tribe (Michigan) had always had her sights set on theater, but after obtaining her degree from the University of Michigan, where she studied in the Theatre & Drama program, she took a job, surprisingly, with Dow Chemical Company. The time at Dow didn't, and couldn't, last long for the performer, who, having never once refrained from using her theatrical passions to honor her heritage, found herself making a mark as the first Native American actress cast in a network soap opera on *As the World Turns*. Walker's fierce, radiating eyes and long black hair starkly contrasted the "blondes with blue eyes" who often populate daytime. Her role on the show as the strong, beautiful Simone and her part in *The Scarlet Letter* with Demi Moore led to her first period Western.

Taking on the Lakota Sioux woman, Manipi, in *Stolen Women, Captured Hearts* placed Walker in a story that recognized Native American sensibilities. Based on the true story of Anna Morgan, who was captured by the Lakota, then traded to the Cheyenne, *Stolen Women, Captured Hearts* is a classically structured romance, but with truly dark undercurrents as the tribe is put at risk by the love between Anna (Janine Turner) and Tokalah (Michael Greyeyes) when Anna's husband enlists the aid of Custer's troops to find her. She is returned but must make the choice between the world of the white man or the Lakota. Besides Walker, the film strove in its casting to include Native American actors, including Apesanahkwat, a Menominee Tribal Chairman.

Walker has always been careful choosing projects, bringing her best to films such as the wild ensemble piece *Outside Ozona*, with Robert Forster, and *K-PAX*, with Jeff Bridges. She will not appear in "traditional" Westerns that emphasize the old clichés, opting instead for films that don't follow the usual path, like *Renegade*, an adaptation of a graphic novel series created by French cartoonist Jean Giraud. The film and performance in which she is most proud is as Mavis Dogblood, a widow who can't come to terms with her husband's death, in *Kissed by Lightning*. Walker is superb as the grieving Mohawk artist, struggling through pain in this award-winning film that was completely created by Native Americans.

Kateri Walker is a Jingle Dress Dancer, too, who performs in ornate dresses and shawls that make a lovely clicking sound as she moves. She travels the world, introducing people to Chippewa culture. Of Hollywood, Native Americans and troubling stereotypes, this actress with the fierce heart says, "What's in the movies isn't who we are: quite the opposite."

FRED WILLIAMSON
HAMMERING THE WEST

JUST AS SOME actors are born to ride a horse, Fred "The Hammer" Williamson was born to stand on a dusty street and face down an enemy in a Western movie shootout. That wasn't commonplace for African American stars in 1971, the year that *Shaft* broke box office records. But Williamson determined that a Western, not an urban action picture, was going to be his first starring vehicle. More to the point, he would appear in one conceived and developed by James Bellah, the son of James Warner Bellah, who'd written John Ford's cavalry trilogy and *Sergeant Rutledge,* starring Woody Strode, who, like Williamson, played professional football. As the eponymous hero in *The Legend of Nigger Charley*, Fred Williamson offered a genuine salute to what had gone before in Western movies, then shot the genre between the eyes and resurrected the hero in his own image.

The year before he became Charley, a runaway slave seeking vengeance, Williamson played Diahann Carol's handsome boyfriend on NBC's *Julia*. Before that, he'd contributed his grin and American Football League reputation to Robert Altman's *M*A*S*H* as Dr. Oliver "Spearchucker" Jones, playing in the football game that rounds out this classic anti-war film.

Williamson had charged into Hollywood with the same toughness that characterized his hammering tackling style as a defensive back for the Oakland Raiders and Kansas City Chiefs. "There are twenty-thousand people in the stadium. Ten are cheering for me, and the other ten are booing me, but it's all about me, and that's what counted. I understood marketability. So when I went into the movie business, I was prepared to market myself in the same way that I did when I played football. I had been on a hit series, and when I went to Paramount and told them I wanted to make a Black Western, they were fine, and when I said it's called *The Legend of Nigger Charley*, they wanted to jump out the window!"

Shot primarily in Virginia at the plantation birthplace of Robert E. Lee, the film had a modest six-hundred-thousand-dollar budget. But it made more than twenty million at the box office because its star knew exactly how to promote it. Williamson remembers, "The power was in making the film controversial. I took out a huge billboard on 42nd Street that said, 'He's coming.' People wanted to know, and then the second one went up, with me holding six-guns, and said, 'Nigger Charley is here.' There were lines around the block to see the movie. There was a Black audience that hadn't been served by Hollywood, particularly in Westerns. They needed a hero."

After this success, Williamson turned to modern action with *The Hammer*, a revenge flick about a boxer beating down the Mafia, then *Black Caesar*, the first of the actor's three collaborations with writer-director Larry Cohen. As Williamson's stature in the film industry rose, he met with John Ford to discuss a biography of Black soldier Josh Clayton, which could have been the great director's last film. The box office demanded a sequel to *Charley*, and Williamson obliged with *The Soul of Nigger Charley*. Directed by Larry Spangler, the movie adopted a slicker, more opulent look than *The Legend of Nigger Charley*, which influenced Quentin Tarantino as he made *Django Unchained* forty years later.

By the mid-1970s, films with African American leads ran a thematic gauntlet from Gordon Parks's drama *The Learning Tree* to the raw action of *Trouble Man* or *Foxy Brown*. These films were turned out at a furious pace, a number of them by veteran Western directors, such as Gordon Douglas (*Slaughter's Big Rip-Off*) and Henry Hathaway (*Hangup*). Williamson re-teamed with veteran Jack Arnold, who'd directed him in *Blackeye*, for *Boss Nigger* (aka *The Boss*), a well-made Western co-starring William Smith and R. G. Armstrong, which Williamson also wrote. The film earned critical nods for letting the subject of race develop subtly and powerfully through the story.

By 1975, Fred Williamson had accomplished what he set out to do with movies: turn himself into an iconic brand. He stayed true to the cowboy genre, making *Take a Hard Ride* with Jim Brown and Lee Van Cleef, before directing his first Western, the comedy *Adiós Amigo*, with Richard Pryor. When he looks back at *The Legend of Nigger Charley*, it's with a satisfied chuckle. "They had one of those big receptions with the theater owners and the studio execs, and they'd ask the Paramount people what their most successful film of the year was, and they'd say, '*Legend of*…' and then let their voices trail off because they were ashamed to say the words. It was great that the film did as well as it did, but that was a bonus, seeing the studio guys squirm a bit."

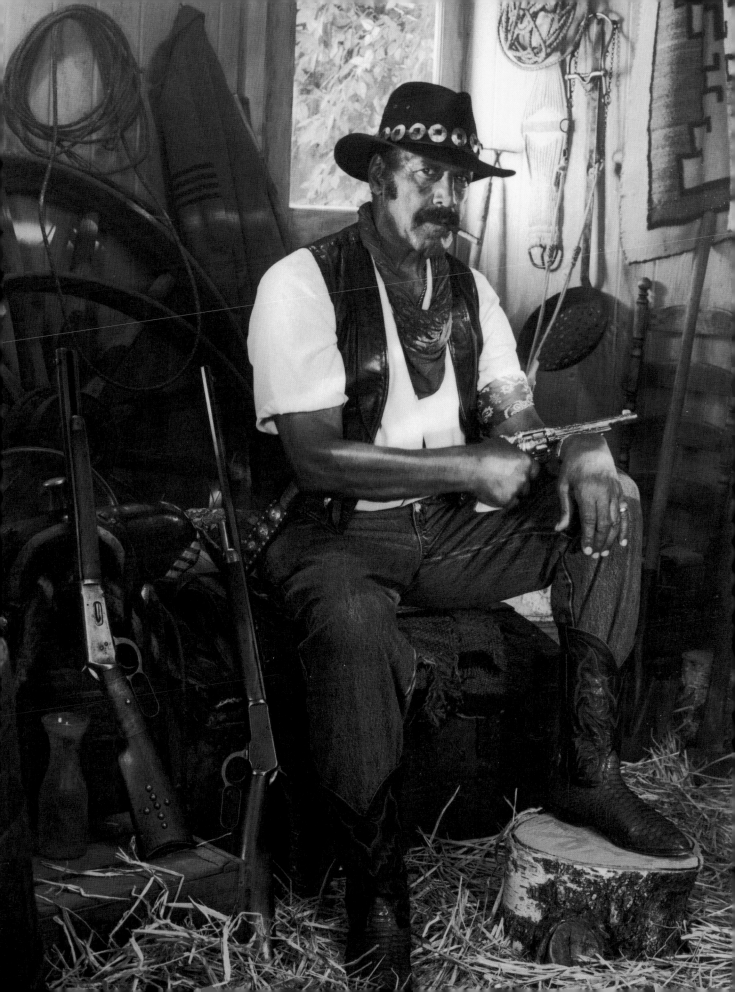

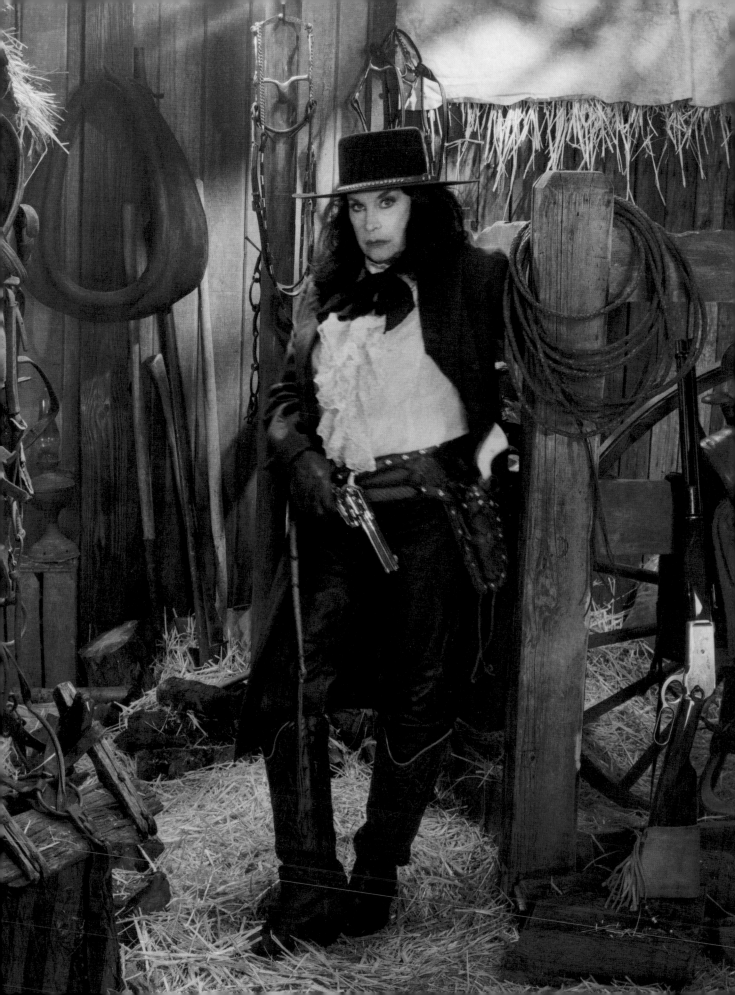

LANA WOOD
BEYOND 'THE SEARCHERS'

IT'S AN UNFORGETTABLE moment from a revered American film.

A little girl climbs from the window of a ranch house and hides in a graveyard while a Comanche raiding party massacres her family. She waits, her screams from the house echoing, and prepares to run when she looks up to see Scar (played by Henry Brandon), a terrifying warrior chief, looming over her.

Audiences reacted with hushed dread at this scene from John Ford's *The Searchers*. But for the nine-year-old actress, it was business as usual. "I was a little girl raised in studios and around films. Henry Brandon was an actor, and I was just trying to show a kind of fear that they wanted. It was the same way I feel about actors now, that this is a person playing a role, and I'm supposed to react to them. It's quite amazing to think now that it's the moment in *The Searchers* that moves the story. It's what begins it all. And to have been a part of this classic film is an amazing thing."

The memories of the production remain vivid for Lana Wood. "I was out there a lot longer than simply for my role because Natalie was also going to shoot. I was filmed first, and then they started with Natalie. So, of course, they didn't send me home, and we stayed, the three of us, me, my mom and Natalie, until she finished. We were in Monument Valley about three weeks. The cabin interiors and the gravesite were all shot at Warner Brothers later."

Lana Wood grew up and moved on, working on episodes of *Have Gun - Will Travel*, *The Real McCoys* and *The Fugitive* before securing a leading role as Eula Harker on the TV-series adaptation of William Faulkner's *The Long, Hot Summer*. She appeared on *Bonanza*, too, but the Ponderosa was just a trail stop for the actress before starring in the successful drama *Peyton Place* for two years. Setting the template for everything from *Dallas*, *Dynasty*, *Knots Landing* to dozens of other evening soap operas, *Peyton Place* is now considered a television classic that broke TV censorship barriers.

A special opportunity came her way when she appeared on two episodes of *The Wild Wild West*. "I was incredibly eager to do it because the show was light, with a comedic touch which I was never allowed to do. I was always the big, bad sexy girl stealing funds and husbands and everything else! At the end of the final episode, I'd already gone to my trailer and changed into my regular clothes. There was a knock at the door, and the assistant director asked me to set. I thought, 'Oh, God, is there something we needed to film?' I was out of my costume. He said it was fine and took me to the set where the entire crew was, and they applauded me, saying I was their favorite guest star. I was very moved. For the crew to do that means a lot."

The Over-the-Hill Gang Rides Again gave Wood the chance to meet and bond with one of her movie idols. "Fred Astaire was so wonderful. My first day on the set, I ran up and introduced myself to Fred. As a kid I had a little television in my room, and I stayed up at night and watched all of those films with Ginger Rogers and knew all the music. And this spry little man with a cocked hat ran over and pulled out a chair for me, and we sat there and talked, and I told him how disappointed I was that 'Needle in a Haystack' was cut out of a showing of *The Gay Divorcee*, and we continued to be chums on the set."

Wood joined the pantheon of the most memorable Bond girls, too, igniting the screen as Plenty O'Toole in *Diamonds Are Forever*, which marked the return of Sean Connery to the 007 role and featured Bruce Glover as a coiled snake of a villain. Parts were never in short supply for the actress, who's appeared in over three-hundred television shows and more than thirty movies. But the independent *Greyeagle*, which had her work with two legendary Westerners, Ben Johnson and Jack Elam, remains a particularly special memory. "Westerns were in a tough spot at that time. There wasn't a great demand for them, so this was a treat to do *Greyeagle*. There's so much heart that goes into indie films because almost everything is against them. It's tough getting the money. It's tough getting the people you want. You've got to have a lot of heart to see all these things through. You're not backed up by a big studio, so it's truly heart that drives these smaller films."

Having been a part of films that are considered iconic today is a notion that still surprises Lana Wood. "You don't think of yourself as being part of a classic, as least I don't. I just think of myself as someone who likes to act. I'm not always happy with all the other things that go along with the business, but put me in a costume and throw me on a set and I'm a really happy person."

ROBERT WOODS
RIDING THE EURO-PLAINS

"I WAS BORN in Colorado, spent my first nine or ten years there growing up on a ranch. I was a cowboy." There's justifiable pride in the voice of Robert Woods as he looks back on the early days that shaped his acting career decades later when he took to the saddle and gun in a series of Euro-Westerns that made him a genre star. But unlike many contemporaries, whose stoic acting style evoked Eastwood's Man with No Name or Franco Nero's Django, Woods did not shun comedy or tense, dramatic scenes; he is an actor who is also an action star, not an action star who tries to act.

"My first one was *Five Thousand Dollars on One Ace*, which we made in Madrid in the spring of 1964 before Clint was there. It sold well to MGM; and because of that, people feel I started the Western trend, which is a nice compliment. That was for producer-director Alfonso Balcázar. I had been in an American repertory theater company in Paris when I was offered a contract for the film, which I refused because I was doing okay, but Balcázar came back with an offer for five pictures, and that started a whole new era."

After *Man from Canyon City* and *Four Dollars for Vengeance*, Woods starred in Franco Geraldi's *Seven Guns for the MacGregors*. Producer Dario Sabotello set up the movie through Columbia Pictures, giving *MacGregors* a high budget, enhancing its production values with a solid supporting cast and an Ennio Morricone score. The saga of the MacGregor brothers riding after bandits who steal family gold was marked by wild comedy and brutal violence and works as both a rollicking adventure and laughter-inducing romp. Woods's starring performance is a key reason for its success. "It was a fun film to make, a good film. It did very well, and I had a lot of offers to do more Westerns."

Woods also had a fine role in director Ken Annakin's epic *Battle of the Bulge,* which took many months to shoot in Spain and resulted in "a lifelong friendship with Henry Fonda. I'd always admired his work, so it was wonderful to be working with him, and I liked Robert Ryan. But I almost wasn't in the film at all. Balcázar had torn up my contract, which was fine, and a friend encouraged me to go to Phil Yordan's office—he was producer-writer—and see about being in *Battle of the Bulge*. Well, it's just not done that way, but I went over and talked to a secre-

tary and told her I was an actor and wanted to be in the film, and she said, rightly, 'So does everybody.' I was leaving with my tail between my legs, and Ken Annakin came out of his office and saw me and said, 'You're my pilot!' He was great and cast me on the spot."

Paolo Bianchini's 1968 film *Gatling Gun* has emerged as Woods's most celebrated Western and a personal favorite of filmmaker Quentin Tarantino. Using a tiny slice of history, with the inventor of the famed machine gun being kidnapped, the film combines elements of the traditional Western and the thriller, mixing in intense action for its star who must rescue Gatling.

"They offered me the film, saying, 'Do you want to do another Western?' But there was no script. I'd just done a modern-day project—a wild thing called *Captain Singrid*—but I loved Paolo, *Gatling*'s director, and I told them to let me talk to somebody about getting the script done, and they really gave me carte blanche to do it as I pleased. I got John Ireland to co-star because John was a friend, so that was easy. Paolo gave me a lot of freedom, working on the script and coming in with ideas. Remember when my character is dragged by the rope? That was me. I always tried to do my own stunts because I didn't want a double and have it look bad. There was the fight in the water, and I damn near broke my back against the waterwheel, but we finished the fight."

The picture's enduring legacy pleases and surprises Woods: "You never know when you're making something great. Things happen all the time. You wonder, 'How is it going to turn out?' When I went to the first screening, I thought it was a damn good film. At that time in the filmmaking community in Italy and Spain, everybody knew everybody. When you'd finish a picture, there were always a lot of tears because it really was like a family breaking up."

Happily married and still acting, Woods has no intention of slowing down. As he says, "I've still got a lot to contribute. But it's amazing: these new Blu-ray special editions of the old Westerns are reaching a brand-new audience, and they appreciate them for what they are and our efforts. I've been honored in Torino and different festivals for these films. And how people respond now, it's so rewarding after all this time. It just shows that there's always the hand of God in everything you do."

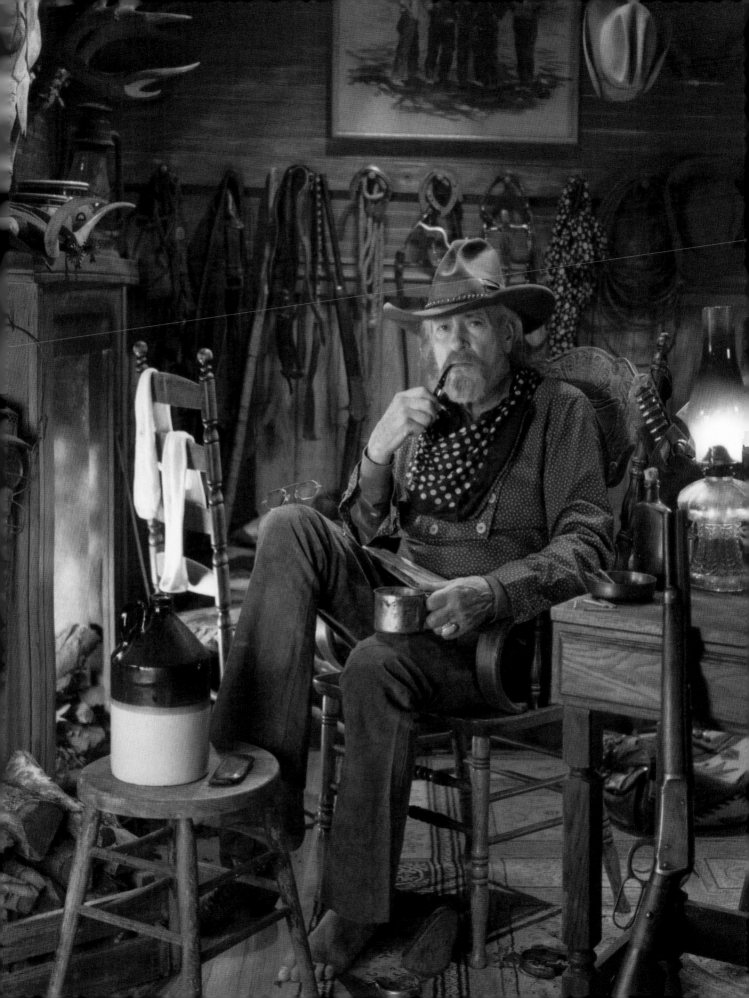

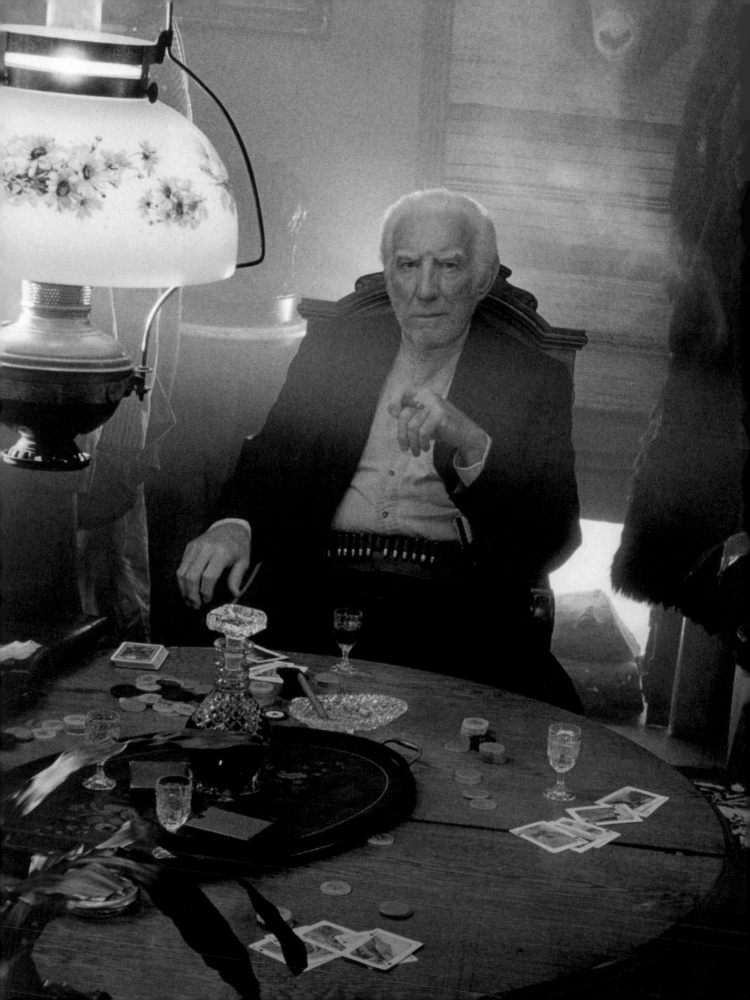

MORGAN WOODWARD
BEST OF THE BAD MEN

THE SCENE OFTEN went like this: a harried cowboy rides like hell into town trying to escape his pursuers, stumbles into the nearest saloon and downs a shot of whiskey in a sweating panic. The bartender asks him what the trouble is, and as he begins to stammer about the bad man hunting him down then Morgan Woodward steps through the batwings, gun raised, eyes narrowed. The cowboy never finishes his sentence as Woodward shoots him once through the heart. The decorated U.S. Army pilot, with degrees in both law and business, arrived in Los Angeles to work for Walt Disney. The fact that he became one of Hollywood's busiest character-actor bad men yields a wide smile. "It surely kept me working, and I got my comeuppance every single time!"

For Woodward, "kept me working" is a typically modest statement from an actor who spent his Arlington, Texas, Saturdays at the movies, riding along with Buck Jones and Tom Tyler, never imagining he'd appear in his first Western movie in 1956 and follow it with four decades of solid work. This Western was Disney's *The Great Locomotive Chase*, and Woodward was cast at the suggestion of school chum Fess Parker, who would also recommend their mutual pal, L. Q. Jones, to Warner Brothers. Woodward had long studied music and hoped for roles in musicals, but, as he frequently joked, "I traded grand opera for horse operas. That's what they were making and how the casting directors saw me." When the producers of *The Life and Legend of Wyatt Earp* went looking for a new deputy to stand alongside Hugh O'Brian, they didn't regard Woodward exclusively as a heavy and cast him as Shotgun Gibbs, a role he played for eighty-one episodes. "We did every show in a week. Interiors at Desilu, then a few days at Melody Ranch. Monday morning, we'd start all over again."

Woodward set records as a regular guest-star on Westerns throughout the 1960s and '70s. Besides doing single episodes on practically every network Western, he appeared on *Bonanza* eight times, *Wagon Train* twelve and *Gunsmoke* nineteen. "*Gunsmoke* was beautifully run, and the cast was wonderful to work with. They really let me do different characters, and some scripts were written with me in mind." Frequent *Gunsmoke* director Vincent McEveety would have Woodward join the cast of *Firecreek* with Henry Fonda, James Stewart, Jack Elam and BarBara Luna. This dark film, with a rough death for outlaw Woodward as he's dragged by a horse, is actually one of the actor's favorites. After *Firecreek*, Woodward and Jacqueline Scott would reunite for Don Siegel's *Death of a Gunfighter*.

Director Stuart Rosenberg gave Woodward the villainous role for which he may be best remembered. As Boss Godfrey in *Cool Hand Luke*, "the man with no eyes," he stands deadly guard over a chain gang, making rifle targets out of any prisoner who doesn't follow orders. "Rosenberg wanted a figure, a symbol of authority that everyone feared, and that's what I played. Of course, you kill Paul Newman, and you are remembered for it. The film plays constantly, and what an incredible cast of actors, just about the best group ever put together."

Off-screen, Woodward was just as well known to his friends and colleagues for his enormous kindness. In his book *Sam Peckinpah: Master of Violence*, Max Evans recalls some hard times when Woodward took him in as a houseguest for months. It was Evans, in fact, who introduced Peckinpah to Woodward. In 2010, Woodward made a gift of a quarter-of-a-million dollars to the University of Texas at Arlington Film Studies Program. "I wanted to pass on my love for acting and film with UT Arlington students by establishing the endowment to assist in recruiting outstanding professors in the field of film, video and screenwriting."

Always deeply appreciative of the fans of his Westerns, Woodward also marvels at the recognition he received for his classic *Star Trek* episode, "Dagger of the Mind," in which he "mind melds" with Mr. Spock. The scene was incredibly tense and racked the actor physically." Like his friends Bruce Boxleitner and L. Q. Jones, Morgan Woodward's screen identities have spanned all genres, even if he always veered toward being a bad man. The acclaim he continues to receive delights him. "To be on the receiving end of that kind of appreciation for the work you've done—well, that's just a great thing."

ROB WORD
KEEPER OF THE FLAME

"MY DAD WAS an adventurer at heart, and it gets hot in Florida, so we started travelling during the summer, pulling an Airstream trailer, which didn't have a bathroom, behind a 1949 two-door Ford with an AM radio and no air conditioning. We went to see *Shane*. And my dad would say, 'Those mountains are the Grand Tetons in Wyoming. That's where we're going to go this summer.' Because we had seen them in *Shane*. These were the times when families would go see movies together."

Producer-historian Rob Word and his family in 1955, when he was eight, visited Arizona's Monument Valley, where John Ford was starting *The Searchers*, and they happened upon the production. "You have to have a Navajo guide to go onto the reservation. My dad was taking 3D photographs of all these spectacular landscapes. We were in a jeep with our guide, going over sand dunes, and we get to where the Ford company was, and they told us, 'There's a John Wayne movie being filmed.' So we watched them shoot for a couple of days. I remember sequences being filmed out in the middle of nowhere. I knew who John Wayne was because I'd seen his Mascot serials on a UHF station out of St. Petersburg. I recognized him from *The Hurricane Express*. My dad asked John Wayne, 'Do you mind taking a picture with my son?' And Wayne said, 'Bring him on over!' I've got a *Davy Crockett* t-shirt on, and Wayne says, 'I like Davy Crockett!' And I piped up, 'Me, too!' Of course, all I knew was Fess Parker, and I'm sure Wayne was thinking bigger thoughts about making *The Alamo*."

Rob Word's excitement bubbles up as he recalls seeing the iconic film being made, but he's just as enthusiastic recalling how he'd immersed himself in poverty row cheapies that flickered on the TV set. Both memories get equal time, springing from his love of cinema, which would carry him from family vacations in the West to Hollywood. "I'd started school as a business major, for my dad, really, then switched to the theater department, and the head of the department had been a cameraman at CBS. When I got out of college I was a cinematographer for ABC News, and I learned so much shooting film every day."

In 1977, producer Brad Marks was preparing an ABC Special about the era of the TV Western, *When The West Was Fun*. Marks needed someone genuinely knowledgeable about Westerns and chose Rob Word, who'd been doing everything from production to hosting movies on local TV stations. After the highly rated special's broadcast, Word's cinematic expertise was put to use at the studios in a number of executive positions, determining the best commercial use of film libraries. This led him to Hal Roach Studios, which was moving into the world of VHS with old titles. "They had a big library, and I already had a reputation for being able to take older films and make money, so they asked me to be the head of production and marketing."

Word combed through Roach's immense library of shorts and features, which he soon shepherded into new versions via Colorization, Inc., a company owned by Roach that was one of the first to transform black-and-white films into color. Word became the company spokesman and the man behind Roach's first Colorization release, *Topper*, starring Cary Grant. *Topper* was a home-market smash, and Word began work on colorizing films in the public domain, which had lost their copyright status, as well as titles from the Roach library to attain new copyrights on the films.

After Hal Roach merged with Robert Halmi Productions and made the classic mini-series *Lonesome Dove*, Word left for ITC, the company responsible for the British TV classics *Thunderbirds* and *Secret Agent*. Noting that Kevin Costner was about to star in *Robin Hood: Prince of Thieves*, Word took old episodes of the *Robin Hood* TV series starring Richard Greene, assembled them into three feature-length movies, adding color and rescoring the music, and then selling them to the Disney Channel. When the Costner movie debuted, over a million units of these "new" Greene films were shipped, proving repurposed old TV shows could have a profitable shelf life.

"You could say Costner came to my rescue again when he was doing *Wyatt Earp*. And there was also *Tombstone*. I called my movie *Wyatt Earp: Return to Tombstone*. I went to CBS and sold them on the idea that we'd shoot new footage of Hugh O'Brian as Wyatt Earp thirty-five years after the O.K. Corral shootout and create flashbacks using the original TV series footage. We also got Bruce Boxleitner as the new sheriff of Tombstone, Marty Kove and "Dandy" Don Meredith. And I had Johnny Cash sing the old theme song that I rewrote some of the lyrics for."

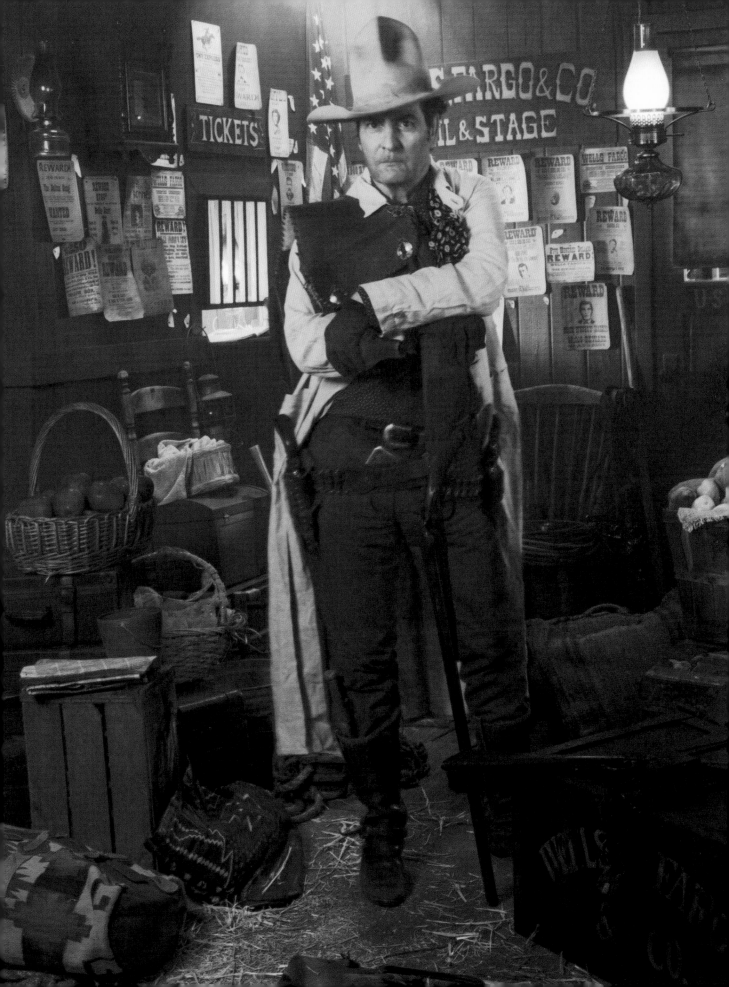

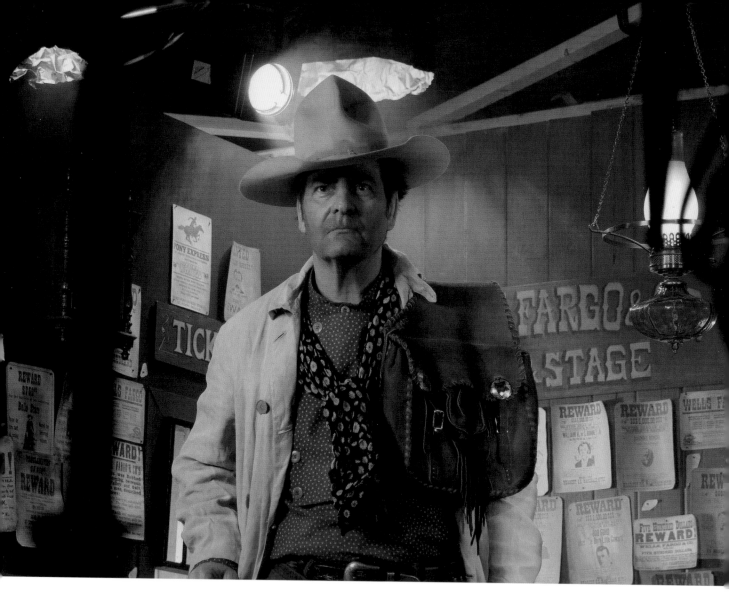

As writer and producer, Word made sure that colorization would be a creative part of the end result. "We shot the new material with Wyatt driving a Model T in black and white and then colorized everything, so there would be a constant visual tone. It was very effective. It did really well. And we thought we would get an order for more, but CBS said that since the Costner *Wyatt Earp* didn't do any business 'the fad' was over. But the people who watched our show were a different demographic than would go see a Kevin Costner movie, so that was disappointing." Despite CBS's indifference, for Rob Word the joy of filming *Return to Tombstone* remains: "It's still the only Wyatt Earp movie to actually film in Tombstone. It was a great experience. I got to play a cowboy in Tombstone."

Word continued to create new Western projects, at the same time spotlighting older films. He repackaged, colorized and rescored half-hour versions of John Wayne's 1930s Monogram Westerns as *Young Duke* for new audiences. More than thirty years ago, he co-founded the Golden Boot Awards to honor Westerns and the men and women who made them, while at the same time helping to raising millions of dollars for charity. Today, among many other projects, he is the host and producer of his own streaming celebrity talk show on YouTube, *A Word on Westerns*, and continues to devote himself to the genre that he professionally and personally loves, with the same enthusiasm as the young kid who met John Wayne on the set of what many consider the finest Western ever made.

"I called my movie 'Wyatt Earp: Return to Tombstone.' I went to CBS and sold them on the idea that we'd shoot new footage of Hugh O'Brian as Wyatt Earp thirty-five years after the 'O.K. Corral' shootout and create flashbacks using the original TV series footage."

HARRIS YULIN
UNMASKING A LEGEND

IN HIS INTRODUCTION to the published version of his screenplay for *Doc*, writer Pete Hamill (*A Drinking Life: A Memoir*) states that "Harris Yulin seemed to go straight to the dark heart of Wyatt Earp." Recruited to the project by close friend Stacy Keach, who played the picture's titular lead, Yulin in 1971's *Doc* approached the iconic lawman figure in novel fashion. Keeping close to Hamill's exceptional script, Yulin, under Frank Perry's direction, played the famous frontier marshal not simply as a questionable lawman with conflicted convictions, who bent the rules in any way that were convenient for him, but also as someone who, knowing politics, had an ambitious agenda and could use the newfound power of the press to his advantage.

Yulin recalls, "We were so used to a certain image of Earp, like Henry Fonda, so to do it this way with Hamill and Frank Perry was the challenge because you're going up against everyone's expectations of this man and their memories of the way he was in movies and television. I grew up with Westerns like everybody else, so I had the same reaction when I read the script, a sense I was seeing a different kind of Wyatt Earp, probably a more accurate one."

Yulin's ice-calm performance set a new standard as he turned Earp into a bullying official with a gun. This less-than-flattering characterization of the American icon was somewhat indebted to James Garner's gritty performance in John Sturges's *Hour of the Gun*, which had the future Jim Rockford invest Earp with an obsessive willingness to break the law in order to exact revenge: Earp's status as a peace officer in this picture, that is, permits him to kill with impunity.

Despite *Doc*'s revisionist approach to the story of Wyatt Earp, Doc Holliday and the Clantons at the O.K. Corral, Yulin, a native Angelino, comes from a family of Western movie traditionalists, being the cousin of screenwriter Sloane Nibley, who penned scripts for Roy Rogers and the Gary Cooper vehicle *Springfield Rifle* before writing dozens of TV episodes for shows like *Rawhide*, *Wagon Train* and *Have Gun - Will Travel*. From the acting side, Yulin was also related to Republic Pictures' leading lady, Linda Stirling, the so-called "Serial Queen of America."

The desire to live an artist's life gripped him early. He studied acting technique with Jeff Corey for a bit and then made a go as a painter in Italy and Israel.

His stage debut came in the early 1960s and was immediately noted by critics for its naturalistic aspects, especially in Shakespearean productions where the great playwright's anachronistic verse became understandable for contemporary audiences via Yulin's delivery. The young actor would subsequently secure roles in notable Broadway revivals of great plays like Lillian Hellman's *Watch on the Rhine* and Henrik Ibsen's *Hedda Gabler* and went on to direct stage productions himself around the United States that included George Bernard Shaw's *Candida*, Arthur Miller's *After the Fall* and Shakespeare's *As You Like It*. It was his relaxed manner on stage, making each role his own, no matter the time period or subject, that brought Yulin to film in Aram Avakian's *End of the Road*, co-starring Stacy Keach. On his naturalistic approach to acting, by the way, Yulin told the *Irish Times* in 2010, "If you don't have something to say about a person, then why are you playing them? If you don't respond to it, then you're in the wrong part."

Alternating successfully between theater, film and television, Yulin took on the role of the lascivious-but-tough tracker Deek Peasley in the *How the West Was Won* TV series. The contrast between his officious take on Wyatt Earp and the charming, deadly rascal he created for *How the West Was Won* demonstrated to all the actor's enormous versatility. In Dan Curtis's *The Last Ride of the Dalton Gang*, co-starring Bo Hopkins and Terry Kiser, he took on another iconic Western figure: Jesse James. His portrayal of the unbalanced bandit is a highlight of this oddly toned Western that mixes raffish comedy with bloody violence.

Yulin's journeys West, though, have been limited since *The Last Ride*, as he soon became known for his sharply etched criminals and crooked cops in films like *Training Day* and *Scarface*. Nominated for an Emmy Award for his guest-starring role in an episode of *Frasier* as a lovesick mobster, Yulin makes a point of returning to his first love, theater, as often as he takes on roles in series television (*Buffy the Vampire Slayer*, *24*, *Ozark*) or playing imposing authority figures in smash hits like *Clear and Present Danger* and *Ghostbusters II*. With more than a hundred-and-twenty screen roles to his credit, the actor continues forging fine performances as he strives ceaselessly to find the personalities in the characters he plays.

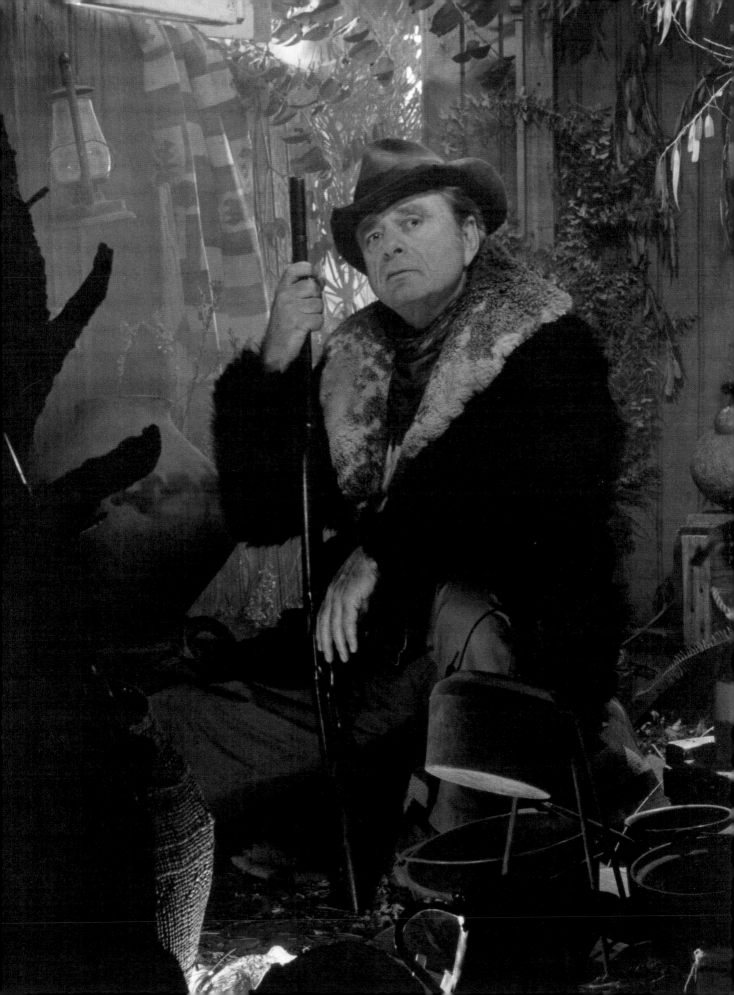

CARVED ON FILM:
Western Movies and the Faces that Made Them

BY C. COURTNEY JOYNER

"It's been a great fifty years. Nobody ever went so far on so little. I got lucky, I'll tell you."

WHEN JACK ELAM made this statement, we'd been talking about his career for a few hours, and the one-time accountant was modest to the extreme about his own impact in film and television. The fact that he'd been asked to stand in front of cameras hundreds of times or that audiences looked forward to seeing "the man with the crooked eye" as much as any lead he supported never fazed him. Elam thought of himself as simply a jobbing actor who worked on classics, bombs and lots of in-betweens, always giving his all because that's what he was paid to do. And then, if he was lucky, another role would come his way, and, more often than not, it was in a Western.

Because Westerns need faces.

From its flickering beginnings, the Western film wasn't just a chance to marvel at wide open spaces and big skies, it was also a place for faces like Elam's: ragged, often villainous, sometimes optimistic, but always distinctive. If John Qualen appeared in a scene, it was often with a message of hope for life on the frontier. But if it was Lee Van Cleef, we knew there was trouble ahead. These actors carried their movie reputations along with their guns, the presence of the Western character actor being as old as cinema itself.

It was still just after the turn of the century, and Edwin S. Porter's lead in *The Great Train Robbery*, Gilbert M. "Broncho Billy" Anderson, would become one of the first movie stars, riding, fighting and clinching the girl in more than three-hundred silent two-reelers for his own Essanay Company, making sure to surround himself with players audiences could instantly label as villain, sidekick or townsfolk. During this early period, production units within studios made their movies with the same actors in short after short and then features.

By 1919, one stalwart, long-faced, sincere cowboy rose above all others to become the ultimate symbol of the West, William S. Hart. Riding his famous pinto, Fritz, Hart made realism a priority—even as he took himself in unexpected directions, sometimes becoming a good-bad man, a man of flaws whose choices of virtue and integrity by the last reel could redeem him. In contrast, Hart's grinning rival Tom Mix was all flashy gunplay and trick horsemanship for the cheering kids in the front row.

As the world went movie crazy, young John Ford was at Universal directing Harry Carey, sometimes with set visitor Wyatt Earp watching, in a series of naturalistic films that flew against the conventions of the typical white hat/black hat Western. What Carey brought was a different face to the genre, a not particularly handsome one. Ford knew that by training his camera on the faces of his leads and supporting players and reading their eyes, he was creating a new style; the flesh and blood of the people in these stories made the stories, not just the gunplay.

The coming of sound in 1927 brought major changes to every studio, star and genre. As companies wrestled with the problems of "talkies," their executives wondered if making Westerns was even possible using the new, bulky sound equipment. Fox Films took the chance with the all-talking *In Old Arizona*, starring Warner Baxter as the Cisco Kid, and scored big. Then, following *The Virginian*, Gary Cooper rocketed to fame, finding himself in dramas as often as on horseback, not limiting himself to the genre as Hart, Mix and the others had done.

John Wayne's face would become the most famous and probably the most profitable the Western genre ever produced, and it was Raoul Walsh who gave the actor his first significant role in a cowboy film, *The Big Trail* for Fox. To bolster his novice leading man, Walsh brought El Brendel, Ian Keith, Tyrone Power, Sr., and Iron Eyes Cody in as grizzled settlers. Walsh and cast endured every hardship imaginable to ensure *Big Trail* would be the most realistic depiction of the struggle West after the Civil War. But the movie wasn't a commercial success, dying upon its release in 1931, which curbed major studio interest in big Westerns.

There would be exceptions, like Cecil B. DeMille's gigantic and insanely inaccurate 1936 production,

The Plainsman, starring Gary Cooper as Wild Bill Hickok and a superb Jean Arthur as Calamity Jane squaring off against gun-runner Charles Bickford. But the studios continued to hedge, leaving smaller companies to meet audience demand. Mascot, Monogram and dozens more thrived making Westerns with old silent stars and upstarts like Wayne and Bob Steele for independent screens. In their backdoor way, the low-budget Westerns had an impact, and their popularity was undeniable. A scruffy outfit emerged during this time as six poverty-row companies that were on the verge of collapse due to outstanding laboratory bills came under the control of Herbert J. Yates, who christened this new group Republic Pictures.

The very first film Republic put into production starred Gene Autry. 1935's *Tumblin' Tumbleweeds*, a major hit, created a brand-new genre, the musical Western, supplying the blueprint for Republic's production schedule for years. Instantly, the new company had a major star, with a unique approach to an old form, despite the fact that Wayne himself, his voice gloriously dubbed, had been "Singin' Sandy" in Monogram's *Riders of Destiny*. Never one to let a business opportunity pass, Yates noted the growing popularity of the comic sidekicks riding beside his heroes, notably Smiley Burnette, who'd come with Autry from his radio show, and George "Gabby" Hayes, who would become as famous as Republic's newcomer Roy Rogers.

It wasn't just Yates who was paying attention to Republic's singers-in-chaps formula; the majors began to exploit it, too. "I'm the rich man's Roy Rogers," declared Errol Flynn after being cast in Warner Brothers' 1939 *Dodge City*, making him the studio's big-money western hero. The Flynn vehicles had their own amply budgeted formula, having the star often muck around with pals Alan Hale and Guinn "Big Boy" Williams. Add the ever-present Ward Bond, Victor Jory or Bruce Cabot to the mix, and you had a rollicking guns-blazing good time.

By the end of the 1930s, the major studios had again turned their cameras West, not wanting the low-budget Republic to snatch up all the box office gold. Universal, always a poor cousin on the verge of bankruptcy, continued with the B productions that were its primary output and brought in the cash that allowed the studio to step up its game once or twice a year. In 1939, it gambled with Westerns built around movie-star pairs. *Destry Rides Again* gave us naïve sheriff James Stewart bumbling his way keeping the peace in lawless town as saloon singer Marlene Diet-

rich fell for him. There was no love lost in *My Little Chickadee*, however, as W. C. Fields traded barbs and innuendos with Mae West. Both of these black-and-white comedies were smashes as it seemed safer and easier for Universal to poke fun at the genre rather than bankrolling epics like DeMille's *Union Pacific* or director Henry King's *Jesse James*.

With stunning location photography capturing the lives of Missouri's infamous James brothers, portrayed by Tyrone Power and Henry Fonda, and the magnificent Jane Darwell standing tall as their mother, King in *Jesse James* surrounded the train robbers with supporting characters who could articulate the lead players' thoughts and help us understand their motivations. Lon Chaney and the gang noisily back up Jesse's plans for his train robberies, demonstrating their loyalty, while John Carradine, as Bob Ford, quietly plans his betrayal. These were the story arcs that were to collide, and it was the supporting actors who pushed them along. Fonda's Frank James barely escapes retribution as Power's Jesse settles into "normal life" with beautiful bride, Nancy Kelly. Then he places his trust in Carradine's Bob Ford. Carradine remembered, "I was standing in front of a theater where *Jesse James* was showing, and a little kid said, 'Did you shoot Jesse?' and I said, 'Yes' and the son of a bitch kicked me in the shin!"

There was another, grittier, take on the Western soon after *Jesse James*. John Ford and producer Walter Wanger had decided to turn Ernest Haycox's story "The Stage to Lordsburg" into *Stagecoach*. For Ford, making Westerns was a "job of work." But, of course, for him, these jobs always meant quite a bit more. *Stagecoach* didn't just touch on life on the frontier, it touched on the human experience of the audiences that came to see it. The film delivered a valuable lesson to Wayne, who was initiated into the unofficial Ford stock company as a leading man of A films, although Ford rarely stopped treating him like a rookie. Later, as a star-producer, Wayne would create a stock company of his own, making sure to work with actors and actresses who had their own filmic identities so that when they appeared opposite him, viewers knew that a showdown was imminent.

As the 1940s began, more than eighty Westerns were produced by every major studio, with the smaller producers hitting the trail with second-and-third-billed cheapies. The Western tale now appeared everywhere, from dime novels to radio plays to movie screens. Fritz Lang, the Austrian-German innovator behind *Metropolis*, prided himself on his

knowledge of the American West and applied those skills while exploiting a thriller-inspired structure for *The Return of Frank James*, with Henry Fonda continuing his role as the elder James brother. Fonda worked with Lang twice and despised him, claiming, "He killed horses." But their collaboration helped cement the actor's identity as an onscreen Westerner. Adding to the dramatic force of *The Return of Frank James* is a rafter-shaking performance by Henry Hull as a bombastic newspaper publisher, forever declaring "Shoot 'em down like dogs!" about anyone who disagrees with his editorials. A Broadway star before his entrance to the movies, Hull was the perfect character actor to accentuate a narrative, chiming in from the sides with advice for the leading man.

Hull, like so many supporting actors during the period, ran second to Walter Brennan, who had emerged as the true character star of the 1930s. Brennan had landed roles in films since the 1920s. When his front teeth were knocked out during a fight scene, which he later called his "lucky break," he suddenly was in demand for older parts as all he had to do was yank out his dentures. He became a favorite of directors Howard Hawks and Delmer Daves, and with his odd, scratching voice, which could erupt or stay in the back of his throat, he was ideally cast in Westerns. In William Wyler's *The Westerner*, Brennan plays the lynch-happy Judge Roy Bean, whose frontier justice ideals run up against an honest cowpuncher (Gary Cooper) accused of rustling. In lesser hands this would have been a programmer. But the amazing humanity of the performances and the honesty in Brennan's interpretation lift the movie. Understated and sly, Brennan captured something rare with Bean: the feeling of being misunderstood, despite the number of men he is going to hang for "insulting Miss Lilly Langtree." *The Westerner* offered more proof that the major studios and producers were ready to spend real money on Westerns and not see them as throwaway pictures.

Fast-growing Republic now had a stable of more than a dozen Western stars, from Allen "Rocky" Lane and Bill Elliott to Jim Davis and Forrest Tucker, all slated for various Western series, chapter-serials and standalone productions. Half of the Republic output was made for the Saturday matinee kiddies and the other half for nighttime crowds. For Yates, this meant upping production so that a new Republic release opened every week, especially when it could feature his cash cows, Gene Autry, Roy Rogers or John Wayne.

Although technically Westerns, the Autry and Rogers musicals existed in a world all their own. They were not period pieces: when Gene wasn't strumming his guitar on Champion, he was chasing down bad guys in a Packard. Responding to current events in a manner that upheld the code of the West, the Autry and Rogers adventures often featured spies and saboteurs, not bandits and varmints. All the while, Yates pressed for more films as Autry trained to join the Army Air Corps. Autry wouldn't begin his tour of duty until 1943, and Yates certainly wished his signature cowpoke a safe return but wanted to be sure he had a backup. Fortunately for Yates, contract-bound Roy Rogers was given a service deferment when the maximum age for draftees was lowered to thirty.

John Wayne's deferment from the military has been the cause of great controversy, given the Duke's image and the military service of his close friends Henry Fonda, James Stewart and John Ford. Because so many leading men were now in uniform, between 1941 and '45 studio executives worried about losing actors to a war that didn't have an end in sight and looked to Wayne and others, like Errol Flynn who was 4F because of his recurring malaria, or Randolph Scott, who was a veteran of the First World War, to take on Western after Western.

In 1941, Warner Brothers cast Flynn as Custer in *They Died with Their Boots On*, the heavily-romantic saga of the Little Big Horn, directed with searing skill by Raoul Walsh. Though Walsh had wanted to shoot at the actual battlefield, the notorious charge Custer led was filmed outside of Los Angeles, with the troop movements reconfigured to show Custer as the final man killed in a heroic stance when, in fact, he was one of the first to die. The interesting sidelight to the battle was the movie's plot twist, that the government's conspiracy to cheat the Sioux drove the conflict and that Custer was sacrificed because he knew about the plot. *They Died with Their Boots On* was a smash, guaranteeing more Westerns for Flynn, whose dashing handsomeness would soon be lost to the eroding effects of alcohol.

One of Wayne's first successes of the 1940s had him co-star with Randolph Scott and Marlene Dietrich in *The Spoilers*, a tale of rivals warring for women and gold in the Klondike. It had been filmed in 1913, 1923 and, starring Gary Cooper, in 1930, with each version featuring a reel-long brawl between its two leads. This remake would be no different as Wayne and Scott slugged it out. Scott, cast against type as the smooth-talking claim jumper, strikes the right chord with his arrogant line delivery with just a hint

of Virginia gentleman, making him a perfect foil. A leading man since the early 1930s, Scott could alternate from modern dress to Western with ease, but as the 1940s wound down, so did the budgets for his starring films, although he was the perfect complement to co-star with Wayne, Cary Grant and Errol Flynn.

Like Scott, Joel McCrea had gotten his start in the 1920s, and by the 1930s found himself under contract to RKO, playing romantic leads. McCrea's earnest acting style made him an ideal choice as a man who finds trouble when, and where, he isn't looking for it. In 1944, McCrea starred in *Buffalo Bill* for director William Wellman at 20th Century-Fox. The Technicolor biography was an enormous success, despite the fact that the gifted, hot-tempered Wellman, a friend of McCrea's, hated the movie and everything about it.

Buffalo Bill ends, for instance, with a disabled boy in the audience of the famed Wild West Show crying out his love for Buffalo Bill as McCrea tips his famous white hat and throws a kiss to the cheering crowd. Wellman said of the moment, "Jesus, it was so saccharine, it made you want to throw up." That scene was forced into the film by studio boss Darryl F. Zanuck, who'd made a deal with his director—if the company financed the dark *The Ox-Bow Incident*, Willman would direct anything else Zanuck demanded: in this case, *Buffalo Bill*. Wellman's passion for *Ox-Bow* was genuine, and he agreed, sensing his old pal and boss was going to end up with one of the greatest Westerns ever made—a film that probably wouldn't make a dime—and another that would strike box office gold. Wellman was right on both counts.

The Ox-Bow Incident, Walter Van Tilburg Clark's novel of mob rule, had drawn Wellman in as soon as his wife read it to him, and he had to own it. Wellman went shopping for a studio, but only Zanuck would permit the film to be made in the way the director wanted: realistic in its intensity, free of compromise. Wellman directed it without flourish, keeping his style as spare as Clark's words. Like Ford, Wellman harked back to his silent films and the great use of the close-up, bringing his camera to the faces of mob and victims as the rope dangles. By concentrating on the pain in the eyes of the three cowboys falsely accused of rustling and murder, played by Dana Andrews, Patrick Ford and Anthony Quinn, the one victim of color, Wellman rendered a transcendent portrait of mob violence and its victims.

By making *Buffalo Bill* and *The Ox-Bow Incident* one after the other, Wellman clearly defined the separate directions of the genre: the slick adventures, jammed with action and comedy, versus darker stories of life and death in the West. Around the world, the Western was still popularly perceived as a mirror of the American experience and the strong cowboy type as the perfect symbol for the nation. But the changes in the country, as soldiers returned from war, were reflected by the men and women standing before and behind the cameras. Many had served and simply couldn't, or wouldn't, blindly copy the old-style Western myth.

It was a different, shadowy world for American movies, as they dealt with the realities of World War II at home. The American crime film was already being reshaped by the artistic vision that would become film noir, and so would the Western as it found parallels between the upheavals experienced by families left shattered by the Civil War and those engendered by the conflicts in in the Pacific or Europe. It also meant seeing the big sky landscape in a different way, a harsh land where death held little meaning. Now, the lone hero character, whether a private detective in L.A. or a marshal scouting the Indian Nation, had to kill his own demons before taking on the ones coming at him with a gun or a war club.

John Ford was the most talented director to exploit these troubling character types. With *My Darling Clementine*, which starred Henry Fonda as Wyatt Earp and Victor Mature in his best role as Doc Holliday, Ford pushed deeper into the Western darkness than he had before. Stuart N. Lake's novel about the O.K. Corral served as the basis for the script, but not its emotional core. Ford relied on what Wyatt Earp had told him years earlier on the set of a Harry Carey two-reeler and painted his Tombstone with those memories: wide open and arid in the desert sun and dangerous at night when assassins like the Clantons (led by a vicious Walter Brennan) could hide in the shadows.

In Fonda, the director had his perfect Wyatt Earp. The Nebraskan actor buried himself in his characters, and so his Wyatt Earp is not a peace officer with a fast gun, but a true cowboy, with a cowboy's rolling gate and sense of right. Earp's allies against the Clantons are his deputized brothers, Virgil and Morgan (Tim Holt and Ward Bond), along with a tortured Victor Mature. It may be seen as odd casting, perhaps forced by 20th Century-Fox as Mature was under contract, but even though he is the most robust tubercular case ever, Mature captures the angry, deeply troubled side of Holliday well.

Ford believed in the "promise of the West" because he believed in the strength of its people, but he also saw the blood on the ground left by outlaws gunning the innocent and treacherous wars perpetrated against Native American tribes. Ford's distrust of government authority, paradoxically, was as large as his devotion and sense of obligation to military duty. In many films his message was clear: politicians could start wars, but it was common men who fought them. After his return from active duty, these sides of his personality were often at odds. The strife showed never so vividly as in *Fort Apache*.

The first of the director's esteemed cavalry trilogy, *Fort Apache* allowed Ford to show both sides of the Indian conflict, nodding toward the idea that the martinet colonel in charge of the outpost (Henry Fonda), the officer who represents Washington policy, is unstable. There's no doubt that Fonda longs to exterminate the Apache to maintain what he sees as the status quo, a sensibility that prompts him to ignore peace treaties, the protests from his experienced captain (John Wayne) and the lost lives of men under his command.

It was a risky approach for Ford, casting everyman Fonda in an unsympathetic light and sending the Ford stock company to their end for all the wrong reasons. We'd come to love Victor McLaglen, Harry Carey, Jr., Ben Johnson and mush-faced Jack Pennick and felt it when they were handed their mission, knowing they probably wouldn't return. As an audience, that familiarity strikes deep with us, and that's exactly Ford's point–sometimes loved ones die following their military oath. *Fort Apache* is a gutsy film for this reason but one that has to be examined for what it says between its moments of grand entertainment. The message the film carries cuts deep and true, exemplified by the dialogue between Wayne and the Mexican star Miguel Inclan as Cochise; their faces creased by experience, both understand that war will mean annihilation for the young men in their armies.

Howard Hawks, after working with Gary Cooper for years, would now turn his eye toward John Wayne for a Western he was preparing, *Red River*. The war years had been good to the Duke professionally as he built up his image starring in an amazing eighteen movies between 1941 and 1945, and his status was to continue unchecked, even as other leading men in Hollywood took to the saddle to challenge him.

"Mutiny on the Bounty Goes West" was writer Borden Chase's description of his script, which featured a massive cattle drive along the Chisholm Trail as the narrative hook, yielding conflicts between a tyrannical cattle baron (Wayne), the men who slave for him and his adopted son (Montgomery Clift). Knowing that the model for Wayne's character was Captain Bligh brings *Red River* into sharper focus. During the 1940s and '50s, the star didn't mind some tarnishing as long as the character's ultimate goal was on the side of right. In the famous last scene, Wayne goads and challenges Clift into a fight and is soundly thumped. The other performances are all finely tuned, especially the work of Harry Carey, father and son. As Harry "Dobe" Carey, Jr., recalled, "*Red River* was my father's last movie, and I was in it with him, although we had no scenes together. He wanted me to use his name, and I was fine being 'Dobe' Carey, but he was sick, and I made a promise to him that I would be Harry Carey, Jr., to carry on the family name. This didn't please my mother, but I told her that dad asked me to do it."

With *Red River*, Dobe Carey began a career that would see him transform from juvenile lead to a Western stalwart. Brennan took out his teeth for the role of Groot, the grumpy trail cook, and gummed the scenery in a signature comic performance that works in direct contrast to Wayne's perfect underplaying. He received the best reviews of his career for *Red River*, even getting a positive nod from John Ford who, legend has it, said, "I never knew the big son of a bitch could act!"

High praise indeed, as Ford soon moved ahead with the second film in his cavalry trilogy, *She Wore a Yellow Ribbon*, with Wayne playing aging bespectacled cavalry officer Nathan Brittles, who takes on a last mission before retirement to capture renegade Cheyenne who've jumped their reservation after the Little Big Horn. Brittles and his command, the Ford stock company, including Victor McLaglen and George O'Brien, must find the renegades and stop them before the situation dissolves into a full-blown war.

Tackling some of the same themes as *Fort Apache*, with Chief John Big Tree as the Cheyenne chief who counsels Wayne against inevitable conflict, *She Wore a Yellow Ribbon* weaves sentimentality around its deeper issues thanks largely to the performance of actress Mildred Natwick. Another Ford regular, Natwick balances comedy with tragedy as an army wife, who spends every day under the shadow of becoming an army widow, showing nothing but humor, strength and true dignity when faced with the worst. Winning an Academy Award for cameraman Winton Hoch, *She Wore a Yellow Ribbon* was a fine way

for John Ford to end the 1940s, as the Western was about to ride hellbent into American living rooms, along with Congress, Korea and the atomic bomb.

"The haunted man" theme had always occupied Westerns but rose to a new level in Henry King's *The Gunfighter*, featuring Gregory Peck and Karl Malden. Bill Bowers, who shared an Academy Award nomination for his script, said his inspiration came from his barhopping days when he'd pal around with various tough-guy actors who could never be left in peace by other drinkers egging them into fights. Bowers scribbled the idea the next morning, seeing it as a great framework for a Western with a gunman protagonist who can't escape his quick-draw reputation.

The Gunfighter quietly introduced a new, savage element to the genre: the psychopathic villain. Skip Homeier's Hunt Bromley, who's determined to shoot it out with Ringo, is no simplified bad guy but a deranged hot-head who's capable of anything. This is the kind of twitching presence we'd seen in urban film noir, but not in the 1880s. In *The Gunfighter*, the villain is a modern, sadistic menace, taking the Western another step from its formulaic roots with a giggling violence that can't be escaped. Perhaps due to this ominous aspect, the film barely broke even.

Ford declared to Peter Bogdanovich that his 1950 *Wagonmaster*, without Wayne but with psychopathic villains, "came closest to what I wanted to achieve." The small film is a sincere tribute to the Mormon settlers who braved the journey West, facing the hardships of nature at its worst when a feral band of shotgun-wielding bank robbers joins the wagon train. *Wagonmaster* retains sadistic power and clear sentiment in equal measure as Ford lets the opposing elements of moral purity and corruption collide while asking, "How can the most peaceful among us face the most violent?" By casting Harry Carey, Jr., and Ben Johnson as the co-leads, supported by Ward Bond and Jane Darwell, the director creates a family unit, though not one bound by blood, rather by faith and the journey toward a new life. What they don't expect is to have that dream nearly killed by an actual family of deranged criminals, including a terrifying James Arness.

The fact that neither *The Gunfighter* nor *Wagonmaster* hit commercially didn't stop experimentation with form in Westerns as stars began to take risks with unusual properties. At Fox, James Stewart lent his power to director Delmer Daves's *Broken Arrow*, detailing the Native American conflict from the point of view of the Apache. Trust and friendship develop between Stewart and Jeff Chandler, even as the treaty they've agreed to is violated by the settlers and Geronimo. It's decided that bloody revenge isn't the answer, despite the murder of Stewart's young Apache bride, played by Debra Paget. While Native American Jay Silverheels is a fiery Geronimo, always defying Cochise, Chandler brings imposing, charismatic power to the legendary Chief. The film helped reset Hollywood's treatment of Native Americans.

Another James Stewart Western, *Winchester '73*, began a remarkable collaboration with director Anthony Mann that established the actor's status as a Western icon. The film follows the trek of a Winchester rifle as it passes from cowboy to outlaw to Indian. Stewart wins the rifle in a shooting contest judged by Wyatt Earp (Will Geer), but when it's stolen, he tracks the gun from town to prairie, through the hands of cavalry and Apache, finally getting it back in time for a shootout with his bank-robber brother. The film reinforced Stewart's image as the drifter worn around the edges, who gets caught up in situations that he's forced to deal with.

Millard Mitchell, whiskers soaked with tobacco juice, rode with Stewart in *Winchester '73* and the superb *The Naked Spur*, while in *The Man from Laramie*, Wallace Ford took the role, and in *The Far Country*, it was Walter Brennan trailing along. These geezers were the voices of conscience and the ones who patched Stewart's wounds after shootouts with Western stalwarts John McIntire, Robert Ryan, Arthur Kennedy and Jack Elam. The Mann westerns often ended on a hopeful note, but whatever demons drove Stewart's character still attended him as he rode toward a new horizon.

Filmed at Gene Autry's Melody Ranch Studios, *High Noon* wasn't going to be a Western about anything but people and their corrosive nature. The story's violence is its feeling of dread, that something in the air is coming for Gary Cooper on his wedding day. *High Noon* struck a particular nerve with 1953 audiences. When our neighbor faces trouble, will we stand up and fight with him or lock our doors?

Producer Stanley Kramer's approach of Gary Cooper was a bold move. Cooper was well-known for being conservative and had gone on record about his views, but he responded enthusiastically to the viewpoint of Carl Foreman's script and what he believed Fred Zinnemann would bring to the film as director. Around Cooper, Zinnemann built the population of Hadleyville with grand and familiar faces: Thomas Mitchell, Otto Kruger, Henry Morgan and Virginia Christine refuse to help Cooper defend the

town while Lon Chaney's arthritic ex-sheriff simply can't. With Lee Van Cleef and Sheb Wooley backing him, pockmarked Ian MacDonald is the revenge-minded killer who wants Cooper's blood. *High Noon*'s story of individualism set box office records, bringing the Western again into the arena of social commentary. The genre was making statements, and audiences were responding favorably—as long as there was still a bad guy to be gunned down and a good guy to cheer.

George Stevens's *Shane* tells the more straightforward story of a hero who rides to the rescue of farmers struggling against cattlemen stealing their land. Stevens fashioned his Western around well-trod traditions and blew them apart with the most graphic killings yet depicted on film. Casting Alan Ladd was a stroke of pure luck after original choice, Montgomery Clift, backed out. Ladd plays Shane as a stoic, taking insult after insult before finally drawing his guns. Jean Arthur and Van Heflin are the couple who befriend Ladd, and he comes to know their son, Brandon deWilde, who mistakenly regards the gunfighter as more of a man than his own hardworking father. Heflin is Ladd's opposite in voice and looks, but he's a decent man who would plow a thousand furrows to feed his family, which is exactly Stevens's point: Heflin is the family man, leading an honest life, deserving of respect from his child.

Jack Palance, in his career-making role as Wilson, becomes the personification of black-clad gun-slinging evil by deriding hapless farmer Elisha Cook, Jr., before blasting him into the muddy Wyoming streets. Stevens insisted the violence have impact and was the first to use a wire to yank actors off their feet, simulating the force of a bullet slamming them. For his death, Palance is catapulted by Shane's gunfire, splintering a stack of barrels.

Universal-International would release eighty-odd westerns during the 1950s, including the Stewart-Mann films, almost all in Technicolor. Jack Arnold was one of the studio's most reliable and creative workhorse directors, making several exceptional Western programmers, including war-hero Audie Murphy's best at Universal, *No Name on the Bullet*. With more military honors than any other enlisted man in World War II and a kill record that would always haunt him, Murphy had come from astonishing poverty, and the life that Hollywood promised was beyond anything he'd imagined. He always claimed he was never an actor, but he gained confidence the more he worked.

Michael Dante acted opposite Murphy in *Apache Rifles* and recalled how "quiet he was. He was like a cat, with these silent movements. He was always very polite, but there was something going on there." That "something going on" was the trauma that Murphy felt from his hellish war experiences. Understanding that Murphy was dealing with his own "combat shock" and always walking a mental tightrope augments the sense of threat and violence he brings.

Randolph Scott had been making solid mid-budget films like Andre De Toth's *Riding Shotgun* when he was given Kennedy's script *Seven Men from Now*, which Wayne had just turned down as star but would produce through his company, Batjac, at Warner Brothers. The script was a searing revenge story, and Scott took the lead, pleasing Wayne, who then hired Budd Boetticher to direct. Experience now lining his eyes, Scott in the 1950s wasn't a man who could be rattled, pushed or have his dignity marred. In *Seven Men from Now*, he didn't play a buttoned-down cowboy hero but a man set on a violent journey. Lee Marvin had been a gangly bit-player who'd been pulled from the ranks to get shot by Scott in *The Stranger Wore a Gun*. By the time of *Seven Men*, Marvin was an audience favorite, who'd earned co-star billing by bringing an unpredictability to his villains.

Shot on budgets of half-a-million dollars and less, the West Boetticher evoked in *The Tall T*, *Buchanan Rides Alone*, *Ride Lonesome*, *Decision at Sundown* and *Comanche Station* was parched and cynical, where you had to bury a man in a tree because the ground was too hard. The director populated his films with his own company of character actors, the next generation of bad men ready to challenge Randolph Scott at every hitching post. Beyond Lee Marvin there was young hillbilly James Best, imposing Claude Akins, James Coburn, all teeth and quick-draw, L. Q. Jones, the easygoing rascal who'd joke and shoot in the same breath and, finally, Richard Boone and Henry Silva.

The Tall T remains a major achievement, too. It is a blistering indictment of how people behave when faced with their own mortality, especially at the hands of the likes of Boone or shotgun-toting Silva. Scott is just a fellow walking down a road, hefting a saddle, who grabs a lift from a buddy driving a stagecoach. His friend is killed by robbers Boone and Silva, who kidnap newlywed passengers Maureen O'Sullivan and John Hubbard.

Burt Lancaster brought director Robert Aldrich over to the A list by hiring him for *Vera Cruz*, with Lancaster a hot-wire of energy alongside Gary Cooper, and the dark-edged *Apache*. Both films featured

Charles Bronson and displayed different aspects of Lancaster's abilities. His performance in *Apache* is a physical wonder as we see him control the emotional and physical pain his character endures. On the other side of the aisle is Kirk Douglas's production of *The Indian Fighter*, a fun action vehicle designed around its grinning, athletic star, here supported by Walter Matthau and Lon Chaney.

Douglas and Lancaster would come together in the decade for their most famous teaming, director John Sturges's *Gunfighter at the O.K. Corral*. Lancaster's Wyatt Earp in the picture is authoritarian, lacking any sense of reluctance about wearing a badge, although he and his brothers have bent more than a few laws themselves. Douglas's Doc Holliday captures the gambler's assurance and fine hand at the poker table and also the gut-twisting alcoholism. Douglas doesn't pare back on Holliday's emotional problems, adding to the suspense over whether he's up to the task of fighting the Clantons.

John Wayne and Ford hadn't collaborated since *The Quiet Man* in 1952, and Wayne had made another eight films since the Irish classic. But as shooting started for *The Searchers*, the actor now ranked in the top ten of box office stars, his influence with the studios enormous. None of this was lost on his old mentor as Wayne's taking the lead in *The Searchers* guaranteed the picture financing. As the single-minded Ethan Edwards, Wayne delivered his most substantial and complex performance yet. With all his violent faults and character defects, he is still the only man to lead the rescue of kidnapped Debbie (Natalie Wood) from the Comanche he hates.

That is, if she wants to be saved.

In one of the most famous scenes in American cinema, Wayne chases down Natalie Wood, who fears he will kill her for "turning Comanche," and scoops her into his arms. The final, painterly moment, with Wayne standing in the doorway watching the family reunited still sears us. Jeff Hunter, who despises Wayne for his bigotry, and Hunter's beloved, Vera Miles, are finally together, too, and Wayne walks away, alone, not part of a family and truly not part of anything.

The performers around Wayne echo his character's reason and anger, battering him from all sides as he continues his mission. Even those characters who side with Ethan don't agree with his methods. Jeff Hunter is purposely earnest in his moral preaching about the treatment of the Indians, and Wayne constantly humiliates him for being naïve. At the homestead, Vera Miles, in her first role for Ford, is the face of strength. Hunter barks about Miles seeing him in the bathtub, and she's frank about her desire for him, all of which resonates with Wayne who knows that Debbie is now old enough to have been with a Comanche.

The film's supporting players add tremendous richness to the story. The moment when Harry Carey, Jr., thinks he sees his sister in the distance, but it's a Comanche wearing her dress after raping her, still shocks audiences. In his role as the Reverend, Ward Bond veers back and forth from bluster to something more quietly effective as he challenges Wayne's racism. From Ford's roster of superb regular players, John Qualen and Olive Carey are the defining image of frontier folks, while ex-rancher Hank Worden, in his fifth role for Ford, is wonderful as the eccentric slow-talking Mose. Ford's son-in-law, Ken Curtis, appears as a suitor, challenging Hunter for Miles's hand.

With *The Searchers*, John Ford had created one of his highest achievements. In contrast, Howard Hawks hadn't made a movie in four years when he started *Rio Bravo* in 1958. The director had always prided himself on his knack of picking commercial projects, but the recent dismal performance of *Land of the Pharaohs gnawed at his confidence*. While mulling new projects, he became interested in the format of one-hour television Westerns and started thinking in terms of characters that rolled from situation to situation, the sorts found on *Cheyenne* and *Maverick*.

Hawks, notably, had not appreciated *High Noon*, telling Peter Bogdanovich, that Cooper in the film "ran around like a wet chicken begging for help, then his Quaker wife saves his guts. He was supposed to be a professional, good with a gun, for God's sakes." Hawks repudiated what he perceived as softness with *Rio Bravo*. The great director ran with a script by Leigh Brackett and Jules Furthman and a magnificent cast that included John Wayne, Dean Martin, Angie Dickinson, Ricky Nelson, Ward Bond and Walter Brennan. Although Wayne hadn't made a Western since *The Searchers*, his starring in the film was seen as a slam dunk by Warner Brothers. Casting Martin only enhanced the dollar potential along; so, too, heartthrob Rick Nelson. Whatever *High Noon* professed in terms of style and theme, Hawks made sure *Rio Bravo* countered. Hadleyville in the earlier picture was a dusty, little black-and-white town, so *Rio Bravo*'s Old Tucson is an elegant, WarnerColor creation with perfectly pressed cowboys and coiffed saloon girls contrasting Dean Martin's grubby drunk.

Hawks was happy to use actors from TV Westerns. Brennan had his role on *The Real McCoys*. Ward Bond was starring on *Wagon Train*. Akins, Russell and Pedro Gonzalez Gonzalez could be seen in a television oater just about any night. Hawks took what he needed from the small screen, then shot the medium full of holes by creating a film that was born for the big screen.

The need for TV programming added to the production of Westerns at every major studio, as well as smaller outfits like Allied Artists. Character actors could count on steady pay if they signed on for a series. Like the production boom of the early 1930s, heroes needed bad men to confront, cattle barons to defy and ranchers to defend. As fast as script pages were churned out, casting offices teemed with grizzled veterans and young upstarts ready to take on the roles. In a 2009 interview, Dobe Carey remembered those mornings when he and the other character actors, actresses and crew waited at bus stops for the special lines going directly to the studios. During the ride, with scripts in their laps and coffee in their hands, they'd learn their lines. "Sometimes you were doing a series, or sometimes it was just a few days on one show and a few days on another, but the work in the Westerns didn't stop."

Character player L. Q. Jones seemed born for the Western, but after making his debut in Raoul Walsh's *Battle Cry*, he was seen as the perfect new recruit in war films until he won the part of Clint Walker's devoted pal, Smitty, in the TV pilot for *Cheyenne*. After Walker became a fan favorite, Warner Brothers starred him in *Yellowstone Kelly* and *Fort Dobbs*. Made for a price, these films did well and attested to the power of TV stars in the movies, a fact that the *The Magnificent Seven* would demonstrate beyond doubt. The planning of an Old West take on *Seven Samurai* had begun with Yul Brynner, who brought the idea of remaking the Kurosawa masterwork to producer Walter Mirisch. A complicated and contentious writing period followed but ended up producing a superb script that brought John Sturges in as director and financing from United Artists with plans for casting six hired guns to accompany Brynner.

TV primarily provided the producers their heroes: Steve McQueen, still starring in *Wanted: Dead or Alive*; Charles Bronson from *Man with a Camera* and James Coburn of *Klondike*. These actors had appeared in dozens of films, but television had given them audience recognition. This was also true of Oscar-nominated Robert Vaughn, who had gone from dramatic features to being a top-billed guest star on TV, rolling from one series to the next, most of them Westerns. Brad Dexter, a solid utility actor who seemed to specialize in playing crooked cops, and young German heartthrob Horst Buchholz completed the team that defends a village against attacks by bandit Eli Wallach and his men.

Even at this early stage, Bronson was seeing his celebrity overseas ignite, with *The Magnificent Seven* adding immeasurably to his popularity in North America. In one of the film's many reissues over the years, Bronson's name, like McQueen's, found its way above Brynner's, and it still remains there.

For McQueen, this was the breakout part he'd been craving, but he was still tied to the very TV show that had made his name valuable, and he was committed to start a new season *Wanted: Dead or Alive* when *The Magnificent Seven* was due to be filmed. In order to get out of *Wanted: Dead or Alive*, the actor staged a car accident, actually smashing into a tree at decent speed, then claiming a neck injury that prevented him from working on the television show as he headed to Mexico to "recuperate." That McQueen went to such extremes to appear in the film wasn't just a mark of his own incredible ambition, but also a sense of business savvy.

The traditional Western came roaring back courtesy of MGM and Cinerama's *How the West Was Won*. Covering all aspects of a frontier family's life over a fifty-year period, the film divided itself into five segments: "The River," "The Plains," "The Civil War," "The Railroad" and "The Outlaws." Most of the segments were directed by Henry Hathaway, with John Ford stepping in for "The Civil War" as George Marshal handled much of the Debbie Reynolds musical material sprinkled throughout.

How the West Was Won indeed touches on all aspects of the winning of the West, from the bravery of the first explorers to the fracturing of the country in the Civil War to the betrayal of the Indian tribes with the building of the railroad. As traditional-seeming *How the West Was Won* is, the film breaks the mold of Western convention in one major way—by focusing on the lives of two women instead of a lone hero. Debbie Reynolds is the driving engine of the film, with the men in her life building out the epic's structure, notably Robert Preston as a wagon master and sharpy-gambler Gregory Peck. Caroll Baker plays Reynolds's sister. Her story begins with her love affair with James Stewart and continues through the Civil War when her son George Peppard goes off to fight and survives to become a lawman who must confront bandit Eli Wallach.

Building the film's episodic structure around Reynolds and Baker allowed MGM to indulge in all-star casting, with James Stewart, Henry Fonda, Richard Widmark and a cameo from John Wayne, as well as Karl Malden, Russ Tamblyn, Agnes Morehead, Walter Brennan, Thelma Ritter and Edward G. Robinson. We love these performers and know them, and that brings delight to the experience of seeing them in all this Cinerama glory.

The same year as the glitzy *How the West Was Won* had its release, John Ford presented his elegy for the traditional Western, *The Man Who Shot Liberty Valance*. Ford's film begins, appropriately, with death—more to the point, the death of John Wayne. The director's final masterwork, which he had to fight to shoot in black and white, addresses the passing of the West and the ideals of the men who built it. The conflict of James Stewart's Rance Stoddard for taking credit for the killing of Lee Marvin's Valance is one of the great balancing acts in the movies—the "tenderfoot" who believes that civilization can tame men with its laws when sometimes the exact opposite, "the way of the gun" upheld by Wayne's character, is the solution.

The Man Who Shot Liberty Valance plays at times like grand opera with Ford's collection of character actors, including Strother Martin and Lee Van Cleef, holding nothing back in their performances. If Lee Marvin as Valance is the hurricane in this tale, causing damage at every turn, then Woody Strode is the silent tower of strength. He stands beside Wayne, tossing him the rifle to kill Marvin. *The Man Who Shot Liberty Valance* was a major hit for the director and Wayne, but Ford would make only one more Western, the flawed, poetic epic, *Cheyenne Autumn*, with Richard Widmark, Karl Malden and Carroll Baker.

With the continued run of Westerns on television, the genre needed a shot of creativity, as the original Western stars showed their age and a new sense of reflection settled into stories and performances. This all fit with Sam Peckinpah's approach to the West as a place of preserved memories, even violent ones. He had earned his critical reputation with the pilot for *The Rifleman* and the superb but short-lived series *The Westerner*, which would open the door to features. *The Westerner* drew its episodes from tales Peckinpah had heard from old timers on camping trips in the California mountains, giving it an unusual realism. The was also the perfect place for Peckinpah to find his own group of actors to carry from project to project, and when he got the chance to direct *Ride the High Country*, they came.

Ride the High Country's story is gloriously simple: a bank hires Randolph Scott and Joel McCrea, longtime friends, to transport gold from a mining camp. Scott has it in mind to betray McCrea and steal the gold but all gets derailed when they try to help a naïve Mariette Hartley escape her wedding into a vicious outlaw family. The old friends must find a way to come together to fight the outlaws and save the young girl's life. L. Q. Jones calls *Ride the High Country* "The greatest Saturday afternoon Western ever made." That assessment is spot-on, as the film is built around the images of Randolph Scott and Joel McCrea from all the Westerns that have come before. We expect Scott and McCrea to show integrity and honesty, and in that moment of Scott's betrayal, we feel McCrea's hurt. In contrast are the performances by Jones, John Anderson, John Davis Chandler and Warren Oates as the peckerwood Hammond brothers. Unlike Ford's inbred brutes of *Wagonmaster*, the Hammonds have backwoods humor and humanity. At best, they're grinning chicken thieves and drunks: at their worst, killers without conscience. R. G. Armstrong had first worked with Peckinpah on the pilot to *The Rifleman*, and here he comes into his own as Mariette Hartley's stern Bible-quoting father.

At the film's climax, when Scott and McCrea must come together to face down the Hammonds, the impact of the scene is incredible, with the delivery of McCrea's beautiful, simple epitaph: "I'll see you later." It is heartbreaking because it is so real and so real because of the cast. Released in 1962, *Ride the High Country* was treated as unimportant by MGM, but the film's reputation grew through the foreign press that had long-regarded the Western as a vital American art form.

In 1964, Clint Eastwood, on hiatus from *Rawhide,* read a script submitted to his agent by an Italian producer, which was called *Magnificent Stranger*. A fan of Kurosawa's *Yojimbo*, Eastwood recognized the plot immediately. He felt another Western version of a Japanese classic would work well, even if made on a low budget. Eastwood accepted, and the history behind the making of Sergio Leone's breakthrough film is beyond the stuff of legend. That is to say, *A Fistful of Dollars*'s impact on the Western and world cinema would end up being almost incalculable. Coming from a completely unknown filmmaker and obscure television star, the film saw release initially only in Europe before it came to the attention of United Artists, which would unleash it three years after *A Fistful* had been shot.

Leone translated the visual style of the classic Western into something his own. But the form Leone created wasn't just about his signature use of camera, cutting or color palette, it was the world in which the characters found themselves. Unlike its American counterpart, the Euro-Western rarely had its footing in the cowboy life or any historic event such as the O.K. Corral or the Oklahoma Land Rush but existed in its own universe, somewhere along the Mexican border, before, during and after a U.S. Civil War that seemed to have been fought by nomads and Spaniards. Of Leone's search for unusual faces for his signature close-ups, Eastwood once said: "Sergio loved circus performers, so there always seemed to be acrobats in the film someplace and Gypsies that he'd hire for the bandits so he could photograph those faces."

Over the next decade or so, more than four-hundred Euro-Westerns would be produced, solidifying the sub-genre's popularity, though some films received minimal or no theatrical distribution in the United States. Still, the demand was enormous, and actors found themselves jumping from one production to the next as their popularity flourished and the need for product increased.

James Coburn, Jack Palance, Telly Savalas, Alex Cord, Robert Ryan, Richard Boone, Richard Crenna, David Jansen, James Garner, Cameron Mitchell, Fred Williamson, Robert Woods and Chuck Connors—all took their turns starring in the new breed of Westerns. And character actors like Lee Van Cleef, Klaus Kinski and Henry Silva shed their supporting status to become stars in their own right. As the boom continued, the Euro-Western yielded another masterwork from the same man who shaped the genre so importantly, Sergio Leone, when he developed *Once Upon a Time in the West* from a story by Bernardo Bertolucci and Dario Argento.

This film's structure centers around a woman, Claudia Cardinale, who faces hired guns as she pursues business interests. Henry Fonda is Frank, the deadliest gunman hired by the railroad to prevent the young woman from pursuing her version of the American Dream. Frank doesn't know it, but he's being stalked by Charles Bronson. From its now-classic opening at the train station with a close-up of Jack Elam trapping a fly in his gun to the sweeping grandeur of Monument Valley, the film is an enormous tapestry that honors Ford as it amplifies his fondness for violence, humor and stunning settings.

Once Upon a Time in the West was designed to not just be the ultimate Euro-Western, but the ultimate Western, period. That was certainly the belief of Paramount chief Robert Evans when the film's large budget was okayed. But brilliant as it was, *Once Upon a Time in the West* failed in the States upon its release. Some blamed the fact that Leone had not been able to deliver Eastwood as his lead. The actor had passed on the script, believing the director was now focused on making sprawling epics at a time when he wanted to concentrate on more intimate projects that would include collaborations with Don Siegel. Robert Evans nevertheless felt that Sergio Leone had created a classic, finding genius in every frame, and time has proven him right.

Wayne and Stewart continued through the 1960s with well-made films that feature family patriarch figures who only take up guns reluctantly. Though still a major box office force, the Duke now recognized and refused to turn away from the effects of age, including weight gain and hair loss. He embraced his belly and craggy face, in fact, throwing his all into the adaptation of Charles Portis's *True Grit*. Hathaway guided this outing, which Wayne made right after having a cancerous lung removed. And Hathaway got the Duke his Oscar, but it was more than that. The director drew from him the best tragi-comic performance Wayne would ever give, as all of life's hard truths were there to be read on Rooster's one-eyed, weathered mug.

The same year as Hathaway's *True Grit*, Sam Peckinpah directed *The Wild Bunch*, his own highly romantic vision of life, death and male sacrifice. The film had a difficult birth as Peckinpah had promised Warner Brothers to deliver Lee Marvin for the role of Pike and similarly tough stars to play opposite him. None of these plans worked out, yet through producer Phil Feldman's efforts, Warner Brothers allotted real money to make the Western, which would now star William Holden leading an ensemble of battle-scarred Hollywood vets, Warren Oates, Ben Johnson and Ernest Borgnine. South Carolina-born Bo Hopkins began his long career with the director as Crazy Lee, threatening hostages with a shotgun before getting himself blown apart by the law. Robert Ryan had been slated for *Once Upon a Time in the West* but opted for *The Wild Bunch* when the Leone film was delayed. In *The Wild Bunch*, Ryan is the tortured Deke Thornton, Bishop's one-time friend, who's paid by the railroad to kill him with the help of "chicken-stealing gutter trash" L. Q. Jones and Strother Martin.

In *The Wild Bunch*, death's as inescapable as dust and scorpions, but this tale of the outlaws' journey to

Mexico for a last score brims with sentiment. Peckinpah admires his protagonists' choices, if not their method, and the romance of dying for a principle. No matter how it's examined, this epic film shot by Lucien Ballard is about the glory of lost causes. L. Q. Jones has called *The Wild Bunch* "really not Sam's best, but there's something there. It's a kind of alchemy that folks respond to." That "alchemy" made *The Wild Bunch* an Oscar-nominated success, earning it eventually a place on the American Film Institute's list of Best American Films.

Due to *The Wild Bunch*, controversy over movie violence began to crest, arousing the ire of critics and politicians. *A Man Called Horse*, with its poster of Richard Harris being suspended on bone hooks, was one of the prime targets for outraged viewers. The film relates to the story of an English aristocrat brought into the Sioux tribe by torture, who ultimately leads the Sioux into battle against their enemy. Supported by Dub Taylor, Iron Eyes Cody and Dame Judith Anderson, Harris completely inhabited both sides of his character's nature, from nobleman to warrior.

As *A Man Called Horse* takes us within the tribe, Robert Aldrich's *Ulzana's Raid* keeps the perspective squarely with young cavalry officer Bruce Davison as he wrestles with the brutal realities of an Apache raiding party. The carnage surpasses Davison's comprehension, and his performance strikes the chord between naiveté and experience as his men die fighting, including the one who truly understands the conflict, the scout MacIntosh, superbly underplayed by Burt Lancaster.

During the early 1970s, it seemed like the Western was at war with itself, tearing down its own mythology, but the essential strength of the form and its roots in American history remained unshakable, no more so than with the presence of John Wayne. Wayne's films through the start of the decade were strictly vehicles designed for him and produced by his son Michael for their Batjac company. *The Cowboys*, however, for which Wayne was brought on only as an actor, remains one of the star's finer works. The movie reinforced what was loved about the genre and brought Duke back to box-office dominance. Wayne had never shied away from adopting a fatherly image. A father of four at an early age, by the time of *The Cowboys*, Wayne had added three more to his personal brood and several grandchildren.

What this meant was that a sense of paternal duty comes through in *The Cowboys* as Wayne takes charge of a group of young boys to herd his cattle

when his regular cowboys quit on him; he becomes the father the boys need if they are to survive in the West. Wayne allows himself a vulnerability in *The Cowboys* that had been rarely seen. He's tough on the boys, but his obvious love for them, especially when he must defend them from the evil Bruce Dern, is touching. Lushly photographed by Robert Surtees and with one of John Williams's best early scores, *The Cowboys* isn't John Wayne's film alone. Slim Pickens offers a nice cameo as an old buddy, which he was, and Colleen Dewhurst is gloriously natural as a travelling madam with a wagon filled with young doves to divert the boys. Roscoe Lee Brown is wonderful as the trail cook who partners with Wayne, and their scenes together ring with truth and friendship.

For all of the talent attached to *The Cowboys*, it is the boys themselves who must hold their own within the story and on the screen. The cast went through rigorous training—some had never ridden a horse, though youngster Clay O'Brien was a rodeo champ. Of the older boys, it is Robert Carradine, in his first film, as the easygoing Slim, who cuts the most realistic figure of a working cowboy. Taking charge after Wayne's death, Carradine rallies the rest to get the herd moving with Duke's signature order: "We're burning daylight!"

Wayne's final film and triumph was *The Shootist*. It may seem inconceivable now that the Duke wasn't the first choice to star in this poignant fable about a legendary gunfighter dying of cancer, but he wasn't. Unsatisfied with the script, George C. Scott had left the project, and it was decided to approach Wayne. Director Don Siegel surrounded Wayne with personalities from his own past. Lauren Bacall had co-starred with Duke in *Blood Alley*, and Richard Boone had previously made three films with Duke, including *The Alamo*. Harry Morgan's strutting rooster of a sheriff is a stark contrast to his Ulysses S. Grant conferring with Wayne's Sherman in *How the West Was Won*, and reaching back ever further to *Stagecoach*, John Carradine shines as a sneaky undertaker. James Stewart likewise delivers a pivotal performance as the doctor who tells Wayne he's dying.

The world, *The Shootist* shows us, always moves on. Some will fit in; others won't. The romantic longing for the outlaw life is an indulgence the film never allows. Not so with Pat *Garrett and Billy the Kid*, perhaps Peckinpah's ultimate statement on life beyond the law in the Old West. A showcase of stellar actors, each bringing their own personalities and histories to this retelling of the legendary, doomed friendship

231

between lawman and outlaw, the film is draped in a shroud of sadness.

Peckinpah returns to the theme of nostalgic memory that he'd been exploring since *Ride the High Country*, as *Pat Garrett*'s characters relive stories of friendship, a killing, a bank robbery and women they bedded. The memories never stop, establishing a dreamlike rhythm, which the faces telling the tales highlight. John Beck is the duplicitous lawman riding along with James Coburn's Pat Garrett. L. Q. Jones is the sneering outlaw who blasts Slim Pickens. R. G. Armstrong is the vitriolic lawman who brings judgment down on Kris Kristofferson's Billy as if he were delivering the Sermon on the Mount, but with a shotgun across his knees. None of these unusual grace notes impressed MGM. Peckinpah's war with the studio and producers broke out full scale during shooting and continued devastatingly in the cutting room.

The truth was that the American Western was losing ground to action movies centered around the police, secret agents and the martial arts, no longer cattle drives or land rushes. The Euro-Western was coughing its last, too. Independent Westerns, such as *The Boss*, starring Fred Williamson, could still find financing, fortunately.

Clint Eastwood stayed true to the genre throughout the 1970s as he became the biggest star in the world. Much of his clout arose thanks to his fourth collaboration with Don Siegel, *Dirty Harry*. But the year before their police thriller, they had made a Western in the Leone tradition. Written by Budd Boetticher, *Two Mules for Sister Sara* is an excellent, humorous vehicle for Eastwood and Shirley MacLaine, who travel to Mexico to destroy a French garrison. The pacing of the film belongs to Siegel, punching home the action sequences, including the dynamiting of a train trestle and the attack on the fort. The film was photographed by Gabriel Figueroa, who shot *The Fugitive* for John Ford, and Ennio Morricone's music makes for one of his liveliest scores.

Eastwood's first film as director after *Play Misty for Me, High Plains Drifter* is the Western as horror film, a perfect crossbreeding of the genres. It's also a demonstration of the actor's power and position as he explores the outer edges of the genre that made him famous. His character is no simple bounty hunter; in fact, when he rides into town, no one can figure out who he is until he forces himself into their lives by getting rid of some outlaws and declaring the town his. As director, Eastwood had already begun to use his own company of actors, with Mitchell Ryan,

Geoffrey Lewis, Anthony James and Jack Ging all making appearances here as they would in other Eastwood projects. Ryan is particularly effective as the one member of the town council who tries to figure out the best way to deal with Eastwood's antihero, keeping him at bay, relying at the same time on his protection.

Phillip Kaufman's historic *The Great Northfield Minnesota Raid*, with Robert Duvall giving a psychotic interpretation of Jesse James, had impressed Eastwood. In turn, he asked for Kaufman to write and direct an adaptation of Forrest Carter's novel *Gone to Texas*, which would be retitled in script form as *The Outlaw Josey Wales*. The novel and film both rely on an old chestnut of a plot device as a Missouri farmer's family is slaughtered and he goes on the revenge trail to find the killers, who are, in this case, Union Army Red Legs. *The Outlaw Josey Wales* is a remarkable work. As Josey sees that he avenges his family, he acquires a new one comprised of various travelers, including Chief Dan George. The picture marks the first time that Eastwood had Native American characters in major roles in one of his Westerns. Chief Dan George, his sagging face a thing of beauty, is the perfect counterpoint to Eastwood's Josey; it isn't that he's Josey's conscience, he's also his spirit guide, ensuring he knows that every choice he makes on his journey will yield a consequence.

Eastwood began the subsequent decade with the enjoyable *Bronco Billy*, the story of a shoe salesman who runs a down-on-its-luck Wild West show. Filling out his cast with Sondra Locke, Geoffrey Lewis and Scatman Crothers, Eastwood created a sweet ballad about the fantasy West. The film earned good reviews and made money, but it was not a full-bore period piece as *The Outlaw Josey Wales* had been. The studios were still careful about that kind of commitment, looking instead to big action films with the likes of Sly Stallone rather than anyone on horseback.

Walter Hill, a disciple of Ford, breathed some grand ideas into the Western with *The Long Riders*, an updating of the Jesse James story, which the actor James Keach wrote and produced with his brother, Stacy. Casting actual sets of brothers (the Carradines, the Keaches, the Quaids) as the famed James, Younger and Miller brothers was not only inspired, it was inspiring. The actors brought a true sense of feeling, of family loyalty or family anger, to their parts, acting with and reacting to their brothers. Particularly memorable is David Carradine as Cole Younger, the wild man who leads his outlaw brothers, here played by Robert and Keith.

For *The Long Riders*, Hill evoked Peckinpah, bringing an almost dreamlike-quality to the violence as we watch dusters fly in the breeze and horses running full tilt before being shot and twisting to the ground in their own dance. Unfortunately, *The Long Riders* underperformed. Television was again the haven for Westerns, with Kenny Rogers starring in *The Gambler* movie series with Bruce Boxleitner and random TV movies from old pros like Burt Kennedy and Andrew V. McLaglen.

Even so, the Western became more and more a rare animal. Contributing to its decline were the deaths of Wayne, Sam Peckinpah, Warren Oates and Lee Marvin. Steve McQueen made his last-ditch effort with the brooding *Tom Horn*, which barely caused a ripple, despite its historical accuracy and the presence of Slim Pickens in one of his final turns. The genre was stuck in a cycle that it couldn't break, forever looking backward to a time when audience still demanded Westerns, but the constant image of the cowboy had vanished from our everyday lives, and the very word "Western" was now regularly associated with something old and completely out of touch or, at worst, racist. The idea of the genre being a place to explore themes and experiment was dead. Then something remarkable happened as two Westerns opened almost simultaneously, Clint Eastwood's *Pale Rider* and Lawrence Kasdan's *Silverado*.

Pale Rider remains an odd combination of *Shane* and *High Plains Drifter*, with Eastwood as the Preacher riding out of Idaho's Sawtooth Mountains to offer his help to a family struggling in a mining camp. Sidney Penny takes on the role as the adoring child of Carrie Snodgress and Michael Moriarty, while Eastwood's character sets himself up in her eyes as an avenging angel once he takes on the mining company's hired guns that are led by the grizzled John Russell. The presence of Russell alone is a treasure, harking back to his own time as the star of TV's *Lawman*.

Silverado embraced the genre freely and completely with no concession to revisionist histories of the West. Lawrence Kasdan was simply making a Western *movie*, and his enthusiasm seeped into every camera shot and every gunshot. Kasdan's delight is palpable as his cast rolls out their performances, some a bit out-of-synch for the period, perhaps, but none lacking in energy or faith in the material. Like his script for *Raiders of the Lost Ark*, *Silverado* gleefully embraces every movie convention Kasdan could work into the pages, from *High Noon* and *Red River* to *Hopalong Cassidy*. The more dramatic moments play out as they should, but then we're returned to the action of the four friends who're making their way to the town of *Silverado* for a date with an old enemy who's now the most corrupt law this side of the Rocky Mountains. Scott Glenn, Danny Glover and Kevin Kline are in fine form, if a little too modern in their stance and attitude, but it is Kevin Costner as Glenn's hot-shot brother who steals the film. Costner is the whirling dervish, the troublemaker who also happens to be the best with a gun.

The 1990s would resurrect the theatrical Western yet again with Kevin Costner's masterwork, *Dances With Wolves*, exploding across screens to the sweeping sound of John Barry's iconic themes. Costner, riding against the wind, head and arms thrown back, became a symbol of all that was free in the American West—and the price paid by the tribes who were there first. Native American stories had become more frequent, but hardly centrally popular, until Costner's film of the adventure of Lt. John Dunbar and his life among the Sioux nation.

Directed and produced by Costner, *Dances With Wolves* is the most profitable Western in movie history, earning more than four-hundred-million dollars worldwide and its place among the best movie epics. At its heart, it is the story of one man and his own choices to stand with the Sioux, their roles highlighted by the expert work of Graham Greene as Kicking Bird and Wes Studi as Toughest Pawnee. The film won seven Academy Awards, including Best Director, Screenplay and Picture, though it came under criticism for its overly-romantic picture of the Sioux.

Considered one of the finest Westerns ever made, Clint Eastwood's *Unforgiven* claimed several Oscars in 1992, including Best Picture. Without a whisper of romanticism, the film offers a scowling look at a land and people who're bloodied daily as they try to cope with the frontier. Eastwood's William Munny has turned his back on his old killing ways and devotes himself to a failing farm and the raising of his young son and daughter. When the chance to make money by killing a cowboy who's mutilated a prostitute materializes, Munny takes the offer, recruits his old partner (Morgan Freeman), and they set out with the stormy, bragging Schofield Kid (Jaimz Woolvett).

The success of *Unforgiven* and *Dances With Wolves* propelled other projects forward, including Costner's own *Wyatt Earp* and the significantly more successful *Tombstone*, starring Kurt Russell, Sam Elliott, Val Kilmer, Charlton Heston and Stephen Lange as a

mealy-mouthed Ike Clanton. *Tombstone*, by no small measure, may now be considered the most popular Western ever made. Hardly the best, but the fervor and pure dedication with which it's been embraced outstrips every other film in the genre, and it has only grown with the passage of time.

In the 2000s, the Western still survives, some years stronger than others. The thought that it will return to its former status is unrealistic, but it can never go away or be abandoned fully because to do that would be to deny too much of ourselves, of both the movie history and the history of this country. Beyond all the landscapes, horses, cattle drives, stampedes and shootouts of every kind, the Western movie draws us in with its own sense of truth etched into the faces of the men and women who have been standing in front of the cameras since the beginning of the past century. These actors are our guides to the past. It is the remarkable and telling faces, the heroes, villains, brave women and hopeful children among them, that made and still make the Western movie what it is—true Americana that reflects us all.

IN LOVING MEMORY
OF
DAVID CARRADINE
R. G. ARMSTRONG
AND INDIANA

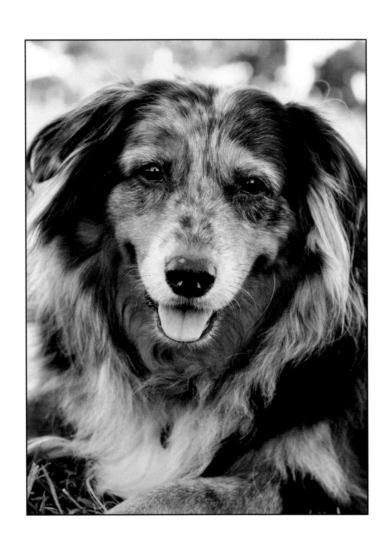

FILMOGRAPHIES:
WESTERN-THEMED MOTION PICTURES AND TELEVISION SHOWS

R. G. ARMSTRONG

1999: *Purgatory*
(Turner Network)
Directed by: Uli Edel; produced and written by Gordon Dawson.
Starring Sam Shepard, Eric Roberts, Randy Quaid, Amelia Heinle.
R. G. Armstrong as The Coachman.

1987: *Independence*
(NBC)
Directed by John Patterson; written by Gordon Dawson.
Starring John Bennett Perry, Anthony Zerbe, Amanda Wyss.
R. G. Armstrong as Uriah Creed.

1986: *Red-Headed Stranger*
(Alive Films)
Written and directed by William D. Witliff.
Starring Willie Nelson, Morgan Fairchild, Katherine Ross, Royal Dano.
R. G. Armstrong as Sherriff Reese Scoby.

1982: *The Shadow Riders*
(CBS/Sony Pictures Television)
Directed by Andrew V. McLaglen; written by Jim Byrnes from the Louis L'Amour novel.
Starring Tom Selleck, Sam Elliott, Ben Johnson, Katherine Ross, Jeff Osterhage.
R. G. Armstrong as Sheriff Miles Gillette.

1979: *The Last Ride of the Dalton Gang*
(ABC Television Films)
Directed by Dan Curtis; written by Earl W. Wallace.
Starring Cliff Potts, Randy Quaid, Larry Wilcox, Sharon Farrell, Bo Hopkins.
R. G. Armstrong as Leland Stanford.

The Legend of the Golden Gun
(NBC/Columbia Pictures Television)
Directed by Alan J. Levi; written by James D. Parriott.
Starring Jeff Osterhage, Carl Franklin, Robert Davi, Kier Dullea.
R. G. Armstrong as Judge Harrison Harding.

1975: *Boss Nigger* aka *The Boss*
(Dimension Pictures)
Directed by Jack Arnold; written by Fred Williamson.
Starring Fred Williamson, D'Urville Martin, William Smith, Barbara Leigh.
R. G. Armstrong as Mayor Griffin.

1973: *My Name is Nobody*
(Universal)
Directed by Tonino Valerii; written by Sergio Leone, Ernesto Gastaldi, Fulvia Morsella.
Starring Terence Hill, Henry Fonda, Leo Gordon, Geoffrey Lewis.
R. G. Armstrong as Honest John.

Pat Garrett and Billy the Kid
(Metro-Goldwyn-Mayer)
Directed by Sam Peckinpah; written by Rudolph Wurltizer.
Starring James Coburn, Kris Kristofferson, Jason Robards, Bob Dylan, Slim Pickens.
R. G. Armstrong as Ollinger.

1972: *The Great Northfield Minnesota Raid*
(Universal Pictures)
Directed and written by Phillip Kaufman.
Starring Cliff Robertson, Robert Duvall, Luke Askew, Royal Dano, Donald Moffat.
R. G. Armstrong as Clell Miller.

Walt Disney's Wonderful World of Color
"Justin Morgan Had a Horse"
(NBC)
Directed by Hollingsworth Morse; written by Calvin Clements, Marguerite Henry.
Starring Don Murray, Whit Bissell, James Hampton.
R. G. Armstrong as Squire Fisk.

1971: *Alias Smith and Jones*
"The Bounty Hunter"
(ABC)
Directed by Barry Shear; written by Roy Huggins, Glenn A. Larson.
Starring Ben Murphy, Pete Duel, Louis Gossett, Jr.
R. G. Armstrong as Max.

J. W. Coop
(Columbia Pictures)
Directed by Cliff Robertson; written by Cliff Robertson and Bud Shrake.
Starring Cliff Robertson, Geraldine Page, John Crawford, Cristina Ferrara.
R. G. Armstrong as Jim Sawyer.

1970: *The High Chaparral*
"Wind"
(NBC)
Directed by Phil Rawlins; written by Clyde Ware.
Starring Leif Ericson, Cameron Mitchell, Henry Darrow, Linda Cristal.
R. G. Armstrong as Henderson.

The McMasters
(Chevron Pictures)
Directed by Alf Kajellin; written by Harold Jacob Smith.
Starring Burl Ives, Brock Peters, David Carradine, Jack Palance, L. Q. Jones.
R. G. Armstrong as Watson.

The Ballad of Cable Hogue
(Warner Brothers)
Directed by Sam Peckinpah; written by Edmund Penney and John Crawford.
Starring Jason Robards, Stella Stevens, David Warner, Strother Martin, L. Q. Jones.
R. G. Armstrong as Quittner.

1968: *Lancer*
"Foley"
(CBS)
Directed by Alexander Singer; written by Sam Peeples.
Starring James Stacey, Wayne Maunder, Andrew Duggan.
R. G. Armstrong as Foley.

Daniel Boone
"The Flaming Rocks"
(NBC)
Directed by Nathan Juran; written by David Duncan.
Starring Fess Parker, Ed Aames, Jimmy Dean, Dorothy Green.
R. G. Armstrong as Garth.

1967: *The Guns of Will Sonnet*
"The Turkey Shoot"
(ABC/Thomas-Spelling Productions)
Directed by Thomas Carr; written by Aaron Spelling.
Starring Walter Brennan, Dack Rambo, William Mims.
R. G. Armstrong as Atwood.

Gunsmoke
"Stranger in Town"
(CBS)
Directed by Darrell Hallenbeck; written by John Dunkle.
Starring James Arness, Milburn Stone, Amanda Blake, Parnell Roberts, Jacqueline Scott.
R. G. Armstrong as Carl Anderson.

Cimarron Strip
"The Battleground"
(CBS)
Directed by Don Medford; written by Christopher Knopf.
Starring Stuart Whitman, Warren Oates, Randy Boone, Telly Savalas.
R. G. Armstrong as William Payne.

Daniel Boone
"The Wolf Man"
(NBC)
Directed by Earl Bellamy; written by William Driskill.
Starring Fess Parker, Ed Aames, Darby Hinton, Patricia Blair.
R. G. Armstrong as Jarvis.

El Dorado
(Paramount)
Directed by Howard Hawks; written by Leigh Brackett.
Starring John Wayne, Robert Mitchum, James Caan, Arthur Hunnicutt, Johnny Crawford.
R. G. Armstrong as Kevin McDonald.

The Virginian
"The Girl on the Pinto"
(NBC/Universal)
Directed by Don McDougall; written by Theodore Apstein.
Starring James Drury, Clu Gulager, Charles Bickford, Sara Lane, Doug McClure.
R. G. Armstrong as Harley.

1966: *Gunsmoke*
"Which Dr."
(CBS)
Directed by Peter Graves; written by John Meston.
Starring James Arness, Milburn Stone, Amanda Blake, Roger Ewing.
R. G. Armstrong as Mooncran.

Bonanza
"The Last Mission"
(NBC)
Directed by R. G. Springsteen; written by William Douglas Lansford.
Starring Lorne Greene, Dan Blocker, Michael Landon, Gregg Palmer.
R. G. Armstrong as Col. Jarrell.

1965: *The Big Valley*
"My Son, My Son"
(ABC/Four Star Productions)
Directed by Paul Heinreid; written by Paul Schneider.
Starring Barbara Stanwyck, Lee Majors, Richard Long, Robert Walker, Jr.
R. G. Armstrong as Wallace Miles.

Major Dundee
(Columbia Pictures)
Directed by Sam Peckinpah; written by Oscar Saul and Harry Julien Fink.
Starring Charlton Heston, Richard Harris, Jim Hutton, James Coburn, Senta Berger.
R. G. Armstrong as Reverend Dahlstrom.

Death Valley Days
"Birthright"
(Filmaster Productions)
Directed by Lee Sholem; written by Stephen Lord.
Starring Jason Evers, Susan Flannery, Hal Baylor.
R. G. Armstrong as Bundage.

Gunsmoke
"The Lady"
(CBS)
Directed by Mark Rydell; written by John Mantley, Norman MacDonnell.
Starring James Arness, Milburn Stone, Amanda Blake, Eileen Heckart.
R. G. Armstrong as Jud.

Rawhide
"Six Weeks at Bent Fork"
(CBS)
Directed by Thomas Carr; written by Mort R. Lewis, Charles Marquis Warren.
Starring Eric Fleming, Clint Eastwood, Paul Brinegar, Raymond St. Jacques, L. Q. Jones.
R. G. Armstrong as Sheriff John Keeley.

1964: *He Rides Tall*
(Universal Pictures)
Directed by R.G. Springsteen; written by Charles Irwin.
Starring Tony Young, Dan Duryea, Madeline Rhue, George Murdock.
R. G. Armstrong as Josh Macloud.

1963: *The Virginian*
"The Small Parade"
(NBC/Universal Pictures)
Directed by Paul Nickell; written by Bernard Gerard.
Starring Lee J. Cobb, James Drury, Gary Clarke, David Wayne.
R. G. Armstrong as Ben Winters.

Death Valley Days
"Deadly Decision"
(Filmaster Productions)
Directed by Sidney Salkow; written by A. Sanford Wolfe.
Starring James Caan, Wakter Brooke, Stanley Andrews.
R. G. Armstrong as Steve.

1962: *Laramie*
"Time of the Traitor"
(NBC/Universal Pictures)
Directed by Joseph Kane; written by John Champion.

Starring Robert Fuller, John Smith, Spring Byington, Lew Ayers.

Rawhide
"Incident of the Lost Woman"
(CBS)
Directed by Thomas Carr; written by Ward Hawkins.
Starring Eric Fleming, Clint Eastwood, Paul Brinegar, Fay Spain, Harry Dean Stanton.
R. G. Armstrong as Hobson

Wagon Train
"The Shiloh Degnan Story"
(ABC)
Directed by Virgil Vogel; written by Harold Swanton.
Starring John McIntire, Denny Miller, Barry Morse, Nancy Gates, Russell Johnson.
R. G. Armstrong as General Kirby.

Wagon Train
"The Charlie Shutup Story"
(ABC)
Directed by Virgil Vogel; written by Gene L. Coon.
Starring John McIntire, Robert Horton, Denny Miller, Dick York, Dorothy Green.
R. G. Armstrong as Muskie.

Ride the High Country
(Metro-Goldwyn-Mayer)
Directed by Sam Peckinpah; written by N.B. Stone.
Starring Randolph Scott, Joel McCrea, Mariette Hartley, James Drury, Ron Starr.
R. G. Armstrong as Joshua Knudsen.

Tales of Wells Fargo
"Winter Storm"
(NBC/Universal Pictures)
Directed by William Witney; written by Frank Gruber, Dick Nelson.
Starring Dale Robertson, Dan Duryea, William Demarest, Eddie Firestone.
R. G. Armstrong as Hanson.

1961: *Bat Masterson*
"No Amnesty for Death"
(NBC)
Directed by Elliot Lewis; written by Richard O'Connor.
Starring Gene Barry, DeForest Kelley, James Anderson.
R. G. Armstrong as MacWilliams.

Cheyenne
"The Return of Mr. Grimm"
(ABC/Warner Brothers Television)
Directed by Lee Sholem; written by George F. Slavin.
Starring Clint Walker, Anita Sands, Myron Healey.
R. G. Armstrong as Mr. Grimm.

Laramie
"The Jailbreakers"
(NBC/Universal Pictures)
Directed by Joseph Kane; written by John C. Champion.
Starring Robert Fuller, John Smith, Spring Byington, Charles Aidman.
R. G. Armstrong as Dawson.

Bonanza
"The Horse Breaker"

(NBC)
Directed by Don MacDougal; written by David Dortort, Frank Chase.
Starring Lorne Greene, Dan Blocker, Michael Landon, Pernell Roberts, Ben Cooper.
R. G. Armstrong as Nathan Clay.

Gunsmoke
"Indian Ford"
(CBS)
Directed by Andrew V. McLaglen; written by John Dunkel, Norman MacDonnell.
Starring James Arness, Milburn Stone, Dennis Weaver, Amanda Blake, Pippa Scott.
R. G. Armstrong as Capt. Betner.

Disney's Wonderful World of Color
"Texas John Slaughter: A Holster Full of Law"
(NBC)
Directed by James Nielson; written uncredited.
Starring Tom Tryon, Ross Martin, Betty Lynn, Bob Steele.
R. G. Armstrong as Billy Soto.

1960: *The Tall Man*
"Bitter Ashes"
(NBC)
Directed by Richard Irving; written by Sam Peeples.
Starring Clu Gulager, Barry Sullivan, Narda Onyx.
R. G. Armstrong as Bailey.

Ten Who Dared
(Walt Disney Productions)
Directed by William Beaudine; written by Ben Watkin.
Starring Brian Keith, John Beal, James Drury, L. Q. Jones, Ben Johnson.
R. G. Armstrong as Howland.

Laramie
"Cemetery Road"
(NBC/Universal Pictures)
Directed by Thomas Carr; written by Buckley Angell.
Starring Robert Fuller, John Smith, Hoagy Charmichael, Jocelyn Brando.
R. G. Armstrong as Matthews.

The Westerner
"School Days"
(NBC)
Directed by Andre DeToth; written by Robert Heverly and Sam Peckinpah.
Starring Brian Keith, Margaret Field, John Anderson.
R. G. Armstrong as Shell Davidson.

1959: *Maverick*
"The Saga of Waco Williams"
(ABC/Warner Brothers Television)
Directed by Leslie Martinson; written by Gene L. Coon.
Starring James Garner, Louise Fletcher, Harry Lauter, Lane Bradford.
R. G. Armstrong as Col. Karl Brent.

Wanted: Dead or Alive
"The Tyrant"
(CBS)
Directed by Don McDougall; written by Tom Gries.
Starring Steve McQueen, Vaughn Taylor, Frank Albertson.
R. G. Armstrong as Asa Wynter.

Lawman
"Battle Scar"
(ABC/Warner Brothers Television)
Directed by Stuart Heisler; written by Laurence Menkin, Don Tate.
Starring Peter Brown, John Russell, Robert Conrad.
R. G. Armstrong as Major Ben Bridges.

No Name on the Bullet
(Universal Pictures)
Directed by Jack Arnold; written by Gene L. Coon.
Starring Audie Murphy, Charles Drake, Joan Evans, Warren Stevens, Whit Bissell.
R. G. Armstrong as Asa Canfield.

Black Saddle
"Client: Dawes"
(NBC/Four Star Productions)
Directed by Roger Kay; written by John McGreevey.
Starring Peter Breck, Russell Johnson, Phyllis Coates.
R. G. Armstrong as Ben Dawes.

Riverboat
"A Night at Trapper's Landing"
(NBC/Universal Pictures)
Directed by Felix Feist; written by Halsey Melone.
Starring Darren McGavin, Burt Reynolds, Ricardo Mantalban, Peter Whitney.
R. G. Armstrong as Ruthgate.

1958: *Zane Grey Theater*
"Let the Man Die"
(CBS/Four Star)
Directed by Roger Kay; written by Aaron Spelling.
Starring Dick Powell, Marsha Hunt, John Hoyt, R. G. Armstrong as Sheriff Les Houghton.

Zane Grey Theater
"The Sharpshooter" – pilot for The Rifleman.
(Four Star)
Directed by Arnold Laven; written by Sam Peckinpah.
Starring Chuck Connors, Dennis Hopper, Johnny Crawford, Leif Ericson.
R. G. Armstrong as Sheriff Fred Tomlinson.

The Rifleman
"The Marshall"
(Four Star)
Directed and written by Sam Peckinpah.
Starring Chuck Connors, Johnny Crawford, Paul Fix, James Drury.
R. G. Armstrong as Sheriff Fred Tomlinson.

The Californians
"Dishonor for Matt Wade"
(NBC)
Directed by Felix Feist; written by Carey Wilbur.
Starring Richard Coogan, Douglas Dumbrille, Carole Mathews, Stacy Keach, Sr.
R. G. Armstrong as Malone.

Have Gun – Will Travel
"Deliver the Body"
(CBS)
Directed by Lamont Johnson; written by Buckley Angell.
Starring Richard Boone, James Franciscus, Robert Gist, Madelyne Rhue.
R. G. Armstrong as Mayor Lovett.

Have Gun – Will Travel
"Killer's Widow"
(CBS)
Directed by Andrew V. McLaglen; written by Alvin Aley.
Starring Richard Boone, Barbara Baxley, Roy Barcroft, Kam Tong.
R. G. Armstrong as Marshall Jaffey.

From Hell to Texas
(20th Century-Fox)
Directed by Henry Hathaway; written by Robert Buckner and Wendell Mayes.
Starring Don Murray, Diane Varsi, Dennis Hopper, Chill Wills.
R. G. Armstrong as Hunter Boyd.

JOHN BECK

1990: *Paradise aka The Guns of Paradise*
"Dangerous Cargo"
(CBS/Lorimar)
Directed by Cliff Bole; written by David Jacobs and Robert Porter.
Starring Lee Horsely, Jenny Beck, Mako.
John Beck as Mathew Grady.

1989: *Paradise aka The Guns of Paradise*
"Squaring Off"
(CBS/Lorimar)
Directed by Nick Havinga; written by David Jacobs and Robert Porter.
Starring Lee Horsely, Jenny Beck, Buck Taylor, Ron Soble.
John Beck as Mathew Grady.

1979: *Buffalo Soldiers*
(NBC)
Directed by Vincent McEveety; written by Jim Byrnes.
Starring John Beck, Stan Shaw, Angel Tompkins, L.Q. Jones.

How the West Was Won
"The Scavengers"
(CBS)
Directed by Ralph Senensky; written by Calvin Clements.
Starring James Arness, Bruce Boxleitner, Fionulla Flannagan, Lee de Broux.
John Beck as Clay Wesley.

1975: *Gunsmoke*
"The Busters"
(CBS)
Directed by Vincent McEveety; written by Jim Byrnes.
Starring James Arness, Milburn Stone, Ken Curtis, Amanda Blake, Gary Busey.
John Beck as Mitch Hansen.

1974: *Sidekicks*
(CBS/Cherokee Productions)
Directed by Burt Kennedy; written by William Bowers and Richard Allan Simmons.
Starring Larry Hagman, Louis Gossett, Jr., Blythe Danner, Denver Pyle, Jack Elam.
John Beck as Luke.

1973: *Pat Garrett and Billy the Kid*
(Metro-Goldwyn-Mayer)
Directed by Sam Peckinpah; written by Rudolph Wurlitzer.
Starring James Coburn, Kris Kristofferson, Slim Pickens, Katy Jurado, Bob Dylan.
John Beck as Poe.

1971: *Lawman*
(United Artists)
Directed by Michael Winner; written by Gerald Wilson.
Starring Burt Lancaster, Robert Ryan, Lee J. Cobb, Sheree North, Robert Duvall.
John Beck as Jason Bronson.

Nichols
(NBC/Cherokee)
Created by Frank Pierson.
Directed by Frank Pierson, Paul Bogart, others; written by Frank Pierson, others.
Starring James Garner, Margot Kidder, John Beck, Stuart Margolin, Neva Patterson.
John Beck as Orv Ketcham in all 24 episodes.

Gunsmoke
"The Typhoon"
(CBS)
Directed by Bernard McEveety; written by Norm MacDonnell, John Meston.
Starring James Arness, Milburn Stone, Ken Curtis, Amanda Blake, Buck Taylor.
John Beck as Moody Fowler.

Lock, Stock, and Barrel

(NBC/Universal)
Directed by Jerry Thorpe; written by Richard Allan Simmons.
Starring Tim Matheson, Belinda J. Montgomery, Neville Brand, Burgess Meredith.
John Beck as Micah.

1970: *Gunsmoke*
"Kiowa"
(CBS)
Directed by Bernard McEveety; written by Norm MacDonnell, John Meston.
Starring James Arness, Milburn Stone, Ken Curtis, Amanda Blake, Victor French.
John Beck as Albert.

Bonanza
"What Are Pardners For?"
(NBC)
Directed by William F. Claxton; written by David Dortort.
Starring Lorne Greene, Dan Blocker, Michael Landon, Slim Pickens, Dabbs Greer.
John Beck as Luke.

Lancer
"Dream of Falcons"
(CBS)
Directed by Don Richardson; written by Sam Peeples, Carey Wilbur.
Starring James Stacy, Andrew Duggan, Wayne Maunder, Elizabeth Baur.
John Beck as Chad Lancer.

1969: *The Silent Gun*
(ABC)
Directed by Michael Caffey; written by Clyde Ware.
Starring Lloyd Bridges, John Beck, Ed Begley, Pernell Roberts, Susan Howard.
John Beck starred as Billy Reed in movie-pilot for potential series.

Bonanza
"The Medal"
(NBC)
Directed by Lewis Allen; written by David Dortort.
Starring Lorne Greene, Dan Blocker, Michael Landon, Dean Stockwell, Susan Howard.
John Beck as Walt Nagel.

Death Valley Days
"Soloman's Glory"
(Flying "A" Productions)
Directed by Harmon Jones; written by William Davis, Jr.
Starring John Beck, Louise Lewis, Tyler McVey, Robert Taylor.
John Beck starred in this episode as Sandy Peters.

The Outcasts
"A Ride to Vengeance"
(ABC)
Directed by Marc Daniels; written by Harold Jack Bloom.
Starring Don Murray, Otis Young, Diana Muldaur, Charles McGraw.
John Beck as Jesse.

CRISPIAN BELFRAGE

2018: *The Bounty Hunter*
(Indican Pictures)
Directed by Chip Baker; written by Chip Baker, Danny Garcia, Jose L. Villanueva, Nick Reynolds.
Starring Crispian Belfrage, Ethan McDowell, David Gilliam.
Crispian Belfrage stars as Bounty Killer.

2018: *The Price of Death*
(High Octane Pictures)
Directed by Chip Baker; written by Chip Baker, Danny Garcia, Aaron Stielstra, Jose L. Villanueva.
Starring Javier Arnal, Cherna

Bascón, Nuria, Beiro.
Crispian Belfrage as Harry Skinner.

2016: *Six Bullets to Hell*
(MVD Entertainment Group)
Directed by Tanner Beard, Russell Quinn Cummings; written by Chip Baker, Tanner Beard, Russell Quinn Cummings, Danny Garcia, Jose L. Villanueva.
Starring Tanner Beard, Crispian Belfrage, Russell Quinn Cummings.
Crispian Belfrage stars as Billy Rogers.

2012: *West of Thunder*
(Indican Pictures)
Directed by Jody Marriott Bar-Lev, Steve Russell; written by Jody Marriott Bar-Lev, Dan Davies.
Starring Dan Davies, Clifford Henry, Corbin Conroy.
Crispian Belfrage as Bartender Zeke

2009: *Triggerman*
(Grindstone Entertainment Group)
Directed by Giulio Base, Terence Hill; written by Marcello Olivieri, Luca Biglione, Marco Barboni, Stefano Voltaggio, Jess Hill.
Starring Terrance Hill, Clare Carey, Maria P. Petruolo.
Crispian Belfrage as Sam Lynchett.

2009: *Doc West*
(Grindstone Entertainment Group)
Directed by Giulio Base, Terence Hill; written by Marcello Olivieri, Luca Biglione, Marco Barboni, Stefano Voltaggio, Jess Hill.
Starring Terrance Hill, Clare Carey, Maria P. Petruolo.
Crispian Belfrage as Sam Lynchett.

TOM BOWER

2019: *As You Like It*
(Random Media)
Directed by Carlyle Stewart; written by Carlyle Stewart.
Starring Graham Greene, Tom Bower, Zach Villa.
Tom Bower stars as Jaques.

2008: *Appaloosa*
(New Line Cinema)
Directed by Ed Harris; written by Robert Knott, Ed Harris, Robert B. Parker (novel).
Starring Ed Harris, Viggo Mortensen, Renée Zellweger.
Tom Bower as Abner Raines.

1997: *Buffalo Soldiers*
(TNT)
Directed by Charles Haid; written by Jonathan Klein, Frank Military, Susan Rhinehart.
Starring Lamont Bentley, Tom Bower, Timothy Busfield, Danny Glover.
Tom Bower stars as Gen. Pike.

1996: *Shaughnessy*
(Allumination Filmworks)
Directed by Michael Ray Rhodes; written by Louis L'Amour (novel), William Blinn.
Starring Matthew Settle, Linda Kozlowski, Tom Bower.
Tom Bower stars as Marshall.

Riders of the Purple Sage
(TNT)
Directed by Charles Haid; written by Zane Grey (book), Gill Dennis.
Starring Ed Harris, Amy Madigan, Henry Thomas.
Tom Bower as Judkins.

1993: *The Ballad of Little Jo*
(Fine Line Features)

237

Directed by Maggie Greenwald; written by Maggie Greenwald. Starring Suzy Amis, Bo Hopkins, Ian McKellen. Tom Bower as Lyle Hogg.

1989: *Desperado: The Outlaw Wars* (Universal Television) Directed by E. W. Swackhamer; written by Elmore Leonard, Andrew Mirisch, William Wisher. Starring Alex McArthur, Richard Farnsworth, James Remar. Tom Bower as Billy Dobbs.

1982: *The Ballad of Gregorio Cortez* (Embassy Pictures) Directed by Robert M. Young; written by Américo Paredes (book), Víctor Villaseñor, Robert M. Young. Starring Edward James Olmos, James Gammon, Tom Bower. Tom Bower stars as Boone Choate.

BRUCE BOXLEITNER

2011: *Love's Resounding Courage* (Hallmark) Directed by Bradford may; written Kevin Bocarde. Starring Wes Brown, Cheryl ladd, Bruce Boxleitner. Bruce Boxleitner stars as Lloyd.

2008: *Aces 'n' Eights* (RHI Entertainment) Directed by Craig R. Baxley; written by Ronald M. Cohen, Dennis Shryack. Starring Casper Van Dien, Bruce Boxleitner, Ernest Borgnine. Bruce Boxleitner stars as D. C. Cracker.

2003: *Gods and Generals* (Warner Bros.) Directed by Ron Maxwell; written by Jeff Shaara (book), Ron Maxwell. Starring Stephen Lang, Robert Duvall, Jeff Daniels. Bruce Boxleitner as Gen. James Longstreet.

2002: *Hope Ranch* (Animal Planet) Directed by Rex Piano; written by C. Thomas Howell, Chris Howell, Lynne Moses, Jim Snider. Starring Bruce Boxleitner, Lorenzo Lamas, Barry Corbin. Bruce Boxleitner stars as J. T. Hope.

1999: *Dead Man's Gun* (Sugar Entertainment Ltd.) Created by Howard Spielman; written by Howard Spielman, John Mandel. Starring Tom Bougers, Bruce Boxleitner, Alexandra Castillo. Bruce Boxleitner as Frank Santee.

1994: *Gambler V: Playing for Keeps* (CBS/ RHI Entertainment) Directed by Jack Bender; written by Jim Byrnes, Cort Casady, Frank Q. Dobbs, David S. Cass Sr., Kelly Junkerman, Caleb Pirtle III, Don Schlitz. Starring Kenny Rogers, Scott Paulin, Brett Cullen. Bruce Boxleitner as Billy Montana.

1994: *Wyatt Earp: Return to Tombstone* (CBS) Directed by Paul Landres, Frank McDonald; written by Danield B. Ullman, Rob Word. Starring Hugh O'Brian, Bruce Boxleitner, Paul Brinegar, Martin Kove, Bo Hopkins. Bruce Boxleitner stars as Sam, Sheriff of Cochise County.

1994: *Gunsmoke: One Man's Justice* (CBS) Directed by Jerry Jameson; written by Harry Longstreet, Renee Longstreet. Starring James Arness, Bruce Boxleitner, Amy Stoch. Bruce Boxleitner stars as Davis Healy.

1988: *Red River* (CBS/MGM/UA Television) Directed by Richard Michaels; written by Borden Chase, Charles Schnee, Richard Fielder. Starring Bruce Boxleitner, James Arness, Gregory Harrison, L. Q. Jones. Bruce Boxleitner stars as Matthew Garth.

1987: *Kenny Rogers as The Gambler, Part III: The Legend Continues* (CBS) Directed by Dick Lowry; written by Jeb Rosebrook, Roderick Taylor. Starring Kenny Rogers, Bruce Boxleitner, Marc Alaimo. Bruce Boxleitner stars as Billy Montana.

1986: *Louis L'Amour's Down the Long Hills* (ABC) Directed by Burt Kennedy; written by Louis L'Amour (novel), Jon Povare, Bart Paul, Ruth Povare. Starring Bruce Boxleitner, Bo Hopkins, Michael Wren. Bruce Boxleitner stars as Scott Collins.

1983: *Kenny Rogers As The Gambler: The Adventure Continues* (CBS/Lion Share) Directed by Dick Lowry; written by Jim Byrnes, Don Schlitz, Cort Casady. Starring Kenny Rogers, Bruce Boxleitner, Linda Evans. Bruce Boxleitner stars as Billy Montana.

1983: *I Married Wyatt Earp* (NBC/Universal Television) Directed by Michael O'Herlihy; written by I. C. Rapoport, Josephine Sarah Marcus Earp, Glenn G. Boyer. Starring Marie Osmond, Bruce Boxleitner, John Bennett Perry. Bruce Boxleitner stars as Wyatt Earp.

1980: *Kenny Rogers as The Gambler* (CBS) Directed by Dick Lowry; written by Jim Byrnes, Don Schlitz, Cort Casady. Starring Kenny Rogers, Christine Belford, Bruce Boxleitner. Bruce Boxleitner stars as Billy Montana.

Wild Times (Metromedia Producers Corporation) Directed by Richard Compton; written by Don Balluck, Brian Garfield (novel). Starring Sam Elliott, Ben Johnson, Bruce Boxleitner. Bruce Boxleitner stars as Vern Tyree in episodes #1.2 and #1.1.

1979: *How the West Was Won* (ABC/MGM Television) Created by Jim Byrnes, Albert S. Ruddy. Directed by Joseph Pevney, Vincent McEveety, others; written by Dick Nelson, others. Starring James Arness, Fionnula Flanagan, Bruce Boxleitner. Bruce Boxleitner stars as Luke Macahan in all 25 episodes.

1975: *Gunsmoke* "The Sharecroppers" (CBS) Directed by Leonard Katzman; written by Earl W. Wallace. Starring James Arness, Milburn Stone, Ken Curtis. Bruce Boxleitner as Toby Hogue.

HORST BUCHOLZ

1978: *How the West Was Won* "Mormon Story" (ABC) Directed by Bernard McEveety; written by Calvin Clements, William Kelley. Starring James Arness, Bruce Boxleitner, Fionnula Flanagan, Morgan Woodward. Horst Bucholz as Sergei.

How the West Was Won "Buffalo Story" (ABC) Directed by Vincent McEveety; written by Calvin Clements, William Kelley. Starring James Arness, Bruce Boxleitner, Fionnula Flanagan, Brian Keith. Horst Bucholz as Sergei.

1960: *The Magnificent Seven* (United Artists/Mirisch Company) Directed by John Sturges; written by William Roberts, Walter Newman. Starring Yul Brynner, Steve McQueen, Charles Bronson, Horst Bucholz, Eli Wallach. Horst Bucholz starred as Chico.

BILLY GREEN BUSH

1991: *Conagher* (TNT/Imagine Entertainment) Directed by Reynaldo Villalobos; written by Louis L'Amour (novel), Jeffrey M. Meyer, Sam Elliott, Katharine Ross. Starring Sam Elliott, Katharine Ross, Barry Corbin. Billy Green Bush as Jacob Teale.

1980: *Tom Horn* (Warner Bros.) Directed by William Wiard; written by Thomas McGuane, Bud Shrake. Starring Steve McQueen, Linda Evans, Richard Farnsworth. Billy Green Bush as U. S, Marshal Joe Belle.

1977: *The Oregon Trail* "Hannah's Girl's" Directed by Don Richardson; written by Nicholas Corea. Starring Rod Taylor, Charles Napier, Andrew Stevens. Billy Green Bush as Niles Sharpe.

1976: *The Invasion of Johnson County* (NBC/Universal Television) Directed by Jerry Jameson; written by Nicholas E. Baehr. Starring Bill Bixby, Bo Hopkins, John Hillerman. Billy Green Bush as Frank Canton.

Barbary Coast "The Dawson Marker" (ABC/Paramount Television) Directed by Alexander Grasshoff; written by Douglas Heyes, William D. Gordon, James Doherty. Starring William Shatner, Doug McClure, John Rubinstein. Billy Green Bush as Dawson.

1975: *Mackintosh and T.J.* (Penland Productions) Directed by Marvin J. Chomsky; written by Paul Savage. Starring Roy Rogers, Clay O'Brien, Joan Hackett. Billy Green Bush as Luke.

1974: *Dirty Sally* "Convict" Written by Jack Miller. Starring Jeanette Nolan, Dack Rambo, Billy Green Bush. Billy Green Bush stars as Otis.

1973: *Gunsmoke* "The Hanging of Newly O'Brien" (CBS) Directed by Alf Kjellin; written by Calvin Clements Sr. Starring Milburn Stone, Amanda Blake, Ken Curtis. Billy Green Bush as Kermit.

1972: *The Culpepper Cattle Co.* (20th Century Fox) Directed by Dick Richards; written by Dick Richards, Eric Bercovici, Gregory Prentiss. Starring Gary Grimes, Billy Green Bush, Luke Askew, Bo Hopkins. Billy Green Bush stars as Frank Culpepper.

1971: *Alias Smith and Jones* "The Legacy of Charlie O'Rourke" (ABC) Directed by Jeffrey Hayden; written by Glen A, Larsen, Dick Nelson, Robert Guy Barrows. Starring Pete Duel, Ben Murphy, Joan Hackett. Billy Green Bush as Charlie O'Rourke.

1970: *Monte Walsh* (National General) Directed by William A. Fraker; written by Lukas Heller, David Zelag Goodman, Jack Schaefer. Starring Lee Marvin, Jeanne Moreau, Jack Palance, Bo Hopkins. Billy Green Bush as Powder Kent.

Bonanza "Long Way to Ogden" (NBC) Directed by Lewis Allen; written by David Dortort, Joel Murcott. Starring Lorne Greene, Dan Blocker, Michael Landon. Billy Green Bush as Spanier.

1963: *Stoney Burke* "Cat's Eyes" (ABC/United Artists Television) Directed by Laslo Benedek; written by Philip Saltzman. Starring jack Lord, Warren Oates, Robert Dowdell. William Bush as 2nd Doctor.

R. D. CALL

2006: *The Work and the Glory III: A House Divided* (Vineyard Productions) Directed by Sterling Van Wagenen; written by Gerald N. Lund (novel), Matt Whitaker. Starring Sam Hennings, Brenda Strong, Eric Johnson. R. D. Call as Boggs.

2005: *The Work and the Glory II: American Zion* (Vineyard Productions) Directed by Sterling Van Wagenen; written by Gerald N. Lund (novel), Matt Whitaker. Starring Sam Hennings, Brenda Strong, Eric Johnson. R. D. Call as Boggs.

1990: *Young Guns II* (20th Century Fox/Morgan Creek Entertainment) Directed by Geoff Murphy; written by John Fusco. Starring Émilio Estevez, Kiefer Sutherland, Lou Diamond Phillips. R. D. Call as D. A. Rynerson.

Guns of Paradise "Devil's Escort"

Directed by Michael Lange; written by David Jacobs, Robert Porter, Joel J. Feigenbaum. Starring Lee Horsley, Jenny Beck, Matthew Newmark. R. D. Call as Fletcher.

1982: *Little House on the Prairie* "He Was Only Twelve: Part I" Directed by Michael Landon; written by Blanche Hanalis, Laura Ingalls (books). Starring Michael Landon, Karen Grassle, Melissa Gilbert. R. D. Call as Dwayne.

JOHN 'BUD' CARDOS

1969: *Five Bloody Graves* (Independent-International Pictures) Directed by Al Adamson; written by Robert Dix. Starring Robert Dix, Scott Brady, Jim Davis. John Cardos as Joe Lightfoot

1968: *Daniel Boone* "The Dandy" Directed by William Wiard; written by Merwin Gerard. Starring Fess Parker, Patricia Blair, Darby Hinton. Johnny Cardos as Longknife.

Daniel Boone "Far Side of Fury" Directed by William Wiard; written by Judith Barrows. Starring Fess Parker, Patricia Blair, Darby Hinton. Johnny Cardos as Tomochi.

1967: *The High Chaparral* (NBC) Directed by Ralph Senensky; written by William F. Leicester. Starring Leif Erickson, Cameron Mitchell, Mark Slade. John Cardos as Third Bandit.

Custer "Dangerous Prey" (ABC/20th Century Fox Television) Directed by Leo Penn; written by Richard Sale, Samuel A. Peeples, David Weisbart, Larry Cohen. Starring Wayne Maunder, Slim Pickens, Michael Dante. Johnny Cardos as Brave Bull.

The Monroes "Ghosts of Paradox" (ABC/20th Century Fox Television) Directed by William Wiard; written by Otis Carney. Starring Michael Anderson Jr., Barbara Hershey, Keith Schultz. Johnny Cardos as Wolf.

1965: *Run Home, Slow* (Emerson Film Enterprises) Directed by Ted Brenner (as Tim Sullivan); written by Don Cerveris. Starring Mercedes McCambridge, Linda Gaye Scott, Allen Richards. John 'Bud' Cardos (unnamed character).

Deadwood '76 (Fairway International Pictures) Directed by James Landis; written by Arch Hall Sr., James Landis, Arch Hall Jr. Starring Arch Hall Jr., Jack Lester, La Donna Cottier. John Cardos as Hawk Russell.

DAVID CARRADINE

2005: *Miracle at Sage Creek* (American World Pictures) Directed by James Intveld; written by Thad Turner. Starring David Carradine, Wes Studi, Michael Parks, Sarah

Aldrich.
David Carradine starred as Ike.

Brothers in Arms
(Sony Home Entertainment)
Directed and written by Jean-Claude La Mare.
Starring David Carradine, Raymond Cruz, Gabriel Casseus.
David Carradine starred as Driscoll.

2002: *The Outsider*
(Hallmark/Showtime)
Directed by Randa Haines; written by Penelope Williamson, Jenny Wingfield.
Starring Tim Daly, Naomi Watts, Keith Carradine, Brett Tucker.
David Carradine as Dr. Henry.

2001: *Warden of Red Rock*
(Showtime)
Directed by Stephen Gyllenhaal; written by James Lee Barrett.
Starring James Caan, David Carradine, Rachel Ticotin, Brian Dennehy, Jim Beaver.
David Carradine starred as Sullivan.

1997: *Dr. Quinn, Medicine Woman*
"Hostage"
(CBS)
Directed by Jerry London; written by Beth Sullivan, Chris Abbott.
Starring Jane Seymour, Joe Lando, Chad Allen, Orson Bean.
David Carradine as Houston Currier.

The Last Stand at Saber River
(Turner Entertainment)
Directed by Dick Lowry; written by Ronald M. Cohen from Elmore Leonard's novel.
Starring Tom Selleck, Suzy Amis, Haley Joel Osment, Keith Carradine.
David Carradine as Kidston.

1991: *The Gambler Returns: The Luck of the Draw*
(CBS)
Directed by Dick Lowry; written by Jeb Rosebrook and Joe Byrne.
Starring Kenny Rogers, Rick Rossovich, Reba McEntire, Claude Aikins, Gene Barry.
David Carradine as Caine.

Brotherhood of the Gun
(CBS)
Directed by Vern Gillum; written by Robert Ward.
Starring Brian Bloom, Jaimie Rose, James Remar.
David Carradine as Artemus.

1990: *The Young Riders*
"Ghosts"
(CBS)
Directed by James Keach; written by Ed Spielman.
Starring Josh Brolin, Stephen Baldwin, Gregg Rainwater.
David Carradine as The Buzzard Eater.

North and South, Book II
(CBS)
Directed by Kevin Connor; written by Richard Fielder, Douglas Heyes and John Jakes.
Starring Kirstie Alley, David Carradine, Patrick Swayze, Olivia DeHavilland.
David Carradine starred as Justin LaMotte in six-part mini-series.

1985: *North and South*
(CBS)
Directed by Richard T. Heffron; written by Douglas Heyes and John Jakes.
Starring Kirstie Alley, David Carradine, Robert Mitchum,

Gene Kelly, Johnny Cash.
David Carradine starred as Justin LaMotte in six-part mini-series.

1980: *High Noon Part II: The Return of Will Kane*
(CBS/Fries Entertainment)
Directed by Jerry Jameson; written by Elmore Leonard.
Starring Lee Majors, David Carradine, Pernell Roberts, M. Emmett Walsh.
David Carradine starred as Ben Irons.

The Long Riders
(United Artists)
Directed by Walter Hill; written by Bill Bryden, Stephen Smith, James Keach, Stacy Keach.
Starring David Carradine, Stacy Keach, Keith Carradine, Dennis Quaid, Robert Carrdine.
David Carradine starred as Cole Younger.

1979: *Mr. Horn*
(Lorimar Productions)
Directed by Jack Starrett; written by William Goldman.
Starring David Carradine, Richard Widmark, Karen Black.
David Carradine starred as Tom Horn.

1975: *Kung Fu*
(ABC/Warner Bros. Television)
Directed by Alex Beaton, Gordon Hessler, others; written by Ed Spielman, Herman Miller, John T. Dugan, others.
Starring David Carradine, Hal Williams, L. Q. Jones.
David Carradine stars as Kwai Chang Caine in all 63 episodes.

1970: *The McMasters*
(Chevron Pictures)
Directed by Alf Kjellin; written by Harold Jacob Smith.
Starring Burl Ives, Brock Peters, David Carradine.
David Carradine as White Feather.

1969: *The Good Guys and the Bad Guys*
(Warner Bros.-Seven Arts)
Directed by Burt Kennedy; written by Ronald M. Cohen, Dennis Shryack.
Starring Robert Mitchum, George Kennedy, Martin Balsam.
David Carradine as Waco.

Heaven with a Gun
(Metro-Goldwyn-Mayer)
Directed by Lee H. Katzin; written by Richard Carr.
Starring Glenn Ford, Carolyn Jones, Barbara Hershey.
David Carradine as Coke Beck.

Young Billy Young
(United Artists)
Directed by Burt Kennedy; written by Burt Kennedy, Heck Allen (novel--as Will Henry).
Starring Robert Mitchum, Angie Dickinson, Robert Walker Jr.
David Carradine as Jesse Boone.

ROBERT CARRADINE

2019: *Bill Tilghman and the Outlaws*
(One-Eyed Horse Productions)
Directed by Wayne Shipley; written by Dan Searles.
Starring Robert Carradine, Johnny Crawford, Lana Wood, Darby Hinton.
Robert Carradine stars as Frank James.

2017: *Justice*
(Universal)
Directed by Richard Gabai; written by John Lewis, Shawn

Justice, D. C. Rahe, Jeff Seats.
Starring Nathan Parsons, Stephen Lang, Jamie-Lynn Sigler.
Robert Carradine as Stratton Collins.

2012: *Django Unchained*
(Columbia)
Directed by Quentin Tarantino; written by Quentin Tarantino.
Starring Jamie Foxx, Christoph Waltz, Leonardo DiCaprio, Samuel L. Jackson.
Robert Carradine as Tracker.

2003: *Monte Walsh*
(TNT)
Directed by Simon Wincer; written by Michael Brandman, Robert B. Parker, David Zelag Goodman, Lukas Heller, Jack Schaefer.
Starring Tom Selleck, Isabella Rossellini, Keith Carradine.
Robert Carradine stars as Sunfish Perkins.

1999: *Gunfighter*
(Amazing Movies)
Directed by Chistopher Coppola; written by Chistopher Coppola.
Starring Robert Carradine, Martin Sheen, George Nix.
Robert Carradine stars as The Kid.

1987: *The Magic World of Disney*
"The Liberators"
Directed by Kenneth Johnson; written by Kenneth Johnson.
Starring Robert Carradine, Larry B. Scott, Cynthia Dale.
Robert Carradine stars as John Fairfield.

1980: *The Long Riders*
(United Artists)
Directed by Walter Hill; written by Bill Bryden, Steven Smith, Stacy Keach, James Keach.
Starring David Carradine, Stacy Keach, Dennis Quaid.
Robert Carradine as Bob Younger.

1975: *The Hatfields and the McCoys*
(ABC)
Directed by Clyde Ware; written by Clyde ware.
Starring Jack Palance, Steve Forrest, Richard Hatch.
Robert Carradine as Bob Hatfield.

1974: *The Cowboys*
(ABC/Warner Bros. Television)
Directed by William Witney, William Wiard, others; written by William Dale Jennings (novel), Jim Byrnes, James Lee Barrett, William Putman, others.
Starring Moses Gunn, Diana Douglas, Jim Davis, A Martinez.
Robert Carradine as Slim in all 12 episodes.

1972: *Kung Fu*
(ABC/Warner Bros. Television)
"Dark Angel"
Directed by Jerry Thorpe; written by Ed Spielman, Herman Miller.
Starring David Carradine, John Carradine, Robert Carradine, Dean Jagger.
Robert Carradine stars as Sonny Jim.

The Cowboys
(Warner Bros.)
Directed by Mark Rydell; written by William Dale Jennings (novel), Irving Ravetch, Harriet Frank Jr.
Starring John Wayne, Roscoe Lee Browne, Bruce Dern, Colleen Dewhurst.
Robert Carradine as Slim Honeycutt.

1971: *Bonanza*
"A Home for Jamie"
(NBC)
Directed by Leo Penn; written by David Dortort, Jean Holloway.
Starring Lorne Greene, Dan Blocker, Michael Landon.
Robert Carradine as Phinney McLean.

JOHNNY CRAWFORD

2019: *Bill Tilghman and the Outlaws*
(One-Eyed Horse Productions)
Directed by Wayne Shipley; written by Dan Searles.
Starring Robert Carradine, Johnny Crawford, Lana Wood.
Johnny Crawford stars as William S. Hart.

1991: *The Gambler Returns: The Luck of the Draw*
(NBC/Artisan Entertainment)
Directed by Dick Lowry; written by Jim Byrnes, Cort Casady, Kelly Junkermann, Jeb Rosebrook, Joe Byrne, Don Schlitz.
Starring Kenny Rogers, Rick Rossovich, Reba McEntire.
Johnny Crawford as Mark McCain.

1990: *Guns of Paradise*
"Crossfire"
(CBS/Lorimar Television)
Directed by Harry Harris; written by David Jacobs, Robert Porter, James L. Conway.
Starring Lee Horsley, Jenny Beck, Matthew Newmark.
Johnny Crawford as Doug McKay.

1989: *Guns of Paradise*
"A gathering of Guns"
(CBS/Lorimar Television)
Directed by Michael Lange; written by Joel J. Feigenbaum, David Jacobs, Robert Porter.
Starring Lee Horsley, Jenny Beck, Matthew Newmark.
Johnny Crawford as Doug McKay.

1983: *Kenny Rogers as The Gambler: The Adventure Continues*
(CBS/Lion Share)
Directed by Dick Lowry; written by Jim Byrnes, Don Schlitz, Cort Casady.
Starring Kenny Rogers, Bruce Boxleitner, Linda Evans.
Johnny Crawford as Masket.

1976: *Little House on the Prairie*
"The Hunters"
(NBC/Ed Friendly Productions)
Directed by Michael Landon; written by Laura Ingalls Wilder, Blanche Hanalis, Harold Swanton.
Starring Michael Landon, Karen Grassle, Melissa Gilbert.
Johnny Crawford as Ben Shelby.

1970: *The Resurrection of Broncho Billy*
(Universal)
Directed by James R. Rokos; written by John Carpenter, Nick Castle, Trace Johnston, John Longenecker, James R. Rokos.
Starring Johnny Crawford, Kristin Harmon, Ruth Hussey.
Johnny Crawford stars as Broncho Billy.

1969: *The Big Valley*
"The Other Face of Justice"
(CBS/Four Star Productions)
Directed by Virgil W. Vogel; written by A. I. Bezzerides, Louis F. Edelman, Don Ingalls.
Starring Richard Long, Peter Breck, Lee Majors.
Johnny Crawford as Deputy Sheriff Billy Norris.

1967: *El Dorado*
(Paramount)
Directed by Howard Hawks; written by Leigh Brackett, Harry Brown (novel).
Starring John Wayne, Robert Mitchum, James Caan.
Johnny Crawford as Luke MacDonald.

1965: *Rawhide*
"Crossing at White Feather"
(CBS Television)
Directed by Richard Whorf; written by Robert Bloomfield.
Starring Clint Eastwood, Paul Brinegar, Steve Raines.
Johnny Crawford as Aaron Bolt.

1965: *Indian Paint*
(Crown International)
Directed by Norman Foster; written By Norman Foster, Glenn Balch (novel).
Starring Johnny Crawford, Jay Silverheels, Pat Hogan.
Johnny Crawford stars as Nishko.

1965: *Branded*
"Coward Step Aside"
(NBC/ Madison Productions)
Directed by Harry Harris; written by Larry Cohen, John Wilder, Jerry Ziegman.
Starring Chuck Conners, Johnny Crawford, Paul Fix, Skip Homeier.
Johnny Crawford stars as Deputy Sheriff Clay Holden.

1963: *The Rifleman*
(ABC/Four Star Productions)
Created by Arnold Laven.
Directed by Arnold Laven, Joseph H. Lewis, others; written by Sam Peckinpah, Thomas Thompson, others.
Starring Chuck Connors, Johnny Crawford, Paul Fix, Leif Erickson, Dennis Hopper.
Johnny Crawford stars as Mark McCain in all 168 episodes.

Tales of Wells Fargo
"The Dealer"
(NBC/Overland Productions)
Directed by Earl Bellamy; written by A. I. Bezzerides.
Starring Dale Robertson, Vic Perrin, Jeanne Bates.
Johnny Crawford as Tommy Peel.

The Restless Gun
"Gratitude"
(NBC/Republic Studios)
Directed by Edward Ludwig; written by Arnold Belgard, Frank Burt.
Starring John Payne, John Litel, Johnny Crawford.
Johnny Crawford stars as Ned Timberlake.

Trackdown
"The Jailbreak"
(CBS/Four Star Productions)
Directed by Donald McDougall; written by John McGreevey.
Starring Robert Culp, James Griffith, Ellen Corby.
Johnny Crawford as Eric Paine.

"The Deal"
Directed by Donald McDougall; written by John Robinson.
Starring Robert Culp, James Griffith, Johnny Crawford.
Johnny Crawford starring as Eric Paine.

"The Boy"
Directed by Thomas Carr; written by John Robinson.
Starring Robert Culp, King Donovan, James Griffith.
Johnny Crawford as Eric Paine.

Wagon Train
"The Sally Potter Story"
(NBC/Revue Productions)

Directed by David Butler; written by Doris Hursley, Frank Hursley. Starring Ward Bond, Robert Horton, Vanessa Brown. Johnny Crawford as Jimmy Bennett.

Zane Grey Theater
"Man Unforgiving"
(CBS/Four Star Productions)
Directed by James Sheldon; written by Bob Barbash, Frank Waldman.
Starring Joseph Cotten, Claude Akins, Mary Shipp.
Johnny Crawford as Billy Prescott.

Adventures of Wild Bill Hickok
"Spurs for Johnny"
(CBS/Romson Productions)
Directed by Louis King; written by Barry Shipman.
Starring Guy Madison, Andy Devine, John Crawford.
Johnny Crawford as Johnny.

1957: *Have Gun – Will Travel*
"The Hanging Cross"
(CBS/Filmaster Productions)
Directed by Andrew V. McLaglen; written by Gene Roddenberry, Herb Meadow, Sam Rolfe.
Starring Richard Boone, Edward Binns, Abraham Sofaer.
Johnny Crawford as Robbie AKA Chiwa.

The Sheriff of Cochise
"I am an American"
(Desilu Productions)
Directed by Lee Sholem; written by Lawrence Resner, Ann Edwards, Stan Jones.
Starring John Bromfield, Stan Jones, Johnny Crawford.
Johnny Crawford stars as Manual Bernel.

1956: *The Lone Ranger*
"The Cross of Santo Domingo"
(ABC/Wrather Productions)
Directed by Earl Bellamy; written by Tom Seller.
Starring Clayton Moore, Jay Silverheels, Denver Pyle.
Johnny Crawford as Tommy McQueen.

2006: *Deadwood*
"A Two-Headed Beast"
(HBO)
Directed By Daniel Minahan; written by David Milch, Regina Corrado.
Starring Timothy Olyphant, Ian McShane, Molly Parker.
Ric Dano as unnamed character.

2004: *Deadwood*
"Sold Under Sin"
(HBO)
Directed by Davis Guggenheim; written David Milch, Ted Mann.
Starring Timothy Olyphant, Ian McShane, Molly Parker.
Ric Dano as unnamed character.

1997: *Rough Riders*
(Affinity Entertainment)
Directed by John Milius; written by John Milius, High Wilson.
Starring Tom Berenger, Sam Elliott, Gary Busey.
Richard Dano as Colonel Shafter's staff in episodes #1.2 and #1.1.

1997: *Gunsmoke: The Long Ride*
(CBS)
Directed by Jerry Jameson; written by Bill Stratton.
Starring James Arness, James Brolin, Amy Stoch, Ali MacGraw.
Richard Dano as Skeeter Padgett.

1975: *Winterhawk*
(Howco International)
Directed by Charles B. Pierce; written by Charles B. Pierce, Earl E. Smith.
Starring Leif Erickson, Woody Strode, Denver Pyle, L. Q. Jones, Dawn Wells.
Michael Dante as Winterhawk.

1969: *Daniel Boone*
"For a Few Rifles"
(20th Century Fox Television)
Directed by John Newland; written by Judith Barrows.
Starring Fess Parker, Patricia Blair, Darby Hinton.
Michael Dante as Akari.

Death Valley Days
"Long Night at Fort Lonely"
(Flying 'A' Productions)
Directed by Jack Hively; written by Claire Whitaker (as Orma Wallengren).
Starring June Dayton, Robert Anderson, Michael Dante.
Michael Dante stars as Clay Squires.

1968: *The Big Valley*
"Deathtown"
(ABC/Four Star Productions)
Directed by Don Taylor; written by A. I. Bezzerides, Louis F. Edelman, Edward J. Lakso.
Starring Richard Long, Peter Breck, Lee Majors.
Michael Dante as Francisco.

1967: *Custer*
(ABC/20th Century Fox Television)
Created by Samuel A. Peeples, David Weisbart.
Directed by Leo Penn, Norman Foster, others; written by John Dunkel, Samuel A. Peeples, David Weisbart, Larry Cohen, Shimon Wincelberg, others.
Starring Wayne Maunder, Slim Pickens, Michael Dante.
Michael Dante stars as Crazy Horse in all 16 episodes.

1965: *Bonanza*
"The Brass Box"
(NBC)
Directed by William F. Claxton; written by Paul Schneider.
Starring Lorne Greene, Dan Blocker, Michael Landon.
Michael Dante as Miguel Ortega.

Arizona Raiders
(Columbia)
Directed by William Witney; written by Alex Gottlieb, Mary Willingham, Willard W. Willingham, Frank Gruber, Richard Schayer.
Starring Audie Murphy, Michael Dante, Ben Cooper.
Michael Dante stars as Brady.

1964: *Apache Rifles*
(20th Century Fox)
Directed by William Witney; written by Charles B. Smith, Kenneth Garnet, Richard Schayer.
Starring Audie Murphy, Michael Dante, Linda Lawson.
Michael Dante stars as Red Hawk.

1959: *Death Valley Days*
"Olvera"
(Flying 'A' Productions)
Directed by Daniel Dare; written by Arthur Rowe.
Starring Stanley, Michael Dante, Craig Duncan.
Michael Dante stars as Capt. Richard Rocha.

The Texan
(CBS Television)
Created by James Gunn, Kathleen Hite.
Directed by Erle C. Kenton;

written by Samuel A. Peeples.
Starring Rory Calhoun, Michael Dante, Mario Alcalde.
Michael Dante stars as Steve Chambers in all 4 episodes.

Westbound
(Warner Bros.)
Directed by Budd Boetticher; written by Berne Giler, Albert S. Le Vino.
Starring Randolph Scott, Virginia Mayo, Karen Steele, Andrew Duggan.
Michael Dante as Rod Miller.

Maverick
"Betrayal"
(ABC/Warner Bros. Television)
Directed by Leslie H. Martinson; written by Richard Macaulay, Winston Miller, James O'Hanlon.
Starring Jack Kelly, Pat Crowley, Ruta Lee.
Michael Dante as Joe.

The Adventures of Rin Tin Tin
"The Matador"
(ABC)
Directed by William Beaudine; written by Roy Erwin.
Starring Lee Aaker, James Brown, Michael Dante.
Michael Dante stars as Ramon Estrada.

Lawman
"The Captives"
(ABC/Warner Bros. Television)
Directed by Stuart Heisler; written by Edmund Morris.
Starring John Russell, Peter Brown, Edgar Buchanan.
Michael Dante as Jack McCall.

1958: *Maverick*
"The Third Rider"
(Warner Bros. Television)
Directed by Franklin Adreon; written by George F. Slavin.
Starring Jack Kelly, Frank Faylen, Barbara Nichols.
Michael Dante as Turk Mason.

Tales of the Texas Rangers
"Edge of Danger"
(CBS)
Directed by George Blair; written by Frank L. Moss.
Starring Willard Parker, Harry Lauter, Michael Dante.
Michael Dante stars as Alfredo.

Cheyenne
"Noose at Noon"
(ABC/Warner Bros. Television)
Directed by Howard W. Koch; written by Dean Riesner, W. C. Tuttle.
Starring Clint Walker, Theona Bryant, Robert Bray.
Michael Dante as Billy Bob.

Fort Dobbs
(Warner Bros.)
Directed by Gordon Douglas; written by George W. George, Burt Kennedy.
Starring Clint Walker, Virginia Mayo, Brian Keith.
Michael Dante as Billings.

Colt .45
"The Deserters"
(ABC/Warner Bros. Television)
Directed by Leslie H. Martinson; written by Tony Barrett, Frederick Brady, Norman Daniels.
Starring Wayde Preston, Angie Dickinson, Michael Dante.
Michael Dante stars as Ab Saunders.

Sugarfoot
"The Dead Hills"
(ABC/Warner Bros. Television)
Directed by Franklin Adreon; written by Earl Baldwin, Paul Gangelin, Louis L'Amour.
Starring Will Hutchins, Ruta Lee, Veda Ann Borg.
Michael Dante as Mike Wilson.

1957: *Maverick*
"Stage West"
(Warner Bros. Television)
Directed by Leslie H. Martinson; written by George F. Slavin, Louis L'Amour.
Starring James Garner, Erin O'Brien, Ray Teal.
Michael Dante as Sam Harris.

Cheyenne
"Hired Gun"
(ABC/Warner Bros. Television)
Directed by Leslie H. Martinson; written by Berne Giler.
Starring Clint Walker, Whitney Blake, Alan Hale Jr.
Michael Dante as Whitey.

Cheyenne
"The Conspirators"
(ABC/Warner Bros. Television)
Directed by Leslie H. Martinson; written by James O'Hanlon, Donald R. Wilson.
Starring Clint Walker, Joan Weldon, Tom Conway.
Michael Dante as Lt. Dowd.

Cheyenne
"Incident at Indian Springs"
(ABC/Warner Bros. Television)
Directed by Thomas Carr; written by George F. Slavin.
Starring Clint Walker, Bonnie Bolding, Dan Barton.
Michael Dante as Roy Curran.

Colt .45
"The Three Thousand Dollar Bullet"
(ABC/Warner Bros. Television)
Directed by Franklin Adreon; written by Eric Friewald, Robert Schaefer.
Starring Wayde Preston, Richard Garland, Toni Gerry.
Michael Dante as Davey Bryant.

Sugarfoot
"Trail's End"
(ABC/Warner Bros. Television)
Directed by Leslie H. Martinson; written by James O'Hanlon, Michael Fessier, Norman A. Fox.
Starring Will Hutchins, Venetia Stevenson, Gordon Jones.
Michael Dante as Walt Lane.

Sugarfoot
"Reluctant Hero"
(ABC/Warner Bros. Television)
Directed by Leslie H. Martinson; written by Dean Riesner, S. Omar Barker.
Starring Will Hutchins, Gloria Talbott, Steve Brodie.
Michael Dante as Ken Brazwell.

2006: *The Plot to Kill: Jesse James*
(History Channel/Indigo Films)
Directed by Mike Loades; written by Josh Rosen.
Starring Fred Chiaventone, Raleigh Dean Craighead, Robert Davi.
Robert Davi as Narrator.

1979: *The Legend of the Golden Gun*
(NBC/Columbia Pictures Television)
Directed By Alan J. Levi; written by James D. Parriott.
Starring Jeff Osterhage, Carl Franklin, Robert Davi.
Robert Davi stars as William Quantrill.

2018: *Any Bullet Will Do*
(Sony Pictures Home Entertainment)
Directed by Justin Lee; written by Justin Lee.
Starring Kevin Makely, Bruce Davison, Jenny Curtis.

Bruce Davison stars as Jonathan Carrington.

1998: *Dead Man's Gun*
"Ties That Bind"
(Sugar Entertainment Ltd.)
Directed by Sturla Gunnarsson; written by Howard Spielman, Ed Spielman, Bruce Zimmerman.
Starring J. B. Bivens, Bruce Davison, Elan Ross Gibson.
Bruce Davison stars as Bill Curtis.

1972: *Ulzana's Raid*
(Universal)
Directed by Robert Aldrich; written by Alan Sharp.
Starring Burt Lancaster, Bruce Davison, Jorge Luke, Richard Jaeckel.
Bruce Davison stars as Lt. Garnett DeBuin.

1995: *Wild Bill*
(United Artists)
Directed by Walter Hill; written by Peter Dexter, Thomas Babe, Walter Hill.
Starring Jeff Bridges, Ellen Barkin, John Hurt.
Lee de Broux as Carl Mann.

1993: *Geronimo: An American Legend*
(Columbia)
Directed by Walter Hill; written by John Milius, Larry Gross.
Starring Jason Patric, Gene Hackman, Robert Duvall.
Lee de Broux as City Marshal Joe Hawkins.

1990: *Young Guns II*
(Morgan Creek Entertainment)
Directed by Geoff Murphy; written by John Fusco.
Starring Emilio Estevez, Kiefer Sutherland, Lou Diamond Phillips.
Lee de Broux as Bounty Hunter.

1988: *Guns of Paradise*
"The Ghost Dance"
(CBS/Lorimar television)
Directed by Joseph L. Scanlan; written by David Jacobs, Robert Porter.
Starring Lee Horsley, Jenny Beck, Matthew Newmark.
Lee de Broux as Christmas.

Longarm
(ABC/Universal Television)
Directed by Virgil W. Vogel; written by David Chisholm, Tabor Evans (novels).
Starring Daphne Ashbrook, Rene Auberjonois, Diedrich Bader.
Lee de Broux as Pat Garrett.

1987: *Outlaws*
"Pursued"
(CBS)
Directed by Phil Bondelli; written by Nicholas Corea, Robert Heverly, Timothy Burns.
Starring Rod Taylor, William Lucking, Charles Napier.
Lee de Broux as Mark Bennett.

1986: *Dream West*
(CBS)
Directed by Dick Lowry; written by Evan Hunter, David Nevin (novel).
Starring Richard Chamberlain, Alice Krige, F. Murray Abraham.
Lee de Broux as Provost in Episode #1.2, Dream West.

1979: *The Sacketts*
(NBC/Media Productions)
Directed by Robert Totten; written by Jim Byrnes, Louis L'Amour (novels)
Starring Sam Elliott, Tom Selleck, Jeff Osterhage.

Lee de Broux as Simpson in Part II, Part I.

How the West Was Won
"The Scavengers"
Directed by Ralph Senensky; written by Calvin Clements Jr. Starring James Arness, Fionnula Flanagan, Bruce Boxleitner. Lee de Broux as Larch.

1978: *True Grit: A Further Adventure*
(ABC/Paramount Television)
Directed by Richard T. Heffron; written by Charles Portis, Sandor Stern. Starring Warren Oates, Lisa Pelikan, Lee Meriwether. Lee de Broux as Skorby.

1977: *The Oregon Trail*
"Suffer the Children"
(NBC/Universal Television)
Directed by Gene Fowler Jr. Starring Rod Taylor, Andrew Stevens, Tony Becker. Lee de Broux as unnamed character.

1976: *The Quest*
"The Buffalo Hunters"
Directed by Earl Bellamy; written by Paul Savage. Starring Kurt Russell, Tim Matheson, Alex Cord. Lee Jones deBroux as Colton.

The Invasion of Johnson County
(NBC/Universal Television)
Directed by Jerry Jameson; written by Nicholas E. Baehr. Starring Bill Bixby, Bo Hopkins, John Hillerman. Lee de Broux as Richard Allen.

1975: *Gunsmoke*
"The Hiders"
(CBS)
Directed by Victor French; written by Paul Savage. Starring Milburn Stone, Ken Curtis, Buck Taylor. Lee de Broux as Quincannon.

1974: *The Red Badge of Courage*
(NBC/20th Century Fox Television)
Directed by Lee Philips; written by John Gay, Stephen Crane (novel). Starring Richard Thomas, Michael Brandon, Wendell Burton. Lee de Broux as The Sergeant.

1972: *Bonanza*
"Forever"
(NBC)
Directed by Michael Landon; written by Michael Landon, David Dortort. Starring Lorne Greene, Michael Landon, Mitch Vogel. Lee de Broux as Krater.

1971: *Bonanza*
"Warbonnet"
(NBC)
Directed by Arthur H. Nadel; written by David Dortort, Robert Biheller (as Robert Blood), Charles Goldwad, Fred Hamilton. Starring Lorne Greene, Dan Blocker, Michael Landon. Lee de Broux as Elias.

The Trackers
(ABC/Aaron Spelling Productions)
Directed by Earl Bellamy; written by Gerald Gaiser. Starring Sammy Davis Jr., Ernest Borgnine, Julie Adams. Lee de Broux as Bartender.

Wild Rovers
(Metro-Goldwyn-Mayer)
Directed by Blake Edwards; written by Blake Edwards. Starring William Holden, Ryan O'Neal, Karl Malden. Lee de Broux as Leaky.

Alias Smith and Jones
"Return to Devil's Hole"
(ABC/Universal/Public Arts Production)
Directed by Bruce Kessler; written by Glen A. Larson, Marion Hargrove (as Knut Swenson), Roy Huggins. Starring Pete Duel, Ben Murphy, Fernando Lamas. Lee de Broux as Hardcase.

1970: *Bonanza*
"Decision at Los Robles"
(NBC)
Directed by Michael Landon; written by David Dortort, Michael Landon. Starring Lorne Greene, Dan Blocker, Michael Landon. Lee de Broux as Gunman #2.

1969: *Gunsmoke*
"The Innocent"
(CBS)
Directed by Marvin J. Chomsky; written by Walter Black. Starring James Arness, Milburn Stone, Amanda Blake. Lee de Broux as Zeal Yewker.

Tell Them Willie Boy Is Here
(Universal)
Directed by Abraham Polonsky; written by Harry Lawton (book), Abraham Polonsky. Starring Robert Redford, Katherine Ross, Robert Blake. Lee de Broux as Meathead.

The Virginian
"The Price of Love"
(NBC/Universal Television)
Directed by Michael Caffey; written by Owen Wister (novel), Richard Carr. Starring John McIntire, Doug McClure, David Hartman. Lee de Broux as Jack Ash.

1968: *Gunsmoke*
"Waco"
(CBS)
Directed by Robert Totten; written by Ron Bishop. Starring James Arness, Milburn Stone, Amanda Blake. Lee de Broux as Fuller.

Gunsmoke
"9:12 to Dodge"
(CBS)
Directed by Marvin J. Chomsky; written by Preston Wood. Starring James Arness, Milburn Stone, Amanda Blake. Lee de Broux as Tim.

Gunsmoke
"Blood Money"
(CBS)
Directed by Robert Totten; written by Hal Sitowitz. Starring James Arness, Milburn Stone, Amanda Blake. Lee de Broux as Stu Radford.

The Guns of Will Sonnett
"The Trap"
(ABC/Thomas/Spelling Productions)
Directed by Jack Arnold; written by Jameson Brewer, Richard Carr, Aaron Spelling. Starring Walter Brennan, Dack Rambo, Royal Dano. Lee de Broux as Alf.

1967: *Gunsmoke*
"A Hat"
(CBS)
Directed by Robert Totten; written by Ron Bishop. Starring James Arness, Milburn Stone, Amanda Blake. Lee de Broux as Cowpuncher.

ROBERT EVANS

1958: *The Fiend Who Walked the West*
(20th Century Fox)

Directed by Gordon Douglas; written by Harry Brown, Philip Yordan, Ben Hecht, Charles Lederer, Eleazar Lipsky. Starring Hugh O'Brian, Robert Evans, Doloras Michaels. Robert Evans as Felix Griffin.

EDWARD FAULKNER

2003: *Hard Ground*
(Hallmark Entertainment)
Directed by Frank Q. Dobbs; written by Frank Q. Dobbs, David S. Cass Sr. Starring Burt Reynolds, Bruce Dern, Amy Jo Johnson. Edward Faulkner as Warden.

1972: *Gunsmoke*
"The Brothers"
(CBS)
Directed by Gunner Hellström; written by Calvin Clements Sr. Starring Milburn Stone, Amanda Blake, Ken Curtis. Edward Faulkner as Drummer.

1971: *Something Big*
(National General)
Directed by Andrew V. McLaglen; written by James Lee Barrett. Starring Dean Martin, Brain Keith, Carol White. Edward Faulkner as Capt. Tyler.

Scandalous John
(Walt Disney Productions)
Directed by Robert Butler; written by Bill Walsh, Don DaGradi, Richard Gardner (book). Starring Brian Keith, Alfonso Arau, Michele Carey. Edward Faulkner as Hillary.

Gunsmoke
"Drago"
(CBS)
Directed by Paul Stanley; written by Jim Byrnes. Starring James Arness, Milburn Stone, Amanda Blake. Edward Faulkner as Trask.

1970: *Rio Lobo*
(National General)
Directed by Howard Hawks; written by Burton Wohl, Leigh Brackett. Starring John Wayne, Jorge Rivero, Jennifer O'Neill. Edward Faulkner as Lt. Harris.

The Intruders
(NBC/Acme Films)
Directed by William A. Graham; written by Douglas Lansford (as William Lansford), Dean Riesner. Starring Don Murray, Anne Francis, Edmond O'Brien. Edward Faulkner as Bill Riley.

The Virginian
(NBC/Universal Television)
"With Love, Bullets and Valentines"
Directed by Philip Leacock; written by Glen A Larson. Starring Stewart Granger, Doug McClure, Lee Majors. Edward Faulkner as Leroy Plimpton.

Chisum
(Warner Bros.)
Directed by Andrew V. McLaglen; written by Andrew J. Fenedy. Starring John Wayne, Forrest Tucker, Christopher George. Edward Faulkner as James J. Dolan.

1969: *The Undefeated*
(20th Century Fox)
Directed by Andrew V. McLaglen; written by James Lee Barrett, Stanley L. Hough. Starring John Wayne, Rock Hudson, Antonio Aguilar.

Edward Faulkner as Anderson.

The Outcasts
"The Candidates"
(ABC/Screen Gems Television)
Directed by Leslie H. Martinson; written by Ben Brady, Don Brinkley, Leon Tokatyan. Starring Don Murray, Otis Young, Edward Faulkner. Edward Faulkner stars as Willis.

The Virginian
(NBC/Universal Television)
"Death Wait"
Directed by Charles S. Dubin; written by Gerald Sanford, Owen Wister (novel). Starring John McIntire, Doug McClure, David Hartman. Edward Faulkner as Matt Clayton.

1968: *The Shakiest Gun in the West*
(Universal)
Directed by Alan Rafkin; written by James Fritzell, Everett Greenbaum, Edmund L. Hartmann, Frank Tashlin. Starring Don Knotts, Barbara Rhoades, Jackie Coogan. Edward Faulkner as Huggins.

Cimarron Strip
"Fool's Gold"
(CBS)
Directed by Herschel Daugherty; written by Christopher Knopf, Palmer Thompson, David Jones. Starring Stuart Whitman, Percy Herbert, Randy Boone. Edward Faulkner as Captain.

1967: *Laredo*
"The Other Cheek"
(NBC/Universal Television)
Directed by Ezra Stone; written by Gene L. Coon. Starring Neville Brand, Peter Brown, William Smith. Edward Faulkner as Ed Garmes.

Iron Horse
"Welcome for the General"
(ABC/Dagonet Productions)
Directed by Alan Crosland Jr.; written by Sherman Tellen, James Goldstone, Stephen Kandel. Starring Dale Robertson, Gary Collins, Robert Random. Edward Faulkner as Jess Sinclair.

1966: *The Virginian*
(NBC/Universal Television)
"Jacob Was a Plain Man"
Directed by Don McDougall; written by Eric Bercovici, Owen Wister (novel). Starring Charles Bickford, Doug McClure, Don Quine. Edward Faulkner as Packer.

The Virginian
(NBC/Universal Television)
"Morgan Starr"
Directed by Anton Leader; written by Herman Miller, Barry Oringer, Owen Wister (novel). Starring Lee J. Cobb, Doug McClure, Clu Gulager. Edward Faulkner as Proctor.

Bonanza
"Credit for a Kill"
(NBC)
Directed by William F. Claxton; written by Frederick Louis Fox. Starring Lorne Greene, Dan Blocker, Michael Landon. Edward Faulkner as Casey Rollins.

The Monroes
"Ordeal by Hope"
(ABC/20th Century Fox Television)
Directed by James B. Clark.

Starring Michael Anderson Jr., Barbara Hershey, Keith Schultz. Edward Faulkner as Ferris.

1965: *The Virginian*
(NBC/Universal Television)
"Nobility of Kings"
Directed by Paul Stanley; written by Richard Fielder, James Duff McAdams, Owen Wister (novel). Starring Lee J. Cobb, Doug McClure, Clu Gulager. Edward Faulkner as Andy Proctor.

The Virginian
(NBC/Universal Television)
"Day of the Scorpion"
Directed by Robert Butler; written by Don Ingalls, Owen Wister (novel). Starring Lee J. Cobb, Doug McClure, Clu Gulager. Edward Faulkner as Andy Proctor.

The Virginian
(NBC/Universal Television)
"The Showdown"
Directed by Don McDougall; written by Gene L. Coon, Owen Wister (novel). Starring Lee J. Cobb, Doug McClure, Clu Gulager. Edward Faulkner as Tom Landers.

The Virginian
(NBC/Universal Television)
"You Take the High Road"
Directed by John Florea; written by Frank Fenton, Daniel B. Ullman, Owen Wister (novel). Starring Lee J. Cobb, Doug McClure, Clu Gulager. Edward Faulkner as Bert.

The Loner
"The Lonely Calico Queen"
Directed by Allen H. Miner; written by Rod Serling. Starring Lloyd Bridges, Jeanne Cooper, Tina Hermensen. Edward Faulkner as Bounty Hunter.

Wagon Train
"The Silver Lady"
Directed by Andrew V. McLaglen; written by Dick Nelson. Starring Robert Fuller, John McIntire, Frank McGrath. Edward Faulkner as Minister.

1964: *The Virginian*
(NBC/Universal Television)
"The Hour of the Tiger"
Directed by Richard L. Bare; written by Harry Kleiner, Owen Wister (novel). Starring Lee J. Cobb, Doug McClure, Clu Gulager. Edward Faulkner as Pete.

The Virginian
(NBC/Universal Television)
"Dark Destiny"
Directed by Don McDougall; written by Frank Chase, Owen Wister (novel). Starring Lee J. Cobb, Doug McClure, Gary Clarke. Edward Faulkner as Striker.

Bonanza
"No Less a Man"
(NBC)
Directed by Don McDougall; written by Jerry Adelman. Starring Lorne Greene, Pernell Roberts, Dan Blocker. Edward Faulkner as Bank Robber in Green Shirt.

Destry
"Destry Had a Little Lamb"
(ABC)
Directed by Gene Nelson; written by Gene L. Coon, Max Brand. Starring John Gavin, Fess Parker, Barbara Stuart. Edward Faulkner as Foggy.

Rawhide
"Incident at Gila Flats"
(CBS)
Directed by Thomas Carr;
written by Paul King, Samuel
Roeca.
Starring Eric Fleming, Clint
Eastwood, Paul Brinegar.
Edward Faulkner as Pvt.
Larson.

1963: *McLintock!*
(United Artists)
Directed by Andrew V. McLa-
glen; written by James Edward
Grant.
Starring John Wayne, Maureen
O'Hara, Patrick Wayne.
Edward Faulkner as Young
Ben Sage.

Gunsmoke
"The Quest for Asa Janin"
(CBS)
Directed by Andrew V. McLa-
glen; written by Paul Savage.
Starring James Arness, Milburn
Stone, Amanda Blake.
Edward Faulkner as Deputy.

Gunsmoke
"The Renegades"
(CBS)
Directed by Andrew V. McLa-
glen; written by John Meston.
Starring James Arness, Dennis
Weaver, Milburn Stone.
Edward Faulkner as Sergeant.

The Virginian
(NBC/Universal Television)
"Siege"
Directed by Don McDougall;
written by Donn Mullally,
Owen Wister (novel).
Starring Lee J. Cobb, Doug
McClure, Gary Clarke.
Edward Faulkner as Gambler.

Rawhide
"Incident of the Gallows Tree"
(CBS)
Directed by Christian Nyby;
written by Albert Aley.
Starring Eric Fleming, Clint
Eastwood, Paul Brinegar.
Edward Faulkner as Cryder.

Laramie
"The Violent Ones"
(NBC)
Directed by Lesley Selander;
written by Paul Savage, Daniel
B. Ullman.
Starring John Smith, Robert
Fuller, Spring Byington.
Edward Faulkner as Cliff.

1962: *Rawhide*
"Incident of the Four Horse-
men"
(CBS)
Directed by Thomas Carr;
written by Charles Larson.
Starring Eric Fleming, Clint
Eastwood, Paul Brinegar.
Edward Faulkner as Carl Galt.

Rawhide
"The Deserters' Patrol"
(CBS)
Directed by Andrew V. McLa-
glen; written by Louis Vittes.
Starring Eric Fleming, Clint
Eastwood, Sheb Wooley.
Edward Faulkner as Rutledge.

Have Gun – Will Travel
"Be Not Forgetful of Strangers"
(CBS)
Directed by Richard Boone;
written by Herb Meadow, Sam
Rolfe, Arthur Sarno Jr.
Starring Richard Boone, Duane
Eddy, Josie Lloyd.
Edward Faulkner as Ben.

Have Gun – Will Travel
"Memories of Monica"
(CBS)
Directed by Gary Nelson;
written by Don Ingalls, Herb
Meadow, Sam Rolfe.
Starring Richard Boone, Judi

Meredith, Bing Russell.
Edward Faulkner as Deputy
Ed Buhl.

Have Gun – Will Travel
"The Hunt"
(CBS)
Directed by Andrew V. Mc-
Laglen; written by Herman
Groves, Herb Meadow, Sam
Rolfe.
Starring Richard Boone, Joan
Elan, Edward Faulkner.
Edward Faulkner stars as
Lieutenant Brager.

1961: *Bonanza*
"The Friendship"
(NBC)
Directed by Don McDougall;
written by Frank Chase.
Starring Lorne Greene, Pernell
Roberts, Dan Blocker.
Edward Faulkner as Bob
Stevens.

Rawhide
"The Long Shakedown"
(CBS)
Directed by Justus Addiss;
written by Albert Aley.
Starring Eric Fleming, Clint
Eastwood, Sheb Wooley.
Edward Faulkner as Lobey.

Have Gun – Will Travel
"The Brothers"
(CBS)
Directed by Andrew V. Mc-
Laglen; written by Robert E.
Thompson, Herb Meadow,
Sam Rolfe.
Starring Richard Boone, Buddy
Ebsen, Paul Hartman.
Edward Faulkner stars as Body
Guard #1.

Have Gun – Will Travel
"The Hanging of Aaron Gibbs"
(CBS)
Directed by Richard Boone;
written by Robert E. Thomp-
son, Herb Meadow, Sam Rolfe.
Starring Richard Boone, Roy
Barcroft, Barry Cahill.
Edward Faulkner as Deputy
Jim Harden.

Have Gun – Will Travel
"Soledad Crossing"
(CBS)
Directed by Andrew V. McLa-
glen; written by Don Ingalls,
Herb Meadow, Sam Rolfe.
Starring Richard Boone,
Edward Faulkner, Natalie
Norwick.
Edward Faulkner stars as Bud
McPhater.

Lawman
"The Promise"
(ABC/Warner Bros. Television)
Directed by Irving J. Moore;
written by John D. F. Black.
Starring John Russell, Peter
Brown, Peggie Castle.
Edward Faulkner as Corporal
Hayden.

*The Little Shepherd of Kingdom
Come*
(20th Century Fox)
Directed by Andrew V. McLa-
glen; written by John Fox Jr.,
Barré Lyndon.
Starring Jimmie Rodgers,
Luana Patten, Chill Wills.
Edward Faulkner as Capt.
Richard Dean.

Gunslinger
"The Buried People"
(CBS/Emirau Productions)
Directed by Andrew V. McLa-
glen; written by John Dunkel,
Louis Vittes.
Starring Tony Young, Preston
Foster, Charles H. Gray.
Edward Faulkner as Corporal.

1960: *Gunsmoke*
"Unwanted Deputy"
(CBS)

Directed by Andrew V. McLa-
glen; written by John Meston,
Marian Clark.
Starring James Arness, Dennis
Weaver, Milburn Stone.
Edward Faulkner as Harry.

Have Gun – Will Travel
"The Puppeteer"
(CBS)
Directed by Richard Boone;
written by Shimon Wincelberg,
Herb Meadow, Sam Rolfe.
Starring Richard Boone, Crah-
an Denton, Denver Pyle.
Edward Faulkner as Cavalry
Sergeant.

Have Gun – Will Travel
"Black Sheep"
(CBS)
Directed by Richard Boone;
written by Shimon Wincelberg,
Herb Meadow, Sam Rolfe.
Starring Richard Boone, Pat-
rick Wayne, Stacy Harris.
Edward Faulkner as Marshal.

Have Gun – Will Travel
"Love of a Bad Woman"
(CBS)
Directed by Andrew V. McLa-
glen; written by Robert Dozier,
Herb Meadow, Sam Rolfe.
Starring Richard Boone,
Geraldine Brooks, Lawrence
Dobkin.
Edward Faulkner as Gunman.

Hotel de Paree
"Vengeance for Sundance"
(CBS)
Directed by Arthur Hiller;
written by Robert Lees
(as J. E. Selby).
Starring Earl Holliman, J. Pat
O'Malley, H. M. Wynant.
Edward Faulkner as Deputy
Sheriff.

1959: *Rawhide*
"Incident of the Shambling
Man"
(CBS)
Directed by Andrew V. Mc-
Laglen; written by Charles
Larson, Fred Freiberger.
Starring Eric Fleming, Clint
Eastwood, Sheb Wooley.
Edward Faulkner as Mason.

Rawhide
"Incident of Fear in the Streets"
(CBS)
Directed by Andrew V.
McLaglen; written by Fred
Freiberger.
Starring Eric Fleming, Clint
Eastwood, Sheb Wooley.
Edward Faulkner as Brett
Mason.

Have Gun – Will Travel
"The Black Handkerchief"
(CBS)
Directed by Andrew V. McLa-
glen; written by Jay Simms,
Herb Meadow, Sam Rolfe.
Starring Richard Boone, Ed
Nelson, Joseph V. Perry.
Edward Faulkner as Dink.

Have Gun – Will Travel
"Incident at Borrasca Bend"
(CBS)
Directed by Andrew V. McLa-
glen; written by Jay Simms,
Herb Meadow, Sam Rolfe.
Starring Richard Boone,
Jacques Aubuchon, Perry Cook.
Edward Faulkner as Curly.

1958: *Have Gun – Will Travel*
"The Road to Wickenburg"
(CBS)
Directed by Andrew V.
McLaglen; written by Gene
Roddenberry, Herb Meadow,
Sam Rolfe.
Starring Richard Boone, Chris-
tine White, Harry Carey Jr.
Edward Faulkner as Jim
Goodfellow.

Have Gun – Will Travel
"The Hanging of Roy Carter"
(CBS)
Directed by Andrew V.
McLaglen; written by Gene
Roddenberry, Herb Meadow,
Sam Rolfe.
Starring Richard Boone, John
Larch, Robert Armstrong.
Edward Faulkner as 2nd Guard.

AL FLEMING

2002: *Legend of the Phantom
Rider*
(A-Mark Entertainment)
Directed by Alex Erkiletian;
written by Robert McRay.
Starring Denise Crosby, Robert
McRay, Stefan Gierasch.
Al Fleming as Garver.

2001: *Aqua Dulce* (short)
(Tribesmen Films)
Directed By Edgar B. Pablos;
written by Edgar B. Pablos.
Starring Nestor Carbonell,
Sydney Bennett, Peter Jason.
Al Fleming as Lyle Bishop.

2000: *The Magnificent Seven*
"Lady Killers"
(MGM Television)
Directed by William Wages.
Starring Michael Biehn, Eric
Close, Andrew Kavovit.
Al Fleming as Burly Fellow.

1999: *The Magnificent Seven*
"Sins of the Past"
(MGM Television)
Directed by Gregg Champion;
written by Steve Hattman.
Starring Michael Biehn, Eric
Close, Dale Midkiff.
Al Fleming as Buffalo Hunter.

1988: *Guns of Paradise*
"The Promise"
(CBS/Lorimar Television)
Directed by Nick Havinga;
written by David Jacobs, Robert
Porter.
Starring Lee Horsley, Jenny
Beck, Matthew Newmark.
Al Fleming as Rider.

ROBERT FORSTER

2018: *Damsel*
(Magnolia Pictures)
Directed by David Zellner, Na-
than Zellner; written by David
Zellner, Nathan Zellner.
Starring Robert Patterson, Mia
Wasikowska, David Zellner.
Robert Forster as Old Preacher.

1978: *Standing Tall*
(NBC/Quinn Martin Produc-
tions)
Directed by Harvey Hart; writ-
ten by Franklin Thompson.
Starring Robert Forster, Will
Sampson, L. Q. Jones.
Robert Forster stars as Luke
Shasta.

1976: *Royce*
(CBS/MTM Productions)
Directed by Andrew V. McLa-
glen; written by Jim Byrnes.
Starring David S. Cass Sr.,
Moosie Drier, Robert Forster.
Robert Forster stars as Royce.

1968: *The Stalking Moon*
(National General)
Directed by Robert Mulli-
gan; written by Alvin Sargent,
Wendell Mayes, Theodore V.
Olsen.
Starring Gregory Peck, Eva
Marie Saint, Robert Forster.
Robert Forster stars as Nick
Tana.

ROSEMARY FORSYTH

1974: *Kung Fu*
"A Small Beheading"
Directed by Richard Lang;
written by Ed Spielman, Her-

man Miller, Eugene Price.
Starring David Carradine, Wil-
liam Shatner, France Nuyen.
Rosemary Forsyth as Ellie
Crowell.

1966: *Texas Across the River*
(Universal)
Directed by Michael Gordon;
written by Wells Root, Harold
Greene, Ben Starr.
Starring Dean Martin, Alain
Delon, Rosemary Forsyth.
Rosemary Forsyth stars as
Phoebe Ann Naylor.

1965: *Shenandoah*
(Universal)
Directed by Andrew V. Mc-
Laglen; written by James Lee
Barrett.
Starring James Stewart, Doug
McClure, Glenn Corbett,
George Kennedy, Ed Faulkner.
Rosemary Forsyth as Jennie.

MAX GAIL

1996: *The Lazarus Man*
"The Sheriff"
(Castle Rock Entertainment)
Directed by John Binder;
written by John Binder, Joshua
Winfield Binder.
Starring Robert Urich, John
Achorn, Max Gail.

Dr. Quinn, Medicine Woman
"Deal With the Devil"
(CBS)
Directed by Bobby Roth;
written by Beth Sullivan,
Nancy Bond.
Starring Jane Seymour, Joe
Lando, Chad Allen.
Max Gail as Mr. Edwin James.

1994: *Sodbusters*
(Republic/Atlantic Films)
Directed by Eugene Levy;
written by John Hemphill,
Eugene Levy.
Starring Kris Kristofferson,
John Vernon, Fred Willard.
Max Gail as Tom Partridge.

BRUCE GLOVER

1988: *Ghost Town*
(New World/Empire)
Directed by Richard McCarthy
as Richard Governor; written
by Duke Sandefur, David
Schmoeller.
Starring Franc Luz, Catherine
Hickland, Jimmie F. Skaggs.
Bruce Glover as Dealer.

1974: *This Is the West That Was*
(Universal Television)
Directed by Fielder Cook;
written by Sam Rolfe.
Starring Ben Murphy, Kim
Darby, Jane Alexander.
Bruce Glover as Sam Ralston.

1973: *One Little Indian*
(Disney Channel)
Directed by Bernard McEveety;
written by Harry Spalding.
Starring James Garner, Vera
Miles, Pat Hingle.
Bruce Glover as Schrader.

1972: *Gunsmoke*
"The Drummer"
Directed by Bernard McEveety;
written by Richard Fielder.
Starring Milburn Stone, Aman-
da Blake, Ken Curtis.
Bruce Glover as Enoch Brandt.

1971: *Scandalous John*
(Walt Disney)
Directed by Robert Butler;
written by Bill Walsh, Don
DaGradi, Richard Gardner.
Starring Brian Keith, Alfonso
Arau, Michele Carey.
Bruce Glover as Sludge.

Yuma
(ABC/Aaron Spelling Pro-
ductions)

Directed by Ted Post; written by Charles A. Wallace. Starring Clint Walker, Barry Sullivan, Kathryn Hays. Bruce Glover as Sam King.

1970: *Bonanza*
(NBC)
"What Are Pardners For?"
Directed by William F. Claxton; written by Davis Dortort, Jack B. Sowards.
Starring Lorne Greene, Dan Blocker, Michael, Landon.
Bruce Glover as Scooter.

1969: *Gunsmoke*
"Coreyville"
Directed by Bernard McEveety; written by Herman Groves.
Starring James Arness, Milburn Stone, Amanda Blake.
Bruce Glover as Titus Wylie.

The Over-the-Hill Gang
(ABC/Thomas/Spelling Productions)
Directed by Jean Yarbrough; written by Jameson Brewer, Leonard Goldberg.
Starring Walter Brennan, Edgar Buchanan, Andy Devine.
Bruce Glover as Deputy Steel.

The Guns of Will Sonnett
"Jim Sonnett's Lady"
(ABC/Thomas/Spelling Productions)
Directed by Jean Yarbrough; written by Richard Carr, Aaron Spelling.
Starring Walter Brennan, Dack Rambo, Jason Evers.
Bruce Glover as Sandy Blake.

1968: *The Big Valley*
"Hunter's Moon"
(ABC/Four Star Productions)
Directed by Bernard McEveety; written by A. I. Bezzerides, Louis F. Edelman, Don Ingalls.
Starring Richard Long, Peter Breck, Lee Majors.
Bruce Glover as Bodkin.

1967: *The Guns of Will Sonnett*
"The Favor"
(ABC/Thomas/Spelling Productions)
Directed by Jean Yarbrough; written by Richard Carr, Aaron Spelling.
Starring Walter Brennan, Dack Rambo, Stephen McNally.
Bruce Glover as Billy.

Dundee and the Culhane
"The Duelist Brief"
(CBS/Filmways Television)
Directed by Leo Penn; written by Andy Lewis.
Starring John Mills, Eddie Baker, Harry Bartell.
Bruce Glover as unnamed character.

1999: *Gunfighter*
(Amazing Movies)
Directed by Christopher Coppola; written by Christopher Coppola.
Starring Robert Carradine, Martin Sheen, George Nix.
Clu Gulager as Uncle Buck Peters.

1996: *Dr. Quinn, Medicine Woman*
"Last Dance"
(CBS)
Directed by Terrance O'Hara; written by Beth Sullivan, Chris Abbott.
Starring Jane Seymour, Joe Lando, Chad Allen.
Clu Gulager as Art McKendrick.

1991: *My Heroes Have Always Been Cowboys*
(The Samuel Goldwyn Company)

Directed by Stuart Rosenberg; written by Joel Don Humphreys.
Starring Scott Glenn, Kate Capshaw, Ben Johnson.
Clu Gulager as Dark Glasses.

1980: *Kenny Rogers as The Gambler*
(CBS)
Directed by Dick Lowry; written by Jim Byrnes, Cort Casady, Don Schlitz.
Starring Kenny Rogers, Christine Belford, Bruce Boxleitner.
Clu Gulager as Rufe Bennett.

1977: *The Oregon Trail*
"The Army Deserter"
(NBC/Universal Television)
Directed by Herb Wallerstein; written by Eugene Price, Stanley Roberts.
Starring Rod Taylor, Charles Napier, Andrew Stevens.
Clu Gulager as Harris.

Charlie Cobb: Nice Night for a Hanging
(NBC/Universal Television)
Directed by Richard Michaels; written by Peter S. Fischer, Richard Levinson, William Link.
Starring Clu Gulager, Ralph Bellamy, Blair Brown.
Clu Gulager stars as Charlie Cobb.

1973: *Kung Fu*
"Blood Brother"
(ABC/Warner Bros. Television)
Directed by Jerry Thorp; written by Ed Spielman, Herman Miller.
Starring David Carradine, Clu Gulager, John Anderson.
Clu Gulager stars as Sheriff Rutledge.

1972: *Molly and Lawless John*
(Producers Distributing)
Directed by Gary Nelson; written by Terry Kingsley-Smith.
Starring Vera Miles, Sam Elliott, Clu Gulager.
Clu Gulager stars as Deputy Tom Clements.

Bonanza
"Stallion"
(NBC)
Directed by E. W. Swackhamer; written by David Dortort, Juanita Bartlett, Fred Hamilton, Mort Zarcoff, Jack B. Sowards.
Starring Lorne Greene, Michael Landon, David Canary.
Clu Gulager as Billy Brenner.

1968: *The Virginian*
(NBC)
Created by Charles Marquis Warren,
Directed by Joel Rogosin, E. Darrell Hallenbeck, Abner Biberman, others; written by Owen Wister (novel), Reuben Bercovitch, Richard Carr, others.
Starring John McIntire, Doug McClure, Clu Gulager, Charles Bickford, Lee J. Cobb.
Clu Gulager stars as Emmett Ryker in 102 episodes.

1964: *Wagon Train*
"The Ben Engel Story"
(ABC)
Directed by Joseph Pevney; written by Betty Andrews.
Starring John McIntire, Robert Fuller, Denny Miller.
Clu Gulager as Harry Diel.

1963: *The Virginian*
(NBC)
"Run Quiet"
Directed by Herschel Daugherty; written by Owen Wister (novel), Ed Adamson, Norman Katkov, Charles Marquis Warren.
Starring Lee J. Cobb, Doug

McClure, Gary Clarke.
Clu Gulager as Jud.

The Virginian
(NBC)
"The Judgment"
Directed by Earl Bellamy; written by Owen Wister (novel), Bob Duncan, Wanda Duncan, Lawrence Roman, Charles Marquis Warren.
Starring Lee J. Cobb, Doug McClure, Gary Clarke.
Clu Gulager as Jake Carewe.

Wagon Train
"The Sam Spicer Story"
(ABC)
Directed by R. G. Springsteen; written by Norman Jolley.
Starring John McIntire, Robert Fuller, Denny Miller.
Clu Gulager as Sam Spicer.

Wagon Train
"The Clarence Mullins Story"
(ABC)
Directed by Jerry Hopper; written by Norman Jolley.
Starring John McIntire, Frank McGrath, Terry Wilson.
Clu Gulager as Clarence Mullins.

1962: *The Tall Man*
(NBC)
Created by Samuel A. Peeples.
Directed by Sidney Pollack, Ed Montagne, others; written by David Lang, Samuel A. Peeples, Frank Price, others.
Starring Barry Sullivan Clu Gulager, George Macready, Ed Nelson.
Clu Gulager stars as Billy the Kid in all 75 episodes.

1961: *Whispering Smith*
"The Devil's Share"
(NBC)
Directed by Lawrence Doheny; written by Joel Murcott.
Starring Audie Murphy, Guy Mitchell, Sam Buffington.
Clu Gulager as Jeff Whalen.

1960: *The Deputy*
"Trail of Darkness"
(NBC/Top Gun Productions)
Directed by Sidney Lanfield; written by Hendrik Vollaerts, Roland Kibbee, Norman Lear.
Starring Henry Fonda, Allen Case, Clu Gulager.
Clu Gulager stars as Sanford.

The Rebel
"Paint a House with Scarlet"
(ABC)
Directed by Irvin Kershner; written by Nick Adams, Andrew J. Fenady, Frederick Louis Fox.
Starring Nick Adams, Clu Gulager, John Anderson.
Clu Gulager stars as Virgil Taber.

1959: *Wagon Train*
"The Stagecoach Story"
(ABC)
Directed by William Witney; written by Jean Holloway.
Starring Ward Bond, Robert Horton, Debra Paget.
Clu Gulager as Caleb Jamison.

Wagon Train
"The Andrew Hale Story"
(ABC)
Directed by Virgil W. Vogel; written by Peter Barry, Jean Holloway.
Starring Ward Bond, Robert Horton, John McIntire, Jane Darwell.
Clu Gulager as Elliott Garrison.

The Deputy
"Shadow of the Noose"
(NBC/Top Gun Productions)
Directed by Robert B. Sinclair; written by Roland Kibbee, Norman Lear.

Starring Henry Fonda, Allen Case, Wallace Ford.
Clu Gulager as The Drifter.

Riverboat
"Jessie Quinn"
(NBC)
Directed by Jules Bricken; written by Tom Seller.
Starring Darren McGavin, Burt Reynolds, Mercedes McCambridge.
Clu Gulager as Beau Chandler.

Law of the Plainsman
"The Hostiles"
(NBC)
Directed by Don Medford; written by Calvin Clements Sr.
Starring Michael Ansara, Dayton Lummis, Gina Gillespie.
Clu Gulager as Truck Garnett.

Laramie
"Fugitive Road"
(NBC)
Directed by Thomas Carr; written by Paul Savage, Daniel B. Ullman.
Starring John Smith, Hoagy Carmichael, Robert Crawford Jr.
Clu Gulager as Private Gil Brady.

Have Gun – Will Travel
"Return of Roy Carter"
(CBS)
Directed by Andrew V. McLaglen; written by Gene Roddenbury, Herb Meadow, Sam Rolfe.
Starring Richard Boone, Clu Gulager, Larry J. Blake.
Clu Gulager stars as Roy Carter.

Wanted: Dead or Alive
"Crossroads"
(CBS/Four Star Productions)
Directed by Don McDougall; written by David Lang.
Starring Steve McQueen, John McIntire, Clu Gulager.
Clu Gulager stars as Joe Collins.

Black Saddle
"Client: Meade"
(NBC/Four Star Productions)
Directed by Roger Kay; written by John McGreevey, Hal Hudson.
Starring Peter Breck, Russell Johnson, Anna-Lisa.
Clu Gulager as Andy Meade.

1966: *The Big Valley*
"The Lost Treasure"
(ABC/Four Star Productions)
Directed by Arthur H. Nadel; written by Jack Curtis, A. I. Bezzerides, Louis F. Edelman.
Starring Richard Long, Peter Breck, Lee Majors.
Buddy Hackett as Charlie Sawyer.

1961: *The Rifleman*
"The Clarence Bibs Story"
(ABC/Four Star Productions)
Directed by David Friedkin; written by Calvin Clements Sr.
Starring Chuck Connors, Johnny Crawford, Buddy Hackett.
Buddy Hackett stars as Clarence Bibs.

1959: *The Rifleman*
"Bloodlines"
(ABC/Four Star Productions)
Directed by Arthur Hiller; written by Arthur Browne Jr.
Starring Chuck Connors, Johnny Crawford, Paul Fix.
Buddy Hackett as Daniel Malakie.

1997: *Rough Riders*
(Affinity Entertainment)
Directed by John Milius;

written by John Milius, Hugh Wilson.
Starring Tom Berenger, Sam Elliott, Gary Busey, Brian Keith, Geoffrey Lewis.
George Hamilton as William Randolph Hearst in episodes #1.2, #1.1.

1981: *Zorro: The Gay Blade*
(20th Century Fox)
Directed by Peter Medak; written by Hal Dresner, Greg Alt, Don Moriarty, Bob Randall, Johnston McCulley, Hal Dresner.
Starring George Hamilton, Lauren Hutton, Brenda Vaccaro.
George Hamilton stars as Zorro the Gay Blade, Don Diego Vega, Bunny Wigglesworth.

1973: *The Man Who Loved Cat Dancing*
(Metro-Goldwyn-Mayer)
Directed by Richard C. Sarafian; written by Marilyn Durham (novel), Eleanor Perry.
Starring Burt Reynolds, Sarah Miles, Lee J. Cobb, George Hamilton, Bo Hopkins.
George Hamilton stars as Willard Crocker.

1967: *A Time for Killing*
(Columbia)
Directed by Phil Karlson, Roger Corman (uncredited); written by Nelson Wolford (novel), Halsted Welles.
Starring Glenn Ford, Inger Stevens, George Hamilton, Harry Dean Stanton, Tim Carey.
George Hamilton as Capt. Bentley.

1961: *A Thunder of Drums*
(Metro-Goldwyn-Mayer)
Directed by Joseph M. Newman; written by James Warner Bellah.
Starring Richard Boone, George Hamilton, Luana Patten, Richard Chamberlain.
George Hamilton stars as Lt. Curtis McQuade.

1959: *Cimarron City*
"The Beauty and the Sorrow"
(NBC)
Directed by Richard Bartlett; written by Halsted Welles.
Starring George Montgomery, Audrey Totter, John Smith.
George Hamilton as Tom Wolcott.

The Adventures of Rin Tin Tin
"The Misfit Marshal"
(ABC/Screen Gems)
Directed by William Beaudine; written by Jerry Thomas.
Starring Lee Aaker, James Brown, Joe Sawyer.
George Hamilton as Elwood Masterson.

1998: *Dead Man's Gun*
"The Trapper"
(Sugar Entertainment)
Directed by Brenton Spencer; written by Howard Spielman, Ed Spielman, Dennys McCoy, Pamela Hickey.
Starring Luc Corbeil, Damon Gregory, Gregory Harrison.
Gregory Harrison stars as Boucher, Trapper.

1988: *Red River*
(CBS/MGM/UA Television)
Directed by Richard Michaels; written by Borden Chase, Charles Schnee, Richard Fielder.
Starring Bruce Boxleitner, James Arness, Gregory Harrison, L. Q. Jones.
Gregory Harrison stars as Cherry Valance.

243

1979: *Centennial*
Created by John Wilder.
(NBC/Universal Television)
Directed by Virgil W. Vogel,
Bernard McVeety, others;
written by James A. Michener,
John Wilder, Jerry Ziegman,
others.
Starring William Atherton,
Raymond Burr, Barbara Carrera, Robert Conrad, Brian Keith,
Jesse Vint.
Gregory Harrison as Levi
Zendt in all 10 episodes.

RICHARD HARRISON

1972: *Fabulous Trinity*
(Film-Allianz)
Directed by Ignacio F. Iquino;
written by Ignacio F. Iquino,
Juliana San José de la Fuente.
Starring Richard Harrison,
Fanny Grey, Fernando Sancho.
Richard Harrison stars as Scott.

Deadly Trackers
(European United)
Directed by Tanio Boccia;
written by Tanio Boccia.
Starring Richard Harrison,
Anita Ekberg, Rik Battaglia.
Richard Harrison stars as Jeff
Carter, James Luke, Django.

Two Brothers in Trinity
(H. P. International)
Directed by Renzo Genta,
Richard Harrison; written by
Renzo Genta.
Starring Richard Harrison,
Donald O'Brien, Anna Zinnermann.
Richard Harrison stars as Jesse
Smith.

1971: *Sheriff of Rock Springs*
(Rasfilm)
Directed by Mario Sabatini;
written by Gianni Luigi, Elido
Sorrentino.
Starring Richard Harrison, Cosetta Greco, Donald O'Brien.
Richard Harrison stars as the
Sheriff.

Acquasanta Joe
(Jugendfilm-Verleih)
Directed by Mario Gariazzo;
written by Mario Gariazzo,
Ferdinando Poggi.
Starring Lincoln Tate, Ty
Hardin, Richard Harrison.
Richard Harrison stars as
Charlie Bennett.

His Name Was King
(Les Films Marbeuf)
Directed by Giancarlo Romitelli; written by Renato Savino.
Starring Richard Harrison,
Anne Puskin, Goffredo Unger.
Richard Harrison stars as John
'King' Marley.

Shoot Joe, and Shoot Again
(Paradise Film Exchange)
Directed by Emilio Miraglia;
written by Jean Josipovici,
Emilio Miraglia.
Starring Richard Harrison, José
Torres, Franca Polesello.
Richard Harrison stars as Joe
Dakota.

*Dig Your Grave Friend... Sabata's
Coming*
(Devon Film)
Directed by Juan Bosch;
written by Ignacio F. Iquino,
Luciano Martino, Juliana San
José de la Fuente.
Starring Richard Harrison, Fernando Sancho, Raf Baldassarre.
Richard Harrison stars as Steve
McGowan.

1970: *Reverend's Colt*
(Oceania)
Directed by León Klimovsky;
written by Tito Carpi, Manuel
Martinez Remis.
Starring Guy Madison, Richard
Harrison, Ennio Girolami.

Richard Harrison stars as
Sheriff Donovan.

Stagecoach of the Condemned
(Devon Film)
Directed by Juan Bosch; written by Lou Carrigan (novel),
Ignacio F. Iquino, Luciano
Martino, Juliana San José de
la Fuente.
Starring Richard Harrison,
Fernando Sancho, Erika Blanc.
Richard Harrison stars as
Robert Walton.

1968: *God Was in the West, Too,
at One Time*
(Circus Film)
Directed by Marino Girolami;
written by Tito Carpi, Manuel Martinez Remis, Amedeo
Sollazzo.
Starring Gilbert Roland, Richard Harrison, Ennio Girolami.
Richard Harrison stars as
Father Pat Jordan.

Day After Tomorrow
(Atlantica)
Directed by Nick Nostro;
written by Nick Nostro, Simon
O'Neill, Carlos Emilio Rodriguez, Giovanni Simonelli,
Mariano de Lope.
Starring Richard Harrison,
Pamela Tudor, Paolo Gozlino.
Richard Harrison stars as
Stan Ross.

Vengeance
(Super International)
Directed by Antonio Margheriti; written by Antonio Margheriti, Renato Savino.
Starring Richard Harrison,
Claudio Camaso, Werner
Pochath.
Richard Harrison stars as Joko,
Rocco Barrett.

1966: *Rojo*
(Petruka Films)
Directed by Leopoldo Savona;
written by Mario Casacci, Rate
Furlan, Antonio Giambriccio,
Roberto Gianviti, Mike Mitchell, Leopoldo Savona, José-María Seone.
Starring Richard Harrison,
Nieves Navarro, Piero Lulli.
Richard Harrison stars as
Donald 'El Rojo' Sorensen.

1965: *One Hundred Thousand
Dollars for Ringo*
(Balcázar Productions)
Directed by Alberto De
Martino; written by Alfonso
Balcázar, Alberto De Martino,
Vincenzo Mannino, Giovanni
Simonelli, Guido Zurli.
Starring Richard Harrison, Fernando Sancho, Luis Induni.
Richard Harrison stars as Lee
'Ringo' Barton.

1964: *Three Ruthless Ones*
(Centauro Films)
Directed by Joaquin Luis
Romero Marchent; written
by Joaquin Luis Romero
Marchent, Jesús Navarro Carrión, Rafael Romero Marchent,
Marcello Fondato.
Starring Richard Harrison,
Fernando Sancho, Gloria
Milland.
Richard Harrison stars as Jeff
Walker.

1963: *Gunfight in the Red Sands*
(Jolly Film)
Directed by Ricardo Blasco;
written by James Donald
Prindle, Albert Band, Ricardo
Blasco.
Starring Richard Harrison, Giacomo Rossi Stuart, Mikaela.
Richard Harrison stars as
Ricardo 'Gringo' Martinez.

RICHARD HERD

1994: *The Adventures of Brisco*

County, Jr.
"High Treason"
(Fox/Warner Bros. Television)
Directed by Joseph Scanlon;
written by Jeffrey Boam, Carlton Cuse, John Wirth.
Starring Bruce Campbell,
Julius Carry, John Austin, Terry
Bradshaw.
Richard Herd as President
Cleveland.

*The Adventures of Brisco
County, Jr.*
"Bye Bly"
(Fox/Warner Bros. Television)
Directed by Kim Manners;
written by Jeffrey Boam,
Carlton Cuse.
Starring Bruce Campbell, Julius
Carry, Billy Drago, Melanie
Smith.
Richard Herd as President
Cleveland.

1993: *Dr. Quinn, Medicine
Woman*
"Where the Heart Is: Part II"
(CBS)
Directed by Chuck Bowman;
written by Beth Sullivan.
Starring Jane Seymour, Joe
Lando, Chad Allen.
Richard Herd as Dr. John
Hansen.

Dr. Quinn, Medicine Woman
"Where the Heart Is: Part I"
(CBS)
Directed by Chuck Bowman;
written by Beth Sullivan.
Starring Jane Seymour, Joe
Lando, Chad Allen.
Richard Herd as Dr. John
Hansen.

1978: *Kate Bliss and the Ticker
Tape Kid*
(ABC)
Directed by Burt Kennedy;
written by William Bowers,
John Rester Zodrow.
Starring Suzanne Pleshette,
Don Meredith, Tony Randall,
Harry Morgan.
Richard Herd as Donovan.

LOUIS HERTHUM

1984: *Louisiana*
(International Cinema)
Directed by Philippe de Broca;
written by Maurice Denuzière
(novels), Dominique Fabre,
Charles E. Israel, Etienne
Périer.
Starring Margot Kidder, Ian
Charleson, Andréa Ferréol.
Louis Herthum as Fellow
student.

1980: *Beulah Land*
"Part II"
(NBC/Columbia Pictures
Television)
Directed by Harry Falk, Virgil
W. Vogel; written by Lonnie
Coleman (novels), J. P. Miller.
Starring Lesley Ann Warren,
Michael Sarrazin, Eddie Albert,
Don Johnson, Paul Rudd.
Louis Herthum as Wounded
Rebel Soldier.

DARBY HINTON

2019: *Bill Tilghman and the
Outlaws*
(One-Eyed Horse Productions)
Directed by Wayne Shipley;
written by Dan Searles.
Starring Robert Carradine,
Johnny Crawford, Lana Wood,
Darby Hinton.
Darby Hinton stars as Cole
Younger.

2018: *Wild Faith*
(AMC 16 Burbank)
Directed by Jesse Low; written
by DJ Perry.
Starring Lana Wood, Darby
Hinton, Christine Marie.
Darby Hinton stars as Gerald.

2015: *Texas Rising*
(History Channel)
Directed by Roland Joffé;
written by Leslie Greif, Darrell
Fetty, George Nihil.
Starring Bill Paxton, Jeffrey
Dean Morgan, Oliver Martinez.
Darby Hinton as President
Burnet in 2 episodes.

1970: *Daniel Boone*
(20th Century Fox Television)
Directed by Nathan Juran, William Wiard, George Marshall,
others; written by Melvin Levy,
Don Ballauck, Jim Byrnes,
Melvin Levy, others.
Starring Fess Parker, Patricia
Blair, Darby Hinton, Albert
Salmi, Ed Ames.
Darby Hinton stars as Israel
Boone in 110 episodes.

1967: *The Big Valley*
"Boy Into Man"
(ABC/Four Star Productions)
Directed by Paul Henreid;
written by A. I. Bezzerides,
Louis F. Edelman.
Starring Richard Long, Peter
Breck, Lee Majors.
Darby Hinton as Chucky.

1964: *Wagon Train*
"The Ben Engel Story"
(ABC)
Directed by Joseph Pevney;
written by Betty Andrews.
Starring John McIntire, Robert
Fuller, Denny Miller.
Darby Hinton as Benjie Diel.

BO HOPKINS

2001: *Cowboy Up*
(Code Entertainment)
Directed by Xavier Koller;
written by James Redford.
Starring Kiefer Sutherland,
Marcus Thomas, Daryl
Hannah.
Bo Hopkins as Ray Drupp.

2000: *South of Heaven, West
of Hell*
(Goldmount Pictures)
Directed by Dwight Yoakam;
written by Dwight Yoakam,
Dennis Hackin, Otto Felix,
Bertheaud.
Starring Billy Bob Thornton,
Luke Askew, Dwight Yoakam.
Bo Hopkins as Doc Angus
Dunfries.

1996: *Shaughnessy*
(Allumination Filmworks)
Directed by Michael Ray
Rhodes; written by Louis L'Amour
(novel), William Blinn.
Starring Matthew Settle, Linda
Kozlowski, Tom Bower.
Bo Hopkins as Rip Bartlett.

1995: *Riders in the Storm*
(Filmopolis Pictures)
Directed by Charles Biggs;
written by Charles Biggs,
Frank Lee.
Starring Bo Hopkins, Kim Sill,
Michael Horse.
Bo Hopkins stars as Billy Van
Owen.

1994: *Cheyenne Warrior*
(Libra Pictures)
Directed by Mark Griffiths;
written by Michael B. Druxman.
Starring Kelly Preston, Bo
Hopkins, Dan Haggerty.
Bo Hopkins stars as jack
Andrews.

Wyatt Earp: Return to Tombstone
(CBS)
Directed by Paul Landres,
Frank McDonald.
Daniel B. Ullman, Rob Word.
Starring Hugh O'Brian, Bruce
Boxleitner, Paul Brinegar.
Bo Hopkins as Rattlesnake
Reynolds.

1993: *The Ballad of Little Jo*
(Fine Line Features)
Directed by Maggie Greenwald;
written by Maggie Greenwald.
Starring Suzy Amis, Bo Hopkins, Ian McKellen.
Bo Hopkins stars as Frank
Badger.

1990: *Big Bad John*
(BCI Eclipse)
Directed by Burt Kennedy;
written by Joseph Berry, Burt
Kennedy, C. B. Wismar.
Starring Jimmy Dean, Jack
Elam, Ned Beatty.
Bo Hopkins as Lester.

1986: *Houston: The Legend
of Texas*
(CBS)
Directed by Peter Levin;
written by Frank Q. Dobbs,
John Binder.
Starring Sam Elliott, Claudia
Christian, Devon Ericson.
Bo Hopkins as Col. Sidney
Sherman.

*Louis L'Amour's Down the
Long Hills*
(ABC)
Directed by Burt Kennedy;
written by Louis L'Amour (novel), Jon Povare, Ruth Povare.
Starring Bruce Boxleitner, Bo
Hopkins, Michael Wren.
Bo Hopkins stars as Jud.

1979: *The Last Ride of the
Dalton Gang*
(NBC)
Directed by Dan Curtis; written by Earl W. Wallace.
Starring Cliff Potts, Randy
Quaid, Larry Wilcox.
Bo Hopkins as Billy Doolin.

1976: *The Invasion of Johnson
County*
(NBC/Universal Television)
Directed by Jerry Jameson;
written by Nicholas E. Baehr.
Starring Bill Bixby, Bo Hopkins,
John Hillerman.
Bo Hopkins stars as George
Dunning.

1975: *Posse*
(Paramount)
Directed by Kirk Douglas;
written by William Roberts,
Christopher Knopf, Larry
Cohen.
Starring Kirk Douglas, Bruce
Dern, Bo Hopkins.
Bo Hopkins stars as Wesley.

1973: *The Man Who Loved Cat
Dancing*
(Metro-Goldwyn-Mayer)
Directed by Richard C.
Sarafian; written by Marilyn
Durham (novel), Eleanor Perry.
Starring Burt Reynolds, Sarah
Miles, Lee J. Cobb.
Bo Hopkins as Billy Bowen.

1972: *The Culpepper Cattle Co.*
(20th Century Fox)
Directed by Dick Richards;
written by Dick Richards, Eric
Bercovici, Gregory Prentiss.
Starring Gary Grimes, Billy
Green Bush, Luke Askew, Bo
Hopkins.
Bo Hopkins stars as Dixie
Brick.

1971: *Cat Ballou*
(NBC/Screen Gems)
Directed by Jerry Paris; written
by Aaron Ruben.
Starring Lesley Ann Warren,
Jack Elam, Tom Mardini.
Bo Hopkins as Clay.

1970: *Monte Walsh*
(National General)
Directed by William A. Fraker;
written by Lukas Heller, David
Zelag Goodman, Jack Schaefer.
Starring Lee Marvin, Jeanne
Moreau, Jack Palance.

Bo Hopkins as Jumpin' Joe Joslin.

Macho Callahan
(Embassy)
Directed by Bernard L. Kowalski; written by Richard Carr, Cliff Gould.
Starring David Janssen, Jean Seberg, Lee J. Cobb.
Bo Hopkins as Yancy.

1969: *Bonanza*
"The Witness"
(NBC)
Directed by Don Richardson; written by David Dortort, Joel Murcott.
Starring Lorne Greene, Dan Blocker, Michael Landon.
Bo Hopkins as Stretch Logan.

The Wild Bunch
(Warner Bros./Seven Arts)
Directed by Sam Peckinpah; written by Walon Green, Sam Peckinpah, Roy N. Sickner.
Starring William Holden, Ernest Borgnine, Robert Ryan, L. Q. Jones.
Bo Hopkins as Crazy Lee.

1968: *The Guns of Will Sonnett*
"Guilt"
(ABC)
Directed by Jean Yarbrough; written by Richard Carr, Henry Rosenbaum, Aaron Spelling.
Starring Walter Brennan, Dack Rambo, Bo Hopkins.
Bo Hopkins stars as Ben Merceen.

The Guns of Will Sonnett
"What's in a Name"
(ABC)
Directed by Jean Yarbrough; written by Richard Carr, Aaron Spelling.
Starring Walter Brennan, Dack Rambo, Edward Andrews.
Bo Hopkins as Wes Redford.

1967: *The Wild Wild West*
"The Night of the Iron Fist"
(CBS)
Directed by Marvin J. Chomsky; written by Michael Garrison, Ken Pettus.
Starring Robert Conrad, Ross Martin, Mark Lenard.
Bo Hopkins as Zack Garrison.

Gunsmoke
"Hard Luck Henry"
(CBS)
Directed by John Rich; written by Warren Douglas.
Starring James Arness, Milburn Stone, Amanda Blake.
Bo Hopkins as Harper Haggen.

The Virginian
"Johnny Moon"
(NBC/Universal Television)
Directed by Abner Biberman; written by Owen Wister (novel), Stanford Whitmore.
Starring Charles Bickford, Doug McClure, Clu Gulager.
Bo Hopkins as Will.

Directed by Walter Hill; Peter Dexter, Thomas Babe, Walter Hill.
Starring Jeff Bridges, Ellen Barkin, John Hurt, Bruce Dern.
John Dennis Johnston as Ed Plummer.

Legend
"Fall of a Legend"
(Paramount Television)
Directed by Michael Vejar; written by Michael Piller, Bill Dial, Ron Friedman, Bob Shayne, John Considine.
Starring Richard Dean Anderson, John d Lancie, Mark Adair-Rios.
John Dennis Johnston as Dan Rusch.

In Pursuit of Honor
(HBO)
Directed by Ken Olin; written by Dennis Lynton Clark.
Starring Don Johnson, Craig Sheffer, Gabrielle Anwar.
John Dennis Johnston as Sgt. Thomas Mulcahey.

1994: *Wagons East*
(Carolco/Tri Star)
Directed by Peter Markle; written by Matthew Carlson, Jerry Abraham.
Starring John Candy, Ellen Greene, Richard Lewis, Ed Lauter.
John Dennis Johnston as A Cattle Rustler.

Wyatt Earp
(Warner Bros.)
Directed by Lawrence Kasdan; written by Dan Gordan, Lawrence Kasdan.
Starring Kevin Costner, Dennis Quaid, Gene Hackman, Martin Kove, Tom Sizemore.
John Dennis Johnston as Frank Stillwell.

1993: *Ned Dressing: The Story of My Life and Times*
"The Smink Brothers"
(CBS)
Directed by Dan Lerner; written by William D. Wittliff.
Starring Brad Johnson, Luis Avalos, Brenda Bakke.
John Dennis Johnston as unnamed character.

1991: *Miracle in the Wilderness*
(TNT)
Directed by Kevin James Dobson; written by Paul Gallico (novel), Michael Michaelian, Jim Byrnes.
Starring Kris Kristofferson, Kim Cattrall, John Dennis Johnston.
John Dennis Johnston stars as Sgt. Sam Webster.

1988: *Long Arm*
(ABC/Universal Television)
Directed by Virgil W. Vogel; written by David Cisholm, Tabor Evans (novels).
Starring Daphne Ashbrook, Rene Auberjonois, Diedrich Bader, Lee de Broux.
John Dennis Johnston as Outlaw.

1985: *Pale Rider*
(Warner Bros.)
Directed by Clint Eastwood; written by Michael Butler, Dennus Shryack.
Starring Clint Eastwood, Michael Moriarty, Carrie Snodgress, Chris Penn, John Russell.
John Dennis Johnston as Deputy Tucker.

1982: *The Blue and the Gray*
"Part 3"
(CBS/Columbia Pictures Television)
Directed by Andrew V. McLaglen; written by John Leekley,

Bruce Catton.
Starring Stacy Keach, John Hammond, Julia Duffy, Warren Oates, Colleen Dewhurst.
John Dennis Johnston as Lt. Hardy.

Bret Maverick
"The Hidalgo Thing"
(NBC/Warner Bros. Television)
Directed by Thomas Carr; written by Gordon T. Dawson.
Starring James Garner, Ed Bruce, Ramon Bieri, Darleen Carr, Dub Taylor.
John Dennis Johnston as Burt Full Moon.

Little House on the Prairie
"He Was Only Twelve: Part I"
(NBC)
Directed by Michael Landon; written by Blanche Hanalis, Laura Ingalls, Paul W. Cooper.
Starring Michael Landon, Karen Grassle, Melissa Gilbert, Jason Bateman.
John Dennis Johnston as Lawrence.

Best of the West
"Tillman Held for Ransom"
(ABC/Paramount Television)
Directed by Howard Storm; written by Earl Pomerantz.
Starring Joel Higgens, Carlene Watkins, Meeno Peluce, Tracey Walter, Tom Ewell.
John Dennis Johnston as Curtis.

L. Q. JONES

1999: *The Jack Bull*
(HBO/New Crime Productions/River One Films)
Directed by John Badham; written by Heinrich von Kleist (book), Dick Cusack.
Starring John Cusack, John Goodman, L. Q. Jones.
L. Q. Jones starred as Henry Ballard.

1998: *The Mask of Zorro*
(TriStar Pictures)
Directed by Martin Campbell; written by Johnston McCulley, Ted Elliott, Terry Rossio, Randall Jahnson, John Eskow.
Starring Antonio Banderas, Anthony Hopkins, Catherine Zeta-Jones.
L. Q. Jones as Three-Fingered Jack

1994: *Lightning Jack*
(Savoy Pictures/Buena Vista International)
Directed by Simon Wincer; written by Paul Hogan.
Starring Paul Hohan, Cuba Gooding Jr., Beverly D'Angelo.
L. Q. Jones as Sheriff.

1988: *Red River*
(CBS/MGM/UA Television)
Directed by Richard Michaels; written by Borden Chase, Charles Schnee, Richard Fielder.
Starring Bruce Boxleitner, James Arness, Gregory Harrison.
L. Q. Jones as Sims.

1983: *Sacred Ground*
(Pacific International Enterprises)
Directed by Charles B. Pierce; written by Charles B. Pierce.
Starring Tim McIntire, L. Q. Jones, Jack Elam.
L. Q. Jones stars as Tolbert Coleman.

1980: *Wild Times*
(Rattlesnake Productions)
Starring Sam Elliott, Ben Johnson, Bruce Boxleitner.
L. Q. Jones as Wild Bill Hickok.

1979: *Buffalo Soldiers*
(NBC/MGM Television)
Directed by Vincent McEveety; written by Jim Byrnes.
Starring John Beck, Stan Shaw, Richard Lawson.
L. Q. Jones as Renegade.

The Sacketts
"Part II"
(NBC/Media Productions)
Directed by Robert Totten; written by Jim Byrnes, Louis L'Amour (novels).
Starring Sam Elliott, Tom Selleck, Jeff Osterhage.
L. Q. Jones as Belden.

The Sacketts
"Part I"
(NBC/Media Productions)
Directed by Robert Totten; written by Jim Byrnes, Louis L'Amour (novels).
Starring Sam Elliott, Tom Selleck, Jeff Osterhage.
L. Q. Jones as Belden.

How the West Was Won
(ABC/MGM Television)
Directed by Vincent McEveety; written by Calvin Clements Sr., John Mantley.
Starring James Arness, Fionnula Flanagan, Bruce Boxleitner.
L. Q. Jones as Batlin

1978: *Standing Tall*
(NBC/Quinn Martin Productions)
Directed by Harvey Hart; written by Franklin Thompson.
Starring Robert Forster, Will Sampson, L. Q. Jones.
L. Q. Jones starred as Nate Rackley.

1976: *Banjo Hackett: Roamin' Free*
(NBC/Columbia Pictures Television)
Directed by Andrew V. McLaglen; written by Ken Trevey.
Starring Don Meredith, Jeff Corey, Gloria DeHaven.
L. Q. Jones as Sheriff Tadlock.

1975: *Winterhawk*
(Howco International)
Directed by Charles B. Pierce; written by Charles B. Pierce, Earl E. Smith (narration written by).
Starring Leif Erickson, Woody Strode, Denver Pyle.
L. Q. Jones as Gates.

Kung Fu
"The Last Raid"
(ABC/Warner Bros. Television)
Directed by Alex Beaton; written by Ed Spielman, Herman Miller, John T. Dugan.
Starring David Carradine, Hal Williams, L. Q. Jones.
L. Q. stars as Major Clarke Bealson.

1974: *Mrs. Sundance*
(ABC/20th Century Fox Television)
Directed by Marvin J. Chomsky; written by Christopher Knopf.
Starring Elizabeth Montgomery, Robert Foxworth, L. Q. Jones.
L. Q. Jones starred as Charles Siringo.

1973: *Pat Garrett and Billy the Kid*
(Metro-Goldwyn-Mayer)
Directed by Sam Peckinpah; written by Rudolph Wurltizer.
Starring James Coburn, Kris Kristofferson, Jason Robards, Bob Dylan, Slim Pickens.
L. Q. Jones as Black Harris.

Kung Fu
"An Eye for an Eye"
(ABC/Warner Bros. Television)
Directed by Jerry Thorpe; writ-

ten by Ed Spielman, Herman Miller, John Furia.
Starring David Carradine, L. Q. Jones, Tim McIntire.
L. Q. Jones stars as Sgt. Straight.

1972: *The Bravos*
(ABC)
Directed by Ted Post; written by Christopher Knopf, David Victor, Douglas Benton, Ted Post (uncredited).
Starring George Peppard, Pernell Roberts, Belinda Montgomery.
L. Q. Jones as Ben Lawler.

Alias Smith and Jones
"McGuffin"
(ABC/MCA Television)
Directed by Alexander Singer; written by Glen A. Larson, Nicholas E. Baehr, Roy Huggins.
Starring Ben Murphy, Roger Davis, Darleen Carr.
L. Q. Jones as Peterson.

Gunsmoke
"Tara"
(CBS)
Directed by Bernard McEveety; written by William Kelly.
Starring James Arness, Milburn Stone, Amanda Blake.
L. Q. Jones as Gecko Ridley

1971: *The Hunting Party*
(United Artists)
Directed by Don Medford; written by Gilbert Ralston (as Gilbert Alexander), Lou Morheim, William W. Norton.
Starring Oliver Reed, Candice Bergen, Gene Hackman.
L. Q. Jones as Hog Warren.

Alias Smith and Jones
"Stagecoach Seven"
(ABC/MCA Television)
Directed by Richard Benedict; written by Glen A. Larson, Dick Nelson, Roy Huggins.
Starring Pete Duel, Ben Murphy, Keenan Wynn.
L. Q. Jones as Clint Weaver.

The Virginian
(NBC/Universal Television)
Created by Charles Marquis Warren.
Directed by Harry Harris, Don McDougall, others; written by Elroy Schwartz, others.
Starring Stewart Granger, Doug McClure, Lee Majors, Lee J. Cobb, Charles Bickford.
L. Q. Jones as Andy Belden in all 25 episodes.

1970: *The McMasters*
(Chevron Pictures)
Directed by Alf Kjellin; written by Harold Jacob Smith.
Starring Burl Ives, Brock Peters, David Carradine.
L. Q. Jones as Russel.

The Ballard of Cable Hogue
(Warner Bros.)
Directed by Sam Peckinpah; written by John Crawford, Edmund Penny.
Starring Jason Robards, Stella Stevens, David Warner.
L. Q. Jones as Taggart.

Gunsmoke
"The Gun"
(CBS)
Directed by Bernard McEveety; written by Donald S. Sanford.
Starring James Arness, Milburn Stone, Amanda Blake.
L. Q. Jones as Sumner Pendleton.

Gunsmoke
"Albert"
(CBS)
Directed by Vincent McEveety; written by Jim Byrnes.
Starring James Arness, Milburn

Stone, Amanda Blake.
L. Q. Jones as Joe Nix.

1969: *The Wild Bunch*
(United Artists)
Directed by Sam Peckinpah; written by Walon Green, Sam Peckinpah, Roy N, Sickner.
Starring William Holden, Ernest Borgnine, Robert Ryan.
L. Q. Jones as T. C.

Gunsmoke
"The Good Samaritans"
(CBS)
Directed by Bernard McEveety; written by Paul Savage.
Starring James Arness, Milburn Stone, Amanda Blake.
L. Q. Jones as Kittridge.

Lancer
"Blind Man's Bluff"
(CBS/20th Century Fox Television)
Directed by Leo Penn; written by Samuel Peeples, Carey Wilber.
Starring James Stacy, Wayne Maunder, Andrew Duggan.
L. Q. Jones as Slate Meek.

1968: *Stay Away, Joe*
(Metro-Goldwyn-Mayer)
Directed by Peter Tewksbury; written by Dan Cushman (novel), Michael A. Hoey.
Starring Elvis Presley, Burgess Meredith, Joan Blondell.
L. Q. Jones as Bronc Hoverty.

Hang 'Em High
(United Artists)
Directed by Ted Post; written by Leonard Freeman, Mel Goldberg.
Starring Clint Eastwood, Inger Stevens, Pat Hingle.
L. Q. Jones as Loomis.

The Big Valley
"Fall of a Hero"
(ABC/Four Star Productions)
Directed by Virgil W. Vogel; written by A. I. Bezzerides, Louis F. Edelman, David Moessinger.
Starring Richard Long, Peter Breck, Lee Majors.
L. Q. Jones as Gus Vandiver.

1967: *The Big Valley*
"Ambush"
(ABC/Four Star Productions)
Directed by Virgil W. Vogel; written by Margaret Armen, A. I. Bezzerides, Louis F. Edelman.
Starring Richard Long, Peter Breck, Lee Majors.
L. Q. Jones as Hutch.

The Big Valley
"Showdown in Limbo"
(ABC/Four Star Productions)
Directed by Bernard McEveety; written by Ken Pettus, Phillip Mishkin, A. I. Bezzerides, Louis F. Edelman.
Starring Richard Long, Peter Breck, Lee Majors.
L. Q. Jones as Earl Vaughn.

The Big Valley
"Court Martial"
(ABC/Four Star Productions)
Directed by Virgil W. Vogel; written by Steven W. Carabatsos, A. I. Bezzerides, Louis F. Edelman.
Starring Richard Long, Peter Breck, Lee Majors.
L. Q. Jones as Curtis.

Hondo
"Hondo and the Death Drive"
(ABC)
Directed by William Witney, written by Andrew J. Fenady, Peter Germano, James Edward Grant, Louis L'Amour.
Starring Ralph Taeger, Kathie Browne, Noah Beery Jr.
L. Q. Jones as Allie.

Cimarron Strip
"The Search"
(CBS)
Directed by Bernard McEveety; written by Christopher Knopf, William Wood, Herman Miller, William Wood.
Starring Stuart Whitman, Percy Herbert, Randy Boone.
L. Q. Jones as Lummy.

Cimarron Strip
"The Battleground"
(CBS)
Directed by Don Medford; written by Christopher Knopf.
Starring Stuart Whitman, Percy Herbert, Randy Boone.
L. Q. Jones as Barnes.

1966: *Noon Wine*
(ABC)
Directed by Sam Peckinpah; written by Katherine Anne Porter (novel), Sam Peckinpah.
Starring Jason Robards, Olivia de Havilland, Theodore Bikel.
L. Q. Jones as Deputy.

The Big Valley
"By Force and Violence"
(ABC/Four Star Productions)
Directed by Virgil W. Vogel; written by Peter Packer, A. I. Bezzerides, Louis F. Edelman.
Starring Richard Long, Peter Breck, Lee Majors.
L. Q. Jones as Cort.

Pistols 'n' Petticoats
"Sir Richard of Wretched"
(CBS/Universal Television)
Directed by Joseph Pevney; written by George Tibbles.
Starring Ann Sheridan, Ruth McDevitt, Douglas Fowley.
L. Q. Jones as 1st Gunman.

A Man Called Shenandoah
"Rope's End"
(ABC/MGM Television)
Directed by Virgil W. Vogel; written by E. Jack Neuman, Daniel B. Ullman.
Starring Robert Horton, Susan Oliver, Michael Ansara.
L. Q. as Ben Lloyd.

1965: *Major Dundee*
(Columbia)
Directed by Sam Peckinpah; written by Harry Julian Fink, Oscar Saul, Sam Peckinpah.
Starring Charlton Heston, Richard Harris, Jim Hutton.
L. Q. as Arthur Hadley.

Gunsmoke
"Dry Road to Nowhere"
(CBS)
Directed by Vincent McEveety; written by Harry Kroman.
Starring James Arness, Milburn Stone, Amanda Blake.
L. Q. Jones as Wally.

Rawhide
"Clash at Broken Bluff"
(CBS)
Directed by Charles F. Haas; written by Louis Vittes.
Starring Clint Eastwood, Paul Brinegar, Steve Raines.
L. Q. Jones as Pee Jay.

Rawhide
"Six Weeks to Bent Fork"
(CBS)
Directed by Thomas Carr; written by Mort R. Lewis.
Starring Clint Eastwood, Paul Brinegar, Steve Raines.
L. Q. Jones as Pee Jay Peters.

Branded
"Rules of the Game"
(NBC)
Directed by Lawrence Dobkin; written by Larry Cohen.
Starring Chuck Connors, Jeanne Cooper, Brad Weston.
L. Q. Jones as Miles.

1964: *Apache Rifles*
(20th Century Fox)
Directed by William H. Witney; written by Charles B. Smith, Kenneth Garnet, Richard Schayer.
Starring Audie Murphy, Michael Dante, Linda Lawson.
L. Q. Jones as Mike Greer.

Gunsmoke
"Chicken"
(CBS)
Directed by Andrew V. McLaglen; written by John Meston.
Starring James Arness, Milburn Stone, Amanda Blake.
L. Q. Jones as Jim Brady.

Rawhide
"The Race"
(CBS)
Directed by Bernard McEveety; written by Robert Lewin.
Starring Eric Fleming, Clint Eastwood, Paul Brinegar.
L. Q. Jones as Luke.

Rawhide
"Incident at Gila Flats"
(CBS)
Directed by Thomas Carr; written by Paul King, Samuel Roeca.
Starring Eric Fleming, Clint Eastwood, Paul Brinegar.
L. Q. Jones as Cpl. Wayne.

The Devil's Bedroom
(Allied Artists)
Directed by L. Q. Jones (as Justus McQueen); written by Claude Hall, Morgan Woodward.
Starring John Lupton, Valerie Allen, Dickie Jones.
L. Q. Jones as Justus McQueen.

Wagon Train
"The Duncan McIvor Story"
(ABC)
Directed by Herschel Daugherty; written by Norman Jolley.
Starring Robert Fuller, John McIntire, Frank McGrath.
L. Q. Jones as Pvt. James Jones.

1963: *Showdown*
(Universal)
Directed by R. G. Springsteen; written by Ric Hardman (as Bronson Howitzer).
Starring Audie Murphy, Kathleen Crowley, Charles Drake.
L. Q. Jones as Foray.

Gunsmoke
"Tobe"
(CBS)
Directed by John English; written by Paul Savage.
Starring James Arness, Dennis Weaver, Milburn Stone.
L. Q. Jones as Skinner.

Rawhide
"Incident at El Crucero"
(CBS)
Directed by Earl Bellamy; written by Charles Larson.
Starring Eric Fleming, Clint Eastwood, Paul Brinegar.
L. Q. Jones as George Cornelius.

Wagon Train
"The Robert Harrison Clarke Story"
(ABC)
Directed by William Witney; written by Gene L. Coon.
Starring John McIntire, Robert Fuller, Denny Miller.
L. Q. Jones as Ike Truman.

Wagon Train
"Charlie Wooster--Outlaw"
(ABC)
Directed by Virgil W. Vogel; written by Leonard Praskins.
Starring John McIntire, Frank McGrath, Terry Wilson.
L. Q. Jones as Esdras.

Empire
"The Convention"
(NBC)
Directed by Abner Biberman; written by Kathleen Hite.
Starring Robert Anderson, Rudy Bond, William Bramley.
L. Q. Jones as L. Q.

Showdown
(Universal)
Directed by R. G. Springsteen; written by Ric Hardman (as Bronson Howitzer).
Starring Audie Murphy, Kathleen Crowley, Charles, Drake.
L. Q. Jones as Foray.

Laramie
"The Stranger"
(NBC)
Directed by Jesse Hibbs; written by Donald S. Sanford.
Starring John Smith, Robert Fuller, Spring Byington.
L. Q. Jones as Sergeant.

Have Gun –Will Travel
"Debutante"
(CBS)
Directed by Gary Nelson; written by Gwen Bagni Gielgud, Herb Meadow, Sam Rolfe.
Starring Richard Boone, Wayne Rogers, Gale Garnett.
L. Q. Jones as Hector McAbee.

1962: *Ride the High Country*
(Metro-Goldwyn-Mayer)
Directed by Sam Peckinpah; written by N. B. Stone Jr.
Starring Joel McCrea, Randolph Scott, Mariette Hartley.
L. Q. Jones as Sylvus Hammond.

Laramie
"Shadow of the Past"
(NBC)
Directed by Herman Hoffman; written by David Lang, Daniel B. Ullman.
Starring John Smith, Robert Fuller, Spring Byington.
L. Q. Jones as Frank Keefer.

Laramie
"Among the Missing"
(NBC)
Directed by Joseph Kane; written by Rod Peterson.
Starring John Smith, Robert Fuller, Spring Byington.
L. Q. Jones as Neeley.

Laramie
"The Replacement"
(NBC)
Directed by Lesley Selander; written by Richard Newman.
Starring John Smith, Robert Fuller, Spring Byington.
L. Q. Jones as Johnny Duncan.

Have Gun –Will Travel
"The Waiting Room"
(CBS)
Directed by Richard Moder; written by Harry Julian Fink, Herb Meadow, Sam Rolfe.
Starring Richard Boone, James Griffith, L. Q. Jones.
L. Q. Jones stars as Bill Renn – Cowboy.

Have Gun –Will Travel
"Lazarus"
(CBS)
Directed by Albert Ruben; written by Jack Laird, Herb Meadow, Sam Rolfe.
Starring Richard Boone, Strother Martin, Dabbs Greer.
L. Q. Jones as Little Fontana.

Wide Country
"Straitjacket for an Indian"
(NBC/MCA Television)
Directed by John Florea; written by Alan Le May.
Starring Earl Holliman, Andrew Prine, Claude Akins.
L. Q. Jones as Whicker.

The Rifleman
"Day of Reckoning"
(ABC/Four Star Productions)
Directed by Lawrence Dobkin; written by Calvin Clements Sr.
Starring Chuck Connors, Johnny Crawford, Paul Fix.
L. Q. Jones as Charley Breen.

Lawman
"The Bride"
(ABC/Warner Bros. Television)
Directed by Richard C. Sarafian; written by Berne Giler, John Tomerlin.
Starring John Russell, Peter Brown, Peggie Castle.
L. Q. Jones as Ollie Earnshaw.

1961: *Wagon Train*
"The Christopher Hale Story"
(ABC)
Directed by Herschel Daugherty; written by Norman Jolley.
Starring Ward Bond, Robert Horton, John McIntire.
L. Q. Jones as Lenny.

Laramie
"Siege at Jubilee"
(NBC)
Directed by Lesley Selander; written by John C. Champion, Rod Peterson.
Starring John Smith, Robert Fuller, Spring Byington.
L. Q. Jones as Truk.

Laramie
"Cactus Lady"
(NBC)
Directed by Maurice Geraghty; written by Maurice Geraghty.
Starring John Smith, Robert Fuller, Arthur Hunnicutt.
L. Q. Jones as Homer.

Tales of Wells Fargo
"Defiant at the Gate"
(NBC)
Directed by R. G. Springsteen; written by Anthony Lawrence, Frank Gruber.
Starring Dale Robertson, Jack Ging, Tom Tully.
L. Q. Jones as Striker.

Death Valley Days
"Queen of Spades"
(Filmaster Productions)
Directed by Darren McGavin; written by Robert Sabaroff.
Starring Tom Drake, L. Q. Jones, Clarke Gordon.
L. Q. Jones stars as Billy Madson.

Two Faces West
"The Noose"
(Screen Gems)
Starring Charles Bateman, Joyce Meadows, Victor French.
L. Q. as unnamed character.

The Life and Legend of Wyatt Earp
"Casey and the Clowns"
(ABC)
Directed by Paul Landres; written by Frank L. Moss, Robert Schaefer, Wilda J. Wilson.
Starring Hugh O'Brian, Morgan Woodward, Stacy Harris.
L. Q. Jones as Tex.

1960: *Ten Who Dared*
(Walt Disney Productions)
Directed by William Beaudine; written by John Wesley Powell, Lawrence Edward Watkin.
Starring Brian Keith, John Beal, James Drury.
L. Q. Jones as Billy 'Missouri' Hawkins.

Cimarron
(Metro-Goldwyn-Mayer)
Directed by Anthony Mann, Charles Walters (uncredited); written by Arnold Schulman, Edna Ferber (novel).
Starring Glenn Ford, Maria Schell, Anne Baxter.
L. Q. Jones as Millis.

Flaming Star
(20th Century Fox)
Directed by Don Siegel; written by Clair Huffaker (novel), Nunnally Johnson.
Starring Elvis Presley, Barbara Eden, Steve Forrest.
L. Q. Jones as Tom Howard.

Laramie
"The Dark Trail"
(NBC)
Directed by Francis D. Lyon; written by Milton Geiger, Daniel B. Ullman.
Starring John Smith, Robert Fuller, Robert Vaughn.
L. Q. Jones as Betts.

Two Faces West
"The Last Man"
(Screen Gems)
Starring Charles Bateman, Joyce Meadows, Francis De Sales.
L. Q. as unnamed character.

The Yank
(Feneday-Kershner-Kowalski Production Co.)
Directed by Irvin Kershner; written by Andrew J. Fenady.
Starring James Drury, John Sutton, L. Q. Jones.
L. Q. Jones stars as Justin.

The Rebel
"Explosion"
(ABC)
Directed by Irvin Kershner; written by Nick Adams, Andrew J. Fenady, Frederick Louis Fox.
Starring Nick Adams, Douglas Spencer, Ross Elliott.
L. Q. Jones as Roy Shandell.

The Rebel
"The Earl of Durango"
(ABC)
Directed by Bernard L. Kowalski; written by Nick Adams, Andrew J. Fenady, Peggy O'Shea, Lou Shaw.
Starring Nick Adams, George Tobias, Jody Lawrance.
L. Q. Jones as Otis Rumph.

Klondike
"The Unexpected Candidate"
(NBC/United Artists Television)
Directed by Lawrence Dobkin; written by Monroe Manning.
Starring Ralph Taeger, James Coburn, Judson Pratt.
L. Q. Jones as Joe Teel.

Klondike
"Saints and Stickups"
(NBC/United Artists Television)
Directed by William Conrad; written by Richard Donovan, Fritz Goodwin.
Starring Ralph Taeger, James Coburn, Whit Bissell.
L. Q. Jones as Joe Teel.

Klondike
"River of Gold"
(NBC/United Artists Television)
Directed by Alvin Ganzer; written by Paul Savage, Pierre Berton.
Starring Ralph Taeger, James Coburn, Joi Lansing.
L. Q. Jones as Joe Teel.

Ten Who Dared
(NBC/Walt Disney Productions)
Directed by William Beaudine; written by Major John Wesley Powell, Lawrence Edward Watkin.
Starring Brian Keith, John Beal, James Drury.
L. Q. Jones as Billy 'Missouri' Hawkins.

Johnny Ringo
"Four Came Quietly"

(CBS/Four Star Productions)
Directed by R. G. Springsteen; written by Frederick Louis Fox.
Starring Don Durant, Karen Sharpe, Mark Goddard.
L. Q. Jones as Billy Boy Jethro.

1959: *Wagon Train*
"The Old Man Charvanaugh Story"
(ABC)
Directed by Virgil W. Vogel; written by Arthur Browne Jr.
Starring Ward Bond, Robert Horton, J. Carrol Naish.
L. Q. Jones as Squirrel Charvanaugh.

Laramie
"Dark Verdict"
(NBC)
Directed by Herschel Daugherty; written by Lee Erwin, Donn Mullally.
Starring John Smith, Hoagy Carmichael, Robert Crawford Jr.
L. Q. Jones as John MacLean.

Tales of Wells Fargo
"The Cleanup"
(NBC)
Directed by Earl Bellamy; written by Martin Berkeley, Clark Reynolds.
Starring Dale Robertson, James Bell, Julie Van Zandt.
L. Q. Jones as Wes.

Wichita Town
"Drifting"
(NBC/Four Star Productions)
Directed by Jerry Hopper; written by Frank Davis.
Starring Joel McCrea, Jody McCrea, Robert Anderson.
L. Q. Jones as Walter.

Black Saddle
"Client: Banks"
(NBC/Four Star Productions)
Directed by John English; written by Antony Ellis, Hal Hudson, John McGreevey.
Starring Peter Breck, Russell Johnson, Anna-Lisa.
L. Q. Jones as Jack Shepherd.

1958: *Buchanan Rides Alone*
(Columbia)
Directed by Budd Boetticher; written by Charles Lang, Jonas Ward (novel).
Starring Randolph Scott, Craig Stevens, Barry Keller.
L. Q. Jones as Pecos Hill.

Jefferson Drum
"The Keeney Gang"
(NBC)
Starring Jeff Richards, Eugene Mazzola, Cyril Deleyanti.
L. Q. Jones as Burdette.

1957: *Gunsight Ridge*
(United Artists)
Directed by Francis D. Lyon; written by Talbot Jennings, Elizabeth Jennings.
Starring Joel McCrea, Mark Stevens, Joan Weldon.
L. Q. Jones as Lazy Heart Ranch Hand.

Annie Oakley
"Dilemma at Diablo"
(VCI Entertainment)
Directed by George Archainbaud; written by Polly James.
Starring Gail Davis, Jimmy Hawkins, Brad Johnson.
L. Q. Jones as Ned Blane.

1956: *Annie Oakley*
"The Robin Hood Kid"
(VCI Entertainment)
Directed by George Archainbaud; written by Robert Schaefer, Eric Freiwald.
Starring Gail Davis, Jimmy Hawkins, Brad Johnson.
L. Q. Jones as Cal Upton.

1955: *Cheyenne*
"Border Showdown"
(ABC/Warner Bros. Television)
Directed by Richard L. Bare; written by Clarke E. Reynolds, Dean Riesner.
Starring Clint Walker, Adele Mara, L. Q. Jones.
L. Q. Jones stars as Smitty.

Cheyenne
"Julesburg"
(ABC/Warner Bros. Television)
Directed by Richard L. Bare; written by Charles Lang.
Starring Clint Walker, L. Q. Jones, Adelle August.
L. Q. Jones stars as Smitty.

Cheyenne
"Mountain Fortress"
(ABC/Warner Bros. Television)
Directed by Richard L. Bare; written by Don Martin, Alan Le May, Winston Miller.
Starring Clint Walker, L. Q. Jones, Ann Robinson.
L. Q. Jones stars as Smitty Smith.

TERRY KISER

1998: *Divorce: A Contemporary Western*
Directed by Eb Lottimer; written by Eb Lottimer.
Starring Elias Koteas, Christopher McDonald, Terry Kiser.
Terry Kiser stars as Gary.

1979: *The Last Ride of the Dalton Gang*
(NBC)
Directed by Dan Curtis; written by Earl W. Wallace.
Starring Cliff Potts, Randy Quaid, Larry Wilcox, Bo Hopkins, R. G. Armstrong.
Terry Kiser as Nafius.

JEFF KOBER

2008: *Aces 'N' Eights*
(Genius Entertainment)
Directed by Craig R. Baxley; written by Ronald M. Cohen, Dennis Shryack.
Starring Casper Van Dien, Bruce Boxleitner, Ernest Borgnine.
Jeff Kober as Tate.

2005: *Love's Long Journey*
(The Hallmark Channel)
Directed by Michael Landon Jr.; written by Douglas Lloyd McIntosh, Michael Landon Jr., Cindy Kelly, Janette Oke.
Starring Erin Cottrell, Logan Bartholomew, William Morgan Sheppard.
Jeff Kober as Mason.

2004: *Hidalgo*
(Buena Vista)
Directed by Joe Johnston; written by John Fusco.
Starring Viggo Mortensen, Omar Sharif, Zuleikha Robinson.
Jeff Kober as Sergeant at Wounded Knee.

2003 *Peacemakers*
"Dead to Rights"
(USA Network)
Created by Rick Ramage, Larry Carroll; written by Rick Ramage.
Starring Tom Berenger, Peter O'Meara, Amy Carlson.
Jeff Kober as major Hansen.

1998: *The Magnificent Seven*
"Safecracker"
(CBS/MGM Television)
Directed by T. J. Scott; written by Rick Husky, John Watson, Pen Densham.
Starring Michael Biehn, Eric Close, Andrew Kavovit.
Jeff Kober as Morgan Coltrane.

1996: *The Lazarus Man*
"The Hold-Up"
(Castle Rock Entertainment)
Directed by John Binder; written by John Binder, Joshua Winfield Binder.
Starring Robert Urich, Ivan Brutsche, Elpidia Carrillo.
Jeff Kober as unnamed character.

1992: *Ned Blessing: The True Story of My Life*
(CBS)
Directed by Peter Werner; written by William D. Wittliff.
Starring Daniel Baldwin, Luis Avalos, Chris Cooper.
Jeff Kober as Tors Buckner.

PAUL KOSLO

1991: *Conagher*
(TNT/Imagine Entertainment)
Directed by Reynaldo Villalobos; written by Louis L'Amour (novel), Jeffrey M. Meyer, Sam Elliott, Katharine Ross.
Starring Sam Elliott, Katharine Ross, Barry Corbin.
Paul Koslo as Kiowa Staples.

1985: *Wildside*
"The Crimea of the Century"
(ABC/Buena Vista Television)
Directed by Richard C. Sarafian; written by Steve Johnson, William Whitehead.
Starring Howard E. Rollins Jr., William Smith, J. Eddie Peck.
Paul Koslo as Sven Johnson.

1983: *Kenny Rogers as The Gambler: The Adventure Continues*
(CBS)
Directed by Dick Lowry; written by Jim Byrnes, Don Schlitz, Cort Casady.
Starry Kenny Rogers, Bruce Boxleitner, Linda Evans, Johnny Crawford.
Paul Koslo as Holt.

1982: *Bret Maverick*
"A Night at Red Ox"
(NBC/Warner Bros. Television)
Directed by William Wiard; written by Gordon T. Dawson, Lee David Zlotoff.
Starring James Garner, Ed Bruce, Ramon Bieri.
Paul Koslo as Fletcher Mayberry.

1980: *Heaven's Gate*
(United Artists)
Directed by Michael Cimino; written by Michael Cimino.
Starring Kris Kristofferson, Christopher Walken, John Hurt, Jeff Bridges, Eric Roberts.
Paul Koslo as Mayor Charlie Lezak.

1979: *The Sacketts*
(NBC)
"Part II, Part I"
Directed by Robert Totten; written by Louis L'Amour (novels), Jim Byrnes.
Starring Sam Elliott, Tom Selleck, Jeff Osterhage.
Paul Koslo as Kid Newton.

How the West Was Won
"The Enemy"
(ABC/MGM Television)
Directed by Gunnar Hellström; written by Ron Bishop, Steve Hayes.
Starring James Arness, Fionnula Flanagan, Bruce Boxleitner, Denver Pyle.
Paul Koslo as Jobe.

1975: *Rooster Cogburn*
(Universal)
Directed by Stuart Millar; written by Charles Portis, Martha Hyer (as Martin Julien).
Starring John Wayne, Katharine Hepburn, Anthony Zerbe, Richard Jordan.
Paul Koslo as Luke.

1974: *Gunsmoke*
"In Performance of Duty"
(CBS)
Directed by Gunnar Hellström; written by William Keys.
Starring Milburn Stone, Ken Curtis, Buck Taylor.
Paul Koslo as Cory.

1972: *The Daughters of Joshua Cabe*
(ABC)
Directed by Philip Leacock; written by Paul Savage.
Starring Buddy Ebsen, Karen Valentine, Lesley Ann Warren.
Paul Koslo as Deke Wetherall.

Joe Kidd
(Universal)
Directed by John Sturges; written by Elmore Leonard.
Starring Clint Eastwood, Robert Duvall, John Saxon, Don Stroud.
Paul Koslo as Roy.

1971: *Scandalous John*
(Buena Vista)
Directed by Robert Butler; written by Bill Walsh, Don DaGradi, Richard Gardner.
Starring Brian Keith, Alfonso Arau, Michele Carey, Bruce Glover, John Ritter.
Paul Koslo as Pipes.

MARTIN KOVE

2018: *3 Tickets to Paradise*
(Comstock Movie Studios)
Directed by Dominic López, Issac Piche; written by James Clark, William Robert Daniels, Isaac Piche.
Starring Aaron Johnson Araza, David Barr, Joe Bell.
Martin Kove as Felix.

2016: *Six Gun Savior*
(Eagle Films)
Directed by Kirk Murray; written by Kirk Murray, Frank Zanca, Loraine Ziff.
Starring Eric Roberts, Martin Kove, Matthew Ziff.
Martin Kove stars as The Mentor.

Traded
(Cinedigm Entertainment Group)
Directed by Timothy Woodward Jr.; written by Mark Esslinger.
Starring Kris Kristofferson, Trace Adkins, Michael Paré.
Martin Kove as Cavendish.

Wild Bill Hickok: Swift Justice
Directed by Dan Garcia.
Starring Mike Mayhall, Leticia Jimenez, Matthew Ziff, Lee Majors.
Martin Kove as Rayord.

2014: *Falcon Song*
(Gravitas Ventures)
Directed by Jason Corgan Brown; written by Jason Corgan Brown, Michelle Poteet Lisanti.
Starring Rainey Qualley, Gabriel Sunday, Martin Kove.
Martin Kove stars as Caspian.

2013: *Our Wild Hearts*
(Old Post Films)
Directed by Ricky Schroder; written by Ricky Schroder, Andrea Schroder.
Starring Eloise DeJoria, Veronica Dunne, Martin Kove.
Martin Kove stars as Grizz.

2007: *The Dead Sleep Easy*
(Odessa Filmworks)
Directed by Lee Demarbre; written by Ian Driscoll.
Starring Vampiro, Anna Sidel, Martin Kove.
Martin Kove stars as Bob Depugh.

2005: *Miracle at Sage Creek*
(American World)
Directed by James Intveld;
written by Thadd Turner.
Starring David Carradine, Wes
Studi, Michael Parks.
Martin Kove as Jess.

2003: *Hard Ground*
(Hallmark Entertainment)
Directed by Frank Q. Dobbs;
written by Frank Q. Dobbs,
David S. Cass Sr.
Starring Burt Reynolds, Bruce
Dern, Amy Jo Johnson.
Martin Kove stars as Floyd.

1994: *Gambler V: Playing for
Keeps*
(CBS)
Directed by Jack Bender; writ-
ten by Jim Byrnes, Cort Casady,
Frank Q. Dobbs, David S. Cass
Sr., Kelly Junkerman, Caleb
Pirtle III, Don Schlitz.
Starring Kenny Rogers, Scott
Paulin, Brett Cullen.
Martin Kove as Black Jack.

*Wyatt Earp: Return to Tomb-
stone*
(CBS)
Directed by Paul Landres;
Frank McDonald; written by
Daniel B. Ullman, Rob Word.
Starring Hugh O'Brian, Bruce
Boxleitner, Paul Brinegar, Bo
Hopkins.
Martin Kove as Ed Ross.

Wyatt Earp
(Warner Bros.)
Directed by Lawrence Kas-
dan; written by Dan Gordon,
Lawrence Kasdan.
Starring Kevin Costner, Dennis
Quaid, Gene Hackman, Tom
Sizemore.
Martin Kove as Ed Ross.

1985: *Wildside*
"Don't Keep the Home Fires
Burning"
(Touchstone Television)
Directed by Harvey S. Laid-
man; written by Tom Greene,
William Whitehead.
Starring Howard E. Rollins Jr.,
William Smith, J. Eddie Peck.
Martin Kove as Lyle Rainwood.

1977: *The White Buffalo*
(United Artists)
Directed by J. Lee Thompson;
written by Richard Sale (novel).
Starring Charles Bronson, Jack
Warden, Will Sampson, Kim
Novak, Clint Walker.
Martin Kove as Jack McCall.

1974: *Gunsmoke*
"In Performance of Duty"
(CBS)
Directed by Gunnar Hellström;
written by William Keys.
Starring Milburn Stone, Ken
Curtis, Buck Taylor.
Martin Kove as Guthrie.

ART LAFLEUR

2007: *Shiloh Falls*
(Radio London Films)
Directed by Adrian Fulle;
written by Adrian Fulle, Art
LaFleur, Gregory Littman,
Roddy Mancuso.
Starring Esteban Powell, For-
rest Witt, Patrick Graves.
Art LaFleur as Sheriff.

1998: *The Magnificent Seven*
"Inmate 78"
(CBS/MGM Television)
Directed by Gregg Champion;
written by John Watson, Pen
Densham, Robert Franke.
Starring Michael Biehn, Eric
Close, Andrew Kavovit.
Art LaFleur as Warden.

1994: *Maverick*
(Warner Bros.)
Directed by Richard Donner;
written by Roy Huggins,
William Goldman.
Starring Mel Gibson, Jodie
Foster, James Garner, Paul L.
Smith, Denver Pyle.
Art LaFleur as Poker Player.

1992: *The Young Riders*
"Shadowmen"
(ABC/MGM Television)
Directed by James Brolin; writ-
ten by Ed Spielman, Charles
Grant Craig, Todd Robinson.
Starring Stephen Baldwin, Josh
Brolin, Don Franklin.
Art LaFleur as Mikham.

1982: *Bret Maverick*
"The Not So Magnificent Six"
(NBC/Warner Bros. Television)
Directed by Leo Penn; written
by Gordon T. Dawson,
Geoffrey Fischer, Shel Willens.
Starring James Garner, Ed
Bruce, Ramon Bieri.
Art LaFleur as Cockeye Pete
Shonsey.

1981: *Best of the West*
"Mail Order Bride"
(ABC/Paramount Television)
Directed by Doug Rogers;
written by earl Pomerantz.
Starring Joel Higgins, Carlene
Watkins, Meeno Peluce.
Art LaFleur as Dooley
Wainright.

RUTA LEE

1969: *The Guns of Will Sonnett*
"Trail's End"
(ABC)
Directed by Jean Yarbrough;
written by Richard Carr,
Kathleen Hite, Aaron Spell-
ing.
Starring Walter Brennan, Dack
Rambo, Morgan Woodward,
Ruta Lee.
Ruta Lee stars as Fan.

1967: *The Wild Wild West*
"The Night of the Gypsy Peril"
(CBS)
Directed by Alan Crosland Jr.;
written by Michael Garrison,
Ken Kolb.
Starring Robert Conrad, Ross
Martin, Ruta Lee.
Ruta Lee stars as Zoe Zagora.

1965: *The Wild Wild West*
"The Night of the Casual
Killer"
(CBS)
Directed by Don Taylor;
written by Michael Garrison,
Bob Barbash.
Starring Robert Conrad, Ross
Martin, John Dehner.
Ruta Lee as Laurie Morgan

1964: *The Virginian*
"The Girl from Yesterday"
(NBC)
Directed by John Florea; writ-
ten by Owen Wister (novel),
Mark Rodgers, Louis Vittes,
Charles Marquis Warren.
Starring Lee J. Cobb, Doug
McClure, Clu Gulager.
Ruta Lee as Jane Carlyle.

The Virginian
"The Long Quest"
(NBC)
Directed by Richard L. Bare;
written by Owen Wister
(novel), Cary Wilber.
Starring Lee J. Cobb, Doug
McClure, Gary Clarke.
Ruta Lee as Judith Holly.

Bullet for a Badman
(Universal)
Directed by R. G. Springsteen;
written by Marvin H. Albert
(novel), Mary Willingham,
Willard W. Willingham.
Starring Audie Murphy, Darren
McGavin, Ruta Lee, Skip
Homier.
Ruta Lee stars as Lottie.

The Travels of Jaimie McPheeters
"The Day of the Lame Duck"
(ABC/MGM Television)
Directed by Robert Altman;
written by Robert Lewis Taylor
(novel), Shimon Wincelberg.
Starring Dan O'Herlihy, Kurt
Russell, Charles Bronson, Mike
Mazurki.
Ruta Lee as Zoe Pigalle.

1963: *Temple Houston*
"Enough Rope"
(NBC/Warners Bros. Tele-
vision)
Directed by Irving J. Moore;
written by Robert Vincent
Wright.
Starring Jeffrey Hunter, Jack
Elam, James Chandler.
Ruta Lee as Lucy Tolliver.

Wagon Train
"The Bleecker Story"
(ABC)
Directed by William Witney;
written by Ted Sherdeman,
Jane Klove.
Starring John McIntire, Robert
Fuller, Frank McGrath.
Ruta Lee as Jenny Hynes.

The Gun Hawk
(Allied Artists)
Directed by Edward Ludwig;
written by Jo Heims, Richard
Bernstein, Max Steeber.
Starring Rory Calhoun, Rod
Cameron, Ruta Lee.
Ruta Lee as Marleen.

Rawhide
"Incident at Alkali Sink"
(CBS)
Directed by Don McDougall;
written by Thomas Thompson.
Starring Eric Fleming, Clint
Eastwood, Paul Brinegar.
Ruta Lee as Lorraine.

Bonanza
"A Woman Lost"
(NBC)
Directed by Don McDougall;
written by Frank Chase.
Starring Lorne Greene, Pernell
Roberts, Dan Blocker.
Ruta Lee as Rita Marlowe.

1962: *Rawhide*
"Incident of the Reluctant
Bride Groom"
(CBS)
Directed by Don McDougall;
written by Winston Miller.
Starring Eric Fleming, Clint
Eastwood, Paul Brinegar, Ed
Nelson.
Ruta Lee as Sheila Delancey.

Cheyenne
"Wanted for the Murder of
Cheyenne Bodie"
(ABC/Warner Bros. Television)
Directed by Paul Landres;
written by Richard Collins,
Joyce Fierro.
Starring Clint Walker, Ruta
Lee, Dick Foran.
Ruta Lee stars as Lenore
(Hanford) Walton.

Gunsmoke
"Jenny"
(CBS)
Directed by Andrew V. McLa-
glen; written by John Meston.
Starring James Arness, Milburn
Stone, Amanda Blake.
Ruta Lee as Jenny Glover.

Outlaws
"Farewell Performance"
(NBC)
Directed by John Florea; writ-
ten by William D. Gordon.
Starring Don Collier, Bruce
Yarnell, Myron McCormick.
Ruta Lee as Alice Healy.

1961: *Laramie*
"Siege at Jubilee"
(NBC)
Directed by Lesley Selander;

written by John C. Champion,
Rod Peterson.
Starring John Smith, Robert
Fuller, Spring Byington.
Ruta Lee as Opal Crane.

Stagecoach West
"The Marker"
(ABC/Four Star Productions)
Directed by Thomas Carr; writ-
ten by Mary M. Beauchamp.
Starring Wayne Rogers, Robert
Bray, Ruta Lee.
Ruta Lee stars as Jenny Forbes.

Stagecoach West
"Blind Man's Bluff"
(ABC/Four Star Productions)
Directed by Thomas Carr;
written by William Powell.
Starring Wayne Rogers, Rich-
ard Eyer, Robert Bray.
Ruta Lee as Della Bell.

1960: *Colt .45*
"Showdown at Goldtown"
(ABC/Warner Bros. Television)
Directed by Lee Sholem; writ-
ten by W. Hermanos, William
F. Leicester, Kenneth Perkins.
Starring Wayde Preston, Ruta
Lee, Robert Colbert.
Ruta Lee stars as Molly
Perkins.

Shotgun Slade
"Killer's Brand"
(MCA-TV)
Directed by Will Jason; written
by Cliff Gould, Frank Gruber,
Charles B. Smith.
Starring Scott Brady, Dean
Fredericks, Ruta Lee.
Ruta Lee stars as Lilly Cody.

The Rebel
"Grant of Land"
(ABC)
Directed by Bernard L. Kow-
alski; written by Nick Adams,
Frank Chase, Andrew J. Fenedy.
Starring Nick Adams, Paul
Richards, Ruta Lee.
Ruta Lee stars as Ellen Barton.

1959: *Wagon Train*
"The Kate Parker Story"
(ABC)
Directed by Tay Garnett;
written by Leonard Praskins,
Howard R. Evans.
Starring Ward Bond, Robert
Horton, Virginia Grey.
Ruta Lee as Evvie Finley.

Colt .45
"The Hothead"
(ABC/Warner Bros. Television)
Directed by Paul Guilfoyle;
written by Mack David, Milton
Raison, Dean Riesner.
Starring Wayde Preston, Troy
Donahue, Ruta Lee.
Ruta Lee stars as Dottie
Hampton.

The Man from Blackhawk
"The Legacy"
(ABC/Screen Gems)
Created by Frank Barton;
written by Frank Barton.
Starring Robert Rockwell, Ruta
Lee, Joe Di Reda.
Ruta Lee stars as Ginnie
Thompson.

Sugarfoot
"MacBrewster the Bold"
(ABC/Warner Bros. Television)
Directed by Leslie Goodwins;
written by Dean Riesner.
Starring Will Hutshins, Ruta
Lee, Robin Hughes.
Ruta Lee stars as Ann Harrison.

U. S. Marshal
"Ghost Town"
(National Telefilm Associates)
Directed by Sutton Roley;
written by Steve Fisher, Mort
Briskin.
Starring John Bromfield, James
Griffith, Dennis Patrick.
Ruta Lee as Ellen Wilson.

U. S. Marshal
"R.I.P."
(National Telefilm Associates)
Directed by Robert Altman;
written by Lee Berg, Mort
Briskin.
Starring John Bromfield, James
Griffith, Ruta Lee.
Ruta Lee as Clara Regan.

U. S. Marshal
"Gold is Where You Find It"
(National Telefilm Associates)
Directed by Paul Guilfoyle;
written by Gordon Gordon,
Mildred Gordon.
Starring John Bromfield, Ro-
dolfo Acosta, John Anderson.
Ruta Lee as Mona Blake.

Bat Masterson
"The Death of Bat Masterson"
(NBC)
Directed by Alan Crosland Jr.;
written by Richard O'Connor
(book), Don Brinkley.
Starring Gene Barry, Claude
Akins, Ruta Lee.
Ruta Lee stars as Nellie
Fontana.

Maverick
"Betrayal"
(ABC/Warner Bros. Television)
Directed by Leslie H. Mar-
tinson; written by Richard
Macaulay, Winston Miller,
James O'Hanlon.
Starring Jack Kelly, Pat Kelly,
Ruta Lee.
Ruta Lee as Laura Dillon.

The Restless Gun
"The Painted Beauty"
(NBC)
Directed by Justus Addiss;
written by Frank Burt, Halsey
Melone.
Starring John Payne, William
Hudson, Ruta Lee.
Ruta Lee stars as Lucy Collins.

Yancy Derringer
"Two of a Kind"
(CBS)
Directed by William F. Clax-
ton; written by Mary Loos,
Richard Sale.
Starring Jock Mahoney, Kevin
Hagen, X Brands.
Ruta Lee as Romilly Vale.

1958: *Gunsmoke*
"Carmen"
(CBS)
Directed by Ted Post; written
by John Meston.
Starring James Arness, Dennis
Weaver, Milburn Stone.
Ruta Lee as Jennie Lane.

Sugarfoot
"The Dead Hills"
(ABC/Warner Bros. Television)
Directed by Franklin Adreon;
written by Earl Baldwin, Paul
Gangelin, Louis L'Amour.
Starring Will Hutshins, Ruta
Lee, Veda Ann Borg.
Ruta Lee stars as Lucy Barron.

Maverick
"Plunder of Paradise"
(ABC/Warner Bros. Television)
Directed by Douglas Heyes;
written by Douglas Heyes.
Starring Jack Kelly, Ruta Lee,
Joan Weldon.
Ruta Lee stars as Dolly.

The Gray Ghost
"Contraband"
(Lindsley Parsons Picture
Corporation)
Written by Virgil Carrington
Jones (book).
Starring Tod Andrews, Phil
Chambers, Irving Bacon.
Ruta Lee as Mrs. Murray.

1957: *Maverick*
"Comstock Conspiracy"
(ABC/Warner Bros. Television)
Directed by Howard W. Koch;

written by Gene Levitt.
Starring James Garner, Ruta Lee, Werner Klemperer.
Ruta Lee stars as Ellen Borsdeen.

1955: *The Twinkle in God's Eye*
(Republic Pictures)
Directed by George Blair; written by P. J. Wolfson.
Starring Mickey Rooney, Coleen Gray, Hugh O'Brian.
Ruta Lee as Ruthie.

KEN LUCKEY

2018: *The Price of Death*
(High Octane)
Directed by Chip Baker; written by Chip Baker, Danny Garcia, Aaron Stielstra, Jose L. Villanueva.
Starring Javier Arnal, Chema Bascón, Nuria Beiro, Crispian Belfrage.
Ken Luckey as Kidd Coffin.

2016: *6 Bullets to Hell*
(MVD Entertainment Group)
Directed by Tanner Beard, Russell Quinn Cummings.
Written by Chip Baker, Tanner Beard, Russell Quinn Cummings, Danny Garcia, Jose L. Villanueva.
Starring Tanner Beard, Crispian Belfrage, Russell Quinn Cummings.
Ken Luckey as Joseph 'Two Gun Joe' Ross.

2011: *The Legend of Hell's Gate: An American Conspiracy*
(Phase 4 Films)
Directed by Tanner Beard; written by Tanner Beard.
Starring Eric Balfour, Lou Taylor Pucci, Henry Thomas.
Ken Luckey as Tyler Thompson.

BARBARA LUNA

1990: *The Young Riders*
"Then There Was One"
(ABC/MGM Television)
Directed by George Mendeluk; written by Ed Spielman, James L. Novack.
Starring Stephen Baldwin, Josh Brolin, Brett Cullen, Anthony Zerbe.
Barbara Luna as Dolores.

1975: *Kung Fu*
"A Lamb to the Slaughter"
(ABC/Warner Bros. Television)
Directed by Harry Harris; written by Ed Spielman, Herman Miller, Robert Specht, David Korn.
Starring David Carradine, Alejandro Rey, Joe Santos.
Barbara Luna as Isela.

1974: *The Hanged Man*
(ABC)
Directed by Michael Caffey; written by Andrew J, Fenady, Ken Trevey.
Starring Steve Forrest, Dean Jagger, Will Geer, Cameron Mitchell, Rafael Campos.
Barbara Luna as Soledad Villagas.

1973: *Gentle Savage*
(Redwine International Films)
Directed by Sean MacGregor; written by Jacar Lane Dancer, Sean MacGregor.
Starring William Smith, Gene Evans, Joe Flynn.
Barbara Luna as Gayle.

1971: *The Gatling Gun*
(Ellman Film Enterprises)
Directed by Robert Gordon; written by Joseph Van Winkle, Mark Hanna.
Starring Guy Stockwell, Robert Fuller, Barbara Luna, Woody Strode, Patrick Wayne.
Barbara Luna stars as Leona.

1970: *Lancer*
(CBS/20th Century Fox Television)
Directed by Robert Butler; written by Samuel A. Peeples, Samuel Roeca.
Starring James Stacy, Wayne Maunder, Andrew Duggan.
Barbara Luna as Anna Baral.

1968: *Firecreek*
(Warner Bros./Seven Arts)
Directed by Vincent McEveety; written by Calvin Clements Sr.
Starring James Stewart, Henry Fonda, Inger Stevens, Jack Elam, Gary Lockwood.
Barbara Luna as Meli.

The Big Valley
"Miranda"
(ABC/Four Star Productions)
Directed by Paul Henreid; written by A. I. Bezzerides, Louis F. Edelman, Ken Pettus.
Starring Barbara Stanwyck, Richard Long, Peter Breck, Lee Majors, Linda Evans.
Barbara Luna as Miranda.

1967: *The High Chaparral*
"The Firing Wall"
(NBC)
Directed by William Witney; written by Richard Sale, Thomas Thompson.
Starring Leif Erickson, Cameron Mitchell, Mark Slade, Henry Darrow.
Barbara Luna as Conchita.

Cimarron Strip
"The Legend of Jud Starr"
(CBS)
Directed by Vincent McEveety; written by Christopher Knopf, Richard Fielder.
Starring Stuart Whitman, Percy Herbert, Randy Boone.
Barbara Luna as Roseanne Todd.

Winchester 73
(NBC/Universal Television)
Directed by Herschel Daugherty; written by Richard Delong Adams, Borden Chase, Stephen Kandel, Stuart N. Lake, Robert L. Richards.
Starring Tom Tryon, John Saxon, Dan Duryea, Joan Blondell, John Dehner.
Barbara Luna as Meriden.

1966: *Laredo*
"Coup de Grace"
(NBC/Universal Television)
Directed by R. G. Springsteen; written by William Raynor, Myles Wilder.
Starring Neville Brand, Peter Brown, William Smith.
Barbara Luna as Carmella Alveras.

1965: *The Wild Wild West*
"The Night of the Deadly Bed"
(CBS)
Directed by William Witney; written by George Schenck, William Marks, Michael Garrison.
Starring Robert Conrad, Ross Martin, J. D. Cannon.
Barbara Luna as Gatita.

1963: *Wide Country*
"Farewell to Margarita"
(NBC)
Directed by Earl Bellamy; written by Mark Rodgers.
Starring Earl Holliman, Andrew Prine, Barbara Luna.
Barbara Luna stars as Margarita Diaz.

1962: *Gunsmoke*
"He Learned About Women"
(CBS)
Directed by Tay Garnett; written by John Meston, John Rosser.
Starring James Arness, Dennis Weaver, Milburn Stone, Amanda Blake, Claude Akins.

Barbara Luna as Chavela.

1961: *Gunslinger*
"The Death of Yellow Singer"
(CBS)
Starring Tony Young, Preston Foster, Charles H. Gray.
Barbara Luna as Elise.

Stagecoach West
"The Big Gun"
(ABC/Four Star Productions)
Directed by Don McDougall; written by N. B. Stone Jr.
Starring Wayne Rogers, Richard Eyer, Robert Bray.
Barbara Luna as Chiquita.

1960: *Death Valley Days*
"Pete Kitchen's Wedding Night"
(Flying A Productions)
Directed by Bud Townsend; written by Virgil C. Gerlach.
Starring Cameron Mitchell, Barbara Luna, Earl Hodgins.
Barbara Luna stars as Dona Rose.

Tales of Wells Fargo
"Vasquez"
(NBC)
Directed by Sidney Salkow; written by James Brooks, Frank Gruber, Gene Reynolds.
Starring Dale Robertson, Cesare Danova, Barbara Luna.
Barbara Luna stars as Rosita.

Overland Trail
"Mission into Mexico"
(NBC)
Directed by Tay Garnett; written by N. B. Stone Jr.
Starring William Bendix, Doug McClure, Robert Loggia.
Barbara Luna as Estrelita.

Bonanza
"El Toro Grande"
(NBC)
Directed by Christian Nyby; written by John Tucker Battle.
Starring Lorne Greene, Pernell Roberts, Dan Blocker.
Barbara Luna as Cayetena Losaro.

1959: *The Texan*
"The Reluctant Bridegroom"
(CBS/Desilu productions)
Starring Rory Calhoun, Rodolfo Acosta, Mario Alcalde.
Barbara Luna as unnamed character.

The Texan
"Showdown at Abileen"
(CBS/Desilu productions)
Directed by Eric C. Kenton; written by Samuel A. Peeples.
Starring Rory Calhoun, Michael Dante, Mario Alcalde.
Barbara Luna as Fawn.

1958: *Zorro*
(ABC/Buena Vista)
Created by Johnston McCulley
Starring Guy Williams, Gene Sheldon, Henry Calvin.
Barbara Luna as Theresa Modesto in 4 episodes.

Have Gun – Will Travel
"Silver Convoy"
(CBS)
Directed by Lamont Johnson; written by Ken Kolb, Herb Meadow, Sam Rolfe.
Starring Richard Boone, Nico Minardos, Barbara Luna.
Barbara Luna stars as Lupita – Peasant Girl.

KARL MALDEN

1971: *Wild Rovers*
(Metro-Goldwyn-Mayer)
Directed by Blake Edwards; written by Blake Edwards.
Starring William Holden, Ryan O'Neal, Karl Malden.
Karl Malden stars as Walter Buckman.

1968: *Blue*
(Paramount)
Directed by Silvio Narizzano, written by Ronald M. Cohen, Meade Roberts.
Starring Terence Stamp, Joanna Pettet, Karl Malden.
Karl Malden stars as Doc Morton.

1967: *The Adventures of Bullwhip Griffin*
(NBC/Buena Vista)
Directed by James Neilson; written by Lowell S. Hawley; Albert Sidney Fleischman.
Starring Roddy McDowell, Suzanne Pleshette, Karl Malden.
Karl Malden stars as Judge Higgins.

1966: *Nevada Smith*
(Paramount)
Directed by Henry Hathaway; written by Harold Robbins, John Michael Hayes.
Starring Steve McQueen, Karl Malden, Brian Keith.
Karl Malden stars as Tom Fitch.

1964: *Cheyenne Autumn*
(Warner Bros.)
Directed by John Ford; written by Mari Sandoz, James R. Webb.
Starring Richard Widmark, Carroll Baker, Karl Malden.
Karl Malden stars as Capt. Wessels.

1962: *How the West Was Won*
(Metro-Goldwyn-Mayer)
Directed by John Ford, Henry Hathaway, George Marshall, Richard Thorpe; written by James R. Webb.
Starring James Stewart, John Wayne, Gregory Peck, Carroll Baker, Henry Fonda, Lee J. Cobb, Karl Malden.
Karl Malden stars as Zebulon Prescott.

1961: *One-Eyed Jacks*
(Paramount)
Directed by Marlon Brando; written by Guy Trosper, Calder Willingham, Charles Neider.
Starring Marlon Brando, Karl Malden, Pina Pellicer.
Karl Malden stars as Sheriff Dad Longworth.

1959: *The Hanging Tree*
(Warner Bros.)
Directed by Delmer Daves; written by Wendell Mayes, Halsted Welles, Dorothy M. Johnson (novel).
Starring Gary Cooper, Maria Schell, Karl Malden.
Karl Malden stars as Frenchy Plante.

1950: *The Gunfighter*
(20th Century Fox)
Directed by Henry King; written by William Bowers, William Sellers, André De Toth.
Starring Gregory Peck, Helen Westcott, Millard Mitchell.
Karl Malden as Mac.

MONTE MARKHAM

1982: *Bret Maverick*
"The Vulture Also Rises"
(NBC/Warner Bros. Television)
Directed by Michael O'Herlihy; written by Gordon T. Dawson, Rogers Turrentine.
Starring James Garner, Ed Bruce, Ramon Bieri.
Monte Markham as Captain Dawkins.

1978: *Shame, Shame on the Bixby Boys*
(CBS)
Directed by Anthony Bowers; written by William Bowers.
Starring Twink Caplan, Robert Ayers, Don "Red" Barry.

Monte Markham as unnamed character.

1971: *Alias Smith and Jones*
"Something to Get Hung About"
(MCA Television)
Directed by Jack Arnold; written by Glen A. Larson, Nicholas E. Baehr, Roy Huggins.
Starring Pete Duel, Ben Murphy, Monte Markham.
Monte Markham stars as Jim Stokely.

1970: *The High Chaparral*
"Too Late the Epitaph"
(NBC)
Directed by James Neilson; written by Leif Erickson, Cameron Mitchell, Henry Darrow.
Monte Markham as Dave Redman.

The Virginian
"Gun Quest"
(NBC/Universal Television)
Directed by Harry Harris; written by Robert Van Scoyk.
Starring Stewart Granger, Doug McClure, Lee Majors.
Monte Markham as Boss Cooper.

1969: *Guns of the Magnificent Seven*
(United Artists)
Directed by Paul Wendkos, written by Herman Hoffman.
Starring George Kennedy, James Whitmore, Monte Markham.
Monte Markham stars as Keno.

1967: *Hour of the Gun*
(United Artists)
Directed by John Sturges; written by Edward Anhalt.
Starring James Garner, Jason Robards, Robert Ryan, Jon Voight.
Monte Markham as Sherman McMasters.

Iron Horse
"Death by Triangulation"
(ABC)
Directed by Otto Lang; written by Louis Vittes, James Goldstone, Stephen Kandel.
Starring Dale Robertson, Gary Collins, Robert Random.
Monte Markham as Dan Patrick.

DICK MILLER

1970: *The Andersonville Trial*
(PBS)
Directed by George C. Scott; written by Saul Levitt.
Starring Cameron Mitchell, William Shatner, Jack Cassidy.
Dick Miller as Sketch Artist.

1967: *A Time for Killing*
(Columbia)
Directed by Phil Karlson, Roger Corman (uncredited); written by Nelson Wolford (novel), Shirley Wolford (novel), Halsted Welles.
Starring Inger Stevens, Glenn Ford, Paul Petersen, George Hamilton.
Dick Miller as Zollicoffer.

1966: *Branded*
"Nice Day for a Hanging"
(NBC)
Directed by Allen Reisner; written by Frank Chase, Larry Cohen.
Starring Chuck Connors, Whitney Blake, Beau Bridges.
Dick Miller as Wrangler.

1964: *The Virginian*
"Big Image... Little Man"
(NBC)
Directed by William Witney; written by Frank Chase, Carey Wilber, Owen Wister.
Starring Lee J. Cobb, Doug Mc-

Clure, Clu Gulager, L. Q. Jones.
Dick Miller as Jon Blake.

Wagon Train
"The Brian Conlin Story"
(ABC)
Directed by Virgil W. Vogel;
written by Frank Chase.
Starring John McIntire, Robert
Fuller, Frank McGrath.
Dick Miller as Michael.

1963: *Gunsmoke*
"Carter Caper"
(CBS)
Directed by Jerry Hopper;
written by John Meston.
Starring James Arness, Dennis
Weaver, Milburn Stone.
Dick Miller as Townsman.

Bonanza
"A Woman Lost"
(NBC)
Directed by Don McDougall;
written by Frank Chase.
Starring Lorne Greene, Pernell
Roberts, Dan Blocker.
Dick Miller as Sam.

1956: *Gunslinger*
(American Releasing Corpo-
ration)
Directed by Roger Corman;
written by Charles B. Griffith,
Mark Hanna.
Starring John Ireland, Beverly
Garland, Allison Hayes.
Dick Miller as Jimmy Tonto.

The Oklahoma Woman
(American Releasing Corpo-
ration)
Directed by Roger Corman;
written by Lou Rusoff.
Starring Richard Denning,
Peggie Castle, Cathy Downs.
Dick Miller as Bartender.

1955: *Apache Woman*
(American Releasing Corpo-
ration)
Directed by Roger Corman;
written by Lou Rusoff.
Starring Lloyd Bridges, Joan
Taylor, Lance Fuller.
Dick Miller as Tall Tree.

CHRIS MULKEY

2019: *Medicine Man*
Directed by Guy Malim;
written by Simon Hung, Guy
Malim.
Starring James Le Gros, Liza
Weil, Nestor Carbonell.
Chris Mulkey as Sheriff Linton
Jones.

2006: *Broken Trail*
(American Movie Classics)
"Part Two"
Directed by Walter Hill; writ-
ten by Alan Geoffrion.
Starring Robert Duvall,
Thomas Haden Church, Greta
Scacchi, Chris Mulkey.
Chris Mulkey stars as Big Ears.

Broken Trail
(American Movie Classics)
"Part One"
Directed by Walter Hill; writ-
ten by Alan Geoffrion.
Starring Robert Duvall,
Thomas Haden Church, Greta
Scacchi, Chris Mulkey.
Chris Mulkey stars as Big Ears.

1980: *The Long Riders*
(United Artists)
Directed by Walter Hill;
written by Bill Bryden, Steven
Smith, Stacy Keach, James
Keach.
Starring David Carradine, Stacy
Keach, Dennis Quaid, Robert
Carradine.
Chris Mulkey as Vernon Biggs.

JAN MURRAY

1976: *Banjo Hackett: Roamin'
Free*

(NBC)
Directed by Andrew V. McLa-
glen; written by Ken Trevey.
Starring Don Meredith, Jeff
Corey, Gloria DeHaven, L. Q.
Jones, Chuck Connors.
Jan Murray as Jethro Swain.

1968: *Cowboy in Africa*
(ABC)
Created by Ivan Tors, Andy
White.
Directed by Alex March;
written by Gordon T, Dawson,
Ivan Tors, Andy White.
Starring Chuck Connors, Tom
Nardini, Ronald Howard.
Jan Murray as Trevor Wel-
lington in African Rodeo: Part
II, Part I.

1961: *Zane Grey Theater*
"The Empty Shell"
(CBS/Four Star Productions)
Directed by David Lowell Rich;
written by Paul Franklin, Bruce
Geller.
Starring Jan Murray, Jean
Hagen, Denver Pyle.
Jan Murray stars as Cletis
Madden.

LOUIS NYE

1963: *The Wheeler Dealers*
(Metro-Goldwyn-Mayer)
Directed by Arthur Hiller; writ-
ten by George J. W. Goodman
(novel), Ira Wallach.
Starring Lee Remick, James
Garner. Phil Harris, Phil Harris,
Chill Wills.
Louis Nye as Stanislas.

1961: *Guestward Ho!*
"The Beatniks"
(ABC/Desilu Productions)
Starring Joanne Dru, Flip Mark,
Mark Miller, J. Carrol Nash,
Louis Nye.
Louis Nye as King Cool.

HUGH O'BRIAN

1994: *Wyatt Earp: Return to
Tombstone*
(CBS)
Directed by Paul Landres,
Frank McDonald; written by
Daniel B. Ullman, Rob Word.
Starring Hugh O'Brian, Bruce
Boxleitner, Paul Brinegar, Bo
Hopkins, Martin Kove.
Hugh O'Brian stars as Wyatt
Earp.

1991: *The Gambler Returns: The
Luck of the Draw*
(NBC)
Directed by Dick Lowry; writ-
ten by Jim Byrnes, Cort Casady,
Kelly Junkerman, Jeb Rose-
brook, Joe Byrne, Don Schlitz.
Starring Kenny Rogers, Rick
Rossovich, Reba McEntire,
David Carradine, Johnny
Crawford, Chuck Connors,
Gene Barry.
Hugh O'Brian as Marshal
Wyatt Earp.

1990: *Gunsmoke: The Last
Apache*
(CBS)
Directed by Charles Correll;
written by Earl W. Wallace.
Starring James Arness, Richard
Kiley, Amy Stoch, Geoffrey
Lewis.
Hugh O'Brian as Gen. Nelson
Miles.

1989: *Guns of Paradise*
(CBS/Lorimar Television)
Created by David Jacobs,
Robert Porter.
Directed by Michael Lange;
written by David Jacobs, Robert
Porter, Joel J. Feigenbaum.
Starring Lee Horsley, Jenny
Beck, Matthew Newmark
Hugh O'Brian as Wyatt Earp
in "Home Again", "A Gathering
of Guns".

1976: *The Shootist*
(Paramount)
Directed by Don Siegel; written
by Glendon Swarthout (novel),
Miles Hood Swarthout, Scott
Hale.
Starring John Wayne, Lauren
Bacall, Ron Howard, James
Stewart, Richard Boone.
Hugh O'Brian as Pulford.

1970: *Wild Women*
(ABC)
Directed by Don Taylor;
written by Vincent Fotre
(novel), Richard Carr, Lou
Morheim.
Starring Hugh O'Brian, Anne
Francis, Marilyn Maxwell.
Hugh O'Brian stars as Killian.

1967: *Africa: Texas Style*
(Paramount)
Directed by Andrew Marton;
written by Andy White.
Starring Hugh O'Brian, John
Mills, Nigel Green.
Hugh O'Brian stars as Jim
Sinclair.

1962: *The Virginian*
"The Executioners"
(NBC)
Directed by David Friedkin;
written by Morton S. Fine, Da-
vid Friedkin, Charles Marquis
Warren, Owen Wister.
Starring Lee J. Cobb, Doug
McClure, Gary Clarke.
Hugh O'Brian as Paul Taylor.

1961-
1955 *The Life and Legend of
Wyatt Earp*
(ABC/Desilu Productions)
Directed by Paul Landres,
Frederick Hazlitt Brennan,
John Dunkel, others; written
by Frederick Hazlitt Brennan,
Paul Landres, Frank McDon-
ald, others.
Starring Hugh O'Brian, Doug-
las Fowley, James Seay, Mason
Alan Dinehart.
Hugh O'Brian stars in all 226
episodes.

1959: *Lawman*
"The Wayfarer"
(ABC/Warner Bros. Television)
Directed by Lee Sholem;
written by William F. Leicester,
Edmund Morris.
Starring Hugh O'Brian, John
Russell, Peter Brown.
Hugh O'Brian stars as Wyatt
Earp.

Alias Jesse James
(Paramount)
Directed by Norman Z.
McLeod; written by William
Bowers, Daniel Beauchamp,
Bert Lawrence.
Starring Bob Hope, Rhonda
Fleming, Wendell Corey, Gene
Autry, James Garner.
Hugh O'Brian as Marshal
Wyatt Earp.

1958: *The Fiend Who Walked
the West*
(20th Century Fox)
Directed by Gordon Douglas;
written by Harry Brown, Philip
Yordan, Ben Hecht, Charles
Lederer, Eleazar Lipsky.
Starring Hugh O'Brian, Robert
Evans, Dolores Michaels.
Hugh O'Brian stars as Daniel
Slade Hardy.

1956: *The Brass Legend*
(United Artists)
Directed by Gerd Oswald;
written by George Zuckerman,
Jess Arnold, Don Martin.
Starring Hugh O'Brian, Nancy
Gates, Raymond Burr.
Hugh O'Brian stars as Sheriff
Wade Addams.

1955: *The Twinkle in God's Eye*
(Republic)

Directed by George Blair;
written by P. J. Wolfson.
Starring Mickey Rooney,
Coleen Gray, Hugh O'Brian.
Hugh O'Brian stars as Marty
Callahan.

White Feather
(20th Century Fox)
Directed by Robert D. Webb;
written by Delmer Daves, Leo
Townsend, John Prebble.
Starring Robert Wagner, Jeffrey
Hunter, John Lund, Debra
Paget.
Hugh O'Brian as American
Horse.

1954: *Broken Lance*
(20th Century Fox)
Directed by Edward Dmytryk;
written by Richard Murphy,
Philip Yordan.
Starring Spencer Tracy,
Robert Wagner, Jean Peters,
Richard Widmark, Earl Hol-
liman.
Hugh O'Brian as Mike De-
vereaux.

Drums Across the River
(Universal)
Directed by Nathan Juran
Written by John K. Butler,
Lawrence Roman.
Starring Audie Murphy, Walter
Brennan, Lyle Bettger.
Hugh O'Brian as Morgan.

*Saskatchewan aka O'Rourke of
the Royal Mounted*
(Universal)
Directed by Raoul Walsh;
written by Gil Doud.
Starring Alan Ladd, Shelly
Winters, J. Carrol Naish.
Hugh O'Brian as Carl Smith.

Taza, Son of Cochise
(Universal)
Directed by Douglas Sirk;
written by George Zuckerman,
Gerald Drayson Adams.
Starring Rock Hudson, Barbara
Rush, Gregg Palmer.
Hugh O'Brian as Settler.

1953: *The Stand at Apache River*
(Universal)
Directed by Lee Sholem; writ-
ten by Arthur A. Ross, Robert J.
Hogan (novel).
Starring Stephen McNally, Julie
Adams, Hugh Marlowe.
Hugh O'Brian as Tom Kenyon.

Back to God's Country
(Universal)
Directed by Joseph Pevney;
written by James Curwood,
Tom Reed.
Starring Rock Hudson, Marcia
Henderson, Steve Cochran.
Hugh O'Brian as Frank
Hudson.

The Man from the Alamo
(Universal)
Directed by Budd Boetticher;
written by Steve Fisher, D. D.
Beauchamp, Niven Busch,
Oliver Crawford.
Starring Glenn Ford, Julie
Adams, Chill Wills.
Hugh O'Brian as Lt. Lamar.

Seminole
(Universal)
Directed by Budd Boetticher;
written by Charles K. Peck Jr.
Starring Rock Hudson, Barbara
Hale, Anthony Quinn.
Hugh O'Brian as Kajeck.

The Lawless Breed
(Universal)
Directed by Raoul Walsh;
written by John Wesley Hardin,
Bernard Gordon, William
Alland.
Starring Rock Hudson, Julie
Adams, Mary Castle.
Hugh O'Brian as Ike Hanley.

1952: *The Raiders*
(Universal)
Directed by Lesley Selander;
written by Polly James, Lillie
Hayward, Lyn Crost Kennedy.
Starring Richard Conte, Viveca
Lindfors, Barbara Britton.
Hugh O'Brian as Hank Purvis.

The Battle at Apache Pass
(Universal)
Directed by George Sherman;
written by Gerald Drayson
Adams.
Starring John Lund, Jeff Chan-
dler, Susan Cabot.
Hugh O'Brian as Lt. Robert
Harley.

The Cimarron Kid
(Universal)
Directed by Budd Boetticher;
written by Louis Stevens, Kay
Lenard.
Starring Audie Murphy,
Beverly Tyler, James Best, Noah
Berry, Jr.
Hugh O'Brian as Red Buck.

1951: *Cave of Outlaws*
(Universal)
Directed by William Castle;
written by Elizabeth Wilson.
Starring Macdonald Carey,
Alex Smith, Edgar Buchanan.
Hugh O'Brian as Garth.

Little Big Horn
(Lippert Pictures)
Directed by Charles Marquis
Warren; written by Harold
Shumate, Charles Marquis
Warren.
Starring Lloyd Bridges, John
Ireland, Marie Windsor.
Hugh O'Brian as Pvt. Al
DeWalt.

Buckaroo Sheriff of Texas
(Republic)
Directed by Philip Ford; writ-
ten by Arthur E. Orloff.
Starring Michael Chapin,
Eilene Janssen, James Bell.
Hugh O'Brian as Ted Gately.

Vengeance Valley
(Metro-Goldwyn-Mayer)
Directed by Richard Thorpe;
written by Irving Ravetch, Luke
Short (novel).
Starring Burt Lancaster, Robert
Walker, Joanne Dru.
Hugh O'Brian as Fasken.

1950: *The Return of Jesse James*
(Lippert Pictures)
Directed by Arthur Hilton;
written by Jack Natteford, Carl
K. Hittleman.
Starring John Ireland, Ann
Dvorak, Henry Hull.
Hugh O'Brian as Lem Younger.

Beyond the Purple Hills
(Columbia)
Directed by John English;
written by Norman S. Hall.
Starring Gene Autry, Champi-
on, Jo-Carroll Dennison.
Hugh O'Brian as Jack Beau-
mont.

MICHAEL PARÉ

2018: *Big Kill*
(Archstone Distribution)
Directed by Scott Martin;
written by Scott Martin.
Starring Jason Patric, Lou
Diamond Phillips, Christoph
Sanders.
Michael Paré as Col. Granger.

2018: *Dogwood Pass*
"Be all my sins remembered"
(Garnet Films)
Directed by Lana Read; written
by Brian Dobbins.
Starring Michael Paré, Michael
Herman, Richard Leo Hunt.
Michael Paré stars as Randall
Montgomery.

2016: *Traded*
(Status media & Entertainment)
Directed by Timothy Woodward Jr.; written by Mark Esslinger.
Starring Kris Kristofferson, Trace Adkins, Michael Paré. Michael Paré stars as Clay.

2015: *Bone Tomahawk*
(RLJ Entertainment)
Directed by S. Craig Zahler; written by S. Craig Zahler. Starring Kurt Russell, Patrick Wilson, Matthew Fox.
Michael Paré as Mr. Wallington.

2014: *The Last Outlaw*
(Barnholtz Entertainment)
Directed by Brett Kelly; written by Janet Hetherington, David A. Lloyd.
Starring Michael Paré, Lawrence Evenchick, Mike Tarp. Michael Paré stars as Sheriff Atherton.

2007: *BloodRayne: Deliverance*
(Cinedigm Entertainment Group)
Directed by Uwe Boll; written by Christopher Donaldson, Neil Every, Masaji Takei.
Starring Natassia Malthe, Zack Ward, Michael Paré. Michael Paré stars as Pat Garrett.

MICHAEL PARKS

2012: *Django Unchained*
(Columbia)
Directed by Quentin Tarantino; written by Quentin Tarantino.
Starring Jamie Foxx, Christoph Waltz, Leonardo DiCaprio. Michael Parks as The LeQuint Dicky Mining Co. Employee.

2008: *Three Priests*
(Gum Spirits Productions)
Directed by Jim Comas Cole; written by Jim Comas Cole, Jay Towle.
Starring Michael Parks, Olivia Hussey, Wes Studi.
Michael Parks stars as Jacob.

2007: *The Assassination of Jesse James by the Coward Robert Ford*
(Warner Bros.)
Directed by Andrew Dominik; Ron Hansen (novel).
Starring Brad Pitt, Casey Affleck, Sam Shepard.
Michael Parks as Henry Craig.

2005: *Miracle at Sage Creek*
(American World)
Directed by James Intveld; written by Thadd Turner.
Starring David Carradine, Wes Studi, Michael Parks.
Michael Parks stars as Justice Stanley.

2000: *Bullfighter*
(Phaedra Cinema)
Directed by Rune Bendixen; written by Rune Bendixen, Majken Gilmartin, L. M. Kit Carson, Hunter Carson.
Starring Oliver Martinez, Michelle Forbes, Assumpta Serna, Donnie Wahlberg, Willem Dafoe.
Michael Parks as Cordobes.

1999: *From Dusk Till Dawn 3: The Hangman's Daughter*
(Buena Vista)
Directed by P. J. Pesce; written by Álvaro Rodriguez, Robert Rodriguez.
Starring Marco Leonardi, Michael Parks, Temuera Morrison.
Michael Parks stars as Ambrose Bierce.

1989: *Billy the Kid*
(TNT)

Directed by William A. Graham; written by Gore Vidal.
Starring Val Kilmer, Ed Adams, Rene Auberjonois.
Michael Parks as Rynerson.

1986: *The Return of Josey Wales*
(Magnum Entertainment)
Directed by Michael Parks; written by Forrest Carter, R. O. Taylor.
Starring Michael Parks, Rafael Campos, Everett, Sifuentes.
Michael Parks stars as Josey Wales.

The Last Hard Men
(20th Century Fox)
Directed by Andrew V. McLaglen; written by Brian Garfield (novel), Guerdon Trueblood.
Starring Charlton Heston, James Coburn, Barbara Hershey, Jorge Rivero.
Michael Parks as Noel Nye.

1967: *Stranger on the Run*
(Universal)
Directed by Don Siegel; written by Dean Riesner, Reginald Rose.
Starring Henry Fonda, Anne Baxter, Michael Parks.
Michael Parks stars as Vince McKay.

1964: *Wagon Train*
"The Michael Malone Story"
(ABC)
Directed by Virgil W. Vogel; written by Gerry Day, David Richards.
Starring Robert Fuller, John McIntire, Frank McGrath.
Michael Parks as Michael Malone.

1963: *Wagon Train*
"The Heather and Hamish Story"
(ABC)
Directed by Allen H. Miner; written by Allen H. Miner.
Starring John McIntire, Frank McGrath, Terry Wilson.
Michael Parks as Hamish Browne.

1962: *Stoney Burke*
"The Mob Riders"
(ABC)
Directed by Leslie Stevens; written by Leslie Stevens.
Starring Jack Lord, Warren Oates, Robert Dowdell, Bruce Dern.
Michael Parks as Tack Reynolds.

Gunsmoke
"The Boys"
(CBS)
Directed by Harry Harris; written by John Meston.
Starring James Arness, Milburn Stone, Amanda Blake.
Michael Parks as Park.

STEFANIE POWERS

1974: *Gone with the West*
(International Cine Film Corporation)
Directed by Bernard Girard; written by Monroe Manning, Douglas Day Stewart, Marcus Demian.
Starring James Caan, Stefanie Powers, Aldo Ray.
Stefanie Powers stars as Little Moon.

Kung Fu
"Cry of the Night Beast"
Directed by Richard Lang; written by Ed Spielman,

Herman Miller, Ed Waters, Abe Polsky.
Starring David Carradine, Albert Salmi, Don Stroud.
Stefanie Powers as Edna.

Shootout in a One Dog Town
(ABC)
Directed by Burt Kennedy; written by Larry Cohen, Dick Nelson.
Starring Richard Crenna, Stefanie Powers, Jack Elam.
Stefanie Powers stars as Letty Crandell.

1972: *The Magnificent Seven Ride!*
(United Artists)
Directed by George McCowan; written by Arthur Rowe.
Starring Lee Van Cleef, Stefanie Powers, Michael Callan, Luke Askew.
Stefanie Powers stars as Laurie Gunn.

Hardcase
(ABC)
Directed by John Llewellyn Moxey; written by Harold Jack Bloom, Sam Rolfe.
Starring Clint Walker, Stefanie Powers, Pedro Armendáriz Jr.
Stefanie Powers stars as Rozaline.

Lancer
"Zee"
(20th Century Fox Television)
Directed by Leo Penn; written by Samuel A. Peeples, Andy Lewis.
Starring James Stacy, Wayne Maunder. Andrew Duggan.
Stefanie Powers as Zee.

Lancer
"The Black McGloins"
(20th Century Fox Television)
Directed by Don Richardson; written by Samuel A. Peeples, Carey Wilber.
Starring James Stacy, Wayne Maunder. Andrew Duggan.
Stefanie Powers as Moira McGloin.

1966: *Stagecoach*
(20th Century Fox)
Directed by Gordon Douglas; written by Joseph Landon, Dudley Nichols, Ernest Haycox.
Starring Ann-Margret, Alex Cord, Red Buttons, Bing Crosby, Van Heflin.
Stefanie Powers as Mrs. Lucy Mallory.

1963: *McLintock!*
(United Artists)
Directed by Andrew V. McLaglen; written by James Edward Grant.
Starring John Wayne, Maureen O'Hara, Patrick Wayne, Stefanie Powers, Chill Wills.
Stefanie Powers stars as Rebecca 'Becky' McLintock.

Bonanza
"Calamity Over the Comstock"
(NBC)
Directed by Charles R. Rondeau; written by Warren Douglas.
Starring Lorne Greene, Pernell Roberts, Dan Blocker.
Stefanie Powers as Calamity Jane.

1961: *Bat Masterson*
"Dead Man's Claim"
(NBC)
Directed by Lew Landers; written by Richard O'Connor (book), George F. Slavin.
Starring Gene Barry, Charles Maxwell, Stefanie Powers.
Stefanie Powers stars as Ann Elkins.

DENVER PYLE

1994: *Maverick*
(Warner Bros.)
Directed by Richard Donner; written by Roy Huggins; William Goldman.
Starring Mel Gibson, Jodie Foster, James Garner.
Denver Pyle as Old Gambler on River Boat.

1993: *Wind in the Wire*
(Planet Incorporated)
Directed by Jim Shea; written by Jim Shea.
Starring Burt Reynolds, Lou Diamond Phillips, Melanie Chartoff.
Denver Pyle as unnamed character.

1979: *How the West Was Won*
"The Enemy"
(ABC/MGM Television)
Directed by Gunnar Hellström; written by Ron Bishop, Steve Hayes.
Starring James Arness, Fionnula Flanagan, Bruce Boxleitner, Paul Koslo.
Denver Pyle as Sgt. Tripp.

1978: *The Life and Times of Grizzly Adams*
Created by Charles E. Seller Jr.
(NBC/Sunn Classic)
Directed by Jack Hively, S. Travis, others; written by Brian Russell, James Simmons, Jim Carlson, Terrence McDonnell, others.
Starring Dan Haggerty, Denver Pyle, Bozo the Bear.
Denver Pyle stars as Mad Jack in 37 episodes.

1976: *Guardian of the Wilderness*
(Sunn Classic)
Directed by David O'Malley; written by David O'Malley, Karen O'Malley, Charles E. Sellier Jr.
Starring Denver Pyle, John Dehner, Ken Berry.
Denver Pyle stars as Galen Clark.

Buffalo Bill and the Indians, or Sitting Bull's History Lesson
(United Artists)
Directed by Robert Altman; written by Arthur Kopit, Alan Rudolph.
Starring Paul Newman, Joel Gray, Kevin McCarthy.
Denver Pyle as The Indian Agent (McLaughlin).

Hawmps!
(Mulberry Square Releasing)
Directed by Joe Camp; written by William Bickley, Joe Camp, Michael Warren.
Starring James Hampton, Christopher Connelly, Slim Pickens.
Denver Pyle as Col. Seymour Hawkins.

The Adventures of Frontier Fremont
(Sunn Classic)
Directed by Richard Friedenberg; written by Richard Friedenberg, David O'Malley, Charles E. Sellier Jr.
Starring Dan Haggerty, Denver Pyle, Tony Mirrati.
Denver Pyle stars as Old mountain man.

1975: *Winterhawk*
(Howco International)
Directed by Charles B. Pierce, Earl E. Smith.
Starring Leif Erickson, Woody Strode, Denver Pyle, L. Q. Jones, Michael Dante.
Denver Pyle stars as Arkansas.

1974: *Kung Fu*
"Cross Ties"
(ABC/Warner Bros.)

Directed by Richard Lang; written by Ed Spielman, Herman Miller, Robert Schlitt.
Starring David Carradine, Barry Sullivan, John Anderson, Harrison Ford, Andy Robinson.
Denver Pyle as Dr. Joseph Colton.

Dirty Sally
"Horse of a Different Color"
(CBS)
Created and written by Jack Miller.
Starring Jeanette Nolan, Dack Rambo, Jon Lormer.
Denver Pyle as Parker

1973: *Kung Fu*
"The Ancient Warrior"
(ABC/Warner Bros.)
Directed by Robert Butler; written by Ed Spielman, Herman Miller, A. Martin Sweiback.
Starring David Carradine, Chief Dan George, Victor French.
Denver Pyle as Mayor Howard Simms.

Cahill U. S. Marshal
(Warner Bros.)
Directed by Andrew V. McLaglen; written by Harry Julian Fink, Rita M. Fink, Barney Slater.
Starring John Wayne, George Kennedy, Gary Grimes.
Denver Pyle as Denver.

Gunsmoke
"Shadler"
(CBS)
Directed by Arnold Laven; written by Jim Byrnes.
Starring Milburn Stone, Amanda Blake, Ken Curtis, Earl Holliman.
Denver Pyle as Cyrus Himes.

1972: *Bonanza*
"Riot"
(NBC)
Directed by Lewis Allen; written by John Hawkins, David Dortort, Fred Hamilton, Robert Pirosh.
Starring Lorne Greene, Michael Landon, David Canary.
Denver Pyle as Warden.

1971: *Something Big*
(National General)
Directed by Andrew V. McLaglen; written by James Lee Barrett.
Starring Dean Martin, Brian Keith, Carol White, Harry Carey, Jr.
Denver Pyle as Junior Frisbee.

1970: *Bonanza*
"The Wagon"
(NBC)
Directed by Lewis Allen; written by John Hawkins, David Dortort, Fred Hamilton, Robert Pirosh.
Starring Lorne Greene, Michael Landon, David Canary.
Denver Pyle as Price Buchanan.

1968: *Bonanza*
"The Passing of a King"
(NBC)
Directed by Leon Benson; written by David Dortort, B. W. Sandefur.
Starring Lorne Greene, Dan Blocker, Michael Landon.
Denver Pyle as Claude Roman.

Five Card Stud
(Paramount)
Directed by Henry Hathaway; written by Marguerite Roberts, Ray Gaulden (novel).
Starring Dean Martin, Robert Mitchum, Roddy MacDowell, Yaphet Kotto.
Denver Pyle as Sig Evers.

Bandolero!
(20th Century Fox)
Directed by Andrew V. Mc-
Laglen; written by James Lee
Barrett, Stanley Hough.
Starring James Stewart, Dean
Martin, Raquel Welch, George
Kennedy, Andrew Prine.
Denver Pyle as Muncie Carter.

The Guns of Will Sonnett
"The Warriors"
(ABC)
Directed by Jean Yarbrough;
written by Richard Carr, Aaron
Spelling.
Starring Walter Brennan, Dack
Rambo, Jim Davis.
Denver Pyle as Sam Cochran.

1967: *Gunsmoke*
"Baker's Dozen"
(CBS)
Directed by Irving J. Moore;
written by Charles Joseph
Stone.
Starring James Arness, Milburn
Stone, Amanda Blake, Harry
Carey, Jr.
Denver Pyle as Cyrus Himes.

Gunsmoke
"Mad Dog"
(CBS)
Directed by Charles R. Ron-
deau; written by Jay Simms.
Starring James Arness, Milburn
Stone, Amanda Blake, Dub
Taylor, George Murdock.
Denver Pyle as Dr, Henry S,
Rand.

Cimarron Strip
"The Last Wolf"
(CBS)
Directed by Bernard McEveety;
written by Christopher Knopf,
Preston Wood.
Starring Stuart Whitman, Percy
Herbert, Randy Boone.
Denver Pyle as Charley Austin.

Hondo
"Hondo and the Hanging
Town"
(ABC)
Directed by Alan Crosland
Jr.; written by Stanley Adams,
Andrew J. Fenady.
Starring, Ralph Taeger, Kathie
Browne, Noah Beery Jr.
Denver Pyle as Judge Amos
Blunt.

The High Chaparral
"A Hanging Offense"
(NBC)
Directed by Leon Benson;
written by Mel Goldberg.
Starring Leif Erickson, Camer-
on Mitchell, Mark Slade, Henry
Darrow.
Denver Pyle as General
Warren.

Welcome to Hard Times
(Metro-Goldwyn-Mayer)
Directed by Burt Kennedy;
written by E. L. Doctorow
(novel), Burt Kennedy.
Starring Henry Fonda, Janice
Rule, Keenan Wynn, Lon
Chaney, Warren Oates.
Denver Pyle as Alfie.

Death Valley Days
"A Wrangler's Last Ride"
(Flying 'A' Productions)
Directed by Jack Shea; written
by Virgil C. Gerlach.
Starring Robert Taylor, Don
Megowan, Susan Brown.
Denver Pyle as Milligan.

1966: *Gunsmoke*
"The Goldtakers"
(CBS)
Directed by Vincent McEveety;
written by Clyde Ware.
Starring James Arness, Milburn
Stone, Amanda Blake, Martin
Landau.
Denver Pyle as Caleb Nash.

Gunsmoke
"By Line"
(CBS)
Directed by Allen Reisner;
written by Les Crutchfield.
Starring James Arness, Milburn
Stone, Amanda Blake, Chips
Rafferty, Glenn Strange.
Denver Pyle as Clab Chummer.

Death Valley Days
"The Resurrection of Dead-
wood Dick"
(Flying 'A' Productions)
Directed by Tay Garnett.
Starring Tol Avery, Hal Baylor,
Winnie Collins.
Denver Pyle as Deadwood Dick
(Real Name: Richard Clark).

Incident at Phantom Hill
(Universal)
Directed by Earl Bellamy; writ-
ten by Frank S. Nugent, Ken
Pettus, Harry Tatelman.
Starring Robert Fuller, Jocelyn
Lane, Dan Duryea, Claude
Akins.
Denver Pyle as 1st Hunter.

Gunpoint
(Universal)
Directed by Earl Bellamy;
written by Mary Willingham,
Willard W. Willingham.
Starring Audie Murphy, Joan
Staley, Warren Stevens, Mor-
gan Woodward, Royal Dano.
Denver Pyle as Cap.

1965: *Gunsmoke*
"Deputy Festus"
(CBS)
Directed by Harry Harris; writ-
ten by Calvin Clements Sr.
Starring James Arness, Milburn
Stone, Amanda Blake, Ken
Curtis, Glenn Strange.
Denver Pyle as Clausius.

Shenandoah
(Universal)
Directed by Andrew V. Mc-
Laglen; written by James Lee
Barrett.
Starring James Stewart, Doug
McClure, Glen Corbett, Rose-
mary Forsythe, Ed Faulkner.
Denver Pyle as Pastor Bjo-
erling.

Wagon Train
"The Silver Lady"
(NBC/Universal-TV)
Directed by Andrew V. McLa-
glen; written by Dick Nelson.
Starring Robert Fuller, John
McIntire, Frank McGrath, Vera
Miles, Henry Silva.
Denver Pyle as Old Man
Clanton.

The Rounders
(Metro-Goldwyn-Mayer)
Directed by Burt Kenedy;
written by Max Evans, Burt
Kennedy.
Starring Glenn Ford, Henry
Fonda, Sue Ane Langdon,
Chill Wills.
Denver Pyle as Bull.

1964: *Gunsmoke*
"The Violators"
(CBS)
Directed by Harry Harris;
written by John Dunkel.
Starring James Arness, Milburn
Stone, Burt Reynolds.
Denver Pyle as Caleb.

Gunsmoke
"No Hands"
(CBS)
Directed by Andrew V. McLa-
glen; written by John Meston.
Starring James Arness, Milburn
Stone, Amanda Blake.
Denver Pyle as Pa.

Bonanza
"Bullet for a Bride"
(NBC)

Directed by Tay Garnett;
written by Tom Seller.
Starring Lorne Greene, Pernell
Roberts, Dan Blocker.
Denver Pyle as Marcus Caldwell.

Death Valley Days
"The Lucky Cow"
(Flying 'A' Productions)
Directed by Murray Golden;
written by Crandall Brown.
Starring Steve Brodie, Jacques
Aubuchon, Phyllis Coates.
Denver Pyle as Zeke.

Death Valley Days
"Big John and the Rainmaker"
(Flying 'A' Productions)
Directed by Harmon Jones;
written by Herman Miller.
Starring Jim Davis, Denver
Pyle, Roy Engel.
Denver Pyle stars as Fenimore
Bleek.

Death Valley Days
"Graydon's Charge"
(Flying 'A' Productions)
Directed by Tay Garnett;
written by John Alexander.
Starring Denver Pyle, Ken
Curtis, Lyle Bettger.
Denver Pyle stars as Ortho
Williams.

Temple Houston
"The Case for William Gotch"
(NBC)
Directed by Leslie Martinson;
written by Herman Groves.
Starring Jeffrey Hunter, Jack
Elam, James Best.
Denver Pyle as Phineas Fallon.

1963: *Gunsmoke*
"The Odyssey of Jubal Tanner"
(CBS)
Directed by Andrew V. McLa-
glen; written by Paul Savage.
Starring James Arness, Milburn
Stone, Amanda Blake, Peter
Breck, Beverly Garland.
Denver Pyle as Aaron.

Bonanza
"Little Man... Ten Feet Tall"
(NBC)
Directed by Lewis Allen;
written by Eric Norden, Frank
Arno.
Starring Lorne Greene, Pernell
Roberts, Dan Blocker.
Denver Pyle as Sheriff Ed.

Bonanza
"The Boss"
(NBC)
Directed by Arthur H. Nadel;
written by Leo Gordon, Paul
Leslie Peil.
Starring Lorne Greene, Pernell
Roberts, Dan Blocker.
Denver Pyle as Sheriff Ed.

Death Valley Days
"The Melancholy Gun"
(Flying 'A' Productions)
Directed by Dick Moder;
written by Stephen Lord.
Starring Ken Scott, Elizabeth
MacRae, Denver Pyle.
Denver Pyle stars as Doctor.

Death Valley Days
"With Honesty and Integrity"
(Flying 'A' Productions)
Directed by Bud Townsend;
written by John Alexander.
Starring Sandy Kenyon, Denver
Pyle, Michael Keep.
Denver Pyle stars as Lucius
Barkey.

Empire
"Unaired Pilot: This Rugged
Land"
(Screen Gems)
Directed by Arthur Hiller;
written by Kathleen Hite,
Frank S. Nugent.
Starring Charles Bronson,
Richard Egan, Ryan O'Neal.
Denver Pyle as unnamed
character.

Rawhide
"Incident of the Rawhiders"
(CBS)
Directed by Ted Post; written
by Jay Simms, Jack Turley.
Starring Eric Fleming, Clint
Eastwood, Paul Brinegar.
Denver Pyle as John Wesley
'Daddy' Quade.

The Virginian
"Vengeance is the Spur"
Directed by Robert Ellis Miller;
written by Roy Huggins, Happy
Kleiner, Owen Wister (novel).
Starring Lee J. Cobb, Doug
McClure, Gary Clarke.
Denver Pyle as Pico Brown.

Laramie
"Vengeance"
(NBC)
Directed by Joseph Kane;
written by Ray Buffum, Rod
Peterson.
Starring John Smith, Robert
Fuller, Spring Byington.
Denver Pyle as Al Morgan.

1962: *Gunsmoke*
"Us Haggens"
(CBS)
Directed by Andrew V.
McLaglen; written by Les
Crutchfield.
Starring James Arness, Milburn
Stone, Ken Curtis, Elizabeth
MacRea.
Denver Pyle as Blackjack
Haggen.

Bonanza
"A Hot Day for a Hanging"
(NBC)
Directed by William F. Clax-
ton; written by Preston Wood,
Elliott Arnold.
Starring Lorne Greene, Pernell
Roberts, Dan Blocker.
Denver Pyle as Sheriff Tom
Stedman.

Cheyenne
"Vengeance is Mine"
(Warner Bros.)
Directed by Robert Sparr;
written by Warren Douglas,
Berne Giler.
Starring Clint Walker, Jean
Willes, George Gaynes.
Denver Pyle as John Hanson.

Cheyenne
"Sweet Sam"
(Warner Bros.)
Directed by Robert Sparr;
written by E. M. Parsons.
Starring Clint Walker, Ronnie
Haran, Roger Mobley.
Denver Pyle as Cyrus Burton.

Lawman
"Explosion"
(Warner Bros.)
Directed by Richard C.
Sarafian; written by Hendrik
Vollaerts.
Starring John Russell, Peter
Brown, Peggie Castle.
Denver Pyle as Sam Brackett.

Geronimo
(United Artists)
Directed by Arnold Laven;
written by Pat Fielder, Arnold
Laven.
Starring Chuck Connors,
Kamala Devi, Pat Conway.
Denver Pyle as Senator Conrad.

*The Man Who Shot Liberty
Valance*
(Paramount)
Directed by John Ford; writ-
ten by James Warner Bellah,
Willis Goldbeck, Dorothy M.
Johnson.
Starring James Stewart, John
Wayne, Vera Miles, Lee Mar-
vin, Woody Strode, Edmund
O'Brien, Strother Martin, John
Carradine, Andy Devine.
Denver Pyle as Amos Car-
ruthers.

1961: *Bonanza*
"Springtime"
(NBC)
Directed by Christian Nyby;
written by John Furia.
Starring Pernell Roberts, Dan
Blocker, Michael Landon.
Denver Pyle as Theodore 'Ted'
Hackett.

Empire
"The Day the Empire Stood
Still"
(Screen Gems)
Directed by Arthur Hiller;
written by Kathleen Hite,
Frank S. Nugent.
Starring Charles Bronson,
Richard Egan, Terry Moore.
Denver Pyle as Tom Rawling.

Laramie
"Siege at Jubilee"
(NBC)
Directed by Lesley Selander;
written by John C. Champion,
Rod Peterson.
Starring John Smith, Robert
Fuller, Spring Byington.
Denver Pyle as Bates.

Laramie
"Strange Company"
(NBC)
Directed by Harold D. Schus-
ter; written by John C. Cham-
pion, Rod Peterson.
Starring John Smith, Robert
Fuller, Spring Byington.
Denver Pyle as Bailey.

Cheyenne
"Winchester Quarantine"
(Warner Bros.)
Directed by Paul Landres;
written by Cy Chermak, Arthur
Fitz-Richard.
Starring Clint Walker, Susan
Cummings, Ross Elliott.
Denver Pyle as Nate Weyland.

Bronco
"Prince of Darkness"
(Warner Bros.)
Directed by Marc Lawrence;
written by Warren Douglas.
Starring Ty Hardin, Efrem
Zimbalist Jr., John Howard.
Denver Pyle as William Mason.

Bronco
"Guns of the Lawless"
(Warner Bros.)
Directed by Richard C. Sarafian;
written by William L. Stuart.
Starring Ty Hardin, Olive
Sturgess, Corey Allen.
Denver Pyle as Petrie Munger.

Bronco
"Stage to the Sky"
(Warner Bros.)
Directed by Robert Sparr;
written by Warren Douglas.
Starring Ty Hardin, Joan
Marshall, Kent Taylor.
Denver Pyle as Nelson.

Bronco
"The Buckbrier Trail"
(Warner Bros.)
Directed by Robert Sparr; writ-
ten by William Bruckner.
Starring Ty Hardin, Mike Road,
Sandra Bettin.
Denver Pyle as Norton
Gillespie.

The Rifleman
"The Decision"
(ABC/Four Star Productions)
Directed by Gene Nelson;
written by Ed Adamson.
Starring Chuck Connors,
Johnny Crawford, Paul Fix.
Denver Pyle as Frank Hazlitt.

The Rifleman
"The Clarence Bibs Story"
(ABC/Four Star Productions)
Directed by David Friedkin;
written by Calvin Clements Sr.
Starring Chuck Connors, John-
ny Crawford, Buddy Hackett,

Lee Van Cleef.
Denver Pyle as George Tanner.

Zane Grey Theater
"The Empty Shell"
(CBS/Four Star Productions)
Directed by David Lowell Rich;
written by Paul Franklin, Bruce
Geller.
Starring Jan Murray, Jean
Hagen, Denver Pyle.
Denver Pyle stars as Nat
Sledge.

Bat Masterson
"End of the Line"
(NBC)
Directed by Eddie Davis;
written by Richard O'Connor
(book), Lee Karson.
Starring Gene Barry, Liam
Sullivan, Joe Sawyer.
Denver Pyle as Walsh.

Maverick
"Family Pride"
(ABC/Warner Bros. Television)
Directed by John Ainsworth;
written by C. L. Moore.
Starring Roger Moore, Anita
Sands, Karl Swenson.
Denver Pyle as Jerry O'Brien.

1960: *Gunsmoke*
"The Wake"
(CBS)
Directed by Gerald Mayer;
written by John Melton.
Starring James Arness, Dennis
Weaver, Milburn Stone.
Denver Pyle as Gus.

Laramie
"Three Rode West"
(NBC)
Directed by Lesley Selander;
written by Jerry Adelman.
Starring John Smith, Robert
Fuller, Vera Miles.
Denver Pyle as Sheriff.

The Rifleman
"The Hangman"
(ABC/Four Star Productions)
Directed by Joseph H. Lewis;
written by Teddi Sherman,
Ward Wood.
Starring Chuck Connors,
Johnny Crawford, Paul Fix.
Denver Pyle as Harold
Tenner.

Two Faces West
"Hand of Vengeance"
(Screen Gems)
Starring Charles Bateman,
Denver Pyle, John Marley.
Denver Pyle stars as Sam.

The Deputy
"The Example"
(NBC)
Directed by Otto Lang; written
by Ralph Goodman, Roland
Kibbee, Norman Lear.
Starring Henry Fonda, Allen
Case, Read Morgan.
Denver Pyle as Frank Barton.

Zane Grey Theater
"A Small Town That Died"
(CBS/Four Star Productions)
Directed by Robert Florey;
written by Bob Barbash.
Starring Dick Powell, Henry
Hull, Beverly Garland.
Denver Pyle as Marshal Joe
Sully.

Shotgun Slade
"Ring of Death"
(MCA-TV)
Directed by Sidney Salkow;
written by Martin Berkeley,
Frank Gruber.
Starring Scott Brady, Bethel
Leslie, H. M. Wynant.
Denver Pyle as Marshal Berry.

Have Gun – Will Travel
"The Puppeteer"
(CBS)
Directed by Richard Boone;
written by Shimon Wincelberg,

Herb Meadow, Sam Rolfe.
Starring Richard Boone, Crah-
an Denton, Denver Pyle.
Denver Pyle as Gen. George
'Pawnee' Croft.

Have Gun – Will Travel
"The Calf"
(CBS)
Directed by Richard Boone;
written by Howard Rodman,
Herb Meadow, Sam Rolfe.
Starring Richard Boone, Stew-
art East, Parker Fennelly.
Denver Pyle as George
Advent.

Have Gun – Will Travel
"Ransom"
(CBS)
Directed by Richard Boone;
written by Howard E. Thomp-
son, Herb Meadow, Sam Rolfe.
Starring Richard Boone, Valerie
French, Robert H. Harris.
Denver Pyle as Col. Celine.

Stagecoach West
"Three Wise Men"
(ABC/Four Star Productions)
Directed by Thomas Carr;
written by D. D. Beauchamp,
Mary M. Beauchamp.
Starring Wayne Rogers, Rich-
ard Eyer, Robert Bray.
Denver Pyle as Marshal Berry.

*The Life and Legend of Wyatt
Earp*
"The Too Perfect Crime"
(ABC)
Directed by Sidney Salkow;
written by Frederick Hazlitt
Brennan.
Starring Hugh O'Brian, Doug-
las Fowley, Morgan Woodward.
Denver Pyle as Hoss Mackey.

*The Life and Legend of Wyatt
Earp*
"A Murderer's Return"
(ABC)
Directed by Roy Rowland;
written by John Dunkel.
Starring Hugh O'Brian, Mor-
gan Woodward, Rachel Ames.
Denver Pyle as Dobie Jenner.

Riverboat
"No Bridge on the River"
(NBC)
Directed by Lamont Johnson;
written by Raphael Hayes.
Starring Darren McGavin,
Noah Beery Jr., Dick Wessel.
Denver Pyle as Jim Bledsoe.

The Alamo
(United Artists)
Directed by John Wayne; writ-
ten by James Edward Grant.
Stars John Wayne, Richard
Widmark, Laurence Harvey,
Linda Cristal, Chill Wills.
Denver Pyle as Thimblerig.

The Tall Man
"Garrett and the Kid"
(NBC)
Directed by Herschel Daugh-
erty; written by Samuel A.
Peeples.
Starring Barry Sullivan, Clu
Gulager, Robert Middleton.
Denver Pyle as Marshal Dave
Leggert.

Wrangler
"Incident at the Bar M"
(NBC)
Directed by David Lowell Rich;
written by Gene Roddenberry.
Starring Jason Evers, Eli Bor-
aks, Jack Ging.
Denver Pyle as unnamed
character.

Tombstone Territory
"Crime Epidemic"
(ABC)
Directed by Herman Hoffman;
written by Melvin Levy.
Starring Pat Conway, Richard
Eastham, Denver Pyle.

Denver Pyle stars as Will
Gunther.

The Man from Blackhawk
"The Man Who Wanted
Everything"
(ABC)
Written by Frank Baron.
Starring Rockwell, Patricia
Donahue, Denver Pyle.
Denver Pyle stars as Arthur
White.

Overland Trail
"The Baron Comes Back"
(NBC)
Directed by Tay Garnett;
written by B. L. James.
Starring William Bendix, Doug
McClure, Gerals Mohr.
Denver Pyle as Jonathan Kale.

Hotel de Paree
"Sundance and the Long Trek"
(CBS)
Directed by Andrew V. McLa-
glen; written by Jack Jacobs.
Starring Earl Holliman, Jea-
nette Nolan, Strother Martin.
Denver Pyle as Fred Taylor.

Pony Express
"Special Delivery"
(California National Produc-
tions)
Directed by Frank McDonald;
written by Paul King, Joseph
Stone.
Starring Grant Sullivan, Don
Dorrell, Denver Pyle.
Denver Pyle stars as Hank
Watson.

Wichita Town
"The legend of Tom Horn"
(NBC/Four Star Productions)
Starring Robert Bice, Nancy
Gates, Jody McCrea.
Denver Pyle as Aaron Faber.

The Texan
"The Guilty and the Innocent"
(CBS)
Directed by Jerry A Baerwitz;
written by Jerry A Baerwitz,
John Grey.
Starring Rory Calhoun, Robert
F. Simon, Percy Helton.
Denver Pyle as Sheriff.

Law of the Plainsman
"The Matriarch"
(NBC/Four Star Productions)
Directed by Arthur Hilton;
written by Teddi Sherman.
Starring Michael Ansara, Lynn
Bari, Denver Pyle.
Denver Pyle stars as Burke
Carew.

1959: *Gunsmoke*
"The Bear"
(CBS)
Directed by Jesse Hibbs;
written by John Melton.
Starring James Arness, Dennis
Weaver, Milburn Stone.
Denver Pyle as Mike Blocker.

Laramie
"The Iron Captain"
(NBC)
Directed by Robert B. Sinclair;
written by E. Jack Neuman,
Robert Pirosh.
Starring John Smith, Hoagy
Carmichael, Robert Crawford
Jr., Robert Fuller.
Denver Pyle as Sheriff Hailey.

Lawman
"The Conclave"
(Warner Bros.)
Directed by Mark Sandrich Jr.;
written by Edmund Jr.
Starring John Russell, Peter
Brown, Lawrence Dodkin.
Denver Pyle as Glen Folsom.

The Rifleman
"The Legacy"
(ABC/Four Star Productions)
Directed by Bernard L. Kowals-
ki; written by Edmund Morris.

Starring Chuck Connors,
Johnny Crawford, Paul Fix.
Denver Pyle as Seth Mitchell.

The Rifleman
"Bloodlines"
(ABC/Four Star Productions)
Directed by Arthur Hiller;
written by Arthur Browne Jr.
Starring Chuck Connors,
Johnny Crawford, Paul Fix.
Denver Pyle as Henry Trumble.

Zane Grey Theater
"A Thread of Respect"
(CBS/Four Star Productions)
Directed by John English;
written by Nina Laemmle,
Aaron Spelling.
Starring Danny Thomas, Nick
Adams, James Coburn.
Denver Pyle as Seth Robson.

Bat Masterson
"Marked Deck"
(NBC)
Directed by Otto Lang; written
by Richard O'Connor (book),
Charles B. Smith, Mikhail
Rykoff.
Starring Gene Barry, Denver
Pyle, Cathy Downs.
Denver Pyle stars as Dan
Morgan.

Have Gun – Will Travel
"The Posse"
(CBS)
Directed by Andrew V.
McLaglen; written by Gene
Roddenberry, Herb Meadow,
Sam Rolfe.
Starring Richard Boone, Perry
Cook, Denver Pyle.
Denver Pyle stars as McKay.

Have Gun – Will Travel
"The Wager"
(CBS)
Directed by Andrew V. McLa-
glen; written by Denis Sanders,
Terry Sanders, Herb Meadow,
Sam Rolfe.
Starring Richard Boone, Den-
ver Pyle, Jacqueline Scott.
Denver Pyle stars as Sid
Morgan.

*The Life and Legend of Wyatt
Earp*
"A Good Man"
(ABC)
Directed by Frank McDonald;
written by John Dunkel.
Starring Hugh O'Brian, Mor-
gan Woodward, Denver Pyle.
Denver Pyle stars as Rev. Oliver
Tittle.

The Texan
"The Telegraph Story"
(CBS)
Directed by Edward Ludwig;
written by Edmund Morris.
Starring Rory Calhoun, Edward
Ashley, Denver Pyle.
Denver Pyle stars as Chip
Andrews.

The Texan
"The Sheriff of Boot Hill"
(CBS)
Directed by Erie C. Kenton;
written by Sid Harris.
Starring Rory Calhoun, Reed
Hadley, Denver Pyle.
Denver Pyle stars as Joe Lufton.

The Texan
"No Place to Stop"
(CBS)
Directed by Erie C. Kenton;
written by Louis L'Amour.
Starring Rory Calhoun, Chuck
Wassil, Charles Arnt.
Denver Pyle as Houston
Blackston.

Tales of Wells Fargo
"Double Reverse"
(NBC)
Directed by David Lowell Rich;
written by Fred Freiberger.
Starring Dale Robertson, Judith

Evelyn, Denver Pyle.
Denver Pyle stars as Wilt
Rawlins.

Cast a Long Shadow
(United Artists)
Directed by Thomas Carr;
written by Martin Goldsmith,
John McGreevey, Wayne D.
Overholser.
Starring Audie Murphy, Terry
Moore, John Dehner.
Denver Pyle as Preacher
Harrison.

The Horse Soldiers
(United Artists)
Directed by John Ford; written
by John lee Mahin, Martin
Rackin, Harold Sinclair.
Starring John Wayne, William
Holden, Constance Towers,
Strother Martin.
Denver Pyle as Jackie Jo.

26 Men
"Fighting Men"
(Russell Hayden productions)
Directed by Joseph Kane;
written by Tom Hubbard.
Starring Tristram Coffin, Kelo
Henderson, Lance Fuller.
Denver Pyle as Clovis.

King of the Wild Stallions
(Allied Artists)
Directed by R. G. Springsteen;
written by Ford Beebe.
Starring George Montgomery,
Diane Brewster, Edgar Bu-
chanan.
Denver Pyle as Doc Webber.

The Restless Gun
"The Pawn"
(NBC)
Directed by Edward Ludwig;
written by Frank Burt, Charles
B. Smith.
Starring John Payne, Onslow
Stevens, Julie Payne.
Denver Pyle as Jeb.

Good Day for a Hanging
(Columbia)
Directed by Nathan Juran;
written by Daniel B. Ullman,
Maurice Zimm, John Reese.
Starring Fred MacMurray, Mar-
garet Hayes, Robert Vaughn.
Denver Pyle as Deputy Ed
Moore.

1958: *Zane Grey Theater*
"The Stranger"
(CBS/Four Star Productions)
Directed by Robert Gordon;
written by Irving Elman, John
Falvo.
Starring Mark Stevens, Dan
Barton, Denver Pyle.
Denver Pyle stars as Sheriff
Tom.

The Deputy
"Shadow of the Noose"
(NBC)
Directed by Robert B. Sinclair;
written by Ralph Goodman,
Roland Kibbee, Norman Lear.
Starring Henry Fonda, Allen
Case, Wallace Ford.
Denver Pyle as Akins.

Have Gun – Will Travel
"The Singer"
(CBS)
Directed by Andrew V. Mc-
Laglen; written by Ken Kolb,
Sam Peckinpah, Herb Meadow,
Sam Rolfe.
Starring Richard Boone, Joan
Weldon, Richard Long.
Denver Pyle as Pete Hollister.

*The Life and Legend of Wyatt
Earp*
(ABC)
Directed by Frank McDonald,
Lewis R. Foster; written by
Frederick Hazlitt Brennan.
Starring Hugh O'Brian, Myron
Healey, Denver Pyle, Don
Haggerty.

253

Denver Pyle stars as Ben Thompson in 7 episodes.

26 Men
"Shadow of Doubt"
(Russell Hayden Productions)
Directed by Oliver Drake;
written by Tom Hubbard.
Starring Tristram Coffin, Kelo Henderson, Denver Pyle.
Denver Pyle as Ranger Haskins.

Jefferson Drum
"Prison Hill"
(NBC)
Starring Jeff Richards, Eugene Mazzola, Cyril Delevanti.
Denver Pyle as Bart Resdake.

Tales of the Texas Rangers
"Texas Flyer"
(CBS)
Directed by George Blair; written by Malcolm Stuart Boylan.
Starring Willard Parker, Harry Lauter, Leslie Bradley.
Denver Pyle as Noah Reed.

Fury
"The Fire Watchers"
(NBC)
Directed by Nat Tanchuck; written by Nat Tanchuck.
Starring Peter Graves, Bobby Diamond, William Fawcett.
Denver Pyle as Mal.

Playhouse 90
"Bitter Heritage"
(CBS)
Directed by Paul Wendkos; written by Joseph Landon.
Starring Franchot Tone, Elizabeth Montgomery, James Drury.
Denver Pyle as Sam Wheeler.

Fort Massacre
(United Artists)
Directed by Joseph M. Newman; written by Martin Goldsmith.
Starring Joel McCrea, Forrest Tucker, John Russell.
Denver Pyle as Collins.

The Left Handed Gun
(Warner Bros.)
Directed by Arthur Penn; written by Leslie Stevens, Gore Vidal.
Starring Paul Newman, Vita Milan, John Dehner.
Denver Pyle as Ollinger.

Broken Arrow
"Bad Boy"
(ABC)
Directed by Ralph Murphy; written by Elliott Arnold (novel), Wallace Bosco.
Starring John Lupton, Michael Ansara, peter J. Votrian.
Denver Pyle as Fred Graf.

Man Without a Gun
"Shadow of a Gun"
(20th Century Fox Television)
Written by Peter Packer.
Starring Rex Reason, Denver Pyle.
Denver Pyle stars as unnamed character.

1957: *Gunsmoke*
"Liar from Blackhawk"
(CBS)
Directed by Andrew V. McLaglen; written by John Melton.
Starring James Arness, Dennis Weaver, Milburn Stone.
Denver Pyle as Hank Shinn.

Wagon Train
"The Zeke Thomas Story"
(Universal)
Directed by John Brahm; written by Halsted Welles.
Starring Ward Bond, Robert Horton, Gary Merrill.
Denver Pyle as Bragg.

Zane Grey Theater
"Blood in the Dust"

(CBS/Four Star Productions)
Directed by Alvin Ganzer; written by L. A. Pogue, Sidney Morse.
Starring Claudette Colbert, Jeff Morrow, Barry Atwater.
Denver Pyle stars as Sheriff.

Zane Grey Theater
"Fugitive"
(CBS/Four Star Productions)
Directed by John English; written by Frederick Louis Fox, Aaron Spelling.
Starring Eddie Albert, Celeste Holm, Peter J. Votrian.
Denver Pyle Marshal Quimby.

Have Gun – Will Travel
"The Colonel and the Lady"
(CBS)
Directed by Andrew V. McLaglen; written by Michael Fessier, Herb Meadow, Sam Rolfe.
Starring Richard Boone, Robert F. Simon, June Vincent.
Denver Pyle as Clay Sommers.

Tales of Wells Fargo
"Renegade Raiders"
(NBC)
Directed by George Waggner; written by William F. Leicester.
Starring Dale Robertson, Denver Pyle, Francis McDonald.
Denver Pyle stars as Jack Powers.

The Restless Gun
"Rink"
(NBC)
Directed by James Neilson; written by Frank Burt, David Dortort.
Starring John Payne, Peter J. Votrian, Denver Pyle.
Denver Pyle stars as Sheriff Jay.

The Gray Ghost
"The Resurrection"
(CBS)
Written by Virgil Carrington Jones (book).
Starring Tod Andrews, Phil Chambers, Karin Booth.
Denver Pyle as Duff.

Casey Jones
"Storm Warning"
(Screen Gems)
Directed by George Blair; written by John K. Butler.
Starring Alan Hale Jr., Bobby Clark, Eddy Waller.
Denver Pyle as Frank Reeder.

The Californians
"The Magic Box"
(NBC)
Directed by William F. Claxton; written by Robert L. Joseph, Gene Levitt.
Starring Adam Kennedy, Sean McClory, Peggy McCay.
Denver Pyle as Slater.

The Lonely Man
(Paramount)
Directed by Henry Levin; written by Harry Essex, Robert Smith.
Starring Jack Palance, Anthony Perkins, Neville Brand.
Denver Pyle as Brad, Red Bluff Sheriff.

Gun Duel in Durango
(United Artists)
Directed by Sidney Salkow; written by Louis Stevens.
Starring George Montgomery, Ann Robinson, Steve Brodie.
Denver Pyle as Ranger Captain.

The Adventures of Jim Bowie
(ABC)
Directed by Lewis R. Foster; written by Monte Barrett (book), David Boehm, Maurice Tombragel.
Starring Scott Forbes, John Miljan, Paul Playdon, Denver Pyle.

Denver Pyle stars as Sam Houston in 3 episodes.

1956: *Gunsmoke*
"Poor Pearl"
(CBS)
Directed by Andrew V. McLaglen; written by Sam Peckinpah, John Melton.
Starring James Arness, Dennis Weaver, Milburn Stone.
Denver Pyle as Willie Calhoun.

Zane Grey Theater
"Muletown Gold Strike"
(CBS/Four Star Productions)
Directed by John English; written by Aaron Spelling.
Starring Rory Calhoun, Barbara Eiler, Bobby Clark.
Denver Pyle as John Baker.

Sheriffs of the USA
(A Conne-Stephens Production)
Starring Keith Andes, Jim Bell, Denver Pyle.
Denver Pyle stars as Davis.

7th Cavalry
(Columbia)
Directed by Joseph H. Lewis; written by Peter packer, Glendon Swarthout.
Starring Randolph Scott, Barbara Hale, Jay C. Flippen.
Denver Pyle as Dixon.

The Lone Ranger
"Quicksand"
(ABC)
Directed by Earl Bellamy; written by Walker A. Tompkins, Robert Leslie Bellem.
Starring Clayton Moore, Jay Silverheels, Ric Roman.
Denver Pyle as Vance Kiley.

The Lone Ranger
"The Cross of Santo Domingo"
(ABC)
Directed by Earl Bellamy; written by Tom Seller.
Starring Clayton Moore, Jay Silverheels, Denver Pyle.
Denver Pyle stars as Arley McQueen.

Yaqui Drums
(Allied Artists)
Directed by Jean Yarbrough; written by D. D. Beauchamp, Jo Pagano, Paul Leslie Peil.
Starring Rod Cameron, Mary Castle, J. Carrol Naish.
Denver Pyle as Lefty Barr.

The Naked Hills
(Allied Artists)
Directed by Josef Shaftel; written by Helen S. Bilkie, Josef Shaftel.
Starring David Wayne, Keenan Wynn, James Barton.
Denver Pyle as Bert Killian / Narrator.

I Killed Wild Bill Hickok
(The Wheeler Company)
Directed by Richard Talmadge; written by Johnny Carpenter.
Starring Johnny Carpenter, Helen Westcott, Tom Brown.
Denver Pyle as Jim Bailey.

Frontier
"The Voyage of Captain Castle"
(NBC)
Directed by Hal W. Polaire; written by Morton S. Fine, David Friedkin.
Starring Jan Arvan, Trevor Bardette, John Frederick.
Denver Pyle as Frank.

Frontier
"Mother of the Brave"
(NBC)
Written by Morton S. Fine, David Friedkin.
Starring John Cliff, Walter Coy, Jim Goodwin.
Denver Pyle as Eben.

1955: *The Lone Ranger*
"The Woman in the White Mask"
(ABC)
Directed by Wilhelm Thiele; written by George W. Trendle, Robert Schaefer, Eric Freiwald, Dan Beattie.
Starring Clayton Moore, Chuck Courtney, Phyllis Coates.
Denver Pyle as Colby.

Steve Donovan, Western Marshal
"Outlaw Actor"
(Jack Chertok Television Productions)
Directed by Charles D. Livingstone; written by Eric Freiwald, Robert Schaefer.
Starring Douglas Kennedy, Eddy Waller, Edit Angold.
Denver Pyle as Vic Hoyt.

Buffalo Bill, Jr.
"Hooded Vengeance"
(Flying 'A' Productions)
Directed by George Archainbaud; written by Maurice Geraghty.
Starring Dickie Jones, Nancy Gilbert, Harry Cheshire.
Denver Pyle as Delafield.

Buffalo Bill, Jr.
"The Black Ghost"
(Flying 'A' Productions)
Directed by George Archainbaud; written by Paul Gangelin.
Starring Dickie Jones, Nancy Gilbert, Harry Cheshire.
Denver Pyle as Landers – Henchman.

Rage at Dawn
(RKO Radio)
Directed by Tim Whelan; written by Horace McCoy, Frank Gruber.
Starring Randolph Scott, Forrest Tucker, Mala Powers.
Denver Pyle as Clint Reno.

1954: *The Lone Ranger*
"The Fugitive"
(ABC)
Directed by Wilhelm Thiele; written by George W. Trendle, Jack Laird, Betty Joyce.
Starring Clayton Moore, Jay Silverheels, Paul Langton.
Denver Pyle as Stack.

The Yellow Mountain
(Universal)
Directed by Jesse Hibbs; written by George Zuckerman, Russell S. Hughes, Robert Blees, Harold Channing Wire.
Starring Lex Barker, Mala Powers, Howard Duff.
Denver Pyle as George Yost.

The Gene Autry Show
"Outlaw of Blue Mesa"
(CBS)
Directed by Frank McDonald; written by Oliver Drake.
Starring Gene Autry, Champion, Margaret Field.
Denver Pyle as Edward Hadley.

The Gene Autry Show
"The Carnival Comes West"
(CBS)
Directed by D. Ross Lederman; written by Buckley Angell.
Starring Gene Autry, Champion, Ann Doran.
Denver Pyle as Jim, the Sheriff.

The Gene Autry Show
"The Sharpshooter"
(CBS)
Directed by Frank McDonald; written by Robert Schaefer, Eric Freiwald.
Starring Gene Autry, Champion, Margaret Field.
Denver Pyle as Clean-shaven Deputy-Henchman.

The Gene Autry Show
"Johnny Jackeroo"
(CBS)

Directed by D. Ross Lederman; written by Robert Schaefer, Eric Freiwald.
Starring Gene Autry, Champion, Ann Doran.
Denver Pyle as Sheriff.

The Adventures of Kit Carson
"Bullets of Mysteries"
(Revue Productions)
Written by Barry Shipman.
Starring Bill Williams, Don Diamond, Edward, Colmans.
Denver Pyle as unnamed character.

The Adventures of Kit Carson
"Stampede Fury"
(Revue Productions)
Written by Barry Shipman.
Starring Bill Williams, Don Diamond, Pamela Duncan.
Denver Pyle as unnamed character.

The Adventures of Kit Carson
"Counterfeit Country"
(Revue Productions)
Starring Bill Williams, Don Diamond, Chris Alcaide.
Denver Pyle as unnamed character.

Annie Oakley
"Annie's Desert Adventure"
(CBS)
Directed by Robert G. Walker; written by Jack Townley.
Starring Gail Davis, Jimmy Hawkins, Brad Johnson.
Denver Pyle as Tom Malloy.

Annie Oakley
"Valley of the Shadows"
(CBS)
Directed by Robert G. Walker; written by Robert Schaefer, Eric Freiwald.
Starring Gail Davis, Jimmy Hawkins, Brad Johnson.
Denver Pyle as Dr. Barnes.

Stories of the Century
"Sam Bass"
(Studio City Television Productions)
Directed by William Witney; written by Milton Raison.
Starring Jim Davis, Mary Castle, Don Haggerty.
Denver Pyle as Henchman Bill Hayes.

Ride Clear of Diablo
(Universal)
Directed by Jesse Hibbs; written by George Zuckerman, D. D. Beauchamp, Ellis Marcus.
Starring Audie Murphy, Susan Cabot, Dan Duryea.
Denver Pyle as Rev. Moorehead.

Hopalong Cassidy
"The Outlaw's Reward"
Directed by George Archainbaud; written by Eric Freiwald, Clarence E. Mulford, Robert Schaefer.
Starring William Boyd, Edgar Buchanan, Harlan Warde.
Denver Pyle as Henchman.

1953: *Death Valley Days*
"Swamper Ike"
(Flying 'A' Productions)
Directed by Stuart E. McGowan; written by Ruth C. Woodman.
Starring Jock Mahoney, Margaret Field, Denver Pyle.
Denver Pyle stars as Art Crowley.

The Lone Ranger
"The Old Cowboy"
(ABC)
Directed by Paul Landres; written by George W. Trendle, Terence Maples, Fran Striker.
Starring John Hart, Jay Silverheels, Russell Simpson.
Denver Pyle as Deputy French.

The Adventures of Kit Carson
"Renegades Wires"
(Revue Productions)
Starring Bill Williams, Don Diamond, Denver Pyle.
Denver Pyle stars as unnamed character.

The Range Rider
"Indian War Party"
(Flying 'A' Productions)
Directed by D. Ross Lederman; written by John K. Butler.
Starring Jock Mahoney, Dickie Jones, Gloria Saunders.
Denver Pyle as Frank L. Sieber.

The Range Rider
"Cherokee Round-Up"
(Flying 'A' Productions)
Directed by D. Ross Lederman; written by Oliver Drake.
Starring Jock Mahoney, Dickie Jones, Gloria Saunders.
Denver Pyle as John Stewart.

Texas Bad Man
(Allied Artists)
Directed by Lewis D. Collins; written by Joseph F. Poland.
Starring Wayne Morris, Frank Ferguson, Elaine Riley.
Denver Pyle as Tench.

Vigilante Terror
(Allied Artists)
Directed by Lewis D. Collins; written by Sidney Theil.
Starring Bill Elliott, Mary Ellen Kay, Robert Bray.
Denver Pyle as Henchman Sperry.

Topeka
(Allied Artists)
Directed by Thomas Carr; written by Milton Raison.
Starring Bill Elliott, Phyllis Coates, Rick Vallin.
Denver Pyle as Jonas Bailey.

Column South
(Universal)
Directed by Frederick De Cordova; written by William Sackheim.
Starring Audie Murphy, Joan Evans, Robert Sterling.
Denver Pyle as Confederate Spy in Yankee Uniform.

Rebel City
(Allied Artists)
Directed by Thomas Carr; written by Sidney Theil.
Starring Bill Elliott, Marjorie Lord, Robert Kent.
Denver Pyle as Greeley.

The Roy Rogers Show
"Loaded Guns"
(NBC)
Directed by Robert G. Walker; written by Milton Raison.
Starring Roy Rogers, Trigger, Dale Evans.
Denver Pyle as Tom Larrabee.

Fort Vengeance
(Allied Artists)
Directed by Lesley Selander; written by Daniel B. Ullman.
Starring James Craig, Rita Moreno, Keith Larsen.
Denver Pyle as Rider Warning About Wagon Train.

The Lone Hand
(Universal)
Directed by George Sherman; written by Joseph Hoffman, Irving Ravetch.
Starring Joel McCrea, Barbara Hale, Alex Nicol.
Denver Pyle as Regulator.

Gunsmoke
(Universal)
Directed by Nathan Juran; written by D. D. Beauchamp, Norman A. Fox.
Starring Audie Murphy, Susan Cabot, Paul Kelly.
Denver Pyle as Greasy.

1952: *The Gene Autry Show*
"The Sheriff is a Lady"
(CBS)
Directed by George Blair; written by Dwight Cummins.
Starring Gene Autry, Champion, Pat Buttram.
Denver Pyle as Dodge Hartman.

The Gene Autry Show
"Bullets & Bows"
(CBS)
Directed by George Blair; written by Robert Schaefer, Eric Freiwald.
Starring Gene Autry, Champion, Pat Buttram.
Denver Pyle as Burr Ramsey.

The Gene Autry Show
"Melody Mesa"
(CBS)
Directed by George Archainbaud; written by Betty Burbridge.
Starring Gene Autry, Champion, Pat Buttram.
Denver Pyle as Professor Sharp.

The Adventures of Kit Carson
"Broken Spur"
(Revue Productions)
Directed by John English; written by Barry Shipman.
Starring Bill Williams, Don Diamond, Denver Pyle.
Denver Pyle stars as Hackett.

The Adventures of Kit Carson
"Highway to Doom"
(Revue Productions)
Directed by John English; written by Eric Taylor.
Starring Bill Williams, Don Diamond, Denver Pyle.
Denver Pyle stars as Flip Kilson.

The Adventures of Kit Carson
"Bandit's Blade"
(Revue Productions)
Directed by John English; written by Eric Freiwald, Robert Schaefer.
Starring Bill Williams, Don Diamond, Denver Pyle.
Denver Pyle stars as Edmund Denning.

Hopalong Cassidy
"Blind Encounter"
Directed by Thomas Carr; written by Clarence E. Mulford, Sherman L. Lowe.
Starring William Boyd, Edgar Buchanan, Pepe Hern.
Denver Pyle as Poynter – Henchman.

The Range Rider
"Secret of the Red Raven"
(Flying 'A' Productions)
Directed by Wallace Fox.
Starring Jock Mahoney, Dickie Jones, Sherry Jackson.
Denver Pyle as Henchman Carl.

The Range Rider
"Rustler's Range"
(Flying 'A' Productions)
Directed by Wallace Fox; written by Elizabeth Beecher.
Starring Jock Mahoney, Dickie Jones, Ruth Brady.
Denver Pyle as Vincent Frost.

The Range Rider
"Outlaw Masquerade"
(Flying 'A' Productions)
Starring Jock Mahoney, Dickie Jones, Christine McIntyre.
Denver Pyle as Henchman Jim.

The Range Rider
"Jimmy the Kid"
(Flying 'A' Productions)
Directed by Wallace Fox; written by Milton Raison.
Starring Jock Mahoney, Dickie Jones, Wendy Waldron.
Denver Pyle as Bill.

The Cisco Kid
"Ghost Town"
(Ziv Television)
Directed by Eddie Davis; written by J. Benton Cheney,

The Range Rider
"Gold Fever"
(Flying 'A' Productions)
Directed by George Archainbaud.
Starring Jock Mahoney, Dickie Jones, Lois Hall.
Denver Pyle as Bushwhacker.

The Roy Rogers Show
"Flying Bullets"
(NBC)
Directed by Robert G. Walker; written by Dwight Cummins.
Starring Roy Rogers, Trigger, Dale Evans.
Denver Pyle as Zeke Miller.

The Roy Rogers Show
"Doublecrosser"
(NBC)
Directed by Robert G. Walker; written by Albert DeMond, Ray Wilson.
Starring Roy Rogers, Trigger, Dale Evans.
Denver Pyle as Bad Boy Wiley.

The Roy Rogers Show
"The Treasure of Howling Dog Canyon"
(NBC)
Directed by Robert G. Walker; written by Albert DeMond, Ray Wilson.
Starring Roy Rogers, Trigger, Dale Evans.
Denver Pyle as Henchman Nash.

Cowboy G-Men
"Salted Mines"
(Telemount-Mutual)
Directed by Lesley Selander; written by Todhunter Ballard.
Starring Russell Hayden, Jackie Coogan, Archie Twitchell.
Denver Pyle as Henchman Gus.

The Maverick
(Allied Artists)
Directed by Thomas Carr; written by Sidney Theirl.
Starring Bill Elliott, Myron Healey, Phyllis Coates.
Denver Pyle as Bud Karnes.

Canyon Ambush
(Monogram)
Directed by Lewis D. Collins; written by Joseph F. Poland.
Starring Johnny Mack Brown, Lee Roberts, Phyllis Coates.
Denver Pyle as Tom Carlton.

Fargo
(Monogram)
Directed by Lewis D. Collins; written by Jack DeWitt, Joseph F. Poland.
Starring Bill Elliott, Myron Healey, Phyllis Coates.
Denver Pyle as Carey.

Desert Passage
(RKO Radio)
Directed by Lesley Selander; written by Norman Houston.
Starring Tim Holt, Joan Dixon, Walter Reed.
Denver Pyle as Allen.

Man from the Black Hills
(Monogram)
Directed by Thomas Carr; written by Joseph O'Donnell.
Starring Johnny Mack Brown, James Ellison, Rand Brooks.
Denver Pyle as Glenn Hartley.

Oklahoma Annie
(Republic)
Directed by R. G. Springsteen; written by Jack Townley, Charles E. Roberts.
Starring Judy Canova, John Russell, Grant Withers.
Denver Pyle as Skip.

The Cisco Kid
"Ghost Town"
(Ziv Television)
Directed by Eddie Davis; written by J. Benton Cheney,

O. Henry.
Starring Duncan Renaldo, Leo Carrillo, Marcia Mae Jones.
Denver Pyle as Bank Robber.

1951: *The Lone Ranger*
"The Hooded Men"
(ABC)
Directed by Hollingsworth Morse; written by George W. Trendle, Joseph Richardson, Dan Beattie, Fran Striker.
Starring Clayton Moore, Jay Silverheels, Mira McKinney.
Denver Pyle as Deputy Allen.

The Lone Ranger
"The Outcast"
(ABC)
Directed by Hollingsworth Morse; written by George W. Trendle, Marjorie E. Fortin, Dan Beattie, Fran Striker.
Starring Clayton Moore, Jay Silverheels, Robert Rockwell.
Denver Pyle as Grayson.

The Gene Autry Show
"Galloping Hoofs"
(CBS)
Directed by George Archainbaud; written by Dwight Cummins.
Starring Gene Autry, Champion, Pat Buttram.
Denver Pyle as Curt Wayne.

The Gene Autry Show
"Killer's Trail"
(CBS)
Directed by George Archainbaud; written by Oliver Drake.
Starring Gene Autry, Champion, Pat Buttram.
Denver Pyle as Frank Blake.

The Gene Autry Show
"Frontier Guard"
(CBS)
Directed by George Archainbaud; written by Fred Myton.
Starring Gene Autry, Champion, Pat Buttram.
Denver Pyle as First Henchman.

The Range Rider
"Western Fugitive"
(Flying 'A' Productions)
Directed by George Archainbaud; written by Oliver Drake.
Starring Jock Mahoney, Dickie Jones, Margaret Field.
Denver Pyle as Blackie - Henchman.

The Range Rider
"The Hawk"
(Flying 'A' Productions)
Directed by George Archainbaud.
Starring Jock Mahoney, Dickie Jones, Louise Lorimer.
Denver Pyle as Charles Todd aka The Hawk.

The Range Rider
"Six Gun Party"
(Flying 'A' Productions)
Directed by George Archainbaud; written by Samuel Newman.
Starring Jock Mahoney, Dickie Jones, Elaine Riley.
Denver Pyle as Barney Kimball.

The Range Rider
"Right of Way"
(Flying 'A' Productions)
Directed by George Archainbaud; written by Eric Freiwald, Robert Schaefer.
Starring Jock Mahoney, Dickie Jones, Margaret Field.
Denver Pyle as Henchman.

The Range Rider
"Gunslinger in Paradise"
(Flying 'A' Productions)
Directed by George Archainbaud; written by Sherman L. Lowe.
Starring Jock Mahoney, Dickie Jones, Elaine Riley.

Denver Pyle as Lawyer Bemis.

The Range Rider
"Dead Man's Shoe"
(Flying 'A' Productions)
Starring Jock Mahoney, Dickie Jones, Louise Lorimer.
Denver Pyle as Gorham.

The Range Rider
"Big Medicine Man"
(Flying 'A' Productions)
Directed by Wallace Fox.
Starring Jock Mahoney, Dickie Jones, Sandra Valles.
Denver Pyle as Henchman Trigger Morrison.

The Cisco Kid
"Hypnotist Murder"
(Ziv Television)
Directed by Eddie Davis; written by J. Benton Cheney, O. Henry.
Starring Duncan Renaldo, Leo Carrillo, Marcia Mae Jones.
Denver Pyle as Professor Jerry Roark.

The Hills of Utah
(Columbia)
Directed by John English; written by Gerald Geraghty, Les Savage Jr.
Starring Gene Autry, Champion, Elaine Riley.
Denver Pyle as Bowie French.

Rough Riders of Durango
(Republic)
Directed by Fred C. Brannon; written by M. Coates Webster.
Starring Allan Lane, Black Jack, Walter Baldwin.
Denver Pyle as Henchman Lacey.

1950: *The Old Frontier*
(Republic)
Directed by Philip Ford; written by Robert Creighton Williams.
Starring Monte Hale, Paul Hurst, Claudia Barrett.
Denver Pyle as Henchman George.

Dynamite Pass
(RKO Radio)
Directed by Lew Landers; written by Norman Houston.
Starring Tim Holt, Lynne Roberts, Regis Toomey.
Denver Pyle as Thurber Henchman.

1949: *Hellfire*
(Republic)
Directed by R. G. Springsteen; written by Dorrell McGowen, Stuart E. McGowen.
Starring Bill Elliott, Marie Windsor, Forrest Tucker.
Denver Pyle as Rex.

Red Canyon
(Universal)
Directed by George Sherman; written by Zane Grey (novel), Maurice Geraghty.
Starring Ann Blyth, Howard Duff, George Brent.
Denver Pyle as Hutch.

The Man from Colorado
(Columbia)
Directed by Henry Levin; written by Robert Hardy Andrews, Ben Maddow, Borden Chase.
Starring Glenn Ford, William Holden, Ellen Drew, Edgar Buchanan.
Denver Pyle as Easy Jarrett.

1948: *Marshal of Amarillo*
(Republic)
Directed by Philip Ford; written by Robert Creighton Williams.
Starring Allan Lane, Black Jack, Eddy Waller.
Denver Pyle as The Night Clerk.

1988: Bonanza: The Next Generation
(CBS)
Directed by William F. Claxton; written by David Dortort, Paul Savage.
Starring Robert Fuller, John Ireland, Peter Mark Richman.
Peter Mark Richman stars as Mr. Dunson.

1971: Yuma
(ABC)
Directed by Ted Post; written by Charles A. Wallace.
Starring Clint Walker, Barry Sullivan, Kathryn Hays.
Peter Mark Richman as Major Lucas.

The Virginian
"Tate, Ramrod"
(Universal)
Directed by Marc Daniels; written by Arthur Browne Jr., Owen Wister (novel).
Starring Stewart Granger, Doug McClure, Lee Majors, James Drury.
Peter Mark Richman as Wade.

1967: The Virginian
"The Gauntlet"
(Universal)
Directed by Thomas Carr; written by Lou Shaw, Owen Wister (novel).
Starring Charles Bickford, Doug McClure, Clu Gulager, James Drury.
Peter Mark Richman as Al Keets.

1964: The Virginian
"The Girl from Yesterday"
(Universal)
Directed by John Florea; written by Mark Rodgers, Louis Vittes, Charles Marquis Warren, Owen Wister (novel).
Starring Lee J. Cobb, Doug McClure, Clu Gulager, James Drury.
Peter Mark Richman as Jack Wade.

1963: The Virginian
"A Portrait of Marie Valonne"
(Universal)
Directed by Earl Bellamy; written by Dean Riesner, Owen Wister (novel).
Starring Lee J. Cobb, Doug McClure, Gary Clarke, James Drury.
Peter Mark Richman as Johnny Madrid.

1969: Lancer
"Angel Day and Her Sunshine Girls"
(20th Century Fox Television)
Directed by Don Richardson; written by Samuel A. Peeples, Jack Turley.
Starring James Stacy, Wayne Maunder, Andrew Duggan.
Peter Mark Richman as Carl Bolton.

1968: Bonanza
"A World Full of Cannibals"
(NBC)
Directed by Gunnar Hellström; written by David Dortort, Preston Wood.
Starring Lorne Greene, Dan Blocker, Michael Landon.
Peter Mark Richman as Richard Vardeman.

Gunsmoke
"Mr. Sam'l"
(CBS)
Directed by Gunnar Hellström; written by Harry Kronman.
Starring James Arness, Milburn Stone, Amanda Blake.
Peter Mark Richman as Norm Trainer.

1967: Daniel Boone
"The Renegade"
(20th Century Fox Television)
Directed by William Wiard; written by Rick Husky, Melvin Levy.
Starring Fess Parker, Ed Ames, Peter Mark Richman.
Peter Mark Richman stars as Hawk.

Iron Horse
"The Passenger"
(ABC)
Directed by William J. Hole Jr.; written by Irving Cummings Jr., Charles R. Marion, James Goldstone, Stephen Kandel.
Starring Dale Robertson, Gary Collins, Robert Random.
Peter Mark Richman as Pierre Le Druc.

1966: The Loner
"Incident in the Middle of Nowhere"
(CBS)
Directed by Joseph Pevney; written by Rod Serling, Andy White.
Starring Lloyd Bridges, Peter Mark Richman, Beverly Garland.
Peter Mark Richman stars as Conway.

1965: The Wild Wild West
"The Night of the Dancing Death"
(CBS)
Directed by Harvey Hart; written by William Tunberg, Fred Feiberger, Michael Garrison.
Starring Robert Conrad, Ross Martin, Peter Mark Richman.
Peter Mark Richman stars as Prince Glo.

1963: Stoney Burke
"The Journey"
(ABC)
Directed by Leslie Stevens; written by Leslie Stevens.
Starring Jack Lord, Warren Oates, Robert Dowdell.
Peter Mark Richman as Redmond.

1959: Hotel de Paree
"Return of Monique"
(CBS)
Directed by Walter Grauman; written by Doris Gilbert.
Starring Earl Holliman, Judi Meredith, Jeanette Nolan.
Peter Mark Richman as Raphael Riordan.

Zane Grey Theater
"Mission to Marathon"
(CBS)
Directed by John English; written by Hal Hudson, Christopher Knopf, Nina Laemmle, Aaron Spelling.
Starring Stephen McNally, John McIntire, Peter Mark Richman.
Peter Mark Richman stars as Gar Durand.

Rawhide
"Incident at Alabaster Plain"
(CBS)
Directed by Richard Whorf; written by David Swift.
Starring Eric Fleming, Clint Eastwood, Sheb Wooley.
Peter Mark Richman as Mastic.

1956: Friendly Persuasion
(Allied Artists)
Directed by William Wyler; written by Jessamyn West, Michael Wilson.
Starring Gary Cooper, Dorothy McGuire, Anthony Perkins.
Peter Mark Richman as Gard Jordan.

1981: Bordello
(Producciones Esmes S. A.)
Directed by Ramón Fernández;

written by Alfredo Mañas.
Starring Isela Vega, Jorge Rivero, Andrés García.
Jorge Rivero stars as Jeremías.

1978: Centennial
(NBC/Universal Television)
Created by John Wilder.
Directed by Paul Krasny; written by James A. Michener (novel), Charles Larsen, John Wilder, others.
Starring Raymond Burr, Barbara Carrera, Richard Chamberlain, William Atherton, Gregory Harrison, Robert Vaughn.
Jorge Rivero as Broken Thumb in 3 episodes.

1977: El Mexicano
(Cinematográfica Filmex S. A.)
Directed by René Cardona, Fernando Durán Rojas; written by Rafael Garcia Travesi.
Starring Jorge Rivero, Jaime Fernández, Jaime Fernández, Félix González.
Jorge Rivero stars as unnamed character in episodes #1.3, #1.2, #1.1.

Volver, Volver, Volver
(Producciones Águila)
Directed by Mario Hernández; written by Antonio Aguilar, Mario Hernández.
Starring Antonio Aguilar, Jorge Rivero, Claudia Islas.
Jorge Rivero stars as Jorge Montalvo.

1976: The Last Hard Man
(20th Century Fox)
Directed by Andrew V. McLaglen; written by Brian Garfield (novel), Guerdon Trueblood.
Starring Charlton Heston, James Coburn, Barbara Hershey, David Carradine.
Jorge Rivero as Menendez.

1974: Guns and Guts
(VCI Home Video)
Directed by René Cardona Jr.; written by Fernando Galiana.
Starring Jorge Rivero, Pedro Armendáriz Jr., Rogelio Guerra.
Jorge Rivero stars as El Pistolero.

1973: Carne de horca
(Estudios Churubusco Azteca S. A.)
Directed by Julio Aldama; written by Antonio Orellana.
Starring Jorge Rivero, Yolanda Ciani, Alfredo Leal.
Jorge Rivero stars as Ricardo.

Los hombres no lloran
(Estudios América)
Directed by Raúl de Anda Jr.; written by Rafael Garcia Travesi, Gregorio Walerstein, Raúl de Anda Jr., Raúl de Anda.
Starring Jorge Rivero, Rodolfo de Anda, Mario Almada.
Jorge Rivero stars as Eladio Garza.

1972: Indio
(Producciones Rodas S. A. de C. V.)
Directed by Rodolfo de Anda.
Starring Jorge Rivero, Mario Almada, Jorge Russek.
Jorge Rivero stars as Indio.

1971: The Two Brothers
(Cinematográfica Filmex S. A.)
Directed by Emilio Gómez Muriel, Tito Novaro; written by Juan Andrés Bueno.
Starring Jorge Rivero, Gregorio Casal, Nadia Milton.
Jorge Rivero stars as José Manuel Zamora.

1970: Rio Lobo
(National General)
Directed by Howard Hawks; written by Burton Wohl, Leigh Brackett.
Starring John Wayne, Jorge Riv-

ero, Jennifer O'Neill, Jack Elam, Christopher Mitchum.
Jorge Rivero stars as Capt. Pierre Cordona.

Soldier Blue
(Embassy)
Directed by Ralph Nelson; written by Theodore V. Olsen (novel), John Gay.
Starring Candice Bergen, Peter Strauss, Donald Pleasence, John Anderson.
Jorge Rivero as Spotted Wolf.

1967: La vuelta del Mexicano
(Cinematográfica Filmex S. A.)
Directed by René Cardona; written by Rafael Garcia Travesi.
Starring Jorge Rivero, Victor Junco, Carlos Cortés.
Jorge Rivero stars as Jacinto Olvera - Carlos

1966: Pistoleros de la frontera
(Cinematográfica Filmex S. A.)
Directed by Alberto Mariscal.
Starring José Baviera, Sonia Infante, Jorge Rivera.
Jorge Rivero stars as unnamed character.

Jinetes de la llanura
(Cinematográfica Filmex S. A.)
Directed by Alberto Mariscal; written by Tafael Garcia Travesi.
Starring Jorge Rivero, Regina Torné, Wolf Ruvinskis.
Jorge Rivero stars as Ramiro Armenta.

El mexicano
(Cinematográfica Filmex S. A.)
Directed by René Cardona.
Starring Jorge Rivera, Tere Velázquez, Jaime Fernández.
Jorge Rivero stars as unnamed character.

1998: Dr. Quinn, Medicine Woman
"The Fight"
(CBS)
Directed by Steve Dubin; written by Eric Tuchman.
Starring Jane Seymour, Joe Lando, Chad Allen.
Richard Roundtree as "Barracuda' Jim Barnes.

1995: Bonanza: Under Attack
(NBC)
Directed by Mark Tinker; written by David Dortort, Denne Bart Petitclerc.
Starring Ben Johnson, Michael Landon Jr., Emily Warfield, Jack Elam.
Richard Roundtree as Jacob.

1993: Bonanza: The Return
(NBC)
Directed by Jerry Jameson; written by David Dortort, Michael Landon Jr., Michael McGreevey, Tom Brinson.
Starring Ben Johnson, Michael Landon Jr., Emily Warfield, Jack Elam.
Richard Roundtree as Jacob Briscoe.

1991: The Young Riders
"Kansas"
(ABC/MGM Television)
Directed by Virgil W. Vogel; written by Ed Spielman, Steven Baum, James Lee Crite.
Starring Stephen Baldwin, Josh Brolin, Travis Fine, Anthony Zerbe.
Richard Roundtree as Calvin.

1990: Bad Jim
(21st Century Film Corporation)
Directed by Clyde Ware; written by Clyde Ware.
Starring James Brolin, Richard Roundtree, John Clark Gable.
Richard Roundtree stars as July.

1987: Outlaws
(CBS/Universal Television)
Created by Nicholas Corea.
Directed by Nicholas Corea, Phil Bondelli, others; written by Nicholas Corea, David Chisholm, Timothy Burns, others.
Starring Rod Taylor, William Lucking, Charles Napier.
Richard Roundtree as Isaiah 'Ice' McAdams in all 12 episodes.

1973: Charley-One-Eye
(Paramount)
Directed by Don Chaffey; written by Keith Leonard.
Starring Richard Roundtree, Roy Thinnes, Nigel Davenport.
Richard Roundtree stars as The Black Man.

1992: The Young Riders
"Lessons Learned"
(ABC/MGM Television)
Directed by Guy Magar; written by Ed Spielman, Steven Baum.
Starring Stephen Baldwin, Josh Brolin, Joseph Romanov.
Mitchell Ryan as Ryan.

1985: North and South
Created by Douglas Heyes.
(ABC/Warner Bros. Television)
Directed by Richard T. Heffron; written by John Jakes (novel), Douglas Heyes, Patricia Green.
Starring Kirstie Alley, Georg Stanford Brown, David Carradine, Hal Holbrook, Robert Mitchum.
Mitchell Ryan as Tillet Main in 6 episodes.

1983: Kenny Rogers as the Gambler: The Adventure Continues
(CBS)
Directed by Dick Lowry; written by Jim Byrnes, Don Schlitz, Cort Casady.
Starring Kenny Rogers, Bruce Boxleitner, Linda Evans, Johnny Crawford, Paul Koslo.
Mitchell Ryan as Charlie McCourt.

1980: The Chisholms
Created by David Dortort, Evan Hunter.
(CBS)
Directed by Edward M. Abroms, Sigmund Neufeld Jr., Mel Stuart, others; written by Evan Hunter, Harold Swanton, David Dortort, Jackson Gillis.
Starring Rosemary Harris, Ben Murphy, James Van Patten.
Mitchell Ryan as Cooper Hawkins in 9 episodes.

1977: Peter Lundy and the Medicine Hat Stallion
(NBC)
Directed by Michael O'Herlihy; written by Marguerite Henry (novel), Jack Turley.
Starring Leif Garrett, Milo O'Shea, Bibi Besch.
Mitchell Ryan as Jethro Lundy.

1973: High Plains Drifter
(Universal)
Directed by Clint Eastwood; written by Ernest Tidyman.
Starring Clint Eastwood, Vera Bloom, Marianna Hill, Geoffrey Lewis.
Mitchell Ryan as Dave Drake.

1971: The Hunting Party
(United Artists)
Directed by Don Medford; written by Gilbert Ralston, Lou Morheim, William W. Norton.
Starring Oliver Reed, Candice Bergen, Gene Hackman, L. Q. Jones.
Mitchell Ryan as Doc Harrison.

1970: *Monte Walsh*
(National General)
Directed by William A. Fraker; written by Lukas Heller, David Zelag Goodman, Jack Schaefer.
Starring Lee Marvin, Jeanne Moreau, Jack Palance, Bo Hopkins, Billy Green Bush.
Mitchell Ryan as Shorty Austin.

The High Chaparral
(NBC)
Directed by Don Richardson; written by Walter Black.
Starring Leif Erickson, Cameron Mitchell, Mark Slade.
Mitchell Ryan as Jelks.

JOHN SAVAGE

2013: *A Sierra Nevada Gunfight*
(Barnholtz Entertainment)
Directed by Vernon E. Mortensen; written by Johnny Harrington, Vernon E. Mortensen.
Starring Kirk Harris, Ryan Balance, Michael Madsen.
John Savage as Father Bill.

2000: *The Virginian*
(TNT)
Directed by Bill Pullman; written by Owen Wister (novel), Larry Gross.
Starring Bill Pullman, Diane Lane, John Savage.
John Savage as Steve.

1999: *The Jack Bull*
(HBO)
Directed by John Badham; written by Heinrich von Kleist (book), Dick Cusack.
Starring John Cusack, John Goodman, L. Q. Jones.
John Savage as Slater.

1991: *Buck ai confine del cielo*
(Media Creative Entertainment)
Directed by Tonino Ricci; written by Tito Carpi, Sheila Goldberg, Tonino Ricci.
Starring John Savage, David Hess, Jennifer Youngs.
John Savage stars as Wintrop.

1981: *Cattle Annie and Little Britches*
(Universal)
Directed by Lamont Johnson; written by David Eyre, Robert Ward.
Starring Scott Glenn, Diane Lane, Burt Lancaster, Rod Steiger.
John Savage as Bittercreek Newcomb.

1972: *Bad Company*
(Paramount)
Directed by Robert Benton; written by David Newman, Robert Benton.
Starring Jeff Bridges, Barry Brown, Jim Davis, Geoffrey Lewis, Ed Lauter.
John Savage as Loney.

JOHN SCHNEIDER

1998: *Dr. Quinn, Medicine Woman*
Created by Beth Sullivan
(CBS)
Directed by Jerry London, Bethany Rooney, James Keach, others; written by Beth Sullivan, Philip Gerson, Joel Ziskin, others.
Starring Jane Seymour, Joe Lando, Shawn Toovey, Chad Allen.
John Schneider as Daniel Simon in 15 episodes.

1993: *Dr. Quinn, Medicine Woman*
"A Cowboy's Lullaby"
(CBS)
Directed by Chuck Bowman; written by Beth Sullivan, Josef Anderson.
Starring Jane Seymour, Joe

Lando, Chad Allen.
John Schneider as Red McCall.

1994: *Texas*
(ABC)
Directed by Richard Lang; written by James A. Michner (novel), Sean Meredith.
Starring Maria Conchita Alonso, Benjamin Bratt, Frederick Coffin.
John Schneider as Davy Crockett.

1989: *Guns of Paradise*
"A Gathering of Guns"
(CBS)
Directed by Michael Lange; written by Joel J. Feigenbaum, David Jacobs, Robert Porter.
Starring Lee Horsley, Jenny Beck, Matthew Newmark.
John Schneider as Pat Garrett.

1986: *Stagecoach*
(CBS)
Directed by Ted Post; written by James Lee Barrett, Ernest Haycox, Dudley Nichols.
Starring Willie Nelson, Kris Kristofferson, Johnny Cash.
John Schneider as Buck – Overland Stage Driver.

JACQUELINE SCOTT

1979: *How the West Was Won*
"The Gunfighter"
(ABC/MGM Television)
Directed by Vincent McEveety; written by Ron Bishop, Steve Hayes.
Starring James Arness, Fionnila Flanagan, Bruce Boxleitner, Morgan Woodward.
Jacqueline Scott as Mrs. Ferguson.

1972: *Gunsmoke*
"The Predators"
(CBS)
Directed by Bernard McEveety; written by Calvin Clements Sr.
Starring James Arness, Milburn Stone, Amanda Blake.
Jacqueline Scott as Abelia.

1969: *Gunsmoke*
"A Man Called 'Smith'"
(CBS)
Directed by Vincent McEveety; written by Calvin Clements Sr.
Starring James Arness, Milburn Stone, Amanda Blake, Earl Holliman.
Jacqueline Scott as Abelia Johnson.

Death of a Gunfighter
(Universal)
Directed by Don Siegel, Robert Totten; written by Joseph Calvelli, Lewis B. Patten (novel).
Starring Richard Widmark, Lena Horne, Carroll O'Connor, Morgan Woodward, Dub Taylor, Royal Dano.
Jacqueline Scott as Laurie Mills.

Here Comes the Brides
"The Deadly Trade"
(ABC)
Directed by Paul Junger Witt; written by N. Richard Nash, Alan Marcus, William Blinn.
Starring Robert Brown, Bobby Sherman, David Soul, R. G. Armstrong.
Jacqueline Scott as Linda.

The Guns of Will Sonnett
"The Sodbuster"
(ABC)
Directed by Jean Yarbrough; written by Richard Carr, Kathleen Hite, Aaron Spelling.
Starring Walter Brennan, Dack Rambo, Jacqueline Scott.
Jacqueline Scott stars as Emily Damon.

1968: *Gunsmoke*
"Abelia"
(CBS)
Directed by Vincent McEveety; written by Calvin Clements Sr.
Starring James Arness, Milburn Stone, Amanda Blake.
Jacqueline Scott as Abelia.

Firecreek
(Warner Bros./Seven Arts)
Directed by Vincent McEveety; written by Calvin Clements Sr.
Starring James Stewart, Henry Fonda, Inga Stevens, Jack Elam, Barbara Luna, Morgan Woodward.
Jacqueline Scott as Henrietta Cobb.

1967: *Gunsmoke*
"Stranger in Town"
(CBS)
Directed by E. Darrell Hallenbeck; written by John Dunkel, Emily Mosher.
Starring James Arness, Milburn Stone, Amanda Blake, R. G. Armstrong.
Jacqueline Scott as Ann Madison.

1966: *Gunsmoke*
"The Whispering Tree"
(CBS)
Directed by Vincent McEveety; written by Calvin Clements Sr.
Starring James Arness, Milburn Stone, Amanda Blake, Ed Asner, Morgan Woodward.
Jacqueline Scott as Ada Stanley.

1965: *Bonanza*
"A Natural Wizard"
(NBC)
Directed by Robert Totten; written by William Blinn, Suzanne Clauser.
Starring Dan Blocker, Michael Landon, Lorne Greene.
Jacqueline Scott as Joy Dexter.

1964: *Gunsmoke*
"Kitty Cornered"
(CBS)
Directed by John Brahm; written by Kathleen Hite.
Starring James Arness, Milburn Stone, Amanda Blake.
Jacqueline Scott as Stella.

Bonanza
"The Hostage"
(NBC)
Directed by Don McDougall; written by Donn Mullally.
Starring Lorne Greene, Pernell Roberts, Dan Blocker.
Jacqueline Scott as Willa Cord.

1963: *Temple Houston*
"Gallows in Galilee"
Directed by Robert Totten; written by E. M. Parsons.
Starring Jeffrey Hunter, Jack Elam, Andy Albin.
Jacqueline Scott as Kate Hagadorn.

Laramie
"The Sometime Gambler"
(NBC)
Directed by Lesley Selander; written by John Meredyth Lucas, Rod Peterson.
Starring John Smith, Robert Fuller, Spring Byington.
Jacqueline Scott as Ellen.

Laramie
"The Wedding Party"
(NBC)
Directed by Jesse Hibbs; written by John C. Champion.
Starring John Smith, Robert Fuller, Spring Byington.
Jacqueline Scott as Stacey Bishop.

Have Gun – Will Travel
"Cage at McNaab"
(CBS)
Directed by Gary Nelson; written by Gene Roddenberry,

Herb Meadow, Sam Rolfe.
Starring Richard Boone, Lon Chaney Jr., Jacqueline Scott.
Jacqueline Scott stars as Nora Larson.

1962: *Gunsmoke*
"Collie's Free"
(CBS)
Directed by Harry Harris; written by Kathleen Hite.
Starring James Arness, Milburn Stone, Amanda Blake.
Jacqueline Scott as Francie.

Bonanza
"The Tall Stranger"
(NBC)
Directed by Don McDougall; written by Ward Hawkins.
Starring Lorne Greene, Pernell Roberts, Dan Blocker.
Jacqueline Scott as Kathie.

Laramie
"Shadow of the Past"
(NBC)
Directed by Herman Hoffman; written by Daniel B. Ullman.
Starring John Smith, Robert Fuller, Spring Byington.
Jacqueline Scott as Francie.

Stoney Burke
"The Wanderer"
(ABC/United Artists Television)
Directed by Leonard J. Horn; written by Milton Geiger.
Starring Jack Lord, Albert Salmi, Jacqueline Scott.
Jacqueline Scott stars as Leora Dawson.

The Virginian
"Throw a Long Rope"
(NBC)
Directed by Ted Post; written by Harold Swanton, Owen Wister (novel).
Starring Lee J. Cobb, Doug McClure, Gary Clarke, James Drury, John Anderson.
Jacqueline Scott as Melissa Tatum.

Wide Country
"The Royce Bennett Story"
(NBC)
Directed by Alan Crosland Jr.; written by Donald S. Sanford.
Starring Earl Holliman, Andrew Prine, Steve Forrest.
Jacqueline Scott as Ella Bennett.

1960: *Have Gun – Will Travel*
"Crowbait"
(CBS)
Directed by Buzz Kulik; written by Shimon Wincelberg, Herb Meadow, Sam Rolfe.
Starring Richard Boone, Russell Collins, Jacqueline Scott.
Jacqueline Scott stars as Amanda - Crowbait's Daughter.

1961: *The Life and Legend of Wyatt Earp*
"Terror in the Desert"
(ABC)
Directed by Paul Landres; written by Frederick Hazlitt Brennan, John D. Gilchriese.
Starring Hugh O'Brian, Steve Brodie, James Seay.
Jacqueline Scott as Beth Grover.

1960: *U. S. Marshal*
"The Man Who Never Was"
(Desilu Productions)
Directed by Robert Altman; written by Jack Jacobs, Mort Briskin.
Starring John Bromfield, James Griffith, Adam Williams.
Jacqueline Scott as Doris Reeves.

U. S. Marshal
"The Triple Cross"
(Desilu Productions)
Directed by Robert Altman; written by Jack Jacobs.

Starring John Bromfield, James Griffith, Jacqueline Scott.
Jacqueline Scott stars as Mrs. Ben Tyler.

1959: *Gunsmoke*
"Love of a Good Woman"
(CBS)
Directed by Arthur Hiller; written by John Meston, Les Crutchfield.
Starring James Arness, Dennis Weaver, Milburn Stone.
Jacqueline Scott as Abbie Twilling.

Have Gun – Will Travel
"Fragile"
(CBS)
Directed by Andrew V. McLaglen; written by Shimon Wincelberg, Frank Pierson, Herb Meadow, Sam Rolfe.
Starring Richard Boone, Werner Klemperer, Jacqueline Scott.
Jacqueline Scott stars as Claire LaDoux.

Have Gun – Will Travel
"The Wager"
(CBS)
Directed by Andrew V. McLaglen; written by Denis Sanders, Terry Sanders, Herb Meadow, Sam Rolfe.
Starring Richard Boone, Denver Pyle, Jacqueline Scott.
Jacqueline Scott stars as Stacy Neal.

Bat Masterson
"The Canvas and the Cane"
(NBC)
Directed by Walter Doniger; written by Richard O'Connor (book), Don Brinkley.
Starring Gene Barry, John Sutton, Jacqueline Scott.
Jacqueline Scott stars as Teresa Renault.

Bat Masterson
"The Black Pearls"
(NBC)
Directed by Alan Crosland Jr.; written by Richard O'Connor (book), Wells Root.
Starring Gene Barry, James Coburn, Jacqueline Scott.
Jacqueline Scott stars as Carol Otis.

Zane Grey Theater
"Make It Look Good"
(CBS)
Directed by Anton Leader; written by Nina Laemmle, Marianne Mosner, Francis Rosenwald.
Starring Arthur Kennedy, Parley Baer, Jacqueline Scott.
Jacqueline Scott stars as Jenny Carter.

1958: *Have Gun – Will Travel*
"Twenty-Four Hours at North Fork"
(CBS)
Directed by Andrew V. McLaglen; written by Irving Rubine, Herb Meadow, Sam Rolfe.
Starring Richard Boone, Morris Ankrum, Jacqueline Scott.
Jacqueline Scott stars as Tildy Buchanan.

U. S. Marshal
"The Triple Cross"
(Desilu Productions)
Directed by Harve Foster; written by Don Martin.
Starring John Bromfield, Paul Richards, Jacqueline Scott.
Jacqueline Scott stars as Joan.

The Sheriff of Cochise
"The Man Who Never Was"
(National Telefilm Associates)
Directed by Robert Altman; written by Mort Briskin.
Starring John Bromfield, Owen Bush, Carole Cook.
Jacqueline Scott as unnamed character.

HENRY SILVA

1984: *Lust in the Dust*
(New World)
Directed by Paul Bartel; written by Philip John Taylor.
Starring Tab Hunter, Divine, Lainie Kazan.
Henry Silva as Bernardo.

1974: *Zanna Bianca alla riscossa*
(American Home Entertainment)
Directed by Tonino Ricci; written by Sandro Continenza, Giovanni Simonelli.
Starring Maurizio Merli, Henry Silva, Renzo Palmer.
Henry Silva stars as Mr. Nelson.

1971: *Black Noon*
(CBS)
Directed by Bernard L. Kowalski; written by Andrew J. Fenady.
Starring Roy Thinnes, Yvette Mimieux, Ray Milland.
Henry Silva as Moon.

1970: *The Animals*
(Levitt-Pickman)
Directed by Ron Joy; written by Richard Bakalyan.
Starring Michele Carey, Henry Silva, Keenan Wynn.
Henry Silva stars as Chatto.

1967: *High Chaparral*
"The Terrorist"
(NBC)
Directed by Ralph Senensky; written by William F. Leicester.
Starring Leif Erickson, Cameron Mitchell, Mark Slade.
Henry Silva as Santos Castaneda.

Cimarron Strip
"Journey to a Hanging"
(CBS)
Directed by Vincent McEveety; written by Christopher Knopf, Jack Curtis, Mel Goldberg.
Starring Stuart Whitman, Percy Herbert, Randy Boone.
Henry Silva as Coffin.

Laredo
"The Bitter Yen of General Ti"
(NBC/Universal Television)
Directed by Charles R. Rondeau; written by John T. Dugan.
Starring Neville Brand, Peter Brown, William Smith.
Henry Silva as Gen. Shen Ti.

1966: *The Hills Run Red*
(United Artists)
Directed by Carlo Lizzani; written by Piero Regnoli.
Starring Thomas Hunter, Henry Silva, Dan Duryea.
Henry Silva as Garcia Mendez.

The Plainsman
(Universal)
Directed by David Lowell Rich; written by Michael Blankfort.
Starring Don Murray, Guy Stockwell, Abby Dalton.
Henry Silva as Crazy Knife.

1965: *Daniel Boone*
"The Mound Builders"
(NBC/20th Century Fox Television)
Directed by Nathan Juran; written by Clyde Ware.
Starring Fess Parker, Ed Ames, Patricia Blair, Darby Hinton.
Henry Silva as Zapotec.

The Reward
(20th Century Fox)
Directed by Serge Bourguignon; written by Michael Barrett (novel), Serge Bourguignon, Oscar Millard.
Starring Max von Sydow, Yvette Mimieux, Efrem Zimbalist Jr.
Henry Silva as Joaquin.

Wagon Train
"The Silver Lady"
(ABC/Universal Television)
Directed by Andrew V. McLaglen; written by Dick Nelson.
Starring Robert Fuller, John McIntire, Frank McGrath, Vera Miles.
Henry Silva as Doc Holliday.

1963: *Wagon Train*
"The Robert Harrison Clarke Story"
(ABC/Universal Television)
Directed by William Witney; written by Gene L. Coon.
Starring John McIntire, Robert Fuller, Denny Miller.
Henry Silva as Sam Singh.

Stoney Burke
"The Weapons Man"
(ABC/United Artists Television)
Directed by Leslie Stevens; written by Leslie Stevens.
Starring Jack Lord, J. D. Cannon, Henry Silva.
Henry Silva stars as Matt Elder.

1962: *Wagon Train*
"The John Turnbull Story"
(ABC/Universal Television)
Directed by Charles F. Haas; written by Gene L. Coon.
Starring John McIntire, Robert Horton, Terry Wilson.
Henry Silva as John Turnbull.

1961: *Stagecoach West*
"The Raider"
(ABC)
Directed by Thomas Carr; written by D. D. Beauchamp, Mary M. Beauchamp.
Starring Richard Eyer, Robert Bray, Henry Silva.
Henry Silva stars as Mel Harney.

1960: *Hotel de Paree*
"Sundance and the Delayed Gun"
(CBS)
Starring Earl Holiman, Strother Martin, Barry McQuire.
Henry Silva as Start Thorne.

1959: *The Jayhawkers!*
(Paramount)
Directed by Melvin Frank; written by Melvin Frank, Joseph Petracca, Frank Fenton, A. I. Bezzerides.
Starring Jeff Chandler, Fess Parker, Nicole Maurey.
Henry Silva as Lordan.

1958: *Ride a Crooked Trail*
(Universal)
Directed by Jesse Hibbs; written by Borden Chase, George Bruce.
Starring Audie Murphy, Gia Scala, Walter Matthau.
Henry Silva as Sam Teeler.

The Bravados
(20th Century Fox)
Directed by Henry King; written by Philip Yordan, Frank O'Rourke (novel).
Starring Gregory Peck, Joan Collins, Stephen Boyd.
Henry Silva as Lujan.

The Law and Jake Wade
(Metro-Goldwyn-Mayer)
Directed by John Sturges; written by William Bowers, Marvin H. Albert (novel).
Starring Robert Taylor, Richard Widmark, Patricia Owens.
Henry Silva as Rennie.

1957: *The Tall T*
(Columbia)
Directed by Budd Boetticher; written by Burt Kennedy, Elmore Leonard.
Starring Randolph Scott, Richard Boone, Maureen O'Sullivan.
Henry Silva as Chink.

1952: *Viva Zapata!*
(20th Century Fox)
Directed by Elia Kazan; written by John Steinbeck.
Starring Marlon Brando, Jean Peters, Anthony Quinn.
Henry Silva as Hernandez.

TOM SIZEMORE

2016: *Traded*
(Cinedigm Entertainment Group)
Directed By Timothy Woodward Jr.; written by Mark Esslinger.
Starring Kris Kristofferson, Trace Adkins, Michael Paré, Martin Kove.
Tom Sizemore as Lavoie.

1994: *Wyatt Earp*
(Warner Bros.)
Directed by Lawrence Kasden; written by Dan Gordan, Lawrence Kasdan.
Starring Kevin Costner, Dennis Quaid, Gene Hackman, Martin Kove, Michael Madsen.
Tom Sizemore as Bat Masterson.

PAUL L. SMITH

1994: *Maverick*
(Warner Bros.)
Directed by Richard Donner; written by Roy Huggins, William Goldman.
Starring Mel Gibson, Jodie Foster, James Garner, James Coburn, Dub Taylor, Geoffrey Lewis, Art LaFleur.
Paul L. Smith as The Archduke.

1979: *The Frisco Kid*
(Warner Bros.)
Directed by Robert Aldrich; written by Michael Elias, Frank Shaw.
Starring Gene Wilder, Harrison Ford, Ramon Bieri.
Paul L. Smith as Person on Philadelphia dock.

1975: *We Are No Angels*
(Flaminia Produzioni Cinematografiche)
Directed by Gianfranco Parolini; written by Abronio Corti, Gianfranco Parolini.
Starring Antonio Cantafora, Paul L. Smith, Renato Cestiè.
Paul L. Smith stars as Raphael McDonald.

Carambola's Philosophy: In the Right Pocket
(Aetos Produzioni Cinematografiche)
Directed by Ferdinando Baldi; written by Ferdinando Baldi, Nico Ducci, Mino Roli.
Starring Antonio Cantafora, Paul L. Smith, Glauco Onorato.
Paul L. Smith stars as Len.

1974: *Carambola*
(Aetos Produzioni Cinematografiche)
Directed by Ferdinando Baldi; written by Ferdinando Baldi, Nico Ducci, Mino Roli.
Starring Paul L. Smith, Antonio Cantafora, Horst Frank.Paul L. Smith stars as Clem.

1970: *His Name Was Madron*
(Four Star Excelsior)
Directed by Jerry Hopper; written by Leo J. McMahon, Edward Chappell.
Starring Richard Boone, Leslie Caron, Gabi Amrani.
Paul L. Smith as Gabe Price.

1963: *Have Gun – Will Travel*
"The Eve of St. Elmo"
(CBS)
Directed by Andrew V. McLaglen; written by Herb Meadow, Sam Rolfe, Jay Simms.
Starring Richard Boone, Warren Stevens, Brett Somers,
George Kennedy.
Paul L. Smith as Sven – Manservant.

WILLIAM SMITH

2005: *Hell to Pay*
(Echo Bridge Home Entertainment)
Directed by Chris McIntire; written by Chris McIntire.
Starring Peter Brown, Jeff Davis, James Drury.
William Smith as Emil Brax.

1997: *The Shooter*
(Artisan Home Entertainment)
Directed by Fred Olen Ray; written by Tony Giglio.
Starring Michael Dudikoff, Randy Travis, Valerie Wildman.
William Smith as Jerry Krants.

1994: *Maverick*
(Warner Bros.)
Directed by Richard Donner; written by Roy Huggins, William Goldman.
Starring Mel Gibson, Jodie Foster, James Garner, James Coburn, Dub Taylor, Geoffrey Lewis, Art LaFleur.
William Smith as Riverboat Poker Player.

1991: *The Young Riders*
"A House Divided"
(ABC/MGM Television)
Directed by James Keach; written by Ed Spielman, Raymond Hartung.
Starring Stephen Baldwin, Josh Brolin, Travis Fine.
William Smith as Marshall Ben Turner.

Spirit of the Eagle
(Amsell Entertainment)
Directed by Boon Collins; written by Boon Collins, Joseph G. Tidwell III.
Starring Dan Haggerty, William Smith, Trever Yarrish.
William Smith stars as Hatchett.

1988: *Gun of Paradise*
"Founders' Day"
(CBS)
Directed by Michael Ray Rhodes; written by David Jacobs, Robert Porter.
Starring Lee Horsley, Jenny Beck, Matthey Newmark.
William Smith as Quincy Bradley.

1985: *Wildside*
(ABC/Buena Vista Television)
Created by Tom Greene.
Directed by Harvey S. Laidman, Richard C. Sarafian, others; written by Tom Greene, Joseph Jones, William Whitehead, Walter Brough, others.
Starring Howard E. Rollins Jr., William Smith, J. Eddie Peck, Meg Ryan.
William Smith stars as Brodie Hollister in 6 episodes.

1980: *Wild Times*
"Episode #1.1"
(Metromedia Producers Corporation)
Directed by Richard Compton; written by Don Balluck, Brian Garfield (novel).
Starring Sam Elliott, Ben Johnson, Bruce Boxleitner, Dennis Hopper, Harry Carey Jr.
William Smith as 1st Marshal.

1979: *The Frisco Kid*
(Warner Bros.)
Directed by Robert Aldrich; written by Michael Elias, Frank Shaw.
Starring Gene Wilder, Harrison Ford, Ramon Bieri.
William Smith as Matt Diggs.

The Rebels
(MCA/Universal Television)
Directed by Russ Mayberry; written by Sean Bain, Robert A. Cinader, John Jakes (novel).
Starring Andrew Stevens, Don Johnson, Doug McClure.
William Smith as John Waverly.

1977: *The Oregon Trail*
"Evan's Vendetta"
(NBC/Universal Television)
Directed by Paul Stanley; written by Budd Arthur (novel), Burt Arthur (novel), John Austin, Nicholas Corea.
Starring Rod Taylor, Charles Napier, Andrew Stevens.
William Smith as unnamed character.

1975: *Gunsmoke*
"Hard Labor"
(CBS)
Directed by Bernard McEveety; written by Earl W. Wallace, Hal Sitowitz.
Starring Milburn Stone, Ken Curtis, Buck Taylor.
William Smith as Latch.

Boss Nigger
(Dimension)
Directed by Jack Arnold; written by Fred Williamson.
Starring Fred Williamson, D'Urville Martin, William Smith, R. G. Armstrong.
William Smith stars as Jed Clayton.

1973: *The Deadly Trackers*
(Warner Bros.)
Directed by Barry Shear, Samuel Fuller; written by Samuel Fuller, Lukas Heller.
Starring Richard Harris, Rod Taylor, Al Lettieri, Neville Brand.
William Smith as Schoolboy.

Kung Fu
"The Chalice"
(ABC/Warner Bros. Television)
Directed by Jerry Thorpe; written by Ed Spielman, Herman Miller, William Kelley.
Starring David Carradine, William Smith, Gilbert Roland.
William Smith as Capt. Luther Staggers.

Gentle Savage
(Redwine International Films)
Directed by Sean MacGregor; written by Jacar Lane Dancer, Sean MacGregor.
Starring William Smith, Gene Evans, Joe Flynn, R. G. Armstrong, Barbara Luna.
William Smith stars as Camper John Allen.

1972: *Gunsmoke*
"Hostage"
(CBS)
Directed by Gunnar Hellström; written by Paul F. Edwards.
Starring Milburn Stone, Amanda Blake, Ken Curtis, James Arness, Geoffrey Lewis.
William Smith as Jude Bonner.

Alias Smith and Jones
"What Happened at the XST?"
(MCA Television)
Directed by Jack Arnold; written by Glen A. Larsen, Roy Huggins.
Starring Ben Murphy, Roger Davis, Keenan Wynn, Geoffrey Lewis.
William Smith as Deputy Orville Larkin.

1970: *Death Valley Days*
"The Contract"
(Flying 'A' Productions)
Directed by Jack Hively; written by William Canning.
Starring Dale Robertson, Richard Bull, Arlene McQuade.
William Smith as Red Eagle.

Death Valley Days
"The Dragon of Gold Hill"

(Flying 'A' Productions)
Directed by Jean Yarbrough;
written by Ann Udell.
Starring, Frontis Chandler,
Mark Jenkins, Tyler McVey.
William Smith as Dan Turner.

Daniel Boone
(NBC/20th Century Fox
Television)
Directed by William Wiard,
Jean Yarbrough, Nathan Juran;
written by Melvin Levy, Ann
Udell, Thomas P. Levy.
Starring Fess Parker, Patricia
Blair, Darby Hinton.
William Smith as Amos Martin
in 3 episodes.

1969: *Death Valley Days*
"The Understanding"
(Flying 'A' Productions)
Directed by Jack Hively; writ-
ten by Lance Hazzard.
Starring Emily Banks, Valentin
de Vargas, Robert Doyle.
William Smith as John Parker.

Death Valley Days
"A Restless Man"
(Flying 'A' Productions)
Directed by Harmon Jones;
written by Phyllis White,
Robert White.
Starring Tol Avery, Emily
Banks, Jason Clark.
William Smith as Marshall
Hendry Brown.

The Over-the-Hill Gang
(ABC)
Directed by Jean Yarbrough;
written by Jameson Brewer,
Lenard Goldberg.
Starring Walter Brennan, Edgar
Buchanan, Andy Devine, Bruce
Glover, Lana Wood.
William Smith as Amos.

1968: *Daniel Boone*
"Flag of Truce"
(NBC/20th Century Fox
Television)
Directed by William Wiard;
written by Irve Tunick.
Starring Fess Parker, Pilar Del
Rey, Joe Jenckes.
William Smith as Campuits.

The Guns of Will Sonnett
"The Fearless man"
(ABC)
Directed by Jean Yarbrough;
written by Richard Carr, Kath-
leen Hite, Aaron Spelling.
Starring Walter Brennan, Dack
Rambo, Paul Richards.
William Smith as Luther.

The Guns of Will Sonnett
"End of the Rope"
(ABC)
Directed by Jean Yarbrough;
written by Richard Carr, Aaron
Spelling.
Starring Walter Brennan, Dack
Rambo, Jason Evers.
William Smith as Deputy.

The Virginian
"Silver Image"
(NBC/Universal Television)
Directed by Don McDougall;
written by Joel Rogosin, Don
Tait, Owen Wister (novel).
Starring John McIntire, Doug
McClure, David Hartman,
James Drury.
William Smith as Spector.

Three Guns for Texas
(Universal)
Directed by Earl Bellamy, David
Lowell Rich, Paul Stanley;
written by John D. F. Black.
Starring Neville Brand, Peter
Brown, William Smith, Albert
Salmi, Dub Taylor.
William Smith stars as Texas
Ranger Joe Riley.

1967: *Daniel Boone*
"A Matter of Blood"
(NBC/20th Century Fox

Television)
Directed by Nathan Juran;
written by Judith Barrows,
Robert Guy barrows.
Starring Fess Parker, William
Smith, Harry Bellaver.
William Smith stars as Catoga.

The Guns of Will Sonnett
"The Favor"
(ABC)
Directed by Jean Yarbrough;
written by Richard Carr, Aaron
Spelling.
Starring Walter Brennan, Dack
Rambo, Stephen McNally,
Bruce Glover.
William Smith as Spence.

Custer
"Death Hunt"
(ABC/20th Century Fox
Television)
Directed by Leo Penn; written
by Steve McNeil, Richard Bart-
lett, Samuel A. Peeples, David
Weisbart, Larry Cohen.
Starring Wayne Maunder, Slim
Pickens, Robert F. Simon.
William Smith as Chief Tall
Knife.

Laredo
(NBC/Universal Television)
Directed by Alan Rafkin,
William Witney, Robert Gist,
others; written by Paul Mason,
Edward J. Lakso, John Mc-
Greevey, others.
Starring Neville Brand, Peter
Brown, William Smith, Claude
Akins.
William Smith stars as Joe Riley
in all 56 episodes.

1965: *The Virginian*
"We've Lost a Train"
(NBC/Universal Television)
Directed by Earl Bellamy; writ-
ten by Borden Chase, Owen
Wister (novel).
Starring Lee J. Cobb, Doug
McClure, Clu Gulager, James
Drury.
William Smith as Joe Riley.

The Virginian
"Timberland"
(NBC/Universal Television)
Directed by Don McDougall;
written by Sheldon Stark,
Owen Wister (novel).
Starring Lee J. Cobb, Doug
McClure, Clu Gulager, James
Drury.
William Smith as Paul Rogers.

1964: *The Virginian*
"Rope of Lies"
(NBC/Universal Television)
Directed by Herschel Daugh-
erty; written by Les Crutch-
field, Owen Wister (novel).
Starring Lee J. Cobb, Doug
McClure, Gary Clarke, James
Drury.
William Smith as Bill.

Wagon Train
"The Richard Bloodgood Story"
(ABC)
Directed by Joseph Pevney;
written by Leonard Praskins.
Starring John McIntire, Robert
Fuller, Frank McGrath.
William Smith as Espada.

Wagon Train
"The Bob Stuart Story"
(ABC)
Directed by Virgil W. Vogel;
written by Calvin Clements Sr.
Starring John McIntire, Robert
Fuller, Frank McGrath, Robert
Ryan, Andrew Prine, Vera
Miles.
William Smith as Thomas
Lance.

1963: *The Virginian*
"A Killer in Town"
(NBC/Universal Television)
Directed by John English;
written by Don Buchan, Wanda

Duncan, Owen Wister (novel).
Starring Lee J. Cobb, Doug
McClure, Gary Clarke, James
Drury.
William Smith as Andy Adams.

Stoney Burke
"Point of Entry"
(ABC/United Artists Television)
Directed by Leonard J. Horn;
written by Leslie Stevens.
Starring Jack Lord, Cesare
Danova, William Smith,
Warren Oates.
William Smith stars as Lieu-
tenant Joe Cardiff.

BO SVENSON

2018: *Railroad to Hell: A Chi-
naman's Chance*
(Ace Studios)
Directed by Aki Aleong; writ-
ten by Aki Aleong.
Starring Reggie Lee, Timothy
Bottoms, Jason Connery,
Danny Trejo.
Bo Svenson as Foreman Bo.

2008: *Chinaman's Chance:
America's Other Slaves*
(Mustard Seed Media Group)
Directed by Aki Aleong; writ-
ten by Aki Aleong, James Taku
Leung, Tiago Mesquita.
Starring Reggie Lee, Timothy
Bottoms, Jason Connery, Er-
nest Borgnine, Geoffrey Lewis,
Martin Kove.
Bo Svenson as Foreman Bo.

2005: *Hell to Pay*
(Echo Bridge Home Enter-
tainment)
Directed by Chris McIntire;
written by Chris McIntire.
Starring Peter Brown, Jeff Da-
vis, James Drury, Lee Majors,
Andrew Prine.
Bo Svenson as Del Shannon.

1998: *Dead Man's Gun*
"The Mimsers"
(Sugar Entertainment Ltd.)
Directed by Ken Jubenvill;
written by Howard Spielman,
Howard Friedlander.
Starring Lysette Anthony,
Chris Humphreys, Kris Kris-
tofferson.
Bo Svenson as Colonel Horace
Buckthorn.

1996: *Cheyenne*
(Vineyard Films)
Directed by Dimitri Logothetis;
written by Frederick Bailey.
Starring Gary Hudson, Bobbie
Phillips, Bo Svenson.
Bo Svenson stars as Capt.
Starrett.

1994: *Lonesome Dove: The Series*
"Last Stand"
(RHI Entertainment)
Directed by Paul Lynch;
written by Rick Drew, Larry
McMurtry.
Starring Scott Bairstow, Chris-
tianne Hirt, Eric McCormack,
Dennis Weaver.
Bo Svenson as Colonel Jeb
Quintano.

1984: *The Manhunt*
(The Samuel Goldwyn Com-
pany)
Directed by Fabrizio De
Angelis; written by Fabrizio De
Angelis, Dardano Sacchetti.
Starring Ethan Wayne, Rai-
mund Harmstorf, Henry Silva,
Ernest Borgnine.
Bo Svenson as Sheriff.

1973: *Kung Fu*
"The Spirit-Helper"
(ABC/Warner Bros. Television)
Directed by Walter Doniger;
written by Ed Spielman, Her-
man Miller, John T. Dygan.
Starring David Carradine, Bo
Svenson, Scott Hylands.
Bo Svenson stars as Pike.

1972: *The Bravos*
(ABC/Universal Television)
Directed by Ted Post; written
by Christopher Knopf, David
Victor, Douglas Benton, Ted
Post.
Starring George Peppard,
Pernell Roberts, Belinda Mont-
gomery, L. Q. Jones.
Bo Svenson as Raeder.

1970: *The Virginian*
"The Price of the Hanging"
(NBC/Universal Television)
Directed by Marc Daniels;
written by Frank Chase.
Starring Stewart Granger,
Doug McClure, Lee Majors,
James Drury.
Bo Svenson as Lonnie.

1969: *The High Chaparral*
"Trail to Nevermore"
(NBC)
Directed by Virgil W. Vogel;
written by Walter Black.
Starring Leif Erickson, Camer-
on Mitchell, Mark Slade.
Bo Svenson as Bennett.

Daniel Boone
"A Pinch of Salt"
(NBC/20th Century Fox
Television)
Directed by William Wiard;
written by Merwin Gerard.
Starring Fess Parker, Charles
Horvath, Paul Stader.
Bo Svenson as Warren Haskins.

Here Come the Brides
Created by N. Richard Nash.
(ABC/Screen Gems Television)
Directed by R. Robert Rosen-
baum, Richard Kinon, E. W.
Swackhamer, others; written
by N. Richard Nash, Alan
Marcus, William Blinn, James
Amesbury, others.
Starring Robert Brown, Bobby
Sherman, David Soul, Joan
Blondell.
Bo Svenson as Big Swede in 10
episodes.

Lancer
"The Wedding"
(CBS/20th Century Fox
Television)
Directed by Sobey Martin;
written by Samuel A. Peeples,
Anthony Spinner.
Starring James Stacy, Wayne
Maunder, Andrew Duggan.
Bo Svenson as Josh.

1968: *The Outcasts*
"The Heroes"
(ABC/Screen Gems Television)
Directed by Joseph Lejtes;
written by Ben Brady, Leon
Tokatyan, Daniel B. Ullman.
Starring Don Murray, Otis
Young, Royal Dano.
Bo Svenson as Pardee.

TIM THOMERSON

2008: *Duel*
(Cinema Epoch)
Directed by Steven R. Monroe;
written by Michael Worth.
Starring Michael Worth, Tim
Thomerson, Karen Kim.
Tim Thomerson stars as
Deston, Jared.

2005: *Hell to Pay*
(Echo Bridge Home Enter-
tainment)
Directed by Chris McIntire;
written by Chris McIntire.
Starring Peter Brown, Jeff Da-
vis, James Drury, Lee Majors,
Andrew Prine.
Tim Thomerson as Reverend.

1999: *The Magnificent Seven*
"The New Law"
(CBS/MGM Television)
Directed by Christopher Cain,
Gregg Champion; written by
Michael Norell, John Watson,
Pen Densham.

Starring Michael Biehn, Eric
Close, Dale Midkiff, Ron
Perlman, Robert Vaughn.
Tim Thomerson as Guy Royal.

1998: *The Magnificent Seven*
"The Collector"
(CBS/MGM Television)
Directed by Gregg Champion;
written by Michael Norell, John
Watson, Pen Densham.
Starring Michael Biehn, Eric
Close, Dale Midkiff, Ron
Perlman, Mike Moroff.
Tim Thomerson as Guy Royal.

1995: *Legend*
"Birth of a Legend"
(Paramount Television)
Directed by Charles Correll;
written by Michael Piller, Bill
Dial, Timothy Burns.
Starring Richard Dean An-
derson, John de Lancie, Mark
Adair-Rios.
Tim Thomerson as John
Wesley Coe.

1994: *The Cisco Kid*
(Turner)
Directed by Luis Valdez; writ-
ten by O. Henry, Michael Kane,
Luis Valdez.
Starring Jimmy Smits, Cheech
Marin, Sadie Frost.
Tim Thomerson as Lundquist.

1989: *The Young Riders*
"Black Ulysses"
(ABC)
Directed by Bruce Kessler;
written by Ed Spielman,
Dennis Cooper.
Starring Stephen Baldwin, Josh
Brolin, Brett Cullen, Anthony
Zerbe.
Tim Thomerson as Colonel
Savage.

1983: *Gun Shy*
(CBS/Walt Disney Productions)
Directed by Peter Baldwin,
Marc Daniels, Alan Myerson.
Starring Barry Van Dyke, Tim
Thomerson, Bridgette Ander-
son, Henry Jones, Geoffrey
Lewis, Keith Mitchell.
Tim Thomerson stars as Theo-
dore Ogilvie in all 6 episodes.

JAN-MICHAEL VINCENT

2000: *Escape to Grizzly
Mountain*
(MGM Home Entertainment)
Directed by Anthony Dalesan-
dro; written by Boon Collins,
Eric Parkinson.
Starring Dan Haggerty, Jan-Mi-
chael Vincent, Miko Hughes.
Jan-Michael Vincent stars as
Trapper.

1975: *Bite the Bullet*
(Columbia)
Directed by Richard Brooks;
written by Richard Brooks.
Starring Gene Hackman,
Candice Bergen, James Coburn,
Ben Johnson.
Jan-Michael Vincent as Carbo.

1971: *Gunsmoke*
"The Legend"
(CBS)
Directed by Philip Leacock;
written by Calvin Clements Jr.
Starring James Arness, Milburn
Stone, Amanda Blake, Buck
Taylor.
Jan-Michael Vincent as Travis
Colter.

1969: *The Undefeated*
(20th Century Fox)
Directed by Andrew V. Mc-
Laglen; written by James Lee
Barrett, Stanley Hough.
Starring John Wayne, Rock
Hudson, Antonio Aguilar, Ben
Johnson, Harry Carey Jr., Royal
Dano, Ed Faulkner.
Jan-Michael Vincent as Bubba
Wilkes.

Bonanza
"The Unwanted"
(NBC)
Directed by Herschel Daugherty; written by David Dortort, Suzanne Clauser, Fred Hamilton, Thomas Thompson.
Starring Lorne Greene, Dan Blocker, Michael Landon.
Jan-Michael Vincent as Rick Miller.

1968: *Bonanza*
"The Arrival of Eddie"
(NBC)
Directed by Marc Daniels; written by David Dortort, John M. Chester, Ward Hawkins, Fred Hamilton.
Starring Lorne Greene, Dan Blocker, Michael Landon.
Jan-Michael Vincent as Eddie.

Journey to Shiloh
(Universal)
Directed by William Hale; written by Heck Allen (novel), Gene L. Coon.
Starring James Caan, Michael Sarrazin, Brenda Scott, Harrison Ford.
Jan-Michael Vincent as Little Bit Lucket.

1967: *The Bandits*
(Lone Star)
Directed by Robert Conrad, Alfredo Zacarías; written by Robert Conrad, Edward Di Lorenzo, Alfredo Zacarías.
Starring Robert Conrad, Manuel López Ochoa, Roy Jenson.
Jan-Michael Vincent as Taye 'Boy' Brown.

JESSE VINT

2017: *Bring Me the Head of Trapper Flint*
Directed by Isaac Medeiros; written by Isaac Medeiros.
Starring Jesse Vint, Erin Hagen, Jeff Shea.
Jesse Vint as Doctor Tulsa McCoy.

1992: *The Young Riders*
Created by Ed Spielman.
(ABC/MGM Television)
Directed by James Keach; written by Ed Spielman, Steven Baum, Charles Grant Craig, Scott Shepherd.
Starring Stephen Baldwin, Josh Brolin, Ty Miller, Don Franklin, Anthony Zerbe.
Jesse Vint as Cody Pierce in 2 episodes.

1982: *Bret Maverick*
"The Not So Magnificent Six"
Directed by Leo Penn; written by Gordon T. Dawson, Geoffrey Fischer, Shel Willens.
Starring James Garner, Ed Bruce, Ramon Bieri, Art LaFleur.
Jesse Vint as Tulsa Jack Turner.

1980: *Belle Starr*
(CBS)
Directed by John A. Alonzo; written by James Lee Barrett.
Starring Eliazabeth Montgomery, Cliff Potts, Michael Cavanaugh, Alan Vint, Geoffrey Lewis.
Jesse Vint as Bob Dalton.

1979: *Centennial*
Created by John Wilder.
Directed by Virgil W. Vogel, Harry Falk, others; written by James A. Michener (novel), John Wilder, Charles Larson, others.
Starring Raymond Burr, Barbara Carrera, Richard Chamberlain, Gregory Harrison, Robert Vaughn, Anthony Zerbe.
Jesse Vint as Amos Calendar in 6 episodes.

1974: *The Godchild*
(ABC/MGM Television)

Directed by John Badham; written by Ron Bishop, Peter B. Kyne (novel).
Starring Jack Palance, Jack Warden, Keith Carradine.
Jesse Vint as Loftus.

1971: *Nichols*
"Where Did Everybody Go?"
(NBC/Warner Bros. Television)
Directed by Frank Pierson; written by Frank Pierson, Buck Houghton.
Starring James Garner, Margot Kidder, Neva Patterson, John Beck, Bill Vint, Alan Vint.
Jesse Vint as Charlie Springer.

Bonanza
"Terror at 2:00"
(NBC)
Directed by Michael Landon; written by David Dortort, Michael Landon.
Starring Lorne Greene, Dan Blocker, Michael Landon.
Jesse Vint as Toby Harris.

1970: *Little Big Man*
(National General)
Directed by Arthur Penn; written by Thomas Berger (novel), Calder Willingham.
Starring Dustin Hoffman, Faye Dunaway, Chief Dan George, Jeff Corey.
Jesse Vint as Lieutenant.

HUNTER VON LEER

1989: *Guns of Paradise*
"The Traveler"
(CBS/Lorimar Television)
Directed by Michael Caffey; written by David Jacobs, Robert Porter.
Starring Lee Horsley, Jenny Beck, Matthew Newmark.
Hunter von Leer as Aleck Varna.

1976: *The Missouri Breaks*
(United Artists)
Directed by Arthur Penn; written by Thomas McGuane.
Starring Marlon Brando, Jack Nicholson, Randy Quaid, Harry Dean Stanton,.
Hunter von Leer as Sandy.

Sara
"Code of the West"
(CBS)
Written by Marian B. Cockrell (novel), Michael Gleason.
Starring Brenda Vaccaro, Louise Latham, Bert Kramer.
Hunter von Leer as Dennis.

1973: *Cahill U. S. Marshal*
(Warner Bros.)
Directed by Andrew V. MvLaglen; written by Harry Julian Fink, Rita M. Fink, Barney Slater.
Starring John Wayne, George Kennedy, Gary Grimes, Royal Dano, Denver Pyle, Harry Carey, Jr.
Hunter von Leer as Deputy Sheriff Jim Kane.

KATERI WALKER

2004: *Renegade*
(Columbia Tristar Home Entertainment)
Directed by Jan Kounen; written by Matthieu Le Naour, Alexandre Coquelle, Gérard Brach, Louis Mellis, Jan Kounen, Jean Girard, Jean-Michel Charlier, Carlo De Boutiny, Cassidy Pope.
Starring Vincent Cassel, Michael Madsen, Juliette Lewis, Ernest Borgnine, Geoffrey Lewis.
Kateri Walker as Kateri.

2000: *Jericho*
(Black Knight Productions)
Directed by Merlin Miller; written by Frank Dana Fran-

kolino, George Leonard Briggs, Robert Avard Miller.
Starring Mark Valley, Leon Coffee, R. Lee Ermey, Buck Taylor.
Kateri Walker as Calypso.

1997: *Stolen Women, Captured Hearts*
(CBS)
Directed by Jerry London; written by Richard Fielder.
Starring Janine Turner, Jean Louisa Kelly, Patrick Bergin, Saginaw Grant, Dennis Weaver.
Kateri Walker as Manipi.

FRED WILLIAMSON

1976: *Joshua*
(Lone Star Pictures International)
Directed by Larry G. Spangler; written by Fred Williamson.
Starring Fred Williamson, Cal Bartlett, Brenda Venus, Isela Vega.
Fred Williamson stars as Joshua.

1975: *Adiós Amigo*
(Atlas Films)
Directed by Fred Williamson; written by Fred Williamson.
Starring Fred Williamson, Richard Pryor, James Brown.
Fred Williamson stars as Big Ben.

Take a Hard Ride
(20th Century Fox)
Directed by Antonio Margheriti; written by Eric Bercovici, Jerrold L. Ludwig.
Starring Jim Brown, Lee Van Cleef, Fred Williamson, Barry Sullivan, Harry Carey, Jr.
Fred Williamson stars as Tyree.

Boss Nigger
(Dimension)
Directed by Jack Arnold; written by Fred Williamson.
Starring Fred Williamson, D'Urville Martin, William Smith, R. G. Armstrong.
Fred Williamson stars as Boss Nigger.

1973: *The Soul of Nigger Charley*
(Paramount)
Directed by Larry G. Spangler; written by Harold Stone, Larry G. Spangler.
Starring Fred Williamson, D'Urville Martin, Denise Nicholas, Richard Farnsworth.
Fred Williamson stars as Charley.

1972: *The Legend of Nigger Charley*
(Paramount)
Directed by Martin Goldberg; written by James Bellah, Martin Goldberg, Larry G. Spangler.
Starring Fred Williamson, D'Urville Martin, Don Pedro Colley.
Fred Williamson stars as Nigger Charley.

LANA WOOD

2019: *Bill Tilghman and the Outlaws*
(One-Eyed Horse Productions)
Directed by Wayne Shipley; written by Dan Searles.
Starring Johnny Crawford, Robert Carradine, Lana Wood, Darby Hinton.
Lana Wood stars as Ms. Darling.

2018: *Wild Faith*
(AMC 16 Burbank)
Directed by Jesse Low; written by DJ Perry.
Starring Lana Wood, Trace Adkins, Darby Hinton.
Lana Wood stars as Opal.

1977: *Grayeagle*
(American International)
Directed by Charles B. Pierce;

written by Brad White, Michael O. Sajbel, Charles B. Pierce, Brad White.
Starring Ben Johnson, Iron Eyes Cody, Lana Wood, Jack Elam, Alex Cord.
Lana Wood stars as Beth Colter.

1972: *Justin Morgan Had a Horse*
(Buena Vista Television)
Directed by Hollingsworth Morse; written by Calvin Clements Jr., Marguerite Henry (novel), Rod Peterson.
Starring Don Murray, R. G. Armstrong, Whit Bissell.
Lana Wood as Kathleen.

1970: *The Over-the-Hill Gang Rides Again*
(ABC)
Directed by George McCowan; written by Richard Carr.
Starring Walter Brennan, Fred Astaire, Edgar Buchanan, Andy Devine, Chill Wills.
Lana Wood as Katie Flavin.

1969: *The Wild Wild West*
"The Night of the Plague"
(CBS)
Directed by Irving J. Moore; written by Ed Adamson, Michael Garrison, Frank L. Moss.
Starring Robert Conrad, Ross Martin, Lana Wood.
Lana Wood stars as Averi Trent.

1967: *The Wild Wild West*
(CBS)
"The Night of the Firebrand"
Directed by Michael Caffey; written by Michael Garrison, Edward J. Lakso.
Starring Robert Conrad, Ross Martin, Pernell Roberts.
Lana Wood as Sheila O'Shaughnessy.

Bonanza
"The Gentle Ones"
(NBC)
Directed by Harry Harris; written by Frank Chase.
Starring Lorne Greene, Michael Landon, Dan Blocker.
Lana Wood as Dana Dawson.

1958: *Have Gun – Will Travel*
"The Teacher"
(CBS)
Directed by Lamont Johnson; written by Sam Rolfe, Herb Meadow.
Starring Richard Boone, Marian Seldes, Andrew Duggan.
Lana Wood as Becky Coldwell.

1956: *The Searchers*
(Warner Bros.)
Directed by John Ford; written by Frank S. Nugent, Alan Le May (novel).
Starring John Wayne, Jeffrey Hunter, Vera Miles, Ward Bond, Natalie Wood, Harry Carey Jr.
Lana Wood as Younger Debbie Edwards.

ROBERT WOODS

1975: *White Fang and the Gold Diggers*
(First Line Films)
Directed by Alfonso Maggi; written by Giuseppe Maggi, Edgar B. Cooper, Piero Regnoli.
Starring Robert Woods, Ignazio Spalla, Franco Lantieri.
Robert Woods stars as Sandy Shaw.

1973: *Sei bounty killersper una strage*
(Silwa Video)
Directed by Franco Lattanzi; written by Ottavio Dolfi, Ambrogio, Molteni.
Starring Robert Woods, Donald O'Brien, Attilio Dottesio.

Robert Woods stars as Stephen McGowan.

Colt in the Hand of the Devil
(Cartoon Media)
Directed by Gianfranco Baldanello; written by Gianfranco Baldanello, Augusto Finocchi.
Starring Robert Woods, William Berger, George Wang.
Robert Woods stars as Roy Koster.

1972: *Kill the Poker Player*
(Kinesis Films)
Directed by Mario Bianchi; written by Mario Bianchi, Paola Bianchi, Luis G. de Blain.
Starring Robert Woods, Frank Braña, Nieves Navarro.
Robert Woods stars as Jonathan Pinkerton - Ace - Senor Londres.

1971: *His Name Was Sam Warbash, But They Call Him Amen*
(Demofilo Fidani)
Directed by Demofilo Fidani; written by Demofilo Fidani, Mila Vitelli Valenza.
Starring Robert Woods, Dino Strano, Benito Pacifico.
Robert Woods stars as Sam Wallash.

Four Candles for Garringo
(I.F.I.S.A.)
Directed by Ignacio F. Iquino; written by Ignacio F. Iquino, Juliana San José de la Fuente, Lou Carrigan (novel).
Starring Robert Woods, Olga Omar, Mariano Vidal Molina.
Robert Woods stars as Sheriff Frank Garringo.

My Name is Mallory ...M Means Death
(Cervo Film)
Directed by Mario Moroni; written by Mario Moroni.
Starring Robert Woods, Gabriella Giorgelli, Teodoro Corrà.
Robert Woods stars as Larry Mallory.

1970: *La sfida dei MacKenna*
(Picturmedia)
Directed by León Klimovsky; written by Pedro Gil Paradela, León Klimovsky, Edoardo Mulargia, Antonio Viader.
Starring Robert Woods, John Ireland, Annabella Incontrera.
Robert Woods stars as Chris.

1969: *La taglia è tua...l'uomo l'ammazzo io*
(Filmar Compagnia Cinematografica)
Directed by Edoardo Mulargia; written by Fabrizio Gianni, Ignacio F. Iquino, Edoardo Mulargia, Fabio, Piccioni.
Starring Robert Woods, Aldo Berti, Marc Fiorini.
Robert Woods stars as Joe Bishop 'El Puro'.

1968: *Gatling Gun*
(Atlántida Films)
Directed by Paolo Bianchini; written by Paolo Bianchini, Claudio Failoni, Franco Calderoni, José Luis Merino.
Starring John Ireland, Robert Woods, Evelyn Stewart.
Robert Woods stars as Cpt. Chris Tanner.

Black Jack
(Cinematografica Mercedes)
Directed by Gianfranco Baldanello; written by Luigi Ambrosini, Augusto Finocchi, Gianfranco Baldanello, Mario Maffei, Mickey Knox.
Starring Robert Woods, Lucienne Bridou, Rik Battaglia.
Robert Woods stars as Jack Murphy - 'Black Jack'.

The Belle Starr Story
(Eureka Films)

Directed by Piero Cristofani, Lina Wertmüller; written by Piero Cristofani, Lina Wertmüller.
Starring Elsa Martinelli, Robert Woods, George Eastman. Robert Woods stars as Cole Harvey.

Pray to God and Dig Your Grave
(Mila Cinematografica)
Directed by Edoardo Mulargia; written by Nino Massari, Edoardo Mulargia, Corrado Patara, Fabio Piccioni.
Starring Robert Woods, Jeff Cameron, Selvaggia.

1967: *Pecos Cleans Up*
(Italcine)
Directed by Maurice Lucidi; written by Adriano Bolzoni, Augusto Caminito, Fernando Di Leo.
Starring Robert Woods, Erno Crisa, Luciana Gilli.
Robert Woods stars as Pecos Martinez.

1966: *2 once di piombo*
(Italcine)
Directed by Maurice Lucidi; written by Adriano Bolzoni.
Starring Robert Woods, Pier Paolo Capponi, Lucia Modugno.
Robert Woods stars as Pecos Martinez.

Johnny Colt
(Ambrosiana Cinematografica)
Directed by Giovanni Grimaldi; written by Giovanni Grimaldi.
Starring Robert Woods, Elga Anderson, Franco Lantieri.
Robert Woods stars as Johnny 'Colt' Blyth - Starblack.

4 Dollars of Revenge
(Balcázar Producciones Cinematográfica)
Directed by Jaime Jesús Balcázar, Bruno Corbucci, Also Grimaldi, Giovanni Grimaldi, José Antonio de la Loma.
Starring Robert Woods, Dana Ghia, Angelo Infanti.
Robert Woods stars as Roy Dexter.

Seven Guns for the MacGregors
(Estela Films)
Directed by Franco Giraldi; Directed by David Moreno Mingote, Fernando Di Leo, Enzo Dell'Aquila, Duccio Tessari.
Starring Robert Woods, Fernando Sancho, Agata Flori.
Robert Woods stars as Gregor MacGregor.

1965: *Man from Canyon City*
(Adelphia Compagnia Cinematografica)
Directed by Alfonso Balcázar; written by Adriano Bolzoni, Attilio Riccio, José Antonio de la Loma.
Starring Robert Woods, Fernando Sancho, Luis Dávila.
Robert Woods stars as Morgan.

Five Thousand Dollars on One Ace
(Balcázar Producciones Cinematográfica)
Directed by Alfonso Balcázar; written by José Antonio de la Loma, Alfonso Balcázar, Sandro Continenza, Helmut Harun.
Starring Robert Woods, Fernando Sancho, Helmut Schmid.
Robert Woods stars as Jeff Clayton.



MORGAN WOODWARD

1994: *The Adventures of Brisco County, Jr.*
"Bounty Hunters' Convention"
(Fox Network/Warner Bros. Television)
Directed by Kim Manners;

written by Jeffrey Boam, Carlton Cuse, James L. Novack.
Starring Bruce Campbell, Julius Carry, Christian Clemenson.
Morgan Woodward as Sam Travis.

1992: *Gunsmoke: To the Last Man*
(CBS)
Directed by Jerry Jameson; written by Earl W. Wallace.
Starring Milburn Stone, Pat Hingle, Amy Stoch.
Morgan Woodward as Sheriff Abel Rose.

1979: *Young Maverick*
"Clancy"
(CBS/Warner Bros. Television)
Directed by Bernard McEveety; written by David E. Peckinpah.
Starring Charles Frank, Susan Blanchard, John Dehner.
Morgan Woodward as Dalton.

How the West Was Won
"The Gunfighter"
(ABC/MGM Television)
Directed by Vincent McEveety; written by Ron Bishop, Steve Hayes.
Starring James Arness, Fionnula Flanagan, Bruce Boxleitner, Jacqueline Scott.
Morgan Woodward as Henry Coe.

1978: *How the West Was Won*
Created by Jim Byrnes, Albert S. Ruddy.
(ABC/MGM Television)
Directed by Vincent McEveety, Bernard McEveety, others; written by Ron Bishop, Steve Hayes, Calvin Clements Jr., William Kelly, Katharyn, Powers, Earl W. Wallace, others.
Starring James Arness, Bruce Boxleitner, Kathryn Holcomb, Fionnula Flanagan.
Morgan Woodward as The Stranger in 3 episodes.

Centennial
"The Massacre"
(NBC/Universal Television)
Directed by Paul Krasny; written by Charles Larson, James A. Michener (novel), John Wilder.
Starring William Atherton, Raymond Burr, Barbara Carrera, Richard Chamberlain, Gregory Harrison, Robert Vaughn, Jorge Rivero.
Morgan Woodward as General Wade.

1977: *The Oregon Trail*
"Wagon Race"
(NBC/Universal Television)
Directed by Lewis Allen.
Starring Rod Taylor, Darleen Carr, Charles Napier, Andrew Prine.
Morgan Woodward as unnamed character.

1976: *The Quest*
"Incident at Drucker's Tavern"
(NBC/Columbia Pictures Television)
Directed by Bernard McEveety; written by Frank Telford.
Starring Gina Alvarado, Tobias Anderson, Julie Cobb, Kurt Russell.
Morgan Woodward as Sam Walker.

1975: *The Last Day*
(NBC/Paramount Television)
Directed by Vincent McEveety; written by Jim Byrnes, Steve Fisher, A. C. Lyles.
Starring Richard Widmark, Barbara Rush, Robert Conrad, Richard Jaeckel, Tom Skerritt.
Morgan Woodward as Ransom Payne.

The Hatfields and the McCoys
(ABC)
Directed by Clyde Ware;

written by Clyde Ware.
Starring Jack Palance, Steve Forrest, Richard Hatch, James Keach, Robert Carradine.
Morgan Woodward as Ellison Hatfield.

1974: *Gunsmoke*
"Matt Dillon Must Die"
(CBS)
Directed by Victor French; written by Ray Goldrup.
Starring Milburn Stone, Ken Curtis, Buck Taylor.
Morgan Woodward as Abraham Wakefield.

Kung Fu
"The Nature of Evil"
(ABC/Warner Bros. Television)
Directed by Robert Michael Lewis; written by Ed Spielman, Herman Miller, Gerald Sanford.
Starring David Carradine, Morgan Woodward, Shelly Novack, John Carradine.
Morgan Woodward stars as The Hanged Man.

1973: *Gunsmoke*
"A Game of Death... An Act of Love: Part 2"
(CBS)
Directed by Gunnar Hellström; written by Paul F. Edwards.
Starring James Arness, Milburn Stone, Amanda Blake, Ken Curtis, Donna Mills.
Morgan Woodward as Bear Sanderson.

Gunsmoke
"A Game of Death... An Act of Love: Part 1"
(CBS)
Directed by Gunnar Hellström; written by Paul F. Edwards.
Starring James Arness, Milburn Stone, Amanda Blake, Ken Curtis, Donna Mills.
Morgan Woodward as Bear Sanderson.

Kung Fu
"Sun and Cloud Shadow"
(ABC/Warner Bros. Television)
Directed by Robert Butler; written by Ed Spielman, Herman Miller, Halsted Welles.
Starring David Carradine, Morgan Woodward, Aimee Eccles.
Morgan Woodward stars as Col. Binns.

Running Wild
(Golden Circle Films Ltd.)
Directed by Robert McCahon; written by Finley Hunt, Robert McCahon, Maurice TomBragel.
Starring Lloyd Bridges, Dina Merrill, Pat Hingle, R. G. Armstrong.
Morgan Woodward as Crug Crider.

One Little Indian
(Buena Vista Distribution Company)
Directed by Bernard McEveety; written by Harry Spalding.
Starring James Garner, Vera Miles, Pat Hingle, Bruce Glover.
Morgan Woodward as Sgt. Raines.

1972: *Gunsmoke*
"The Sodbusters"
(CBS)
Directed by Robert Butler; written by Ron Bishop.
Starring Milburn Stone, Amanda Blake, Ken Curtis, Buck Taylor, Alex Cord.
Morgan Woodward as Lamoor Underwood.

Gunsmoke
"The Wedding"
(CBS)
Directed by Bernard McEveety; written by Harry Kronman.
Starring James Arness, Milburn Stone, Amanda Blake, Sam



Elliott.
Morgan Woodward as Walt Clayton.

Hec Ramsey
"Mystery of the Green Feather"
(NBC/Universal Television)
Directed by Herschel Daugherty; written by Harold Jack Bloom, John Meston.
Starring Richard Boone, Rick Lenz, Rory Calhoun.
Morgan Woodward as Ben Buckley.

1971: *Bonanza*
"The Prisoners"
(NBC)
Directed by William F. Claxton; written by David Dortort, Arthur Heinemann.
Starring Lorne Greene, Dan Blocker, Michael Landon.
Morgan Woodward as Sheriff Clyde Morehouse.

Yuma
(ABC)
Directed by Ted Post; written by Charles A. Wallace.
Starring Clint Walker, Barry Sullivan, Kathryn Hays, Peter Mark Richman, Bruce Glover.
Morgan Woodward as Arch King.

1970: *The High Chaparral*
"The Badge"
(NBC)
Directed by Arthur H. Nadel.
Starring Leif Erickson, Cameron Mitchell, Henry Darrow, Gary Busey.
Morgan Woodward as Billings.

The High Chaparral
"The Journal of Death"
(NBC)
Directed by Leon Benson; written by Frank Chase, Ramona Chase.
Starring Leif Erickson, Cameron Mitchell, Mark Slade.
Morgan Woodward as U. S. Marshal Ted Garnett.

The Wild Country
(Buena Vista Distribution Comapany)
Directed by Robert Totten; written by Calvin Clements Jr., Paul Savage, Ralph Moody.
Starring Steve Forrest, Vera Miles, Ron Howard, Dub Taylor Jack Elam.
Morgan Woodward as Ab Cross.

1969: *Bonanza*
"Old Friends"
(NBC)
Directed by Leon Benson; written by David Dortort, Barney Slater.
Starring Lorne Greene, Dan Blocker, Michael Landon.
Morgan Woodward as Jess Waddle.

The Virginian
"The Bugler"
(NBC/Universal Television)
Directed by Anton Leader; written by Gerry Day, Jeb Rosebrook, Charles Marquis Warren, Owen Wister (novel).
Starring John McIntire, Doug McClure, Tim Matheson, James Drury.
Morgan Woodward as Col. Mark Hamilton.

Death of a Gunfighter
(Universal)
Directed by Don Siegel, Robert Totten; written by Joseph Calvelli, Lewis B. Patten (novel).
Starring Richard Widmark, Lena Horne, Carroll O'Connor, Jacqueline Scott, Dub Taylor, Royal Dano.
Morgan Woodward as Ivan Stanek.



Lancer
"The Great Humbug"
(CBS/20th Century Fox Television)
Directed by William Hale; written by Samuel A. Peeples, Laurence Heath.
Starring James Stacy, Wayne Maunder, Andrew Duggan, Sam Elliott.
Morgan Woodward as Jay McKillen.

The Guns of Will Sonnett
"Trail's End"
(ABC)
Directed by Jean Yarbrough; written by Richard Carr, Kathleen Hite, Aaron Spelling.
Starring Walter Brennan, Dack Rambo, Morgan Woodward, Ruta Lee.
Morgan Woodward stars as Wilk.

1968: *Bonanza*
"Pride of a Man"
(NBC)
Directed by William F. Claxton; written by Ward Hawkins, Helen B. Hicks.
Starring Lorne Greene, Dan Blocker, Michael Landon.
Morgan Woodward as Will McNabb.

The High Chaparral
"The Buffalo Soldiers"
(NBC)
Directed by Joseph Pevney; written by Walter Black.
Starring Leif Erickson, Cameron Mitchell, Mark Slade.
Morgan Woodward as Hilliard.

Firecreek
(Warner Bros./Seven Arts)
Directed by Vincent McEveety; written by Clavin Clements Sr.
Starring James Stewart, Henry Fonda, Inger Stevens, BarBara Luna, Jacqueline Scott.
Morgan Woodward as Willard.

Cimarron Strip
"Heller"
(CBS)
Directed by Gunnar Hellström; written by Christopher Knopf, Austin Kalish, Irma Kalish.
Starring Stuart Whitman, Percy Herbert, Randy Boone, Tuesday Weld.
Morgan Woodward as Logan Purcell.

1967: *The Virginian*
"Requiem for a Country Doctor"
(NBC/Universal Television)
Directed by Don McDougall; written by Judith Barrows, Chester Krumholz, Charles Marquis Warren, Owen Wister (novel).
Starring Charles Bickford, Doug McClure, Clu Gulager, James Drury.
Morgan Woodward as Randall.

Cimarron Strip
"The Last Wolf"
(CBS)
Directed by Bernard McEveety; written by Christopher Knopf, Preston Wood.
Starring Stuart Whitman, Percy Herbert, Randy Boone, Albert Salmi, Denver Pyle.
Morgan Woodward as Bill Henderson.

Cimarron Strip
"The Roarer"
(CBS)
Directed by Lamont Johnson; written by Christopher Knopf, William Wood.
Starring Stuart Whitman, Richard Boone, Percy Herbert, Robert Duvall.
Morgan Woodward as Walter Forcey.

Hondo
"Hondo and the Hanging Town"
(ABC)
Directed by Alan Crosland Jr.; written by Stanley Adams, Andrew J. Fenady, James Edward Grant, Louis L'Amour, George F. Slavin.
Starring Ralph Taeger, Kathie Browne, Noah Beery Jr., Denver Pyle.
Morgan Woodward as Col. Jake Spinner.

1966: *Bonanza*
"Four Sisters from Boston"
(NBC)
Directed by Alan Crosland Jr.; written by John M. Chester.
Starring Lorne Greene, Dan Blocker, Michael Landon.
Morgan Woodward as Luke Catlin.

The Monroes
"War Arrow"
(ABC/20th Century Fox Television)
Directed by Robert Totten; written by Donald S. Sanford.
Starring Michael Anderson Jr., Barbara Hershey, Keith Schultz, Ben Johnson, DubTaylor.
Morgan Woodward as Crocker.

Iron Horse
"Cougar Man"
(ABC)
Directed by Robert Totten; written by Robert Sabaroff, James Goldstone, Stephen Kandel.
Starring Dale Robertson, Gary Collins, Robert Random, Joe Don Baker.
Morgan Woodward as Al Grundy.

Pistols 'n' Petticoats
"No Sale"
(CBS)
Directed by Ezra Stone; written by George Tibbles.
Starring Ann Sheridan, Ruth McDevitt, Douglas Fowley.
Morgan Woodward as Hangman.

Death Valley Days
"An Organ for Brother Brigham"
(Flying 'A' productions)
Directed by Harmon Jones; written by Claire Whitaker.
Starring Hedley Mattingly, Morgan Woodward, John Anderson.
Morgan Woodward stars as Luke Winner.

Gunpoint
(Universal)
Directed by Earl Bellamy; written by Mary Willingham, Willard W. Willingham.
Starring Audie Murphy, Joan Staley, Warren Stevens, Edgar Buchanan, Denver Pyle, Royal Dano.
Morgan Woodward as Drago Leon.

Branded
"The Wolfers"
(NBC)
Directed by Larry Pierce; written by Larry Cohen, Frank Paris.
Starring Chuck Connors, Bruce Dern, Zeme North.
Morgan Woodward as Clyde.

1965: *Bonanza*
"Lothario Larkin"
(NBC)
Directed by William Witney; written by Warren Douglas.
Starring Lorne Greene, Pernell Roberts, Dan Blocker.
Morgan Woodward as Mike Gillis.

Daniel Boone
"The Christmas Story"
(NBC/20th Century Fox Television)
Directed by Maurice Geraghty; written by Stephen Lord.
Starring Fess Parker, Ed Ames, Patricia Blair, Darby Hinton.
Morgan Woodward as Elisha Tully.

Daniel Boone
"The First Stone"
(NBC/20th Century Fox Television)
Directed by Harry Harris; written by Theodore Apstein, Herman Miller.
Starring Fess Parker, Ed Ames, Patricia Blair, Darby Hinton.
Morgan Woodward as Tom Sutton.

The Big Valley
"The Guilt of Matt Bentell"
(ABC)
Directed by Lewis Allen; written by Paul Savage, A. I. Bezzerides, Louis F. Edelman.
Starring Richard Long, Peter Breck, Lee Majors, Linda Evans, Barbara Stanwyck.
Morgan Woodward as Aaron Condon.

Wagon Train
"The Jarbo Pierce Story"
(ABC/Universal Television)
Directed by William Witney; written by Calvin Clements Sr.
Starring John McIntire, Robert Fuller, Frank McGrath.
Morgan Woodward as Clyde.

1964: *Wagon Train*
"The Hide Hunters"
(ABC/Universal Television)
Directed by Virgil W. Vogel; written by John McGreevey.
Starring John McIntire, Robert Fuller, Frank McGrath.
Morgan Woodward as Zach Ryker.

Wagon Train
"The Santiago Quesada Story"
(ABC/Universal Television)
Directed by Virgil W. Vogel; written by Gerry Day.
Starring John McIntire, Robert Fuller, Frank McGrath.
Morgan Woodward as Jute Pardee.

Rawhide
"The Photographer"
(CBS)
Directed by Vincent McEveety; written by Clyde Ware.
Starring Eric Fleming, Clint Eastwood, Paul Brinegar, Eddie Albert.
Morgan Woodward as Kale Maddox.

The Devil's Bedroom
(Allied Artists)
Directed by L. Q. Jones; written by Claude Hall, Morgan Woodward.
Starring John Lupton, Valerie Allen, Dickie Jones, L. Q. Jones.
Morgan Woodward as unnamed character.

1963: *Bonanza*
"The Toy Soldier"
(NBC)
Directed by Tay Garnett; written by Warren Douglas.
Starring Lorne Greene, Pernell Roberts, Dan Blocker.
Morgan Woodward as McDermott.

The Virginian
"The Small Parade"
(NBC/Universal Television)
Directed by Paul Nickell; written by Bernard Girard, John Hawkins, Ward Hawkins, Charles Marquis Warren, Owen Wister (novel).
Starring Lee J. Cobb, Doug

McClure, Gary Clarke, James Drury, R. G. Armstrong.
Morgan Woodward as Jack Bandon.

Wagon Train
"The Sam Pulaski Story"
(ABC/Universal Television)
Directed by Allen H. Miner; written by Allen H. Miner.
Starring Robert Fuller, John McIntire, Frank McGrath.
Morgan Woodward as Pocky.

Wagon Train
"Charlie Wooster--Outlaw"
(ABC/Universal Television)
Directed by Virgil W. Vogel; written by Leonard Praskins.
Starring John McIntire, Frank McGrath, Terry Wilson.
Morgan Woodward as Ciel.

Temple Houston
"Jubilee"
(NBC)
Directed by Robert Totten; written by John Robinson, Paul Savage.
Starring Jeffrey Hunter, Jack Elam, Paul Birch.
Morgan Woodward as Sheriff Ivers.

The Gun Hawk
(Allied Artists)
Directed by Edward Ludwig; written by Jo Heims, Richard Bernstein, Max Steeber.
Starring Rory Calhoun, Rod Cameron, Ruta Lee.
Morgan Woodward as Deputy 'Mitch' Mitchell.

1962: *Wagon Train*
"The Martin Onyx Story"
(ABC/Universal Television)
Directed by Jerry Hopper; written by Robert Libbott.
Starring Robert Horton, John McIntire, Jack Warden.
Morgan Woodward as Second Killer.

Have Gun – Will Travel
"Man in an Hourglass"
(CBS)
Directed by Jerry Hopper; written by Anthony Lawrence, Gustave Field, Herb Meadow, Sam Rolfe.
Starring Richard Boone, Edgar Buchanan, James Stacy.
Morgan Woodward as Canute – Henchman.

Lawman
"The Witness"
(ABC/Warner Bros. Television)
Directed by Gunther von Fritsch; written by Jack Hawn.
Starring John Russell, Peter Brown, Peggie Castle.
Morgan Woodward as Nathan Adams.

1961: *Bonanza*
"The Secret"
(NBC)
Directed by Robert Altman; written by John Hawkins.
Starring Lorne Greene, Pernell Roberts, Dan Blocker, Michael Landon.
Morgan Woodward as Deputy Sheriff Rick Conley.

Wagon Train
"The Kitty Allbright Story"
(ABC/Universal Television)
Directed by David Butler; written by Norman Jolley.
Starring John McIntire, Robert Horton, Polly Bergen.
Morgan Woodward as Barney.

Wagon Train
"The Jed Polke Story"
(ABC/Universal Television)
Directed by Virgil W. Vogel; written by Peter Germano.
Starring John McIntire, Robert Horton, Terry Wilson.

Morgan Woodward as Walt Keene.

Wagon Train
"The Patience Miller Story"
(ABC/Universal Television)
Directed by Mitchell Leisen; written by Jean Holloway.
Starring Ward Bond, Robert Horton, Rhonda Fleming.
Morgan Woodward as Chief Spotted Horse.

Tales of Wells Fargo
"Trackback"
(NBC)
Directed by R. G. Springsteen; written by Ed Adamson, Frank Gruber.
Starring Dale Robinson, William Demarest, Virginia Christine.
Morgan Woodward as Steve Taggart.

The Life and Legend of Wyatt Earp
(ABC)
Directed by Paul Landres, Sidney Salkow, others; written by Frederick Hazlitt Brennan, Wilda McGinnis, others.
Starring Hugh O'Brian, Douglas Fowley, Morgan Woodward.
Morgan Woodward stars as Shotgun Gibbs in 79 episodes.

1960: *Bonanza*
"Death at Dawn"
(NBC)
Directed by Charles F. Haas; written by Laurence E. Mascott.
Starring Michael Landon, Lorne Greene, Pernell Roberts, Dan Blocker.
Morgan Woodward as Sheriff Biggs.

Wagon Train
"The Jeremy Dow Story"
(ABC/Universal Television)
Directed by Virgil W. Vogel; written by Harold Swanton.
Starring Robert Horton, John McIntire, Leslie Nielsen.
Morgan Woodward as Jubal Ash.

Wagon Train
"The Alexander Portlass Story"
(ABC/Universal Television)
Directed by Jerry Hopper; written by Peter Barry, Dick Nelson, Leonard Praskins.
Starring Ward Bond, Robert Horton, Peter Lorre.
Morgan Woodward as Jupe.

Bat Masterson
"The Big Gamble"
(NBC)
Directed by Franklin Adreon; written by Richard O'Connor (book), Michael Fessier.
Starring Gene Barry, Arch Johnson, Morgan Woodward.
Morgan Woodward stars as Kana.

The Texan
"Town Divided"
(CBS)
Directed by Edward Ludwig; written by Robert Leslie Bellem.
Starring Rory Calhoun, Morgan Woodward, June Blair.
Morgan Woodward stars as mark Jordan.

1959: *Frontier Doctor*
"Strange Cargo"
(Studio City Television Productions)
Directed by William Witney; written by Terence Maples, Milton Raison.
Starring Rex Allen, John Dierkes, Harry Hickox.
Morgan Woodward as unnamed character.

The Restless Gun
"Incident at Bluefield"

(NBC)
Directed by Edward Ludwig; written by Frank Burt, Herman Groves.
Starring John Payne, Alan Hale Jr., John Litel.
Morgan Woodward as J. B. Cauter.

Cimarron City
"Blind Is the Killer"
(NBC)
Directed by John Meredyth Lucas; written by Robert C. Dennis, David Lord.
Starring George Montgomery, Audrey Totter, John Smith, Robert Fuller.
Morgan Woodward as Flip.

1958: *Wagon Train*
"The Bill Tawnee Story"
(ABC/Universal Television)
Directed by David Butler; written by Dwight Newton, Hendrik Vollaerts.
Starring Ward Bond, Robert Horton, Macdonald Carey.
Morgan Woodward as Ben Lafferty.
The Life and Legend of Wyatt Earp
"Three"
(ABC)
Directed by Frank McDonald; written by Frederick Hazlitt Brennan.
Starring Hugh O'Brian, Morgan Woodward, Stuart Randall.
Morgan Woodward stars as Captain Langley.

The Life and Legend of Wyatt Earp
"The Manly Art"
(ABC)
Directed by Frank McDonald; written by Daniel B. Ullman.
Starring Hugh O'Brian, Tom Brown, Morgan Woodward.
Morgan Woodward stars as Starbuck.

The Restless Gun
"The Way Back"
(NBC)
Directed by Edward Ludwig; written by Robert Leslie Bellem, Frank Bonham, Frank Burt.
Starring John Payne, Dan Blocker, Bek Nelson, James Coburn.
Morgan Woodward as Jubal Carney.

The Restless Gun
"The Manhunters"
(NBC)
Directed by Edward Ludwig; written by Frank Burt, Richard Harper, Herbert Little Jr., David Victor.
Starring John Payne, Tom Pittman, Kay Stewart.
Morgan Woodward as Ben Cotterman.

Ride a Crooked Trail
(Universal)
Directed by Jesse Hibbs; written by Borden Chase, George Bruce.
Starring Audie Murphy, Gia Scala, Walter Matthau, Henry Silva.
Morgan Woodward as Durgan.

Buckskin
"The Outlaw's Boy"
(NBC)
Directed by Edward Ludwig; written by Harold Swanton.
Starring Tom Nolan, Sally Brophy, Michael Lipton.
Morgan Woodward as Pike Meadows.

Broken Arrow
"The Outlaw"
(20th Century Fox Television)
Directed by Bernard L. Kowalski; written by Elliott Arnold (novel), Herbert Purdom.

Starring John Lupton, Michael Ansara, Philip Ober.
Morgan Woodward as Blue.

Sugarfoot
"Hideout"
(ABC/Warner Bros. Television)
Directed by Montgomery Pittman; written by Russell S. Hughes, Maurita Pittman.
Starring Will Hutchins, Paul Fix, Peter Brown.
Morgan Woodward as Yates.

Cheyenne
"The Gamble"
(ABC)
Directed by Leslie H. Martinson; written by Albert Aley, L. L. Foreman.
Starring Clint Walker, Evelyn Ankers, Theodora Davitt.
Morgan Woodward as Bradan.

1957: *Tales of Wells Fargo*
"Renegade Raiders"
(NBC)
Directed by George Waggner; written by William F. Leicester.
Starring Dale Robinson, Denver Pyle, Francis McDonald.
Morgan Woodward as Phil Slavin.

Gunsight Ridge
(United Artists)
Directed by Francis D. Lyon; written by Talbot Jennings, Elisabeth Jennings.
Starring Joel McCrea, Mark Stevens, Joan Weldon, Slim Pickens, L. Q. Jones.
Morgan Woodward as Tex – Lazy Heart Ranch Hand.

1956: *Westward Ho, the Wagons!*
(Buena Vista Film Distribution Company)
Directed by William Beaudine; written by Thomas W. Blackburn, Mary Jane Carr.
Starring Fess Parker, Kathleen Crowley, Jeff York.
Morgan Woodward as Obie Foster.

Zane Grey Theater
"A Quiet Sunday in San Ardo"
(CBS/Four Star Productions)
Directed by Ted Post; written by James Edmiston, Aaron Spelling, James Edmiston.
Starring Wendall Corey, Gerald Mohr, Peggie Castle.
Morgan Woodward as Pete Daley.

The Great Locomotive Chase
(Buena Vista Film Distribution Company)
Directed by Francis D. Lyon; written by Lawrence Edward Watkin.
Starring Fess Parker, Jeffrey Hunter, Jeff York, Harry Carey Jr., Slim Pickens.
Morgan Woodward as Alex.

ROB WORD

2004: *Wild West Tech*
"Western Towns"
(History Channel)
Directed by Laura Verklan; written by Laura Verklan
Starring Keith Carradine, James A. E. Fuentez, Drew Gomber.
Rob Word as Clay Allison.

1994: *Outlaws: The Legend of O.B. Taggart*
(Northern Arts Entertainment, Inc.)
Directed by Rupert Hitzig; written by Mickey Rooney.
Starring Ben Johnson, Mickey Rooney, Randy Travis, Ernest Borgnine, Ned Beatty.
Rob Word as Pike.

HARRIS YULIN

2001: *American Outlaws*
(Warner Bros./Morgan Creek Entertainment)
Directed by Les Mayfield; written by Roderick Taylor, John Rogers.
Starring Colin Farrell, Scott Caan, Ali Larter, Ronny Cox.
Harris Yulin as Thaddeus Rains, President Rock Northern Rail Road.

2000: *The Virginian*
(TNT)
Directed by Bill Pullman; written by Owen Wister (novel), Larry Gross.
Starring Bill Pullman, Diane Lane, John Savage, James Drury, Dennis Weaver.
Harris Yulin as Judge Henry.

1979: *The Last Ride of the Dalton Gang*
(NBC)
Directed by Dan Curtis; written by Earl W. Wallace.
Starring Cliff Potts, Randy Quaid, Larry Wilcox, Royal Dano, Terry Kiser, Bo Hopkins.
Harris Yulin as Jesse James.

1978: *How the West Was Won*
Created by Jim Byrnes, Albert S. Ruddy.
Directed by Bernard McEveety, Vincent McEveety; written by Calvin Clements Jr., John Mantley, Earl W, Wallace, Howard Fast.
Starring James Arness, Bruce Boxleitner, Fionnula Flanagan, Kathryn Holcomb, Slim Pickens.
Harris Yulin as Deek Peasley in 5 episodes.

1977: *Ransom for Alice!*
(NBC/Universal Television)
Directed by David Lowell Rich; written by Jim Byrnes.
Starring Gil Gerard, Yvette Mimieux, Charles Napier, Gene Barry.
Harris Yulin as Isaac Pratt.

1975: *Little House on the Prarie*
"Child of Pain"
(NBC)
Directed by Victor French; written by Blanche Hanalis, Laura Ingalls Wilder (books), John Meston.
Starring Michael Landon, Karen Grassle, Melissa, Gilbert.
Harris Yulin as John Stewart.

1971: *'Doc'*
(United Artists)
Directed by Frank Perry; written by Pete Hamill.
Starring Stacy Keach, Faye Dunaway, Harris Yulin.
Harris Yulin stars as Wyatt Earp.

ACKNOWLEDGMENTS

I'm sincerely grateful for the enlightened support of a number of individuals and their commitment to this portrait collection, most especially the crew, who passionately worked to bring this book to fruition:

Robert Zinner, master wardrobe, armorer, props and artifacts
Poppy Ruiz, project coordinator
Randy Lalaian, set builder and special effects
Carol Hills, set builder and dresser
Linda Sixfeathers, hair and makeup artist
Robert Burkinshaw, antiques dealer
Cody Merrick, production assistant
Danny Chuchian, set builder and special effects
Tami Orloff, stylist
Denise Chuchian-Ocampo, hairstylist
Paula June Cantu, makeup artist
Lance Todd, set dresser
Max Aria, set photographer

This book project owes much to the support and assistance of Maxine Hansen, The Autry Museum of the American West, Roger Corman, Dusan Stulik, Ph.D., Gary P. Carver, Ph.D., Darlene T. Carver, Gina and Kim Weston, Gray Frederickson, Bill and Walt Olsen, Henry Parke, Gregory Gast, Terry "Slim" Callahan, Andrea Thompson, Judy Diamond, Terry Later, James Craigmiles, Chanel Capra, Alicia Allain, Orien Richman, Juan Bastos, Nancy DeNicola, Raymond Rahimzadeh, Diana Anderson, Rosemary and Thomas Warkentin, Bill Reinhart, Aaron Carver, Philip Fagan, Russell Dodson, Ron Shipp, Andres TaTa Carranza, Christy and Paul Haines, Peter Alexander, Jack Gelnak, Marlon Marcelo, JC O'Neal, Chris Kriesa, Ray Galindo, Gerardo Perez, Rina Cueva, Andy Marx, Patricia Clements, Inga Binga, Spencer Canon, Steve Stafford and Indiana.

Inestimable thanks to Rob Word, producer and Western historian, Al Frisch, Hollywood authority on movie costumes and guns, and Phil Spangenberger, *True West's* Firearms Editor and producer of Wild West shows.

Finally, the diligent interns: Jake Schmidt, Jincy Brown Jennings, Claire Reedy, Alyssa Valencia and Madison Nenkervis.